THE
VATICAN
COLLECTIONS
THE PAPACY AND ART

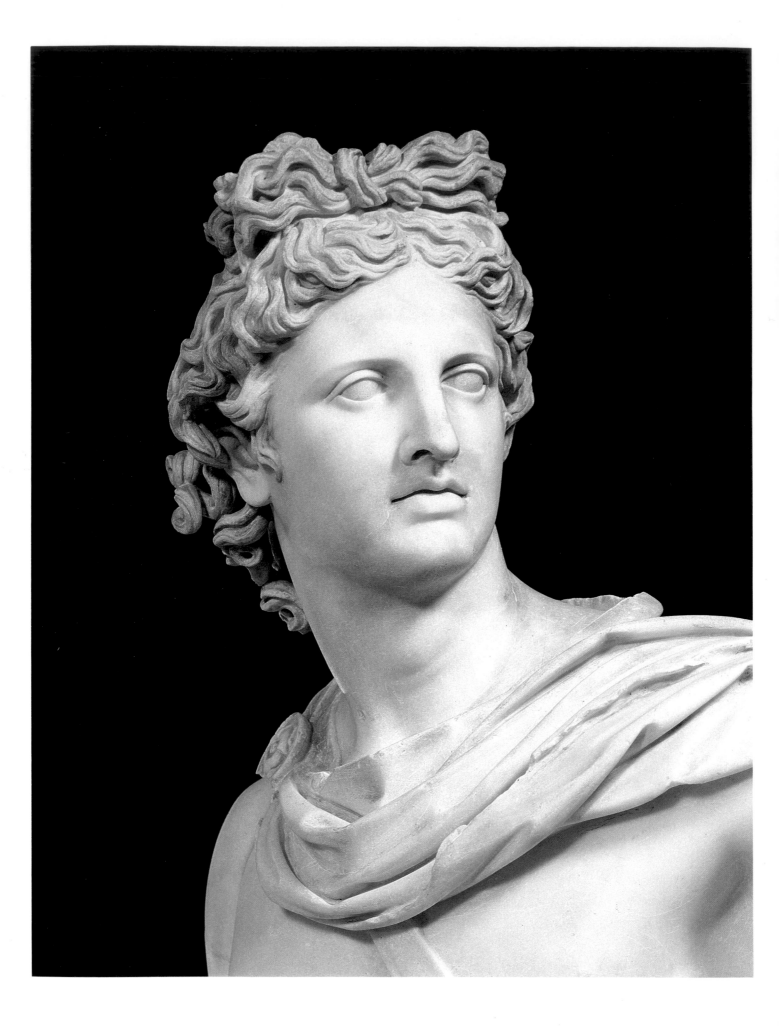

THE VATICAN COLLECTIONS

THE PAPACY AND ART

OFFICIAL PUBLICATION AUTHORIZED BY THE VATICAN MUSEUMS

THE METROPOLITAN MUSEUM OF ART, NEW YORK

HARRY N. ABRAMS, INC., PUBLISHERS, NEW YORK

THE EXHIBITION SCHEDULE IS AS FOLLOWS:

THE METROPOLITAN MUSEUM OF ART, NEW YORK
FEBRUARY 26—JUNE 12, 1983

THE ART INSTITUTE OF CHICAGO
JULY 21—OCTOBER 16, 1983

THE FINE ARTS MUSEUMS OF SAN FRANCISCO
NOVEMBER 19, 1983—FEBRUARY 19, 1984

THE EXHIBITION HAS BEEN ORGANIZED BY:

CARLO PIETRANGELI
DIRECTOR GENERAL
MONUMENTI MUSEI E GALLERIE PONTIFICIE

PHILIPPE DE MONTEBELLO
DIRECTOR
THE METROPOLITAN MUSEUM OF ART

OLGA RAGGIO
CHAIRMAN, DEPARTMENT OF EUROPEAN SCULPTURE AND DECORATIVE ARTS
THE METROPOLITAN MUSEUM OF ART

MARGARET E. FRAZER
CURATOR, DEPARTMENT OF MEDIEVAL ART
THE METROPOLITAN MUSEUM OF ART

The exhibition has been organized by The Metropolitan Museum of Art, New York, and the Musei Vaticani, Vatican City State.

The exhibition's tour of the United States is sponsored by Philip Morris Incorporated through a generous grant to The Metropolitan Museum of Art.

Pan Am has been designated by The Metropolitan Museum of Art as the official carrier of the exhibition for its transportation assistance.

An indemnity has been granted by the Federal Council on the Arts and Humanities.

The installation of the exhibition at the Metropolitan Museum is made possible, in part, by grants from Manufacturers Hanover Corporation; Merrill Lynch, Pierce, Fenner & Smith Inc.; and The Robert Wood Johnson, Jr. Charitable Trust; at The Art Institute of Chicago, by major funding from Continental Illinois National Bank with additional support from the City of Chicago; and at The Fine Arts Museums of San Francisco, by a generous grant from Standard Oil Company of California and the Chevron Companies.

Front cover/jacket: Melozzo da Forlì. *Music-Making Angel* (detail of cat. no. 76 A). Pinacoteca

Frontispiece: Copy after a bronze attributed to the Greek sculptor Leochares. *The Apollo Belvedere* (detail of cat. no. 20). Marble. C. A.D. 130–40. Museo Pio-Clementino

Back cover/jacket: Melozzo da Forlì. *Music-Making Angel* (detail of cat. no. 76 B). Pinacoteca

Copyright © 1982 The Metropolitan Museum of Art

Published by The Metropolitan Museum of Art, New York
Bradford D. Kelleher, Publisher
John P. O'Neill, Editor in Chief
Ellen Shultz, Editor, assisted by Amy Horbar
Designed by Irwin Glusker
 with Kristen Reilly, Christian von Rosenvinge, and Carla Borea

Library of Congress Cataloging in Publication Data
Main entry under title:
The Vatican collections.

 A catalogue of an exhibition to be shown at the Metropolitan Museum of Art, New York, Feb. 26–June 12, 1983; the Art Institute of Chicago, July 21–Oct. 16, 1983; and the Fine Arts Museums of San Francisco, Nov. 19, 1983–Feb. 19, 1984.
 Includes bibliographical references.
 1. Art—Vatican City—Exhibitions. 2. Christian art and symbolism —Vatican City—Exhibitions. 3. Vatican— Exhibitions. I. Metropolitan Museum of Art (New York, N.Y.) II. Art Institute of Chicago. III. Fine Arts Museums of San Francisco.
N6920.V28 1983 707'.4'013 82-14305
ISBN 0-87099-321-6
ISBN 0-87099-320-8 (pbk.)
ISBN 0-8109-1710-6 (Abrams)

CONTENTS

POPE
JOHN PAUL II

HIS HOLINESS POPE JOHN PAUL II ANNOUNCED THE EXHIBITION "THE VATICAN COLLECTIONS: THE PAPACY AND ART" ON APRIL 29, 1982, IN THE AULA DEL SINODO IN THE VATICAN TO AN ASSEMBLED GROUP OF VATICAN OFFICIALS, AMERICAN PRELATES, MUSEUM DIRECTORS, AND REPRESENTATIVES OF THE PRESS:

Through your efforts to promote the patrimony of art that is preserved in the Vatican, you are giving an eloquent testimony to your esteem for art and for its role in helping to uplift the human spirit to the uncreated source of all beauty.

In its constant concern not to neglect the spiritual dimension of man's nature, and to urge the world to direct its gaze upwards to God—the Designer and Creator of the universe—the Holy See welcomes your devoted collaboration with the Vatican Museums as they strive to communicate to as many people as possible all the cultural benefits of that artistic heritage of which they are the custodian.

In particular, I am happy that our meeting today coincides with the official announcement of the Vatican Exhibition in the United States entitled "The Vatican Collections—The Papacy and Art." This unprecedented event, which was fostered by Cardinal Cooke as a result of my own visit to the United States, immediately found the ready and generous cooperation of so many distinguished persons.... This important initiative, jointly organized by the Vatican Museums and The Metropolitan Museum of Art of New York, in collaboration with The Art Institute of Chicago and The Fine Arts Museums of San Francisco, likewise received the enthusiastic welcome of the Archdioceses of New York, Chicago, and San Francisco.... My special gratitude goes to all the representatives of the museums involved and especially to the directors thereof.

In accordance with the purpose of the exhibition itself, the works of art will begin to relate the long and interesting relationship between the Papacy and art throughout the centuries. Above all, these works of art will have a contribution to make to the men and women of our day. They will speak of history, of the human condition in its universal challenge, and of the endeavors of the human spirit to attain the beauty to which it is attracted. And, yes! These works of art will speak of God, because they speak of man created in the image and likeness of God; and in so many ways they will turn our attention to God himself.

And thus the history of the Church repeats itself: her esteem for art and culture is renewed at this moment and in this generation as in the past....

FOREWORD

The 237 works of art (catalogued as 168 entries) selected for "The Vatican Collections: The Papacy and Art" are a most extraordinary distillation and synthesis of some of the highest moments of human artistic achievement. They will provide the great majority of Americans who have never visited Rome with a unique opportunity to see and to better understand some of the most admired ancient and Renaissance masterpieces—such as the *Apollo Belvedere*, the *Belvedere Torso*, the group of *Marsyas and Athena* after Myron, Raphael's tapestry *The Miraculous Draught of Fishes*, Leonardo's *Saint Jerome*, and Caravaggio's *Deposition*. But above and beyond the presentation of these supremely important works, this exhibition has an entirely different dimension. It is not a mere anthology of treasures culled from the Vatican Museums, but is instead a thoughtful selection of works drawn from the entire range of artistic holdings within the Vatican, including the basilica of Saint Peter's and its Treasury, the Papal Apartments, and the Apostolic Library. Ranging in date from Greek sculptures and vases of the fifth century B.C. to contemporary works of art by André Derain and Henri Matisse, these objects reflect the history of papal patronage and collecting and are thereby able to convey a broad cultural and historical message.

Ever since the founding, about A.D. 320, of the church of Saint Peter's on the site of the tomb of Saint Peter, popes have commissioned, preserved, and collected works of art. In order to show the development and changing meaning of these activities throughout the centuries, this exhibition has been divided into five sections. In the first one, some of the few surviving remains from the decoration of Old Saint Peter's—such as three fine mosaics, two frescoes of Saints Peter and Paul, and a series of reliefs from the fifteenth-century ciborium of the high altar—kindle the visitor's imagination, providing a glimpse of the medieval church that stood for twelve centuries on the site now occupied by the great Renaissance basilica. In the second section, which covers papal patronage from the Late Gothic to the end of the Baroque period, the works exhibited evoke the beauty of the papal palaces in the Vatican, as well as the continuous concern of the popes for the preservation of Roman antiquities and the decoration of Saint Peter's. The colorful murals of the palace interiors are brought to mind by a group of thirteen-to-fourteenth-century frescoes and by precious Flemish tapestries of the early sixteenth century. One of Raphael's best-known tapestries, *The Miraculous Draught of Fishes*, and two of the most splendid and admired sculptures from the Vatican Belvedere—the *Apollo Belvedere* and the *Belvedere Torso*—present, in a dramatic and unique juxtaposition, the harmonious and powerful vision that lies at the heart of High Renaissance art.

A complete set of pontifical vestments and the monumental silver-gilt cross and candlesticks commissioned in 1582 for the main altar of Saint Peter's recall the solemn splendor of the new church, and several rare works by Gian Lorenzo Bernini remind the visitor of the role played by this artist, as well as by the great seventeenth-century popes Urban VIII and Alexander VII, in fostering Baroque art.

With the dawn of the eighteenth century, the focus of papal patronage shifted from the commissioning of great artistic ensembles to an emphasis on historical studies and systematic collecting. Two sections of the exhibition are devoted to this period. The first conveys the essence of the three eighteenth-century collections at the Vatican Museums: the Early Medie-

val reliquaries from the treasury of the Sancta Sanctorum and its precious Byzantine and Romanesque ivories in the Museo Sacro, founded in 1756 by Benedict XIV; the antiquities excavated in Rome during the course of the eighteenth century—including the *Apollo Musagetes* and the *Eros of Centocelle*—in the Museo Pio-Clementino, created by Clement XIV and the future Pius VI in 1770; and the important collection of paintings exhibited in the Pinacoteca that includes rare panels by Sassetta, Gentile da Fabriano, and Fra Angelico, and Raphael's beautiful predellas from his *Coronation of the Virgin* altarpiece and Baglioni *Deposition*.

Nineteenth-century archaeological inquiry is reflected in the creation of four museums under the pontificates of Gregory XVI (1831–46) and Pius IX (1846–78). As antiquities continued to be excavated in Rome and in the papal states, they were collected in the Museo Gregoriano Egizio, Museo Gregoriano Etrusco, Museo Gregoriano Profano, and Museo Pio Cristiano, all established toward the middle of the nineteenth century. It is from their immense holdings that the fourth section of the exhibition presents, in chronological sequence, a selection of significant works: a group of precious Greek and Etruscan vases, several Roman portraits, rare Early Christian and Jewish inscriptions, all enhanced by such better-known masterpieces as the *Augustus of Prima Porta* and the statue of *"The Good Shepherd."*

The popes' interest in art did not exhaust itself with the development of the archaeological museums in the nineteenth century. During the twentieth century—as illustrated in the final section of this exhibition—papal patronage and collecting expanded in new directions. Moving beyond the heritage of Western art, Pius XI founded the Pontificio Museo Missionario-Etnologico in 1926 to "illustrate the efforts of all those who seek to increase the kingdom of God on earth"; from it the exhibition has drawn several African works and examples of the art of various peoples of Oceania and Pre-Columbian South America.

The last museum to be established in the Vatican is the Collezione d'Arte Religiosa Moderna, created in 1973 by Paul VI. A selection of its works by such artists as Georges Rouault, Ben Shahn, Henri Matisse, and Giacomo Manzù closes the exhibition in a tribute to the continuing concern of the Church for art that expresses the religious aspirations of mankind.

This brief outline of the structure of the exhibition reveals the extent of its educational range and the significance of the artistic and historical issues it illuminates. No less important are those instances in which the exhibition has brought new contributions to knowledge. One example is the cleaning and removal of earlier restorations from the *Apollo Belvedere*. Many paintings also have been cleaned, as have a group of terracotta sketch-models by Bernini, adding to our knowledge and understanding of these works of art.

In conclusion, it should be emphasized that the value of this exhibition resides not only in the supreme quality of the individual objects it presents, but also in the cultural experience that it provides of the single longest and most influential collecting tradition in the Western world.

Philippe de Montebello
Director, The Metropolitan Museum of Art

James N. Wood
Director, The Art Institute of Chicago

Ian McKibbin White
Director, The Fine Arts Museums of San Francisco

ACKNOWLEDGMENTS

His Holiness Pope John Paul II's mission to visit and to speak to all peoples of the world inspired the creation and realization of this unprecedented exhibition. In its many aspects, it reflects his will to understand and to foster man's spiritual growth and aspirations to artistic greatness. I am immensely grateful to the Holy See for the privilege of bringing these historic and beautiful works of art to the United States in order to give our visitors joy in the appreciation of the creative spirit in man's nature that transcends his worldly ambitions.

His Eminence Terence Cardinal Cooke, Archbishop of New York and a Trustee of The Metropolitan Museum of Art, played a principal role in making the exhibition possible. He viewed it as an instrument to extend the effect and meaning of His Holiness's visit to the United States, and Cardinal Cooke's continuous commitment and concern were central to its realization. He was joined by His Eminence Agostino Cardinal Casaroli, Secretary of State of the Vatican, in his receptiveness to the wishes of the Holy Father. Cardinal Casaroli patiently and efficiently brought our plans for the exhibition to fruition. In this he was aided by His Eminence Sergio Cardinal Guerri, Pro-President of the Pontifical Commission for the Vatican City State, who guided our ideas and hopes until the exhibition became a reality. His successor, His Excellency Archbishop Paul Marcinkus, who for years had envisioned such an important enterprise, nurtured our exhibition with energy and understanding throughout the exciting period of its formulation. His Excellency Marchese Don Giulio Sacchetti, Special Delegate of the Pontifical Commission, consistently supported the exhibition's formation, development, and realization. I thank them sincerely for their ready assistance and much-needed cooperation.

Cardinal Cooke would also wish me to acknowledge the many advocates in the United States who helped support the exhibition. The most prominent among these are his aide Monsignor Eugene Clark and Lawrence K. Fleischman, Vice President of the Friends of American Art in Religion.

To my colleague and friend Professor Carlo Pietrangeli, Director General of the Vatican Museums, I also give warm thanks. His wide knowledge of papal patronage and the Vatican Collections, as well as of the broader history of artistic accomplishments throughout the centuries, infused our exhibition with special meaning and taste. Dr. Walter Persegati, Secretary and Treasurer of the Vatican Museums, was also indispensable to the exhibition's creation. Ever alert to all facets of its organization, he oversaw each stage along the way with dedication, sound judgment, and helpful tolerance.

I am sincerely indebted to the heads of the other art collections in the Vatican. His Excellency Archbishop Lino Zanini, Delegate to the Fabbrica of Saint Peter's; the Reverend Alfons Stickler, Prefect of the Apostolic Vatican Library; and Monsignor Giovanni Sessolo, Camerlengo, and his predecessor Monsignor Antonio Masci, of the Capitolo of Saint Peter's, were most cooperative in sending to the United States some of their most glorious and historic treasures.

My gratitude extends as well to Dr. Olga Raggio, Chairman of the Metropolitan Museum's Department of European Sculpture and Decorative Arts, who planned and carried through the exhibition in all its aspects with her accustomed flair, using her broad knowledge of Rome and the Vatican to devise the exhibition's theme: to reveal the works of

art through a history of the papacy's patronage of art. Dr. Margaret Frazer, Curator in the Department of Medieval Art and the exhibition's coordinator, monitored the development and growth of the exhibition with constant vigilance and energy from its inception to its installation. Together with me, they continuously refined the selection and display of the works to be exhibited. John P. O'Neill, Editor in Chief, worked for more than two years with Vatican and Metropolitan curators, editors (in particular, with Ellen Shultz), and production specialists to produce the exhibition catalogue. Metropolitan curators who greatly assisted in this project include Dr. Dietrich von Bothmer, Chairman, Department of Greek and Roman Art; Dr. Joan R. Mertens, Curator, Department of Greek and Roman Art; and Katharine Baetjer, Curator, Department of European Paintings.

James Pilgrim, my Deputy Director, supervised with dedication and intelligence both the exhibition's curatorial and administrative apparatus. Because of lack of space in these pages, he must represent the many other people at the Metropolitan Museum who donated their skills, time, and energy to ensure the quality and success of this undertaking.

The exhibition's magnitude and complexity were such that every service of the Vatican Museums was called upon to give of its time and dedication. I wish to acknowledge the help and advice of the heads of the Vatican Museums: Dr. Georg Daltrop, Dr. Mario Ferrazza, Dr. Fabrizio Mancinelli, Monsignor Gianfranco Nolli, the Reverend Jozef Penkowski, and Professor Francesco Roncalli. These individuals were essential to the formulation and outcome of the exhibition, as were the members of the Conservation staff: Dr. Nazzareno Gabrielli; Professor Gianluigi Colalucci; and Sig. Ulderico Grispigni, who expertly restored and prepared the works of art for exhibition, and Patricia Bonicatti, who was invaluable in arranging innumerable appointments, organizing photography, and coordinating many other activities. I also wish to thank the professional staffs of the Fabbrica of Saint Peter's, especially Professor Architect Giuseppe Zander and Dr. Architect Pier Luigi Silvan; Dr. Giovanni Morello of the Apostolic Library, and Professor Agostino Paravicini-Bagliani; and Monsignor Ennio Francia and Monsignor Salvatore Garofalo of the Capitolo of Saint Peter's who, with unfailing good will and industry, granted access to information about their collections. I also wish to emphasize the perceptive and enlightened cooperation given by the directors and staffs of the recipient museums, James N. Wood of The Art Institute of Chicago and Ian McKibbin White of The Fine Arts Museums of San Francisco.

In conclusion, it is my privilege to acknowledge the contributors of financial support, without whom the exhibition would not have been possible. They are first and foremost Philip Morris Incorporated, the sponsor of the national tour; Pan Am, which provided transportation assistance; and the Federal Council on the Arts and Humanities, which granted an indemnity. We also wish to acknowledge grants toward local installation costs: in New York, from Manufacturers Hanover Corporation, Merrill Lynch, Pierce, Fenner & Smith Inc., and The Robert Wood Johnson, Jr. Charitable Trust; in Chicago, from the Continental Illinois National Bank, and the City of Chicago; and in San Francisco, from Standard Oil Company of California and the Chevron Companies.

Philippe de Montebello
Director, The Metropolitan Museum of Art

For centuries great artists and craftsmen have looked to the Vatican as both one of their benefactors and as a preserver of their works. Now it is with pride and satisfaction that we help to bring a stunning selection of these works of art to the United States.

As sponsor of the American tour of "The Vatican Collections: The Papacy and Art," we hope to make a significant contribution to the enjoyment of our cultural heritage. This is in truth a landmark event. We are excited to be part of it as a manifestation of the growing cooperation between business and our great cultural institutions.

George Weissman
Chairman and Chief Executive Officer, Philip Morris Incorporated

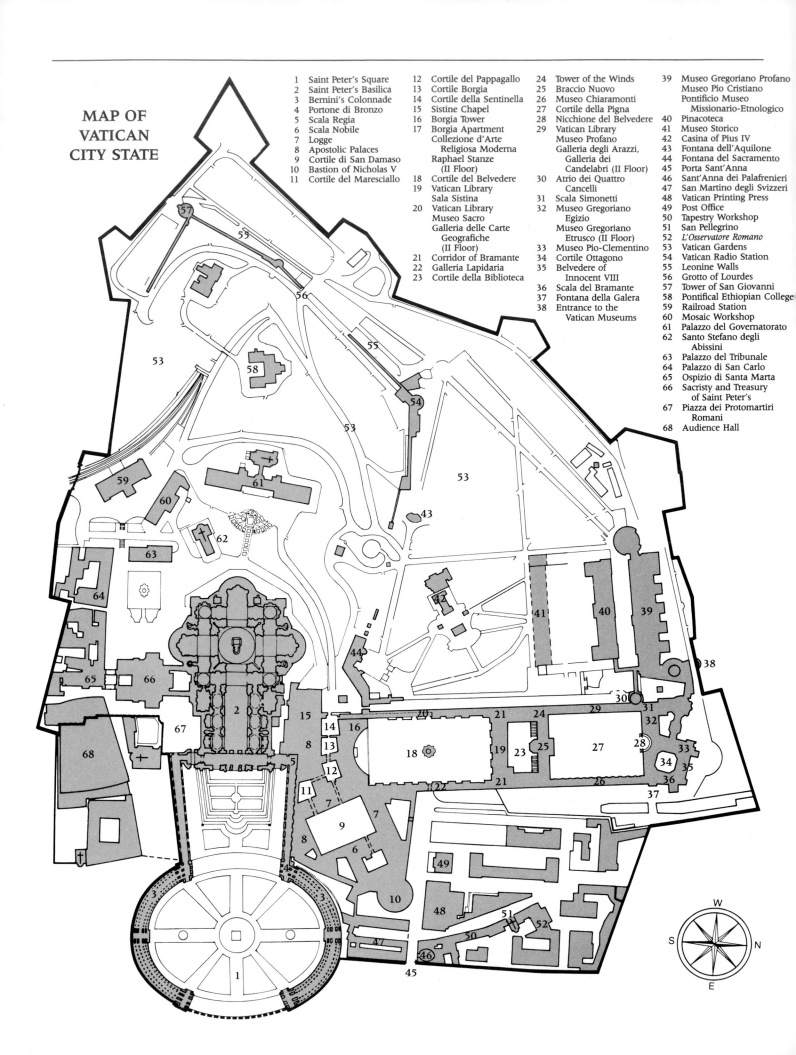

MAP OF VATICAN CITY STATE

1 Saint Peter's Square
2 Saint Peter's Basilica
3 Bernini's Colonnade
4 Portone di Bronzo
5 Scala Regia
6 Scala Nobile
7 Logge
8 Apostolic Palaces
9 Cortile di San Damaso
10 Bastion of Nicholas V
11 Cortile del Maresciallo

12 Cortile del Pappagallo
13 Cortile Borgia
14 Cortile della Sentinella
15 Sistine Chapel
16 Borgia Tower
17 Borgia Apartment
 Collezione d'Arte
 Religiosa Moderna
 Raphael Stanze
 (II Floor)
18 Cortile del Belvedere
19 Vatican Library
 Sala Sistina
20 Vatican Library
 Museo Sacro
 Galleria delle Carte
 Geografiche
 (II Floor)
21 Corridor of Bramante
22 Galleria Lapidaria
23 Cortile della Biblioteca

24 Tower of the Winds
25 Braccio Nuovo
26 Museo Chiaramonti
27 Cortile della Pigna
28 Nicchione del Belvedere
29 Vatican Library
 Museo Profano
 Galleria degli Arazzi,
 Galleria dei
 Candelabri (II Floor)
30 Atrio dei Quattro
 Cancelli
31 Scala Simonetti
32 Museo Gregoriano
 Egizio
 Museo Gregoriano
 Etrusco (II Floor)
33 Museo Pio-Clementino
34 Cortile Ottagono
35 Belvedere of
 Innocent VIII
36 Scala del Bramante
37 Fontana della Galera
38 Entrance to the
 Vatican Museums

39 Museo Gregoriano Profano
 Museo Pio Cristiano
 Pontificio Museo
 Missionario-Etnologico
40 Pinacoteca
41 Museo Storico
42 Casina of Pius IV
43 Fontana dell'Aquilone
44 Fontana del Sacramento
45 Porta Sant'Anna
46 Sant'Anna dei Palafrenieri
47 San Martino degli Svizzeri
48 Vatican Printing Press
49 Post Office
50 Tapestry Workshop
51 San Pellegrino
52 L'Osservatore Romano
53 Vatican Gardens
54 Vatican Radio Station
55 Leonine Walls
56 Grotto of Lourdes
57 Tower of San Giovanni
58 Pontifical Ethiopian College
59 Railroad Station
60 Mosaic Workshop
61 Palazzo del Governatorato
62 Santo Stefano degli
 Abissini
63 Palazzo del Tribunale
64 Palazzo di San Carlo
65 Ospizio di Santa Marta
66 Sacristy and Treasury
 of Saint Peter's
67 Piazza dei Protomartiri
 Romani
68 Audience Hall

THE
VATICAN
COLLECTIONS

─────

THE PAPACY AND ART

THE
VATICAN
MUSEUMS

T he only public collection of antiquities that existed in Rome until the sixteenth century was that of the Capitoline museums, whose origins may be traced back to 1471, when Pope Sixtus IV (1471–84) donated the Lateran bronzes to the people of Rome. The birth of the Vatican Museums coincides with the ascent to the papacy of Julius II (1503–13; see fig. 1). However, this first Vatican collection was of a somewhat different character—almost a princely private collection.

In 1503, the new pope transferred to the Vatican the statue of Apollo, which, until then, he had kept in the garden of his cardinal's residence at San Pietro in Vincoli. The sculpture was placed in the Palazzetto of Innocent VIII, designed by Pollaiuolo on the pleasant Belvedere hillside (fig. 2), a place of repose, chosen by the popes, not far from the Vatican Palace. Hardly any time had elapsed since Pinturicchio had decorated the Vatican apartments of Alexander VI (1492–1503), and very soon Michelangelo would fresco the ceiling of the Sistine Chapel (1508–12) for the same Julius II while Raphael would paint the walls of the Stanza della Segnatura (1509–11), the pontiff's private library.

To better utilize the Palazzetto del Belvedere, Julius II commissioned Bramante to connect it with the pope's apartment—the so-called Stanze of Raphael—by means of a walkway that would reach the upper floor of the Belvedere. The walk, supported by a series of arches that compensated for the uneven terrain, was to be level.

Included in this project was the creation of a garden courtyard planted with orange trees and embellished with fountains, next to Pollaiuolo's building. In the walls of the courtyard were niches that would be filled with sculptures—

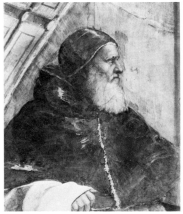

FIG. 1. RAPHAEL. POPE JULIUS II (DETAIL). FRESCO. 1511–12. STANZA D'ELIODORO

probably works already in the Vatican—such as the *Apollo Belvedere*, thirteen gigantic marble masks that were set into the courtyard walls, and a statue of a Roman lady, looking like Venus, with Amor beside her, called the *Venus Felix*. In 1506, the modest collection was enriched by the *Laocoön* group (discovered at the Baths of Trajan in January of that year), and, soon after, by the statue of Hercules carrying the little Telephus—described as a portrait of Commodus, "the wicked and dirty emperor," by Ulisse Aldrovandi.

Francesco Albertini, in 1510, spoke of the marvels of ancient and modern Rome; he recalled, first, "the Antiquario delle Statue," and noted that above a door to the courtyard one read the Virgilian motto "Procul este, prophani" (Begone, ye profane ones), indicating that this Parnassus, or garden of the Hesperides, was to be a place dedicated only to the initiated: the men of letters, the thinkers, and the artists. In fact, the works in the Belvedere were often copied by Raphael; Michelangelo, and his friend Francisco de Hollanda (who made splendid colored drawings after the antique statues in the papal collections); Maarten van Heemskerck, who visited Rome from 1535 to 1536; Primaticcio, who had casts of the sculptures made for Francis I; Baccio Bandinelli, who ran an academy in Rome; and by many other artists. Between 1513 and 1516, Leonardo da Vinci was the guest of Pope Leo X (1513–21).

In 1512, the orange grove in the center of the courtyard was enhanced by the addition of two gigantic statues that recently had been discovered in the Campus Martius: the *Tiber* and the *Nile*. Also acquired at this time, from the Maffei Collection, was the *Sleeping Ariadne*, then known as the *Cleopatra*, which adorned a fountain in a corner of the courtyard. Placed in the opposite corner, in a niche designed by

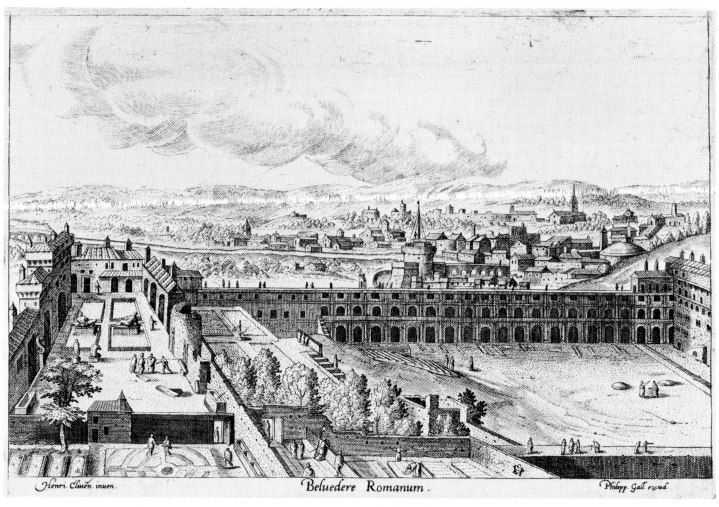

FIG. 2. HENDRIK van CLEVE. VIEW OF THE BELVEDERE FROM THE WEST. ENGRAVING. 1550

Michelangelo, was a statue of a river-god (with a restored head)—called *Tigris*, or the *Arno*—that was also transformed into a fountain.

The two noteworthy accessions under Clement VII (1523–34) were the *Venus ex balneo*, a replica of Praxiteles' *Aphrodite of Knidos*, and the torso of a colossal statue of Hercules, which became famous as the *Torso del Belvedere* and won the admiration of generations of artists, the first of whom was Michelangelo.

The last sculpture to join the Antiquario was the *Antinous*, a Praxitelean statue of Hermes that was found in a vineyard near the Castel Sant'Angelo and acquired in 1543. With this sculpture, the four corners of the courtyard and the center niches in the walls were complete. The two gigantic river-gods were placed in the center, among the orange trees.

In the mid-sixteenth century, the time of Julius III (1550–55), the Antiquario underwent the first change. *Ariadne-Cleopatra* was removed from her niche—and replaced with a modern statue of a river-god—to decorate a grotto at the end of the Corridor of Bramante in the library.

The successors of Julius III, Paul IV (1555–59) and Pius IV (1560–65), dedicated themselves mostly to adorning with ancient statues the Teatro del Belvedere and the "Casina" built by Pirro Ligorio in the gardens.

During the pontificate of Pius V (1566–72)—who was pope during the Counter-Reformation period—a new strictness seemed to prevail at the Vatican. The statues in the Antiquario came to be regarded as pagan "idols," whose presence was inadmissible in the Papal Palace. It was feared that, like the monuments of classical antiquity, they would distract the pilgrims who visited Rome to venerate the tombs of the martyrs. The pope decided to donate some of the statues from the Teatro del Belvedere and the Casina of Pius IV to the people of Rome, to be preserved on the Campidoglio. Other gifts were sent to Florence, to Grand Duke Cosimo I, to the Cardinal of Augsburg, and to Archduke Maximilian II. The pope even considered dismantling the entire collection of the Antiquario, but, when several cardinals pleaded with him not to do so, he decided that the statues could remain, but that they should always be kept hidden. In fact, for some time the wall niches had been fitted with wooden shutters to preserve the precious sculptures from inclement weather (fig. 3).

The rigors of the Counter Reformation passed, but nothing new entered the Vatican's small collection of antique sculpture until the beginning of the eighteenth century, when Clement XI (1700–1721), with the advice of the Veronese antiquarian Francesco Bianchini, assembled an "Ecclesiastical

Museum'' in the Belvedere, consisting primarily of carved inscriptions and bas-reliefs collected as historical documentation.

The museum lasted only a short time, and was dispersed even before the death of the pope, but its basic idea was revived by the Vatican Library. In the Galleria Clementina—formed in the time of Clement XII (1730–40)—a collection of coins (Cardinal Alessandro Albani's collection) and a collection of Etruscan vases (Cardinal Filippo Antonio Gualterio's collection) were exhibited alongside books and manuscripts. The museum grew during the next pontificate, that of Benedict XIV (1740–58), the erudite Bolognese and devotee of art and culture. Several private collections subsequently were added to the so-called Vatican Museum: those of Cardinal Gaspare Carpegna, which included furnishings from the catacombs, porcelain vases, and paintings; of Francesco Ficoroni; of Gori, a priest from Florence; of Saverio Scilla, which contained a large number of pontifical coins; and the gold glasses assembled by Senator Buonarroti and Cardinal Flavio I Chigi.

With Francesco Vettori's donation, the pope decided to create a new museum, the Museo Cristiano, to be located at the end of the Gallery of Urban VIII. The installation was completed in 1756. The purpose of the museum was to document Christianity from its beginnings, and Vettori was named director for life. The gallery was fitted out with beautiful cabinets made of brierwood; its monumental entrance was designed by Paolo Posi, and its ceiling was painted by Stefano Pozzi.

Pope Clement XIII (1758–69) decided to transfer the profane collection to an expressly designated location at the end of the Galleria Clementina, to be called the Museo Profano (fig. 4). This museum would exhibit the numismatic and the glyptic collections, as well as bronzes and ivories. (Upon the suggestion of Cardinal-Librarian Alessandro Albani, Johann Joachim Winckelmann was named director of this new museum and Rome's Commissioner of Antiquities.) The ceiling was also painted by Pozzi, and the handsome cabinets of precious Brazilian wood ornamented with gilt-bronze mounts, still seen today, were designed by Luigi Valadier and added at the time of Pius VI (1775–99).

Until the pontificate of Clement XIV (1769–74), there were two distinct collections of ancient art in the Vatican: the Antiquario, in the Belvedere, which remained unchanged from the mid-sixteenth century; and the ''Vatican Museum'' proper, in the library, which was divided into sacred and profane sections.

In Rome, there were also the Museo Capitolino, and the Pinacoteca attached to it, on the Campidoglio—the prestigious seat of civic authority, but under the direct control of the central government—the only public museums of painting and sculpture in the papal state. If a statue were excavated, or a painting purchased, it was destined, automatically, for the Capitolino, although the collection already was full, with no room to expand.

Clement XIV concerned himself with the continual outflow from Rome of antiquities, which were being sold by private collectors with Italian and foreign dealers serving as

FIG. 3. NORTH FAÇADE OF THE BELVEDERE STATUE COURT, SHOWING ONE OF THE NICHES FITTED WITH WOODEN SHUTTERS (DETAIL). DRAWING. 1720–27. LONDON, THE BRITISH LIBRARY

middlemen. Rome had become, at that time, the main center of the art market for antiquities, and attracted English, German, and Russian collectors.

Clement XIV's treasurer, Giovanni Angelo Braschi, the future Pius VI, advised the pope to acquire antiquities destined to be sent abroad—the Barberini candelabra, the *Meleager* by Skopas, and the Mattei Collection—and, in 1771, an immediate need arose to create a new museum to house these objects. The new museum was called the Clementino. The Palazzetto del Belvedere, where the Antiquario delle Statue already was installed, was chosen as the site. Alessandro Dori was the papal architect, commissioned to adapt the Belvedere to its new function, while the direction of the work fell to Giovanni Battista Visconti, Roman Commissioner of Antiquities, who had succeeded Winckelmann in 1769. The first spaces to be utilized were the loggia and the adjacent ground-floor rooms, which were transformed into the Galleria

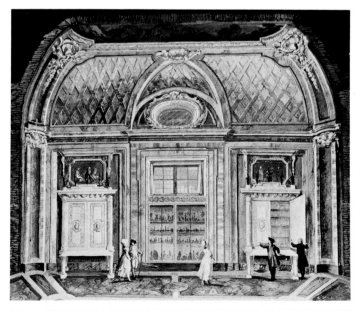

FIG. 4. UNKNOWN PAINTER. *VIEW OF THE MUSEO PROFANO OF THE VATICAN LIBRARY*. FRESCO. c. 1780–81. APARTMENT OF CARDINAL ZELADA (NOW THE MUSEO GREGORIANO ETRUSCO)

delle Statue, the Sala dei Busti, and the Sala degli Animali. The small chapel of San Giovanni Battista, frescoed by Andrea Mantegna—which was the chapel of the Palazzetto of Innocent VIII—was still preserved at this stage. During the course of this work, Dori died. He was succeeded by Michelangelo Simonetti, who continued to be occupied with the museum for the rest of his life.

Once the transformation of the Palazzetto's ground floor had been effected, attention was directed toward making better use of the courtyard where the Antiquario had been; a portico was constructed, thus permitting the removal of the unaesthetic wooden shutters that protected the sculptures. When work was completed at the end of 1773, an inscription commemorating the founding of the new museum was placed in the courtyard.

Contemporaneously, progress was being made at the library. In 1772, in the Corridor of Bramante, Gaetano Marini had initiated and organized the epigraphical collection, while, next to the Museo Sacro, the Gabinetto dei Papiri was sumptuously redecorated. In 1771, funds had been made available to repair the walls, and, the following year, the refurbishing consisted of decorating the floor and walls with colored marbles, and the ceiling with Anton Raphael Mengs's allegorical painting (see figs. 5, 30) of the founding of the Museo Clementino (1772–73).

With the ascension to the papal throne of Pius VI (1775–99), former treasurer of Clement XIV, work on the museum continued (see fig. 6). In 1776, the pope decided to construct two new wings: on one side, lengthening the Galleria delle Statue by linking it with the old Stanza del Torso to create the Sala degli Animali, and building a new gallery, later to be called the Gabinetto delle Maschere; on the other side, creating a complex of very large galleries—the Sala delle Muse, Sala Rotonda, and the Sala a Croce Greca—which by means of the grand staircase (now named after Simonetti), would link the museum with the library (the Museo Profano). The planning and direction of the work by Simonetti necessitated the demolition of the Mantegna chapel, which met with no objections from contemporary scholars.

The new areas, inspired by the architecture of ancient Rome, were ingeniously joined to the old, resulting in more articulated spaces with varying perspectives. This was accomplished by using ancient materials (columns, capitals, paving mosaics, and statues serving as telamones; see fig. 7). Statues were placed on antique bases, or, if the bases were modern, they were richly decorated; busts were set on marble shelves, on two levels; and landscapes were painted on the walls behind some of the most important statues.

The ceilings of the museum were decorated by Tommaso Conca (Sala delle Muse), Domenico De Angelis (Gabinetto delle Maschere), and Cristoforo Unterberger (Galleria delle Statue, Sala dei Busti); the stuccowork was modeled by Gaspare Sibilla, Giacinto Ferrari, and others; the decorative marble sculptures were by Francesco Antonio Franzoni. These new additions were well advanced in 1784 when the Scala Simonetti was opened to the public. One of those responsible for the museum, G. B. Visconti, died in September of that year. His youngest son, Filippo Aurelio, succeeded him as

Commissioner of Antiquities, which included the direction of the museum, while a brother, Ennio Quirino Visconti, was named director of the Museo Capitolino in 1785, and, like his father, continued to oversee the growth of the Vatican Museum and to prepare the impressive seven-volume illustrated catalogue, in folio, completed in 1807.

In 1785, Simonetti began the arrangement of the Galleria dei Candelabri on the second floor, above the Galleria Clementina of the library; upon Simonetti's death in 1787, the very young Giuseppe Camporese finished the construction of the Museo Pio-Clementino and designed the new entrance, the Atrio dei Quattro Cancelli, and, above it, the Sala della Biga (1786–87), whose decoration was not completed until the next year.

A three-room picture gallery, the Pinacoteca, was set up in 1790 to display works gathered especially from the papal

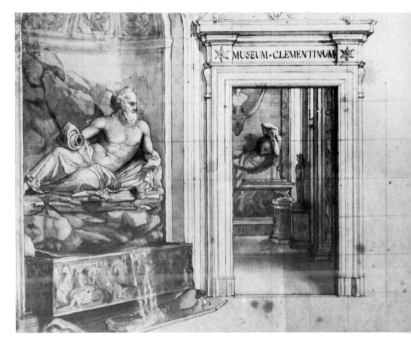

FIG. 5. ANTON RAPHAEL MENGS. *ENTRANCE TO THE MUSEUM CLEMENTINUM* (DETAIL). PREPARATORY DRAWING. 1772/73. FERMO, BIBLIOTECA COMUNALE

palaces, in space that was created in the early eighteenth century by covering over a terrace; it is now the Galleria degli Arazzi.

Meanwhile, the collections continued to grow, as a result of excavations—at Castrum Novum (Torre Chiaruccia, near Civitavecchia), Otricoli, Palestrina, Tivoli, Ostia, "Roma Vecchia" (the Villa dei Quintili), and the Lateran—and acquisitions—the group of Muses and Philosophers from the so-called Villa of Cassius, near Tivoli; Praxiteles' *Apollo Sauroktonos*; the colossal *Genius of Augustus*; the *Juno Sospita*, from Lanuvium; the *Aphrodite* by Doidalsas; the *Diskobolos* of Myron; and the *Mosaic of the Masks*. By 1792, the museum already contained 1,445 items.

The final years of the pontificate of Pius VI were particularly eventful; even the tiny papal states were involved in the French Revolution, the rise of Napoleon, and the occupation

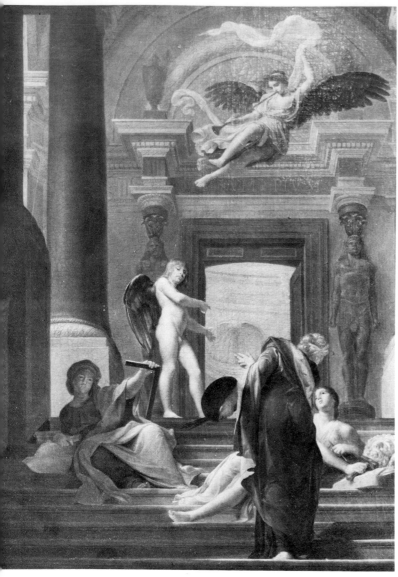

FIG. 6. BERNARDINO NOCCHI. *ALLEGORY OF THE MUSEO PIO-CLEMENTINO*. OIL ON CANVAS. c. 1790. ROME, MUSEO DI ROMA

drea Sacchi, and Guercino's *Saint Petronilla*—all from the Pinacoteca, except for the Guercino, which had been in the Palazzo del Quirinale. Valuable coins and the precious gems and cameos from the Museo Profano were pillaged and the collection practically wiped out. Meanwhile, Pius VI, taken prisoner at the Quirinale and sent to France, died in Valence in 1799.

A new pope, Pius VII (1800–1823), was elected in Venice the following year, and on July 3 triumphantly entered Rome.

One of the first provisions regarding the arts, supported by Cardinal-Secretary of State Consalvi, was the nomination, for life, of the celebrated sculptor Antonio Canova as Inspector General of the Fine Arts for the Pontifical State (August 1802); Canova's prestigious name was favorably accepted by all sides. Then came the Constitution of October 1, 1802, drafted by the new Commissioner of Antiquities, Carlo Fea, which prohibited the export from Rome of works of art, and stated that private owners of art objects that were for sale had to declare them at the Camerlengato. Finally, an annual sum of ten thousand scudi was allotted for acquisitions. Thus, private owners who, until then, because of the competition, could dispose of their works of art at very good prices by selling them to Roman and non-Roman art dealers, now had only one buyer, the state, and, therefore, were forced to accept prices advantageous to the Holy See. A consultative commission of experts was set up to carry out the acquisitions.

Newly acquired works of art gradually filled in the gaps left by Napoleon in the museums, but the Pinacoteca, irreparably damaged, was closed and the remaining paintings used to decorate the Vatican palaces.

The early years of the pontificate of Pius VII were marked by good relations with the French. The pope even went to Paris in 1804 for the coronation of Napoleon as emperor.

In 1805, work began on the new Museo Chiaramonti: The Corridor of Bramante, some 318 meters long, was cleared for the purpose. Half of it was used to establish a Galleria Lapidaria by transferring to it the collection of inscriptions that Marini had begun to organize at the other end of the corridor. In turn, all the antiquities that were acquired following the law of 1802 were arranged, in orderly fashion, along the walls where the inscriptions had been.

In 1808, relations with France worsened and the pope was deported to Savona. Although the French occupied Rome from 1809 to 1814, men of the highest order administered the city—from which it, in fact, benefited.

Canova remained as Director of the Imperial Museums of the Vatican and the Campidoglio. At this time, the Galleria dei Candelabri was lengthened to include the Pinacoteca of Pius VI. The old gallery then became known as the Galleria delle Miscellanee; the new one, as the Galleria dei Candelabri.

After the fall of Napoleon, the Congress of Vienna (1814–15) ruled that works of art removed by the French were to be returned. On August 28, 1815, Canova, nominated Pontifical Plenipotentiary for the recovery of works of art, arrived in Paris, where his mission was greatly obstructed by the French. However, the assistance of the allied powers, notably England, helped in regaining a majority of the art

of a large part of Europe by the armies of the new "Caesar." The pope was obliged to subscribe to the harsh terms of the Treaty of Tolentino (1797), which called for the ceding of a selection of art masterpieces from the Vatican and from throughout the papal states, as well as ancient manuscripts from the library, to be chosen by a commission of experts created by the Directorate and removed from the Vatican between April and June of 1797. After an eventful voyage by land and sea across the rivers and canals of France, the works of art reached Paris, where there was a spectacular procession, in the manner of an ancient triumph (fig. 8). The Louvre, renamed the Musée Napoléon, was the site chosen to exhibit the *Apollo Belvedere*; the *Laocoön*; the *Antinous*; the *Belvedere Torso*; the *Ariadne*; the statues of the Muses; the *Zeus from Otricoli*; the *Meleager*; the Doidalsas *Aphrodite*; the *Diskobolos*; the *Amazon*, from the Mattei Collection; the colossal statues of the *Tiber*, the *Nile*, *Ceres*, and the *Melpomene*; as well as *The Martyrdom of Saint Peter* by Guido Reni, *The Martyrdom of Saint Erasmus* by Poussin, *The Mass of Saint Gregory* by An-

removed from the Vatican and the Roman states. Despite all this, Pius VII made a spontaneous gift of a number of works to King Louis XVIII. The library, simultaneously, was reacquiring part of its plundered collections other than the coins and gems, which, mostly, had been dispersed.

The works reached Rome in two phases: Those that came by land arrived in January, and those that were shipped by sea came in July and August of 1815.

Among other works, two colossal statues remained in Paris—the *Tiber*, and the *Melpomene* from the courtyard of the Palazzo della Cancelleria in Rome—as well as some portrait statues and decorative art.

On February 21, 1816, the pope visited the museum to see the recovered paintings and sculpture. He ordered the construction of a new wing to house recently acquired antiquities, the installation of the new Pinacoteca in the Borgia Apartment, and the lengthening of the Galleria dei Candelabri as far as the Galleria delle Carte Geografiche. The consultative commission was reestablished to oversee the acquisition of such works as the *Athena Giustiniani*, the famous fresco of *The Aldobrandini Wedding*, and a group of Egyptian sculptures; the last, set up in the semicircular corridor behind the Belvedere Niche (the Nicchione), became the nu-

cleus of the Museo Egizio.

The new wing, the Braccio Nuovo of the Museo Chiaramonti, was begun in 1817, after designs by Raffaele Stern, and completed in 1822 by the architect Pasquale Belli after Stern's death.

This light-flooded gallery in the neoclassical style, about seventy meters long and more than eight meters wide, was decorated with mosaics and antique columns, and a barrel-vaulted ceiling containing skylights. Statues were placed in niches, and busts on brackets or column-shaped pedestals. On the walls were a series of allegorical bas-reliefs by Maximilien Laboureur. The Braccio Nuovo was inaugurated by the pope on February 14, 1822.

The Museo Chiaramonti was ornamented from 1817 on—through the munificence of Canova—with a series of lunettes painted by young artists (among whom was Francesco Hayez) illustrating the efforts of the pope toward furthering the fine arts and culture.

Pius VII created the Pinacoteca, initially, with works already in the Vatican Palace that had been returned by France, adding Titian's altarpiece (once at the Quirinale) from San Niccolò dei Frari, near Venice; works drawn from the Capitoline museums; ancient frescoes; and, above all, paintings

FIG. 7. BÉNIGNE GAGNERAUX. *PIUS VI ACCOMPANIES THE KING OF SWEDEN, GUSTAVUS III, ON A VISIT TO THE MUSEO PIO-CLEMENTINO.* OIL ON CANVAS. 1785. STOCKHOLM, ROYAL PALACE

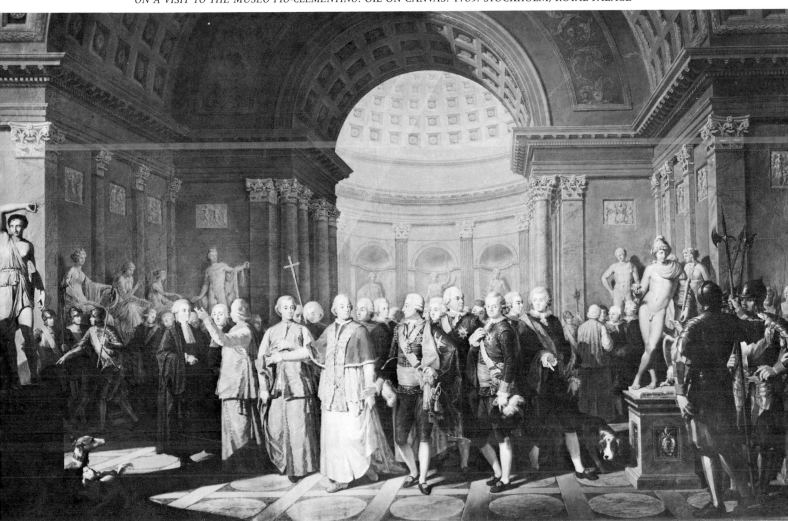

belonging to churches and convents in the pontifical states that had been retrieved from Paris and were held in the Vatican. To the protests of the original owners, Consalvi harshly replied that the works had been lost as a result of the war and had been reconsigned by the allies to the pope so that they could be exhibited to the public, and that the pope could, therefore, dispose of them as he wished.

And so, added permanently to the Vatican collections were paintings by Fra Angelico, works by Raphael and Perugino that were previously in Perugia and Foligno, Raphael's *Transfiguration*, Caravaggio's *Deposition*, *The Communion of Saint Jerome* by Domenichino, Andrea Sacchi's *Saint Romuald*, and Barocci's *Annunciation* and *Blessed Michelina*.

The Pinacoteca, installed in the Borgia Apartment, remained there only a few years, as the rooms were unsuitable. In 1821, the paintings were transferred to the Sala della Bologna, adjacent to the third-floor Logge di San Damaso.

Upon the death of Pius VII, Leo XII (1823–29) became pope. Several important acquisitions during his pontificate were arranged through the Camuccini brothers: the *Caryatid*, which was restored by Thorvaldsen; the *Demosthenes*; the *Amazon*, from Hadrian's Villa; reliefs from Trajan's Forum that were formerly at the Villa Aldobrandini; and the Greek *Relief with a Horseman*, from the Giustiniani family.

In 1824, the Vatican acquired the *Marsyas* by Myron, and a group of portraits, found at Veii, of the Julio-Claudian family, and purchased the *Mosaics of the Athletes*, from the Baths of Caracalla. During this period, the group of sculptures found at Tor Marancia, a bequest to the museum by Princess Marianna of Savoy, Duchess of Chablis, also entered the Vatican. The Pinacoteca was enriched by two important Umbrian works: the altarpiece of *The Coronation of the Virgin* by Pinturicchio, and Lo Spagna's *Nativity*—purchased from the Spineta Monastery near Todi—as well as by the celebrated fresco by Melozzo da Forlì, *Sixtus IV Nominates Platina Prefect of the Vatican Library* (transferred from the library).

Under this pontificate, three large rooms, once used by Pius VI for the Pinacoteca and subsequently transformed by Canova into the new Galleria dei Candelabri, were adapted as galleries. The creation of a permanent place for the Pinacoteca, and a new spectacular view from the Galleria dei Candelabri to the chapel of Saint Pius V, would be completed under Pope Pius VIII (1829–30).

The pontificate of Gregory XVI (1831–46) marked a period of great activity at the Vatican Museums. After Canova died (1822), the office of Inspector General, to which he had been reinstated in 1814 by Pius VII, was discontinued. The museum operated under the direction of the sculptor Antonio d'Este (1754–1837). In 1832, the sculptor Giuseppe Fabris had been named associate—and eventual successor—to d'Este. The idea of a sculptor as director of a museum of ancient sculpture was so deeply rooted at the Vatican that the practice endured—save for a brief hiatus—until 1920. In fact, the director of the museum personally repaired sculptures—generally, this meant complete restorations of the works of art.

Pope Gregory XVI barely had completed the installation of the Pinacoteca in the space readied by his predecessors

when that, too, proved unsuitable; five years later, it was therefore necessary to transfer the paintings to the apartment of Saint Pius V—four rooms, in addition to the chapel. Purchases in this period included the predella by Francesco del Cossa of *The Miracles of Saint Vincent Ferrer* and Titian's *Portrait of the Doge Nicolò Marcello*. The Galleria degli Arazzi moved to the space vacated by the old Pinacoteca—where it remains. It was now possible to display Raphael's precious "Scuola Vecchia" tapestries. These had been stolen during the French Revolution and then sold at a low price, but, fortunately, they were recovered in 1812 and later restored.

About 1837, an important initiative was undertaken by the library, that of assembling in the Museo Cristiano a collection of more than one hundred valuable Byzantine paintings and "primitives" from churches and convents in the pontifical state; these were hung in what became known as the Sala degli Indirizzi. The following year, the library handsomely displayed its own collection of ancient frescoes, the gem being *The Aldobrandini Wedding*, in the adjacent Sala di Sansone.

Gregory XVI founded the Museo Gregoriano Etrusco (fig. 9). It was installed in the apartment of the cardinal-librarian, behind the Nicchione del Belvedere, on the ground floor of the building erected by Pius IV in 1562 as the summer residence of the popes.

The establishment of the Etruscan museum coincided with renewed interest in Etruria, occasioned by the excava-

FIG. 8. ACHILLE-JOSEPH-ÉTIENNE VALOIS. *THE TRIUMPH.*

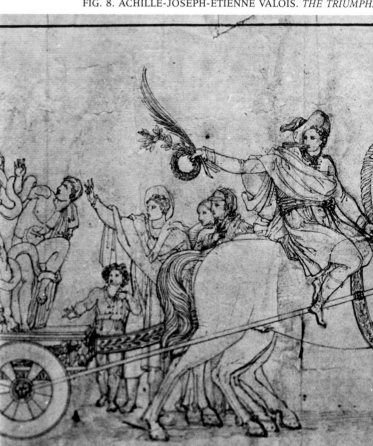

tions in progress and the studies of them that were underway at the newly formed Instituto di Corrispondenza Archeologica and at the Pontifical Archaeological Academy. An agreement had been signed, in 1834, with the Campanari brothers of Toscanella, to undertake the excavations and to divide the objects that were recovered. However, it became necessary to prevent the continual exportation of excavated works, which, despite the protective laws, were disappearing from the pontifical state.

Perhaps the impetus for the creation of the museum was the purchase, in 1835, of the *Mars of Todi*, followed by the acquisition, shortly thereafter, of the exceptionally rich material from the Regolini-Galassi tomb at Cerveteri. After only three months of preparation, the Etruscan museum was inaugurated on February 2, 1837, by Gregory XVI. It contained sculptures, bronzes, terracottas, goldsmiths' work, and Etruscan inscriptions; a group of Greek and Etruscan vases found in the tombs; and, also, furnishings from the archaic necropolises on the Albani hills—all assembled by type of object. There were also an ideal reconstruction of an Etruscan tomb and copies of tomb paintings from Tarquinia and Vulci.

Gregory XVI created the Museo Egizio at a time of heightened interest in Egyptian antiquities, encouraged also by the recent discoveries of J. F. Champollion. As already noted, during the reign of Pius VII the Vatican had assembled a small, specialized sampling of Egyptian art; this was increased greatly after collecting all the Egyptian antiquities—in addition to imitations—in Rome that were public property or that belonged to the state (for example, from the Musei Capitolino, Borgiano, and Kircheriano, and from scattered monuments). Four imposing galleries were put to use, a semicircular one and a series of small rooms on the floor below the Museo Etrusco, decorated by Giuseppe Fabris in a style inspired by the objects to be displayed. The new museum was inaugurated in February 1839 (fig. 10).

This left unresolved the problem of the Graeco-Roman antiquities, which were accumulating in different places in the Vatican palaces. The pope, as a result, decided to found a new museum—the Lateran—using the palace erected by Domenico Fontana for Pope Sixtus V (1585–90), which, improperly cared for, was on the verge of collapse. Once restoration was quickly completed, the museum was set up on two floors. On the ground floor, fourteen rooms were adapted for the Graeco-Roman antiquities, and three rooms on the floor above were set aside for paintings. The Museo Profano Lateranense and the Pinacoteca Lateranense were opened to the public on March 16, 1844, with, among other works, the *Marsyas*; the reliefs from Trajan's Forum; the *Sophokles* from Terracina; the group of Julio-Claudian statues from Veii and Cerveteri; the Braschi *Antinous*, acquired in 1844; and the large *Mosaics of the Athletes*. The Pinacoteca received some eighteenth-century copies after paintings that had been

RRIVAL OF WORKS OF ART FROM THE VATICAN, IN PARIS IN 1798 (DETAIL). DRAWING. SÈVRES, MUSÉE NATIONAL DE CÉRAMIQUE

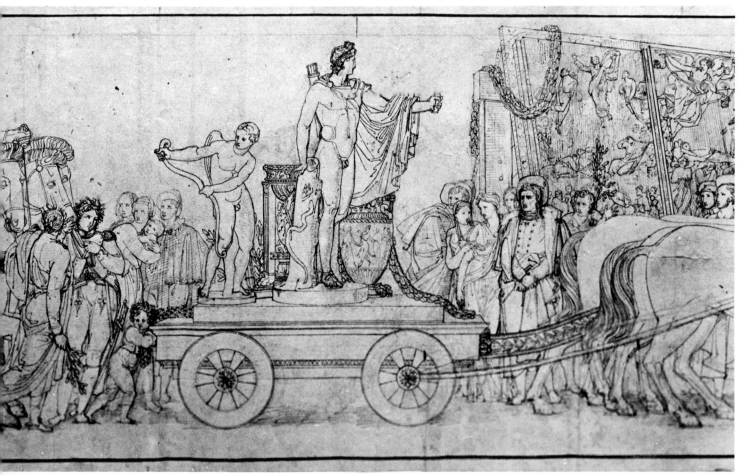

FIG. 9. VIEW OF THE MUSEO GREGORIANO ETRUSCO
IN 1838. LITHOGRAPH (FROM *L'ALBUM*, 5, 1838–39)

reproduced in mosaic in Saint Peter's. Among the recently acquired works were *The Coronation of the Virgin* by Filippo Lippi; the Montelparo polyptych by l'Alunno; *The Annunciation* by Cavalier d'Arpino; two paintings by Palmezzano; and the *Portrait of George IV* by Thomas Lawrence, donated by the British king to Pius VII.

The ascent of Pius IX (1846–78) to the papal throne ushered in a period of great political upheaval: the riots of 1848; the Roman Republic of 1849, when Pius had to leave the papal states; and the capture of Rome by Italian troops in 1870, ending the temporal power of the popes. Several important archaeological discoveries enriched the Vatican Museum at this time: Lysippus' *Apoxyomenos* (found in Trastevere in 1849), the *Augustus of Prima Porta* (discovered in the Villa of Livia in 1863), and the huge bronze *Hercules* (found in 1866 near the Theater of Pompeius), called the Mastai after Pius IX (Mastai-Ferretti). A special commission instituted in 1852 to further research on the catacombs produced notable results. A series of sculptors alternating as director general of the museum continued with Pietro Tenerani and Ignazio Iacometti, while at the Museo Pio-Clementino the rooms were renovated in keeping with current tastes and the walls painted a deep Pompeian red as background for the sculptures.

In 1857, the Pinacoteca once again was installed in the apartment of Gregory XIII in the third loggia of the Cortile di San Damaso. In this period, Leonardo's *Saint Jerome*, a Fra Angelico *Madonna*, the Camerino triptych by l'Alunno, and Guercino's *Saint Margherita* were added to the collections. Where the Pinacoteca had been, a Galleria dei Santi e Beati was established, with mediocre contemporary works, the best of which was the *Gorkum Martyrs* by Cesare Fracassini.

Pope Pius IX created a huge new museum at the Lateran, the Pio Cristiano, which he inaugurated on November 9, 1854. It contained sarcophagi—in large part, from the churches of Rome—and inscriptions from churches and from the catacombs. The collection, the first of its kind in importance and scope, included copies of catacomb paintings and two groups of medieval frescoes from San Nicola in Carcere

and Sant'Agnese fuori le Mura.

Under Pope Leo XIII (1878–1903), Carlo Ludovico Visconti, an archaeologist, became the new director general; he remained at his post for a decade, followed by the sculptor Alberto Galli. Two special directors were nominated: the archaeologist Orazio Marucchi, for the Musei Lateranensi and Egizio; and Bartolomeo Nogara, an Etruscan scholar, for the Museo Gregoriano Etrusco. For the Vatican exhibition for the pope's Jubilee—held during this period—Sultan Habdul Hamid donated the celebrated *Cippus of Abercio* (Abercio was a bishop of Hierapolis in the second century A.D.). The Falcioni Collection of Etruscan and Roman antiquities was acquired for the Museo Gregoriano Etrusco, and the Greek stele of an athlete for the Museo Pio-Clementino.

Queen María Cristina de Borbón, Regent of Spain, donated two precious Tournai tapestries, and Prince Rospigliosi, the Rospigliosi polyptych by Bartolomeo di Tommaso, a rare Quattrocento painting from Umbria. The library was enhanced by the large collection of Cardinal Randi's papal coins.

During the pontificate of Saint Pius X (1903–14), the collections of the Museo Sacro (in the Vatican Library) were augmented, in 1906, by the precious medieval relics found in the altar of the Sancta Sanctorum, the chapel of the medieval Palazzo Lateranense. In 1909, the large Pinacoteca Vaticana was founded in new, more suitable quarters on the ground floor of the Corridor of Pius IV, under the gallery of the library. The new Pinacoteca contained 277 paintings, of which fifty-six were from the old Pinacoteca, nineteen from the Lateran Pinacoteca (which was abolished), and 181 from the Biblioteca Apostolica—the collection of "primitives." Thus, the three groups of paintings in the pontifical palaces finally were united in one location.

The first two volumes of the large catalogue of ancient sculpture by Walther Amelung were published then, as well as the first three volumes of the catalogue of coins by C. Serafini.

During the time of Pope Benedict XV (1914–22), the Museo Lateranense and the Museo Gregoriano Egizio underwent renovation, and the Museo Gregoriano Etrusco was reorganized under Bartolomeo Nogara, the new director general (from 1920).

The next pope, Pius XI (1922–39), a scholar, had been prefect of the Biblioteca Ambrosiana in Milan. The signing of a concordat with the Italian state during his pontificate (in 1929) created the state of Vatican City. For the benefit of visitors, a new entrance to the museums was built on the Viale Vaticano, and a modern Pinacoteca, to house the picture gallery of Pius X, was constructed, both completed in 1932.

The latter, by the architect Luca Beltrami, its large rooms well designed with overhead illumination, was further enriched by the so-called Scuola Vecchia tapestries by Raphael, some precious fragments of frescoes by Melozzo da Forlì from the apse of the Santi Apostoli—until then stored in the Sacristy of Saint Peter's—and several gifts, including the Castellano Collection, the highlight of which was Guido Reni's *Fortuna Gavotti*. Among the more recent gifts was the important *Portrait of Clement IX* by Carlo Maratta.

The new building also housed the offices of the director

general, the library, the photographic archives, and storage space for paintings. In 1923, a paintings conservation studio was established; in 1926, a workshop for restoring tapestries and carpets; and, in 1933, a laboratory for scientific research.

A rearrangement of the Museo Gregoriano Etrusco, begun in 1920, was inaugurated on February 19, 1925. Valuable material from the necropolis at Vulci was included in the collection donated a few years later by Marchese Benedetto Guglielmi of Civitavecchia.

During 1925, a Jubilee year, the "Esposizione Missionaria" took place at the Vatican. When the exhibition closed, rather than disperse the precious objects, Pius XI decided to create the Pontificio Museo Missionario Etnologico. It was established in the Palazzo Lateranense, in twenty-seven rooms and four galleries—to which was added the celebrated Borgia Collection from Velletri, formerly at the Sacra Congregazione di Propaganda Fide.

Following a new division of directorial responsibilities, three noted scholars were put in charge of the different departments of the Vatican Museum: they were the archaeologist Filippo Magi (Classical art); Enrico Josi, also an archaeologist (Early Christian art); and the art historian Deoclecio Redig de Campos (who oversaw the paintings in the Pinacoteca and the Vatican palaces).

A Roman, Pius XII (1939–58), became the next pope. During World War II, the museums were closed from the summer of 1943 until September 30, 1944. Part of the museums' space was used to store Italian works of art that were transferred to the Vatican from the war zones; part, as a supply depot for the needy; and the remainder, as a dormitory for the Guardia Palatina, who welcomed many Italians and foreigners whom the war had endangered.

After the war, the galleries were restored and reopened. In the Cortile delle Corazze, the reliefs from the Flavian period that had been discovered in 1939 under the Palazzo della Cancelleria, along with a frieze of the Julio-Claudian period from the "Altar of the Vicomagistri," were put on display. After 1870, and the loss of jurisdiction over a vast territory of archaeological value, the only acquisitions by the Vatican, other than gifts or purchases, had been those excavated within the area of the tiny state or its extraterritorial dependencies, such as the Palazzo della Cancelleria. One of the above-mentioned reliefs, which was discovered outside the confines of the palace—and, thus, was not under Vatican jurisdiction—was exhibited at the Museo Capitolino. A few years later, the Italian state donated this relief to the Vatican.

The 1939 centenary celebration of the Museo Gregoriano Egizio was marked by the publication of a special collection of essays contributed by specialists from all over the world, and by a notable accession—the Grassi Collection of small objects of Egyptian and Islamic art. The Pinacoteca participated with loans to important exhibitions abroad, and hosted, in the Vatican palaces, a memorable Fra Angelico exhibition.

The twenty-year reign of Pius XII was a very active period for the museums. After the death of Bartolomeo Nogara in 1954, Filippo Magi was acting director for the next seven years. The reorganization of the ancient sculpture in storage provided the opportunity to publish an excellent catalogue

FIG. 10. VIEW OF THE MUSEO GREGORIANO EGIZIO IN 1839. LITHOGRAPH (FROM *L'ALBUM*, 5, 1838–39)

by Guido von Kaschnitz-Weinberg, and allowed Hermine Speier to identify the *Head of a Horse*—originally, from one of the pediments of the Parthenon—that, until then, had been ignored. By means of an exchange with the city of Rome, the missing part of the Greek stele of an athlete was reinstated. Under the direction of Dr. Magi, the sixteenth-century restorations of the *Laocoön* were removed, and many scientific catalogues and guidebooks were published.

Following a study by Luigi Pareti of the material from the Regolini-Galassi tomb (in the Museo Gregoriano Etrusco), it was reorganized, as was the gallery of bronzes and stone urns. The collection of Italiote vases was rearranged in collaboration with A. D. Trendall, who also published them in a catalogue. The layout of the new space allowed for the reorganization of the Sala delle Terracotte, the Falcioni Collection, and the Roman Antiquarium.

The tapestry collection acquired seven scenes from the series of ten illustrating the life of Urban VIII woven in the Barberini tapestry factory in the seventeenth century; the other three were recovered later, in Paris and in Brussels.

Meanwhile, the museum prepared to welcome the masses of people that, yearly, flocked to Rome in greater numbers. During the 1950 Jubilee year, the Vatican Museums were visited by more than one million people, sometimes as many as 12,000 a day.

Next to the Pinacoteca, a department of contemporary art was created in 1957 to house valuable works that the pope received as gifts from Italian and non-Italian artists selected according to a definite plan.

A highlight of the pontificate of John XXIII (1958–63) was the decision to use the Palazzo Lateranense that, in medieval times, had been the papal residence once again for that purpose, as well as for some of the offices of the Vicariate of Rome. The three museums in the Lateran—the Gregoriano Profano, Pio Cristiano, and Missionario-Etnologico—were to be reunited in the Vatican. The Lateran museums were, therefore, closed to the public in February 1963, and the collections carefully put in storage; in the meantime, work start-

ed on the new wing in the Vatican. It was completed under the next pontiff, Paul VI (1963–78). His reign signaled a period of exceptional activity for the museums and a new openness on the part of the Vatican toward contemporary art. The three directors general then were Count Paolo dalla Torre di Sanguinetto, followed by the acting director Professor Roncalli di Montorio (Director of Etruscan and Italic Antiquities) and by Dr. Redig de Campos, noted scholar of Renaissance art.

Reorganization of the Pinacoteca began in 1963, starting with the "primitive" paintings and those of Fra Angelico. The curator is Dr. Fabrizio Mancinelli, responsible for medieval and modern art in the Vatican Museums.

A new regulation, adopted in 1971, divided the Vatican Museums into eight departments: Early Christian, Byzantine, Medieval and Modern, Etruscan-Italic, Classical, Oriental, Epigraphical, and Ethnological, with a director at the head of each one. In keeping with tradition, a director general appointed by the pope presides over the entire complex. Under his jurisdiction are the scientific research laboratory, the conservation studio, and the auxiliary services: the library, photographic archives, and the catalogue office.

In the conservation studio, perhaps the most demanding assignments of late have been the work on Michelangelo's *Pietà*, damaged by a vandal on May 21, 1972; Pietro Cavallini's Crucifix (at San Paolo fuori le Mura in Rome); and Raphael's *Transfiguration*.

The ever-increasing number of visitors, between 1972 and 1975, necessitated the installation of a closed-circuit television system. Visitors' services were reorganized and expanded, and selected itineraries were devised that took into consideration the diversified interests of the public. The new organization was studied in detail by Dr. Walter Persegati, Secretary and Treasurer of the Vatican Museums since 1971, drawing upon the most advanced examples in the field.

A section of the Vatican gardens, adjacent to the Pinacoteca, was chosen as the site of the new wing to house the former Lateran museums. The architectural firm of Vincenzo, Fausto, and Lucio Passarelli designed the new modern building. The architects' main concerns were that it fit in, harmoniously, among the old Vatican palaces, and that the works of art on display be presented in a well-lit and well-thought-out format. The arrangement of the interior is daring, and includes an avant-garde system of modular iron supports on which the sculptures rest. The completed building measures about 70,000 square meters.

The Museo Pio Cristiano was reorganized by Professor Enrico Josi, with the collaboration of Father Umberto M. Fasola, from 1966 to 1970. It occupies the mezzanine of the new building, on the balcony overlooking the Museo Gregoriano Profano, and contains sculpture, mosaics, and architectural fragments, as well as a rich epigraphical collection.

The Museo Gregoriano Profano, which occupies ground-floor space, was organized by Dr. Georg Daltrop, Director of Classical Antiquities, and was inaugurated in 1970 (fig. 11). On exhibition are 640 works, mostly from the Lateran, with several important additions that include the Flavian reliefs from the Palazzo della Cancelleria, the Chiaramonti *Niobid*, and the *Aurae of Palestrina*. Also exhibited are Roman copies of Greek originals and Roman sculpture from the Late Republican to the Late Imperial periods. Within these broad subdivisions, arrangement is by type, subject, and provenance. Two large galleries were set aside for the display of the floor *Mosaics of the Athletes*. Other rooms were reserved for the Laterano-Profano Lapidario, whose organization is a model of its kind: The inscriptions, mounted on sliding, see-through panels, were selected by Dr. Ivan Di Stefano Manzella.

The Pontificio Museo Missionario-Etnologico, housed in a partly subterranean space, with Father Jozef Penkowski as curator, was opened in 1973. It consists of a main gallery of about three thousand objects (about five percent of the collection)—which is geared toward the general public, and demonstrates the religious expression of twenty-five non-European countries and cultures—and a second gallery for scholars.

The Museo Gregoriano Etrusco received the Mario Astarita Collection of Greek, Etruscan, and Italic vases, terracottas, and bronzes, now displayed in a special room that was opened in 1971. The collection also includes numerous fragments, making possible useful exchanges with museums in Berlin (Charlottenburg) and New York (the Metropolitan Museum). The first three rooms of the Museo Gregoriano Egizio (directed by Monsignor Gianfranco Nolli) also were rearranged.

In 1973, a new institution, the Museo Storico, was set up in a large room below the Vatican gardens. There are carriages and motor vehicles from the pontifical stables, arms from the Renaissance, and paraphernalia from the dissolved Army Corps (the Guardia Nobile, Guardia Palatina, and the Gendarmi). The Collection of Modern Religious Art, also formed under the pontificate of Paul VI, was inaugurated on June 23, 1973. Offering a panorama of contemporary art, "in relation to its capacity to express a religious feeling" (in the words of Mario Ferrazza, curator of the Vatican's collection of contemporary art), the earlier collection was augmented, significantly, by gifts from individuals, and as a result of a special national committee organized after an appeal to artists by the pope—in the Sistine Chapel, on May 7, 1964—for a rapprochement between the Church and the contemporary art world. The new collection was installed in areas in the Borgia Tower and Apartment, in the adjacent rooms, as well as in a series of spaces under the Sistine Chapel. In all, some fifty-five rooms provide well-articulated and impressive exhibition space.

The 542 works on exhibition (about half of the collection) include paintings, sculpture, and graphic art, organized by Monsignor Pasquale Macchi with the assistance of Professor Dandolo Bellini, Dr. Mario Ferrazza, and Patrizia Pignatti. After its founding, the museum sponsored numerous exhibitions and seminars, some in collaboration with the association known as Friends of American Art in Religion.

In 1977, the *Bollettino dei Monumenti Musei e Gallerie Pontificie* was first published; it provides an annual summing-up of new accessions, restorations, studies, and changes in installations in the museums.

Under the current pope, John Paul II, elected after the brief reign of John Paul I (1978), the newly arranged first three rooms of the Museo Gregoriano Etrusco opened in 1979, with

the reinstalled Regolini-Galassi tomb. In 1981, the base of the Column of Antoninus Pius, previously in the Cortile della Pigna, was restored and set up in the Cortile delle Corazze, and the Museo Lapidario (formerly in the Palazzo Lateranense) was reinstalled in the Museo Gregoriano Profano.

In 1979, the Department of Medieval and Modern Art organized a traveling exhibition based upon the restoration of Raphael's *Transfiguration* that included photographic enlargements of the work in progress, made possible for the first time through new techniques developed by the Polaroid Corporation. The same year, a special exhibition by the Department of Classical Antiquities focused on *Athena* and *Marsyas*. In 1980, the Department of Nineteenth Century and Contemporary Art presented two exhibitions: one, of recent accessions of modern religious art; the other (organized in the United States by the Friends of American Art in Religion), entitled "A Mirror of Creation," consisted of American landscapes.

The Braccio di Carlo Magno, built by Gian Lorenzo Bernini to the left of Saint Peter's Square, is used for temporary exhibitions assembled by the Vatican. In 1981, to celebrate the three-hundredth anniversary of the death of the sculptor,

an extremely successful exhibition was held there, in collaboration with the Biblioteca Apostolica and the Reverenda Fabbrica of Saint Peter's.

There are also small rotating exhibitions on various subjects of current interest—such as newly restored works—in specially equipped rooms near the Pinacoteca.

The cleaning of Michelangelo's frescoes in the Sistine Chapel was begun in 1980 by the conservation studio, with extraordinary results; the task will take about twelve years to complete. Another recent project of enormous complexity has been the restoration of those paintings and sculptures included in the current Vatican exhibition in the United States—among them, the *Apollo Belvedere*. Through loans from the Vatican Museums, the Holy See, in recent years, has supported exhibitions of high cultural value throughout the world. In this context is the Vatican exhibition in America—one without precedent—which underscores the noble efforts of the popes, over the course of five centuries, in rescuing works of art from neglect and in spreading art and culture by sharing the collections of the Vatican Museums.

Carlo Pietrangeli

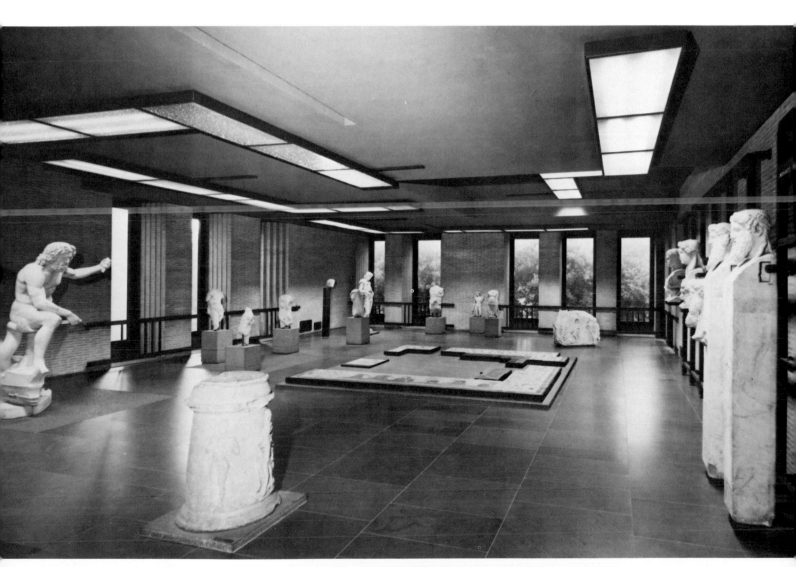

FIG. 11. INSTALLATION VIEW OF THE NEW WING OF THE MUSEO GREGORIANO PROFANO
BUILT BY VINCENZO, FAUSTO, AND LUCIO PASSARELLI

OLD SAINT PETER'S

Saint Peter, to whom Christ gave the keys to his kingdom, was crucified in the Circus of Nero on the west bank of the Tiber River near the populous quarter of Rome, now called Trastevere, where most Jews and other Near Easterners lived. He was interred in a simple burial immediately to the north of the circus. Physical remains of the circus have been discovered by archaeologists south of the present-day basilica of Saint Peter's, abutting its eighteenth-century Sacristy. During World War II, excavations beneath the basilica revealed an extensive and handsome necropolis of mausoleums of the second and third centuries A.D., belonging mostly to the prosperous middle-class families of freedmen. An inscription on one of these mausoleums specifically refers to its being next to the circus. In the middle of this necropolis, an open area was found that contained a simple shrine on which were inscriptions indicating that, from about A.D. 270, the site had been venerated by the Christian community of Rome as the burial place of Saint Peter.

In the early fourth century, when the Emperor Constantine began to patronize the Christian Church, a great basilica was erected over this site. The necropolis was partially demolished in order to provide level ground for the church, and what was left of it was filled in to support the foundations and pavement of the new building. It appears that the construction of the basilica occurred roughly between 320 and 330. The excavations of forty years ago revealed extensive traces of the foundations of this building and something of its rising walls, which, coupled with old drawings and accounts of the sixteenth and early seventeenth centuries, permit a fairly accurate description of the basilica's appearance.

Old Saint Peter's was an extremely large building, measuring about 208 x 355 feet (63 x 108 meters). It comprised a nave and two aisles on each side, abutting, at the altar end, a lateral transept, which, although narrow, extended sideways well beyond this main vessel (fig. 12). On the center line of the nave and transept, a vaulted, semicircular apse opened out, at the midpoint of whose chord rose a monumental trophy structure placed directly above the site venerated as that of Peter's burial. This structure was surmounted by a baldacchino, supported by four twisted and carved columns of Greek marble, which, along with two others, were donated by the emperor. These elaborate columns served as the inspiration for the great twisted columns designed by Gian Lorenzo Bernini to enframe the pontifical altar of the Renaissance church; incorporated into the piers supporting the dome of the present basilica, they survive to this day. When the Constantinian basilica was completed, it achieved its major impression through its size—the approximately 110-foot-high wooden roof over the nave was equal to that of the much later Gothic cathedral of Notre-Dame in Paris—rather than through the elaborateness of its decoration. Envisaged at the time of the basilica's construction, but erected only over a longer period, was a forecourt, or atrium, which was as wide and as long as the nave. Completed in the early sixth century, the atrium was a large, open, paved area surrounded on all four sides by columnar porticoes, preceded by a monumental gatehouse and focused on an imposing central fountain. Some of the fountain's decorative classical elements survive today in the niche of the Cortile della Pigna of the Vatican palaces.

The Vatican Basilica, as it was originally called, remained essentially unaltered for about twelve hundred years. During this period, however, it received innumerable artistic embellishments in the form of rich liturgical furnishings, mosaics, frescoes, statues, and decoratively carved tombs. As a result, the basilica became the embodiment of important religious sentiment, and a monument of historical documentation, as well as a remarkable assemblage of Early Christian, medieval, and Early Renaissance art.

Alfred Frazer

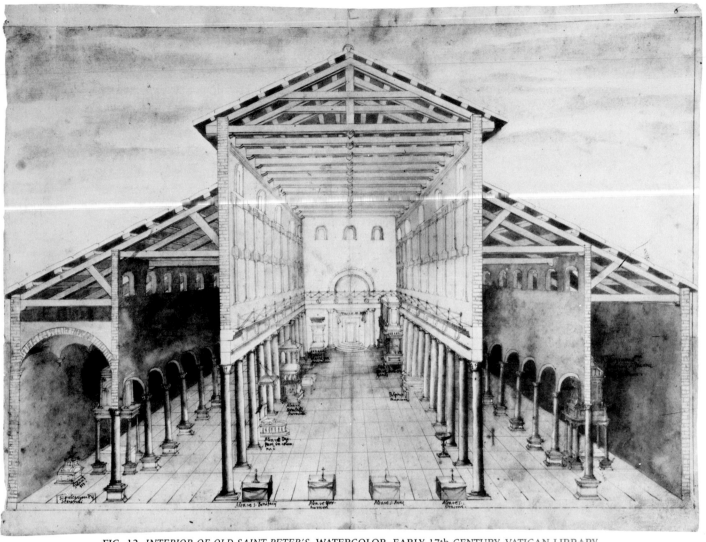

FIG. 12. *INTERIOR OF OLD SAINT PETER'S*. WATERCOLOR, EARLY 17th CENTURY. VATICAN LIBRARY

THE
FABBRICA
OF SAINT PETER'S

The Italian word *fabbrica*, derived from the Latin *fabrica*, signifies the working place of a *faber*, or artificer—an artisan who is a specialist yet not necessarily an artist. In the Middle Ages, a broad distinction arose between the *homo faber*, an artisan of initiative and personality, and the *homo mechanicus*, an ordinary manual craftsman. The workshop of the *homo faber* was considerably more important. Gradually, a new sense of the word *fabbrica* developed in Italy, in the context of the building of sacred edifices, especially the great cathedral churches and sanctuaries (fig. 14).

In Tuscany, cathedral construction was coordinated within the Opera del Duomo, or cathedral works, in the Central European sense. Elsewhere in Italy, the terms *fabbrica* or, in the case of Venice, *procuratoria*, prevailed.

Old Saint Peter's, built by the Emperor Constantine between A.D. 320 and 330—following a tradition that has been confirmed by modern archaeological research—by the time of the Early Renaissance was filled to overflowing with a collection of medieval altars and tombs that spanned a millennium. By the fifteenth century, an obvious need existed for a general restoration of the basilica. To that end, Pope

27

Nicholas V (1447–55) consulted the eminent architect and theorist Leon Battista Alberti, and, with great courage, decided to build a new basilica to replace the old one. He ordered work to begin according to plans by Alberti's follower Bernardo Rossellino, but such difficulties as the Fall of Constantinople (1453) and the pope's death did not permit the building to progress very far during the fifteenth century.

Pope Julius II (1503–13) inaugurated Saint Peter's as we know it today. It was built after the designs of Donato Bramante, with successive additions by Antonio da Sangallo the Younger and, of course, Michelangelo. A series of measures undertaken by Julius II favored the formation of the body that would later be known as the Reverenda Fabbrica di San Pietro (in Latin and in Italian commonly abbreviated R.F.S.P.).

The basilica works set a lively example, proving its efficiency as its dramatic achievements were continually unveiled to the Roman people and to foreign visitors. Such an event as the completion of Michelangelo's cupola (finished after his death by Giacomo della Porta and Domenico Fontana) had far-reaching consequences; the solutions to technical problems that permitted raising the greatest dome in Christendom were closely studied by theorists as well as by architects. The actual building crafts as practiced at Saint Peter's also were emulated elsewhere. Thus, in a seventeenth-century contract for the façade of the Roman church of Sant'Andrea della Valle, it was stipulated that the travertine was to be worked with the same degree of perfection as on Bernini's grand colonnade, which almost rings the piazza of Saint Peter's. The basilica organization continued to develop and flourish in the eighteenth century, overseeing the construction of Carlo Marchionni's monumental Sacristy (of 1776–84) at the southern arm of the transept of Saint Peter's, and, to be sure, the Vatican Museums, themselves.

Pope Clement VII (1523–34) had created a college of sixty members, entrusted with the task of administering the basilica's construction. Once the cupola had been completed, Clement VIII (1592–1605) substituted for the college a congregation of cardinals headed by the archpriest of the basilica as prefect. Benedict XIV (1740–58) strengthened its role with the constitution ''Quanta curarum'' (of 1751). The congregation's powers, diminished by Pius IX in 1863, were reinforced by Saint Pius X's (1903–14) apostolic constitution of 1908, ''Sapienti Consilio,'' and, again, by Paul VI's apostolic constitution of 1967, ''Regimini Ecclesiae Universae.'' Its statutes provide for the R.F.S.P. to have a cardinal-president, assisted by a prelate, with the title of delegate, who holds the same office on the administrative committee. Whereas, in times past, the Fabbrica had been in charge of building, today it is more concerned with maintenance; it tends to avoid ambitious restoration projects. However, important works have been completed in recent decades, such as the strengthening of the windows in the drum of the cupola and the excavation of the Vatican necropolis (fig. 13), both projects realized in the reign of Pius XII (1939–58).

The Fabbrica gives constant service to the basilica and its dependencies, under both routine and special circumstances, through its corps of workers known as the ''Sampietrini.''

FIG. 13. (*ABOVE*): VIEW OF THE NECROPOLIS UNDER THE BASILICA OF SAINT PETER'S

Today, there are about sixty, each gifted in one of the building arts: among them are carpenters, masons, carvers, painters, cabinetmakers, electricians, and plumbers.

The sole organization within the Fabbrica of Saint Peter's that can perform work other than that ordered by the basilica or the Holy See is the Studio del Mosaico, whose operations are, perhaps, the most fascinating to the popular imagination. It was gradually realized, in the course of the sixteenth century, that mosaic decoration on the vast walls of the basilica was more luminous and durable than painting in fresco. Many Mannerist and Baroque painters produced designs for the mosaicists working in Saint Peter's, including Girolamo Muziano; Cesare Nebbia; Giovanni de' Vecchi; Girolamo Sicciolante, called Sermoneta; Cavalier d'Arpino; Francesco Vanni; Cristofano Roncalli, called Pomarancio; Pietro da Cortona; Andrea Sacchi; Giovanni Lanfranco; Giovanni Francesco Romanelli; and Carlo Maratta. The Studio del Mosaico was formally instituted by Benedict XIII in 1727. Today, the basilica's mosaicists achieve more accurate and more brilliant effects than ever before, through the use of bits of opaque enamel instead of the traditional stone or glass. The studio has at its disposal no fewer than 32,000 shades of enamel—capable of giving chromatic effects as subtle as those of any Impressionist painting—from which its artisans can choose.

Giuseppe Zander

BIBLIOGRAPHY: G. Fumagalli, ''Lo Studio del Mosaico Vaticano,'' in *L'Osservatore della Domenica*, 46, 15 (3288), April 9, 1978.

FIG. 14. (*RIGHT*): ALTERNATIVE SUGGESTIONS CONCERNING THE TECHNIQUE FOR REMOVING AND SETTING UP THE VATICAN OBELISK. ENGRAVING (FROM DOMENICO FONTANA, *DEL MODO TENUTO NEL TRASPORTARE L'OBELISCO VATICANO*, ROME, 1589)

SAGRISTIA DI Sᵗᵒ
PIETRO
ARTE DELLA FABRICA

DIVO CÆS. DIVI
IVLII F. AVGVSTO
TI CÆS. DIVI AV GV
F. AVGVS. SACRVM

1

FRONT OF A SARCOPHAGUS WITH THE "TRADITIO LEGIS," AND TWO RELIEF SLABS WITH SIMILAR ORNAMENTATION

Rome: front, c. A.D. 370; relief slabs, c. A.D. 400
Marble, front: height, 29 5/16" (74.5 cm), width, 87" (221 cm); relief with The Confession of Peter: *height, 30 13/16" (78.3 cm), width, 41 3/4" (106 cm); relief with* The Miracle of the Spring *and* The Miracle of Healing: *height, 30 1/16" (76.3 cm), width, 43 1/8" (109.5 cm)*
Reverenda Fabbrica di San Pietro

Until 1981, these three reliefs were considered part of a single sarcophagus. The presumed ends originally had nothing to do with the front, but, because they were appropriate in theme, they were joined together about 1590. No traces of chisel marks are visible on the backs of the two smaller carvings. Since, in antiquity, the front and ends always constituted a homogeneous box, it is improbable that these two smaller pieces belonged to the same sarcophagus. Where the end pieces meet the front, the edges of all three panels have been beveled to a forty-five degree angle so that right angles are formed. This manner of attaching the reliefs to create a sarcophagus was not usual in ancient sculpture.

The front slab was broken into four pieces and reassembled. One break begins behind the second column in the upper left and extends to the ankles of the seated Christ, in the center; the background is broken vertically just to Christ's right; a further break runs obliquely from the feet of Christ through the figure of Peter and ends at the top, near the second column from the right. Along these breaks are many repairs, some major. Further, the heads of Pilate and of

the apostle in the second niche from the left have been restored, as have both of Christ's arms, the right arm of Paul, the right hand of Pilate and the basin below it, as well as tips of noses, the front portion of the head of the lamb, Isaac's right leg, and Abraham's left hand. Abraham's sacrificial knife has been broken off.

The relief on the front is divided into seven sections by eight columns, with a faceted architrave in the form of a portico. The richly ornamented columns have decorated bases, shafts encircled with grape vines or acanthus vines (the two middle ones have winged genii, as well), and Composite capitals. The architrave has beaded moldings in the central and right-hand niches, and there is a leaf cyma at the bottom. In the three central niches, the giving of the *nova lex* —the New Law— or the "traditio legis," is represented. A youthful Christ, seated in the center, appears to be above the heavens. Christ gives the open scroll in his left hand to Peter, who receives it in his own draped hands. Christ's right hand is raised as though he were speaking (both arms undoubtedly are correctly restored). His feet are resting on a veil that Caelus spreads above himself. Christ turns to look at Paul, who approaches from the right. In the niche on the far left is the Sacrifice of Isaac (who kneels on an altar) by Abraham (who holds a knife aloft in his right hand), an allusion to the paradigm of salvation by death. As a counterpart, on the far right, the Roman Pilate is seated on a podium, and a servant standing behind him is pouring water over his hand from a jug. In front of Pilate, separated by a column, stands Christ, turned toward his judge. In the context of fourth-century thought on salvation, Pilate evokes that "*felix culpa, quae talem ac tantum meruit habere redemptorem*" (from the Exsultet of the Easter liturgy).

The axial symmetry of the composition is apparent in the identical ornamentation of opposite pairs of columns. Narrower and wider niches

alternate at the sides. In the central and end niches, Christ, Abraham, and Pilate face front, while, in the subsidiary niches, Peter and Paul appear in profile. The figures in the foreground seem almost three-dimensional, compared to the accessory figures crowded in behind them. A wealth of linear folds in the drapery makes for a certain elegance of form. A classicizing accent is unmistakable in the style, anticipating the Theodosian period—as in the reliefs on the base of the Obelisk of Theodosius in Istanbul (of 390).

Legitimized by having received the Law, Peter occupies a central position in both of the smaller reliefs. In *The Confession of Peter*—on the left end—a narrow framing border was cut away on the right side in order to connect the panel to the front of the sarcophagus. Two rectangular holes near the top—made to hold the clamps that secured the lid when the pieces were reused as a sarcophagus—have been repaired. The right forearm of Peter has been restored; Christ's restored right hand has again broken off. Peter is shown receiving Christ's exhortation to build the Church on the rock depicted, despite the fact that it was Peter who disclaimed him—to which the cock on the column refers. (The capstone of the round building should be noted, especially, as it bears the monogram of Christ.)

The upper border and the top of the cupola of the right-hand structure in the relief on the right end, showing *The Miracle of the Spring* and *The Miracle of Healing*, have been cut away (as confirmed by the measurements). The head of Christ has been repaired, as have the right hand of the bleeding woman, the top of the olive tree, and the two rectangular clamp holes near the top. The head of Peter appears to have been considerably reworked, to judge from the background surface. In this panel, Peter, as the leader chosen by God, causes the living water to spring from a stone.

All three reliefs were discovered beneath Saint Peter's. In the drawings by C. Menestrier, there

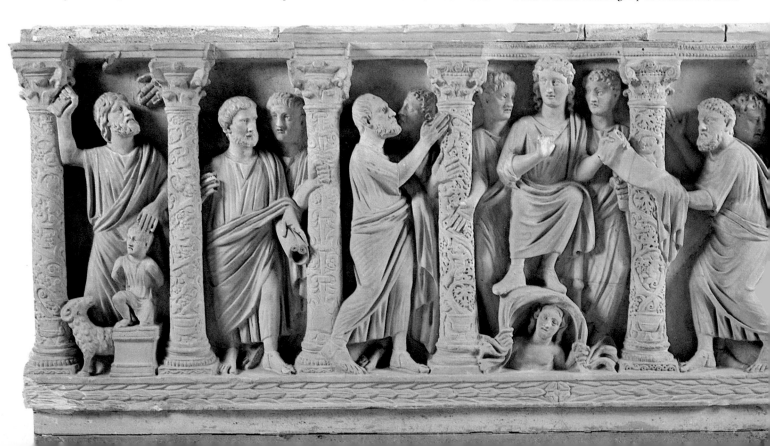

is the notation "sub Sixto V" below the view of the front (192 r.), and the date 1591 below the relief of *The Confession of Peter* (193 r.), although Sixtus V died on August 27, 1590. Yet, Menestrier believed that the reliefs belonged together. Antonio Bosio (1575–1629) saw the sarcophagus at the entrance to the convent of the Theatine monks at Sant'Andrea della Valle; Paolo Aringhi (1600–1676) remembered it in the Villa Pamphili (now the Villa Doria-Pamphili); and it was seen in the courtyard of Sant'Agnese in the Piazza Navona by Giovanni Gaetano Bottari (1689–1775). Since the founding of the Museo Pio Cristiano, in 1854, the sarcophagus had been displayed in the Palazzo Lateranense as number 174. At the suggestion of Monsignor Ludwig Kaas (1881–1952), it was returned to the grottoes below Saint Peter's, on October 8, 1949.

The combination of the images as a parable of salvation, conceived around the figure of Peter and the spot where he was interred, suggests that this was a sarcophagus for a pope. Possibly, it held the body of Sixtus V for the brief time that it lay in the chapel of Saint Andrew in Saint Peter's, before being removed in 1591 to Santa Maria Maggiore—or, perhaps, it was used for one of Sixtus's three short-reigned successors.

The Menestrier drawings are in the Biblioteca Apostolica Vaticana, lat. 10545, fols. 192/3.

<div align="right">G. D.</div>

BIBLIOGRAPHY: A. Bosio, *Roma sotterranea*, Rome, 1632, pp. 85–87; P. Aringhi, *Roma subterranea novissima*, I, Rome, 1651, pp. 316–18; G. G. Bottari, *Roma sotterranea: Sculture e pitture sagre estratte dai cimiteri di Roma*, I, Rome, 1737, pp. 131–37, pls. 33–34; F. W. Deichmann, G. Bovini, and H. Brandenburg, *Repertorium der christlich-antiken Sarkophage, I, Rom und Ostia*, Wiesbaden, 1967, pp. 274–77, no. 677, pl. 106 (with extensive bibliography); J. Engemann, *Gnomon*, 41, 1969, p. 490; K. Wessel, "Der siebennischige Säulensarkophag in den Grotten von St. Peter," in *Pantheon*, 27, 1969, pp. 120–28 (claiming this as a new, early-17th-century work based on a 4th-century original); H. Brandenburg, in *Römische Mitteilungen*, 86, 1979, pp. 464–65, pl. 149, 1.

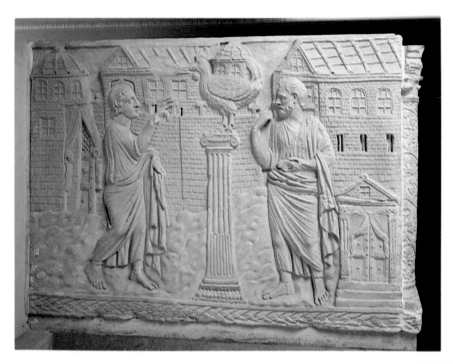

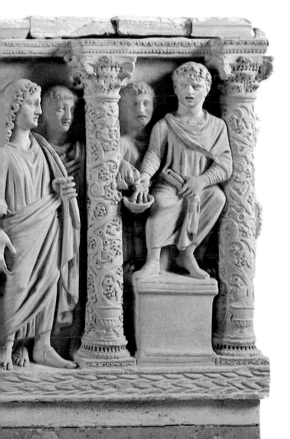

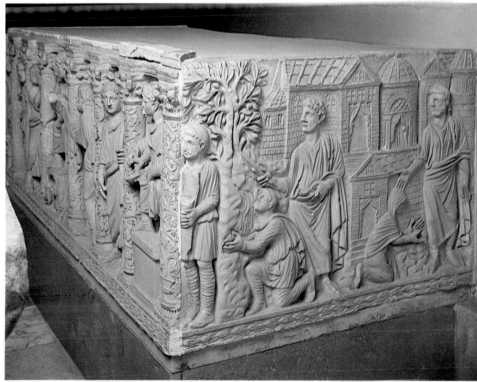

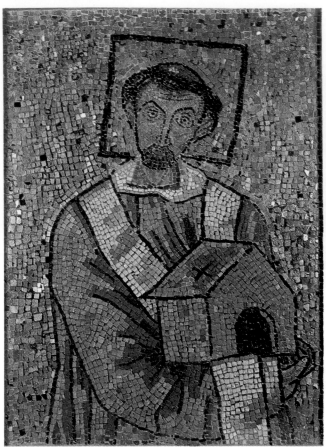

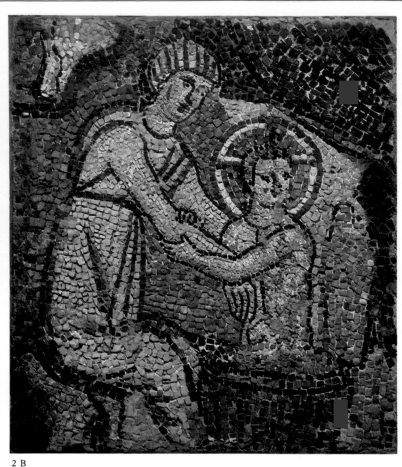

2 A

2 B

2

TWO MOSAIC FRAGMENTS

Rome, 705–6
A. Pope John VII *(705–7)*
 Height, 33 11/16" (85.5 cm); width, 25 3/8"
 (64.5 cm)
B. The Bath of the Christ Child
 Height, 23 5/8" (60 cm); width, 21 1/4"
 (54 cm)
Reverenda Fabbrica di San Pietro

Pope John VII, of Greek ancestry, had a funerary oratory built in the north aisle of Old Saint Peter's, against the inner wall of the eastern façade, and, on March 21, 706, he dedicated the oratory to Holy Mary, the Mother of God (*Dedicatio Domus Huius S[an]c[t]ae D[e]i Genitricis d[i]e XXI M[ensis] Mart[i] Ind[ictionis] III*). The pope was buried in front of the altar of the oratory in 707. During the Renaissance, the chapel was referred to as Santa Maria ad Praesepio because it contained a relic of Christ's crib. When the chapel was destroyed in the early seventeenth century, sketches were made of about one-half of its surviving mosaic decoration, some of which was saved, including these two fragments. Both come from the large mosaic that was placed over the half-ciborium, above the altar, on the east

wall. There was an over-life-size central image, perhaps Eastern in type, of the Virgin as Queen of Heaven, raising her arms in prayer, to whom John (on the left)—his square halo signifying that he is living—offered a conventionally depicted model of his oratory. Rectangular panels with scenes from the Infancy, Ministry, Passion, and Resurrection of Christ framed this iconic representation on three sides. The fragment of *The Bath of the Christ Child*, from the lower-right section of the Nativity, was directly over the panel of the Virgin.

Above the altar was a mosaic of the Virgin and the Christ Child, flanked by Saints Peter and Paul, and on the oratory's north wall were scenes from the lives of the princes of the apostles. The mosaics on the south wall were destroyed before the seventeenth century, but the *Liber Pontificalis* speaks of images of the reverend fathers—perhaps, as Josef Wilpert suggests, busts of apostles or early theologians, as in the frescoes, executed during the reign of Pope John VII, at Santa Maria Antiqua, the Greek church in the Roman Forum.

The mosaic fragment of Pope John has been extensively restored; only the upper part of the head retains original marble and glass tesserae in tones of white and beige, modeled in purples, russet, and dark sienna. In better condition is the fragment with *The Bath of the Christ Child*. Set in a landscape, a turbaned nursemaid, perhaps Salome, washes the Child, who stands in a golden basin—resting on a tall pedestal—into

which a second servant, formerly on the left, had poured water. Richly colored white, yellow, pink, purple, green, red, blue, and gold marble and glass cubes of different sizes are set deeply and widely apart, into the white mortar bed, in a technique that P. J. Nordhagen suggests came from Byzantium.

Precious materials were used throughout the oratory. The lower walls were reveted in marble, and supporting the ciborium were twisted columns carved with vine scrolls imitating those over the tomb of Saint Peter. The mosaic decoration reflects John's devotion to the Mother of God, and the chapel's funerary purpose. As the Queen of Heaven, the Virgin, surrounded by scenes of Christ's Incarnation and childhood, intercedes for the donor. The large number of panels illustrating the Ministry of Christ—and, especially, that of Saint Peter, the first bishop of Rome—as well as the images of the reverend fathers, may have been chosen as exemplars for John's papacy. Finally, Christ's death and resurrection were depicted to emphasize that, for man, the way to salvation was through Christ.

M. E. F.

BIBLIOGRAPHY: E Müntz, "Notes sur les mosaïques chrétiennes de l'Italie, IV. L'Oratoire de pape Jean VII," in *Revue Archéologique*, 1877, pp. 145–62; P. J. Nordhagen, "The Mosaics of John VII (705–707 A.D.)," in *Acta ad Archaeologiam*, 2, 1965, pp. 121–66; J. Wilpert and W. M. Schumacher, *Die römischen Mosaiken der kirchlichen Bauten vom IV–XIII Jahrhundert*, Freiburg and Vienna, 1976, pp. 167–74.

3

APPLIQUÉ RELIEFS OF CHRIST IN MAJESTY, PETER, PAUL, AND THREE UNIDENTIFIED APOSTLES

Limousin workshop active in Rome, shortly before 1215
Copper, with champlevé enamel and gilding
Christ: height, 16 ⅛" (41 cm); apostles: height, 8 ¹¹/₁₆–10 ¼" (22–26 cm)
Biblioteca Apostolica Vaticana, Museo Sacro, Inv. nos. 2430, 2428, 2429, 2431, 2432, 2433 (respectively)

Each appliqué relief is made from a single sheet of copper worked in repoussé, with the addition of direct chiseling, engraving, champlevé enamel, and mercury gilding. The enameling is dark blue, light blue, turquoise, dark green, glaucous green, dark red, and white. The eyes are inset pearls of dark blue, presumably of glass. Small cabochons also presumably of glass—some of which are lost—are additional insets that decorated the crown, book, and borders of the garment of the largest figure, Christ. The three preserved original cabochons are amber and garnet-red in color. The orange cabochon in the center of Christ's chest is a replacement. The borders of the garments of all of the figures are variously engraved with lozenge, circle, quatrilobe, *vermiculé* (rinceau), and crosshatched decoration. Each figure has two holes, in the chest and between the feet, for attachment to a lost background; the rivets also are lost. Both the enameled and the gilt surfaces have suffered throughout from pitting and abrasion. The backs of the three unidentified apostles are each incised with a letter (**F**, **G**, and a reverse **S**), which may represent guides for assembly within a larger context.

Christ is seated, his right hand held out and above his shoulder in a gesture of blessing; in his left hand is a codex, formerly jeweled, fastened with two straps. He wears a crown, an orphrey, and a mantle draped over his left shoulder and across his lap. The apostles, although standing, are each about half the size of Christ. They also hold closed and decorated codices in their left hands. Peter and one of the unidentified apostles holds a codex with a veiled hand. The apostles' right hands, unlike Christ's, are posi-

tioned within the contours of their bodies. Paul, tentatively identified by his bald head and long beard, uses both hands to grasp his codex. All of the figures, including Christ, are barefooted and bearded.

The style, especially apparent in the fall of the looping lines of the drapery folds, seems to be a codification of a classicistic trend evident in a whole series of metalwork objects produced by Mosan and Rhenish artists about 1200. A prime example is the shrine of Saints Piatas and Nicasius in Tournai Cathedral, completed in 1205 by Nicholas of Verdun (*Rhein und Maas*, 1972, K–5). Variations of this style may be seen in certain roughly contemporary stone sculptures in Emilia and Tuscany, as in Benedetto Antelami's marble *Deposition* relief in Parma Cathedral, dated 1178 (G. de Francovitch, 1952, fig. 194), and in the marble pulpit reliefs, dating to about 1200, formerly in San Pietro Scheraggio in Florence (T. P. F. Hoving, 1961, pp. 116–26, figs. 4–7). This classicistic style, transferred to artists from the Limousin working in Italy, is exemplified not only by the Vatican reliefs but also by the large appliqué figure of the hermit Saint Barontus (height, 21 ½" [54.5 cm]) from the enameled sarcophagus of the saint in the crypt of the church dedicated to him in Pistoia (M.-M. Gauthier, 1972, pp. 287–88, fig. 9). This figure, now in the Allen Memorial Art Museum at Oberlin College, may be a product of the same workshop that produced the Vatican reliefs.

The present reliefs probably come from the large enameled and arcaded rectangular closing panel that originally covered, yet gave access to, the niche of the Confessio of Saint Peter in Saint Peter's. This panel was made for Innocent III (1198–1216) on the occasion of the Twelfth Ecumenical Council of Lateran IV, in 1215. In a

hypothetical reconstruction of the panel proposed by Marie-Madeleine Gauthier (1968), Christ in Majesty appears in the center beneath a copper-gilt arch or lunette (preserved in the Museo del Palazzo Venezia in Rome). Twelve relief busts of Old Testament prophets, identified by inscriptions that also announce the coming of Christ, appear on the lintel-like, horizontal member of this arch. Twelve busts of apostles occupy the arch, itself, while a centrally held disk bears images, in relief, of the Lamb of God with the four Evangelists' symbols. The background of all of these relief figures is engraved with a *vermiculé* (rinceau) pattern. The reverses of the arch and lintel are engraved with a series of seated bishops within an arcade. On the reverse of the disk is an engraved enthroned bishop, probably Innocent III, himself, holding Peter's keys—thereby specifically underscoring the apostolic succession of the bishops of Rome, the direct heirs of Peter.

The full-length reliefs of the apostles shown here are the only remnants of the series of twelve, which must have been arranged symmetrically, in two registers, surrounding Christ (as suggested by Gauthier). Paul and Peter probably stood next to Christ. The surmounting bronze grille, still in its original location, bears in its inscription the name of Innocent III, which, in turn, provides a *terminus ante quem*, because Innocent died in 1216.

The appliqué figures were removed to the Vatican Library during the papacy of Benedict XIV (1740–58). They have been exhibited in the Museo Sacro since the end of the nineteenth century.

W. D. W.

BIBLIOGRAPHY: W. Stohlman, *Gli Smalti del Museo Sacro Vaticano* (*Catalogo del Museo Sacro della Biblioteca Apostolica Vaticana*, II), Vatican City, 1939, pp. 33–34, nos. S22, S20, S21, S23, S24, and 1416 (respectively); M.-M. Gauthier, "La Clôture émaillée de la confession de Saint Pierre au Vatican, lors du Concile de Latran, IV, 1215," in *Synthronon, Recueil d'études par André Grabar et un groupe de ses disciples*, Paris, 1968, pp. 237–46, figs. 4, 5, 9; L. von Matt, G. Daltrop, and A. Prandi, in *Art Treasures of the Vatican Library*, New York, n.d., p. 181, nos. 138–140.

Comparative works cited: G. de Francovitch, *Benedetto Antelami*, Florence, 1952, pl. 107, fig. 194; M.-M. Gauthier, "L'art de l'émail champlevé en Italie à l'époque primitive du gothique," in *Il Gotico a Pistoia*, Rome, 1972, pp. 287–88, fig. 9; T. P. F. Hoving, "A Long-Lost Romanesque Annunciation," in *The Metropolitan Museum of Art Bulletin*, XX, 4, December 1961, pp. 116–26, figs. 4–7; *Rhein und Maas, Kunst und Kultur 800–1400*, Cologne, 1972, pp. 323–24, K–5.

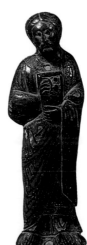

4

—

TWO COSMATESQUE PANELS

Rome, 12th–early 13th century
Marble, serpentine, and porphyry, with borders
of red lacquer, black enamel, white marble, and
gold glass
Large panel: height, 34" (86.3 cm), width, 45"
(114.3 cm), depth, 5" (12.7 cm); small panel:
height, 34" (86.3 cm), width, 18¾" (47.6 cm),
depth, 5" (12.7 cm)
Reverenda Fabbrica di San Pietro

The panels are heavily restored, and parts of
the borders are missing.

Cosmati mosaic work is essentially a medieval art that originated in Rome—where Cosmati
pavements, cloisters, campanili, church furniture,
and tombs abound—but spread to other parts
of Italy and even beyond. It differs from tessellated mosaics in that the designs are determined
by the shapes of the semiprecious stones that
are used: rectangular or circular pieces are surrounded by small triangular or bullet-shaped
ones. In tessellated mosaics, the shapes of the
tesserae have no influence on the design. The
twelfth- and thirteenth-century families of craftsmen who created this marble and mosaic work
have become famous as the Cosmati, probably
after Cosma and his four sons—the last family
to work in the style—although not all scholars
think that the Cosmati can be differentiated
from the Laurentians. The latter and the Vas-
salletti were the most celebrated families of
Cosmati craftsmen. All were master decorators,
but many were also builders.

The two panels consist of large rectangles of
porphyry and serpentine, each surrounded by a
narrow border of triangular pieces and set into
a wide, molded, marble border, which is surrounded, in turn, by broad borders consisting
of small pieces of red lacquer, black enamel,
white marble, and gold glass. The most salient
features of the borders' designs are eight-petaled
rosettes and eight-pointed floral motifs. The
borders of the two panels differ.

One aspect of the twelfth-century Renaissance
in Rome clearly is exemplified by these panels:
the use of such antique materials as serpentine—
known as "verde antico"—and porphyry, cut
into pieces and placed in a new context. Because of their probable total dimensions and their
overall design, the panels seem most apt to have
come from two choir screens; they are similar
to the choir screen of San Cesareo in Rome.

The only information concerning the history
of either panel is an old photograph showing
the larger panel set into the wall of a seventeenth-century chapel in the Grotte. The panel
was surmounted by a statue of the Virgin and
Child in a niche, flanked by marble panels with
cherubs and by small panels similar in type to
the large panel.

K. R. B.

5

—

FOUR COLONNETTES, DECORATED WITH COSMATI MOSAIC WORK

Rome, 12th–early 13th century
White marble, blue and black enamel, red
lacquer, and gold glass
A–C.: overall height, 40¾" (103.5 cm),
height of base slabs, 1⅛" (2.9 cm), depth,
4½" (11.4 cm); D.: height, 40½" (102.9
cm), height of base slab, 3" (7.6 cm),
depth, 4½" (11.4 cm)
Reverenda Fabbrica di San Pietro

The marble inlays in the shafts of the colonnettes are heavily restored. The fact that three of
the colonnettes have twisted shafts and the fourth
is fluted may indicate that, originally, they were
not designated for the same monument. However, the shafts of all four are similarly decorated
with tiny triangular pieces of blue and black
enamel, red lacquer, white marble, and antique
gold glass. Two of the twisted colonnettes are
crowned with capitals composed of two pairs
of eagles with wings displayed, while the capital of the third consists of stylized acanthus
leaves. The capital of the fluted colonnette is similar to,
but not exactly the same as, the latter.

These colonnettes, products of the twelfth-century Renaissance in Rome, copy and reinterpret Roman and Late Antique forms, while the
eagles with wings displayed betray a familiarity
with the contemporary Byzantine art that flourished south of Rome.

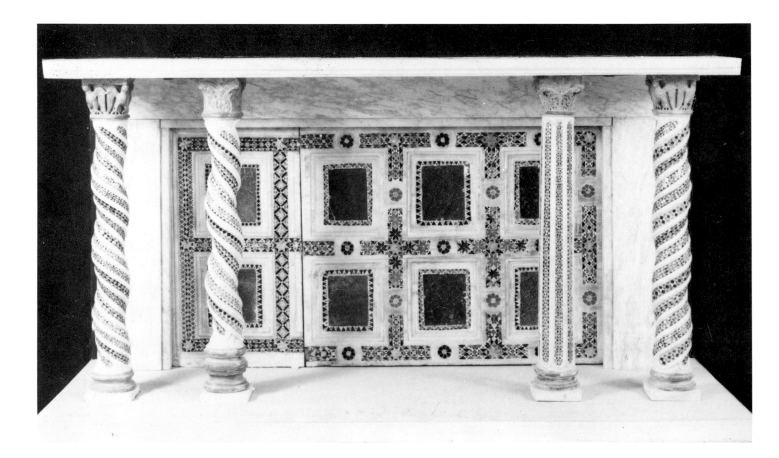

We know from Giacomo Grimaldi's description in *Instrumenta Antiqua* of 1619 that the two colonnettes with eagle capitals came from the aedicula of the tomb of Urban VI, who died in 1389. Grimaldi's drawing of the sarcophagus (showing its lid, and the bust of Nicholas III) on folio 116 r. would seem to support his statement, since the front of the sarcophagus is decorated with escutcheons bearing eagles with wings displayed. The accuracy of Grimaldi's description and drawing is confirmed by Tiberio Alfarano, who apparently saw the tomb still in its original place just prior to 1588. We do not know yet how these four colonnettes were used before the two were incorporated into the tomb of Urban VI, although various proposals have been advanced. In 1606, under the direction of

Pope Paul V, the two colonnettes with eagle capitals, together with the two present ones, were incorporated into an episcopal throne in the Grotte. In the center of the throne was the famous marble statue of the seated Saint Peter, which, according to Gustave Clausse, had been brought from the exterior of the main entrance of the basilica. The statue was flanked by two angels, considered by some to be late works of Arnolfo di Cambio. The three statues between these four colonnettes were placed on a high platform of Cosmati work, supported by crouching lions. Above the colonnettes was a seventeenth-century marble frieze decorated with cherubs, surmounted by a Gothic Cosmati-work canopy. According to Clausse, the throne was located in the chapel of Santa Maria ad Porticum

at the southern extremity of the Grotte. Today, the colonnettes support a restored mosaic showing Christ between Saints Peter and Paul, but, as late as 1935, the mosaic was described as being within a tabernacle. Thus, the Cosmatesque canopy of the seventeenth-century throne still may have been associated with the colonnettes as recently as 1935.

K. R. B.

BIBLIOGRAPHY: G. Clausse, *Les Marbriers romains et le mobilier presbytéral*, Paris, 1897, pp. 332–34; A. L. Frothingham, *The Monuments of Christian Rome*, New York, 1908, pp. 143, 249–50; G. Cascioli, *Guida illustrata alle Sacre Grotte Vaticane*, Rome, 1925; P. Laurentius Dionysius, *Sacrarum Cryptarum Vaticanae Basilicae Monumenta*, Rome, 1928; G. B. Ladner, *Die Papstbildnisse des Altertums und des Mittelalters*, II, Vatican City, 1970, pp. 209–11.

6

TWO FRESCO FRAGMENTS

Rome, second half of the 13th century
A. Saint Peter
 Height, 15 ⅜" (39 cm); width, 10⅞" (27.6 cm)
B. Saint Paul
 Height, 15" (38 cm); width, 10⅝" (27 cm)
Reverenda Fabbrica di San Pietro

These vivid, painted fragments come from a thirteenth-century fresco cycle illustrating the life of Saint Peter that decorated the portico of Old Saint Peter's. From sketches by Giacomo Grimaldi of the few frescoes that survived from this cycle, made shortly before the portico's destruction in the early seventeenth century, it seems certain that these fragments came from the scene that depicted the episode in which the two apostles to the Romans appeared to the sleeping Emperor Constantine, who, according to legend, was afflicted with leprosy. They instructed him to seek a cure from Pope Silvester I (314–35).

The fragments show only the busts of what were, originally, half-length figures of the apostles standing behind the emperor's bed. The scene takes place before a partially arcuated portico adjoining an apsed structure seen in cross section behind the emperor's head; a small portion of a yellow pier from this structure is visible behind Saint Paul's right shoulder in the fresco fragment. The background is a deep turquoise. The figures are modeled in shades of ocher, olive green, and red, with a deep russet outlining their facial features, the characteristics of which had been established in Early Christian times. White is used to highlight Peter's face and for the traditional color of his hair and short beard. The artist exhibits a free and sure hand in his painting, employing broad strokes to form the major folds of the apostles' draperies and a finer brush for the heads, which he outlined with a stylus. Since the frescoes were to be seen from some fifty feet below, the top two-thirds of the saints' heads and haloes were raised in relief, to give them extra prominence.

No contemporary documents survive that record the commissioning of these frescoes or the

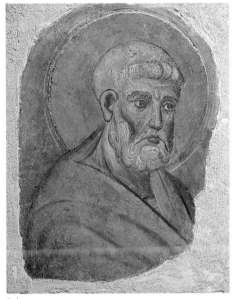

6 A

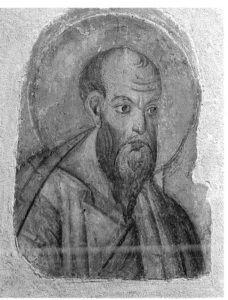

6 B

name of the artist. On the basis of comparisons with Roman painting of the second half of the thirteenth century, and of references to the cycle by Vasari and by later historians of Rome, however, Antonio Muñoz suggests that the frescoes were painted during the pontificate of Urban IV (1261–64). Irene Hueck proposes that the artist went to Assisi in the early 1270s to paint a series of apostles in the upper church of San Francesco, at the gallery level of the north transept's east wall. The close stylistic relationship between the Roman and Assisi frescoes is patent, but the latter seem to be the work of a different, though allied, artist, whose figures are more sophisticated and exhibit a more highly developed sense of realistic modeling and a grandeur achieved through the use of an expressive line. Hans Belting accepts Hueck's attribution of the Roman and Assisi works to the same master, but dates the Old Saint Peter's frescoes to 1279–80.

The stylistic influence of the life of Saint Peter cycle from the portico of Old Saint Peter's can-

not be assessed properly, due to the small amount of surviving contemporary work. The fresco program, however, seems to have had a considerable effect, particularly on the early-fourteenth-century frescoes of scenes from the life of Saint Peter at San Piero a Grado, near Pisa—as P. D'Achiardi has shown.

M. E. F.

BIBLIOGRAPHY: P. D'Achiardi, "Gli affreschi di S. Piero a Grado presso Pisa e quelli già esistenti nel portico della basilica Vaticana," in *Atti del Congresso Internazionale di Scienze Storiche*, VII, Rome, 1905, pp. 193–285; A. Muñoz, "Le pitture del portico della vecchia basilica vaticana e la loro datazione," in *Nuovo bullettino di archeologia cristiana*, XIX, 1913, pp. 175–80; S. Waetzoldt, *Die Kopien des 17. Jahrhunderts nach Mosaiken und Wandmalerei in Rom*, Vienna–Munich, 1964, pp. 66–67; I. Hueck, "Der Maler der Apostelszenen im Atrium von Alt-St. Peter," in *Mitteilungen des Kunsthistorischen Instituts in Florenz*, 14, 1969, pp. 115–44; H. Belting, *Die Oberkirche von San Francesco in Assisi: Ihre Dekoration als Aufgabe und die Genese einer neuen Wandmalerei*, Berlin, 1977, pp. 51, 90–95, reviewed by I. Hueck, in *Zeitschrift für Kunstgeschichte*, 41, 1978, pp. 326–34 (esp. p. 331).

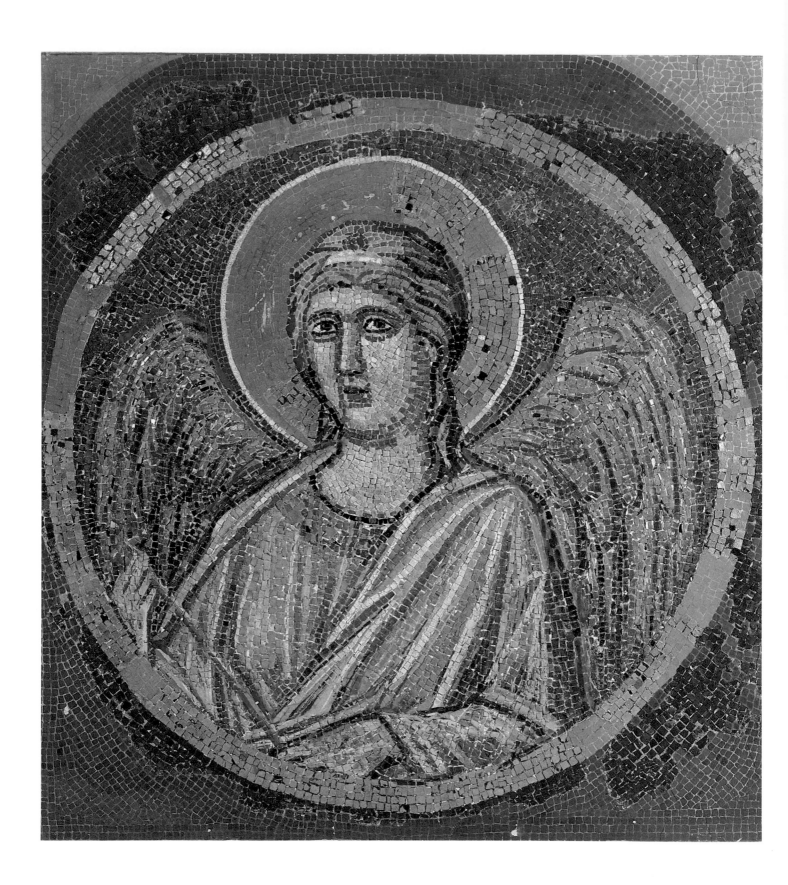

7

GIOTTO (1267?–1337), attributed to
BUST OF AN ANGEL
Italy (Tuscany), c. 1310
Mosaic
Diameter, 23 13/16" (60.5 cm)
Reverenda Fabbrica di San Pietro

In 1610, a mosaic bust of an angel in a medallion was given to the church of San Pietro Ispano in Boville Ernica, near Frosinone. An accompanying inscription noted that it had been part of the *Naviculae S. Pietri* (the nave of Saint Peter's), and was painted by Iottus [*sic*] for the atrium of the old Vatican basilica. A similar bust, discovered in 1911 underneath an eighteenth-century copy, also was assumed to have belonged to the mosaic known as the *Navicella*. This gigantic mosaic was located above the entrance to the atrium of the old Constantinian basilica but is now inside the portico of Saint Peter's.

It is documented that Giotto was invited to Rome by Pope Boniface VIII (1295–1303) for the celebration of the jubilee that the pope had organized in 1300 and that he painted several frescoes at San Giovanni in Laterano. The only extant fragment of these frescoes shows the pope at the moment of the proclamation, very much in the style and attitude of Arnolfo di Cambio's portrait bust (cat. no. 8). The fact that Giotto was in Rome about 1300 led some scholars to assume that the design for the *Navicella* corresponded to that time. Recent research, however, has brought to light a 1313 document confirming that Giotto had spent time in Rome after that date. The style of the *Navicella*, in spite of its present condition (the product of extensive restoration in the seventeenth century), and some drawings made shortly before this disfiguration, indicate that the painter had acquired a maturity that only could be the result of his work at the Cappella degli Scrovegni in Padua, completed about 1309. Based on this fact, and on the 1313 document, a date of about 1310 is very probable for the *Navicella*, since, by then, Giotto had finished his work in Padua, and he was back in Florence in 1311. Boniface VIII had died in 1303, and in 1309 the Holy See had been moved to Avignon, where it remained until 1377. Consequently, the large mosaic could not have been a papal commission, but, rather, was the idea of Cardinal Stefaneschi, who was canon of Saint Peter's and its keeper in the absence of the popes.

On close examination, there are conspicuous differences between the Boville Ernica and Vatican angels. The former is very well preserved, while the latter has suffered considerable losses all over, but mostly on the upper-left part of the head and nimbus, and has been heavily restored. Though the overall design of both is very close, the features of the Boville Ernica angel are more delicate, the light softer, and few shadows disturb the glowing colors. In the Vatican angel we can see a much stronger contrast of light and shadow that, in part, is the reason for a certain hardness of the features. Cesare Gnudi explains these differences between the two angels by the possible location of both medallions in relation to the *Navicella*. They could have been on its

frame, together with several others that have never been found, or on either end of an inscription beneath. In either case, the Vatican angel would have been on the right, only partly illuminated, and the Boville Ernica one on the left, receiving light from some source to the upper right of the main composition. The discrepancies, however, are strong enough to suggest that different hands worked on what is believed to be Giotto's design. It is very unlikely that the painter, himself, participated in the mosaic, as he was not skilled in this type of craftsmanship, and it is just as unlikely that, at the peak of his career, he would have been interested in experimenting in a new medium, regardless of how much he admired the mosaics that he saw in Rome.

C. G–M.

BIBLIOGRAPHY: R. Salvini, *Giotto*, Milan, 1952, 1962; C. Gnudi, *Giotto*, Milan, 1959, pp. 175–80, fig. 145c; M. Calvesi, *Treasures of the Vatican*, Switzerland, 1962, pp. 30–40, colorplate; E. Baccheschi, *The Complete Paintings of Giotto*, New York, 1966, pp. 110, no. 112, ill.

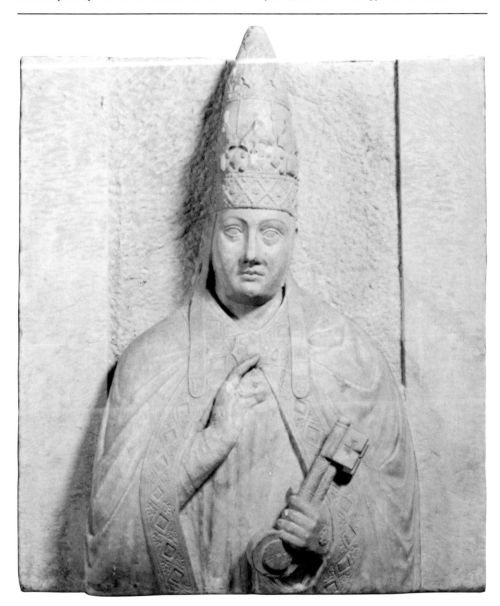

8

ARNOLFO DI CAMBIO (c. 1245–c. 1310)
PORTRAIT BUST OF POPE BONIFACE VIII (1295–1303)

Italy (Tuscany), c. 1296
Marble
Height, 47¼" (120 cm); width, 37⅜" (95 cm);
depth, 13¾" (35 cm)
Reverenda Fabbrica di San Pietro

After the abdication of the ascetic Celestine V (1294), Boniface VIII became pope in 1295. He implemented his desire to glorify the Church and its pontiff by patronizing the best artists available. Arnolfo di Cambio, who had been one of Nicola Pisano's assistants in Tuscany, but who had a mind and a style of his own, was in Rome at that time. Among other works, Boniface commissioned Arnolfo—both as an architect and as a sculptor—to build a monument in honor of Saint Boniface IV, in which he wanted to have his own sepulcher. The work was dedicated in 1296, although it might not have

been finished until 1300, the year of the Jubilee.

At the beginning of the sixteenth century, Julius II accomplished what other popes before him had attempted: the demolition of the Constantinian basilica, and its replacement, on the site, by the basilica of Saint Peter's as it is today. One of the many victims of that destruction was the shrine of Saint Boniface IV, of which the sepulcher of Boniface VIII, two angels, and several architectonic fragments have been preserved. There is no evidence, other than tradition, to indicate where the bust of Boniface was placed in relation to the shrine. It is not certain whether Arnolfo's work was only a monument, with the tomb under a baldacchino, or if it was a chapel. If the latter were so, the bust could have been attached to the chapel wall, and the pope would have been represented in life and after death, within the same space. Though the similarities between both representations are obvious, Arnolfo conveyed to the living image a portrait-like quality that is particularly noticeable in the asymmetry of the features, which lack the serenity and sublime expression of those of the dead effigy. The bust represents Boniface frontally; his right hand is raised in an attitude of blessing, while, with his left, he holds Saint Peter's symbolic keys. He wears an unusually high, double-crowned tiara, and a cope held together by a morse under his bare neck. The ornamentation on both tiara and cope shows Arnolfo's fondness for minute detail, in contrast to the sculpture's overall compact and almost geometric volume. This latter quality brings to mind Giotto's fresco portrait of the pontiff painted in 1300, at the time of the jubilee, when the painter was quite young and the sculptor was over sixty. In spite of the difference in years, it is not unlikely that the mature Arnolfo let himself be influenced by the innovative talent of the junior artist.

Due to the many vicissitudes that this bust has undergone, the right side of the face has sustained considerable damage, three of the fingers of the right hand have been broken and restored, and the finial of the tiara has been lost. Recently, the face was restored, the added fingers removed, and the overall surface cleaned. In old photographs the bust has no background, but in more recent ones it is shown in front of a partially broken-off slab, which has now been completed. Whether this background—or part of it—is the original, or a re-creation of it, is not clear. One way or the other, this portrait of the strong-willed pontiff with his mesmerizing expression, as Arnolfo saw it, has managed to survive.

C. G–M.

BIBLIOGRAPHY: G. Vasari, *Le Vite*, 1568, Club del Libro ed., Milan, 1962, p. 231; G. Poggi, "Arnolfo di Cambio e il sacello di Bonifacio IV," in *Rivista d'Arte*, III, 1905, pp. 187–98; G. Lander, "Die Statue Bonifaz VIII in der Lateransbasilika und die Entstehung der dreifach gekrönten Tiara," in *Römische Quartalschrift für christliche Altertumskunde und für christliche Kirchengeschichte*, I, II, 1934, pp. 35–68; H. Keller, "Der Bildhauer Arnolfo di Cambio und seine Werkstatt," in *Jahrbuch der preussischen Kunstsammlungen*, LV, 1934, pt. 2, pp. 25–28, fig. 22; G. Fiocco, "Giotto e Arnolfo," in *Rivista d'Arte*, XIX, 1937, nos. 3, 4, pp. 221–39; J. B. de Toth, *Grutas Vaticanas*, Vatican City, 1960, no. 35, ill.; *The Vatican and Christian Rome*, Vatican City, 1975, p. 12, colorplate; A. M. Romanini, *Arnolfo di Cambio*, Florence, 1980, pp. 84–101, figs. XI–XV, pls. 76–104.

9

—

COPE, WITH SCENES OF CHRIST AND THE VIRGIN, SAINTS, AND SERAPHIM

England, c. 1280–1300
Red silk twill, embroidered with gold and silver-gilt threads and colored silks
Height, 54" (137.2 cm); width, 122" (309.9 cm)
Biblioteca Apostolica Vaticana, Museo Sacro, Inv. no. 2447

Richly embroidered in silk and metal threads, this pluvial cope—a processional and ceremonial ecclesiastical vestment—is one of the finest late-thirteenth-century examples of *opus anglicanum*, the renowned medieval embroidery produced in England primarily in the thirteenth and fourteenth centuries. The ground is heavy red silk (samite), and the design is executed in underside couching, split-stitch, and laid-and-couched work. The figures, wearing mantles of gold and robes of blue or green and yellow, are enclosed in eight-pointed stars and even-arm crosses that alternate along the diagonal. In the center of the back, in ascending order, are the Virgin and Child, the Crucifixion, and the Coronation of the Virgin, surrounded by seraphim standing on wheels, the apostles with Saint Paul, Saints Margaret and Catherine of Alexandria—the often-paired virgin martyrs—and Saint Stephen the protomartyr and Saint Lawrence—two of the original seven deacons of the Roman Church.

The design has been trimmed along the semi-circular edge. The orphrey, an embroidered strip, would have run in opposing directions from the center of the back, following the straight edge, in order to be correctly oriented on either side of the front opening, which would have been fastened by a morse. The place of the original

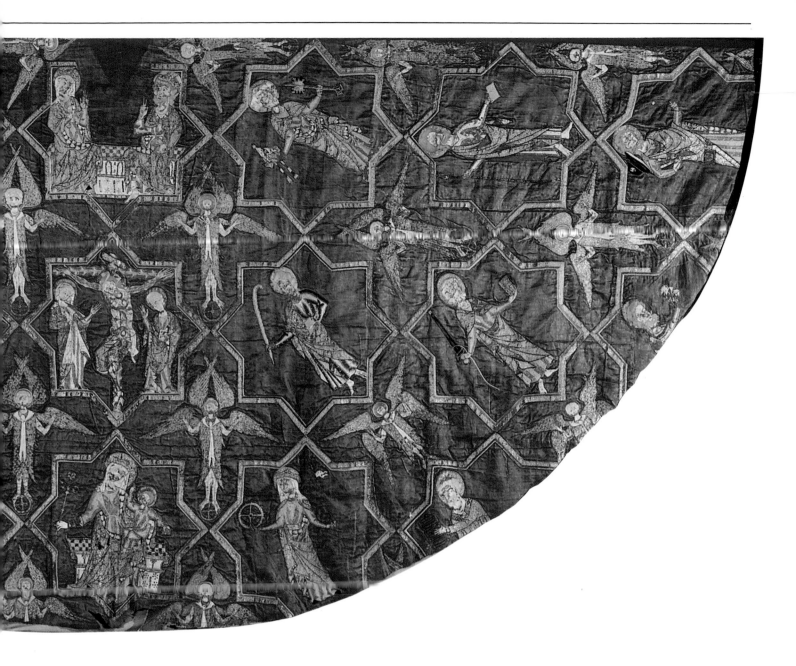

triangular hood, at the center of the back, can still be discerned where the silk is less faded.

Unlike many examples of *opus anglicanum*, the Vatican cope does not depict specifically English saints. R. W. Lee, however, has discussed the particularly English character of the representations, as seen in details—notably, of Saint Margaret, who stabs the dragon with the bannered cross, in accordance with a thirteenth-century English legend, and in the single figure of Saint Philip holding three loaves of bread, as on an English cope that bears his name in embroidery, in the cathedral of Toledo. Unusual, and unique in *opus anglicanum*, is the depiction of Saint Peter holding the papal tiara in addition to the keys.

In iconography, style, and technique, the Vatican cope compares with other surviving English embroideries. Several copes combine similar scenes—especially the English type of the Coronation, with Christ personifying the three figures of the Trinity and seated, with the Virgin, on a single throne. The Syon cope in the Victoria and Albert Museum is the closest to the Vatican cope, combining framed figures of the apostles and of seraphim with central compartments containing the Crucifixion and the Coronation of the Virgin. The figure style and the use of color have been compared to English manuscript illumination of the late thirteenth century, and the star-and-cross motif is found in the Westminster Abbey retable of about the same date.

The Vatican cope, which had been preserved in a convent in Rome, was given to the Museo Sacro by Pius X (1903–14) in 1910. It is among the earliest in a long line of Gothic luxury embroideries commissioned in England for use throughout Europe. Notable examples survive in churches as well as in major museums, including The Metropolitan Museum of Art. A number of copes in Italy, such as those in San Giovanni in Laterano in Rome, and in Pienza, are the heritage of the papacy. By 1295, the Vatican inventory recorded more than one hundred examples of *opus anglicanum*, reflecting papal commissions, and gifts to Rome from English ecclesiastics, royalty, and nobility. In the 1320s and 1330s, both the Archbishop of Canterbury and the Bishop of Ely sent copes to the pope. The copes received by Nicholas IV (1291) and Boniface VIII (about 1295) from Edward I are closer in date to the present example. Although the earlier history of the Vatican cope cannot be established, its quality and style are in keeping with this kind of prized gift.

C. G–M., B. D. B.

BIBLIOGRAPHY: R. W. Lee, "An English Gothic Embroidery in the Vatican," in *Memorie della Pontificia Accademia Romana di Archeologia*, ser. III, III, 1932, pp. 1–34; A. G. L. Christie, *English Medieval Embroidery*, Oxford, 1938; *Opus Anglicanum: Medieval English Embroidery* (exh. cat.), London, Victoria and Albert Museum, September 26–November 24, 1963.

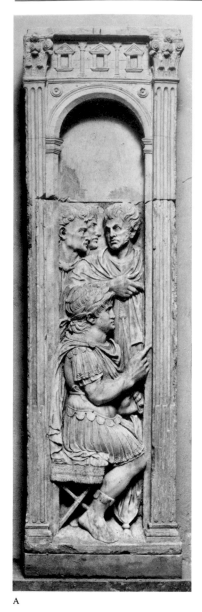

A

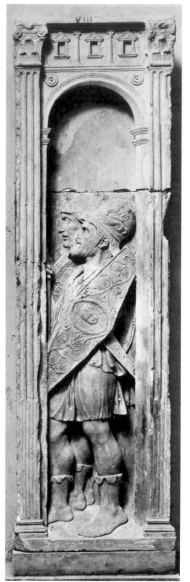

B

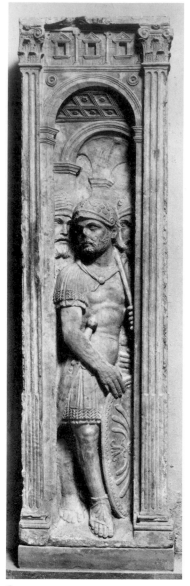

C

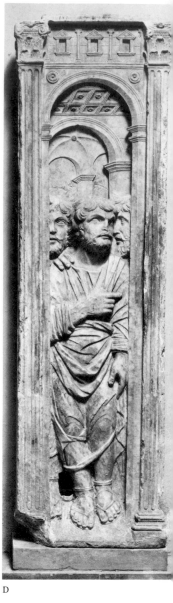

D

10

Probably by **PAOLO ROMANO** (c. 1415–1470) and his workshop

EIGHT RELIEFS, WITH THE TRIALS OF THE APOSTLES PETER AND PAUL

A. The Emperor Nero and Three Roman Officials
B. Two Roman Soldiers
C. Three Roman Soldiers
D. Saint Peter in Chains between Two Guards
E. Three Roman Soldiers
F. Three Roman Soldiers
G. Saint Paul in Chains between Two Guards
H. Three Roman Officials

Rome, c. 1460–64
Marble
Height, each, 52 ⅜" (133 cm); width, each, 14 ⁹⁄₁₆"
(37 cm), including marble base preserved only
in reliefs E, F
Reverenda Fabbrica di San Pietro

The first of the reliefs (A) shows the Emperor Nero, faithfully portrayed after his Roman effigies, seated on a *sella curulis*, holding a scepter and presiding over the trials of the two apostles, who were martyred during the persecutions of the Christians in A.D. 64–67. Both events, divided among seven scenes, take place under the coffered ceiling of a tribunal. The architectural backgrounds, showing perspective views of arches and vaults, are preserved only in reliefs C, D, E, and F, but they presumably continued in the other four segments. The present sequence of the reliefs—based upon the conclusions of a recent, unpublished study by the architect Pier Luigi Silvan—takes into account the correct alignment of the architectural perspectives, and, much more importantly, the structure of the reliefs themselves, each of which, as Silvan was the first to observe, is cut at a forty-five-degree angle on one or the other side—a detail that clearly shows that they originally were meant to be paired cornerwise.

Although the reliefs, traditionally, are known

to have come from the so-called ciborium of Sixtus IV (1471–84) on the high altar of Saint Peter's, no satisfactory suggestion as to their placement within the architectural design of the ciborium can be found, either in the generalized sketch in Grimaldi's codex (R. Niggl, ed., 1972, p. 199, fig. 85), or in the studies of Hugo von Tschudi (1887), Fritz Burger (1907), or Adolfo Venturi (1908), who assumed that the vertical panels were intended to be seen as a horizontal unified relief. Once it was understood that they must have decorated the four corners of an architectural structure, Silvan was able to reconcile their measurements with those of the perimeter of the ciborium itself, as revealed by the 1940–51 excavations of the Confessio of Peter. Moreover, the height of the carvings is the same as that of the four large reliefs with scenes from the lives and martyrdoms of Saints Peter and Paul (still walled in, in the ambulatory, beneath the Confessio), which decorated the four faces of the ciborium of Sixtus IV. The ciborium was supported by four porphyry columns, and, in its

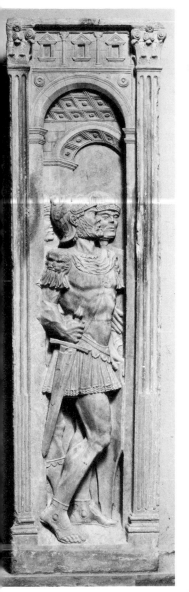
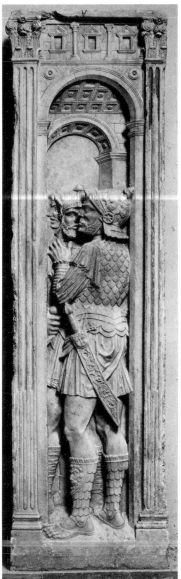
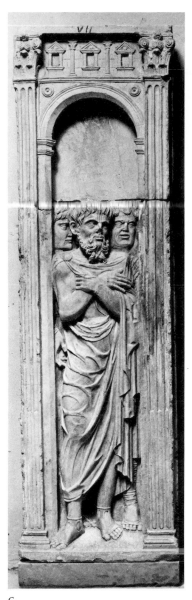
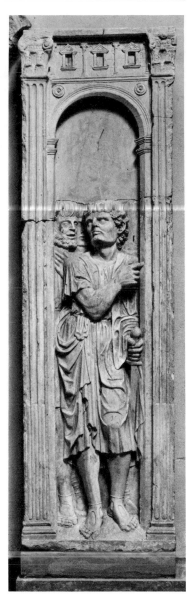

F G H

overall design, must have been inspired by the monumental ciborium of Cardinal d'Estouteville erected in 1461–63 in Santa Maria Maggiore. The corner reliefs of the Trials of Peter and Paul must have occupied a place similar to that of the triple Corinthian pilasters that flanked the main narrative scenes by Mino da Fiesole on the entablature of the latter ciborium (C. Seymour, 1966, p. 159, fig. 21).

The style of the Trials is generally quite typical of the conservative, classicizing manner so often found in Roman works of the third quarter of the fifteenth century. Yet, when one compares the four large "stories" of the time of Sixtus IV, with their skillful recombination of elements borrowed from the Column of Trajan and other imperial sculptures, and their somewhat grander and more fluid style, one has the distinct impression that the archaizing vigor and wiry directness of the Trials belong to an earlier master. The crowding of the figures beneath a coffered ceiling recalls the Donatellesque organization of one of the reliefs on the Aragonese Arch in Na-

ples (G. L. Hersey, 1973, fig. 37), and the angular and curiously expressive faces, the muscular and veined arms, and the bony hands of the figures are characteristic of the sculptures executed by Paolo Romano and his workshop during the pontificate of Pius II (1458–64). Especially striking are comparisons with the two colossal statues of Saints Peter and Paul carved in 1461–62 by Romano and his assistants for the steps in front of Saint Peter's (A. Venturi, 1908, figs. 756–757). These observations support a suggestion first advanced by Giuseppe Cascioli (1925, p. 26), and recently confirmed by Silvan, that the reliefs of the Trials were executed some fifteen years before the large "stories" commissioned by Sixtus IV. If carved under Pius II, the panels of the Trials would have decorated the corners of a fairly simple marble ciborium, the shape of which we know from a medal of 1470 (G. F. Hill, 1930, no. 764). It was this earlier ciborium that, under Sixtus IV, was modified and enriched by the addition of the four large narrative reliefs.

The eight carvings were set into the wall of the Cappella delle Partorienti, in the Grotte, about 1616. In 1949, they were moved to Room VI, and in 1977 they were reinstalled in Room IV of the Grotte.

<div align="right">O. R.</div>

BIBLIOGRAPHY: F. L. Dionysius, *Sacrarum Vaticanae Basilicae Cryptarum Monumenta*, Rome, 1828, pp. 50–51, no. 2, Tab. XXIII; H. von Tschudi, "Das Konfessionstabernakel Sixtus IV in St. Peter zu Rom," in *Jahrbuch der Königlich Preussischen Kunstsammlungen*, 8, 1887, pp. 11–24; F. Burger, "Das Konfessionstabernakel Sixtus IV u. sein Meister," in *Jahrbuch der Königlich Preussischen Kunstsammlungen*, 28, 1907, pp. 95–111, 150–67; A. Venturi, *La Scultura del Quattrocento* (Storia dell'Arte italiana, 6), Milan, 1908, p. 1128; G. Cascioli, *Guida illustrata delle Sacre Grotte Vaticane*, Rome, 1925, p. 26.

Comparative works cited: G. F. Hill, *A Corpus of Italian Medals of the Renaissance before Cellini*, London, 1930; C. Seymour, *Sculpture in Italy 1400 to 1500*, London, 1966; R. Niggl, ed., *G. Grimaldi, Descrizione della Basilica antica di S. Pietro in Vaticano*, Biblioteca Apostolica Vaticana, Vatican City, 1972; G. L. Hersey, *The Aragonese Arch at Naples 1443–1475*, New Haven, 1973.

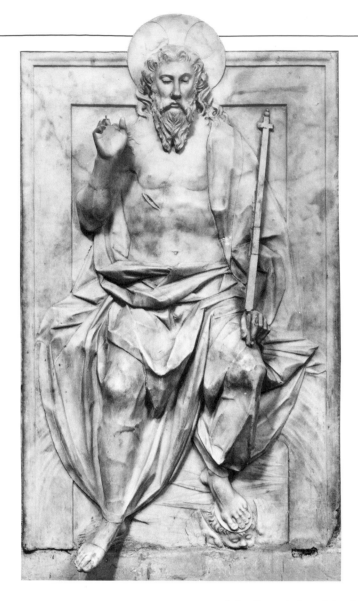

BIBLIOGRAPHY: K. Prijatelj, *Ivan Duknović*, Zagreb, 1957, p. 22, figs. 30–33; idem, "Profilo di Giovanni Dalmata," in *Arte Antica e Moderna*, 7, 1959, p. 288; J. Balogh, "Ioannes Duknovich de Tragurio," in *Acta Historiae Artium*, 7, 1960–61, pp. 51–78.

Comparative works cited: F. M. Torrigio, *Le Sacre Grotte Vaticane*, Viterbo, 1618; M. Cerrati, *Tiberii Alpharani de basilicae Vaticanae antiquissima et nova structura*, Rome, 1914; R. Niggl, ed., *G. Grimaldi, Descrizione della Basilica antica di S. Pietro in Vaticano*, Biblioteca Apostolica Vaticana, Vatican City, 1972.

12

ANDREA BREGNO (1418–1503)
RELIEF, WITH THE APOSTLE SAINT ANDREW

Rome, 1491
Marble
Height, 47⅛" (119.7 cm); width, 31¾" (80.6 cm)
New York, The Metropolitan Museum of Art, Gift of J. Pierpont Morgan, 1917, 17.190.1736 a–c

Standing in a shallow niche flanked by two Corinthian pilasters decorated with delicately carved candelabra, this noble figure of Saint Andrew was made for the marble altar erected in 1491 in the old basilica of Saint Peter's. The altar was commissioned by a French prelate, Guillaume de Perrier, and stood inside the front wall of the basilica, at the left of the door of the Last Judgment, as shown on the 1571 plan by Tiberio Alfarano (M. Cerrati, 1914, p. 70). A drawing made prior to the dismantling of the altar in 1606 shows its original aspect: three apostles stand in niches against the wall—Saint Peter in the center, flanked by Saint Paul, on the left, and Saint Andrew, on the right (R. Niggl, ed., 1972, p. 133, fig. 47). In 1612, the two reliefs of Saint Peter and Saint Paul were obtained by Monsignor Giovanni Battista Simoncelli, a member of Paul V's household, who transported them to his native village of Bauco (now Boville Ernica), south of Rome, and used them to decorate the entrance to his own family chapel.

The classicistic style of the two saints from Boville Ernica is so typical of the apostles on the marble altars commissioned between 1491 and 1495 by Perrier for various Roman churches that Muñoz could easily establish that these figures, originally, were part of the lost Perrier altar from Old Saint Peter's. When, in 1912, the relief of Saint Andrew surfaced on the Italian art market, the evidence was complete.

All of the Perrier altars have been associated by Ernst Steinmann (1899, pp. 226–31) with Andrea Bregno, on the basis of their stylistic affinity with some of his most famous Roman works: the tomb of Cardinal Nicholas of Cusa (died 1464) in San Pietro in Vincoli, the tomb (c. 1465) of Cardinal d'Albret (died 1465) in Santa Maria in Aracoeli, and the Borgia altar (1473) in Santa Maria del Popolo. In particular, this type of apostle—draped in an ample Roman toga worn over a pleated tunic and gathered at the side by the hand holding a book—so characteristic of the Perrier altars, can be found on several earlier Bregno monuments: in addition to the Borgia altar, on the Piccolomini altar in

11

GIOVANNI DALMATA (IVAN DUKNOVIĆ)
(c. 1440–c. 1510)
RELIEF, WITH THE BLESSING CHRIST

Rome, c. 1479
Marble
Height, 51½" (130.8 cm); width, 27⅞" (71 cm)
Reverenda Fabbrica di San Pietro

This imposing image of the Redeemer enthroned in heaven was the central panel of the tomb of Cardinal Bernardino Eroli in Old Saint Peter's. Flanking the central image were a relief of Saint Peter and one of Saint Paul and, below the effigy of the deceased, there were a long inscription and two panels with Eroli's coat of arms, as shown in two drawings in Giacomo Grimaldi's codex (R. Niggl, ed., 1972, p. 161, fig. 61, p. 338, fig. 206). Initially, the tomb was erected in the right transept of the old basilica, but later it was moved to the left nave (M. Cerrati, 1914, pp. 52, 82). It was disassembled in 1606 during the demolition of the nave ordered by Paul V, but most of its sculptural decoration was saved and the single elements reinstalled in various parts of the Grotte below Saint Peter's (F. M. Torrigio, 1618, pp. 36, 44, 52, 76). The present relief is in fairly good condition, except for the broken fingers of Christ's blessing hand, and the transverse arm of the cross.

When Cardinal Eroli died in 1479, Giovanni Dalmata had just completed his most famous work: the great funerary monument of Paul II in Saint Peter's, the execution of which he shared with Mino da Fiesole. The solemn vision of the Eroli *Christ* has a direct precedent in the reliefs of God the Father and of the Resurrected Christ on the tomb of Paul II. Similar in both are the vigorous geometry of the sharp, angular folds, and the introspective, icon-like face of the Redeemer.

In studying the sources of Dalmata's style, Jolán Balogh has stressed the importance of Florentine, rather than Roman, influences. His Resurrection relief seems to her to betray a recollection of details of works by Luca della Robbia and, especially, by Verrocchio. Yet, none of these comparisons accounts for the strikingly expressive, almost rugged forms that are so characteristic of Dalmata's style. The *Relief with the Blessing Christ*, as well as those of Saints Peter and Paul, from the Eroli tomb, are of such powerful individuality that one may wonder whether the sources of their semiabstract style are not to be found, ultimately, in the Byzantine icons of the sculptor's native Dalmatia. *O. R.*

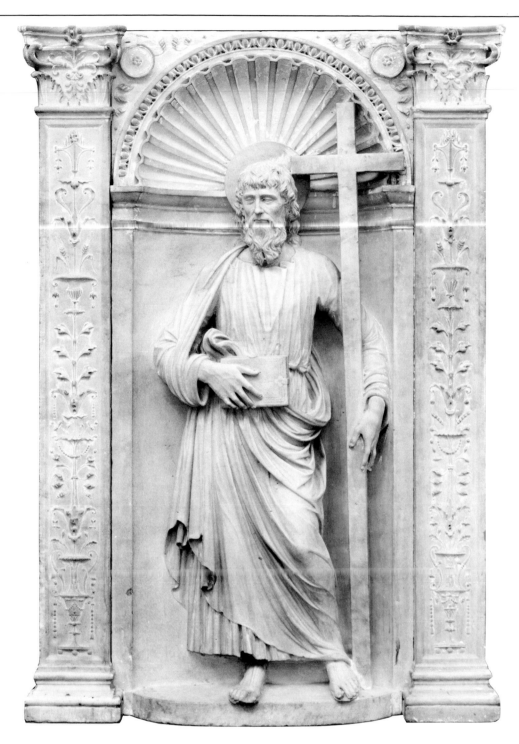

the Duomo in Siena and on the marble tabernacle at Santa Maria della Quercia in Viterbo.

While one may be confident that Bregno was responsible for the basic design of all of the Perrier altars, the differences in the way that single figures are handled suggest that they were carved by various sculptors employed in Bregno's busy studio. As remarked on by Muñoz (1911, p. 173), the three apostles from the Perrier altar at Saint Peter's are especially close to the figures on the tomb of Cardinal Giovanni Battista Savelli (1495–98) in Santa Maria in Aracoeli. Here we find the same elongated canon and the same predilection for narrowly pleated garments and sharply defined outlines. The sculptural style, indeed, seems to echo the refined and precious classicism so often to be found in Roman works of the 1490s.

In the New York *Saint Andrew*, the sharp and exquisite handling of the architectural ornament and the sensitive quality of the saint's well-drawn features argue strongly in favor of an attribution to Bregno himself. A point so far unnoticed is that the sculptor's own fine, taut features, as recorded in the portrait over his tomb at Santa Maria sopra Minerva (H. Egger, 1927, pl. XXVI), served as a model for the face of the apostle, who was his patron saint.

The recent history of the relief is not known. Presumably, it was in Italy until 1909, when it was sold by the dealer Alfredo Barsanti to J. Pierpont Morgan. *O. R.*

BIBLIOGRAPHY: A. Muñoz, "Ancora delle opere d'arte di Boville Ernica provenienti da S. Pietro in Vaticano," in *Bollettino d'Arte*, 6, 1912, pp. 239–42; J. Breck, *Catalogue of Romanesque, Gothic and Renaissance Sculpture*, The Metropolitan Museum of Art, New York, 1913, pp. 70–72, no. 73; G. C. Sciolla, "Profilo di Andrea Bregno," in *Arte Lombarda*, 15, 1970, p. 55.

Comparative works cited: E. Steinmann, "Andrea Bregno's Thätigkeit in Rom," in *Jahrbuch der Königliche Preussischen Kunstsammlungen*, 20, 1899, pp. 216–32; A. Muñoz, "Reliquie artistiche della vecchia basilica Vaticana a Boville Ernica," in *Bollettino d'Arte*, 5, 1911, pp. 161–82; M. Cerrati, *Tiberii Alpharani de basilicae Vaticanae antiquissima et nova structura*, Rome, 1914; H. Egger, "Beiträge zur Andrea Bregno—Forschung," in *Festschrift Schlosser*, Vienna, 1927, pp. 122–28; R. Niggl, ed., *G. Grimaldi, Descrizione della Basilica antica di S. Pietro in Vaticano*, Biblioteca Apostolica Vaticana, Vatican City, 1972.

THE
APOSTOLIC
PALACES

Many of the works of art now in the Vatican Museums testify to the enlightened and magnificent care taken by the popes in building and decorating their Vatican residence. The Apostolic palaces (fig. 15) are situated to the right, north of Saint Peter's, and comprise three distinct groups of buildings: to the west is the oldest nucleus of medieval palaces, with their Renaissance façade overlooking the open courtyard of San Damaso, toward Saint Peter's Square; to the north is the matching wing built by Gregory XIII (1572–85); to the east is the imposing, almost square, mass of the early-seventeenth-century Palace of Sixtus V (1585–90), which, to this day, serves as the residence of the pope.

For almost a thousand years, until the twelfth century, the popes resided near the basilica of San Giovanni in Laterano, the cathedral church of Rome. To be sure, in the ninth century, Leo IV (847–55) enclosed the Vatican hill within powerful walls, and, in the twelfth century, Eugene III (1145–53) and Innocent III (1198–1216) built a fortified dwelling to house the pope and the Curia close to Saint Peter's. Yet, it was Nicholas III (1277–80) who initiated the construction of a larger apostolic palace. It was to have four wings, surrounding a central courtyard, containing the papal apartments, three meeting halls, a palace chapel and a private chapel, and four defensive towers. Only the south and west wings of this palatial complex were built under Nicholas III, but the walls of some of the papal rooms were already embellished with frescoed friezes—as shown by the beautiful thirteenth- and fourteenth-century mural fragments discovered only recently (see cat. no. 13A–C). Construction of this medieval palace came to a halt during the Avignon papacy (1309–77) and the Great Schism (1378–1417), but with the election of the first great Renaissance pope, Nicholas V (1447–55), the Apostolic Palace entered a new and most splendid period. Nicholas V added a north wing, overlooking the Belvedere courtyard, that extends up along the Vatican hill. The austere façade blends with the earlier medieval building, but inside, on all three floors, the distribution of vaulted, regularly proportioned rooms, with their Early Renaissance mullioned windows, proclaims the new style. In 1447, Fra Angelico was called upon to fresco the pope's private chapel, the chapel of Saint Nicholas; the palace chapel; and the walls of a small *studiolo*. While the latter two were destroyed in the sixteenth century, the gem-like clarity of Angelico's cycles of Saint Lawrence and Saint Stephen still can be admired in the small chapel on the second floor of the palace.

Nicholas V's passion for books and for buildings was revived by one of his successors, Sixtus IV (1471–84), to whom we owe the formal creation, in 1475, of the Vatican Library, and the construction, between the palace and Saint Peter's, of the new Palatine Chapel—later known as the Sistine Chapel. The chapel was built between 1475 and 1480, and, by 1483, its walls were frescoed with the portraits of the first thirty-one popes (between the windows) and with the series of scenes from the lives of Moses and Christ by Pietro Perugino, Sandro Botticelli, Domenico Ghirlandaio, Bernardino Pinturicchio, Cosimo Rosselli, and Luca Signorelli. Their brilliant colors, enhanced by touches of gold, must have given the new chapel the gaiety and splendor of a page from an illuminated manuscript.

As the Apostolic Palace was nearly complete, Innocent VIII (1484–92) turned his attention toward the large stretch of green that extended up the Vatican hill to the "mons sancti Aegidii," where, in 1487, he had a pavilion erected, with an open loggia and crenellated walls, later to be known as the Palazzetto del Belvedere. It was one of the first pleasure villas to be built in Rome since antiquity. Above the entrance to the small papal apartment was a wreath with the pope's coat

FIG. 15. THE APOSTOLIC PALACES, AS SEEN FROM THE PIAZZA OF SAINT PETER'S

of arms carried by two angels, in glazed terracotta (see cat. no. 14). In the last years of the fifteenth century, Alexander VI (1492–1503) added the Borgia Tower to the east of the Apostolic Palace. He engaged Pinturicchio to decorate the five rooms of his apartment on the ground floor with paintings of the most festive and tapestry-like narrative cycles of the time (fig. 17). The election of Julius II (1503–13) ushered in an era in which the intimate character of the fifteenth-century papal residence was transformed by the sublime works of Raphael and Michelangelo and by the grandiose architectural plans of Donato Bramante. To Bramante we owe the Belvedere courtyard, designed to link the Apostolic Palace to the villa of Innocent VIII, and the three loggias of the new east façade of the palace, itself. It was Raphael who frescoed the new apartment of Julius II, on the floor above the Borgia rooms: the Stanza della Segnatura (fig. 16), which was the

pope's private library; the Stanza d'Eliodoro; and the Stanza dell'Incendio. Michelangelo, of course, was responsible for the monumental ceiling of the Sistine Chapel (fig. 18), with its episodes from the Old Testament, prophets, and Sibyls. By the time of Julius II's death, in 1513, Raphael had finished frescoing the Segnatura, a collective apotheosis of the eternal truths, and the Stanza d'Eliodoro, representing the divine protection of the Church. Under Leo X (1513–21), he continued to work in the Stanza dell'Incendio, and completed Bramante's loggias on the east side of the palace. Acting as architect and painter, with many students and followers, Raphael oversaw the mural decoration of the *Logge* with scenes from the Old and New Testaments and with intricate grotesques and *stucchi* inspired by those of the Domus Aurea of Nero. Shortly after 1514, he also prepared the cartoons for the so-called Scuola Vecchia series of ten tapestries with

FIG. 16. (*BELOW, TOP*): RAPHAEL'S FRESCOES IN THE STANZA DELLA SEGNATURA, WITH *THE DISPUTÀ* (*CENTER*). 1509–11
FIG. 17. (*BELOW, BOTTOM*): BERNARDINO PINTURICCHIO. *THE RESURRECTION*.
FRESCO. 1492–94. SALA DEI MISTERI, BORGIA APARTMENT
FIG. 18. (*RIGHT*): THE SISTINE CHAPEL, WITH A VIEW OF MICHELANGELO'S *LAST JUDGMENT*. FRESCO. 1536–41

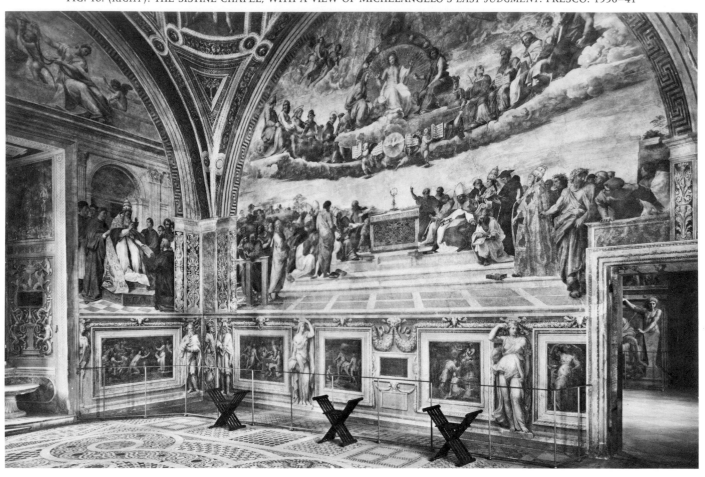

episodes from the lives of the Apostles Peter and Paul, commissioned by Leo X to decorate the Sistine Chapel—an admirable cycle, which embodies all of the majesty and poetry of Raphael's genius, as we see in one of the most beautiful of his compositions, *The Miraculous Draught of Fishes* (cat. no. 17).

Two years after the death of Leo X, Clement VII (1523–34) became pope and he looked to Michelangelo to paint the powerful fresco of *The Last Judgment* on the altar wall of the Sistine Chapel. The gigantic mural was completed by 1541, under Paul III (1534–49). This pontiff's reign marked still another phase in the decoration of the papal palace, to which was added Antonio da Sangallo's magnificent Sala Regia (of 1538–72), with its stuccoes by Perino del Vaga and Daniele da Volterra and its murals by Vasari and other Mannerist painters, and the Pauline Chapel, with Michelangelo's poignant frescoes of *The Conversion of Saul* and *The Martyrdom of Saint Peter* (of 1542–50). The completion of these great projects lasted well into the 1570s, transforming the old Apostolic Palace into the most magnificent of all Renaissance palaces, a magnet and source of inspiration for generations of artists throughout Europe.

Olga Raggio

BIBLIOGRAPHY: D. Redig de Campos, *I Palazzi Vaticani*, Bologna, 1967.

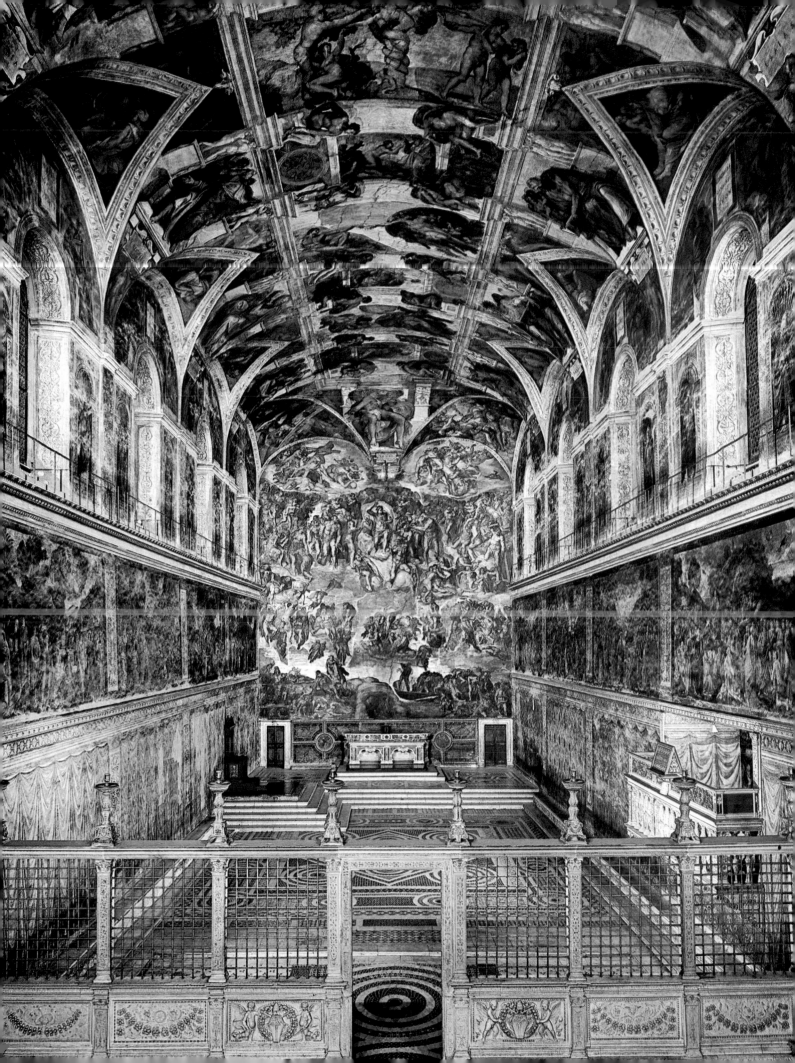

13

JACOBUS PICTOR (?)
A–C. FRAGMENTS OF A FRIEZE WITH GRIFFINS
Last quarter of the 13th century

These three fragments were part of the frieze of a small room on the second floor of the papal palace in the Vatican, in the wing built by Nicholas III (1277–80). The room, used by Nicholas V (1447–55) as a cubicle, adjoins the Sala della Falda and the Sala delle Paramenti (Hall of Vestments). The fragments occupied the space between the original ceiling and the one existing at the time of Nicholas V. They were discovered in 1948, detached from the wall in 1968, and, between 1972 and 1975, transferred onto Masonite and then restored. The fragments contain elements belonging to two very different decorative systems. The oldest consists of a band ornamented with a series of circles in each of which is a griffin, alternating with floral designs; in the register below, the swirls of floral motifs form intersecting circles. At a later period, the

decoration was modified by superimposing on the part with the swirls—while maintaining, as the primary element, the band with the griffins—another frieze with swirls of acanthus leaves interspersed with the coat of arms of Boniface IX (1389–1404). The oldest frieze is contemporary with the construction and original decoration of the little room—during the pontificate of Nicholas III, or slightly later—as confirmed by the style of the ornament.

The mention of a certain "Jacobus pictor," who was paid, in 1286 and 1288, "pro picturis . . . pluris" executed in the Vatican Palace, is documented, but there are no clear indications that he worked in this room or elsewhere—such as in the Sala dei Chiaroscuri (known, at one time, as the Sala del Pappagallo), or in the Sala degli Svizzeri, where, even today, above the ceiling, fragments of thirteenth-century decorations are to be found.

F. M.

BIBLIOGRAPHY: D. Redig de Campos, "Relazione II," in *Rendiconti della Pontificia Accademia Romana di Archeologia*, XXXIII–XXXIV, 1945–48, pp. 391–92; *Monumenti Musei e Gallerie Pontificie. Catalogo della Pinacoteca Vaticana*, I, W. F. Volbach, *I dipinti dal X secolo fino a Giotto*, Vatican City, 1979, pp. 27–31.

JACOBUS PICTOR (?)
13 A. FRAGMENT OF A FRIEZE WITH GRIFFINS
Last quarter of the 13th century
Fresco, transferred to Masonite
Height, 33⅞" (86 cm); width, 90¼" (153 cm)
Pinacoteca, Inv. no. 2325/3

The fresco, restored between 1972 and 1975, occupied the west wall. All that remains of the fragment is part of the thirteenth-century decoration. In the lower section of the fragment there is no trace of the frieze from the time of Boniface IX.

JACOBUS PICTOR (?)
13 B. FRAGMENT OF A FRIEZE WITH GRIFFINS
Last quarter of the 13th century
Fresco, transferred to Masonite
Height, 43⁵⁄₁₆" (110 cm); width, 47⅛" (119.5 cm)
Pinacoteca, Inv. no. 2325/18

Restored between 1972 and 1975, and situated, originally, on the east wall, this fragment shows most clearly all the elements of the thirteenth-century decorative scheme—the band with the griffins, above, and the swirls of floral motifs, below. Nothing remains in the lower part of the fragment from the frieze dating from the time of Boniface IX.

JACOBUS PICTOR (?) AND UNKNOWN PAINTER
13 C. FRAGMENTS OF TWO FRIEZES OF DIFFERENT DATES
Last quarter of the 13th century, and the pontificate of Boniface IX (1389–1404)
Fresco, transferred to Masonite
Height, 43¹¹⁄₁₆" (111 cm); width, 58¼" (148 cm)
Pinacoteca, Inv. no. 2325/17

This fresco, restored between 1972 and 1975, also decorated the east wall. It contains elements of two separate designs: above, the thirteenth-century frieze with griffins; below, with a later border clearly superimposed on an older fresco, the frieze from the time of Boniface IX, including the pope's coat of arms, and, on the side, traces of the swirling acanthus-leaf decoration.

13 A

13 B

13 C

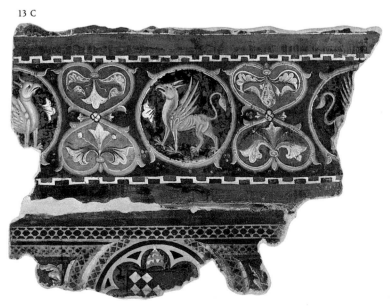

14

BENEDETTO BUGLIONI (c. 1461–1521)
**WREATH, WITH THE ARMS OF POPE
INNOCENT VIII (1484–92) SUPPORTED
BY TWO ANGELS**

Florence, 1484–92
Glazed terracotta
Diameter of wreath, 47⅝" (121 cm); height: left
* angel, 37¼" (96 cm), right angel, 35½" (90 cm)*
Musei Vaticani, Inv. no. 4087

A wreath surrounds the coat of arms of the Genoese Giovanni Battista Cibo (later Pope Innocent VIII; 1484–92): a shield gules, with a bend checky argent and azure and a chief silver, with the cross of the Republic of Genoa, gules. Above it are the papal tiara and the crossed keys, one gold and the other silver. The shield shows signs of having been hit with a sharp metal point in an attempt to deface the checkered bend, while the continuous fruit-and-flower wreath, cast in six pieces, has numerous plaster repairs. The two angels are well preserved, except for losses on the hands and feet. Because of the unfinished edges of their forearms, the angels recently have been placed closer to the wreath than in their former installation in the Borgia Apartment, thus conveying the impression of supporting the wreath from below rather than from the sides, as before.

The earliest mention of this armorial occurs in Agostino Taja's description of the Cortile del Belvedere, written about 1712 (*Descrizione del Palazzo Apostolico Vaticano*, Rome, 1750, p. 399): It was over the doorway leading into the apartment of Innocent VIII, on the northern side of the courtyard, as shown also in an anonymous Italian drawing of about 1720–27 in the British Library in London (see C. Pietrangeli, Introduction, cat. p. 16, fig. 3). In 1771, when this doorway became the entrance to the Clementine museum, the armorial was replaced by the arms of Clement XIV (1769–74), as we see in Anton Raphael Mengs's allegorical fresco on the ceiling of the Gabinetto dei Papiri (see G. Daltrop, cat. p. 117, fig. 30). About 1844, the armorial was moved to the new Museo Gregoriano Profano in the Palazzo Lateranense. In 1897, it was returned to the Vatican to be shown in the Borgia Apartment, which had just been restored and installed as a museum of decorative arts. It remained there until about 1964, when the Collection of Modern Religious Art was moved into the Borgia Apartment.

Both the armorial and the angels must have been executed shortly after 1487, the date of the completion of the Belvedere villa. Although the bright enameled colors of the stemma seem to be close to those used by Andrea della Robbia's workshop, the modeling of the angels—who are of different proportions—bears no resemblance to the clarity of outline, the rhythm of the drapery patterns, or to the facial types of the della Robbia repertory. The armorial was ascribed by Allan Marquand to Benedetto Buglioni, after comparison with documented works by Buglioni, of 1487–88—three wreaths with the monogram of Jesus, and the figures of Saint Peter and Saint Benedict—in the vault of the refectory of San Pietro dei Cassinensi in Perugia. We can confirm this attribution by comparing the two Belvedere angels with Buglioni's altarpiece of the *Resurrection*, documented to 1490, in the Museo Civico in Pistoia (A. Marquand, 1921, p. 27, fig. 21), where the figure of Christ displays the same strongly Verrocchiesque features as the right-hand angel of the Belvedere armorial. Other elements, such as the somewhat elaborate treatment of the clinging draperies and the type of the left angel, also recall details of Verrocchio's tomb of Cardinal Niccolò Forteguerri (of 1483) in Pistoia Cathedral, a work that, undoubtedly, must have made a lasting impression upon Buglioni.

The armorial's vivid polychromy was well in keeping with the fresco decorations of the apartment of Innocent VIII, to which the airy landscapes, grotesques, and putti in the main rooms, and Mantegna's miniature-like wall paintings in the small papal chapel, must have lent a cheerful, informal character.

O. R.

BIBLIOGRAPHY: A. Marquand, *Benedetto and Santi Buglioni*, Princeton, 1921, p. 3, fig. 1; C. Pietrangeli, "Il Museo Clementino Vaticano," in *Rendiconti della Pontificia Accademia di Archeologia*, 27, 1951–52, p. 94; D. Redig de Campos, *I Palazzi Vaticani*, Bologna, 1967, p. 76; E. Micheletti, "Benedetto Buglioni," in *Dizionario biografico degli italiani*, XV (1972), pp. 26–27.

15

THE "MYSTIC WINE" TAPESTRY

Flanders, first quarter of the 16th century
Tapestry, in wool and silk, with silver and
silver-gilt threads
Height, 54¾" (139 cm); width, 68⅛" (173 cm)
Palazzo Vaticano, Appartamento Pontificio, Inv.
no. 3833

The weft is of two-ply wool, three-ply silk, and silver and silver-gilt thread; the warp is of two-ply wool, with eight to ten threads per centimeter. The tapestry was restored in 1868—when those portions in silk that had been lost or damaged were rewoven in wool—and again in 1955, preserving the old restorations.

The tapestry was given to Pius IX by the Chapter of Santa Maria Maggiore in Rome, which had had it restored by Eraclito Gentili (cf. P. Gentili, 1874, p. 47). It was displayed in the Palazzo del Quirinale, at the 1870 "Esposizione Romana" (cf. *L'Esposizione Romana*, 1870, p. 58), and then was hung in the Galleria degli Arazzi in the Vatican (cf. D. Farabulini, 1884, n. p. 97). Transferred to the Borgia Apartment in 1898, the tapestry was first in the Sala dei Santi (cf. S. Le Grelle, 1925, p. 75) and then in the Sala dei Pontifici—where it remained until 1962, and from which it was taken to the papal apartment. It was exhibited in Antwerp in 1954.

The scene is framed by a continuous frieze of floral and vegetal elements in which grape vines predominate. The subject of the tapestry is based upon the grape—symbolic of the Passion and of the Eucharist. In the center are the Virgin and Child, before whom a woman kneels, holding a chalice in her right hand. The woman clearly is wearing modern clothing, and her facial features are so personalized that this image is probably a portrait. Jesus offers her a bunch of grapes from the chalice. The significance of this scene is suggested by the inscription on the scroll in the upper left: BIBITE • VINVM • Q[VO]D • MISCVI • VOBIS • PROVE 9 (Proverbs 9:5), which is a reference to Wisdom, who invites men to dine. The woman is, therefore, in all likelihood an allegory of the Church, for whom Christ, by offering the bunch of grapes, "pours" the Eucharistic wine. The identities of the two lateral figures are clarified by the scrolls that accompany them. The figure on the left, like the woman, wears

modern clothing, and the distinctiveness of his features seems to indicate that this, too, is a portrait. The inscription on his scroll, PORREXIT • MANVM • SVAM • IN • LIBACIONE • ET • LIBAVIT • DE SANGVINE • VVE • 50, is from the Vulgate Ecclesiastes 50:15, the text of which speaks of Simon, son of Onia, High Priest of the Old Law, so that he is probably Simon who prefigures Christ, High Priest of the New Law. The figure on the right, holding a scroll with the words AMM̄RM̄ • /ERIT • POTIOBIBĒTIBVS • ILLAM/VSA • 29, from Isaiah (24:9), most likely is Isaiah; the text prefigures the Passion, suggesting the Eucharistic interpretation of the wine as the blood of Christ. In the background, two singing angels are accompanying themselves on the harp and on a small viola, as two other angels listen and observe the action in the foreground. A typically Northern landscape is visible behind them.

According to Pietro Gentili (1868, p. 6), who cites the archive sources, the tapestry was donated to the Chapter of Santa Maria Maggiore by Julius II. The choice of so rare a subject is not surprising when we recall that Julius II's uncle, Sixtus IV, had participated in a debate about the blood of Christ, initiated in 1462 by Pius II, and had published, in 1472, a treatise entitled *De Sanguine Christi (Of Christ's Blood)* (cod. Vat. lat. 1051, 1052). Given its theme, the tapestry was probably commissioned by Julius II. Its extremely high quality indicates, moreover, that it was woven in an important Flemish workshop early in the sixteenth century—perhaps from a cartoon by an artist close to Quentin Metsys. Considering its dimensions, it is possible—as suggested by X. Barbier de Montault (1879, p. 185)—that the tapestry was an altarpiece.

F. M.

BIBLIOGRAPHY: P. Gentili, *Breve relazione di un arazzo fiammingo rappresentante Gesù Bambino in grembo alla Beata Vergine con allusione al SS.mo Sacramento della Eucaristia*, Rome, 1868; *L'Esposizione Romana delle opere di ogni arte eseguite nel culto cattolico. Giornale illustrato*, Rome, 1870, no. 7, p. 58; P. Gentili, *Sulla Manifattura degli Arazzi*, Rome, 1874, p. 47; X. Barbier de Montault, "Inventaire Descriptif des Tapisseries de Haute-Lisse Conservées à Rome," in *Mémoires de l'Académie des Sciences et Arts d'Arras*, II, X, 1879, pp. 184–85; D. Farabulini, *L'arte degli arazzi e la nuova Galleria dei Gobelins al Vaticano*, Rome, 1884, n. p. 97; *Musei e Gallerie Pontificie*, S. Le Grelle, *Guida delle Gallerie di Pittura*, Rome, 1925, p. 75.

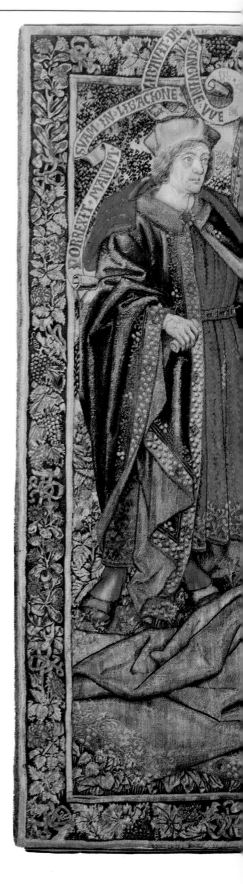

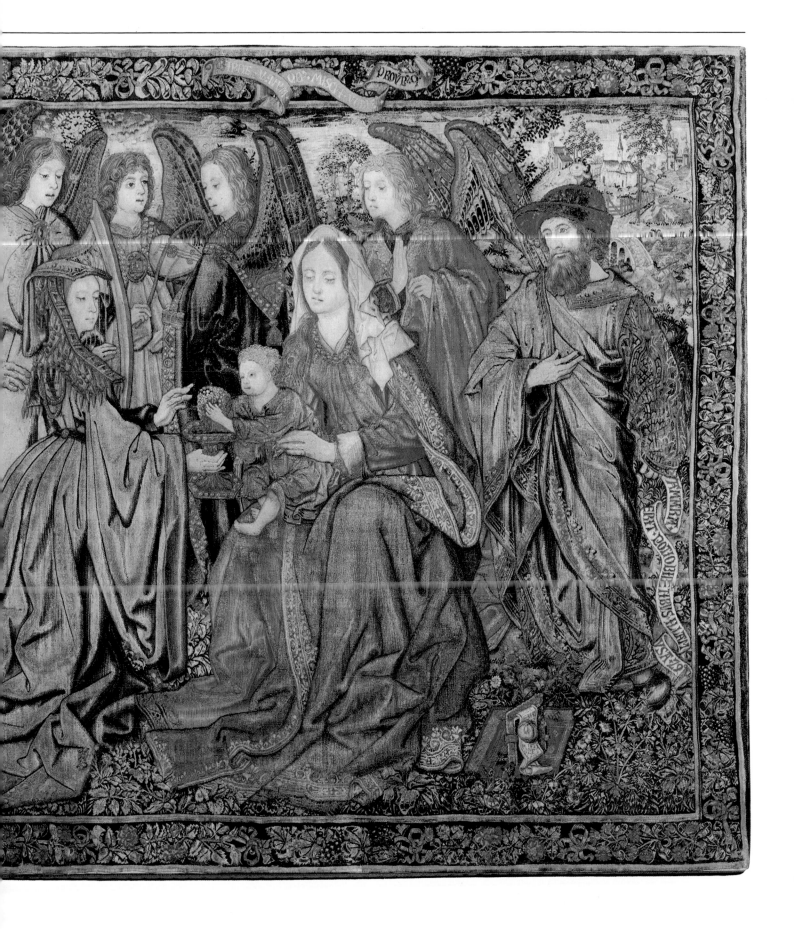

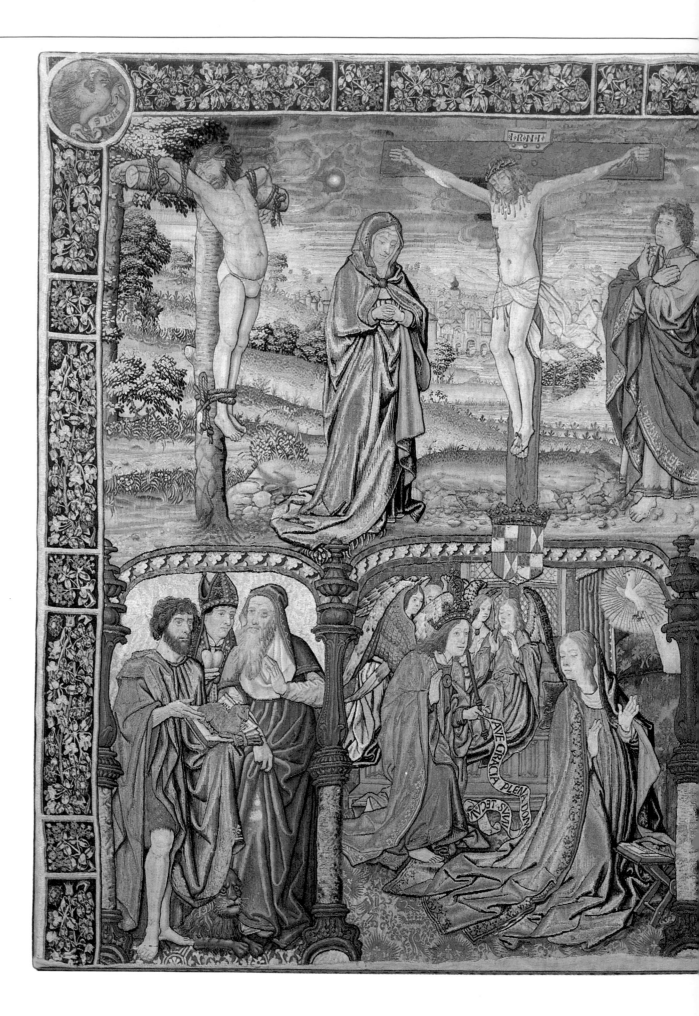

TAPESTRY, WITH THE CRUCIFIXION, THE ANNUNCIATION, AND SAINTS

Flanders, first quarter of the 16th century
Tapestry, in wool and silk, with silver-gilt threads
Height, 71 ¹¹/₁₆" (182 cm); width, 76" (193 cm)
Palazzo Vaticano, Appartamento Pontificio, Inv.
 no. 3830

The weft is of two-ply wool, three-ply silk, and silver-gilt thread; the warp is of two-ply wool, with eight to nine threads per centimeter. Missing are about thirty centimeters of the lower part of the tapestry, including the floral border and the tondi in the corners, with the symbols of the Evangelists Luke and Matthew. According to Barbier de Montault (1879, pp. 183–84), who gives a fairly precise description, in the second half of the nineteenth century the tapestry was in Saint Peter's, and it was exhibited for the first time at the "Esposizione Romana" of 1870, at which point it seems to have been undamaged. Subsequently, it was moved to the Sala delle Sibille in the Borgia Apartment, where it remained until 1962, when it was transferred to the papal apartments.

The field is divided into two areas. Above, against the background of a hilly Northern landscape with trees and houses, is the Crucifixion. Below, framed by arcades supported by Composite columns, are three scenes. In the center is the Annunciation, set in an interior. On the left is Saint John the Baptist, with a book and a lamb; Saint Augustine, holding his heart in his hand; and Saint Jerome, with the lion beside him. On the right are Saint Catherine of Alexandria, who treads upon the wheel of her martyrdom and grips the sword with which she was killed, and Saint Martha, who holds a basin of holy water. No longer visible (it was in the lost portion of the tapestry) is the dragon that was trampled by the saint, but its presence was attested by Barbier de Montault. At the foot of the cross is the Spanish royal crest, which, along with certain resemblances in facial type, suggests that the angel of the Annunciation and the Virgin are, respectively, Ferdinand and Isabella, the "Catholic Kings." The crest clearly indicates that the tapestry was a gift from the Spanish royal family, although, stylistically, it appears to have been made in Flanders early in the six-teenth century. Considering its dimensions, it is likely that it was designed as an altarpiece.

F. M.

BIBLIOGRAPHY: X. Barbier de Montault, "Inventaire Descriptif des Tapisseries de Haute-Lisse Conservées à Rome," in *Mémoires de l'Académie des Sciences et Arts d'Arras*, II, X, 1879, pp. 183–84; *Musei e Gallerie Pontificie*, S. Le Grelle, *Guida delle Gallerie di Pittura*, Rome, 1925, p. 67.

RAPHAEL'S TAPESTRIES FOR THE SISTINE CHAPEL

c. 1515–21

The tapestry depicting the Miracle of the Fishes and the two borders with the Hours and the Seasons are part of a series devoted to the Apostles Peter and Paul, commissioned from Raphael by Leo X, about 1513–14, for the Sistine Chapel (cf. J. Shearman, 1972, pp. 1–20). Raphael received the first payment for the cartoons on June 16, 1515, and the final sum on December 20, 1516 (cf. V. Golzio, 1936, pp. 38, 51). The tapestries were woven in Brussels in the workshop of Pieter van Aelst; work began before July 1517, since, at the end of that month, Antonio De' Beatis reported as finished ("fornito") the one entitled *The Giving of the Keys* (idem, p. 370). Curiously, De' Beatis spoke of sixteen tapestries, while only ten have come down to us. Unless there was an error, one wonders whether, initially, a larger series was planned to cover completely the walls of the area of the chapel set aside for laymen— between the railing and the entrance wall.

According to the Venetian ambassador, Marino Sanuto, in July 1519 three tapestries were delivered; the papal master of ceremonies, Paris de Grassis, wrote that, for the papal Mass of December 26, 1519, in the Sistine Chapel, there were seven hangings, and "qui ut fuit universale judicium, sunt res quibus non est aliquid in orbe pulcrius, ut unumquodque pretium est valoris duorum milium ducatorum auri in auro" ("as was universally believed, the tapestries are the most beautiful things in the world, and the price of each one was two thousand gold ducats") (idem, pp. 101, 103). Marcantonio Michiel, who saw them the next day, counted among the tapestries *The Miraculous Draught of Fishes, The Giving of the Keys, Saint Peter Healing a Cripple, The Martyrdom of Saint Stephen, The Conversion of Saint Paul, The Blinding of Elima,* and *The Sacrifice of Lystra.* In the inventory of tapestries drawn up at the death of Leo X in December 1521 (cf. J. Shearman, 1972, p. 138), *The Death of Ananias, Saint Paul in Prison,* and *The Preaching of Saint Paul in Athens* are included.

The vicissitudes of the tapestries after their arrival in Rome were reconstructed, in 1958, by J. Shearman and J. White in two long articles, and reexamined by Shearman in his 1972 monograph on Raphael's tapestries and cartoons. In 1527, during the Sack of Rome, the series was stolen and sold by the troops of Charles V. *The Conversion* and *The Preaching of Saint Paul* were acquired by Isabella d'Este, and then stolen by pirates, who took them to Tunisia. A marine captain, Cazadiavolo, brought them to Venice in 1528 and sold them to Zuanantonio Venier. Later, the two tapestries ended up in Constantinople, where they were acquired by Constable Anne de Montmorency, who gave them to Julius III in 1554. As for the rest of the series, in 1530 Clement VII received an offer for several tapestries then in Lyons—perhaps the same ones that, on March 31, 1531, were exhibited in the Sistine Chapel along with the so-called Scuola Nuova tapestries, which had just been completed.

We know that, in 1532, four tapestries and a fragment were in Naples, and that Clement VII was negotiating to acquire them. It was probably during the pontificate of Paul III that the practice developed of displaying the series on great holy days, such as Easter and Corpus Christi, at the end of the street leading to Saint Peter's: first, on the portico in front of the basilica; then, following Bernini's reorganization of the piazza in the seventeenth century, in the Braccio of Constantine. In 1798, the series was once again carried off, this time to Genoa and then to Paris, and finally, in 1808, it was returned to the Vatican. Pius VII decided to put the tapestries on permanent display, and had them placed in the apartment of Saint Pius V. Gregory XVI transferred them to the so-called Galleria degli Arazzi, reuniting them with the Scuola Nuova series, and, in 1932, Pius XI had them installed in the room dedicated to Raphael in the new Pinacoteca.

The tapestries originally were hung in the Sistine Chapel, in the area used by the clergy; only *The Preaching of Saint Paul* was on the other side of the railing, in the section reserved for laymen. The initial disposition of the individual tapestries has continued to be debated, and the most reliable reconstruction seems to be that proposed by Shearman and White (1958, pp. 197–203).

The series clearly was based on an iconographic program drawn up by a theologian in the circle of Leo X, and certainly reflects the thinking of the pontiff; events from his life are illustrated in the lower borders of the individual tapestries. The Peter and Paul cycles document, through subtle parallels in the activities of the two apostles, the origin of their authority in Christ, and, hence, the primacy of the spiritual power of the pope, the divine nature of his mission and his judgment, and, finally, the duty of the Church to actively propagate the Word of Christ. In short, the series represents Leo X's response to the heretical propositions of several cardinals (during the pontificate of Julius II) who had questioned the legality and supremacy of papal power. Of the cartoons executed by Raphael and his workshop, seven remain—all in the Victoria and Albert Museum in London. In the past, they had been attributed to Giovan Francesco Penni alone, but, recently, numerous scholars— particularly Shearman—have returned them to Raphael, if also with the assistance of Giulio Romano, Penni, Giovanni da Udine, and the young Perino del Vaga. Their elegant monumentality, the frequent theatricality of the compositional schemes and of the gestures of the figures, the predominance of the figures over the landscape, and the type of architecture that is depicted make the tapestries a key moment in the artistic development of Raphael. In fact, they document the adoption by the master from Urbino of an artistic vocabulary that characterizes his late work and that marks the beginnings of the "tragic" style (cf. P. De Vecchi, 1981, p. 86) that would find in *The Transfiguration* its most perfect manifestation.

The wefts of the tapestry and of the borders are of three-ply wool, two-ply silk, and silver-gilt thread. The warps are of three-ply wool, with seven threads per centimeter. The tapestry and borders were restored in 1982, and the older restorations were partially preserved.

PIETER VAN AELST (active c. 1532), after a cartoon by **RAPHAEL** (Urbino 1483– Rome 1520)

17. THE MIRACULOUS DRAUGHT OF FISHES

c. 1519

Tapestry, in silk and wool, with silver-gilt threads
Overall: height, 15' 11⁵⁄₁₆" (490 cm), width,
14' 5⁵⁄₈" (441 cm); original part: height,
14' 1¹¹⁄₁₆" (431 cm), width, 15' 8³⁄₁₆" (478 cm)
Pinacoteca, Inv. no. 3867

This tapestry, in the group delivered by van Aelst to Leo X in 1519, was seen by Michiel in the Sistine Chapel that December. It was among the last of the tapestries returned to the chapel after the Sack of Rome, and was one of two given to Julius III in 1554 by Constable Anne de Montmorency. According to Shearman, Raphael intended it for the right of the altar.

The subject, from Luke (5:1–11), recounts the Miraculous Draught of Fishes, specifically, the episode in the vocation of Peter when, amazed by the quantity of fish that were caught, "he fell down at Jesus's knees, saying, Depart from me; for I am a sinful man, O Lord. . . . And Jesus said unto Simon, Fear not; from henceforth thou shalt catch men." According to Shearman, recognizable in the panorama in the background are the *mons Vaticanus* (the Vatican hill), with the towers along the wall of Leo IV, and Saint Peter's under construction. The cranes in the foreground, symbols of vigilance, are contrasted with the seagulls that allude to sin and apostasy. In the lower border are two episodes in the life of Giuliano de' Medici (later, Pope Leo X): on the left, his arrival in Rome for the conclave; on the right, the election of March 11, 1513. The border was conceived to resemble a relief and was executed in chiaroscuro. In Raphael's design, the tapestry had a separately woven frieze on the right, which Shearman identifies as the Four Elements. The direct attribution of the cartoon of *The Miraculous Draught of Fishes* to Raphael is unanimous, while to Giovanni da Udine, perhaps, belongs the invention of the group of cranes in the foreground, as well as other animalistic details. The prototype of the two fishermen who pull in the nets is found in Michelangelo's cartoon for *The Battle of Cascina*. According to Vasari, the lost cartoon for the lower border was executed by Penni, as were those for the lower borders of all the other tapestries. For *The Miraculous Draught of Fishes*, Raphael seems to have wavered between two compositional ideas, both documented in a sheet—variously attributed—in the Albertina (R 85) in Vienna. On one side of the sheet, the composition is the same as that adopted later for the tapestry, while, on the reverse, Christ and the apostles are moved to the background, and the spectators' attention is concentrated on the apparently secondary group of people left on the shore after the preaching of the Redeemer. Raphael originated this arrangement of relegating the principal event to the background, and it remained a favorite compositional device, from 1514 to 1520. The painter from Urbino, in fact, adopted it in the fresco *The Fire in the Borgo* (in the Stanza dell' Incendio), and in *The Transfiguration*. Probably, though, it was more suited to a single composition than to a series, which, perhaps, explains why it was not used for *The Miraculous Draught of Fishes*.

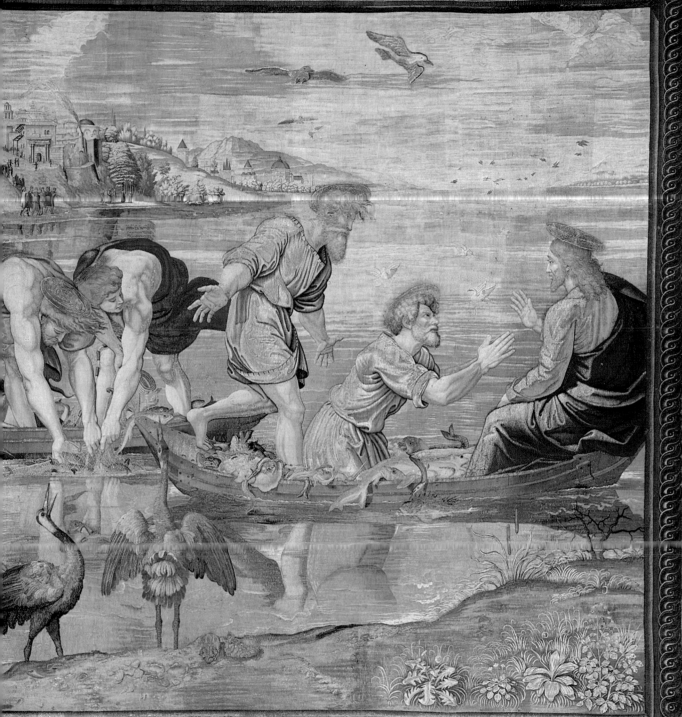

PIETER VAN AELST (active c. 1532), after a cartoon by **RAPHAEL** (Urbino 1483–Rome 1520)

18. BORDER, WITH THE SEASONS

Tapestry, in silk and wool, with silver-gilt threads
Overall: height, 15' 11 5/16" (490 cm), width,
* 31 1/2" (80 cm); original part: height, 15' 5 7/8"*
* (472 cm), width, 25 3/16" (64 cm)*
Pinacoteca, Inv. no. 3867/A

In the reconstruction proposed by Shearman, this border was located to the right of *The Healing of the Cripple*. It portrays the sequence of the Four Seasons characterized by the fruits produced by nature. The two embracing young people at the top, below the coat of arms, represent Spring; the woman with the sheaf of wheat clearly is Summer; while the putti climbing on the grape vines symbolize Autumn. The group of the shrouded, seated figure and Juno—borne aloft, in flight, on a stormy cloud, surrounded by two peacocks who serve to identify her, and by two putti who are personifications of the Winds—signifies Winter. According to Shearman, the allegorical theme that unites the borders (see cat. no. 19) is the triumph of Virtue over Chance. The Seasons allude, specifically, to the blind manifestations of the forces of nature, and express, particularly, the preoccupation of the Medici that is explained by their motto, "Le tems revient."

The cartoon of the tapestry is lost, but the quality of the images and the freshness of invention point to Raphael, rather than to his workshop, as the author.

PIETER VAN AELST (active c. 1532), after a cartoon by Raphael's workshop

19. BORDER, WITH THE HOURS

Tapestry, in silk and wool, with silver-gilt threads
Overall: height, 16' 4 1/16" (498 cm), width,
* 31 7/8" (81 cm); original part: height, 16' 1 11/16"*
* (492 cm), width, 30 11/16" (78 cm)*
Pinacoteca, Inv. no. 3878

This border was restored in 1982, partially preserving the older repairs. In the case of the figure of Night, where the weft was totally lacking, a method of conservation was adopted whereby the threads of the warp were fastened to a cloth support that had been appropriately dyed and then sewn onto the verso of the tapestry.

Shearman's reconstruction places this border to the right of *The Death of Ananias*. Three groups of two figures, each pair back to back, represent the division of the day into the time spans that determine its length—just as the succession of the Seasons determines the division of the year. Above, Apollo and Diana sit on either side of an architectural support, on top of which is an hourglass. The base of the support is encircled by a serpent biting its tail, another symbol of time. Just below are the allegorical figures of Day and Night, the latter recognizable by her dark skin color and by the bat that she holds in her left hand. Day and Night sit on a clock, supported by a monumental candelabrum, probably—as suggested by Arnold Nesselrath—one of those in the Galleria dei Candelabri in the Vatican. Beside them are two figures with cornucopias, symbolic of the abundance produced by Time.

The cartoon of this border is lost, and no preparatory drawings are known. The type of imagery and its level of inventiveness would exclude the direct participation of Raphael, who probably entrusted the entire work to his studio. The hand of the young Perino del Vaga perhaps is discernible in the telamon at the bottom.

F. M.

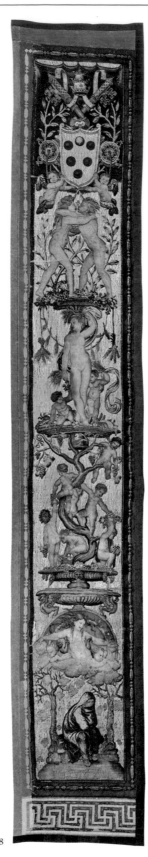

18

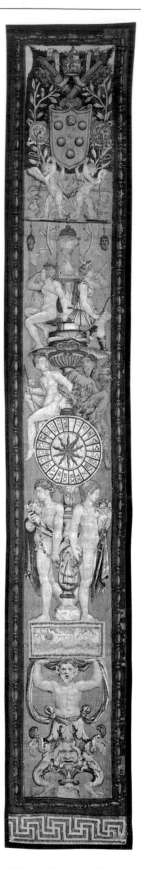

19

BIBLIOGRAPHY: J. White and J. Shearman, "Raphael's Tapestries and their Cartoons," in *The Art Bulletin*, XL, 1958, pp. 193–221, 299–323; L. Dussler, *Raphael*, London–New York, 1971, pp. 101–8; J. Shearman, *Raphael's Cartoons and the Tapestries for the Sistine Chapel*, London–New York, 1972; P. De Vecchi, *Raffaello. La Pittura*, Florence, 1981, pp. 80–88.

THE
BELVEDERE

THE BEGINNING OF THE COLLECTION
OF CLASSICAL STATUES IN THE VATICAN

Francesco Albertini was the first to report on the ancient statues in the Vatican in his *Opusculum de mirabilibus novae et veteris Urbis Romae*. This manuscript, dedicated to Julius II (1503–13), was completed June 3, 1509, and was published in 1510. Albertini writes of the *Apollo Belvedere*: "What may I say about the very beautiful statue of Apollo, which, if I may say so, appears alive, and which your Beatitude transferred to the Vatican?" An earlier drawing of the statue (fig. 19) in the *Codex Escurialensis* includes a notation giving its location "in the garden of San Pietro in Vincoli." From 1471, Giuliano della Rovere, the future Pope Julius II, had been cardinal of the titular church of San Pietro in Vincoli, and, as such, the owner of the statue. Nothing certain of its earlier whereabouts can be determined. In any case, Andrea del Castagno, who died in 1457, seems to have seen it, as demonstrated by the figure of David that he painted on a leather shield (now in the National Gallery of Art in Washington, D.C.). The lack of references to the *Apollo Belvedere* in the fifteenth and early sixteenth century may indicate that the statue had been known for a long time, and that no one remembered either the place or the time of its discovery—unlike the *Laocoön* group, for example, which was discovered on January 14, 1506, purchased by Julius II on March 23, 1506, and, in the same year, placed in the Cortile del Belvedere. This is the only antique sculpture in the collection of Julius II about whose provenance and installation his contemporaries reported in detail.

Apollo's connection to the Vatican goes back to the *Liber Pontificalis*, a papal history in the form of sequentially ordered biographies of the bishops of Rome, which had been begun in the sixth century and was expanded upon gradually over the years. There it is written that the Apostle Peter lies buried "in the Sanctuary of Apollo, by the place where he was crucified, . . . on the Vatican" (I, 118). During the pontificate of Silvester I (314–35), a basilica dedicated to the Apostle Peter was erected by the Emperor Constantine "in the Sanctuary of Apollo, which contains the coffin with the body of Saint Peter (I, 176)." In his poem "Antiquaria Urbis," written during the papacy of Julius II and published in 1513, Andreas Fulvius expressly stated that the Vatican hill (fig. 22) is sacred to Apollo: "Vaticanus apex, Phoebo sacratus, ubi olim auguria hetrusci vates captare solebant" (v. 33). The description of the hill as the place "where Etruscan priests used to watch for auguries" refers to the "Vaticinia" (or "prophecies"), from which it is supposed that the "Vaticanus collis" took its name. By placing the statue of Apollo in the Belvedere Julius II provided visual expression for this tradition at the Vatican, and, moreover, by directing Raphael to depict Parnassus in the Stanza della Segnatura, he clarified how he wished to have the tradition understood.

In 1508, Julius II commissioned Raphael to paint the frescoes in the Stanza della Segnatura. Over the north window he represented Parnassus (fig. 20), with Apollo in the center, surrounded by the nine Muses and various ancient and modern poets. Above the fresco, next to the winged personification of Poetry, is the motto "numine afflatur" ("suffused by divine will"). This is a reference to a phrase from Virgil's *Aeneid* (VI, 50), "adflata est numine" ("suffused with the breath of the imminent god, Apollo"). In Julius's time, if one opened the window below the fresco of Parnassus, one looked out upon the Belvedere (fig. 21). Thus, Raphael's fresco of Parnassus refers to an actual presence on the other side of the wall, to the ancient statue of Apollo on the Vatican hill. The painting is a representation and an interpretation of the Belvedere, revealing its significance to Julius II as *mons Parnassus*, replete with the Delphic Apollo.

When Julius II learned of the discovery of a sculpture in the Sette Sale, he immediately dispatched to the site his architect Giuliano da Sangallo, who recognized that this was the

Laocoön spoken of by Pliny in classical literature.

In explaining the work, the first reports from Rome also referred to the second book of Virgil's *Aeneid*, in which Aeneas, as a firsthand witness, relates the fate of the Trojan priest of Apollo, Laocoön. For Aeneas, the death of Laocoön represented the first *prodigium* of the downfall of Troy, and he understood it as a *numen*, a decisive act of the gods. Aeneas imparts to Laocoön's death a religious significance for the course of Roman history. To Aeneas that history was merely a series of fated events, guided by divine intervention, the ultimate objective of which was his own mission to Rome,

FIG. 19. *THE APOLLO BELVEDERE.* EARLY-16th-CENTURY COPY OF A LATE-15th-CENTURY DRAWING (FROM THE *CODEX ESCURIALENSIS*, FOLIO 53 r.)

the promised land. It is this theological interpretation of Roman history and sovereignty that Jacopo Sadoleto evokes in his poem celebrating the newly rediscovered *Laocoön*, in which he praises the sculpture as "an image of divine art," a symbol of the renewal of Rome, following the return of the popes from Avignon, and of the reawakening of its ancient glory. The rediscovered *Laocoön* was a welcome sign for Julius II, one that symbolized the rebirth of Rome. He acquired the sculpture in March, and on April 18, 1506, he laid the cornerstone of the new Saint Peter's, the visible embodiment of that spirit of renewal: "He will have charged that these very images of Laocoön and his children be placed in the Vatican for the perpetual remembrance of this accomplishment." As early as June 1, 1506, Cesare Trivulzio reported to his brother Pomponio of the installation of the *Laocoön* in the "Villetta di Belvedere, and he has had made for it a space like a chapel," referring to the central niche in the south wall of the Cortile between the *Apollo* and the *Venus*: Apollo, who always accompanied Aeneas as an interpreter of the *fata* and a guide to the promised land, and Venus as the matriarch of the Julian line. Giuliano della Rovere was said to have called himself Pope Julius after Caesar. Thus, Julius II believed that he was fulfilling a divine mission to give the world a lasting order through spiritual renewal just as Anchises, according to Virgil, sent Aeneas on his way from Troy to carry out his mission for Rome: "Bring peace to all men." Julius II not only wished to glorify the examples set by his ancestors, the founders of Rome's former grandeur, but, especially, he strove to measure up to and even to surpass those ancestors. This ambition is most apparent in his plans for the new Saint Peter's. Bramante, his architect, is supposed to have remarked that the pope wished to pile the Pantheon on top of the vaults of the Basilica of Maxentius, which, at that time, was considered a "temple of peace." In 1506, then, the pope's idea of a renewal materialized with this vast undertaking, even as the newly recovered *Laocoön* reminded the pope of the cost involved in obtaining objects of historical significance. In an epigram affixed to the *Laocoön* immediately after the discovery of the sculpture, the priest of Apollo, Laocoön, addressed the pope: "If the example of my suffering is not enough for you, Let the downfall of the Bentivoglio be a warning."

The entrance from Bramante's corridor into the Cortile was inscribed "procul este, profani" ("Begone, ye uninitiated!"), a quote from Virgil's *Aeneid* (VI, 258). The Cumaean Sibyl who calls out these words to Aeneas as he prepares to descend into the underworld—to meet the shade of his father, Anchises, who will show him in prophecy a vision of the future Rome—is the one into whom Apollo breathed "divining spirit." Thus, the quotation "procul este, profani" is the counterpart to, and the justification for, Raphael's motto "numine afflatur"—inspired by the mantic spirit of the Delphic god Apollo, lord of Parnassus.

In his Cortile, Julius II sought to translate into reality the landscape of Arcadia that Virgil discovered in the world

FIG. 20. (*OPPOSITE*): RAPHAEL. *PARNASSUS.* FRESCO. 1508–11. NORTH WALL, STANZA DELLA SEGNATURA

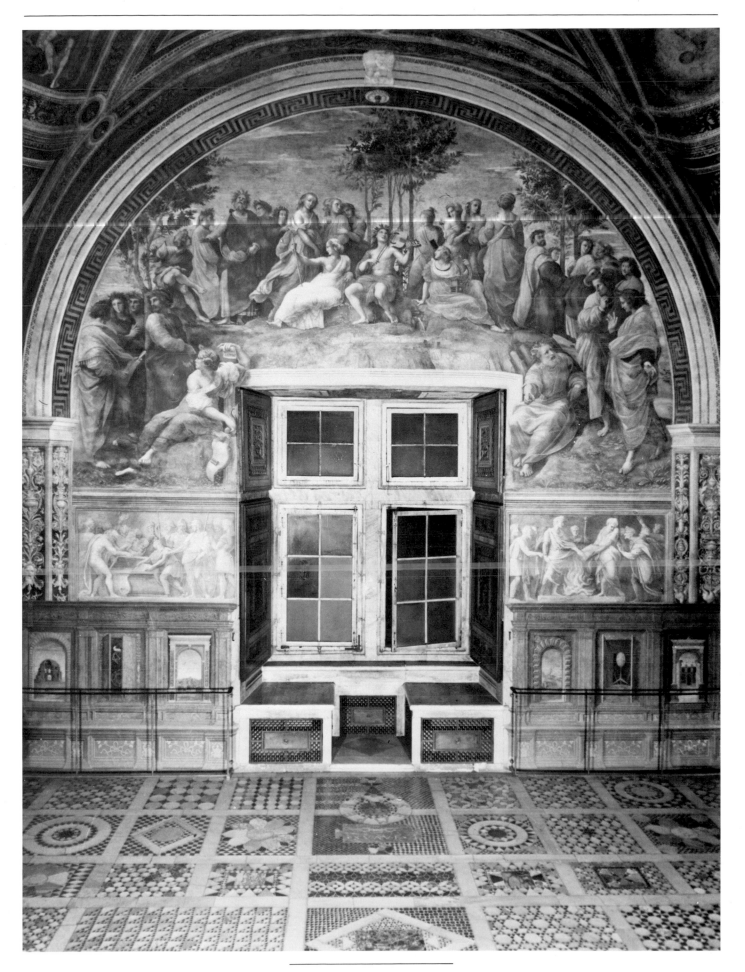

of the imagination. Since Arcadian life took place far from the hurly-burly of mankind, ordinary mortals were denied access to it. Nonetheless, when, on April 18, 1510, the ambassador of the Venetian Republic, Girolamo Donato, was ushered into the Belvedere for an audience with Julius II, he found the pope planting trees, and, during the interview, the pontiff continued his activity. In such a garden, antique statues appear out of context, and, instead, take on a metaphorical significance. Ancient gods become mere abstractions, stripped of their original primeval quality. What remains is only that aspect of their identity that is compatible with a continued existence in a Christian setting: Apollo embodies poetry and the imagination; Venus, all-encompassing love; and Laocoön, sensitivity and suffering. During this same period (1508–12), Michelangelo was commissioned by Julius II to fresco the ceiling of the Sistine Chapel with his classical depiction of the Sibyls. These five seers take their place alongside the seven prophets of the Old Testament in presaging the coming salvation.

The successor of Julius II, Leo X (1513–21), born Giovanni de' Medici, son of Lorenzo the Magnificent, who "consider[ed] not least those undertakings that lead to the advance of science and the fine arts," explained, through his secretary, Jacopo Sadoleto, the importance of such activity; he assures us that "the Creator has vouchsafed nothing more significant or more useful to mankind, aside from the worship of His divinity, than those studies that serve to beautify and ennoble human existence, but are in every particular practical and useful: comforting in adversity as well as beneficial and honorable in prosperity, the more so inasmuch as without them we lack all of life's charm and all communal coherence."

After the Sack of Rome in 1527, the seated figure signed by Apollonios must have been added to the sculpture court. It owes its name, the *Belvedere Torso*, to its fragmentary condition and to its location—although until the end of the nineteenth century no one doubted that it was a representation of Hercules. One hundred years before, between 1432 and 1435, Cyriacus of Ancona had seen this sculpture and copied the artist's signature on the stone.

It was Michelangelo, however, who first made the *Torso* famous. He described himself as a disciple of the *Belvedere Torso*, and often spoke of having studied it intensively, as the Genoese painter Giovanni Battista Paggi reported. Deferring to Michelangelo's authority regarding the *Torso*, Gian Lorenzo Bernini quotes him as having said of it: "Truly this was created by a man who was wiser than Nature! Pity that it is a torso." A glance at the Sistine Chapel frescoes shows to what degree Michelangelo drew inspiration from the *Belvedere Torso*; his seated figures are variations and elaborations upon the theme. Never did he copy or imitate it superficially, but his concern was to penetrate to the essence of the original, in spirit, as expressed in the figure of the Prophet Jonas above the *Last Judgment*. Vasari writes: "Michelangelo needed to

FIG. 21. PERINO DEL VAGA. *THE BELVEDERE, AS SEEN FROM THE STANZA DELLA SEGNATURA.* FRESCO. 1537–41. ROME, CASTEL SANT'ANGELO

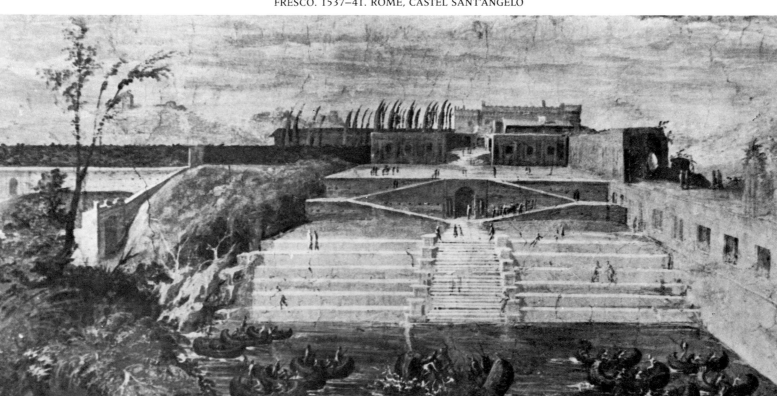

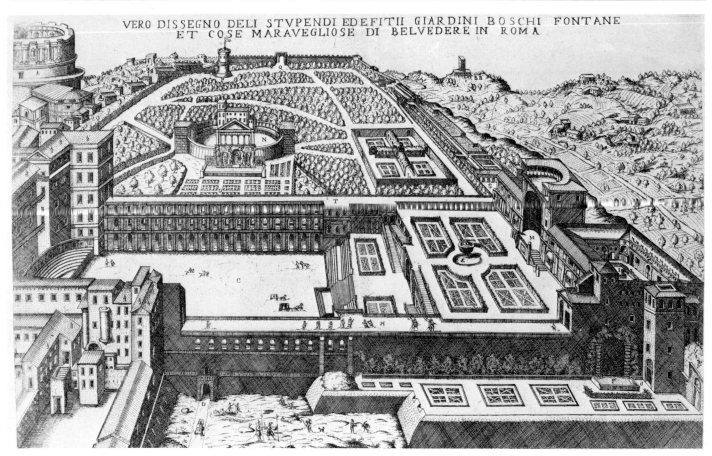

FIG. 22. AFTER MARIO CARTARO. BIRD'S-EYE PERSPECTIVE OF THE VATICAN,
SHOWING THE STANZE (*LEFT*) AND THE VILLA DEL BELVEDERE (*RIGHT*).
ENGRAVING. 1574. NEW YORK, THE METROPOLITAN MUSEUM OF ART

see the works of others only once in order to grasp them fully, and to use them in such a way that no one was aware of it." In spite of various suggestions for its restoration that are reflected, for example, in numerous small bronzes of the sixteenth century, the *Torso* is the only sculpture among the celebrated antiquities of the Belvedere that has remained unrestored. After the *Torso* was given a place in the center of the sculpture court, and was left there unrestored, it became a symbol of past greatness from antiquity.

The *Apollo* and the *Torso*, therefore, are milestones in the early history of the Vatican Museums. The statue of Apollo embodies the mantic tradition perpetuated since time immemorial on this spot depicted by Raphael, in the fashion of his time, as Parnassus.

At first, sculptures from antiquity were assembled on the site, to enhance the home of the *Pontifex Maximus* in an Arcadian landscape of his own creation. The placement of the *Torso* in the center of this garden represented a change in the concept of the Belvedere sculpture court. Since it appeared that no one could be found to complete the *Torso*, its incompleteness became the initial cause of its fame. As a relic from antiquity that could not be completed, it assumed an exemplary value and significance. Michelangelo saw in the fragment a "divinitas" of natural beauty, a divine spark that still infused the ancient work. The *Torso*, which survived

the Counter Reformation untouched, as the only fragmentary and unrestored sculpture in the collection, became a symbol of the frailty of earlier greatness. As a reminder of *vanitas*, of the transience of everything earthly and temporal, it remained in its place during the second half of the sixteenth century, while the statues in the niches were hidden behind wooden screens. In spite of their fame, the sculptures left in the Cortile del Belvedere settled, like Sleeping Beauty, into a sleep of two centuries, to be brought back to a new life only in the second half of the eighteenth century with the establishment of the Museo Pio-Clementino.

Georg Daltrop*

BIBLIOGRAPHY: A. Michaelis, "Geschichte des Statuenhofes im vaticanischen Belvedere," in *Jahrbuch des Deutschen Archäologischen Instituts*, 5, 1890, pp. 5–72, which includes a compilation of all the important publications in chronological order; R. Lanciani, *Scavi di Roma I*, Rome, 1902, pp. 154–57; E. Steinmann, *Die Sixtinische Kapelle*, II, Munich, 1905, pp. 75–79; J. S. Ackerman, *The Cortile del Belvedere, Studi e documenti per la storia del Palazzo Apostolico Vaticano III*, Vatican City, 1954; W. Lotz, in *Kunstchronik*, 11, 1958, pp. 96–100; H. H. Brummer, *The Statue Court in the Vatican Belvedere* (Stockholm Studies in the History of Art, 20), Stockholm, 1970.

*My original text and notes (dedicated to Max Wegner) will be published in *Boreas* (Münstersche Beiträge zur Archäologie 6), 1983.

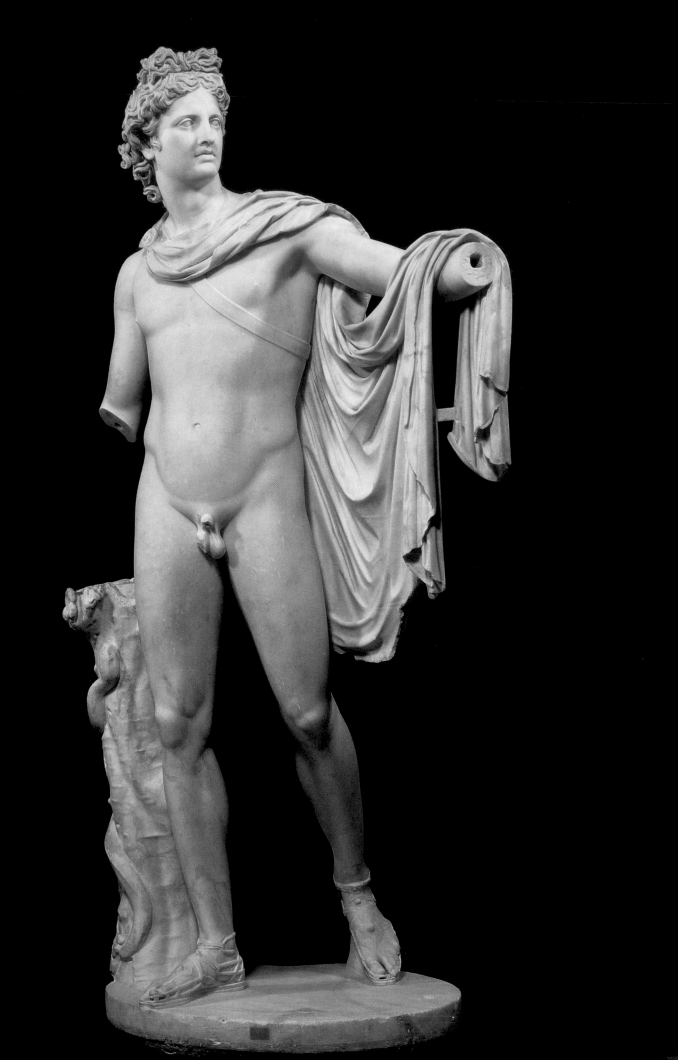

20

THE APOLLO BELVEDERE

*Roman copy, c. A.D. 130–40, after a Greek bronze
original, c. 330 B.C., attributed to Leochares*
*Parian marble, with possible traces of original
pigment in the hair*
*Total height, 88 ³/₁₆" (224 cm), height of base,
3 ¹⁵/₁₆" (10 cm), height of head and neck, 15 ¾"
(40 cm); width, 46 ½" (118 cm); depth, 30 ⁵/₁₆"
(77 cm)*
*Museo Pio-Clementino, Cortile Ottagono, Inv. no.
1015*

The statue is completely preserved except for parts of both forearms and the two hands, with their attributes. The right upper arm, the legs below the knees and above the ankles, the lower part of the support, the base between the feet and in front of the left foot, as well as the ends of the cloak draped on either side of the left forearm are broken. Also damaged are the hair; the lower part of the border of the cloak; the top of the support; the bottom of the quiver; and the back, between the shoulder blades, where a hole was made (now filled in) for the iron rod that, from 1511 to 1981, secured the statue to the base and to the wall.

The provenance is unknown, yet the good condition of the statue suggests that it was never buried. At the end of the fifteenth century, it stood in the garden of San Pietro in Vincoli (*Codex Escurialensis*, fol. 53 r.); early in the sixteenth century, after the beginning of Julius II's pontificate (1503), but, at the latest, before 1509, it was placed in the sculpture court of the Belvedere, on the very spot where it customarily stands today. At the request of Clement VII, it was restored in 1532 by Giovanni Angelo Montorsoli, who had been recommended to the pope by Michelangelo (G.Vasari, *Le Vite*, 1568, Milanesi ed., VI, Florence, 1878, pp. 632–33). Montorsoli restored the left hand, altered the right forearm with an open hand turned away

from the body, and lengthened the support so that the right hand could rest on it (this hand had been attached, originally, to the upper thigh, as evidenced by the surviving *puntello*, or brace). From the second half of the sixteenth century until 1770, the statue was hidden behind a wooden partition placed over its niche in the Cortile. It was taken to Paris, where it remained from 1798 until 1816. In 1924–25, under B. Nogara, the additions by Montorsoli were removed by Guido Galli. Since 1981, the *Apollo* again has been freestanding; by fitting the breaks together more accurately it has been made perfectly upright (the statue now leans back some two inches at the level of the head).

Apollo, here, is a mature man, poised in midstride, his left arm extended forward, his head turned at a right angle to the direction of his movement. The open quiver filled with arrows refers to the bow that Apollo once carried in his left hand, and suggests that he held an arrow in his lowered right hand. The bow was probably quite large (κλυτότοξος), so that its lower tip rested on the base—to which an ancient depression in the plinth might attest. The support in the form of a tree trunk with laurel leaves and remains of fillets may well be an addition of the copyist; the small snake coiling upward suggests as much.

The composition unifies the movement and torsion of the statue. The weight of the body rests on the slightly advanced right foot, while only the toes of the left foot touch the ground. The flow of movement is restrained by the position of the left arm. As in classical contrapposto, the free leg corresponds to the active arm. The torsion of the figure and the boldly advancing open pose, however, distinguish it from the contained compositions of Polykleitos. Among surviving sculpture from antiquity, the degree of immediacy of this representation, and its spirit of permanence in the face of all that is transitory,

are unique to the *Apollo Belvedere*—a creation of the end of the classic period in Greece, the time of Alexander the Great.

The original was undoubtedly of bronze. The distinctive style, of which the marble copy is only a reflection, has led scholars to associate it with a leading Attic master, Leochares. A statue of Apollo by him is mentioned in Pausanias (I.3.4) as having stood in the Athenian Agora, in front of the temple of Apollo Patroos, as a counterpart to a statue of Apollo Alexikakos —the deflector of evil—made by Kalamis after the plague of 430 B.C. The nobility of the *Apollo Belvedere* would seem to fit such an identification.

The *Apollo Belvedere* embodies the Apollonian ideal of the Greeks. Since the sixteenth century, it has lived on in countless copies, imitations, variations, quotations, parodies, and caricatures, as well as in illustrations and reproductions. On the occasion of the purchase of the Parthenon sculptures by England, the House of Commons exalted the *Apollo* as the standard of all art. The ultimate praise was expressed by Johann Joachim Winckelmann: "The statue of Apollo is the highest ideal of art among all the works of antiquity to have survived destruction."

G. D.

BIBLIOGRAPHY: W. Amelung, *Die Sculpturen des vaticanischen Museums*, II, Berlin, 1903, pp. 256–69, no. 92, pl. 12; W. Helbig, *Führer durch die öffentlichen Sammlungen klassischer Altertümer in Rom: Die Päpstlichen Sammlungen im Vatikan und Lateran*, I, 4th ed., Tübingen, 1963, no. 226; G. Galli, in *Rendiconti della Pontificia Accademia Romana di Archeologia*, 3, 1924–25, pp. 473–74, ills. 3–4; G. Daltrop, "Zur Überlieferung und Restaurierung des Apoll vom Belvedere," in *Rendiconti della Pontificia Accademia Romana di Archeologia*, 48, 1975/76, pp. 127–40; idem, "Zum Attribut in der rechten Hand des Apoll vom Belvedere," in *Greece and Italy in the Classical World* (Acta of the XI International Congress of Classical Archaeology, London, 1978 [1979]), pp. 224–25; O. R. Deubner, "Der Gott mit dem Bogen: das Problem des Apollo im Belvedere," in *Jahrbuch des Deutschen Archäologischen Instituts*, 94, 1979, pp. 223–44.

21

THE BELVEDERE TORSO

Athens, mid-1st century B.C.
Parian marble
Height, 62 ⅝" (159 cm); width, 33 ¹/₁₆" (84 cm);
 depth, 34 ¼" (87 cm)
Museo Pio-Clementino, Sala delle Muse,
 Inv. no. 1192

The *Torso* remained unrestored in post-Classic times. The head and chest, both arms, and both legs (the right one above the knee, the left one below it) are broken off. Both buttocks were pieced on, as the roughened surfaces, with their dowel holes, indicate (the iron dowels were removed in 1923). Among other areas, the two upper thighs were damaged. Virtually none of the antique surface of the marble remains.

The *Torso* probably was never buried. Its provenance is unknown, although, between 1432 and 1435, Cyriacus of Ancona copied the artist's signature from this "figura que dicitur Herculis," then in the possession of Cardinal Prospero Colonna. An Umbrian painter made a drawing of the *Torso* about 1500, noting that it belonged to the sculptor Andrea Bregno. Between 1532 and 1535, Maarten van Heemskerck sketched it in the sculpture court of the Belvedere. At the beginning of the eighteenth century, for protection, it was brought into the fountain house in the "Stanza del Torso" (the southern arm of what is now the Sala degli Animali); it was possibly set up in the Vestibolo Rotondo of the Clementine museum in 1773, and from 1784 to 1973, aside from the years of its exile in Paris (1798–1816), its place was in the center of the Vestibolo Quadrato, also known as the Atrio del Torso.

The powerful body of a man of advanced age is seated on a rock. The upper torso bends forward, to the right, as the body turns left. The right arm was lowered, perhaps leaning on the thigh, while the left arm was raised at the side; correspondingly, the left leg extended forward and the right one somewhat back. The animal skin spread over the stone seat with its head lying on the left thigh was commonly thought to be a lion's skin until the end of the nineteenth century, so that the identification of the Herculean figure as Hercules himself seemed plausible. Since it is, in fact, the skin of a panther, the figure is more closely related to either Dionysos, a satyr, or even to Marsyas. Other suggestions have included Skiron, Polyphemus, Philoktetes, and Prometheus, or a mythical athlete—for example, the boxer Amykos—although none of the identifications is as convincing and as appropriate as the original one: Hercules.

The artist's signature appears on the front of the stone seat: "Apollonios, son of Nestor, the Athenian, created [this work]." His style is marked by an elemental strength and a pronounced, elastic vitality. The complexity of movement is mirrored in the construction of the figure. The contrapposto composition has been pushed to its limits, as expressed in the powerful modeling of the muscles. The style of the artist's signature—and of the work itself—points to the last century of the Roman Republic. Because the name occurred frequently in this period, one cannot automatically identify the Apollonios who sculpted the *Torso* with the one who created the Capitoline *Jupiter*.

The meaning of a sculpture is intimately tied

to one's interpretation of it. If, as Winckelmann did, one sees "expressed in this Hercules here before us how he purified himself with fire from the dross of humankind, and achieved immortality and a seat among the gods," then a sacred setting might have been intended for the statue. Nonetheless, the large number of works with analogous inscriptions that survived from the period of the *Belvedere Torso* suggests that artists at that time, above all Athenians, worked for the Roman art market. Classical models set the tone, then, so that we cannot be certain whether a statue was created for a "sacral" existence or the "profane" sphere of connoisseurship and taste.

It took the artistic sensitivity of Michelangelo to rediscover the *Torso*, and to accord it its proper status. Some 250 years later, the same Winckelmann who sought to free himself from the Baroque chose a "Baroque" sculpture from antiquity on which to lavish his masterly descriptions.

G. D.

BIBLIOGRAPHY: W. Amelung, *Die Sculpturen des Vaticanischen Museums*, II, Berlin, 1903, pp. 9–20, no. 3, pl. 2; W. Helbig, *Führer durch die öffentlichen Sammlungen klassischer Altertümer in Rom: Die Päpstlichen Sammlungen im Vatikan und Lateran*, I, 4th ed., Tübingen, 1963, no. 265; A. Schmitt, "Römische Antikensammlungen im Spiegel eines Musterbuchs der Renaissance," in *Münchner Jahrbuch der bildenden Kunst*, 21, 1970, pp. 107–13, ill. 2; C. Schwinn, *Die Bedeutung des Torso vom Belvedere für Theorie und Praxis der bildenden Kunst vom 16. Jahrhundert bis Winckelmann*, Bern, 1973; G. Säflund, "The Belvedere Torso," in *Opuscula Romana*, XI, 6, 1976, pp. 63–84; L. Eckhart, "Zum Torso vom Belvedere," in *Greece and Italy in the Classical World* (Acta of the XI International Congress of Classical Archaeology, London, 1978 [1979]), p. 225.

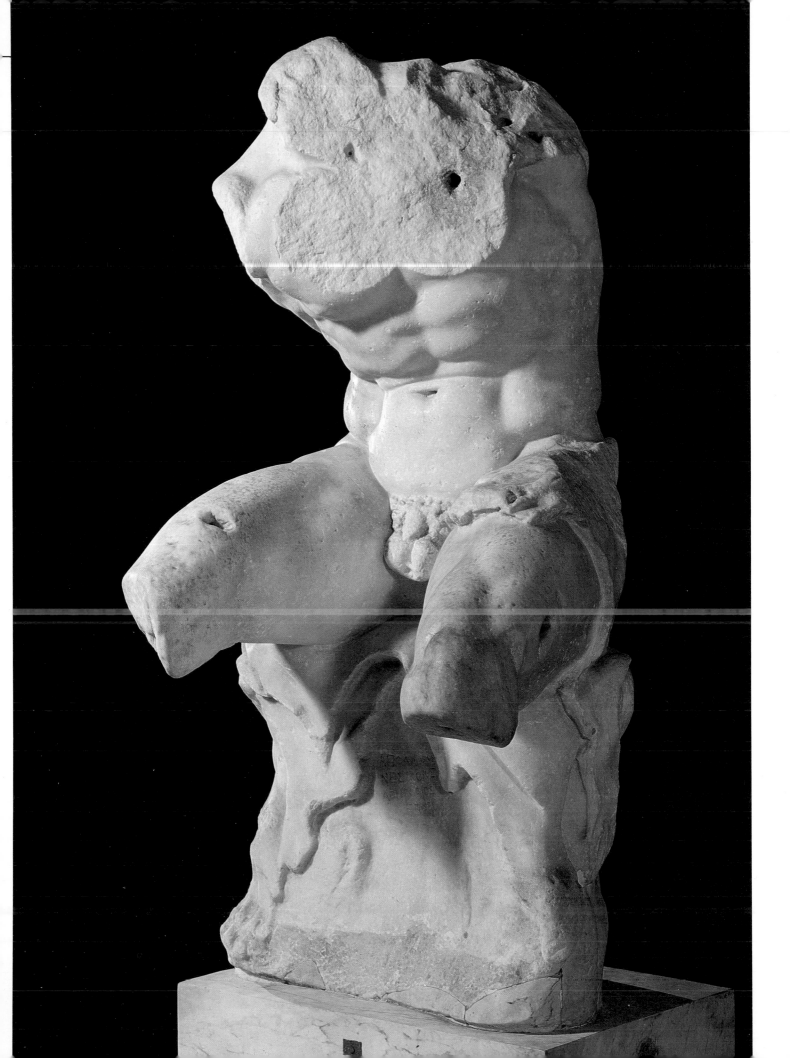

THE TREASURY OF SAINT PETER'S

The Treasury of Saint Peter's, or what remains of it, is the repository for those vestments and sacred objects (fig. 23) created for liturgical use and donated over the centuries by visitors to Rome, who came to venerate the apostle's tomb. The Treasury's history begins with the very foundation of the basilica by Constantine, early in the fourth century. The account in the *Liber Pontificalis* of the quantity and richness of the sacred furnishings with which Constantine and his successors endowed the church cannot fail to amaze us. Yet, the generosity of its donors was offset by the greed of its plunderers. The history of the Treasury of Saint Peter's is the story of barbaric deeds as well as of the devotion and generosity of the faithful, who attempted to restore what had been lost. First to be looted was the basilica's Sacristy, as recorded in the *Liber Pontificalis*; the act was perpetrated by Julian the Apostate. Subsequent plunderers were Alaric in 410; the Visigoths in 545; the Longobards in 731; the Saracens in 846; and, in 1084, the Normans, led by Robert Guiscard. During the High Middle Ages, the atrium and portico of the basilica frequently were the scenes of battle and pillage by rival factions among Roman patrician families, with disastrous consequences for the Treasury.

Unfortunate, too, was the schism that led the papacy to abandon Rome for a long exile in Avignon; yet, it was no less devastating than the civil warfare of the early fifteenth century, during which Saint Peter's was repeatedly sacked; in 1413, the troops of Ladislas of Naples even stabled their horses inside the basilica.

The pacification of the Church and the return of the

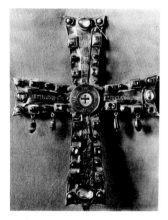

FIG. 23. *CRUX VATICANA.* BYZANTINE, 6th CENTURY. TREASURY OF SAINT PETER'S

popes from Avignon coincided with an influx of new gifts, but the Sack of Rome of 1527, by the imperial Landsknechts, was a further setback. During the Napoleonic period, French commissaries once more plundered and scattered the basilica's treasures. The *direptio gallica* was no less complete and destructive than the *direptio germanica* of 1527. Whatever little was saved or recovered resulted from the initiative of a handful of canons.

Until the end of the last century, even though the liturgical objects in the basilica occupied only two small rooms, among the treasures was the altar garniture by Gentili (see cat. nos. 22–23). The Treasury was expanded in 1909, and rearranged in 1949, but it was not until 1975, with the introduction of such monumental works as the *Sarcophagus of Junius Bassus*, and the tomb of Sixtus IV by Pollaiuolo, that the Vatican Chapter organized its exceptional treasures, according to the latest museological criteria, adopting the most advanced means to ensure the conservation of its collections.

All the existing areas to the right of the Sacristy by Marchionni (of 1686), including the Cappella dei Beneficiati and its Sacristy, were newly installed in 1975. This installation was designed and carried out by the architect Franco Minissi, who preserved the original character of the chapel and its Sacristy, achieving a clear distinction between the primary architectural space and the secondary museum space. He eliminated direct lighting in the new rooms and suppressed the formal values of the spaces occupied by the objects on exhibition, making the objects themselves the focal points of the Treasury Museum.

Ennio Francia

BIBLIOGRAPHY: A. Lipinsky, *Il Tesoro di S. Pietro, guida-inventario*, Vatican City, 1950; F. S. Orlando, *Il Tesoro di San Pietro*, Milan, 1958.

ANTONIO GENTILI (c. 1519–1609)
ALTAR CROSS AND CANDLESTICKS
Goldsmith's work by Gentili
Rock crystals by Giovanni Bernardi (1496–1553)
and Muzio de Grandis (c. 1525–c. 1596)
Rome, completed 1582
Silver gilt, rock crystal, and lapis lazuli
Height: cross, 76" (193 cm); candlesticks, 39 ⅜"
(100 cm)
Reverenda Capitolo di San Pietro

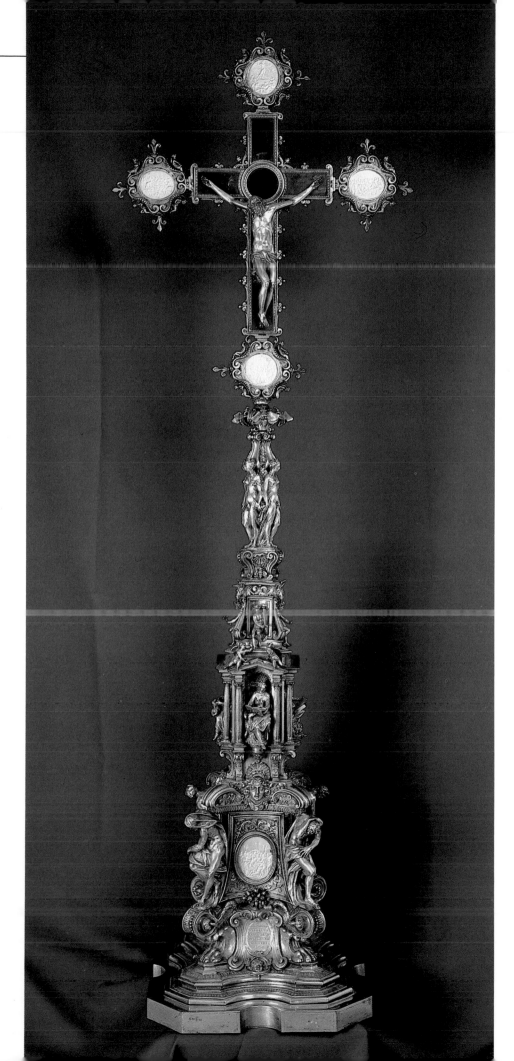

Antonio Gentili's fame as one of the foremost Renaissance goldsmiths is derived almost entirely from this magnificent altar garniture. The cross and candlesticks were commissioned by Cardinal Alessandro Farnese (1520–1589) for the high altar of Saint Peter's and installed in 1582. An anonymous "Avviso da Roma" states that they took four years of continuous work, were valued at 18,000 scudi—including 6,500 scudi for the workmanship—and were inaugurated on the morning of Pentecost, when Cardinal Farnese himself sang the Mass.

Cardinal Farnese had long outlived the reign of his uncle, Pope Paul III (1534–49), yet he had the cross embellished with his uncle's coat of arms and devices, while his own appear on the candlesticks. In her recent study, Anna Beatriz Chadour explains how these heraldic motifs have both christological and dynastic bearings. Thus, one of the *imprese* on the candlesticks shows the ship *Argo* slipping past the treacherous Symplegades—a classical metaphor for salvation, as well as for the Farnese family's fortunes. So, too, aside from being the preeminent Farnese devices, the lilies and unicorns lavishly employed in the decoration of all three pieces have immemorial Christian associations.

Among the sixteen rock crystals, framed against lapis lazuli, those on the cross are engraved with scenes of the Passion, while the crystals on the candlesticks depict the miracles performed by Christ. One crystal (with the Healing of Jairus's Daughter) is signed by Muzio de Grandis, Gentili's contemporary, but Chadour believes that the majority were engraved, decades earlier, by the much-better-known Giovanni Bernardi, and that they were saved by Cardinal Farnese for this special purpose.

The base of the cross is four sided; the crucifix slides onto it by means of its shaft, which is concealed and, thus, unadorned, except for Gentili's signature. On the back, each of the roundels on the arms of the crucifix has one of the four Doctors of the Church, with the Ascension of the Virgin in the center plaque. The crowning rock crystal on the front, over the corpus, shows the Resurrection. The imagery in the lower registers methodically builds up to this, as to a triumphant climax—from the tortuously strained Michelangelesque figures of slaves at the bottom, to the seated Evangelists, the putti holding instruments of the Passion, and, finally, to the Victories supporting the crucifix. The figural decoration of the three-sided candlesticks reads in a similar upward progression, from earthbound slavedom, through the unidentified prophets and Sybils, up to the cary-

atids with laurel wreaths. Possibly, there is a play upon the resemblance between the Italian words *cariatide* and *carità* (or "charity"), as the maidens also have infants sporting at their feet.

Gentili undoubtedly needed workshop assistance to complete these compositions teeming with figures. Splendid as the designs are, there are discernible differences in quality in the three pieces, the best executed being the cross. The corpus probably is based upon a model by Guglielmo della Porta (died 1577), a sculptor often employed by the Farnese.

Almost a century later, in 1671, the cross and candlesticks received attention from another papal nephew, Cardinal Francesco Barberini. He contributed four additional candlesticks, made by Carlo Spagna, still in the Vatican Treasury. They follow Gentili's in outline, but are more Baroque in detail. The expansion of the set was necessary for greater visibility beneath the showy baldacchino that Bernini provided for the high altar. So that the cross would continue to dominate, it was raised slightly by inserting two bands of ornament, featuring the Barberini bees,

above and below the Victories. The entire set of seven, normally shown in the Treasury Museum of Saint Peter's, is used only upon rare occasions—most recently, at the coronation of Pope John Paul II.

J. D. D.

BIBLIOGRAPHY: A. B. Chadour, "Antonio Gentili und der Altarsatz von St. Peter," Ph.D. dissertation, Münster, 1980; W. Gramberg, "Notizen zu den Kruzifixen des Guglielmo della Porta und zur Entstehungsgeschichte des Hochaltarkreuzes in S. Pietro in Vaticano," in *Münchner Jahrbuch für Kunstgeschichte*, 32, 1981, pp. 95–114.

22 (back of cross)

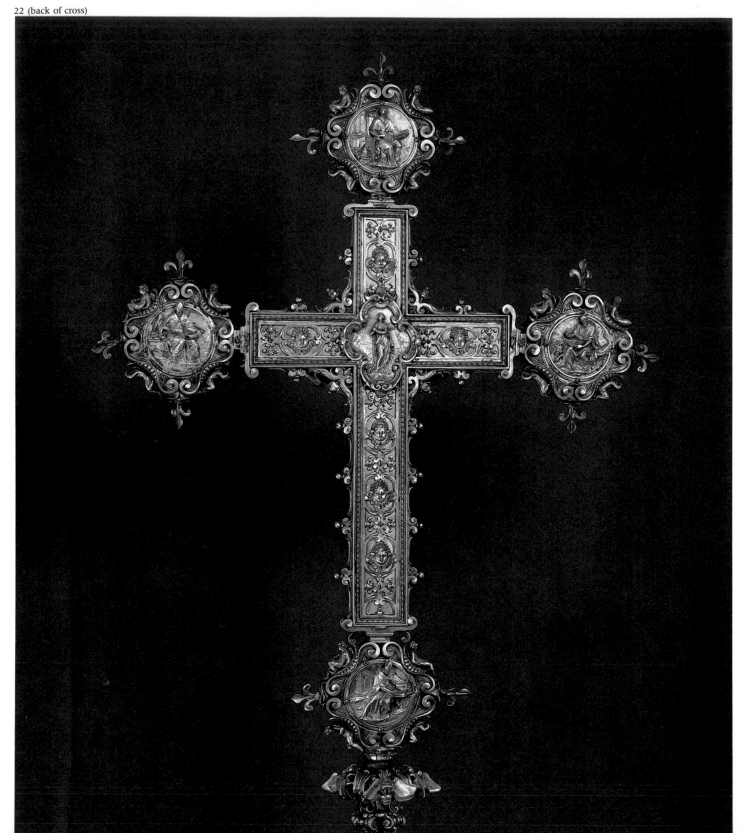

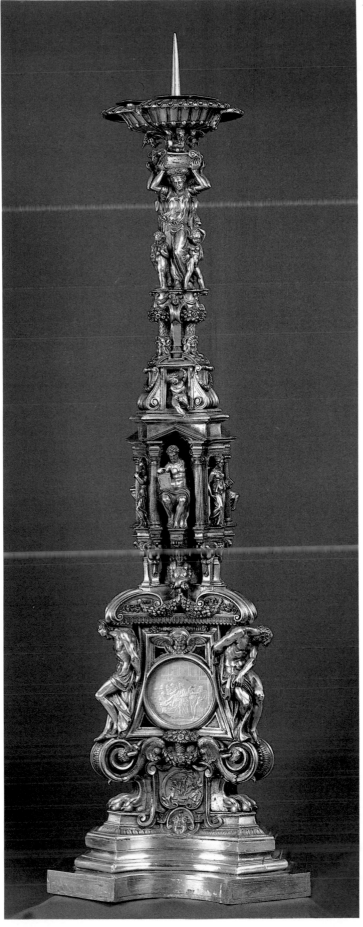
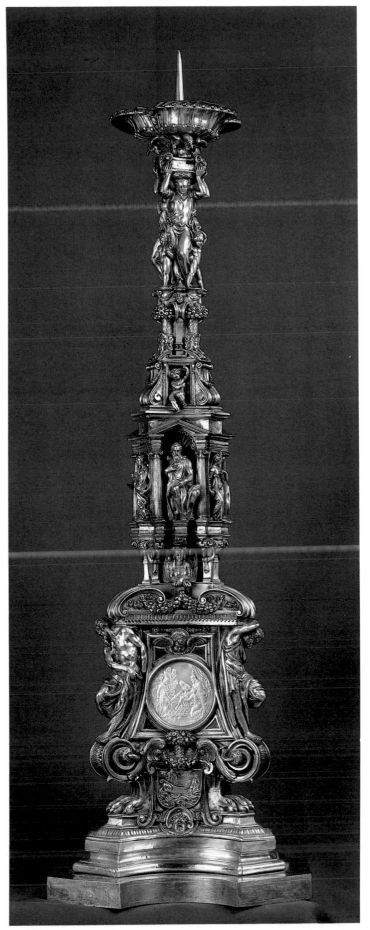

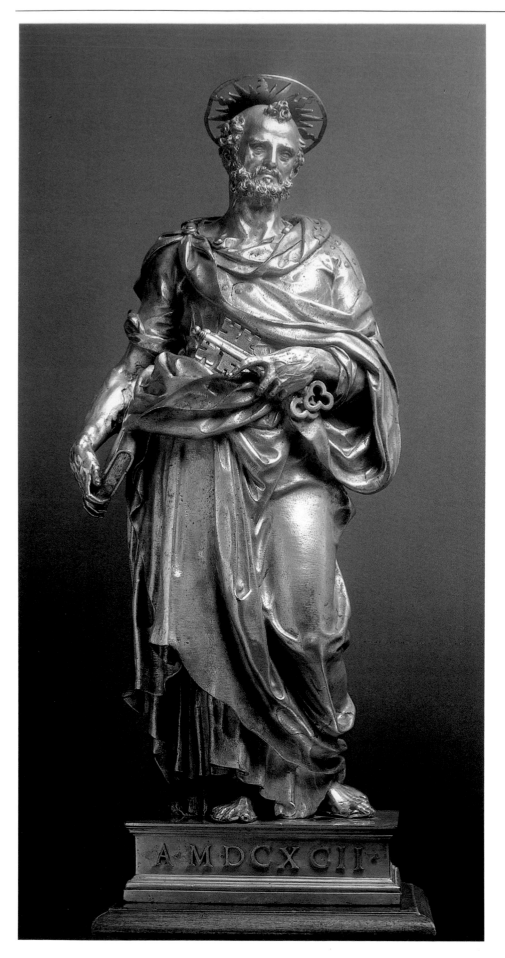

24

SEBASTIANO TORRIGIANI (died 1596)
SAINT PETER AND **SAINT PAUL**

Rome, c. 1585
Gilt bronze
Height, 34 1/2" (87.6 cm)
Reverenda Capitolo di San Pietro

These imposing figures of the two apostles have not been studied thoroughly. Assertions exist concerning them, but with no documentary confirmation. According to Gaetano Moroni (*Dizionario di erudizione storico-ecclesiastica*, IX, Venice, 1841, p. 70), they were presented to Saint Peter's by Pope Gregory XIII, who died in April 1585. Monsignor G. Cascioli (*Guida al Tesoro di S. Pietro*, Rome, 1925, p. 22) stated, without giving sources, that the statues were made in 1585 by Sebastiano Torrigiani, along with a set of six candlesticks in gilt bronze ordered by Gregory XIII; that they were restored in 1611 by Pietro Gentili (son of Antonio, maker of the silver-gilt candlesticks and altar cross shown in catalogue numbers 22–23); and that they were restored again, by order of Cardinal Francesco Barberini, in 1692. They did, indeed, acquire Baroque bases adorned with the Barberini bees and dated 1692. Yet, since at least the late seventeenth century, *Saint Peter* and *Saint Paul* have been associated more with the Gentili altar set than with the Torrigiani candlesticks (also in the Treasury of Saint Peter's).

The more one learns of Sebastiano Torrigiani, the more his main role appears to have been

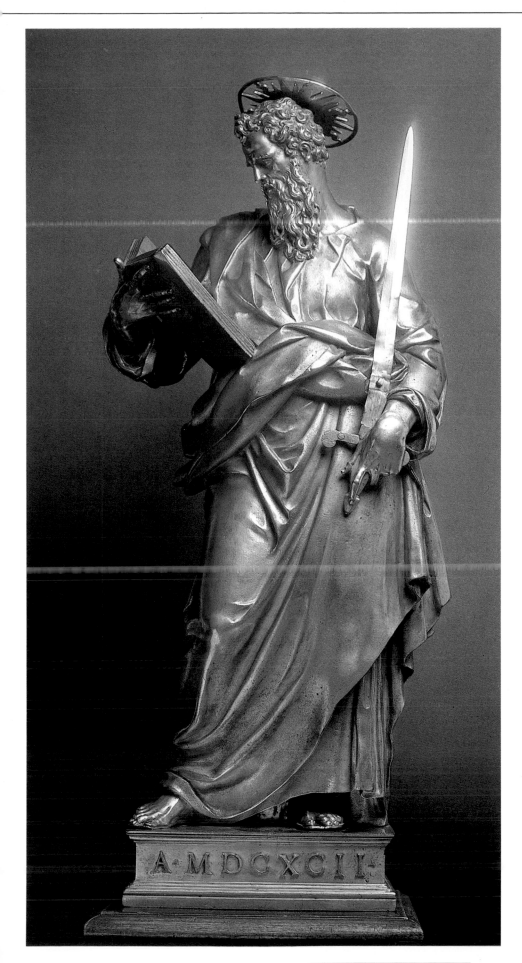

that of founder rather than sculptor. He was the son-in-law of Guglielmo della Porta, several of whose later works he cast, and he became head of the Vatican foundry, according to G. Baglione (*Le Vite de'pittori, scultori et architetti*, Rome, 1642, p. 323). He made the casts of the colossal statues of Saints Peter and Paul atop the columns of Trajan and Marcus Aurelius, following models by other sculptors, but the poses of those figures show only a generic resemblance to the present ones. Busts of Gregory XIII and Sixtus V in Berlin-Dahlem used to be attributed to Torrigiani on the basis of Baglione's statement that Torrigiani made the bust of Sixtus V now in the cathedral of Treia. Recent scholarship, however, tends to assign the models for the Berlin busts to Taddeo Landini, best known as author of the Fontana delle Tartarughe in Rome (U. Schlegel, in *Bildwerke der christlichen Epochen . . . aus den Beständen der Skulpturenabteilung . . . Berlin-Dahlem*, Munich, 1966, nos. 588–589). The massed draperies and graphic literalness of the Vatican saints are found in much Counter-Reformation sculpture before the onset of the Baroque. Yet, it must be said that their physiognomies have a biting acerbity that relates them fairly well to the busts claimed for Torrigiani and/or Landini.

J. D. D.

BIBLIOGRAPHY: F. S. Orlando, *Il Tesoro di San Pietro*, Milan, 1958, pp. 90–91.

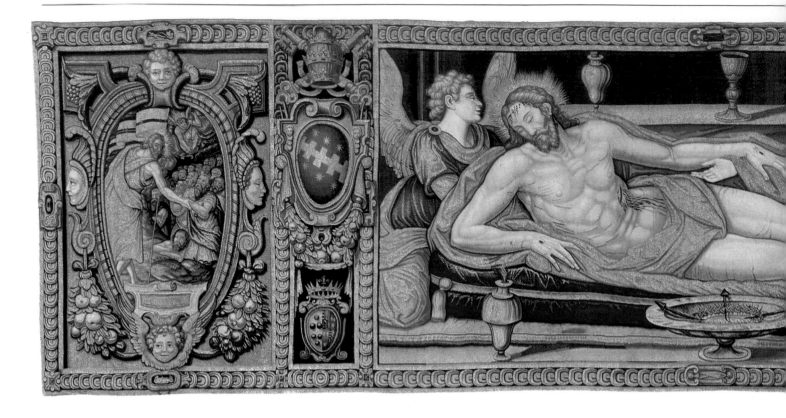

25

A–M. THE VESTMENTS OF CLEMENT VIII (1592–1605)

c. 1593–97

The vestments of Clement VIII, named for the pontiff to whom they were given, about 1597, comprise one altar frontal, a cope with its ornamental clasp, a chasuble, two dalmatics, two stoles, a maniple for the celebrant and two for the deacons, a case for the corporal, a chalice veil, and three missal covers. The *bruste de camici* (or "surplice cases"), mentioned in the payment records, were scattered; they still existed in 1930, although they were reassembled to form what, in the inventories, is referred to as a faldstool. Also lost is the "gold and silk tapestry [*panno*] with the Last Supper," perhaps made as an altarpiece, documented, as well, by the records of payment (C. Conti, 1875, pp. 58–59).

The technique used to produce these vestments appears to have been rather unusual: all were woven as tapestries, in silk, with gold and silver (silver-gilt) threads; the warps are silk, with ten to thirteen threads per centimeter. To judge from the minimal damage that they have undergone, and from the brightness of their colors, it would seem that the vestments were hardly used; the last pontiff to have done so might have been Benedict XIII, who wore them on January 22, 1726 (P. Gentili, 1874, p. 40). The first documented restoration was in 1789, and their absence, at that time, from the Sistine Chapel treasury perhaps prevented the tapestries from being taken to Paris by Napoleon's commissioners. It is likely that on that occasion —or, more

probably, in 1870, when they were displayed at the "Esposizione Romana" (*L'Esposizione Romana*, 1870, p. 22)—the fronts and backs of the two dalmatics and of the chasuble were separated, in order to display them side by side. In 1935, Monsignor Zampini, sacristan of the apostolic palaces, removed the vestments from the treasury of the Sistine Chapel, entrusting the Vatican Library to exhibit them to the public. In 1964, following a rearrangement, some of the vestments were transferred to the care of the Vatican Museums, which already had received the altar frontal (restored in 1957). All the other pieces were restored between 1978 and 1981, by the Vatican Museums' tapestry conservation studio, for their American exhibition.

The history of the origins of this set of vestments is known to us, in part, through the documents published by C. Conti (1875, pp. 106–7), which mention that the vestments were commissioned by Ferdinand I, Grand Duke of Tuscany. However, the idea of presenting the pope with a gift of particular significance had begun much before Ferdinand became grand duke, as deduced from a document published by Detlef Heikamp ("Die Arazzeria Medicea im 16. Jahrhundert: Neue Studien," in *Münchner Jahrbuch der bildenden Kunst*, XX, 1969, p. 74), without referring, specifically, to this set of vestments. In a letter from Rome dated December 27, 1577, Ferdinand, then a cardinal, wrote to his brother Francesco, Grand Duke of Tuscany, informing him of a conversation with Gregory XIII in which the pope had reminded him of Francesco's promise to donate a series of tapestries for the Sistine Chapel, since those by Raphael only could be used on "happy" occasions, not for Advent and Lent. There were to be seven tapestries in all. The subject was to be the Passion, and Vasari had been chosen to provide the cartoons. For

reasons unknown to us, the project was never realized, despite the fact that the pope, himself, was ready personally to pay the cost, if the grand duke decided not to honor his pledge. Upon the death of Francesco, his brother Ferdinand, once again a layman, became grand duke and married Christine of Lorraine, and the project was revived—although the recipient of the gift, in the meantime, had changed—all the more so, since the new pope, an Aldobrandini, came from a family with Florentine origins. The commission to weave the vestments was entrusted to Guasparri di Bartolomeo Papini, chief weaver at the Medici manufactory, who then purchased the necessary gold and silver on April 30, 1593. Alessandro Allori was chosen to execute the cartoons, which he delivered before January 4, 1595, the recorded date of payment. The work, which progressed rapidly, clearly was accomplished by more than one weaver. On May 31, 1595, Papini was paid for the cope, two "surplice cases," and the "tapestry of the Last Supper." As to the other items, it is probable that they were completed by the spring of 1597. In fact, according to a document published by Conti (1875, p. 60), on June 21, 1597, an expenditure is recorded for a set of vestments composed of a chasuble and two "tonacelle," which—bearing in mind that, in form, there is no clear-cut distinction between a dalmatic and a *tonicella*— could be that given to Clement VIII. A date relatively close to this is suggested by a memorandum to Ferdinand I, of October 23, 1595, in which Girolamo S. Jacopi speaks of the possibility of finishing the work in a year. The memo also asked for instruction regarding the placement of the papal and grand-ducal arms, with their Medici and Medici-Lorraine charges, to which Ferdinand replied: "Leave enough space in order to make the small arms of His Highness, below,

but do not make the coat of arms of the pontiff yet'' (C. Conti, 1875, pp. 106–7). The arms on the cope and the altar frontal had already been executed, but they did not conform to the wishes of the grand duke; consequently, those areas in question were cut out and, as on the other vestments, only later were the desired arms sewn on. On the two dalmatics and on the chasuble, evidently still being worked on at the time, spaces were left for the papal coats of arms, with only the warp in place, below which a Medici shield, without the Lorraine arms, was woven. Of the vestments, that worn by the pope—namely, the chasuble—was the only item on which the simple Medici shield was retained, while the arms on the other two chasubles on which heraldic shields were sewn combined Medici and Lorraine arms.

The use of shields uniting Medici and Lorraine bearings was a very common practice dating to the sixteenth century, but it might also indicate —as suggested by the document of 1595—that the tapestry was a gift not only of the grand duke, but of his wife, Christine, as well.

The iconography of the set is extremely complex, and it is probable that the program was drawn up by a theologian at the Medici court—possibly by Ferdinand, himself. The overall imagery suggests that the vestments were made to be used primarily during Holy Week. It was not mere accident that, until the last century (D. Farabulini, 1884, p. 83), the altar frontal was placed before the altar of the Sistine Chapel on Holy Thursday. However, the complexity of the individual motifs and of their combined significance allowed for the vestments to be worn also on different occasions, such as when Benedict XIII used them on January 22, 1726. The dominant decorative motif of the altar frontal is an elaboration of the Eucharistic theme, which

is most apparent in the central imagery: the dead Christ interpreted as the Eucharistic body. In the scene of Christ in the Garden of Olives, on the chasuble, Jesus receives the chalice from the hands of an angel, thus underscoring the Eucharistic moment of this episode. On the cope, as well, Eucharistic subject matter prevails, specifically, in the scene of the Sacrifice of Isaac, an event that presages the bloody sacrifice of Christ, and in the image of Melchizedek, whose bloodless sacrifice of the bread and wine prefigures the Last Supper.

In all probability, the presence of marian episodes on one of the dalmatics and, perhaps more significantly, on the altar frontal is a reference to the place for which they were made—that is, to the Sistine Chapel, dedicated to Our Lady of the Assumption.

The attribution to Allori of the cartoons for all the vestments is documented, and even those for the altar frontal—for which records of payment are still missing—may be assigned to him on the basis of their evident stylistic connection. As official painter to the Medici court, Allori designed cartoons for the Florentine tapestry manufactory from 1575 to about 1598. In this set, and particularly in the panel with the dead Christ, the influence of Bronzino, who was Allori's teacher and friend, is distinctly apparent, while, less explicit than in other works, and mediated by Francesco Salviati, are the influences of Michelangelo and Raphael—seen, above all, in the images on the cope. The antique references in some of the representations, such as in the Descent into Limbo, probably are due to the rarity with which many of the scenes were portrayed and to the difficulty of finding related compositional prototypes other than, perhaps, in miniatures. The results of this choice—based on the iconographic needs of the design pro-

gram and, also, on the repertory of ornament available—are somewhat archaic, for, although maintaining the richness and inventiveness typical of Florentine Late Mannerism, they are marked by a relative sobriety that comes from the necessary adherence to a fixed subject matter.

Fabrizio Mancinelli

BIBLIOGRAPHY: P. Gentili, *Sulla manifattura degli arazzi. Cenni Storici*, Rome, 1874, pp. 40–41; C. Conti, *Ricerche storiche sull'arte degli arazzi in Firenze*, Florence, 1875, pp. 19, 58–60, 106–7; D. Farabulini, *L'Arte degli Arazzi e la nuova Galleria dei Gobelins al Vaticano*, Rome, 1884; H. Goebel, *Wandteppiche*, 1, II, Leipzig, 1928, p. 387.

GUASPARRI DI BARTOLOMEO PAPINI,
after a cartoon by Alessandro Allori (1535–1607)

25 A. ALTAR FRONTAL

Florence, c. 1593–97
Tapestry, in silk, with silver-gilt threads
Height, 40⅛" (102 cm); width, 141¹/₁₆" (371 cm)
Biblioteca Apostolica Vaticana, Museo Sacro,
Inv. no. 2780

The weft is of silk, with silver-gilt threads; the warp, of three-ply white silk, with ten to thirteen threads per centimeter. The condition is good. During the 1957 restoration of the tapestry, it was ascertained that, originally, in place of the papal shield, there had been Medici-Lorraine coats of arms, surmounted by the grand-ducal crown, above another, unidentifiable coat of arms. These two coats of arms were cut away and replaced by the current ones, woven with a white warp.

At the center of the altar frontal is the dead Christ, supported by two angels; in the foreground is a basin containing the crown of thorns

and the nails of his martyrdom; in the background is an altar with a chalice. The presence of the altar and the angels indicates that this is a *melismos*, traditional in Byzantine iconography (cf. R. Hamman MacLean, *Die Monumentalmalerei in Serbien und Macedonien vom 11. bis zum frühen 14. Jahrhundert*, II, Giessen, 1976, pp. 147–50) to represent the Eucharistic body of Christ. At the left of the central scene is the Descent into Limbo; at the right, instead of the more usual *Noli me tangere*, is the Appearance of Christ to Mary. This latter scene was probably introduced because the altar frontal was made for the Sistine Chapel, which is dedicated to the Virgin of the Assumption. Its typically Easter iconography is confirmed by the fact that the altar frontal usually was displayed on Holy Thursday.

GUASPARRI DI BARTOLOMEO PAPINI,
after a cartoon by Alessandro Allori
(1535–1607)
25 B. COPE
Florence, c. 1593–97
Tapestry, in silk, with silver-gilt threads
Height, 59⁷⁄₁₆" (151 cm); width, 125⅝" (319 cm)
Biblioteca Apostolica Vaticana, Museo Sacro, Inv. no. 2773

The weft is of silk, with silver-gilt threads; the warp, of three-ply white silk, ten to thirteen threads per centimeter. The cope, in a fine state of preservation, was conserved in 1980–81. A gap in the small oval space in the pagan altar at the upper right, as well as other, similar lacunae were repaired by attaching an appropriately colored cotton and linen canvas support to the back. It also was discovered that, originally, in place of the two current coats of arms, a single, large combined Medici-Lorraine coat of arms, above which was the grand-ducal crown, had been woven into the design.

The central scene in the orphrey shows the Original Sin (Genesis 3:6), to the right of which are busts—with identifying inscriptions—of Jacob (Genesis 25:26), IVDAS, son of Jacob (Genesis 29:35), and [P]HARE[Z], son of Judah (Genesis 38:29); further down, to the right center of the cope, is ESRON, son of Pharez (I Chronicles 2:5). On the orphrey's left side are DAVID (II Samuel 1:14), SOLOMON, son of David (I Kings 1:12), and R[EH]OBOAM, son of Solomon (I Kings 11:43); further down, to the left center, is Abia, son of Rehoboam (I Chronicles 3:10).

On the hood is the Sacrifice of Isaac (Genesis 22:10–11), immediately above the bust of a man identifiable as Melchizedek (Genesis 14: 18–19), King of Salem and "Priest of the Most High God," to whom Abraham paid a tithe and who offered the bread and wine in sacrifice. Significantly, above him, half hidden by the hood, is a vine whose branches are laden with clusters of grapes. On either side, two pairs of angels hold up a miter and a papal triregnum, respectively. Angels with banderoles and censers, as well as floral elements in which grapes and olives predominate, complete the rich decoration of the vestment.

The two genealogical sequences with Jacob and Solomon particularize, in the genealogy of Christ, the iconographic theme of the vestment. Jacob is the father of the Hebrews, while David is the patriarch of the family to which Jesus belonged. It is to Christ, to the nature of his sacrifice and of his ministry, aside from that of the Eucharist, that the Sacrifice of Isaac and the figure of Melchizedek allude. The first, in fact, presages the bloody sacrifice of Christ on the cross; the second refers to the type of Christ's ministry and of his priesthood—not following, as Saint Paul testifies (Hebrews 7:11–28), the order of Aaron, but that of Melchizedek. Moreover, Melchizedek is a priest who, instead of offering a bloody sacrifice, offers—as did Christ—the bread and wine, thus prefiguring the Eucharist, the overriding theme of the decoration of the complete vestment.

25 B

GUASPARRI DI BARTOLOMEO PAPINI,
after a cartoon by Alessandro Allori
(1535–1607)

25 C. CHALICE VEIL

Florence, c. 1593–97
Tapestry, in silk, with silver-gilt threads
Height, 35⅞" (91 cm); width, 46¹/₁₆" (117 cm)
Biblioteca Apostolica Vaticana, Museo Sacro, Inv.
no. 2774

The weft is of silk, with silver-gilt threads; the warp, of three-ply yellow silk threads, ten to thirteen per centimeter. The condition of the tapestry is good, as it was conserved in 1981. The design is in the form of a rebus: Two angels, holding censers and incense boats, flank a large basin filled with flowers, over which is a scroll with the inscription APPARVERVNT·. The inscription, taken together with the word for flowers—"flores apparuerunt"—unquestionably has Easter connotations; in fact, it is the beginning of a line from the Song of Solomon (2:12): "Flores apparuerunt in terra nostra" ("The flowers appear on the earth"). There are no coats of arms, only the grand-ducal crown at the top, in the center of the border. Within the figural field, above and below, are two lines of seven rings each, into which two sticks could be inserted to facilitate raising the veil over the chalice.

25 C

GUASPARRI DI BARTOLOMEO PAPINI,
after a cartoon by Alessandro Allori
(1535–1607)

25 D. MISSAL COVER

Florence, c. 1593–97
Tapestry, in silk, with silver-gilt threads
Height, 21¹¹/₁₆" (55 cm); width, 30¹¹/₁₆" (78 cm)
Biblioteca Apostolica Vaticana, Museo Sacro, Inv.
no. 2771

The weft is of silk, with silver-gilt threads; the warp, of three-ply yellow silk threads, ten to thirteen per centimeter. The tapestry was conserved in 1981, and is in good condition.

A young woman, veiled and crowned, is seated on a cloud, with a starry sky broken by rosy clouds in the background. Her left hand, resting on a book on which the dove of the Holy Spirit is depicted, holds a scepter. With her right arm, she embraces a ciborium in the form of a tiny circular temple from which rays issue forth, directed toward her. There are no crests or emblems on the border.

This scene is clearly an allegory of the Blessed Virgin, but, because of such elements as the temple, symbolic of religion and of wisdom, at the same time the subject might be an allegory of the Church. The marian references are drawn from the Litany of Our Lady of Loreto, which was created by Sixtus V in 1587, and which figured prominently in the frescoes in the apse of Santa Maria in Trastevere in Rome executed during the reign of Clement VIII. On the missal cover, Mary appears as the "Morning Star," as indicated by the stars in the sky, rosy with dawn, and as "Queen of all the Saints," as denoted by the crown and the scepter, as well as by the stars, symbols of the saints—because, "They shall shine, and shall dart about as sparks

25 D

through the stubble" (Wisdom 3:7), "And they that be wise shall shine as the brightness of the firmament; and they that turn many to righteousness as the stars forever and ever" (Daniel 12:3). She is also depicted as the "Seat of Wisdom,"

as symbolized by the temple—"Wisdom hath builded her house" (Proverbs 9:1)—and by the book with a representation of the Holy Spirit. Typical of Mary, in addition to the Loreto elements, is the blue color of her robes.

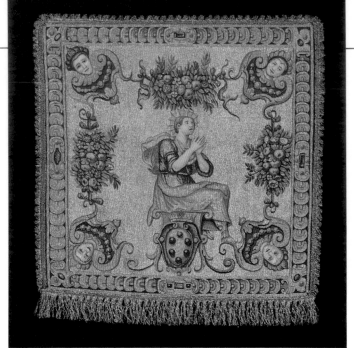

25 E

GUASPARRI DI BARTOLOMEO PAPINI,
after a cartoon by Alessandro Allori
(1535–1607)
25 E. MISSAL COVER
Florence, c. 1593–97
Tapestry, in silk, with silver-gilt threads
Height, 21¹¹/₁₆" (55 cm); width, 21¹/₄" (54 cm)
Biblioteca Apostolica Vaticana, Museo Sacro, Inv.
no. 2770

The weft is of silk, with silver-gilt threads; the warp, of three-ply yellow silk threads, ten to thirteen per centimeter. The tapestry was conserved in 1981, and is in good condition.

A young woman is seated on the Medici coat of arms, hands clasped and eyes turned toward heaven. This image corresponds to what Cesare Ripa (*Iconologia*, Rome, 1603, p. 471) identified as "True and Certain Hope."

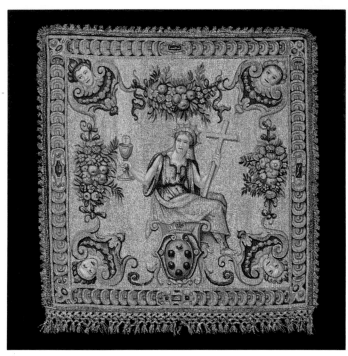

25 F

GUASPARRI DI BARTOLOMEO PAPINI,
after a cartoon by Alessandro Allori
(1535–1607)
25 F. MISSAL COVER
Florence, c. 1593–97
Tapestry, in silk, with silver-gilt threads
Height, 21¹¹/₁₆" (55 cm); width, 21¹/₄" (54 cm)
Biblioteca Apostolica Vaticana, Museo Sacro, Inv.
no. 2772

The weft is of silk with silver-gilt threads; the warp, of three-ply yellow silk threads, ten to thirteen per centimeter. The tapestry was conserved in 1981, and is in good condition.

The young woman seated on the Medici coat of arms holds a chalice in her right hand and a cross in her left. With the exception of the color of her garments—which are red and pink, rather than white—and the fact that she is seated, rather than standing, the figure corresponds to Ripa's identification of "Christian Faith" (C. Ripa, *Iconologia*, Rome, 1603, p. 149).

25 G

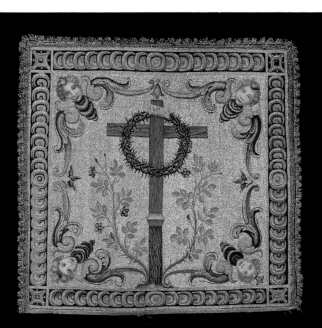

GUASPARRI DI BARTOLOMEO PAPINI,
after a cartoon by Alessandro Allori
(1535–1607)
25 G. CORPORAL CASE
Florence, c. 1593–97
Tapestry, in silk, with silver-gilt threads
Height, 20¹/₂" (52 cm); width, 20¹/₂" (52 cm)
Biblioteca Apostolica Vaticana, Museo Sacro, Inv.
no. 2781

The weft is of silk, with silver-gilt threads; the warp, of three-ply white silk, ten to thirteen threads per centimeter. The condition is good, following conservation in 1981.

The decoration is the traditional wooden cross, upon which is hung the crown of thorns. From the base of the cross two branches of flowering brambles issue forth. The same floral ornamentation characterizes the decoration of the chasuble (see cat. no. 25 H). There is no identifying coat of arms.

GUASPARRI DI BARTOLOMEO PAPINI,
after a cartoon by Alessandro Allori
(1535–1607)

25 H. CHASUBLE

Florence, c. 1593–97
Tapestry, in silk, with silver-gilt threads
Height, 55⅛" (140 cm); width, 40⅛" (102 cm)
Biblioteca Apostolica Vaticana, Museo Sacro, Inv.
 nos. 2769, 2730

The weft is of silk, with silver-gilt threads; the warp, of three-ply yellow silk, with ten to thirteen threads per centimeter. The condition is good. The chasuble was conserved in 1980–81. During conservation, it was found that, initially, a space was left on the warp for the papal arms; later, the threads of the warp were cut away and the coat of arms of Clement VIII sewn on. Since the warp is of two different colors—that of the chasuble, yellow; that of the coat of arms, white—it is possible that considerable time elapsed before the coat of arms was woven in.

On the front, within the cross, starting at the top, is a representation of Christ Crowned with Thorns (John 19:5), flanked by two angels; at the center, Veronica; below, Pilate Washing His Hands (Matthew 27:24); and, at the bottom, two crossed flagella. On the back, in descending order, within the vertical band, are Christ in the Garden of Olives (Luke 22:39–44); Christ at the Column; and the Repentance of Peter (Matthew 26:69–75), with the attribute of the apostle, the

cock, directly above him. In the spaces at the sides of the cross and of the column are praying angels in flight, surrounded by flowering brambles—a motif drawn not from the Gospels of the Evangelists but from apocryphal sources.

Throughout, the iconography of this vestment is related to the cycle of the Passion of Christ—specifically, to the celebrations of Holy Week. Of the so-called Sorrowful Mysteries of the Rosary, only the Crucifixion is excluded, while the Road to Calvary is alluded to, if not actually represented, by the image of Veronica. A typically Eucharistic motif is the angel offering the chalice to Jesus. The images of Pilate and Peter contrast two opposite forms of repentance. The proximity of Peter to the coat of arms of Clement VIII is an obvious reference to the pontiff for whom the chasuble was made—inasmuch as it was the vestment of the celebrant.

GUASPARRI DI BARTOLOMEO PAPINI,
after a cartoon by Alessandro Allori
(1535–1607)

25 I. DALMATIC

Florence, c. 1593–97
Tapestry, in silk, with silver-gilt threads
Height, 53¾" (136 cm); width, 57½" (146 cm)
Biblioteca Apostolica Vaticana, Museo Sacro, Inv.
 nos. 2777, 2778

The weft is of silk, with silver-gilt threads; the

warp, of three-ply yellow silk threads, ten to thirteen per centimeter. The tapestry is in fine condition, after the conservation of 1980–81. Then, it was shown that, originally, the space with the papal arms was left empty, with only the warp in place, and that, later, the coat of arms of Clement VIII was woven separately, with a white rather than a yellow warp, and sewn onto the vestment. The present grand-ducal shield, with the Medici-Lorraine coat of arms, also was woven on a white warp and was sewn on over a preexisting shield that was actually part of the dalmatic and had only the Medici arms.

On the front of the dalmatic, at the top, is the Annunciation (Luke 1:28–35), with the Evangelists Luke and Matthew and their respective symbols at the sides. At the center is a terraqueous globe, with two crossed trumpets superimposed upon it, and two angels at either side, with the words IN OMNE, perhaps the beginning of a line, "In omnem terram exivit sonus eorum," from Psalm 18 (5); below is the Adoration of the Magi (Matthew 2:11).

On the back of the dalmatic, at the top, is the Baptism of Christ (Mark 1:9–12), with the Evangelists John and Mark, and their symbols, on either side. Below, between two angels with censers, is the Ascension of Christ (Luke 24:51).

The decoration of the dalmatic with scenes recounted by the Evangelists indicates that the vestment probably was made for the deacon (or subdeacon) who was entrusted with reading

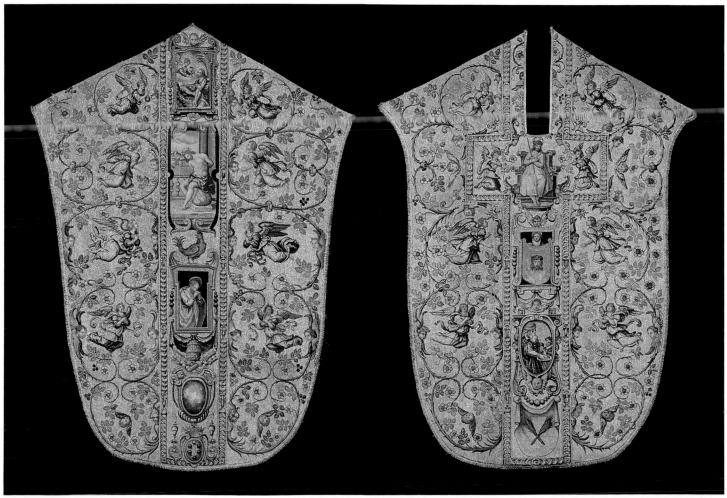

25 H (back and front)

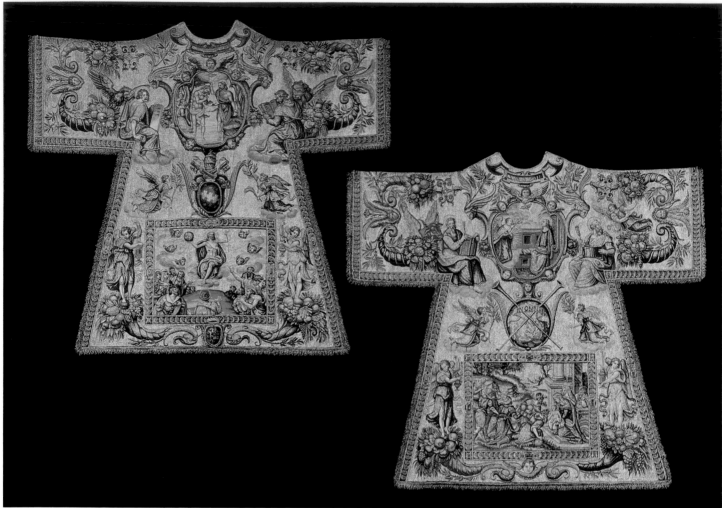

25 I (back and front)

from the Gospels. The inclusion, on the front, of the two episodes from the life of Mary undoubtedly was determined by the place in which the vestment was to be used—the Sistine Chapel, which is dedicated to the Virgin of the Assumption. The two christological scenes on the other side of the dalmatic are related to the imagery on the chasuble (see cat. no. 25 H) and focus on the theme of salvation through baptism.

GUASPARRI DI BARTOLOMEO PAPINI,
after a cartoon by Alessandro Allori
(1535–1607)

25 J. DALMATIC

Florence, c. 1593–97
Tapestry, in silk, with silver-gilt threads
Height, 52¾" (134 cm); width, 57⅞" (147 cm)
Biblioteca Apostolica Vaticana, Museo Sacro,
Inv. nos. 2727, 2731

The weft is of silk, with silver-gilt threads; the warp, of three-ply yellow silk threads, ten to thirteen per centimeter. The dalmatic is in a fine state of preservation. During conservation in 1980–81, it was ascertained that, initially, the space with the papal arms was left empty, with only the warp in place, and that, later, the coat of arms of Clement VIII was sewn on. As to the grand-ducal arms, the present ones with the Medici-Lorraine

arms were woven separately with a white warp, and then sewn over a Medici shield without Lorraine arms.

On the front of the dalmatic, at the top, is the Giving of the Keys (John 21:15–17), with Saint Peter at the left and, at the right, Isaiah, the subject of the scene below. In the center is a globe, at either side of which are angels with olive branches; superimposed over the globe are two crossed trumpets, and the words IN OMNE, perhaps taken from the passage in Psalm 18 (5) that begins ''In omnem terram exivit sonus eorum''; below is the scene of Isaiah Healing Hezekiah (II Kings 20:1–11; Isaiah 38:1–22), in the upper right of which is the sundial that the prophet used to give Hezekiah the sign that he would recover.

On the back of the dalmatic, at the top, is the Conversion of Saint Paul, in the middle (Acts 9:3–9), flanked by Saint Paul, to the left, and, to the right, by Aaron, the protagonist of the scene below. At the bottom is Aaron's Flowering Rod (Numbers 17:8; Hebrews 9:4).

What all the scenes have in common is a sign given by God—determining the investiture of Peter, the conversion of Paul, the healing of Hezekiah, and the recognition of the authority of Aaron as High Priest of the Hebrews. Central to the iconography of the dalmatic is the contrasting of episodes from the Old and the New Testaments to illustrate the superiority of the New Law over

the Old Law—the theme of Saint Paul's Epistles to the Romans and to the Hebrews. In this view, it is possible that Allori, the designer, erred, transposing the pairing of the scenes and the respective prophets and apostles. Given its subject, it is probable that the dalmatic was worn by the deacons responsible for reading from the Epistles.

25 K, L (details)

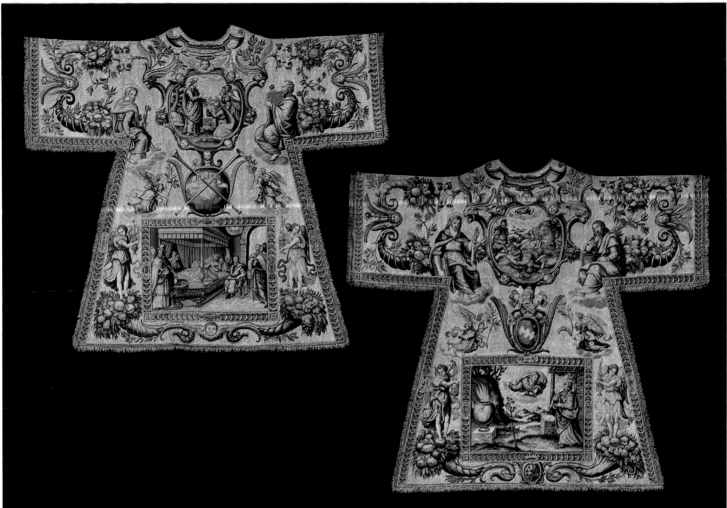

25 J (front and back)

GUASPARRI DI BARTOLOMEO PAPINI,
after a cartoon by Alessandro Allori
(1535–1607)

25 K. STOLE

Florence, c. 1593–97
Tapestry, in silk, with silver-gilt threads
Length, 80¹⁵/₁₆" (231 cm); width, 5⅛" (13 cm)
Biblioteca Apostolica Vaticana, Museo Sacro,
Inv. no. 2776a–b

The weft is of silk, with silver-gilt threads; the warp, of three-ply white silk, ten to thirteen threads per centimeter. The condition is good, following conservation in 1981. The decorative motif consists of the combination of two instruments of the Passion—the lance and the rod with the sponge soaked in vinegar.

GUASPARRI DI BARTOLOMEO PAPINI,
after a cartoon by Alessandro Allori
(1535–1607)

25 L. MANIPLE

Florence, c. 1593–97
Tapestry, in silk, with silver-gilt threads
Length, 33⅞" (86 cm); width, 5⅛" (13 cm)
Biblioteca Apostolica Vaticana, Museo Sacro,
Inv. nos. 2728, 2733

The weft is of silk, with silver-gilt threads; the warp, of three-ply white silk, ten to thirteen threads per centimeter. The condition is good, following conservation in 1981. Like the stole (see cat. no. 25 K), the maniple is decorated with one of the instruments of the Passion—in this case, the scourge.

GUASPARRI DI BARTOLOMEO PAPINI,
after a cartoon by Alessandro Allori
(1535–1607)

25 M. CLASP

Florence, c. 1593–97
Tapestry, in silk, with silver-gilt threads
Height, 5⅛" (13 cm); width, 9¹/₁₆" (23 cm)
Biblioteca Apostolica Vaticana, Museo Sacro,
Inv. no. 2782

The weft is of silk, with silver-gilt threads; the warp, of three-ply yellow silk threads, ten to thirteen per centimeter. Following conservation in 1981 the clasp is now in good condition.

The clasp—whose decoration depicts the bound hands of Christ—was used to fasten a cope across the chest. 　　　　　*F. M.*

25 M

Thorough research by Dr. Angelica Frezza on all documents pertaining to the vestments, completed for the 1980 "Medici" exhibition in Florence, is being published currently. I owe many thanks to Msgr. Gianfranco Nolli for his most valuable assistance in clarifying numerous points on the complex iconography of these vestments; to Dr. Marcello del Piazzo for information concerning the coats of arms; and to Candace Adelson for some helpful suggestions regarding the weaving technique.

NEW
SAINT PETER'S
AND
BAROQUE ROME

The creation of the new Saint Peter's took one hundred and seventy-six years, from the time of Nicholas V's decision, about 1450, to replace the medieval basilica with a Renaissance structure, until the consecration of the new church, by Urban VIII, in 1626. It was Julius II (1503–13) who approved Bramante's Greek-cross plan, with its lofty dome supported on four gigantic piers: a pure and grandiose design, to which—after consideration of some alternative suggestions made by Raphael and Antonio da Sangallo the Younger—Michelangelo returned in 1546, when Paul III (1534–49) made him architect of Saint Peter's. Michelangelo carried out his powerful and majestic designs for the apse and the southwest transept, the four piers, and the drum of the cupola. When, in 1590, under Sixtus V (1585–90), the immense, soaring dome was finally raised by Giacomo della Porta and Domenico Fontana, the Renaissance church truly was born.

One last task, however, was still to be accomplished: the demolition and rebuilding of the remaining eastern part of the old church. In 1606, Paul V (1605–21) entrusted the completion of Saint Peter's to Carlo Maderno. By extending the nave further east, Maderno changed Bramante's and Michelangelo's plan from a Greek to a Latin cross. The harmonious porportions of Maderno's nave, and the serene beauty of the new atrium and pedimented façade—completed, after his designs, in 1614—added a dynamic majesty to the great Renaissance basilica that clearly announced the oncoming Baroque age.

Already, in the 1580s, Gregory XIII (1572–85) had begun the marble facing of the small order of pilasters in the choir, transept, and adjoining chapels. The polychrome decoration was sumptuous in style, enriched by mosaics, gilded stuccoes,

and paintings. The vivid, yet cool colors; the Michelangelesque references in the design; and the wealth of elaborate allegories that figure in the decoration also characterize the altar cross and candlesticks commissioned by Cardinal Alessandro Farnese for the papal altar (see cat. nos. 22–23), and the liturgical vestments (cat. no. 25A–M) woven in the 1590s for Clement VIII, the pontiff to whom the chapel of the Confessio owes its plan and ornamentation.

Like Paul V, Urban VIII (1623–44) also turned his attention to the embellishment of the interior of Saint Peter's. His first concern was with the crossing, where the papal altar and the surrounding space were in need of enhancement in order to serve as a proper setting for the important ceremonies held in the basilica. He entrusted the project to the young Gian Lorenzo Bernini (1598–1680), and this commission, in 1624, marked the beginning of the artist's lifelong activity at Saint Peter's: an association that was to transform the church and its piazza into the greatest artistic achievement of the Catholic Counter Reformation and the supreme expression of the Roman Baroque.

Bernini created the baldacchino, the triumphal bronze canopy that stands above the papal altar, supported by four twisted columns; the four balconies, set into the pillars under the dome, for the exhibition of the major relics of the basilica; and the four colossal statues of the saints (below the balconies) associated with these relics: Longinus, Helen, Veronica, and Andrew—a program that unified the great space of the crossing with an unprecedented boldness of imagination.

The impetus given by Urban VIII to the decoration of Saint Peter's led to the enrichment of many chapels and altars throughout the church with paintings by the finest artists of the day: Giovanni Lanfranco, Andrea Sacchi, Pietro da Cortona, and Nicolas Poussin—whose famous *Martyrdom*

FIG. 24. THE NAVE OF SAINT PETER'S, WITH THE BALDACCHINO AND THE *CATHEDRA PETRI*, BOTH BY GIAN LORENZO BERNINI

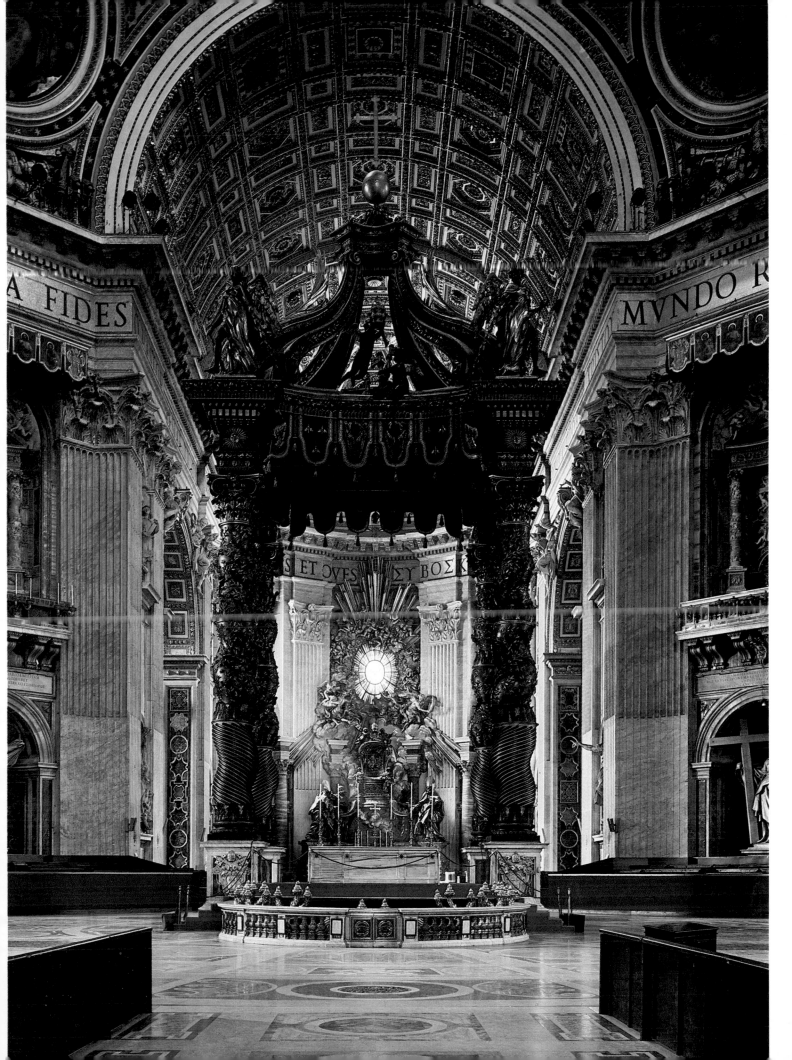

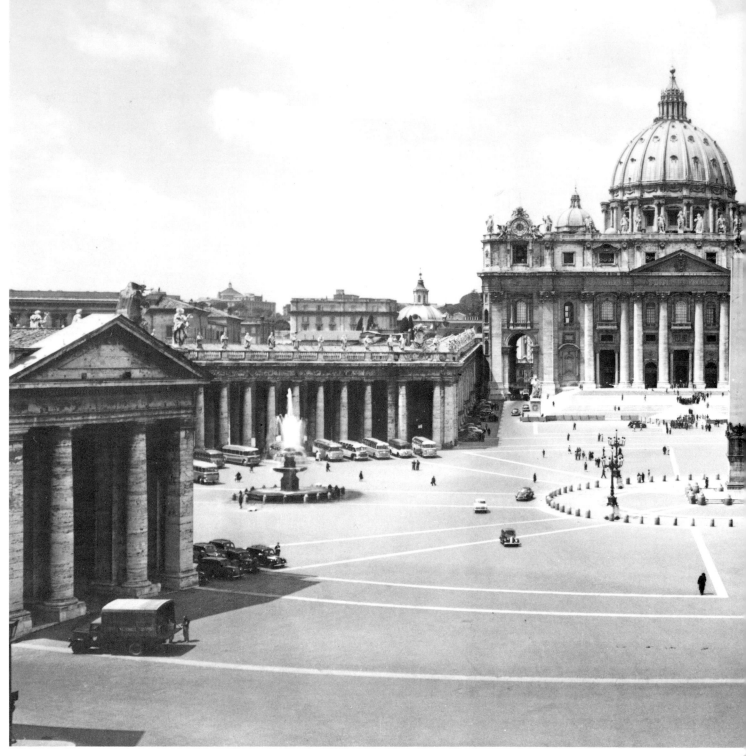

FIG. 25. SAINT PETER'S BASILICA AND T[

of *Saint Erasmus* (cat. no. 86) was painted for the altar of Saint Petronilla. Bernini, himself, made two funerary monuments for Saint Peter's: the tomb of Countess Matilda of Tuscany (of 1632–37) and the tomb of Urban VIII (of 1627–47), for which there are two surviving terracotta sketches (cat. nos. 27, 28).

During the eleven years in which Innocent X was pope (1644–55), the preferred sculptor was Alessandro Algardi (1598–1654), whose *Baptism of Christ* (cat. no. 30) gained him the patronage of the pontiff; Innocent X also commissioned from him the great marble relief of *The Meeting of Pope Leo I and Attila* (of 1647–54), for one of the chapel's in

Saint Peter's.

With the election to the papacy of Alexander VII (1655–67), Bernini again enjoyed full favor. In answer to this pope's desire to add not only to the magnificence of Saint Peter's, but to that of the whole of Rome, Bernini's artistic powers reached ever more extraordinary heights. From 1657 on, he carried out the great oval colonnade of the piazza of Saint Peter's (fig. 25); the majestic new Scala Regia, which leads from the colonnade to the old Apostolic Palace; and, in the apse of the basilica, the visionary installation of the Cathedra Petri (fig. 24), held aloft, as it were, by the four statues of the Fathers of the Church, with the transparent dove of

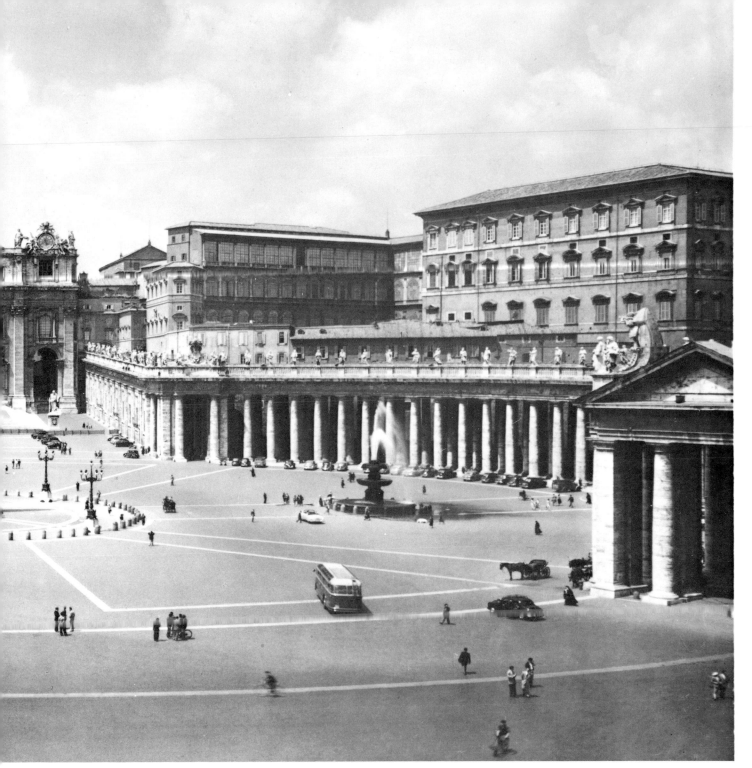

…AZZA ENCLOSED BY BERNINI'S COLONNADE

the Holy Spirit high above, amidst an angelic glory. By transcending the traditional boundaries between architecture, painting, and sculpture, Bernini created a new visual language that was capable of transmitting through form, color, and light the deepest emotions and mystical feelings of the Christian faith. The master's works for Alexander VII outside the Vatican—such as the sculptural decoration of the Chigi Chapel at Santa Maria del Popolo (cat. no. 31)—bear the imprint of the same perfervid imagination.

The city itself, which the pope's contemporaries called "Roma Alessandrina," benefited from some of the seventeenth century's most brilliant achievements in architecture and urban planning. During the pontificates of Alexander VII and of Clement IX (1667–69)—for whom Bernini created the angels of the Ponte Sant'Angelo—Rome became, more than ever, the "first city of the world."

<div align="right">Olga Raggio</div>

BIBLIOGRAPHY: S. Schüler-Piroli, *2000 Jahre Sankt Peter, Die Weltkirche von den Anfängen bis zur Gegenwart*, Olten, 1950, pp. 491–692; A. Schiavo, *San Pietro in Vaticano. Forme e Strutture*, Rome, 1960; P. Portoghesi, *Roma Barocca. The History of an Architectonic Culture*, Cambridge, Mass., and London, 1970; E. M. Jung-Inglessis, *St. Peter's*, Florence, 1980, pp. 7–19.

Comparative works: J. Ackerman, *The Architecture of Michelangelo*, 2 vols., 2nd rev. ed., London, 1964; R. Wittkower, *La Cupola di San Pietro di Michelangelo*, Florence, 1964; I. Lavin, *Bernini and the Crossing of St. Peter's*, New York, 1968; H. Hibbard, *Carlo Maderno and Roman Architecture, 1580–1630*, University Park, Pa., 1971; R. Wittkower, *Gian Lorenzo Bernini: The Sculptor of the Roman Baroque*, 3rd rev. ed., Oxford, 1981.

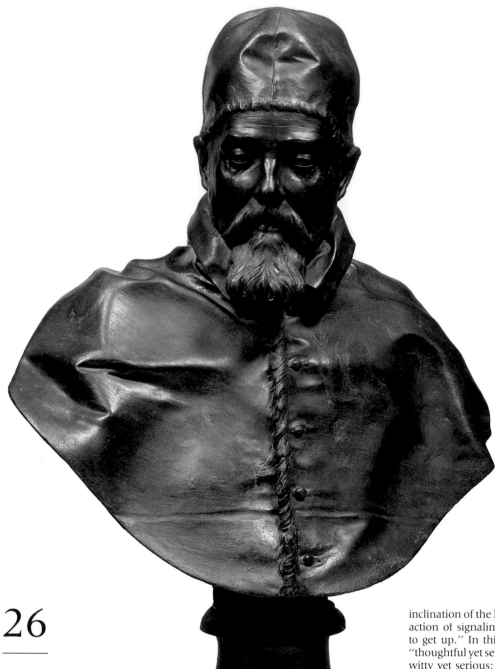

26

GIAN LORENZO BERNINI (1598–1680)
BUST OF POPE URBAN VIII (1623–44)

Rome, c. 1632–33
Bronze
Height, with base, 39 ⅜" (100 cm)
Biblioteca Apostolica Vaticana, Museo Sacro,
 Inv. no. 2427

Cast in one piece with its base, this bust is a very fine contemporary replica of a portrait of the pope by Bernini, of which there are two marble versions: one, formerly in the Barberini Collection, is now in the Galleria Nazionale d'Arte Antica in the Palazzo Barberini in Rome (R. Wittkower, 1981, pl. 39); the other, recently discovered, is in The National Gallery of Canada in Ottawa (R. Wittkower, 1969, p. 63). The surface of the bronze is of amazing freshness, crisply yet broadly chased; the back shows the tooling of the original terracotta model, which,

most probably, was the one that Bernini used for the Barberini marble. The marble bust has been variously dated in the literature, but its execution in 1632 seems certain on the basis of its similarity to an engraved portrait of Urban VIII by Claude Mellan, dated 1631, and to a strikingly vivid and accurate description of the work in a letter of 1632. The writer, Lelio Guidiccioni, was a friend of Bernini, and his words captured the essence of the pope's likeness in unmistakable terms: "The bust has no arms, but a slight motion of the right shoulder and a lifting of his *mozzetta*, in addition to the inclination of the head, . . . clearly indicates the action of signaling with the arm to someone to get up." In this portrait, the pope appears "thoughtful yet serene, suave yet full of majesty, witty yet serious: he smiles and is venerable" (C. D'Onofrio [1967], p. 382).

The Vatican bronze, another version of which is in the Palazzo Comunale in Camerino, was made for the Palazzo Barberini library, where it occupied a niche above the wooden paneling made by Giovan Battista Soria in 1633. The bust was described in 1642 by Girolamo Teti, and remained at the Palazzo Barberini until 1902, when the Vatican Library acquired the Barberini library, together with its paneling.

O. R.

BIBLIOGRAPHY: G. Teti, *Aedes Barberinae ad Quirinalem*, Rome, 1642, p. 31; M. T. De Lotto, in *Bernini in Vaticano* (exhib. cat.), Rome, 1981, pp. 114–15.

Comparative works cited: C. D'Onofrio, *Roma vista da Roma*, Rome [1967]; R. Wittkower, "A New Bust of Urban VIII by Bernini," in *The Burlington Magazine*, 111, 1969, p. 63; *idem, Gian Lorenzo Bernini: The Sculptor of the Roman Baroque*, 3rd rev. ed., Oxford, 1981.

27

GIAN LORENZO BERNINI (1598–1680)
CHARITY, WITH FOUR CHILDREN
Rome, c. 1627–28
Terracotta, with traces of gilding
Height, 15 ⅜" (39 cm)
Biblioteca Apostolica Vaticana, Museo Sacro,
* Inv. no. 2423*

Charity's stance is a spiraling contrapposto. She
holds a large child, who is feeding at her left
breast, while she turns her head toward a little
boy standing to her right. Leaning against a
downturned torch, he seems to be wiping away
his tears. On the other side of Charity, two babies,
crouching on the ground, embrace and kiss.

In 1980–81, a thick coat of black paint was
removed from the surface of the sculpture. Some
traces of an earlier water gilding were left,
however, as well as a gold-leaf edge applied as a
border to Charity's garments. The back of the
group is unfinished. The artist worked the clay
with fingers and modeling tools, achieving an
effect of lively, energetic contrasts between the
deep undercutting and sharp edges of the crum-
pled draperies and the tender surfaces of the
naked bodies, highlighted by delicate brushwork
—as on Charity's right shoulder—or by the ap-
plication of a granular film of clay wash to the
flesh of the two kissing babies.

The technique and the amazing freshness of
the group have precise parallels in the handling
of some of the clay sketches by Bernini now in
the Fogg Art Museum—especially, the sketch
of a helmeted female figure for the memorial to
Carlo Barberini (R. Norton, 1914, p. 46, pl. XI).
There is no doubt, indeed, that this is one of
Bernini's probably numerous compositional
studies for the figure of Charity on the tomb of
Urban VIII in Saint Peter's (R. Wittkower, 1981,
no. 30, pl. 49). The still Mannerist double tor-
sion of the figure; the complication of her
clinging, windswept garments; and the sensi-
tive modeling of the children recall Bernini's early
admiration for the paintings of Guido Reni and
suggest a very early date for this study. A precise
point of reference is offered by the two earliest
extant drawings for the tomb: the architectur-
al outline in the Albertina (H. Thelen, 1967,
no. 35) and the Windsor Castle project (*idem*, no.
36), both dating from 1627. In the Charity in
the Windsor drawing, the gesture of the child
on the left wiping a tear, and the faceted han-
dling of the draperies recall, very closely, the
Vatican terracotta, suggesting a similar date. This
work was probably one of the many terracottas
owned by Cardinal Flavio Chigi (1641–93),
which are described in the 1692 inventory of
his collection in the Casino at the Quattro
Fontane (Archivio Chigi 1805, f. 275). The group
came from the Chigi Collection to the Vatican
Library in 1923.

O. R.

BIBLIOGRAPHY: F. Mancinelli, in *Bernini in Vaticano*
(exhib. cat.), Rome, 1981, p. 108.

Comparative works cited: R. Norton, *Bernini and Other
Studies in the History of Art*, New York, 1914; H. Thelen,
Francesco Borromini: Die Handzeichnungen, Graz, 1967; R.
Wittkower, *Gian Lorenzo Bernini: The Sculptor of the Roman
Baroque*, 3rd rev. ed., Oxford, 1981.

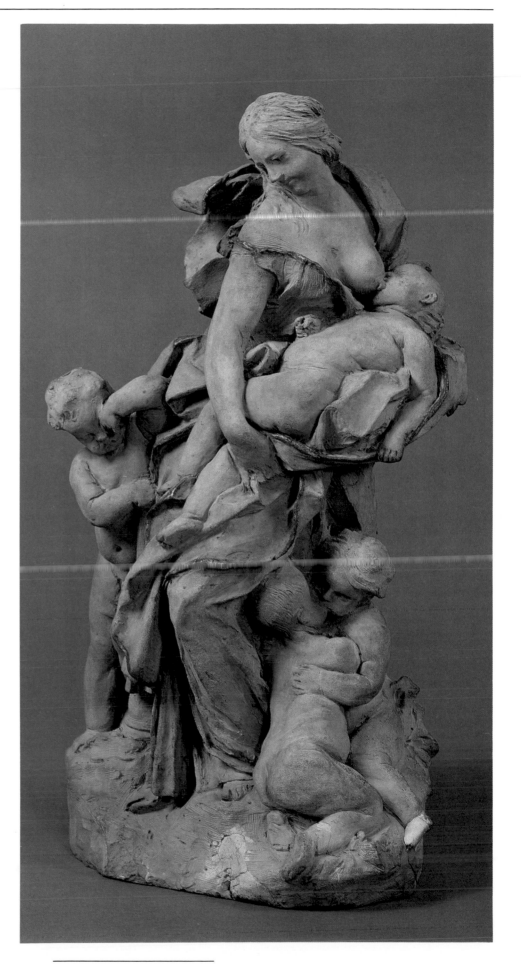

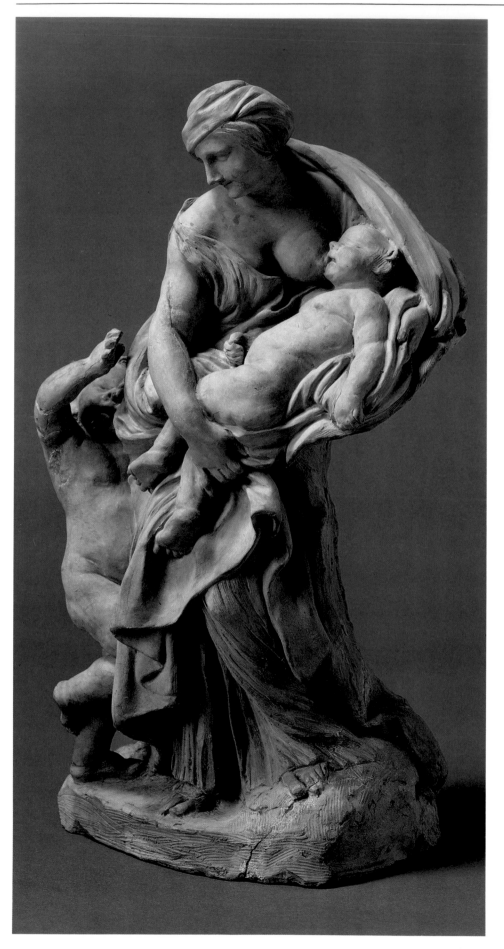

GIAN LORENZO BERNINI (1598–1680)
CHARITY, WITH TWO CHILDREN
Rome, c. 1634–39
Terracotta
Height, 16 ⅜" (41.6 cm)
Biblioteca Apostolica Vaticana, Museo Sacro,
* Inv. no. 2422*

In 1982, a thick coat of black paint was removed from the surface of this sculpture group, revealing the buff color of the terracotta and some minor firing cracks and repairs. The group is unfinished on the back, but on the front the draperies and the flesh areas seem to have been smoothed over with the fingers for a more unified effect. Although the composition corresponds very closely to Bernini's marble version on the tomb of Urban VIII in Saint Peter's (R. Wittkower, 1981, no. 30, pl. 49), there are significant differences in detail: both Charity and the sleeping baby have more pointed features than the marble figures, and the crying infant clings to her more closely, pulling his arm across his tearful face rather than raising his arm toward her. Thus, the terracotta clearly must be understood as a nearly final *modello*, immediately preceding its execution in marble.

The changes between this group and the earlier sketch (cat. no. 27) show Bernini's progress from a still conventional, fragmented, and essentially Mannerist formula toward a strongly monumental composition. The windswept draperies of the first Charity have now become more ponderous, cradling the infant who has fallen asleep while feeding. By simplifying the pose, as well as the component elements of Charity, Bernini conveys the feeling of her all-embracing maternal nature: a powerfully controlled creation, she has been organically related to the overall architecture of the papal monument.

Construction of the tomb of Urban VIII lasted from 1628 to 1647, when the finished monument was unveiled. During the initial phase of the project, Bernini worked briefly on the model of the statue of Urban VIII. This may have been finished in April 1631, but he kept restudying the compositions of the two allegories for several more years. According to a document of March 25, 1630 (O. Pollak, 2, 1931, p. 602), Bernini had not yet decided whether Charity was to be accompanied by two or three children, but since, in 1639, work was begun in earnest on the marble block, a date of 1634–39 seems to be the most likely for the Vatican *modello*.

The group came to the Vatican Library from the Chigi Collection in 1923. It was probably one of the many terracottas assembled by Cardinal Flavio Chigi, which are described in the 1692 inventory of the Casino at the Quattro Fontane (Archivio Chigi 1805, f. 275).

O. R.

BIBLIOGRAPHY: M. T. De Lotto, in *Bernini in Vaticano* (exhib. cat.), Rome, 1981, pp. 108–9.

Comparative works cited: O. Pollak, *Die Kunsttätigkeit unter Urban VIII*, 2 vols., Vienna, 1928, 1931; R. Wittkower, *Gian Lorenzo Bernini: The Sculptor of the Roman Baroque*, 3rd rev. ed., Oxford, 1981.

29

GIAN LORENZO BERNINI (1598–1680)
BUST OF A YOUNG MAN

c. 1635
Oil on canvas
Height, 26⅝" (67.7 cm); width, 19¹¹/₁₆" (50 cm)
Pinacoteca, Inv. no. 2409

This picture was discovered in the storage rooms of the Floreria Apostolica in 1979, and was restored the same year. Only the background had been slightly damaged. There are no markings that might provide a clue to the painting's provenance.

The work represents the bust of a young man of about twenty years of age, with what appears to be a cloak draped on his right shoulder. The light enters from the left, leaving the left side of the face completely in shadow. The likeness is in the form of a sketch, as though it were a studio design destined to remain as such. It displays an extremely sober chromatic range, limited to a few basic tones, with slightly reddish vibrations showing, even in the parts hit by reflected light. The highly plastic figure of the young man is modeled in broad, firm strokes, with a flat brush, and the dark red preparation of the background is used to good advantage for the parts in shadow—as in Poussin. Stylistically, the painting can be placed within Bernini's circle, and, insofar as qualitative level, sureness of brushstroke, and expressive intensity are concerned, it may be attributed to Bernini, himself, rather than to artists of his entourage, such as Carlo Pellegrini or Francesco Mola, or to such a weak follower as Giacinto Brandi. The bearing of the figure is in the style of Bernini, very similar to his *Bust of Costanza Buonarelli* (which dates to about the mid-1630s) and to the *Portrait of Bernini Dressed as Saint George* (of about 1635) by Pellegrini, one of Bernini's assistants in the thirties; the latter portrait was executed, according to V. Martinelli ("Le pitture del Bernini," in *Commentari*, I, 1950, p. 100), following preliminary suggestions from Bernini. The outline, in particular, in Pellegrini's portrait is identical to that of the Vatican head, and the mannerisms in the rendering of certain details— for example, the musculature of the neck—are analogous. The style of brushstroke and the chromatic range are completely different, however, and reveal the work of the assistant. The impasto and the use of light in the Vatican picture are close to another work, the result of a Bernini-Pellegrini collaboration: *The Martyrdom of Saint Maurice*, painted between 1636 and 1640 for Saint Peter's. Specifically, the analogies concern the heads of the two armed men on the right side of the painting; they are completely different, stylistically and technically, from all the others, and were probably done by Bernini, himself (cf. F. Mancinelli, "Carlo Pellegrini, Gian Lorenzo Bernini. Il Martirio di S. Maurizio," entry, 1981, no. 39, pp. 65–66). Also typical of Bernini in the Vatican painting are some light brushstrokes along the right side of the face, which detach the head from the background—not unlike the effect in the *Small Portrait of a Child*, in the Galleria Borghese, which Grassi (*Bernini Pittore*,

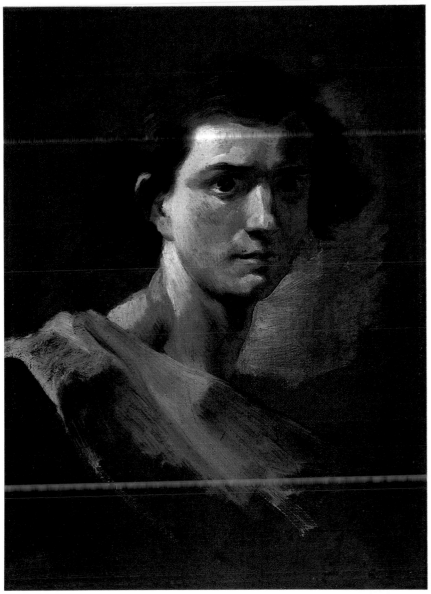

Rome, 1945, p. 24) restored to Bernini.

The *Bust of a Young Man* in the Pinacoteca Vaticana is, therefore, a rare example of a pictorial effort by the master, and forms part of those studies of which the *Head of an Old Man*—perhaps a Saint Paul—(now in a private collection) is a much later example. Chromatically and technically still under the influence of *The Martyrdom of Saint Erasmus* by Poussin (see cat. no. 86), Bernini's treatment of light in the *Bust of a Young Man* anticipates Velázquez's *Self-Portrait* (in the Galleria Borghese) and is, therefore, datable to about 1635. The identity of the subject remains unknown, but, as Maurizio Marini suggests, a certain family resemblance makes one think that he was a close relative of Bernini.

F. M.

BIBLIOGRAPHY: F. Mancinelli, "Gian Lorenzo Bernini— Busto di giovane," entry in *Bernini in Vaticano* (exhib. cat.), Rome, 1981, no. 40, pp. 68–69.

30

ALESSANDRO ALGARDI (1598–1654)
THE BAPTISM OF CHRIST

Rome, c. 1644–45
Terracotta
Height, 19³/₁₆" (48.7 cm); width, 18¹³/₁₆" (47.8 cm)
Biblioteca Apostolica Vaticana, Museo Sacro,
 Inv. no. 2426

When the group was cleaned in 1982, and a coat of brown paint was removed from its surface, a pale, buff-colored terracotta and some minor repairs were revealed. The smooth, sensitive modeling of the figures—with their long, nervous fingers and limbs—and their delicately differentiated textures confirm the attribution of this terracotta to Algardi, as suggested by Olga

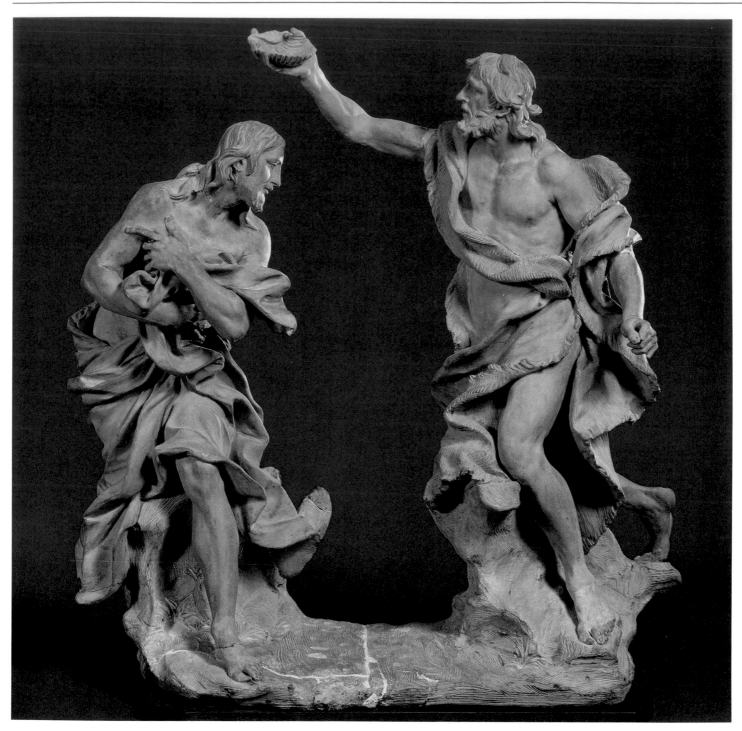

Raggio (1971) and, independently, by Jennifer Montagu (1972). Yet, even more convincing than the facture of the sculpture is the purely Algardian character of the group: a carefully studied composition, whose two figures have been developed along a series of intersecting diagonal lines, offering multiple views from the front as well as from the back. The vibrant, sympathetic dialogue of the forms, beautifully expressed by the vivacity of the poses and the extraordinary animation of the draperies, recalls the best qualities of Algardi's drawings, as well as many details of his bronze statuettes, such as the *Saint Michael and the Devil* (in the Museo Civico in Bologna). The *Baptism* group looks forward, also, to Algardi's most famous two-

figure composition: the monumental marble relief of *The Meeting of Pope Leo I and Attila* in Saint Peter's, a commission for which the sculptor supplied models as early as 1646. The Vatican terracotta, unfortunately, has lost the small angel that was poised, as if in flight, over the rock below Jesus, linking the two figures above the waters of the river and adding to the picturesque animation of the group. We know of its existence, for it is described in a seventeenth-century inventory and is preserved in a particularly fine bronze version, with the arms of the Franzoni family, in The Cleveland Museum of Art (J. Montagu, 1972, pp. 65, 76, fig. 1).

The style of the terracotta, which is typical of Algardi's work in the 1640s, suggests that it is a

study for a now-lost silver group of the Baptism of Christ, which the artist made shortly after the election of Pope Innocent X (1644–55). The work was presented to the pontiff, who was especially pleased with it, since it was an allusion to his name—Giovanni Battista Pamphili—and to his patron saint. In his will, Algardi left the terracotta model for this group to his patron and executor, Monsignor Cristofano Segni. After the death of Segni, about 1780, the model was sent to Bologna and was still in the Segni Collection, where it was seen by Marcello Oretti. It cannot, therefore, be identified with the Vatican terracotta, which, most likely, is the work described in an inventory of about 1666 of the collection of Cardinal Flavio Chigi in the Casino

of the Quattro Fontane as "un battesimo di S. Gio Battista di terracotta alto pal. doi" (Archivio Chigi 702, f. 116 v.). The present group came to the Vatican from the Chigi Collection in 1923.

<div align="right">O. R.</div>

BIBLIOGRAPHY: O. Raggio, "Alessandro Algardi e gli stucchi di Villa Pamphili," in *Paragone*, 251, 1971, pp. 16–17; J. Montagu, "Le Baptême du Christ d'Alessandro Algardi," in *Revue de l'Art*, 15, 1972, pp. 64–78.

31

GIAN LORENZO BERNINI (1598–1680)
DANIEL IN THE LIONS' DEN

Rome, c. 1655
Terracotta
Height, 16 ⅜" (41.6 cm)
Biblioteca Apostolica Vaticana, Museo Sacro,
* Inv. no. 2424*

In 1980–81, a coat of black paint was removed from the surface of this terracotta, revealing modeling of great subtlety and smoothness. Although this statuette is considerably more finished than other surviving sketch-models by Bernini, it is clearly a preparatory study for the marble statue of Daniel commissioned in 1655 by Pope Alexander VII for the Chigi Chapel at Santa Maria del Popolo and installed there in 1657. Five preparatory drawings by Bernini for the *Daniel* survive in Leipzig (I. Lavin et al., 1981, pp. 164–69, nos. 32–36), and the present terracotta is related to one of them (no. 33).

In the *Daniel* and its pendant statue of *Habakkuk and the Angel* (see cat. no. 32), Bernini evoked the story of the two prophets as recounted in Bel and the Dragon, the third apocryphal addition to the Book of Daniel. There, it is told how the Prophet Daniel was cast into the lions' den by the Babylonians, but was saved by the Lord and nourished by the Prophet Habakkuk, who, miraculously, was transported to Daniel's cave by an angel. The story, which is read in the Catholic Liturgy on the Tuesday before Palm Sunday, was considered a prefiguration of the Resurrection of Christ, as well as a symbol of salvation through the Eucharist. Bernini's visualization of the two prophets was deeply influenced by these concepts. In the Vatican model, Daniel's slender body appears to rise toward a vision, to be enveloped by a spiritual breeze, his drapery flickering across his body like a flame. In trying out his composition in the malleable medium of clay, Bernini seems to have sought a serpentine outline and a luminous smoothness of masses that helped him to achieve the plastic definition of his final composition in marble. The terracotta was described in the 1692 inventory of the collection of Cardinal Flavio Chigi in the Casino at the Quattro Fontane (Archivio Chigi 1805, f. 275) as "un modello del Danielle di terracotta del Popolo, fatto dal Bernini." It came from the Chigi Collection to the Vatican Library in 1923.

<div align="right">O. R.</div>

BIBLIOGRAPHY: F. Mancinelli and M. T. De Lotto, in *Bernini in Vaticano* (exhib. cat.), Rome, 1981, pp. 126–27.

Comparative work cited: I. Lavin et al., *Drawings by Gianlorenzo Bernini from the Museum der Bildenden Künste Leipzig, German Democratic Republic* (exhib. cat.), The Art Museum, Princeton University, 1981.

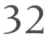

GIAN LORENZO BERNINI (1598–1680)
HABAKKUK AND THE ANGEL

Rome, c. 1655
Terracotta
Height, 20½" (52 cm)
Biblioteca Apostolica Vaticana, Museo Sacro, Inv.
no. 2425

When the terracotta was cleaned in 1980–81, a coat of black paint was removed from its surface. A highly finished sculpture—except for the back, which was left partly in the rough—this figure of Habakkuk corresponds so closely to Bernini's marble in the Chigi Chapel at Santa Maria del Popolo that it cannot be considered a preparatory study. Yet, the quality of its modeling has so much in common with that of Bernini's statuette of Daniel (see cat. no. 31) that we should assume that this group served as a finished *modello*, or, possibly, as a presentation piece. Another example of a similarly highly finished *modello* by Bernini is his terracotta bozzetto of *The Blessed Ludovica Albertoni* (of 1671–74), recently acquired by the Victoria and Albert Museum (M. P. Mezzatesta, 1982, no. 10).

The *Habakkuk* group, which is slightly larger than the average Bernini sketch-model, conveys all the complexity and subtlety of the artist's invention. Habakkuk surrenders to the will of the angel, who is about to lift him by his hair and transport him to Daniel's cave. The tension expressed by their meeting gazes, the contrast between the powerful physique of the prophet and the supernatural grace of the angel, the expressivity of the tightly bunched and cascading draperies, the play of intersecting diagonal lines—all owe much to Bernini's earlier portrayals of mystical experiences, such as the *Saint Longinus* and *The Ecstasy of Saint Theresa*. *Habakkuk and the Angel* was described in an inventory of about 1666 of Cardinal Flavio Chigi's collection at the Casino of the Quattro Fontane as ''una figura di terra cotta alta pal: doi e mezzo in circa rappresenta un vecchio con un'Angelo che lo tiene per gli capelli'' (Archivio Chigi 702, f. 116 v.). It came from the Chigi Collection to the Vatican Library in 1923.

O. R.

BIBLIOGRAPHY: F. Mancinelli and M. T. De Lotto, in *Bernini in Vaticano* (exhib. cat.), Rome, 1981, pp. 127–28.

Comparative work cited: M. P. Mezzatesta, *The Art of Gian Lorenzo Bernini, Selected Sculpture* (exhib. cat.), Kimbell Art Museum, Fort Worth, 1982.

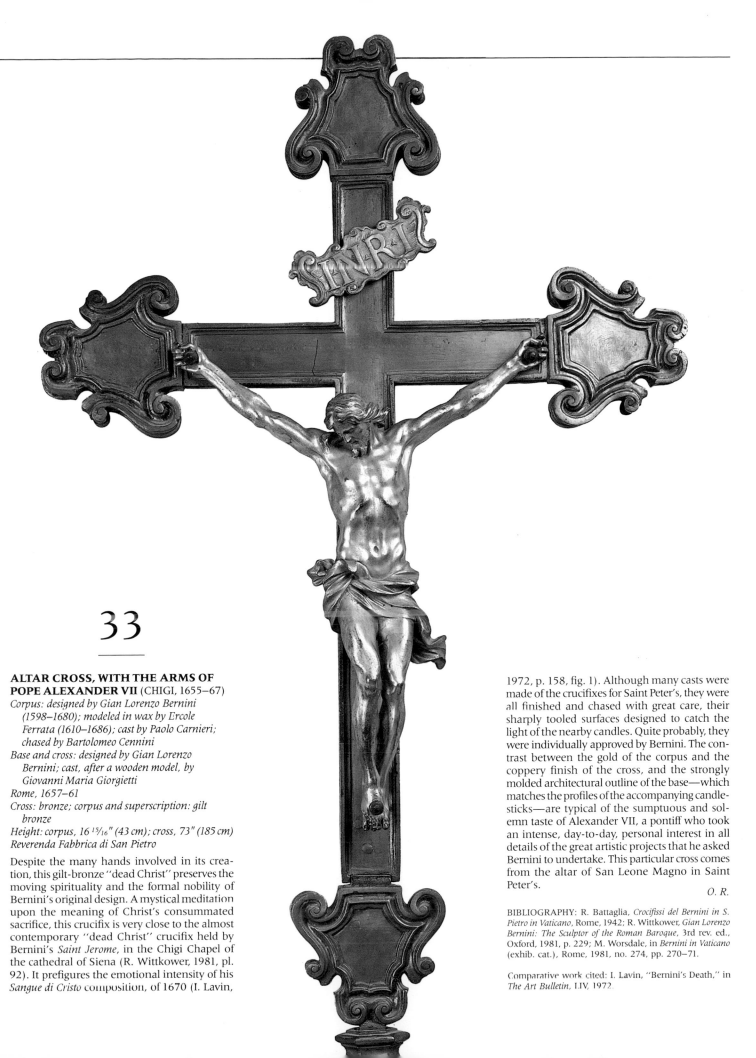

33

ALTAR CROSS, WITH THE ARMS OF POPE ALEXANDER VII (CHIGI, 1655–67)

Corpus: designed by Gian Lorenzo Bernini (1598–1680); modeled in wax by Ercole Ferrata (1610–1686); cast by Paolo Carnieri; chased by Bartolomeo Cennini

Base and cross: designed by Gian Lorenzo Bernini; cast, after a wooden model, by Giovanni Maria Giorgietti

Rome, 1657–61

Cross: bronze; corpus and superscription: gilt bronze

Height: corpus, 16 15/16" (43 cm); cross, 73" (185 cm)

Reverenda Fabbrica di San Pietro

Despite the many hands involved in its creation, this gilt-bronze "dead Christ" preserves the moving spirituality and the formal nobility of Bernini's original design. A mystical meditation upon the meaning of Christ's consummated sacrifice, this crucifix is very close to the almost contemporary "dead Christ" crucifix held by Bernini's *Saint Jerome*, in the Chigi Chapel of the cathedral of Siena (R. Wittkower, 1981, pl. 92). It prefigures the emotional intensity of his *Sangue di Cristo* composition, of 1670 (I. Lavin,

1972, p. 158, fig. 1). Although many casts were made of the crucifixes for Saint Peter's, they were all finished and chased with great care, their sharply tooled surfaces designed to catch the light of the nearby candles. Quite probably, they were individually approved by Bernini. The contrast between the gold of the corpus and the coppery finish of the cross, and the strongly molded architectural outline of the base—which matches the profiles of the accompanying candlesticks—are typical of the sumptuous and solemn taste of Alexander VII, a pontiff who took an intense, day-to-day, personal interest in all details of the great artistic projects that he asked Bernini to undertake. This particular cross comes from the altar of San Leone Magno in Saint Peter's.

O. R.

BIBLIOGRAPHY: R. Battaglia, *Crocifissi del Bernini in S. Pietro in Vaticano*, Rome, 1942; R. Wittkower, *Gian Lorenzo Bernini: The Sculptor of the Roman Baroque*, 3rd rev. ed., Oxford, 1981, p. 229; M. Worsdale, in *Bernini in Vaticano* (exhib. cat.), Rome, 1981, no. 274, pp. 270–71.

Comparative work cited: I. Lavin, "Bernini's Death," in *The Art Bulletin*, LIV, 1972.

THE
LIBRARY
MUSEUMS

BIBLIOTECA APOSTOLICA VATICANA

From its very beginning, the Apostolic See amassed an extensive assortment of books and archives about which early documentation is quite scarce. Many times scattered, the collections took years to build up again. The modern Biblioteca Vaticana, heir to the ancient papal libraries, dates to the fifteenth century—more precisely, to the pontificate of the humanist pope Nicholas V (1447–55), an impassioned collector of ancient texts, who, at his death, left more than 1,500 manuscripts, many of which he had had copied in the famous Florentine workshop of Vespasiano da Bisticci. Already, at that time, the library of Nicholas V was the greatest in Europe. Even though partly dispersed, it forms the nucleus of the present Vatican Library.

It was Sixtus IV (1471–84), however, who was the library's true founder, and his papal bull of June 15, 1475, "Ad decorem militantis Ecclesiae," established its functions: "for the promotion of the Catholic faith, for the use of scholars and for the renown of the Roman Pontiff." The pope personally endowed the newly created institution, and named as its librarian the humanist Bartolomeo Sacchi, best known as Platina. The library was assigned four rooms on the ground floor of the palace of Nicholas V. In a fresco now in the Pinacoteca Vaticana, Melozzo da Forlì immortalized Platina's nomination (fig. 26). The librarian kneels before the enthroned pontiff, who is surrounded by his relatives, including Giuliano della Rovere, the future Pope Julius II (1503–13).

The library remained in this location for more than a century. Its burgeoning collections necessitated transfer to a new home, which Sixtus V (1585–90) had the palace architect, Domenico Fontana (fig. 27), build, across from the Cortile del Belvedere, along the wide stairway leading to the Cortile della Pigna. The library has since expanded, first into the west wing that encloses the Cortile del Belvedere, begun in the time of Pius IV (1560–65), and, later, into the facing wing. Transferred to the area immediately below this by Leo XIII (1878–1903) and modernized by Pius XI (1922–39), who had been its prefect, the library gained four floors of storage space through the efforts of Paul VI (1963–78). Preparations for additional space recently have begun.

The Biblioteca Apostolica Vaticana currently houses more than 70,000 volumes of manuscripts, 100,000 individual autographs, about 7,000 incunabula and one million volumes printed later, 100,000 engravings and maps, thousands of parchments, and tens of thousands of archival volumes and files. This immense bibliographic resource is always available to scholars, who come from all over the world to draw upon it (fig. 29).

The magnificently frescoed Salone Sistino and the two galleries leading from it, for some time, have been of the most conspicuous artistic interest in the library, and are open to all visitors to the Vatican Museums. Among the works of art in these rooms are busts and statues of the Roman period, papal busts, terracotta models, and the Treasury of the Sancta Sanctorum, a group of precious objects from the Early Middle Ages. Globes and scientific instruments shown here include two large planispheres; one of them, the work of Girolamo da Verrazzano, brother of Giovanni, contains the first depiction of the Atlantic coast of North America. There are textiles and vestments dating back to the earliest centuries of the Church, liturgical objects, and an array of gifts sent to the popes over the course of the last two centuries by world leaders and dignitaries. There is no lack of instructive curiosities, as, for instance, the very strange-looking machine invented by Bramante to stamp documents with the papal bull, or the more recently added fragments of lunar rock that commemorate Apollo XI's voyage to the moon.

The artistic strengths of the Biblioteca Vaticana, however, are found in the Museo Sacro and the Museo Profano, the first museums in the Vatican opened to the public, and the core around which the imposing complex of Vatican Museums, as they exist today, was gradually formed.

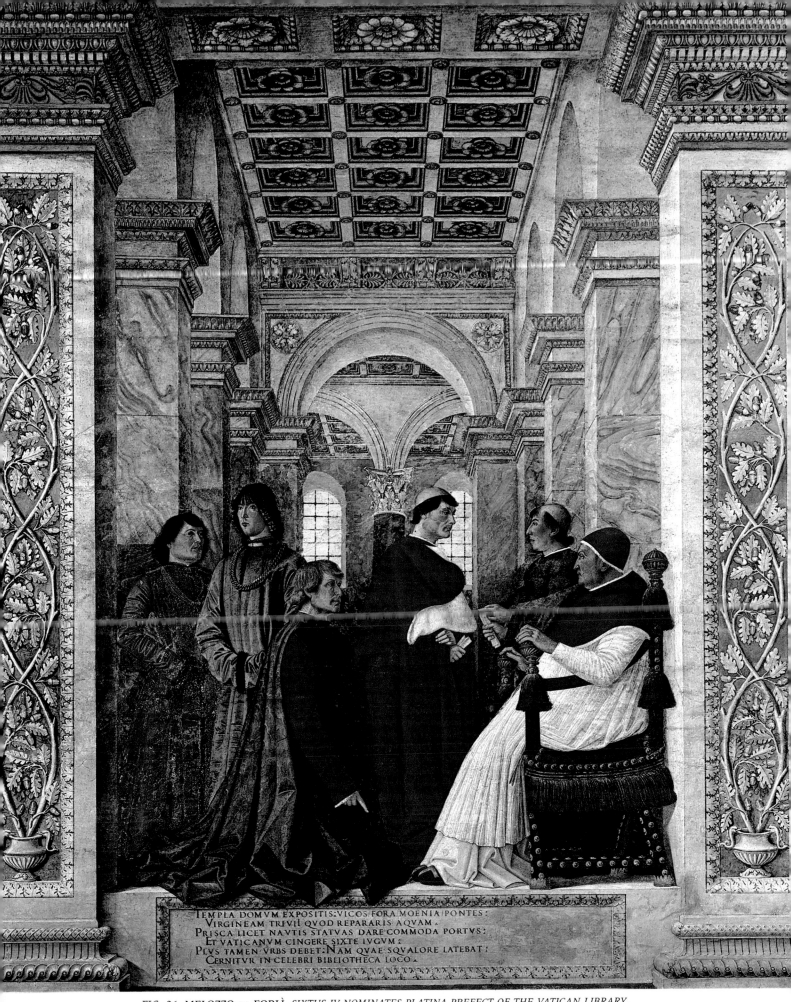

FIG. 26. MELOZZO DA FORLÌ. *SIXTUS IV NOMINATES PLATINA PREFECT OF THE VATICAN LIBRARY.*
FRESCO. 1475–77. PINACOTECA (ORIGINALLY IN THE LIBRARY OF SIXTUS IV)

MUSEO SACRO

The custom of keeping works of art and antiquities in libraries, alongside books and manuscripts, goes very far back in time. So it was at the Vatican. Marble statues, among them the famous *Hippolytus*, adorned the Salone Sistino almost from the date of its construction. Mainly for decorative purposes, a number of ancient vases were soon lined up along the shelves containing manuscripts. Collections of coins and medals, astronomical instruments, and the gleanings of naturalists—even a botanical garden—were all housed in the library at one time or another.

The formation of a proper museum did not occur until the pontificate of Benedict XIV (1740–58), who founded the Museo Sacro (fig. 28), or, more accurately, the Museo Cristiano, in the Vatican Library. Illustrious precedents were not lacking; there was the "Metallotheca Vaticana," one of the first and most extensive collections of natural history specimens, scientifically catalogued by the papal physician Michele Mercati and exhibited by order of Saint Pius V (1566–72) in several rooms near the palace of Innocent VIII, later occupied by the Museo Pio-Clementino. There was also the Museo Ecclesiastico of Clement XI (1700–1721), created to house the collection of Roman and Christian antiquities assembled by Francesco Bianchini but dissolved shortly thereafter. These collections were substantially different in character from the semiprivate ones formed by Julius II, or from the coins and objects garnered by Marcellus II (1555), for example.

The grand collections of antiquities for which Renaissance Rome was celebrated grew in importance during the seventeenth century, through the efforts of the princes and cardinals of the new papal families—chiefly the Barberini, Chigi, and Albani. In the eighteenth century, the extraordinary passion for excavations and epigraphical studies, characteristic Roman pursuits of the day, gave rise to important archaeological discoveries and the exploration of the catacombs. Aside from officially authorized excavations, others were initiated by private citizens motivated by the widespread enthusiasm for collecting and, especially, by the demand for antiquities on the international market. Many of the discoveries were dispersed throughout Europe, despite the existence of laws designed to stem the outflow of art objects. These laws were renewed and toughened by the popes during the eighteenth century, but with little effect.

The prevailing attitude toward collecting focused not so much on the aesthetic merits of an object as on its documentary value. Museums were seen as a check on the dispersal of such a heritage of documentation, whereby the objects would be preserved for present and future study. This explains the particular care taken in assembling the host of Early Christian inscriptions and memorials that came to light when the catacombs were excavated, for they testified eloquently to the examples of the martyrs.

The papacy of Benedict XIV—friend to scholars and a dedicated scholar, himself—provided the ideal atmosphere for realizing the cherished project of a Museo Cristiano. Benedict recognized it as a necessity, and "a work worthy of a pope and of Rome." A museum of sacred antiquities that would be a counterpart to the secular holdings of the museums of the Campidoglio was supported by archaeologists and cultivated amateurs such as Scipione Maffei, Giuseppe Bianchini, and Giovanni Bottari, the Vatican librarian. As the Oratorian monk Bianchini urged the pope: "In the museum founded by you, Most Blessed Father, by figuring the terms of the consuls whose names are registered on the tombs of many martyrs, we could count the persecutions of the Caesars; so that for the first five centuries of the Christian era, we shall proceed with uncertainty no more, as formerly, but on an easy road, smoothed by the gravestones of the ancient Christians."

Bottari outlined a program, observing that once all the remains were assembled the result would be "one of the most sumptuous Museums of Christian erudition—which, were it to be enriched by all the instruments of the martyrdoms, all the lanterns, the glassware, a hundredfold of terracotta seals, the vases, tools, and utensils without number . . . would be one of the great wonders of the world." He then proposed to

FIG. 27. *DOMENICO FONTANA PRESENTING HIS PLAN FOR THE NEW LIBRARY TO SIXTUS V.* OIL ON CANVAS. SALA SISTINA (BUILT IN 1587–89, AFTER FONTANA'S DESIGN), VATICAN LIBRARY

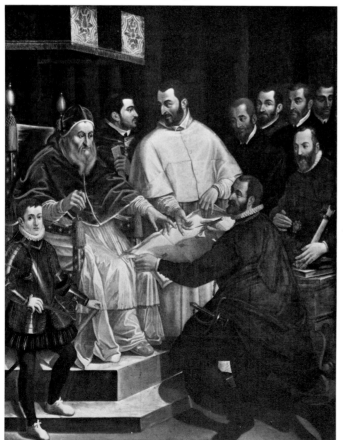

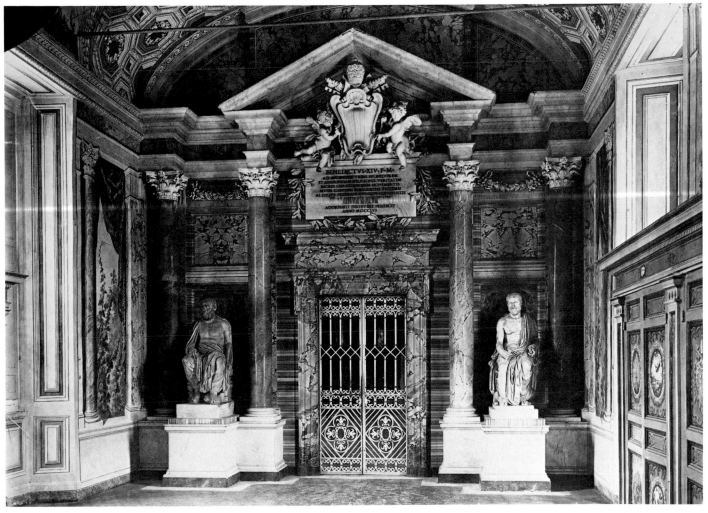

FIG. 28. ENTRANCE TO THE MUSEO SACRO. THE DOOR IS FLANKED BY ANCIENT STATUES AND SURMOUNTED BY THE COAT OF ARMS OF BENEDICT XIV; THE INSCRIPTION OVER THE DOOR RECORDS THE MUSEUM'S OPENING DATE (1756) AND ITS FUNCTION OF PRESERVING RELICS OF THE CHRISTIAN PAST

install the new museum in a stable and secure place, spacious and easy of access, as in one of those endless corridors in the Vatican Palace, precisely "that vast one in front of the great Library."

The pope, who, at first, had thought of setting up this museum on the Campidoglio—where he had already organized a paintings gallery and had increased, considerably, the existing collections of antiquities—acceded to Bottari's suggestions. He decided to create a museum in a space fashioned at one end of the Gallery of Urban VIII in the Vatican Library, which previously had housed such notable antiquities as the famous Albani Collection of medallions, bought in 1738 by Clement XII (1730–40), and the Etruscan vases of Cardinal Filippo Antonio Gualterio.

In 1741, the library was further enriched with the important collection of Cardinal Gaspare di Carpegna, who had been Vicar of Rome from 1671 to 1714. The collection included funerary lamps and other objects from the catacombs; coins and medals; countless Roman vases, busts, and statues; as well as paintings and drawings by major artists. To the same period dates the acquisition of the lead seals collected by Francesco Ficoroni, a dealer famous in his day, and the casts with the impressions of more than 6,500 cameos, owned by

the painter and architect Pier Leone Ghezzi. The papal coins collected by Saverio Scilla and the gold glass that once belonged to Senator Filippo Buonarroti further augmented this antiquarian assemblage, which was added to by papal purchases and gifts. The whole was installed in the northern wing of the library, facing the Belvedere, completed by Clement XII and referred to as the "Museo Vaticano" in contemporary documents, as well as in a large dedicatory inscription placed there in 1749.

The arrival of another collection, that of Francesco Vettori, containing clay lamps, cameos, coins, seals, weights and rings, gold glass, images of Christ in various materials, and other sacred antiquities, hastened the construction deadline for the new museum, for whose embellishment Pope Benedict XIV hired the best-known artists of the day. The entrance was ennobled by the palace architect Paolo Posi's theatrical perspective of marble columns, at the center of which was the papal coat of arms, flanked by ancient statues. Stefano Pozzi decorated the ceiling of the room with images of Faith and the Church Triumphant. Along the walls were ranged twenty massive walnut bookcases with gilt-bronze mounts, made especially for the occasion. Later on, the bookcases were crowned with small bronze busts of the first twenty-four

cardinal-librarians, the work of Luigi Valadier.

On October 4, 1757, with the publication of his apostolic letter "Ad optimarum artium," Benedict XIV decreed the opening of the Vatican Museums for "publico Litteratorum commodo." A few days earlier, he had named Vettori as their "prefect and curator for life."

Many more objects were to enrich the museum, among them, gold glass from the Chigi Collection; the antiquities collected by Gori of Florence, including important ivory diptychs; inscriptions and tombstones gathered from all over Rome by Giuseppe Bianchini; and a number of Early Christian sarcophagi removed from churches, convents, and villas, and later restored by the sculptor Bartolomeo Cavaceppi. The majority of the inscriptions and reliefs were framed and then walled in above the bookcases. These stone slabs became a special form of decoration, cut, as they were, from sarcophagi, and exhibited in a strictly symmetrical way. Unfortunately, this display necessitated dividing up monuments, assembling others out of sections from different objects, and even filling in missing pieces, making identification of the original works of art virtually impossible.

Vettori went on adding new collections, including that of Giuseppe Simone Assemani, who had been the library's *primo custode*, or first keeper. A major addition, it comprised sacred antiquities, many of Eastern origin.

Further gains were made by Benedict's successors. Under Pius VII (1800–1823), paintings with religious subjects, from the collection of the lawyer Agostino Mariotti, were added (1820). The pontificate of Gregory XVI (1831–46) saw the arrival of several collections, notably the gems belonging to Cardinal Zurla, and ancient Near Eastern seals carved in precious stones, given by the Polish Jesuit missionary Massimiliano Ryllo, upon his return from Persia. There were also direct purchases. The paintings collection grew steadily, on the initiative of Monsignor Gabriele Laureani, another *primo custode*, who added altarpieces from churches and convents in the papal states.

The excavations in the catacombs continued, systematically, to yield up their treasures during the lengthy reign of Pius IX (1846–78), founder of the Pontificia Commissione per l'Archeologia Sacra. Meanwhile, the archaeologist Giovanni Battista De Rossi, Prefect of the Museo Cristiano, reorganized the contents of the museum according to an updated cataloguing system.

Leo XIII institutionalized the policy of transferring gifts offered to the pope to the library museums.

It was under Saint Pius X (1903–14) that the Museo Sacro was endowed with the incomparable Treasury of the Sancta Sanctorum, a unique concentration of Early Christian objects. Discovered in 1903 in a large cypress chest within the altar of the Lateran Oratory of San Lorenzo, at the top of the Scala Santa, the Treasury consists of reliquaries, ivories, enamels, textiles (see cat. nos. 37–39), and liturgical vestments, some dating to the first centuries. Also found in the Treasury were the "brandea," or strips of linen, that were especially revered for having touched the bodies of the martyrs persecuted by the Romans. Transferred in 1906 to the Vatican, the Treasury was not exhibited publicly until 1934,

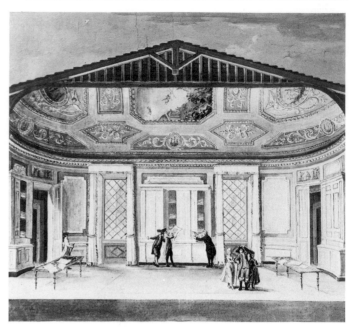

FIG. 29. UNKNOWN PAINTER. *VISITORS CONSULTING PRINTS IN THE SALA DELLE STAMPE OF THE VATICAN LIBRARY.* FRESCO. C. 1780–81. APARTMENT OF CARDINAL ZELADA (NOW THE MUSEO GREGORIANO ETRUSCO)

in the reign of Pius XI. At his urging, a total reorganization of the much-expanded Museo Sacro was undertaken in 1937. From 1964, the Treasury of the Sancta Sanctorum has been displayed in the chapel of Saint Pius V, an elegant space that had been frescoed by Giorgio Vasari and his assistants with scenes from the life of Saint Peter Martyr.

There are two other areas of exceptional interest in the Museo Sacro. Under Clement XIV (1769–74), a new room, the Gabinetto dei Papiri, was planned by the Cardinal-Librarian Alessandro Albani to display the papyrus scrolls from Ravenna, dating from the sixth to the ninth century. The decoration was completed during the papacy of Pius VI (1775–99), as was that of the contemporaneous Museo Profano. The ceiling by Anton Raphael Mengs is a fine display of neoclassical allegory: History leans upon a defeated Time, while Fame sounds the trumpet and indicates the door to the "Museo Clementinum." Today, the scrolls are stored in the library proper, and the gallery contains the collection of gold glass from the catacombs.

From the Gabinetto dei Papiri, one enters the noble Sala delle Nozze Aldobrandine, named after a Roman fresco that was found on the Aventine in the early seventeenth century—and which has become world famous as *The Aldobrandini Wedding*—showing the preparations for a nuptial ceremony. Pius VI acquired it from the Aldobrandini estate and, at first, placed it in the Borgia Apartment. The Sala delle Nozze Aldobrandine, to which Gregory XVI had the fresco moved in 1838, dates to the time of Paul V (1605–21). Its ceiling is frescoed with episodes from the life of Samson, by Guido Reni, and among the Roman frescoes in the room is the *Eroine di Tor Marancia*, discovered in a house near the Porta San Sebastiano in 1816. Pius IX added a group of frescoed scenes from the *Odyssey* in 1853 and other ancient paintings and mosaics.

MUSEO PROFANO

Even after the founding of the Museo Sacro, works of art continued to be exhibited in other parts of the Vatican Library. For example, most of the Carpegna Collection of cameos, ivories, and bronzes never became part of the Museo Sacro, but was shown instead, along with the Albani medallions, in the Galleria Clementina, in the north wing of the library, near the Cortile della Pigna.

The Museo Profano was organized under Clement XIII (1758–69) in a space that was created by closing off some arches overlooking the Cortile della Pigna. The walls and pavement were inlaid with a profusion of costly marbles, and the ceiling was frescoed also by Pozzi, with an allegory of the Spirit of Rome wresting some ancient relics from the hands of Time. Niches beside the entrances were designed to hold busts of the orators and philosophers of antiquity; today, they contain bronze heads of the emperors Augustus, Nero, and Septimius Severus, and of the consul Caelius Balbinus. Along the side are two large cabinets with marble shelves and doors of gilt glass. There were two other elegant cabinets: one, of Indian Ficus wood, the gift of Cardinal Albani, was filled with medals; the other, lined in yellow Portuguese wood, was surmounted with metal and stone busts and statuettes. Mosaics with turquoise backgrounds, found at Herculaneum, were set above the cabinets. Today, the mosaics are gone, but a fresco of the Museo Profano, in the apartment of Cardinal Zelada—now the Museo Gregoriano Etrusco—provides a clue to their appearance.

Above the door in the Museo Profano is the coat of arms of Clement XIII, inscribed with the name of the pope and the date, 1767, when the museum was founded—the result of the efforts of Cardinal Albani, the passionate connoisseur and Vatican librarian, who was responsible for naming the renowned archaeologist J. J. Winckelmann as its first curator.

Another inscription, in bronze, commemorates Pius VI, to whom we owe the appearance of the room as it is now. He had the old iron doors of the large cabinets replaced with the present ones, which bear his arms in gilt bronze, and he commissioned Andrea Mimmi to build four new cabinets, based on designs by Luigi Valadier, using precious woods that, originally, had been brought from Brazil to decorate the Sacristy of Saint Peter's. A signal accomplishment of Pius VI—one that gives the Museo Profano much of its present luster—was to put Valadier, a splendid silversmith, in charge of refashioning the mountings of the cameos and hard-stones. In 1779, Valadier was made "Superintendent for the restoration of the ancient bronzes and the mounting of cameos in both the Museo Sacro and the Museo Profano," and he took full advantage of the opportunity to create totally new works of art. He had the largest cameos framed in gold and silver, flanked by statuettes and colonnettes, and studded with gems, lesser cameos, gold medallions, and various friezes, combining the ancient and the modern. They were set upon pedestals and bases of precious marbles. Smaller cameos were grouped in twos and threes on metal pedestals, with a correspondingly less sumptuous treatment.

Ivory carvings and rock crystals, previously in the Carpegna Collection, were incorporated into the doors of the large cabinets. Many of the ivories, in order to fit, were cut up and resectioned, making identification of the originals rather difficult.

Luigi Valadier was succeeded by his son Giuseppe, a well-known architect and the designer of several study cabinets for coins. It was his special task to mount the large Hellenistic cameo that had belonged to the Gonzaga and then to Queen Christina of Sweden, and which Pius VI had bought in 1794 from Prince Odescalchi for 20,000 scudi.

Unfortunately, most of these glorious objects were dispersed, together with the medals collection, when the Vatican Library was sacked by General Berthier and his officers during the French occupation of Rome in 1797. Other treasures, such as the famous Albani medallions, were transferred to Paris, under the terms of the infamous Treaty of Tolentino (1797)—never to return. The engravings commissioned by Pius VI from the Calcografia Camerale in 1784 are a pale reminder of the Museo Profano's original holdings; the 250 prints reproduce more than 585 objects, of which at least 200 are cameos with their special mounts.

Despite the greed of the invaders, many treasures escaped the pillaging because they were hidden or stored elsewhere. Remaining in the Museo Sacro were hard-stone and marble busts and reliefs, bronze statuettes, and, above all, those objects that were incorporated in the cabinet doors. Little else was returned after Napoleon's fall and its aftermath, so that the Museo Profano has not regained its former splendor. The Museo Sacro has, however, expanded beyond the limits implied by its name, its collections encompassing objects and antiquities of a more varied character and origin.

Giovanni Morello

BIBLIOGRAPHY: S. Le Grelle, "Saggio storico delle collezioni numismatiche vaticane," in C. Serafini, Le monete e le bolle plumbee pontificie del Medagliere Vaticano . . . , Milan, 1910; idem, Monumenti Musei e Gallerie Pontificie, V, Guida alle Gallerie di Pittura, Rome, 1925; C. Pietrangeli, "Il Museo Clementino Vaticano," in Rendiconti della Pontificia Accademia Romana di Archeologia, XXVII, 1951–52, pp. 87–109; R. Righetti, "Le Opere di glittica dei Musei annessi alla Biblioteca Vaticana," in Rendiconti della Pontificia Accademia Romana di Archeologia, XVIII, 1955–56, pp. 279–348; C. Pietrangeli, "I Musei Vaticani al tempo di Pio VI," in Bollettino dei Monumenti Musei e Gallerie Pontificie, I, 2, 1959–74, pp. 7–45; J. Ruysschaert, "The Apostolic Vatican Library," in The Vatican and Christian Rome, Vatican City, 1975, pp. 307–33; G. Daltrop and A. Prandi, in Art Treasures of the Vatican Library, New York, n.d.; G. Morello, "Il Museo 'Cristiano' di Benedetto XIV," in Bollettino dei Monumenti Musei e Gallerie Pontificie, II, 1981, pp. 53–89.

CAPSELLA AFRICANA

Early Christian, late 5th–early 6th century
Silver
Height, 4 ⅜" (10.7 cm); length, 6 ⁷⁄₁₆" (16.3 cm);
* width, 2 ¹⁵⁄₁₆" (7.5 cm)*
Biblioteca Apostolica Vaticana, Museo Sacro, Inv.
* no. 859*

On the domical lid of this oval reliquary casket, a saint holds a laurel wreath of martyrdom, as the hand of God appears from the clouds above to place another wreath on his head. Two tall candelabra with flaming candles flank the martyr, who stands on terraced ground from which flow the four rivers of Paradise. The sides of the reliquary are decorated with imagery symbolizing salvation through Christ. The principal scene shows the Lamb of God, with a cross that seems to rise from behind his back, approached on either side by four lambs—representing the apostles—emerging from the portals of two arcaded basilicas, behind which are palm trees. On the other side of the casket, a stag and a doe crouch to drink from the four rivers of Paradise (a reference to Psalm 42:1), which issue from beneath the cruciform monogram of Christ. The three scenes are bordered by bands of laurel wreaths. The base is a modern replacement.

The reliquary was found in 1884 in the ruins of a small church at Henchir Zirara, near Aïn-Beida, in Algeria—one and one-half meters (about five feet) below the pavement, at the north corner of the apse—according to a report prepared a few years later and published by Giovanni Battista De Rossi. The reliquary, originally, was housed in a wooden casket (which subsequently disintegrated) and set into an oval cavity carved in a large block of stone. De Rossi dated the building to the early sixth century, on the basis of the style of its architectural sculpture, but thought that the reliquary had been made in the fifth century.

Paradisaic imagery, like that on the capsella, is widespread in Early Christian art, particularly in monumental church and funerary decorative programs. Certain aspects of the reliquary, however, betray its North African origins, especially the blazing candles flanking the saint, and the basilicas from which the lambs emerge, the forms of which resemble that of the basilica on a mosaic pavement in a church at Tabarka, in Tunisia, of about A.D. 400.

The capsella's reliefs are executed with verve and ease, but without proper attention to stylistic details. For example, the martyr's hands are disproportionate, and the ornamental edging of the robes is incomplete. In the scene with the Lamb of God, the artist apparently ran out of space and, awkwardly, had to squeeze in the last lamb but one, on the right.

The absence of comparative material makes it difficult to date the capsella with precision, but its style appears more in keeping with the early-sixth-century date of the basilica where it was found than with De Rossi's fifth-century date. The capsella lacks the elegant classicism and the refined finish of the fifth-century silver oval reliquary in the cathedral of Grado in North-

34

BOTTOM OF A DRINKING VESSEL, WITH PORTRAIT BUSTS OF A HUSBAND AND WIFE

Alexandria, first half of the 3rd century A.D.
Glass and gold foil
Diameter, 4 ¼" (10.8 cm)
Biblioteca Apostolica Vaticana, Museo Sacro, Inv.
* no. 743*

The disk containing the portraits and the inscription is intact; its periphery and part of the rim on the underside—which, originally, formed the foot of the vessel—are fragmentary. There is some discoloration, mostly around the border.

The husband and wife are portrayed frontally before a parapet. She wears a tunic and a palla knotted at the breast, while he is dressed in a tunic and pallium from which his right hand, posed in a gesture of speech, emerges. The woman's hair is parted in the middle, drawn back loosely over her ears and gathered at the nape of her neck. The husband has short hair and a close-clipped moustache. Just within the band surrounding the portrait, at the top, is the Latin inscription GREGO RIBIBE[E]TPROPINATVIS •, which Georg Daltrop and Adriano Prandi read as "Gregori bibe [e]t propina tuis" ("Gregory, drink and drink to thine").

The details of the costumes and coiffures, and the naturalistic, classicizing style of this double portrait, are extremely close to those of the "gold-glass" portrait in the center of the third-century gemmed cross in the Museo Civico in Brescia, thus suggesting a comparable third-century date for the Vatican example. This medallion is one of the finest extant in the "brushed technique," in which the shadows producing the modeling are made by a moderately stiff brush. The technique, which was reserved for portraits, is thought to exemplify Alexandrian workmanship, either as practiced in Egypt or by immigrant artists living in Rome.

"Gold glass" was made by attaching a gold-leaf silhouette to a background of clear or blue glass by means of a transparent glue—sometimes honey—and then scratching the design into the gold leaf with a needle. A second piece of glass was then fused over the top to protect the work. Fragments of gold-glass drinking vessels frequently marked specific tombs in the catacombs. Most scholars believe that the vessels were used by the deceased during his lifetime, rather than having been made for funerary purposes. This piece obviously celebrated the marriage or anniversary of the couple. It was found attached to a tile, in the Catacomb of Pamphilus, on May 31, 1926.

K. R. B.

BIBLIOGRAPHY: G. Daltrop, in *Art Treasures of the Vatican Library*, New York, n.d., pp. 48, 168, no. 37, colorplate p. 53.

ern Italy (H. Buschhausen, 1971, B.18). Rather, the treatment of the eyes, hair, and drapery of the martyr seems closer to that of the figures on a silver reliquary from the Chersonese (now in the Hermitage in Leningrad), dated by control stamps to the reign of Justinian I (527–65) (H. Buschhausen, 1971, B.21).

M. E. F.

BIBLIOGRAPHY: G.-B. De Rossi, "La capsella d'argent africaine," in *Bulletin monumental*, 55, 1889, pp. 315–97; H. Buschhausen, *Die spätrömischen Metallscrinia und frühchristlichen Reliquiare*, Vienna, 1971, pp. 242–43, B.15; G. Daltrop, in *Art Treasures of the Vatican Library*, New York, n.d., pp. 64, 170, nos. 60–61, ills. pp. 70, 71.

36

RELIQUARY, FOR THE HEAD OF SAINT SEBASTIAN

Rome, 7th–9th century
Silver, with partial gilding, and niello
Height, 7 11/16" (19.5 cm); diameter, 8 1/16" (20.5 cm);
thickness of silver, c. 1/8" (c. 3 mm)
Biblioteca Apostolica Vaticana, Museo Sacro,
Inv. no. 864

The reliquary is composed of a shallow silver bowl, raised on a tall base, with a domical lid crowned by a finial, whose topmost element has broken away. The bowl has a wide flange decorated with raised ridges into which the smaller flange of the lid fits securely. The lid's flange is pierced by four square and four circular holes, the latter corresponding to holes in the flange of the bowl, which were used for securing the lid at different times in its history. Stylized large and small acanthus leaves in low relief decorate

the bowl's exterior. On the lid, larger palmettes, inlaid in niello, alternate with smaller palmettes embellished in gilt. Inside, niello and gilt medallions of abstract designs surround a rosette (lid) and a Latin monogram (bowl) that has been variously read as "Adeodatus" or, most recently, by Ernst Kitzinger, as "Pantaleon." The shallow knop of the base is inscribed in niello: ADDECORE̅[M] CAPITIS BEATI SEBASTIANI GRE̅G[ORIUS] IIII EP̅IS[COPUS] OP[US] F[ECIT] (Bishop Gregory IV made the work to adorn the head of Saint Sebastian).

Early in his reign, Pope Gregory IV (827–44) transferred Saint Sebastian's relics from the cemetery of the same name on the Via Appia to an altar in the pope's newly constructed Oratory of Saint Gregory the Great at Saint Peter's basilica (*Le Liber Pontificalis*, II, ed. L. Duchesne, 1886–92, p. 74). He seems to have separated the head from the other relics and placed it in the silver

bowl, just as Pope Paschal I (817–24), his predecessor, put the head of Saint Cecilia in an *arcella* when her body was brought from its Roman catacomb to the church in Trastevere that bears her name (*Le Liber Pontificalis*, op. cit., pp. 58–60). The ciborium shape of the bowl-*cum*-reliquary curiously anticipates a reliquary form that was to become very popular in Europe from the twelfth century on. Shortly after Gregory's translation of Saint Sebastian's relics to Saint Peter's, Leo IV (847–55) brought the head in its silver reliquary to Santi Quattro Coronati in Rome, his former titular church, and, with the relics of numerous other saints, including the head of Saint Cecilia, he filled four urns, which were immured in the crypt below the main altar (*Le Liber Pontificalis*, op. cit., p. 116).

For his reliquary, Gregory IV reused an earlier silver bowl that was made for the man whose monogram decorates its interior. It is usually dated sometime in the sixth or the seventh century. The bowl's shape, thick walls, and mode of decoration derived from such Late Roman and Early Byzantine covered silver bowls as the fourth-century example from the Mildenhall treasure (found in Suffolk, England) and an early-fifth-century one from Carthage, both in the British Museum, and a fragmentary seventh-century monogrammed bowl in the Musée d'Art et d'Histoire in Geneva. The reliquary's shallow, refined acanthus forms were also popular on sixth-century silver plates, such as one with a grazing horse in the Hermitage. The tightly regularized pattern of acanthus leaves and palmettes, however, and the way in which the bowl's framing lines consistently cut off the tips of the leaves, as well as the alternating niello and silver gilt of the palmettes on the lid—although this niello may have been added by Gregory IV when he converted the bowl to a reliquary—point to an early medieval date, perhaps even in the eighth century.

M. E. F.

BIBLIOGRAPHY: P. Liebaert, "Le reliquaire du chef de Saint Sébastien," in *Mélanges d'archéologie et d'histoire*, XXXIII, 1913, pp. 479–92; W. F. Volbach, "Reliquie e reliquiari orientali in Roma," in *Bollettino d'Arte*, 30, 1937, pp. 337–50; J. Braun, *Die Reliquiare des christlichen Kultes und ihre Entwicklung*, Freiburg im Breisgau, 1940, pp. 225–26; G. Daltrop, in *Art Treasures of the Vatican Library*, New York, n.d., pp. 64, 170, no. 62, ill. p. 70.

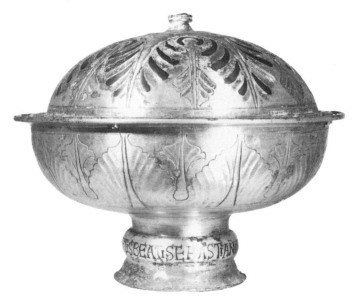

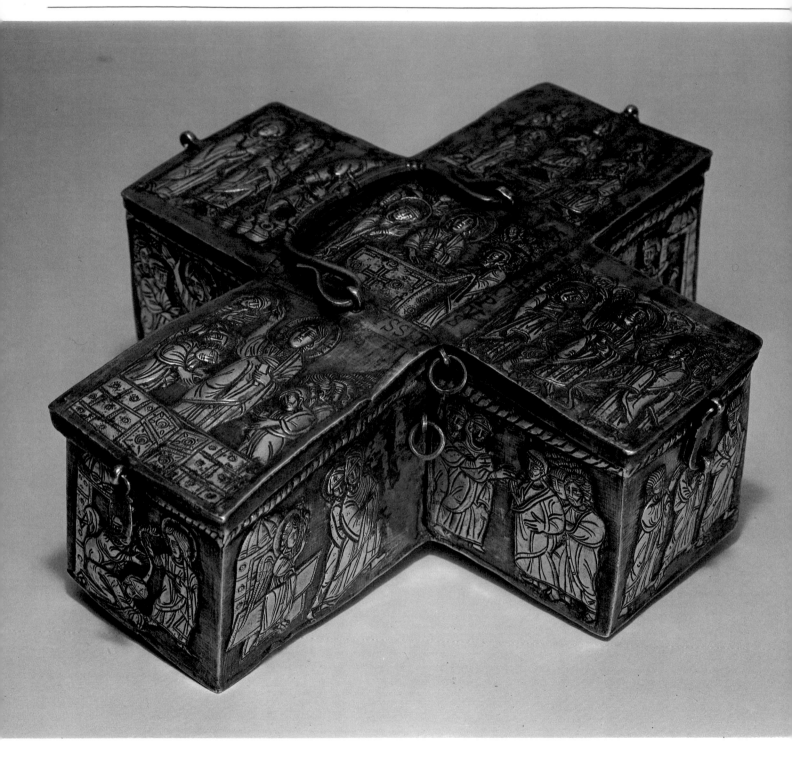

37

CASKET, FOR A RELIQUARY OF THE TRUE CROSS

Rome, 817–24
Silver, with partial gilding, and niello
Length, 11 ⅝" (29.5 cm); width, 9 ⅞" (25 cm);
height, c. 3 ⅞" (c. 9.8–10 cm); thickness of silver,
c. ¹/₁₆" (c. 1.5 mm)
Biblioteca Apostolica Vaticana, Museo Sacro, Inv.
no. 985

This cross-shaped casket once held a richly gemmed gold cross that contained particles of the True Cross of Christ and probably also of the Christ Child's umbilicus and preputium. It was made for Pope Paschal I (817–24), according to the niello inscription surrounding the central scene of the Communion of the Apostles on the lid: PASCHALIS EPISCOPVS PLEBI DEI FIERI IVSSIT. The casket and its cross were discovered early in this century with other relics and reliquaries in a cypress-wood chest that Pope Leo III (795–816) had placed in the main altar of the Oratory of San Lorenzo, the Sancta Sanctorum,

which served as the private chapel of the popes at the Palazzo Lateranense, their residence. The earliest reference to the silver casket occurs in the twelfth-century inventory of the oratory written by John the Deacon during the reign of Alexander III (1159–81); although without specific evidence, it has been suggested that the relic that it contained and the reliquary of the sandals of Christ (see cat. no. 39) were brought to a Church council at the Lateran, during the time of Nicholas I (858–67) (*Le Liber Pontificalis*, II, ed. L. Duchesne, 1886–92, p. 157).

The casket is made of thick sheets of silver

cut and soldered together and worked in repoussé on the lid and sides with scenes of events from the life of Christ. Christ among the Doctors (Luke 2:46), the Marriage at Cana (John 2:1), Christ's Mission to the Apostles (Matthew 28:16–20), and his appearance to the apostles after his resurrection (John 20:19–29) encircle the lid's central Communion scene. The sides are decorated with a cycle of events that followed Christ's resurrection, including the discovery of the empty tomb by the holy women (Matthew 28:1–10; John 20:1–12), Christ's appearance to the apostles at Emmaus, as well as other appearances to his apostles (Luke 24:36–50; John 20: 19–29)—beginning with an unusual scene that may depict Christ conducting Adam from Hades, as related in the Apocryphal Gospels. The emphasis on events after the Crucifixion is appropriate for a reliquary that contained the ''life-giving'' cross.

The figures on both the lid and the sides are of squat proportions, with large heads and conventional expressions. Whereas these stylistic traits may have resulted from working with such thick silver, they are characteristic of international ninth-century style, as reflected in such manuscripts as the *Sacra Parallela* (in the Bibliothèque Nationale in Paris, Gr. 923), formerly thought to be Roman but recently attributed to Palestine by Kurt Weitzmann. The style prevailed in Roman works, as well. For example, many of the drapery patterns on the reliquary—specifically, the deeply etched double-line folds over the legs—and the compositional convention of showing crowds by portraying only the first figure fully, the next partially, and the rest as tops of heads, are found in the mosaics made for Pope Paschal I at Santa Prassede and Santa Maria in Domnica in Rome.

The events depicted on the lid of this casket seem to have been chosen to honor the Virgin Mary. She played a prominent role in the Gospel accounts of Christ among the Doctors and the Marriage at Cana, and was present in the room through whose closed doors Christ appeared. She is, however, seldom, if ever, shown at the Communion or Mission of the Apostles, as she is depicted here, clearly singled out by Christ. If Pope Paschal I had this reliquary made for the Oratory of San Lorenzo at the Lateran, as is usually implied in the literature, the emphasis on the Virgin makes little sense. The casket would have been far more appropriate for one of the great churches dedicated to the Virgin in Rome—for example, Paschal's own foundation of Santa Maria in Domnica, or Santa Maria Maggiore—to which he gave generously during his pontificate (*Le Liber Pontificalis*, op. cit., pp. 60–63).

M. E. F.

BIBLIOGRAPHY: P. Lauer, *Le Trésor du Sancta Sanctorum* (Fondation Eugène Piot, *Monuments et Mémoires*, 15), 1906, pp. 49–59, 66–71; H. Grisar, *Die römische Kapelle Sancta Sanctorum und ihr Schatz*, Freiburg im Breisgau, 1908, pp. 62–80, 97–100; C. Cecchelli, ''Il tesoro del Laterano,'' in *Dedalo*, 1926–27, VII, pp. 146–54; V. Elbern, ''Rom und die karolingische Goldschmiedkunst,'' in *Roma e l'età carolingia*, Istituto di Storia dell'Arte dell'Università di Roma, Rome, 1976, pp. 345–55; A. Prandi, in *Art Treasures of the Vatican Library*, New York, n.d., pp. 171–72, nos. 70–74, ills. pp. 84, 85 (colorplate), 87–89; K. Weitzmann, *The Miniatures of the Sacra Parallela, Parisinus Graecus 923*, Princeton, 1979, pp. 17–18.

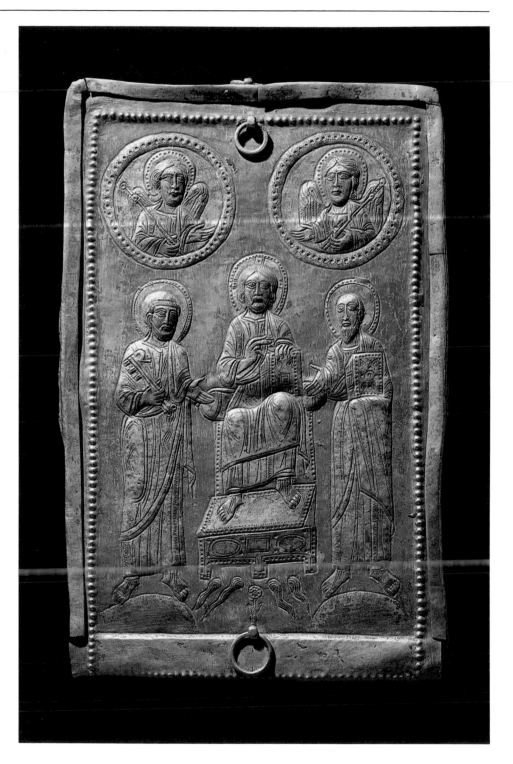

38

CASKET, FOR A RELIQUARY OF THE TRUE CROSS

Rome, 9th century
Silver gilt
Height, 11 ³/₁₆" (30 cm); width, top, 7 ³/₄" (19.7 cm); bottom, 8 ¼" (21 cm); depth, 2 ⁷/₁₆" (6.2 cm); thickness of silver, c. ¹/₁₆" (c. 1.5 mm)
Biblioteca Apostolica Vaticana, Museo Sacro, Inv. no. 1888

This casket, with the silver, cross-shaped reliquary displayed next to it (see cat. no. 37), was found early in this century in the chest in the main altar of the Sancta Sanctorum. John the Deacon, a twelfth-century witness, stated that the chest contained a silver reliquary with an enameled reliquary of the True Cross inside; both are now in the Museo Sacro.

On the lid of the casket is a representation of the enthroned Christ flanked by Saints Peter and Paul. From beneath the footstool of the throne flow the four rivers of Paradise on either side of a flower, symbolic of the paradisaic garden. Christ

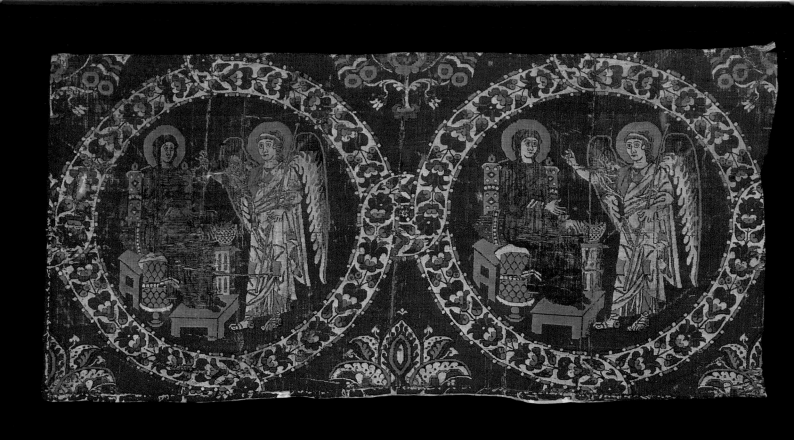

is adored by the two angels in medallions at the top.

The hieratic quality of the scene on the cover is echoed in the smaller panel with the symbols of the Evangelists flanking the Lamb of God on the front of the casket. In contrast to these, however, is the narrative character of the scenes from Christ's life that appear on the other three sides: the Annunciation, the Visitation, and the Nativity, on the right; the three Magi and a shepherd gazing at the star of Bethlehem, at the rear; and the Magi Bringing Gifts and the Presentation in the Temple(?), on the left. The scenes complement the more extensive Infancy cycle on the enameled reliquary cross.

Although the casket is not dated by an inscription, it most likely was made for Pope Paschal I (817–24). The enameled reliquary that it contained bears his inscription, as does the silver, cross-shaped casket (see cat. no. 37) to which it is closely related in figural style, material, and construction (both are made of two sheets of thick silver cut and bent to shape). The figures in each are stocky, their faces large and broad, and their draperies described by a limited number of double-line folds, with little attempt at variation in the height of the relief. The figures on the rectangular casket, however, are poorer in quality, and the artist less accomplished, although the caskets probably came from the same Roman workshop.

Despite the static execution of the rectangular casket, its hieratic display of figures is impressive, and the artistic vocabulary clearly

of the time of Pope Paschal I. Notwithstanding the ineptly foreshortened arms of the apostles who gesture to Christ, on the lid, in pose Peter and Paul distinctly resemble the same two apostles in Pope Paschal's mosaic in the apse of Santa Prassede in Rome.

More broadly interpreted, the scenes on the lid and on the front, in their retrospective canon, underscore the casket's position in the art of Carolingian Rome. Like the subjects of Paschal's mosaic cycles, they depend on Early Christian models. Christ flanked by the apostles to the Jews and the Gentiles, both of whom were martyred in Rome, was a dominant theme in Early Christian funerary art and in monumental apse compositions. The Lamb of God and the symbols of the apostles, moreover, appeared on the arch of triumph of more than one Early Christian basilica. Thus, this casket takes its place among the recorded works that bear witness to the conscious revival of Early Christian Rome in the late eighth and the ninth century.

M. E. F.

BIBLIOGRAPHY: P. Lauer, *Le Trésor du Sancta Sanctorum* (Fondation Eugène Piot, *Monuments et Mémoires*, 15), 1906, pp. 28, 60–66; H. Grisar, *Die römische Kapelle Sancta Sanctorum und ihr Schatz*, Freiburg im Breisgau, 1908, pp. 81–83; C. Cecchelli, "Il tesoro del Laterano," in *Dedalo*, 1926–27, VII, pp. 146–54; A. Prandi, in *Art Treasures of the Vatican Library*, New York, n.d., p. 173, nos. 78–81, ills. pp. 94, 95; V. Elbern, "Rom und die karolingische Goldschmiedkunst," in *Roma e l'età carolingia*, Istituto di Storia dell'Arte dell'Università di Roma, Rome, 1976, pp. 345–55.

39

THE ANNUNCIATION

Constantinople, 8th–early 9th century
Silk-compound twill
Height, 13 ¼" (33.7 cm); width, 27" (68.6 cm)
Biblioteca Apostolica Vaticana, Museo Sacro, Inv. no. 2446

The Annunciation to Mary appears twice, in repeat pattern, within beautifully designed medallions on this very fine and rare fragment of silk. The Archangel Gabriel approaches the Virgin, who sits on a jeweled throne flanked by baskets for the wool with which she was believed to have woven the veil of the temple in Jerusalem. The fabric lined the rectangular silver reliquary for the sandals of Christ (see cat. no. 37), one of the most precious relics of the Sancta Sanctorum at the Lateran in Rome, where the reliquary is recorded as early as the mid-ninth century.

The Annunciation, like a similar silk fragment depicting the Nativity, also from the Sancta Sanctorum, was probably cut from fabric imported from Constantinople and used for one of the hundreds of curtains that were given to Roman churches by the popes during the eighth and ninth centuries, as recorded in the *Liber Pontificalis*. One of these curtains, with a medallion of the Nativity comparable in size to that of *The Annunciation* silk, was illustrated in the fres-

coes that Pope John VII (705–7) had painted in the church of Santa Maria Antiqua in the Roman Forum.

The richness and complexity of the design and coloration of *The Annunciation* place it in the forefront of a group of highly prized decorative silks, many with secular subjects, that survive because they were used in Western medieval churches to wrap relics. In style, it is particularly close to a group of silks recently dated to the ninth century, including a fragment with two warriors in the Abegg-Stiftung Bern, in Riggisberg, Switzerland. The figures have broad faces and large eyes set high in their foreheads, with big, round, black pupils that appear to be suspended from the upper eyelids. The figures' light brown hair is described by a limited number of repeated dark lines and swirls; the noses, seen in three-quarter view, have a curious sharp indentation to show—not very successfully—the shape of the nostrils; the hands are rendered expressively. The draperies are formed of strongly defined, broad folds; Gabriel's are animated by numerous gold patches.

The task of finding stylistic parallels to the Vatican silk outside the medium is rendered extremely difficult by the dearth of art that survived the proscription of religious imagery in the Byzantine world in the mid- to late eighth century, and, again, in the early to mid-ninth century. The full faces, with their prominent eyes, however, are characteristic of some late-eighth- and early-ninth-century icons recently discovered at the Monastery of Saint Catherine on Mount Sinai. The gold banding of the angel's robes is found in the frescoes at Santa Maria Foris Portas in Castelseprio in Northern Italy, probably of the eighth or ninth century, and in some Early Carolingian manuscripts. Finally, the facial features, drapery style, and, especially, the form of the hands and their gestures can be seen in late-ninth-century Byzantine art—as in the mosaics of Hagia Sophia in Thessalonike, which seem to reflect the style developed during the previous century.

M. E. F.

BIBLIOGRAPHY. A. Prandi, in *Art Treasures of the Vatican Library*, New York, n.d., pp. 104, 174, no. 94, colorplate p. 109; J. G. Beckwith, "Byzantine Tissues," in *Actes du XIVᵉ Congrès international des études byzantines*, Bucharest, 1971 (pub. 1974), pp. 343–53.

40

TRIPTYCH, WITH DEESIS AND SAINTS

Byzantine, late 10th–early 11th century
Ivory, partially painted and gilded
Closed: height, 9 ¹⁵⁄₁₆" (25.2 cm), width, 6 ⁹⁄₁₆"
(16.7 cm), depth, 1 ⅛" (2.9 cm); open: width,
13" (33 cm)
Biblioteca Apostolica Vaticana, Museo Sacro,
Inv. no. 2441

Christ sits on a richly jeweled throne, flanked by archangels, in the upper register of the triptych's central panel. The Virgin and Saint John the Baptist stand on either side of him and raise their hands in supplication, in a composition called a Deesis, which illustrates the prayers of intercession in the Byzantine liturgy. A frieze of apostles' busts divides the upper from the lower register, where five other apostles stand in various postures of speech and contemplation. Military, medical, and bishop saints and martyrs, shown full length or in bust medallions, are similarly

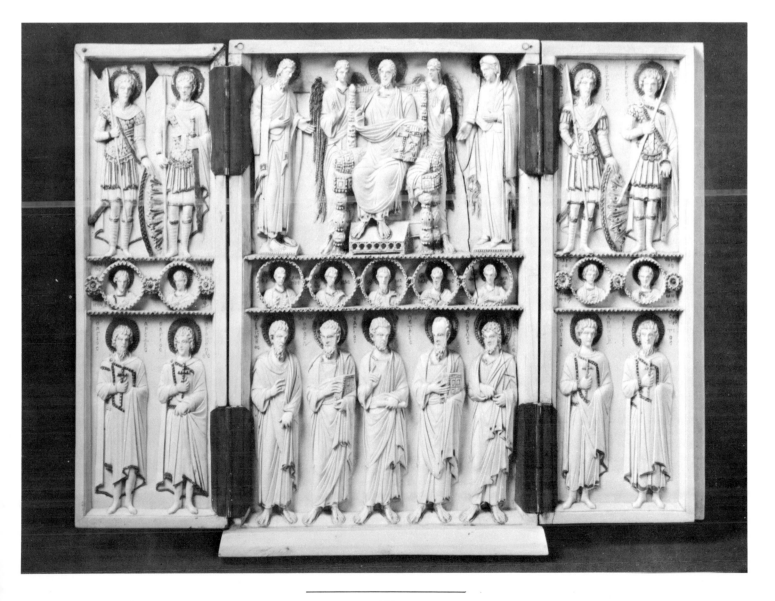

40 (back of central panel)

displayed on the two sides of the wings. A jeweled cross set in a vine scroll (both, partially painted and gilded) decorates the back of the central panel. Originally, the haloes, furniture, angels' wings, and the decorative jeweled and embroidered areas of the clothing also were gilt, and the incised inscriptions filled with red paint.

Parts of the backgrounds of the central and left panels, including the right arms of the Virgin and Saint John, the right angel's left wing, and the triptych's base and hinges, are replacements that were made before the first publication of the triptych in 1755, when the ivory belonged to Pope Benedict XIV (1740–58), who had acquired it from a collection in Todi, Italy.

The artist of this triptych sought to create a balance between reality and the spiritual world. He carved his figures in high relief, with exceptional skill and sensitivity (some, like Christ, the Virgin, and Saint John, are deeply undercut), in carefully differentiated poses and expressions. Yet, no two figures communicate directly with each other; the saints seem to contemplate privately the glory of Christ, and to reinforce the prayers of the Virgin and Saint John for the salvation of mankind—especially, for that of the triptych's owner. The jeweled cross in paradise, on the reverse, represents Christ's triumph over death, which opened the way for man's salvation.

Two other ivory triptychs of similar iconography and fine quality survive. One, of the second half of the eleventh century (in the Louvre), still has its original cornice and base; the other (in the Museo del Palazzo Venezia in Rome) bears inscriptions that probably refer to the Emperor Constantine VII Porphyrogenitos (912–59). Although the three triptychs do not seem to be copied one from the other, they clearly belong to a particular type of image that was suitable for imperial—or, at least, aristocratic—patrons. The Vatican triptych should be dated between the other two. Its figures are less realistically portrayed than those of the Palazzo Venezia ivory, yet its three-dimensional modeling still has a

subtlety that is lacking in the Louvre triptych. The faces and throats of the figures, for example, are carved with a feeling for the bone and muscle structure beneath the skin, as occurs on earlier tenth-century ivories, such as the paired apostles on plaques in Vienna, Dresden, and Venice. The figures on the triptych, however, are less volumetrically conceived than the apostles on these ivories, and seem to resemble works of the late tenth and early eleventh century in Byzantium—among them the miniature of Christ in a Gospel lectionary at Mount Sinai (Ms. 204, fol. 1 r.), and some standing saints in the Menologium of Basil II in the Vatican Library (Ms. gr. 185, pp. 124, 349, 424).

M. E. F.

BIBLIOGRAPHY: A. Goldschmidt and K. Weitzmann, *Die byzantinischen Elfenbeinskulpturen des X–XIII Jahrhunderts*, II, Berlin, 1934, no. 32, reprinted with a new foreword, Berlin, 1979; C. R. Morey, *Gli oggetti di avorio e di osso del Museo Sacro Vaticano. Catalogo del Museo Sacro Vaticano*, I, Vatican City, 1936, no. A 68; I. Kalavrezou-Maxeiner, "Eudokia Makrembolitissa and the Romanos Ivory," in *Dumbarton Oaks Papers*, 31, 1977, pp. 305–25.

41

SAINT THEODORE TYRO

Constantinople, first half of the 14th century
Miniature mosaic
Height, 5 ½" (14 cm); width, 2 ½" (6.4 cm)
Biblioteca Apostolica Vaticana, Museo Sacro,
* Inv. no. 1191*

Saint Theodore Tyro, one of the most popular military saints in Byzantium, is depicted in this small mosaic icon made of miniature cubes of glass, marble, and semiprecious stones, set in a wax base and framed and backed in wood. Originally, the frame was covered by a larger, probably ornamental, silver one. The saint, clothed in elaborate military costume that derives, ultimately, from Roman models, stands on a multicolored floor against a gilt background. His vermilion tunic and cuirass and his deep-emerald cloak are shot with gold, and his red trousers are decorated with light-green and gold zigzags, a color scheme repeated in the brightly colored halo and in the image's mosaic floor, patterned with crosses. His shoes are bound with white *fasciae*. A large, oblong shield is slung over his back, suspended from a white band that extends across his chest. He holds a silver-tipped spear in his right hand and, from under his cloak, he clutches the hilt of his sword with his left. The rich coloration of the mosaic is completed by a framing line of gold and white tesserae and by a black inscription in Greek identifying the saint. A later inscription on a metal plaque attached to the lower-right corner calls Theodore a general and a martyr.

Although there has been some loss of mosaic cubes in the cloak, hair, and beard, and in the background behind the saint's legs, the artistic delicacy and sensitivity of the icon shine forth. Saint Theodore's face, for example, is subtly modeled in beige and yellow tones, his cheeks, ears, and nostrils highlighted with rose pink. The virtuoso technique is also evidenced by the minute tesserae used to form the saint's neck.

The richness of the materials and the refine-

ment of the imagery are characteristic of the small body of miniature portable icons that survives. The earliest example dates from the eleventh century, but the majority seem to have been made in the thirteenth and fourteenth centuries. As Otto Demus has pointed out, the icons portray subjects that were appropriate to the Byzantine imperial court, such as Saint Theodore, who, together with Saints Demetrius, George, and Theodore Stratelates, was a patron of the emperor. Most of the miniature icons probably were made for the imperial family or the high aristocracy, to be used for themselves or as gifts.

This icon of Saint Theodore is related to other portraits of military saints of the early fourteenth century—such as those in the frescoes of the Kariye Djami in Istanbul—not only in his elegant and colorful costume and his soft, curly hair piled high on his head, but also in his long-waisted and attenuated body and his flexed left leg (which imparts action to an otherwise static, relatively diminutive figure). In concept, Saint Theodore, however, is less vigorous, and more delicate and stylized, than the saints in the frescoes, probably indicating that the icon dates from sometime during the second quarter of the fourteenth century.

M. E. F.

BIBLIOGRAPHY: O. Demus, "Two Palaeologan Mosaic Icons in the Dumbarton Oaks Collection," in *Dumbarton Oaks Papers*, 14, 1960, pp. 87–119; A. Prandi, in *Art Treasures of the Vatican Library*, New York, n.d., pp. 177–78, no. 120, colorplate p. 135; I. Furlan, *Le Icone bizantine a mosaico*, Milan, 1979, no. 38.

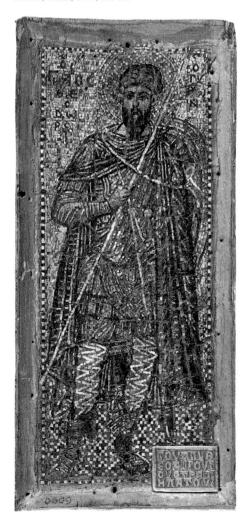

42

DIPTYCH

Central Italy, Rambona, c. A.D. 900
Ivory
Height, 12¼" (31.1 cm); total width, 10¾"
 (27.3 cm)
Biblioteca Apostolica Vaticana, Museo Sacro,
 Inv. no. 2442

During the Carolingian era, the format of Late Antique consular diptychs was revived for ecclesiastical purposes. This important example comes from the convent abbey of Rambona (near Ancona).

The left panel is divided into three zones. In the center is the Crucifixion of the living triumphant Christ, between the Virgin—above whose head is the inscription MVLIER EN (His mother) —and Saint John, identified by the inscription DISSIPVLE ECCE (Behold the apostle). The cross is surmounted by an oversized double placard inscribed EGO SVM IHS NAZARENVS/REX IVDEORVM (I am Jesus of Nazareth/King of the Jews). To the left and right, the Sun and the Moon witness the event, while, at the top, two angels support a medallion portraying God the Father offering a benediction. Below the Crucifixion is the unusual, if not unique, representation of the she-wolf suckling Romulus and Remus, which carries the inscription ROMVLVS ET REMVLVS A LVPA NVTRITI (Romulus and Remus fed by the wolf).

The right panel, likewise, is organized into three zones. At the top, the enthroned Virgin and Child are positioned between two seraphim, who stand on interlaced circles. Standing below, amidst inhabited vine tendrils, are the three patron saints of the abbey of Rambona, and at at the bottom is a semiprostrate saint holding palm branches (?). These scenes are accompanied by the quasi-literate inscription CONFESSORIS DNI SCIS GREGORIVS SILVESTRO FLA/VIANI CENOBIO RAMBONA AGELTRVDA CONSTRVXI/QVOD EGO ODELRIGVS INFIMVS DNI SERBVS ET ABBAS/SCVLPIRE MINI BIT IN DOMINO AMEN, loosely translated as: "To the saints Gregory, Silvester, and Flavian, confessors of Christ, for the monastery of Rambona, which Ageltruda built. I, Odelricus, who humbly serve God, request this sculpture to be made." Based upon this inscription, it would seem that the diptych was carved locally for the Abbot Odelricus, in honor of the monastery of Rambona and its patron saints. However, it is not certain whether the Ageltruda referred to is the spouse of Guido, Count of Spoleto, who became King of Italy, and then emperor in 891. A document of 898 mentions the territory of Rambona where the monastery stands. The appearance of the she-wolf at the foot of the cross, and the victorious aspect of this interpretation of the Crucifixion, might be an allusion to Ageltruda as the representative of a new Christian Empire in Rome.

Certain aspects of the style of the diptych would tend to support a date of about 900. The flat, linear treatment of the figures, in combination with the geometric reduction of the drapery folds, produces a formal and hieratic composition of densely filled surfaces that are characteristic of the late phase of Langobardic

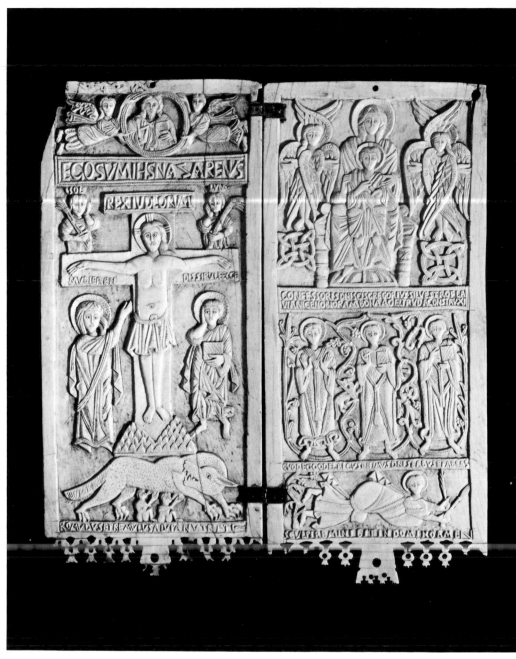

sculpture. The introduction of the tendril motif, especially, enhances the diptych pictorially, as in other early-tenth-century Northern Italian ivories—such as the panels with the four Evangelists, in Lyons, or the book cover with symbols of the Evangelists, in Cologne (A. Goldschmidt, I, 1914, nos. 170–174). The abstraction of the human form—which functions more as a sacred symbol—evolves directly from Langobardic art of the eighth century. The figures in the Christ in Majesty on the stone altar of Duke Ratchis, of about 740, in the church of San Martino in Cividale, display the same geometric reduction on the part of the sculptor as those in the Rambona diptych. Thus, the diptych is a late manifestation of the Langobardic style that was still flourishing in central Italy about 900.

Both panels terminate in continuous crenellated crowns, this striking geometric openwork at the lower edge of the frame clearly based upon early Islamic decoration. It is difficult to understand this type of design within the context of Langobardic art, since no comparable example of such a juxtaposition exists. Alternatively, Charles R. Morey has proposed that the ivory is actually of Islamic origin, imported from the East and subsequently planed down and carved with Christian scenes. During the Carolingian period, the recycling of earlier ivories was commonplace, due to the apparent shortage of new materials, and the Rambona diptych may be a rare manifestation of this phenomenon.

C. T. L.

BIBLIOGRAPHY: A. Goldschmidt, *Die Elfenbeinskulpturen aus der Zeit der karolingischen und sächsischen Kaiser, VIII.–XI. Jahrhundert,* I, Berlin, 1914–18, no. 181; C. R. Morey, *Gli oggetti di avorio e di osso del Museo Sacro Vaticano. Catalogo del Museo Sacro,* I, Vatican City, 1936, no. A 62, pp. 60–62; H. Fillitz, "Die Spätphase des 'Langobardischen' Stiles," in *Jahrbuch der Kunsthistorischen Sammlungen in Wien,* XVIII, 1958, pp. 7–72; A. Prandi, in *Art Treasures of the Vatican Library,* n.d., pp. 113, 175–76, nos. 103–104, ills. pp. 117, 118.

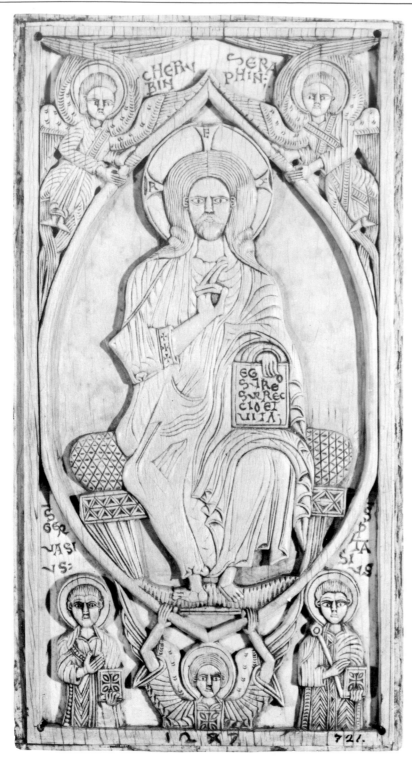

43

**PLAQUE FROM A BOOK COVER, WITH
A *MAIESTAS DOMINI***

Italy, Venice or Amalfi
Late 11th–early 12th century
Ivory
Height, 9 9/16" (24.3 cm); width, 5 1/16" (12.9 cm)
Biblioteca Apostolica Vaticana, Museo Sacro,
 Inv. no. 2443

This imposing *Maiestas Domini* was originally
the central composition of a book cover. Other
individual related ivory plaques in the Museo
Nazionale in Ravenna and in the Abegg-Stiftung
Bern aided Adolph Goldschmidt (1926, IV, pp.
43–44, nos. 147–150, pl. LIII) and Charles R.
Morey (1936, pp. 68–70, no. A 71, pl. 14) in
reconstructing one side of the book cover; the
other side, they believed, also consisted of ivory
plaques arranged around a Crucifixion panel (in
the Musée de Cluny in Paris). Clearly, this other
cover is a later pastiche, as indicated by the vari-
ant coloring and measurements, the recutting

of several of the plaques, and by the addition of
a new plaque and spacing strips when the
"pseudo-cover" in the Musée de Cluny was
made up (D. MacK. Ebitz, 1979, pp. 136–67,
figs. 80–83). A more radical reconstruction out
of the same ivories can be proposed: the Vati-
can *Maiestas Domini* mounted on one cover,
framed by a border of medallions containing
busts of the twelve apostles and an Evangelist
symbol at each corner. This reconstruction, with
Christ enthroned in a mandorla, flanked by a
cherub (CHERV/BIN) and a seraph (SERA/PHIN;)
and by the Evangelists' symbols, conforms to
standard iconography of the Carolingian period
in the West. The message inscribed in the open
book that Christ holds on his knee, EG O/SV[M]RE/
SVRREC/CIOET/VITA; (John 11:25), figures, tradi-
tionally, in Last Judgment iconography: as the
Son of God, Christ judges; as the Son of Man,
he redeems the sin of Adam and offers the resur-
rection and the life by suffering the Crucifixion
—depicted on the other side of the reconstruct-
ed book cover. Saints Gervasius (S̄[ANCTVS]
GER/VASI/VS,) and Protasius (P[RO]TA/SI/VS) appear
below Christ in the *Maiestas Domini*; their parents,
Saints Vitalis and Valeria, are shown below
the Crucifixion.

While the iconography is Western, the unusu-
al style of the Crucifixion and of the *Maiestas
Domini* with the Last Judgment is based largely
on Middle Byzantine models—specifically, on
several eleventh-century enamels (cf. K. Wessel,
Byzantine Enamels, Greenwich, Conn., 1967, figs.
34, 37 a; L. von Matt, *Die Kunstsammlungen der
Biblioteca Apostolica Vaticana Rom*, Cologne, 1969,
pls. 82–83). Such design elements as the chev-
ron pattern of nested **V** folds on the garments of
Gervasius and Protasius are identical to the folds
in two alternating colors on these Byzantine
enamels (K. Wessel, op. cit., 1967, pp. 29, 128,
142, 145–46, figs. 30, 45 d–f, 46 o). Based on
the epigraphy of the numerous inscriptions and
on the overall arrangement of each cover—a
border of busts in medallions framing a central
image (cf. K. Wessel, op. cit., figs. 13 a–b, 25,
27 a–b, 41 a; L. von Matt, op. cit., 1969, pls. 82,
84–85)—the Vatican ivory dates the book cover
to 1100 (the crudely inscribed "1247" on the
border is a later addition). Because of their
eccentric style, Hermann Schnitzler (1965, pp.
226–27) suggested that the plaques were manu-
factured in the seventeenth or eighteenth century,
perhaps in Milan, but Hermann Fillitz (1967,
pp. 32–34) compared them, despite differences
in subject matter, with secular Fatimid-style ivory
horns and caskets. This connection is evidenced
by such identical motifs as wings, the similarity
with which figures are articulated by neat, par-
allel incisions on the flat surface of the relief,
and the equal emphasis on negative spaces be-
tween areas in relief. These are works from the
same source. An inscription on a Fatimid-style
ivory writing case in The Metropolitan Muse-
um of Art has led some scholars to attribute these
ivories to a shop of transplanted Muslims
working, perhaps, in Amalfi during the elev-
enth century. However, it is equally plausible that
the workshop can be located in Venice, because
of the strong correspondence between the saints
on the book cover—including the unusual Saint
Hermagoras—and saints with cults or church
dedications in Venice, such as Gervasius, Prota-
sius, and Vitalis.

Whether carved in Venice or Amalfi, the *Maiestas Domini* and the related plaques are a hybrid of Western iconography, Byzantine models, and the Fatimid style, characteristic of the political, economic, religious, and cultural situation of Italy, between the East and the West, during the Middle Ages.

The *Maiestas Domini* plaque is first mentioned in 1756 as being in the Camaldolese monastery on the island of San Michele in the Venetian lagoon. By the mid-nineteenth century it was in the Biblioteca Apostolica Vaticana.

D. MACK. E.

BIBLIOGRAPHY: A. Goldschmidt, *Die Elfenbeinskulpturen aus der romanischen Zeit, XI.–XIII. Jahrhundert*, IV, Berlin, 1926, pp. 1, 13, 14, no. 112, pl. LIII; C. R. Morey, *Gli oggetti di avorio e di osso del Museo Sacro Vaticano. Catalogo del Museo Sacro*, I, Vatican City, 1936, pp. 68–70, no. A 71, pl. 14; H. Schnitzler, "Ada-Elfenbeine des Barons v. Hüpsch," in *Festschrift für Herbert von Einem*, eds. Gert von der Osten and Georg Kauffmann, Berlin, 1965, pp. 226–27; H. Fillitz, *Zwei Elfenbeinplatten aus Süditalien* (Monographien der Abegg-Stiftung Bern, 2), Bern, 1967, pp. 8–9, 32–34, fig. 5; D. MacK. Ebitz, "Two Schools of Ivory Carving in Italy and Their Mediterranean Context in the Eleventh and Twelfth Centuries," Ph.D. dissertation, Harvard University, Cambridge, Mass., 1979, pp. 128–385, fig. 71.

44

DIPTYCH, WITH SCENES FROM THE LIFE OF CHRIST AND THE VIRGIN

Northeastern (?) France, c. 1250
Ivory
Height, 12" (30.5 cm); width, 7 ½" (19 cm)
Biblioteca Apostolica Vaticana, Museo Sacro,
 Inv. no. 2444

During the Gothic era, a new preference for small portable ivory images for private devotion found its most characteristic form in the diptych. This elegant carving, chronologically, is one of the earliest Gothic diptychs, and revives a format not used in the Latin West since the ninth century (see cat. no. 42). One wing focuses on an abbreviated cycle of the life of the Virgin and the other on the Passion of Christ, with each organized into registers composed of articulated arcades. On the left, reading from the third register down, are the Annunciation and the Nativity; the Massacre of the Innocents and the Flight into Egypt; and the Adoration of the Magi. On the right are the Crucifixion; the Deposition; and the Lamentation. In the gables surmounting the left three registers is the Coronation of the Virgin, and, on the right, the Last Judgment. A certain centrality in the compositions of the individual scenes, and the enlargement of the axial figures, ultimately dictated the organization of the overall design program.

This diptych, as well as a triptych (with painted wings) in Lyons were made by the same atelier of ivory carvers and are distinguished by a comparable formal elegance and by vigorously modeled figures composed within an architectural system. Other closely related diptychs (in the Wallace Collection in London, and the Hermitage in Leningrad) share nearly identical scenes. In spite of the relative homogeneity of this ivory group, there is little agreement regarding the localization of the atelier that produced it. While

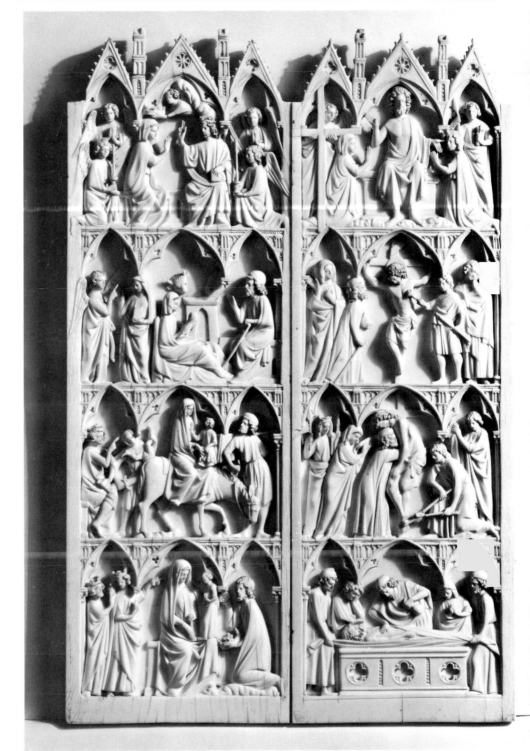

Morey regarded the ivories as Northern Italian, most scholars consider them Northern French, of the later thirteenth century. The large geometric volumes of the figures have been compared to the mid-thirteenth-century illuminations in the scroll of Saint Éloi (in the Musée Carnavalet in Paris; D 7075); indeed, such ivories originally were polychromed. The style, likewise, has been linked to monumental sculpture, as revealed by the suppleness of the folds. The aristocratic attitudes of the gracefully carved figures justifiably might be compared to the sculpture of Reims Cathedral, as they have been to that of Thérou-

anne. The significance of this ivory group, however, lies in the fact that it initiated a carving tradition that lasted until the beginning of the Renaissance.

C. T. L.

BIBLIOGRAPHY: R. Koechlin, *Les Ivoires français*, I, Paris, 1924, p. 82, II, Paris, 1924, no. 37; C. R. Morey, *Gli oggetti di avorio e di osso del Museo Sacro Vaticano. Catalogo del Museo Sacro*, I, Vatican City, 1936, no. A 82; L. Grodecki, *Ivoires français: arts, styles et techniques*, Paris, 1947, pp. 90–91; D. Gaborit-Chopin, *Ivoires du moyen âge*, Fribourg, 1978, pp. 114, 206; P. Verdier, "Le triptyche d'ivoire à volets peints," in *Bulletin des Musées et Monuments Lyonnais*, VII, 1982, pp. 17–30.

45

HEXALOBE PLAQUE, WITH THE RESURRECTION OF CHRIST

Siena, early 14th century
Copper, with champlevé enamel and gilding
Diameter, 3" (7.6 cm)
Biblioteca Apostolica Vaticana, Museo Sacro,
 Inv. no. 2434

Well preserved, this small hexalobe copper plaque is remarkable for the dramatic impact of its color and its linear composition. Opaque dark blue and red enamel offset the gilt border and the gilt reserved figure composed of engraved, enamel-filled lines. Christ, cross-nimbed and wearing only a loose mantle, rises from an open sarcophagus, the lid of which has been pushed

back at an abrupt angle. He triumphantly holds a long thin staff, surmounted by a cross and bearing a fluttering cross-decorated banner. His left foot rests on the forward edge of the sarcophagus, in front of which four sleeping soldiers in chain mail and Gothic armor are sprawled. The sky is punctuated by a series of stars in reserve. Rosettes, also in reserve, are centered in the lozenges that mark the points interspersed among the lobes. Three of these rosettes have suffered later drilling. While the original context of the plaque is uncertain, it once must have been held in place by a bezel.

In proportions and linear animation, the figure style is loosely related to the panels with Passion subjects on the back of Duccio's *Maestà* (of 1308–11) in Siena. However, the specific style of the Resurrection plaque is characteristic of a series of Sienese enamels dating from the end of the thirteenth into the first decades of the fourteenth century. Included in this series are the

46

SIX MEDALLIONS, WITH SAINTS CATHERINE OF ALEXANDRIA, ELIZABETH OF HUNGARY, LOUIS OF TOULOUSE, JAMES THE GREAT, PAUL, AND PETER

Siena, after 1317 or c. 1320
Copper, with champlevé enamel and gilding
Diameters, without frames, 2 1/4–2 5/16" (5.7–5.9 cm)
Biblioteca Apostolica Vaticana, Museo Sacro,
 Inv. nos. 2435–2440

Except for the chipped background above Saint Catherine's left shoulder, these imposing medallions are in excellent condition. It is uncertain when their cast-and-tooled frames were made. W. Frederick Stohlman considered them modern. A similar frame is found on a closely related but slightly larger enameled medallion with Saint Anthony in the Kunstgewerbemuseum in East Berlin (P. de Castris, 1980, fig. 4).

The opaque enamel of the present medallions is dark blue in the backgrounds and red in the various details. As in the Resurrection plaque (cat. no. 45), the figures are reserved in copper gilt, with interior enamel-filled engraved lines and hatchings. Two of the backgrounds have reserved ornamentation in copper gilt: the fleurs-

de-lis behind Saint Louis and the shells behind Saint James. The narrow, red encircling bands in four of the medallions are decorated with tiny reserved diagonal crosses or quatrilobes (Saints Catherine, Louis, James, and Paul). Three of the busts are frontal (Saints Louis, James, and Paul); the remaining ones are rendered in three-quarter view.

All six saints are nimbed, and bear one or more attributes, which, in lieu of inscriptions, readily identify them. Saint Catherine holds a palm in her right hand and the wheel of her martyrdom in her veiled left hand. In her veiled right hand Saint Elizabeth holds a flaming pot, a symbol of spiritual love, to which she points with her left hand. Saint Louis, youthful and beardless, wears a bishop's miter and holds a crosier, an episcopal symbol of pastoral authority, in his left hand; he gives an episcopal blessing with his right. Saint Paul, bald and with a long beard, clutches a sword and a book. Peter, with curly hair and short beard, grasps his keys and a book.

While the original context of these medallions is unknown, they probably belonged to a larger group that once decorated an altar—in a manner similar to the enameled medallions on the altar of Saint James in Pistoia (M.-M. Gauthier, 1972, pp. 208–12, 385–86, ill. 163). Thus, they may have been part of the border divisions that separated a series of larger images in a christological or hagiographical cycle.

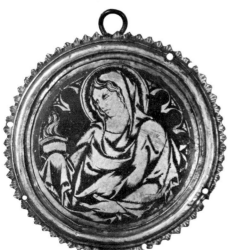

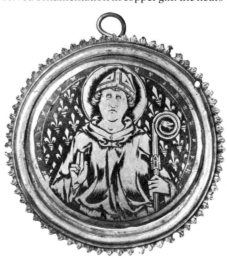

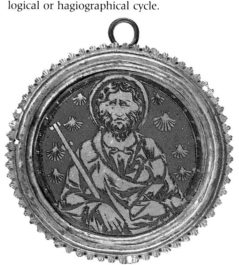

medallions on the late-thirteenth-century altar of Saint James in Pistoia Cathedral (M.-M. Gauthier, 1972, pp. 208–12, 385–86, ill. 163), the six medallions with busts of saints in the Vatican (see cat. no. 46), and the quatrilobe enamels on the early-fourteenth-century inscribed processional cross from Trequanda, near Siena, and now in Cleveland (W. D. Wixom, 1979, pp. 133–39, figs. 86–87, 89, 90–94, and back cover in color). The technique of using opaque enamel—dark blue in the background, red in decorative details, and enamel-filled engraved lines in the figures in reserve—continues that of an earlier and contemporary group of enameled objects produced in the Upper Rhine, such as the processional cross (of about 1280) from the Lake Constance region, also now in Cleveland (H.-J. Heuser, 1974, pp. 156–57, figs. 313–323; W. D. Wixom, 1979, p. 139, fig. 99; see also M.-M. Gauthier, 1972, pp. 267–68, 388, 407, ills. 216, 217).

Inexplicably, Gauthier attributed the Resurrection hexalobe to the master of the translucent enamel Passion plaques on the large reliquary of the Bolsena Corporal by Ugolino di Vieri and associates, dated 1338, in the cathedral of Orvieto. This date seems too late for the present work, which, stylistically and technically, is more akin to the medallions on the Pistoia altar.

W. D. W.

BIBLIOGRAPHY: W. F. Stohlman, *Gli Smalti del Museo Sacro Vaticano* (*Catalogo del Museo Sacro della Biblioteca Apostolica Vaticana*, II), Vatican City, 1939, pp. 43–44, pl. XXII, no. S 73; M.-M. Gauthier, *Émaux du moyen âge occidental*, Fribourg, 1972, p. 388, no. 168, ill.

Comparative works cited: H.-J. Heuser, *Oberrheinische Goldschmiedekunst im Hochmittelalter*, Berlin, 1974, pp. 156–57, figs. 313–323; W. D. Wixom, "Eleven Additions to the Medieval Collection," in *Bulletin of The Cleveland Museum of Art*, LXVI, 3, March–April 1979, no. X, pp. 133–39, figs. 86–87, 89, 90–94, 99.

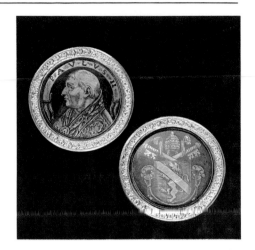

47

The figural style, physiognomic types, and the fluid, curvilinear drapery, in general, reflect contemporary Sienese painting. The figures of Simone Martini (c. 1284–1344) seem especially similar, particularly several in his *Maestà* fresco (of 1315) in the Palazzo Pubblico in Siena, or his representation of Saint Louis on a panel of 1317 in Naples.

The technique is identical to that of the Resurrection plaque, although the scale of the figures in the medallions is larger and, by contrast, almost heroic. A medallion inscribed "Saint Elizabeth," in the Louvre, closely allied with the present series in both style and technique, has been variously attributed. Guccio di Mannaia, the artist of the translucent enameled quatrilobes on the signed chalice in Assisi, the gift of Pope Nicholas IV (1288–92), was suggested by Gauthier (1972, pp. 212–14, 388, ill. 166) as the artist of the Louvre enamel. Tondino di Guerrino, one of two artists responsible for the translucent enamels on a signed chalice in the British Museum, was assigned to the Louvre plaque by Pierluigi Leone de Castris (1980, p. 25). Another clearly related medallion, that of Saint Anthony in Berlin, and a rectangular plaque of the Enthroned Virgin and Child with Saints Peter and Paul in the Bargello in Florence—both examples of opaque enamels with enamel-filled engraved figures in reserve—also have been attributed to Tondino by de Castris (1980, pp. 24–27). Without accepting any attribution to a

specific artist, we can easily recognize a common style and technique in the Vatican, Louvre, Berlin, and Bargello enamels. Slightly variant, stylistically, and by a different hand, is the technically identical, inscribed processional cross from Trequanda in Cleveland (W. D. Wixom, 1979, pp. 133–39, figs. 86–87, 90–94, and back cover in color).

A *terminus post quem* is provided by the date of 1317 for the canonization of Saint Louis of Toulouse, shown nimbed in the Vatican medallion. A date immediately following for the six Vatican medallions is confirmed by their stylistic affinity to the work of Simone Martini.

These enamels were in the collections of Clement XIII (1758–69). Their earlier history is unknown.

W. D. W.

BIBLIOGRAPHY: W. F. Stohlman, *Gli Smalti del Museo Sacro Vaticano* (*Catalogo del Museo Sacro della Biblioteca Apostolica Vaticana*, II), Vatican City, 1939, pp. 44–45, nos. S 76–S 81, pl. XXII; M.-M. Gauthier, *Émaux du moyen âge occidental*, Fribourg, 1972, p. 388–89, no. 169, ill. (Saint Louis of Toulouse); P. de Castris, "Tondino di Guerrino e Andrea Riguardi orafi e smaltisti a Siena (1308–1338)," in *Prospettiva*, 21, April 1980, p. 24; M.-M. Gauthier, "Émaux gothiques," in *Revue de l'art*, 51, 1981, p. 36, fig. 8 (Saint Catherine).

Comparative works cited: M.-M. Gauthier, op. cit., 1972, pp. 208–14, 385–86, 388, ills. 163, 166; W. D. Wixom, "Eleven Additions to the Medieval Collection," in *Bulletin of The Cleveland Museum of Art*, LXVI, 3, March–April 1979, no. X, pp. 133–39, figs. 86–87, 89, 90–94, and back cover in color; P. de Castris, op. cit., 1980, pp. 24–27.

PAIR OF MEDALLIONS, WITH THE PORTRAIT OF POPE PAUL II (1464–71) AND THE BARBO COAT OF ARMS

Florence, 1464–71
Silver, niello, and silver gilt
Diameter, Paul II and coat of arms, each, 1¾"
(4.5 cm)
Biblioteca Apostolica Vaticana, Museo Sacro, Inv. nos. 2079, 2085

The two roundels decorated the front and back of the binding of a manuscript presented to Paul II: *Aristea. Ad Philocratem fratrem* (Vat. lat. 8913). Known as *The Letter of Aristeas*, the manuscript is the first translation into Latin, by the Pisan Mattia Palmieri, of a third-century-B.C. Hellenistic text referring to the Septuagint version of the Pentateuch. The illumination on its first page, the work of a Roman miniaturist, shows Palmieri offering his book to the pope (*Quinto Centenario*, 1976, p. 16).

The two niello medallions suggest, however, that they are by a goldsmith and that the design was by a Florentine painter. The quality of the niello engraving is of unusual distinction and may be compared to that of the two sumptuous Florentine niello book covers presented by Cardinal Jean de la Balue to Paul II, about 1467–69 (*Decorative Arts of the Italian Renaissance*, 1959, p. 153, ills.). The effigy of Paul II may appear to be superficially related to the pope's effigy on the numerous medals cast for him by Cristoforo di Geremia, but, in fact, the suavity of outline, the degree of idealization, and the plasticity achieved in this portrait make it much closer in style to the works of Filippo Lippi (1406?–1469).

O. R.

BIBLIOGRAPHY: X. Barbier de Montault, *La Bibliothèque Vaticane et ses annexes*, Rome, 1867, p. 84, no. 405; *Legature Papali da Eugenio IV a Paolo V* (exhib. cat.), Vatican City, Biblioteca Apostolica Vaticana, 1977, no. 12, p. 8, pls. XII. XIII; *Palazzo Venezia: Paolo II e le fabbriche di San Marco* (exhib. cat.), Rome, Museo del Palazzo Venezia, 1980, no. 9, pp. 29–30.

Comparative works cited: *Decorative Arts of the Italian Renaissance 1400–1600* (exhib. cat.), The Detroit Institute of Arts, November 18, 1958–January 4, 1959; *Quinto Centenario della Biblioteca Apostolica Vaticana 1475–1975*, Vatican City, 1976.

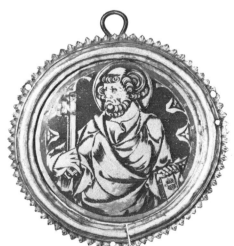

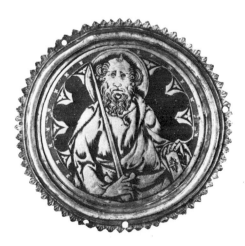

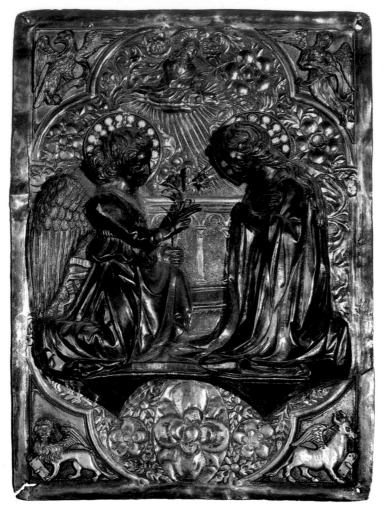

48

BOOK COVER PLAQUE, WITH THE ANNUNCIATION

Italy, Sulmona, c. 1470
Silver, partly gilt, and enamel
Height, 8½" (21.5 cm); width, 6⅛" (15.5 cm)
Biblioteca Apostolica Vaticana, Museo Sacro,
 Inv. no. 2037

This beautiful repoussé relief, in which the angel and the Virgin appear almost in the round, is stamped twice with the mark of Sulmona (in the Abruzzi) for the years about 1468–83 (V. Pace, 1972, p. 79). The plaque, a rare example of Sulmonese goldsmiths' work, which achieved great distinction between the last quarter of the fourteenth century and the end of the fifteenth, originally must have belonged to an Evangelistary. The symbols of the Evangelists, cast and riveted to the corners of the plaque, in design are related to those on a set of well-known Sulmonese book covers in the cathedral of Lucera (Apulia), which carry the mark for about 1430–40 (op. cit., figs. 30–31). The haloes of the Virgin and the angel—decorated with ogival compartments filled with white enamel and outlined in filigree—are also applied as independent plaquettes, as are the haloes of Mary and Saint John on the Lucera book covers.

The application of filigree and enamel, and, especially, the large flowers and the rich foliage in the background of the scene, immediately call to mind the magnificent decoration on the bust of Saint Pamphilus in the cathedral of Sulmona (P. Piccirilli, 1918, p. 118, fig. 4). The bust was executed in 1458–59 by one of the best masters of Sulmona, Giovanni di Marino di Cicco. The style of Mary and the angel, who kneel in front of an altar rail with Gothic arches, and of God the Father, in the sky, suggests that their author was familiar with contemporary Florentine sculpture. The suavely lyrical contours and the plasticity of the figures are especially close to the works of Luca della Robbia (1400?–1482) and agree with a date in the late 1460s. The book cover is a work of unusual distinction and may well have been executed by Giovanni di Marino di Cicco. No provenance has been determined for this plaque; in the nineteenth century, it probably was removed from a manuscript in the Vatican Library and deposited for safekeeping in the Museo Sacro.

O. R.

BIBLIOGRAPHY: X. Barbier de Montault, *La Bibliothèque Vaticane et ses annexes*, Rome, 1867, p. 105, no. 485; E. Mattiocco, "L'oreficeria medievale abruzzese. La scuola di Sulmona" (Atti del II Convegno nazionale della cultura abruzzese), in *Abruzzo*, 6, 1968, p. 400.

Comparative works cited: P. Piccirilli, "Il busto di S. Panfilo nella Cattedrale di Sulmona," in *Rassegna d'Arte*, 18, 1918, pp. 116–19; V. Pace, "Per la storia dell'Oreficeria Abruzzese," in *Bollettino d'Arte*, 1972, pp. 78–89.

49

ALTAR CROSS

Rome, 1489
Silver, partly gilt, and niello
Height, 16⅞" (43 cm)
Biblioteca Apostolica Vaticana, Museo Sacro,
 Inv. no. 2057

Incised on the front and back of the shaft of the cross is the following dedicatory inscription: GENTILIS • /DE • SANCTIS/DOCTOR/DONAVIT/ • A • APLO/DEI/AHO/M̄CCCC/LXXXVIIII/ROM (Doctor Gentile de Sanctis Gave to God's Apostle Andrew in 1489 Rome). The main decorative elements of the cross are the silver filigree scrolls applied on both sides, serving as foils for the hollow, cast-silver figures: Christ, flanked by two mourning Marys and by the Magdalene, repeated twice, in the top and bottom quatrefoils. A motif of Saint Andrew's crosses, in niello, appears along the edges of the cross. The clearly Tuscan outline of the cross is emphasized by the gilded fillet around its contours, while the interplay of white silver with touches of gilding in the hair, beard, and loincloth of Christ, and in the draperies of the holy women, strikes a delicately pictorial note. On the back of the cross, the four lobed medallions have lost their decoration, which, judging from the hatched ground of two of them, must have been painted in translucent enamel.

As shown by Eugène Müntz (1898, pp. 104–20), numerous Tuscan as well as Northern Italian goldsmiths, attracted by the opportunities for patronage at the papal court, settled in Rome during the pontificate of Innocent VIII (1484–92). In the absence of a strongly defined Roman school, the fact that these craftsmen were of various origins determined the somewhat eclectic, yet conservative, character of their works. In the case of this cross, the extensive use of filigree, a technique originally favored by Venetian goldsmiths, and the Sienese type of the figures—especially the ascetic harshness of Christ—suggest that it was the collaborative product of such a recently established goldsmith's workshop.

In the Museo Sacro the cross is mounted on a tall, gilt-bronze foot composed of seven sections. Of these, only three seem germane to the cross: a "sleeve" decorated with a niello plaque engraved with a flowered bush growing from three hillocks, and two knobs chased with acanthus leaves and mounted with six plain silver lozenges.

The provenance of the cross is not known, but the allusion to Saint Andrew suggests that it may come from Saint Peter's, where, until 1606, the head of the apostle, one of the most important relics in the basilica, was kept in an altar tabernacle erected by Pius II (1458–64) in the left nave.

The cross was first described in the 1880s in Giovanni Battista De Rossi's manuscript inventory (no. 633).

O. R.

BIBLIOGRAPHY: W. F. Volbach, *La Croce—Lo sviluppo nell'oreficeria sacra* (Guida del Museo Sacro, 2), Vatican City, 1938, p. 12, ill.

Comparative work cited: E. Müntz, *Les arts à la cour des papes Innocent VIII, Alexandre V, Pie III (1484–1503)*, Paris, 1898.

50

FIVE NIELLO BOOK COVER PLATES, WITH CHRIST BLESSING AND THE FOUR EVANGELISTS

Italy, Lombardy, early 16th century
Silver, niello, and silver gilt
Christ: height, 4¹/₁₆" (10.3 cm), width, 3⅝" (9.2 cm); Saint Luke: height, 1¹⁵/₁₆" (4.9 cm), width, 1¹¹/₁₆" (4.3 cm); Saint Matthew: height, 1¹⁵/₁₆" (4.9 cm), width, 1⅝" (4.2 cm); Saint John: height, 1¹⁵/₁₆" (4.9 cm), width, 1¹¹/₁₆" (4.3 cm); Saint Mark: height, 1⅞" (4.8 cm), width, 1⅝" (4.2 cm)
Biblioteca Apostolica Vaticana, Museo Sacro, Inv. nos. 2073, 2080, 2083, 2086, 2089

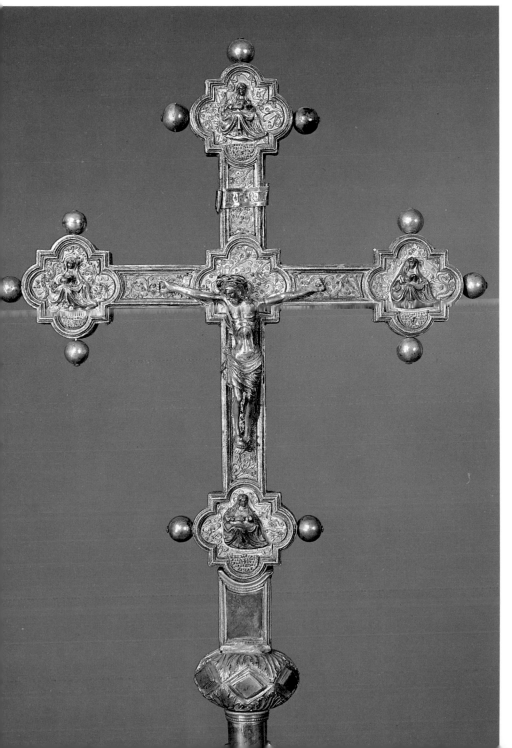

This set of niello book cover plates comes from the sumptuous binding of a thirteenth-century Evangelistary in the Vatican Library (Vat. lat. 8892). The plate with Christ blessing occupied the center, and the hexagonal plates with the Evangelists the four corners of the front cover. On the reverse side, a central plate with the Agnus Dei was surrounded by hexagonal plates with the symbols of the Evangelists. Two silver-gilt clasps with a scrollwork tendril motif similar to that surrounding the plate with Christ blessing complete the decoration of the binding. The delicate elegance of this motif is quite typical of the ornamental vocabulary of early-sixteenth-century Lombard goldsmiths. A similar light scrollwork ornament is applied along the outlines of a silver cross in the church of the Incoronata in Lodi, executed by the brothers Rocchi in 1512, as well as around the triangular base of a silver cross, dated 1511, in the Museo Poldi Pezzoli in Milan (F. Malaguzzi Valeri, 1917, 3, pl. X, p. 307, fig. 358).

The Lombard origin of the niello plates is further confirmed by the style of the designs themselves, which recalls the austere and earnest mood of the figures painted by Bramantino (c. 1465–1530) and the Lombard masters close to him. The plates are described in the manuscript inventory by Giovanni Battista De Rossi (nos. 714–714 A–1).

O. R.

BIBLIOGRAPHY: X. Barbier de Montault, *La Bibliothèque Vaticane et ses annexes*, Rome, 1867, pp. 84–85, nos. 405–406.

Comparative work cited: F. Malaguzzi Valeri. *La corte di Ludovico il Moro*, Milan, 1917.

51

VALERIO BELLI (1468–1546)
THREE INTAGLIO MEDALLIONS, WITH SCENES FROM THE PASSION OF CHRIST

Vicenza, c. 1524
Rock crystal and silver gilt
Height, each: with frame, 4½" (11.5 cm),
 without frame, 3⅞" (10 cm); width, each:
 with frame, 4⅞" (12.5 cm), without
 frame, 4⅜" (11.1 cm)
A. The Betrayal of Christ
 Inscribed: VALERIVS VICENTINVS • F
 Inv. no. 2413
B. Christ Carrying the Cross
 Inscribed: VALERIVS VICENTINVS • F
 Inv. no. 2412
C. The Entombment
 Inscribed: VALERIVS • DEBELLIS • VICEN • F •
 Inv. no. 2415
Biblioteca Apostolica Vaticana, Museo Sacro

These three oval medallions belong with a rock crystal crucifix, signed VALERIV/S • VIN • F, also in the Museo Sacro. Both crucifix and medallions have been identified with the "croce di cristallo divina," which, according to Vasari, was made by Valerio Belli for Clement VII (1523–34). The cross is probably the one mentioned in the papal inventory as "a rock crystal cross with a crucifix and other figures carved in it with a silver-gilt base, which was bought from Valerio da Vicenza in the month of . . . 1524 for ducats . . ." ("*I crocie di cristallo intagliatovi un crocifisso et altre figure con piè d'argento dorato, quale si comperò da Valerio da Vicenza nel mese di . . . 1524 per d . . .*") (E. Müntz, 1888, p. 74).

The three crystal plaques must have been inserted in the silver-gilt base, as occurs in an earlier rock crystal crucifix, of similar form, made by Belli about 1510–15 (now in the Victoria and Albert Museum). Comparison between the carvings on these two works shows how soon Belli, after his arrival in Rome in 1520, abandoned his dry Northern Italian Mantegnesque style in favor of the High Renaissance idiom of Raphael and Michelangelo.

A brilliant master of crystal and hard-stone carving, a goldsmith, and a medalist, Belli was anxious, however, to adapt designs by other artists for his compositions. The medallion with *The Betrayal of Christ* is based upon a drawing by Polidoro da Caravaggio (1496/1500–1543) now at Windsor Castle, but it is interesting to note how, in this translation into crystal, Polidoro's dramatic chiaroscuro and nervously violent style have been purified by Belli and transformed, through the skilled definition of light planes, into a deeply harmonious, classicizing frieze—the poetic creation of a master who has been called, aptly, "an instinctive Hellenist" (J. Pope-Hennessy, 1980).

No designs for the other two medallions are known, but their many Raphaelesque quotations make it quite conceivable that they also are based on sketches by Polidoro or by another of Raphael's students. Their very high quality puts them among the finest of Belli's works, possibly even superior to the rock crystal plaques of the famous casket of Pope Clement VII, completed in 1532 (now in the Museo degli Argenti in the Palazzo Pitti in Florence). Bronze plaquettes, cast after the Vatican crystals, exist in various collections (J. Pope-Hennessy, 1965, pp. 9–10, nos. 7–9).

The crucifix and the medallions were a gift of Pius IX (1846–78), who bought them in 1857 from the poorhouse in Bologna, to which they had been bequeathed a few years earlier by a woman who had received them from a French commissar. It is likely that the crystals lost their original silver-gilt mount at the beginning of the nineteenth century.

O. R.

BIBLIOGRAPHY: E. Müntz, "L'Oreficeria a Roma durante il regno di Clemente VII," in *Archivio Storico dell'Arte*, 1, 1888, pp. 14–23, 35–42, 68–74; A. G. Cotton and R. M. Walker, "Minor Arts of the Renaissance in the Museo Cristiano," in *The Art Bulletin*, 17, 1935, pp. 132–40 (with earlier bibliography); F. Antal, in A. E. Popham and J. Wilde, *The Italian Drawings of the Fifteenth and Sixteenth Centuries in the Collection of His Majesty the King at Windsor Castle*, 1949, p. 295, no. 692; E. Steingräber, "Das Kreuzreliquiar des Marc'Antonio Morosini in der Schatzkammer von San Marco," in *Arte Veneta*, 15, 1961, p. 56; J. Pope-Hennessy, "The Italian Plaquette," in *Proceedings of the British Academy*, 1, 1964, reprinted in *The Study and Criticism of Italian Sculpture*, New York, 1980, pp. 215–17; idem, *Renaissance Bronzes from the Samuel H. Kress Collection*, London, 1965, pp. 9–10, nos. 7–9; F. Barbieri, "Valerio Belli," in *Dizionario biografico degli italiani*, 7, 1965, p. 682.

52

MEDALLION, WITH THE IMPERIAL APOTHEOSIS OF CHARLES V

Medallion: The Netherlands, Antwerp,
 c. 1560–70; bronze-gilt frame: Florence,
 early 18th century
Silver, cast and chased, the frames of gilt copper
 and gilt bronze, with lapis lazuli, simulated
 rubies, and glass
Height, overall, 10 1/16" (25.5 cm); width, overall,
 8¾" (22.2 cm); diameter of medallion, 6 11/16"
 (17 cm)
Biblioteca Apostolica Vaticana, Museo Sacro,
 Inv. no. 2105

The relief shows Charles V, seated on a high throne, with the full complement of his imperial attributes: clad in classicizing armor and wearing the imperial crown over his helmet, he holds the insignia of the Holy Roman Empire—the sword and the globe surmounted by a cross—and is flanked by the twin pillars of Hercules. At his feet is the imperial eagle, in whose beak is a ring to which are attached the cords that tie together six princes defeated by Charles. On the left are Francis I, King of France, accompanied by an unidentified warrior (possibly one who was captured with the king at the Battle of Pavia in 1525), and the Turkish Sultan Suleiman II, in the act of retreating. On the right are the German adversaries of Charles V: John Frederick, Elector of Saxony; Philip, Landgrave of Hesse; and William, Duke of Cleve.

The scene reproduces quite faithfully the opening plate of a well-known series of twelve prints, *The Victories of Charles V (Divi Caroli V Imp. Opt. Max. Victoriae)*, engraved in 1555 by Dirck Volckertsz. Coornhert, after designs by Maarten van Heemskerck, and published in 1556 by Hieronymus Cock, in Antwerp (F. W. M. Hollstein, 8, n.d., p. 241, nos. 167–178). The only important difference between the print and our medallion occurs on the left side, where the engraving shows Pope Clement VII instead of the unidentified warrior. In the medallion, the scene seems to take place on a platform, supported by an entablature, in front of a curtain drawn across three open arches. The lower segment of the

51 A 51 C

51 B

roundel is decorated with strapwork ornament, diamond points, and a caryatid mask, all of which typify the ornamental vocabulary of such Netherlandish designers as Cornelis Floris II and his followers, Jacob Floris de Vriendt I and Jan Vredeman de Vries. Equally typical of their work is the molding of the medallion, with its egg-and-dart motif, cartouches, and semicircular loops. Similar medallion designs are engraved in J. Floris's *Compertimentorum Quod vocant multiplex Genus . . .*, printed in Antwerp in 1566 by Hieronymus Cock; they occur frequently on Dutch monuments of the third quarter of the sixteenth century.

Eugène Plon was the first to suggest Leone Leoni as the possible author of the Vatican medallion, mainly on the basis of Leoni's reputation as the favorite sculptor of Charles V and on a general affinity between the imagery of the medallion and Leoni's many sculptures and medals of the emperor. Plon's attribution was accepted as the most plausible by A. G. Cotton and R. M. Walker, although they acknowledged some difficulty in finding stylistic correspondences among Leoni's works.

New evidence for the study of this relief came with the discovery of its close similarity to a plate in *The Victories of Charles V*, published in 1960 by S. Williams and Jean Jacquot. These authors suggested that Heemskerck must have known the relief and based his design upon it, introducing the figure of Clement VII as one more defeated adversary of the emperor. A comparison, however, of the Heemskerck print and the silver medallion shows that the latter is based upon the engraving, not the other way around. Moreover, the presence of decorative details that do not appear in ornamental prints before

1555–60 makes an earlier date extremely unlikely for the silver relief.

The plates of *The Victories of Charles V* were sufficiently well known to have been used as models for a series of eight wooden reliefs now in the Kunsthistorisches Museum in Vienna, probably carved in southern Germany or in the Tyrol, about 1560–70 (*Sonderausstellung Karl V*, 1958, p. 31, nos. 66–73). The Viennese reliefs seem to have been made to decorate a small cabinet, of the same type as the so-called Wrangel-Schrank, dated 1566 (in the Westfälisches Landesmuseum für Kunst und Kulturgeschichte in Münster), and other related southern German cabinets, which often show strong Netherlandish influences. The silver medallion in the Vatican also may have been intended, originally, for a portable cabinet or writing box. Its extremely fine chasing, with minute heraldic and

costume details, is faithfully copied from the Heemskerck print and seems most likely the work of a Netherlandish goldsmith. It was probably made in Antwerp—famous, about 1560, for its goldsmiths, silversmiths, and jewelers, working in close association with local designers and engravers. The narrative aspect of the Vatican medallion and its glorification of Charles V recall, in particular, an imposing silver-gilt basin (now in the Louvre) embossed and chased with scenes from the battles of Charles V's campaigns, made in Antwerp in 1558–59 (J. F. Hayward, 1976, p. 396, pl. 597).

The medallion is mounted in a double frame; the first, made of gilt copper and set with lapis lazuli and simulated rubies, may be germane to the piece, but the outside bronze-gilt frame has an elaborate Late Baroque cartouche in the style of Florentine designs of the early eighteenth century, such as the bronze cartouches made in 1708–11 by Massimiliano Soldani for the reliefs of the *Seasons* (now in the Bayerisches National-museum in Munich) (K. Lankheit, 1962, pls. 95, 96).

The medallion was a gift of Pius IX (1846–78).

O. R.

BIBLIOGRAPHY: X. Barbier de Montault, *La Bibliothèque Vaticane et ses annexes*, Rome, 1867, p. 106, no. 490; E. Plon, *Benvenuto Cellini*, Paris, 1883, p. 275, pl. XXXIV; E. Molinier, *Les Plaquettes*, Paris, 1886, p. 21, no. 354; E. Plon, *Leone Leoni et Pompeo Leoni*, Paris, 1887, p. 252; A. G. Cotton and R. M. Walker, "Minor Arts of the Renaissance in the Museo Cristiano," in *The Art Bulletin*, 17, 1935, pp. 151–62; S. Williams and J. Jacquot, "Ommegangs Anversois," in *Les Fêtes de la Renaissance*, 2, Paris, 1960, p. 373.

Comparative works cited: *Sonderausstellung Karl V*, Vienna, Kunsthistorisches Museum, 1958; K. Lankheit, *Florentinische Barockplastik: Die Kunst am Hofe der letzten Medici 1670–1743*, Munich, 1962; J. F. Hayward, *Virtuoso Goldsmiths and the Triumph of Mannerism 1540–1620*, London, 1976; F. W. H. Hollstein, *Dutch and Flemish Etchings, engravings and woodcuts 1450–1700*, Amsterdam, n.d.

53

Probably by NICOLAS MOSTAERT (NICOLÒ PIPPI) OF ARRAS (active 1578–1601/4), after a wax model by Daniele da Volterra (1509–1566), based on drawings attributed to Michelangelo (1475–1564)

THE DESCENT FROM THE CROSS

Flemish, executed in Rome, c. 1579
Ivory, cut out and mounted on a slate plaque, set in an ebony frame inlaid with silver ajouré and engraved ornamental plaquettes and with eight cutout cherubs holding instruments of the Passion
Relief: height, 11 7/16" (29 cm); width, 8 15/16" (22.7 cm); overall (including frame): height, 17 15/16" (45.5 cm); width, 14 15/16" (38 cm)
Biblioteca Apostolica Vaticana, Museo Sacro, Inv. no. 2445

The relief is based on a well-known composition, the idea for which was attributed, as early as 1610, to Michelangelo (O. Doering, 1894, pp. 48, 55). This, indeed, is borne out by two drawings—one in the Teylers Museum in Haarlem (A 25 r.), the other in the British Museum (1860-6-16-4)—often attributed to Michelangelo. The Haarlem red-chalk study, depicting the nucleus of the composition, with the body of Christ being lowered from the cross, was assigned by B. Berenson and F. Knapp to Sebastiano del Piombo; by Erwin Panofsky, Wolfgang Stechow, and Marita Horster to Daniele da Volterra; but accepted as a Michelangelo by H. Marcuard, H. Thode, L. Goldscheider, J. Wilde, Frederick Hartt, and Charles De Tolnay (refs., in *Corpus . . .*, 1975, no. 89 r., p. 82). The black-chalk sketch in the British Museum, a study for the mourning Virgin sustained by a Mary and by Saint John, was ascribed to Daniele da Volterra by E. Panofsky and F. Baumgart, but was accepted as a Michelangelo by B. Berenson, H. Thode, A. E. Brinckmann, and J. Wilde (refs., in J. Wilde, 1953, no. 69, p. 108), as well as by Hartt (1971, no. 451, p. 321).

Among the many reliefs in various mediums and sizes that reflect the extraordinary popularity of this composition (M. Horster, 1965, p. 199), only three examples—all in Florence and of nearly identical dimensions—are relevant for a complete understanding of the Museo Sacro ivory. They are: a well-known stucco relief in the Casa Buonarroti (W. Stechow, 1928, p. 92; L. Goldscheider, 1973, pl. XXXI), a wax relief in the Museo Nazionale (R. W. Lightbown, 1970, p. 37, ill.), and an ivory in the Museo degli Argenti of the Palazzo Pitti (C. R. Morey, 1936, fig. 47).

Morey was the first to observe the close conformity of the Pitti ivory to the Vatican ivory, and to suggest that both were carved by the same master: an Italian artist, working about the middle of the sixteenth century. Recent scholarship, however, has clarified in further detail the mutual relationship of the three reliefs and the authorship and dating of the Pitti ivory.

The stucco relief in the Casa Buonarroti appears to be a rough cast taken from the Museo Nazionale wax. The wax was attributed by Horster to Daniele da Volterra, and dated in the 1560s on the basis of a newly discovered copy drawn by Vasari.

As to the Pitti ivory (C. Piacenti Ashengreen, 1968, pp. 14, 152), it must be identified now with one of several replicas made after an ivory relief, "sul disegno di Daniele da Volterra," by Nicolò Pippi, and delivered to the Medici Guardaroba on May 13, 1579 (*Archivio di Stato, Florence, Guardaroba*, 79, p. 39). The original ivory, still unlocated, was sent as a gift to the Viceroy of Catalonia, Don Ermando de Toledo, but the Vatican relief most likely is another of the copies mentioned in the Florentine document. Such replicas probably were carved with the help of stucco casts, like the one in the Casa Buonarroti for which Daniele da Volterra's authorship is now confirmed.

If we accept the currently prevailing attribution to Michelangelo of the Teylers Museum drawing, we must conclude that Daniele reused and adapted this early composition shortly after the death, in 1564, of Michelangelo (a direct reference to whom, in the Vatican ivory, is the old man standing behind Mary). The ivory replicas of 1579 were commissioned as devotional objects, inspired by the desire to multiply and codify the master's compositions as religious Counter-Reformation symbols, much as happened with his Pietà composition for Vittoria Colonna (C. De Tolnay, 1953).

Both the Pitti and Vatican reliefs, in all likelihood, were executed in Rome. In 1578, Pippi was not only settled in the city, but also was considered one of the leading Flemish sculptors, of an excellence comparable to Giovanni Bologna in Florence (R. Beer, 1891, CXCVIII, no. 8471). Known especially for his works in marble, such as the Last Judgment relief (of 1579) for the tomb of the Duke of Cleve at Santa Maria dell'Anima in Rome (A. Venturi, 1937, fig. 517), Pippi must have been also an accomplished ivory carver.

In the Vatican relief, the Michelangelesque composition has been adapted with a remarkable feeling for its melodious and emotional impact. A precise, sensitive use of the chisel, reflecting the control of a hand used to making drawings after the master's Roman works, here results in a noble stylization and a pronounced graphic quality.

The ebony frame does not appear to be contemporary with the relief. The style of the cherubs carrying the instruments of the Passion, and of the ornamental plaquettes, suggests that the frame was made in southern Germany, about 1700.

The ivory was the gift of Gregory XVI (1831–46), who, according to a letter recently discovered by Giovanni Morello in the Vatican Library archives, purchased it in 1835 from a Tommaso Pansieri.

O. R.

BIBLIOGRAPHY: X. Barbier de Montault, *La Bibliothèque Vaticane et ses annexes*, Rome, 1867, pp. 44, 71, no. 310; C. R. Morey, *Gli oggetti di avorio e di osso del Museo Sacro Vaticano. Catalogo del Museo Sacro*, I, Vatican City, 1936, pp. 42–50, 89, pl. XXXII.

Comparative works cited: R. Beer, "Acten, Regenten und Inventaren aus dem Archivio General zu Simanca," in *Jahrbuch der Kunsthistorischen Sammlungen des allerhöchsten Kaiserhauses*, 12, 2, 1891, no. 8471; O. Doering, *Philipp Hainhofers Beziehungen zum Herzog Philipp II in Pommern-Stettin*, Vienna, 1894; W. Stechow, "Daniele da Volterra als Bildhauer," in *Jahrbuch der Preussischen Kunstsammlungen*, 49, 1928, pp. 82–92; A. Venturi, *Storia dell'Arte Italiana*, X, 3, Milan, 1937, pp. 632–42; C. De Tolnay, "Michelangelo's Pietà Composition for Vittoria Colonna," in *Record of the Art Museum*, Princeton University, 13, 1953, pp. 44–62; J. Wilde, *Italian Drawings in the British Museum: Michelangelo and His Studio*, London, 1953; M. Horster, "Eine unbekannte Handzeichnung aus dem Michelangelo-Kreis und die Darstellung der Kreuzabnahme im Cinquecento," in *Wallraf-Richartz Jahrbuch*, 28, 1965, p. 199; C. Piacenti Ashengreen, *Il Museo degli Argenti a Firenze*, Milan, 1968; R. W. Lightbown, "Le cere artistiche del Cinquecento," in *Arte Illustrata*, 3, 1970, nos. 34–36; F. Hartt, *Michelangelo Drawings*, New York, 1971; L. Goldscheider, *Michelangelo*, London, 1973; C. De Tolnay, *Corpus dei disegni di Michelangelo*, I, Novara, 1975.

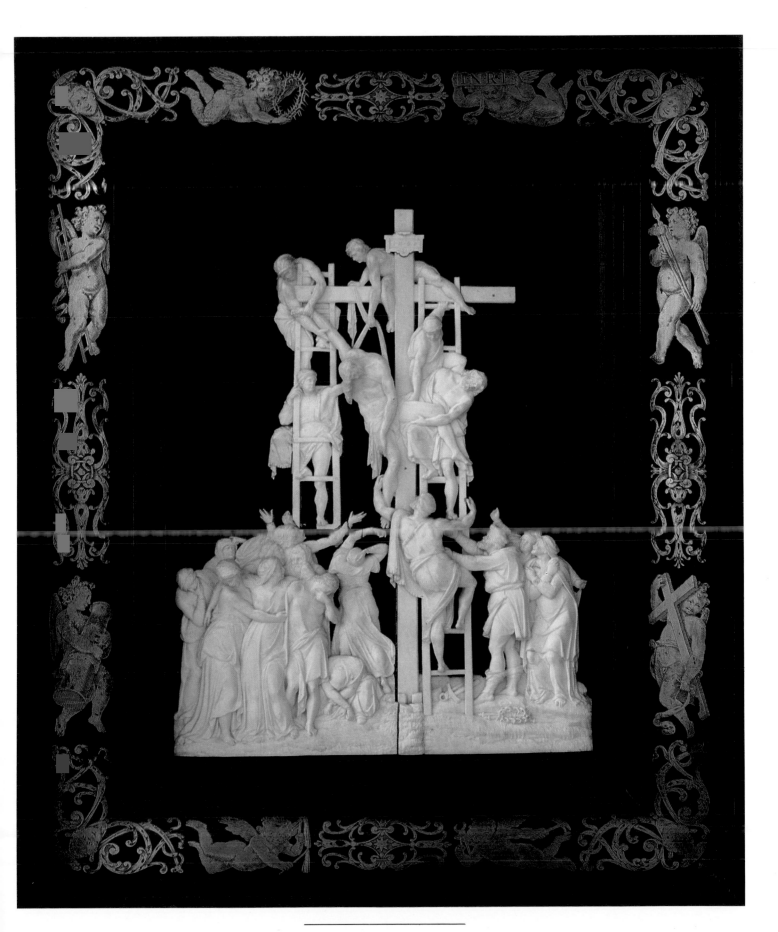

MUSEO
PIO·CLEMENTINO

Clement XIV (1769–74) and Pius VI (1775–99) were the founders of this museum. The purchase of the Fusconi and Mattei collections in 1770, and their transfer to the Palazzetto del Belvedere, the fifteenth-century villa of Innocent VIII on the Vatican hill, brought about a revival of interest in antique sculptures along with those already in the sculpture court of the Belvedere. Yet, underlying the creation of the new museum were the moving forces of the eighteenth century. When Clement XIV dissolved the Jesuit Order on July 21, 1773, with the (papal) brief "Dominus ac Redemptor," he thereby considered the Counter Reformation ended. During the second half of the sixteenth century, the statue court of the Palazzetto del Belvedere had fallen victim to the fanatical proponents of the Counter Reformation. In the second half of the eighteenth century, this same sculpture court became the nucleus of the new Museo Pio-Clementino.

Clement XIV had Anton Raphael Mengs portray his vision of the new museum in a ceiling fresco in the Gabinetto dei Papiri of the Vatican Library, a commission awarded in 1771 and completed by July 1772 (see fig. 30). In a framed central painting set between the figures of Moses and Peter, the founding of the Museo Pio-Clementino is depicted as an allegory. The personification of History is seated in the center of the scene, wearing a white robe with a pink mantle over her left arm. She lifts her head, crowned with a laurel wreath, to look at a Janus-like figure in a green robe standing before her, to whom she appears to be listening. This figure with a double face—indicating knowledge of both past and future—has raised his hand as he speaks. His youthful face, turned toward her, is in the light; his bearded, old face, in shadow, looks away. History is writing in a large open book propped against the wings of an old man in a brown robe, a scythe resting on his arm, who sits in front of her—an allegorical representation of Time in the form of Saturn, the Kronos of the ancient Greeks. A winged boy, a spirit reminiscent of

Amor wearing an oak wreath in his hair, rushes toward History; he looks back with an air of mischief, for he is clutching a number of scrolls in his arms, testaments from the past that he has rescued from the deterioration wrought by Time in order to entrust to History. Hovering above the scene on white wings, wearing a yellow-gold gown and a billowing lavender mantle, is the figure of Fame. She sounds a trumpet to the glory of the Clementine museum, toward which her left hand is pointing and which is identified by an inscription above its entrance.

The assembly of allegorical personages is depicted as though gathered in 1772 in the old sculpture court of the Belvedere, the virtual forecourt of the new Museo Pio-Clementino. Above the open door is the lower portion of the coat of arms of Clement XIV, with the ends of a garland of oak leaves hanging down on either side. Until a short time before (1771), the coat of arms of Innocent VIII, held aloft by two angels (see cat. no. 14), had occupied that place. The expressive gesture of the Janus-like figure invites History to visit the new museum, and History records the occasion of the opening. The youthful Janus face proclaims the dawn of a new age, and the presence of Saturn, Amor, and Fame suggests that it is to be a golden one.

At the foot of the painting, the seated figure of Peter functions almost as a pillar, supporting History, lending permanence to this moment and serving as a witness to her act. Above his head two angels hold a tablet inscribed with the words of Christ, SVPER/HANC PETRAM/A[E]DIFICABO/ECCLESIAM/MEAM (Matthew 16:18), which serves as a base for the picture. The institution of the Church gives the heathen past a home in the new Museo Pio-Clementino. As the caretaker and trustee of antiquity, the museum ensures that the past will not be forgotten. An ancient inscribed stone depicted at the bottom of the picture provides eloquent testimony to this intention. It is lying within the gaze of the aging figure of Time, its edges chipped and grass beginning to grow up around

it. The acronym in its last line is apt: H[OC] M[ONUMENTUM] H[EREDEM] N[ON] S[EQUITUR] (the right to the burial place shall not pass to the heirs to the fortune), here suggesting that the Church, though heir to the treasures of antiquity, will not share its burial place, its demise. The stone was a gift to the pope from Jacopo Bellotti in 1771, and is, today, exhibited in the Galleria Lapidaria.

The sixteenth-century sculpture court of the Belvedere was a garden area in the open air, but the new museum was given the interior rooms of the Palazzetto del Belvedere. The architect Alessandro Dori began reconstruction of the papal chambers in January 1771. The open arches of the loggia were closed in, and the long space set up as a sculpture gallery. The walls separating the apartment wing to the east were removed, and erected in their place, corresponding to the sequence of rooms, were three large arches in the form of the Serliana (the Palladian motif of a wide central arch resting on columns and flanked by narrow openings). In this manner, the apartments were brought together to form the Sala dei Busti, in which primarily Roman portraits, such as the dual portrait of the Gratidii (see cat. no. 129), are displayed. In the following years, 1772–73, the statue court of the Belvedere gained a portico. The old disposition of the ancient statues—with the *Apollo*, the *Laocoön*, and the *Venus* on the south side—was maintained, as an engraving by Vincenzo Feoli (fig. 31) makes clear, but, through the integration of sculpture and architecture, the aesthetic effect was intensified. The formation of the Cortile Ottagono from the old statue court of the Palazzetto del Belvedere was a first step toward the establishment of a museum of art. Under the following pontificate, that of Pius VI (1775–99), the Museum Pium, in fact, came into being, and was incorporated into the existing Museum Clementinum by the architect Simonetti, to create the Museo Pio-Clementino.

Pius VI spared neither effort nor cost in the expansion of the museum founded by his predecessor at his own urging. Though, prior to his pontificate, existing rooms had been adequate to display the ancient statues, Pius VI set about erecting new buildings especially for these monuments of antiquity. By 1784, the tenth year of his pontificate, an inscription on the site where the new museum joins the Library already proclaimed the realization of his plan: "Pius VI constructed the Museum Pium for the study of the fine arts and as an ornament to the Vatican Palace as a wholly new building, uniting it with the Clementine Museum occupying portions of structures from the time of Innocent VIII, and moreover enriching it most generously with an extraordinary wealth of ancient monuments in 1784, the tenth year of his pontificate."

Thus, the new museum was intended to foster study of, devotion to, and research on the fine arts. The numerous illustrious visitors at that time testify to the tremendous support accorded this idea. The pope insisted on guiding the Swedish King Gustavus III through his museum himself (the visit is depicted in a fresco in the library; see fig. 32). Artists, poets, and writers accepted the pope's challenge, and the regard for the *Apollo Belvedere* and for the *Laocoön* group was heightened. This is especially apparent in the discussion be-

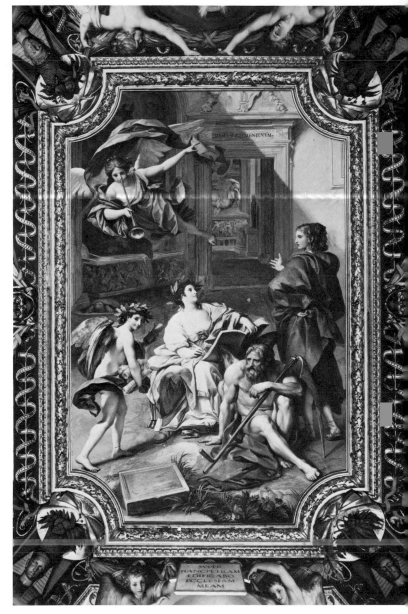

FIG. 30. ANTON RAPHAEL MENGS. *ALLEGORY OF THE MUSEO CLEMENTINO*. FRESCO. 1772. CEILING, GABINETTO DEI PAPIRI, VATICAN LIBRARY

fore the English House of Commons concerning the purchase of the Parthenon sculptures on February 15, 1816:

Chairman of the committee: "To which of the works you have seen in Italy do you think the Theseus [of the Elgin marbles] bears the greatest resemblance?"
The sculptor Joseph Nollekens (1737–1823): "I compare that to the Apollo Belvedere and Laocoön."
Chairman: "Do you think the Theseus as fine a sculpture as the Apollo?"
Nollekens: "I do."
Chairman: "Do you think it has more or less ideal beauty than the Apollo?"
Nollekens: "I cannot say it has more than the Apollo."

There followed this exchange with John Flaxman (1755–1826):

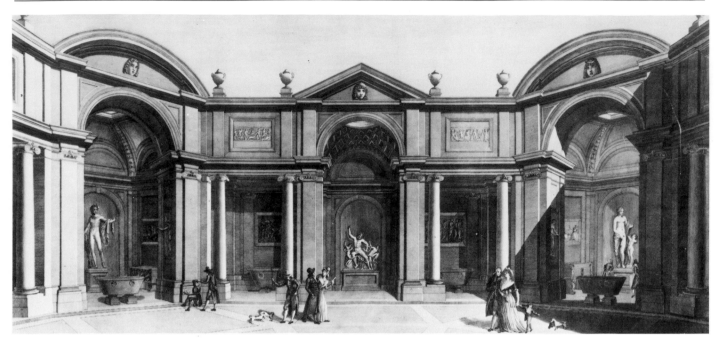

FIG. 31. VINCENZO FEOLI. *VIEW OF THE SOUTH SIDE OF THE CORTILE OTTAGONO*. (THE INSTALLATION
OF THE *APOLLO BELVEDERE*, THE *LAOCOÖN*, AND THE *VENUS FELIX* IS THE
SAME AS IN THE 16th CENTURY, BUT THE PORTICO WAS ADDED IN 1772–73.) ENGRAVING. c. 1790

Chairman: "In what estimation do you hold the Theseus, as compared with the Apollo Belvedere and the Laocoön?"

Flaxman: "If you would permit me to compare it with a fragment I will mention, I should estimate it before the Torso Belvedere."

Chairman: "As compared with the Apollo Belvedere, in what rank do you hold the Theseus?"

Flaxman: "I should prefer the Apollo Belvedere certainly, though I believe it is only a copy."

Chairman: "Supposing the state of the Theseus to be perfect, would you value it more as a work of art than the Apollo?"

Flaxman: "No; I should value the Apollo for the ideal beauty, before any male statue I know."

The painter Sir Thomas Lawrence (1769–1830) gave a different evaluation when asked to rate the Parthenon sculptures:

Chairman: "Do you conceive any of the Elgin Marbles to be of a higher class than the Apollo Belvedere?"

Lawrence: "I do; because I consider that there is in them an union of fine composition, and very grand form, with a more true and natural expression of the effect of action upon the human frame than there is in the Apollo, or in any of the other most celebrated statues."

And Benjamin West (1738–1820) contributed to the protocol:

"The Apollo of the Belvedere, the Torso, and the Laocoön, are systematic art; the Theseus and the Ilissus stand supreme in art."

The pope could not have hoped for a more resounding response to the new arrangement of the old statues in the Belvedere courtyard.

The reopening of the Cortile does full justice to the second motive in the inscription, that of ornamenting the Vatican Palace. The third statement in the dedicatory inscription from 1784 relates that Pius VI created his museum as something wholly new, a "fundamentis extruxit." From the Scala Simonetti, this phrase is visible over the entrance to the Biblioteca Apostolica, as well as from the Cortile Ottagono, above the entrance to the Sala degli Animali, and, in a slightly altered form, from the center of the floor of the Galleria delle Statue. In this last place one reads (in Latin): "Pius VI built the entire museum from this stone to the library, and decorated it." In fact, this pope had expanded the Galleria delle Statue to the west, connecting it to the Sala degli Animali. Although, in the process, the chapel containing late-fifteenth-century frescoes by Mantegna was sacrificed, the unity of the museum, as well as the arrangement and accessibility of the galleries, was immeasurably enhanced. The entrance to the Galleria delle Statue from the Cortile Ottagono was closed, to give prominence to the center of the museum. The courtyard now could be entered only from the Vestibolo Rotondo on the east and from the Sala degli Animali on the west, giving it an axial orientation. Simonetti's new building was aligned along that same axis, adding to it the Sala delle Muse and the Sala Rotonda—the latter a counterpart to, though far more grandiose than, the Vestibolo Rotondo.

The wall painting in the Sala Alessandrina of the library shows how Pius VI wished to present his museum (see fig. 33). A similar view appears in the painting by Bernardino Nocchi, with its allegorical figures reminiscent of the ceiling fresco by Mengs. From the foot of the Scala Simonetti one looks up, through the Sala a Croce Greca as a kind of vestibule, at the monumental entry portal to the Sala Rotonda, flanked by telamones and inscribed on its architrave: "Museum Pium." This is the view at the end of the over-300-meter-

long corridor, beside the courtyard of Bramante to the west; the arrangement is repeated on a smaller scale on the east side, where an inscription on the architrave over the entrance to the Vestibolo Rotondo reads: "Museum Clementinum." The sequence of grand staircase, vestibule, and imposing domed gallery would become a model for subsequent art museums.

The exhibition galleries are named either for their architectural form—the Sala a Croce Greca is a Greek cross with four arms of equal length; the Sala Rotonda is circular—or after the subjects of the works displayed in them, such as the Sala delle Muse or the Sala degli Animali. In the Sala Rotonda, in front of each pilaster that divides up the space, is a colossal bust on a truncated porphyry column. There are images of gods and of mortals, of Jupiter, Juno, and Ceres, and of Claudius, Hadrian, and Antinous. Copies of works from the fifth century B.C. by Pheidias and his followers are side by side with portraits from the time of the Roman Empire (the first century B.C. to the sixth century A.D.). According to Giovanni Battista Visconti, the first eloquent chronicler of the Museo Pio-Clementino, ancient art maintained the same high standard, whether from the age of Perikles in the fifth century B.C. or from the time of Hadrian well into the second century A.D. Thus, ancient monuments of the most diverse provenance are here placed together in a systematic arrangement and take on a visual and logical unity within their architectural context.

Found in a Tiburtine villa were numerous portraits of famous Greeks—those of the Seven Sages, as well as other philosophers, poets, and orators. One of these, the portrait *Herm of Perikles* (see cat. no. 124)—"son of Xanthippos, the Athenian," as the inscription on its shaft proclaims—achieved particular significance shortly after its discovery. In the summer of 1779, the poet Vincenzo Monti (1754–1828) recited his "Prosopopea di Pericle" in the "Arcadia," to such acclaim that this poem is still displayed in a frame next to the portrait. Referring to Pius VI he wrote: "Even in the realm of the Greek Elysium, though remote from grace, there is nonetheless one illustrious spirit worthy of doing you homage."

Pius VI died in Valence, on the Rhone, as a prisoner of Napoleon, at the age of eighty-two, on August 29, 1799. Following the agreement made at Tolentino on February 19, 1797, the chief works of his museum were to be delivered to the French, and this was accomplished after the occupation of Rome under General Berthier on February 10, 1798. On July 27 and 28, 1798, the plundered art was paraded through Paris in a ceremony organized in the manner of a Roman triumphal procession. When the Musée Napoléon opened in the Louvre on April 10, 1800, Bonaparte insisted on personally affixing an inscribed bronze tablet to the base of the statue of Apollo.

It seemed, then, that the generation that created the Museo Pio-Clementino would also experience its dissolution. Yet, the idea that gave birth to this museum would prove to be much stronger, and more vital, contagious, and long-lived: the Pio-Clementino can still be admired in almost its original form even today—though now it is but a part of a museum, within a museum.

<div align="right">Georg Daltrop</div>

BIBLIOGRAPHY: G. B. and E. Qu. Visconti, *Il Museo Pio-Clementino*, I–VII, Rome, 1782–1807; P. Massi, *Indicazione antiquaria del Pontificio Museo Pio-Clementino in Vaticano*, Rome, 1792; A. Michaelis, *Ein Jahrhundert kunstarchäologischer Entdeckungen*, 2nd ed., Leipzig, 1908; B. Nogara, *Origine e sviluppo dei Musei e Gallerie Pontificie*, Rome, 1948; C. Pietrangeli, "Il Museo Clementino Vaticano," in *Rendiconti della Pontificia Accademia Romana di Archeologia*, 27, 1951/52, pp. 87–109; idem, *Scavi e scoperte di antichità sotto il pontificato di Pio VI*, 2nd ed., Rome, 1958; idem, "I musei Vaticani al tempo di Pio VI," in *Bollettino dei Monumenti Musei e Gallerie Pontificie*, I, 2, 1959–74, pp. 7–45; S. Howard, "An Antiquarian Handlist of the Pio-Clementino," in *Eighteenth Century Studies*, 7, 1973, pp. 40–61; S. Röttgen, "Das Papyruskabinett von Mengs in der Biblioteca Vaticana, ein Beitrag zur Idee und Geschichte des Museo Pio-Clementino," in *Münchner Jahrbuch der bildenden Kunst*, 31, 1980, pp. 189–245; H. von Steuben, "Das Museo Pio-Clementino," in *Antikensammlungen im 18. Jahrhundert*, ed. H. Beck et al. (Frankfurter Forschungen zur Kunst, 9), Berlin, 1981, pp. 149–65.

FIG. 32

FIG. 33

DOMENICO DE ANGELIS. *(LEFT): VISIT OF THE SWEDISH KING, GUSTAVUS III, TO THE MUSEO PIO-CLEMENTINO IN 1784, (RIGHT): PIUS VI VISITS THE MUSEUM THAT BEARS HIS NAME.* FRESCOES. 1818. SALA ALESSANDRINA, VATICAN LIBRARY

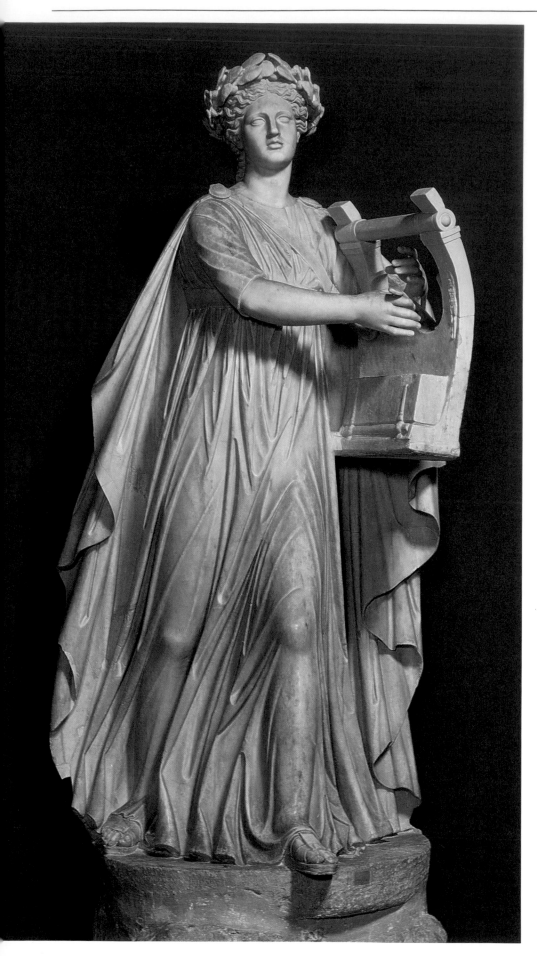

APOLLO MUSAGETES

Roman, 2nd century A.D. *(Hadrianic period),
 after a Greek original*
Marble
Height, 79¾" (202.5 cm)
Museo Pio-Clementino, Sala delle Muse, Inv. no. 310

The statue as it appears today is complete. Extensive modern restoration—above all, of the head and kithara—probably gives us an accurate idea of the *Apollo*'s original form. The head, added separately, has been part of the work since antiquity.

Together with eight statues of Muses (including cat. nos. 55, 56), the *Apollo* was discovered in the so-called Villa of Cassius, near Tivoli, by Domenico De Angelis in 1775. It was restored by Gaspare Sibilla, then acquired by Pius VI, and carried off by Napoleon to Paris, where it remained from 1798 to 1816.

The god Apollo, caught in a vigorously forward-striding pose, is characterized as a kitharode by the musical instrument whose strings he plucks and by his long, high-waisted robe. He also wears a chiton with sleeves, and a full-length cloak, draped across his back and fastened with two large buttons at the shoulders. His motion causes the robe to billow behind him. The head is raised, graced by a laurel wreath with a large jewel in the center; the hair is parted, some tied back, the rest falling freely. The kithara is secured by a band over his right shoulder. On the inside of the kithara's forward arm is the hanging Marsyas, in relief. Most of the kithara is restored, but the lower portion is surely antique.

The conception of this Apollo was based upon Greek models. The sense of movement in the drapery and the play of the folds, especially, are treated with a restraint that recalls the classicism of Hadrian's time. Though majestically cool, something of the originally dynamic image of the kithara-playing god, nonetheless, has found its way into the statue.

Although this Apollo is represented as the leader of the choir of the Muses, the vitality of the striding god is hardly compatible with the calmly standing and seated Muses; the statue, perhaps, was created as a single figure, and only later displayed with the assembled Muses.

The ancients regarded Apollo as the preserver of moral order and noble moderation. He was the god of the arts, particularly of music, and leader of the Muses, as Homer reported (*Iliad*, I, 603–4). Musical instruments and the bow are his attributes (for the bow, see cat. no. 20). Apollo is the source not only of the unerring arrow, but also of the apt song. Plato (*Republic*, 399 E) was convinced of the ethical effects of Apollonian music: "We are doing nothing new in granting precedence to Apollo and the instruments of Apollo [lyre and kithara] over Marsyas and his instruments [wind instruments]." *G. D.*

BIBLIOGRAPHY: G. Lippold, *Die Skulpturen des Vaticanischen Museums*, III, 1, Berlin, 1936, p. 60, no. 516, pls. 6–7; W. Helbig, *Führer durch die öffentlichen Sammlungen klassischer Altertümer in Rom: Die Päpstlichen Sammlungen im Vatikan und Lateran*, I, 4th ed., Tübingen, 1963, no. 82; K. M. Türr, "Eine Musengruppe hadrianischer Zeit," in *Monumenta Artis Romanae*, X, Berlin, 1971, pp. 36–40, 67–68, pls. 28, 30.

55

SEATED MUSE, THALIA

Roman, 2nd century A.D. (Hadrianic period),
* after a Greek original*
Pentelic marble
Height, 62 ¹³/₁₆" (159.5 cm)
Museo Pio-Clementino, Sala delle Muse, Inv. no. 295

This considerably damaged seated Muse has
been accurately restored, except for the posi-
tion of the right forearm and the *pedum* (or
shepherd's crook); the tympanum is, undoubt-
edly, correctly restored, given the curved depres-
sion in the folds of the garment on the left thigh.

This statue, too, was discovered by De Angelis
in 1775, in the so-called Villa of Cassius, with
the seven other Muses and the *Apollo Musagetes*
(see cat. nos. 54, 56). Like them, it was restored
by Sibilla, acquired by the pope, and taken to
Paris by Napoleon.

The mask, *pedum*, tympanum, and ivy wreath
characterize this youthful woman seated on a
rock as Thalia, the Muse of comedy and light
verse. She wears several layered garments: a chi-
ton buttoned along the arms under a chiton
without sleeves fastened with a large button on
each shoulder and secured by a belt, and a cloak
draped loosely over her legs. The wreath sug-
gests her affinity to Dionysos.

This type of Muse, of which five additional
statues and two heads survive, is notable for its
easy, relaxed, cross-legged pose, slender propor-
tions, wealth of movement in the composition,
and plasticity. The gracefully inclined head is
particularly effective in the version in the Museo
Gregoriano Profano (Inv. no. 9969), which, of
the two, is of superior execution and better
preserved. The Pio-Clementino Muse is a reflec-
tion, in the classicistic style of the second centu-
ry A.D., of the original, which was created in the
Late Classic period of the fourth century B.C.

The *Thalia* belongs to a group of Muses
whose attributes suggest their particular province
and function. In the rendering, an attempt was
made to capture the essence of each Muse; it
was only later that this differentiation of the
individual Muses gave way to the schema of
the nine. Ensembles of Muses were considered
appropriate decoration for private Roman li-
braries, reflecting the creative and literary ambi-
tions of their owners, as Cicero attests (*Ad fam.*,
7, 23, 2). The frequent combination of poets
and Muses on sarcophagi and in mosaics of the
Late Roman Empire may derive from actual dis-
plays of grouped statues.

 G. D.

BIBLIOGRAPHY: G. Lippold, *Die Skulpturen des Vatican-
ischen Museums*, III, 1, Berlin, 1936, p. 27, no. 503, pl. 4;
W. Helbig, *Führer durch die öffentlichen Sammlungen
klassischer Altertümer in Rom: Die Päpstlichen Sammlungen
im Vatikan und Lateran*, I, 4th ed., Tübingen, 1963, no.
63; K. M. Türr, "Eine Musengruppe hadrianischer Zeit,"
in *Monumenta Artis Romanae*, X, Berlin, 1971, pp. 32–35,
67, pls. 25, 26.

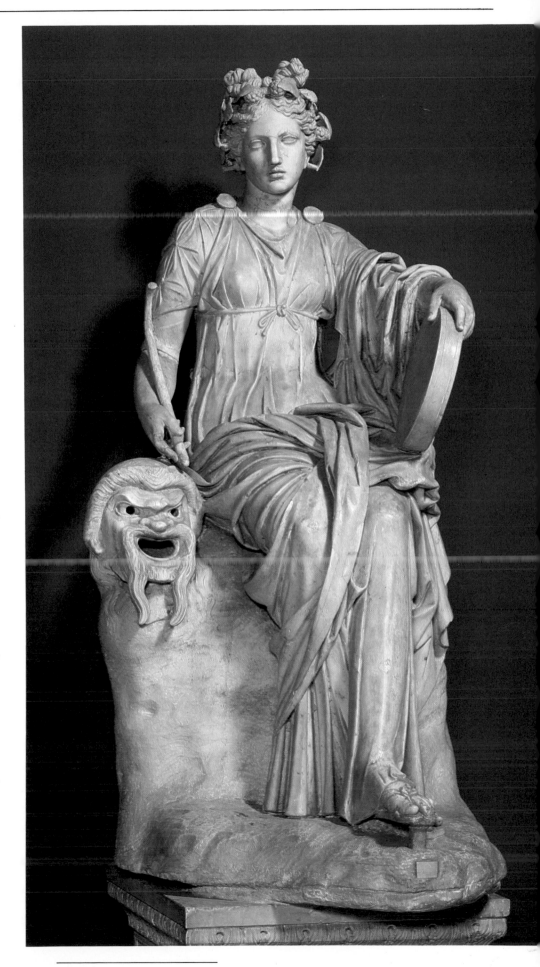

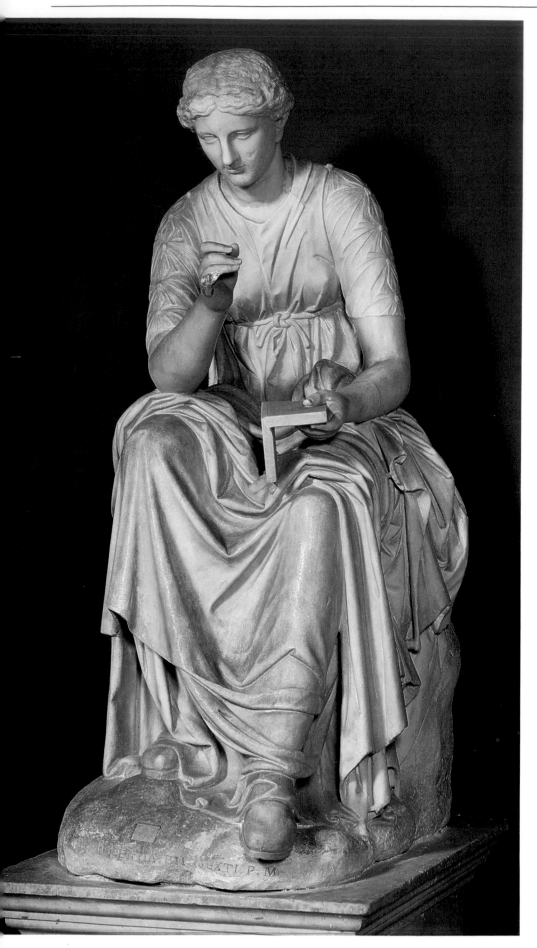

SEATED MUSE, CALLIOPE

Roman, 2nd century A.D. *(Hadrianic period), after
a Greek original*
Pentelic marble
Height, 50 13/16 " (129 cm)
Museo Pio-Clementino, Sala delle Muse, Inv. no. 312

This seated Muse is, doubtlessly, correctly restored. The head, worked separately and in large part a restoration, is not the original one; the marble appears to match, but not the style of execution.

De Angelis discovered this statue, together with seven other Muses and the *Apollo Musagetes* (see cat. nos. 54, 55). Sibilla was also the restorer, and, after its acquisition by the pope, Napoleon carried it off to Paris along with the other statues.

The writing tablet in her left hand identifies this figure as Calliope, the Muse of heroic poetry, the epic, and the elegy. One corner of the diptych on her lap is original; thus, the position of the left hand corresponded roughly to the hand as restored. She leaned on her right arm, and, in her right hand, she probably held a stylus. The *Calliope* wears a sleeved chiton, buttoned along the arm; a sleeveless, tightly belted chiton over that; and a cloak on which she sits and which lies across her lap.

This type of Muse, of which eleven similar examples exist (see Bibliography), derives from the basic scheme for seated figures first formulated in Late Classic times, during the fourth century B.C. The arm rests on the slightly higher leg with the foot drawn back, and the upper body turns in the direction of the advanced foot. The bending and turning of the body, here, particularly emphasize the meditative aspect of the elegiac Muse. The pose is, nevertheless, natural—as are the academic arrangement and deep modeling of the drapery. Such individual statues as the *Calliope* began to be represented as part of a group during the Hadrianic period, its components drawn from the rich store of Classic and Hellenistic images available to the sculptor.

In the late period, the Muses became schematic figures from a long-outmoded tradition. At one time, however, they were vital forces. In the epics of Homer, they inspired the poet with speech and with song. At the beginning of the *Iliad,* Homer asks the Muse of heroic poetry to sing of the wrath of Achilles; at the beginning of the *Odyssey,* he begs her to name for him the hero who was cast about after destroying the sacred city of Troy.

G. D.

BIBLIOGRAPHY: G. Lippold, *Die Skulpturen des Vaticanischen Museums,* III, 1, Berlin, 1936, p. 56, no. 515, pls. 7, 8; W. Helbig, *Führer durch die öffentlichen Sammlungen klassischer Altertümer in Rom: Die Päpstlichen Sammlungen im Vatikan und Lateran,* I, 4th ed., Tübingen, 1963, no. 80; K. M. Türr, "Eine Musengruppe hadrianischer Zeit," in *Monumenta Artis Romanae,* X, Berlin, 1971, pp. 28–31, 66, pl. 20.

57

EROS OF CENTOCELLE

Roman, 2nd century A.D. (Hadrianic period), after a
Greek original from the early fourth century B.C.
Marble
Height, 33 ½ " (85 cm)
Museo Pio-Clementino, Galleria delle Statue, Inv.
no. 769

This statue of a boy is well preserved, although
lacking both forearms from the elbows down,
and both legs below the thigh. Other minor dam-
age was sustained by the nose (restored) and
hair. Two vertical grooves on the back, each with
a large square hole, are evidence of the place
where wings were once attached.

The Eros was found in Centocelle, along the
Via Labicana, by Gavin Hamilton, from whom
Clement XIV acquired the statue in April 1772.
It was removed by Napoleon to Paris, where it
remained from 1798 to 1816.

The long-haired boy stood upright, most of
his weight on the left leg, the right one relaxed,
though only slightly, as the position of the thigh
indicates. Other copies of the statue show that
the winged Eros stood calmly, deep in thought,
a bow in his left hand. Presumably, the right
hand, at his side, held an arrow. The propor-
tions are Classic, reflecting the influence of Poly-
kleitos, especially in the way that the body is
slightly closed on the side of the supporting leg.
The delicate curvature of the central axis of
the compact torso and the modeling endow the
sculpture with a sense of movement. This kind
of sculptural form, and the tightly curled hair,
suggest that this copy was based on a bronze
original, while the lifelessness of the smooth mar-
ble and the unskilled use of the drill for the hair
are characteristic of Roman copies from the sec-
ond century A.D.

According to the ancient writers, in cult images
Eros was depicted as a boy of considerable
beauty, with a quiet grace of gesture. Praxiteles,
especially, is said to have created figures of this
type—which the *Eros of Centocelle* undoubtedly
resembles. Statues of Eros were found in gym-
nasiums, and the Spartans are known to have
sacrificed to him before going into battle. Eros
embodies the yearning of the soul, which he
accompanies through life and death, and leads
to higher bliss.

In Roman imperial times, Eros was reinter-
preted as a god of death and, therefore, the type
of the *Eros of Centocelle* appeared frequently as a
tomb statue; as the spirit of death, Thanatos, he
held a torch in his lowered right hand.

G. D.

BIBLIOGRAPHY: W. Amelung, *Die Sculpturen des Vatican-*
ischen Museums, II, Berlin, 1903, pp. 408–13, no. 250,
pl. 45; W. Helbig, *Führer durch die öffentlichen Samm-*
lungen klassischer Altertümer in Rom: Die Päpstlichen
Sammlungen im Vatikan und Lateran, I, 4th ed., Tübingen,
1963, no. 116; P. Zanker, *Klassizistische Statuen, Studien*
zur Veränderung des Kunstgeschmacks in der römischen
Kaiserzeit, Mainz, 1974, pp. 108–9, pls. 81, 82.

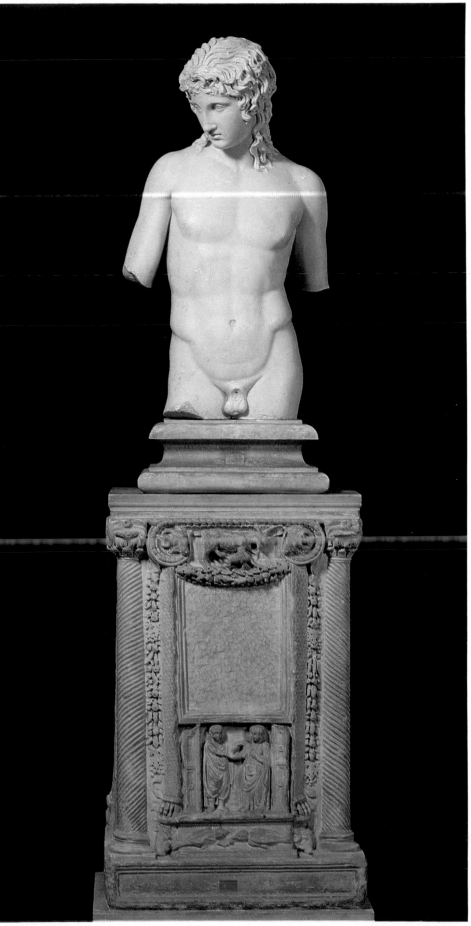

58

59

FUNERARY ALTAR

Roman, last quarter of the 1st century A.D.
Marble
Height, 33 1/16" (84 cm); width, 22 7/16" (57 cm);
depth, 16 15/16" (43 cm)
Museo Pio-Clementino, Galleria delle Statue,
Inv. no. 770

The inscription on the front of this square mono-lith must have been chiseled off before the altar was set up in the Museo Pio-Clementino. Otherwise, the altar has been only slightly damaged; the top, at the back, is restored.

Before it was acquired by the Vatican, this tomb altar is known to have been in San Lorenzo fuori le Mura. Since about 1780, it has served as a base for the *Eros of Centocelle* (see cat. no. 57).

At the edges of the block are columns with inward-twisting fluting and Composite capitals. Beside each column is the leg of a tripod deco-rated with scales and with paws for feet. Each leg supports a volute composed of bead-and-reel ornament and containing a ram's head fac-ing inward; between the volutes a goat nurses its kid. Through the volutes passes a garland, the ends of which hang down between the col-umns and the tripod legs. Below the tablet with the now-missing inscription is a relief of a man and wife in an open doorway, their right hands clasped in the gesture of *dextrarum iunctio* (see cat. no. 129). This scene and the legs of the tri-pod rest on a relief of birds fighting over an in-sect (a cicada), with rams' heads at either end. On each of the narrow sides of the altar is a laurel tree with birds at the foot of the trunk, framed at the back by an Ionic pilaster.

The composition of the altar's pictorial ele-ments, the inscription, the dress and rendering of the figures, and the characteristic drill holes in the carving of the garland point to a date in the Late Flavian period of the last quarter of the first century A.D. The group of the suckling goat evokes a bucolic idyll, to be understood as a symbol of peace and prosperity.

Tomb monuments in the form of altars could be used as libation altars, supports for sarcophagi, or as memorials. This funerary altar displays all the features of a memorial that the freedman Rhamnus once consecrated to the Manes of T. Vestricius Hyginus and his wife, Vestricia He-tera, as its inscription indicated before it was chiseled away.

G. D.

BIBLIOGRAPHY: *Corpus Inscriptionum Latinarum*, VI, 4, fasc. 1, p. 2790, no. 28639; W. Amelung, *Die Sculpturen des Vaticanischen Museums*, II, Berlin, 1903, pp. 413–14, no. 250a, pl. 45; W. Altmann, *Die römischen Grabaltäre der Kaiserzeit*, Berlin, 1905, p. 162, no. 204, ill. 132; N. Himmelmann, *Über Hirten-Genre in der antiken Kunst* (Abhandlungen der rheinisch-westfälischen Akademie der Wissenschaften, 65), Opladen, 1980, p. 123, pl. 41.

59 A. CANDELABRUM

Roman, 1st century A.D.
Marble
Total height, 72 5/8" (184.5 cm); height of base,
28 7/16" (72.2 cm); height of upper part,
44 11/16" (113.5 cm)
Galleria dei Candelabri, II 51, Inv. no. 2482

The candelabrum consists of a base, shaft, and bowl. The feet have been damaged and restored. The heads of the Erotes in the reliefs on the base are weathered, or missing.

Although known since the end of the fifteenth century—the candelabrum is shown in a draw-ing in the *Codex Escurialensis*—it was not until January 1772 that Clement XIV brought it to the Vatican from the church of Sant'Agnese in Rome.

The mock feet at the lower corners, upon which the three-sided base rests, consist of the bodies and wings of sphinxes and the claws of lions; between the sphinxes are ornamental re-liefs with palmettes, vines, and rosettes. On each of the three center panels of the base is an Eros, whose thighs terminate in acanthus leaves sprouting vines and rosettes. The Erotes hold baskets of fruit, bunches of grapes, fillets, a horn of plenty, or a *pedum*. Above these panels is a frieze of blossoms and palmettes, with rams' heads in the corners. The shaft, a baluster set on a profiled foot, appears to rise out of a calyx of acanthus leaves with blossoms. The middle of the shaft is encircled by a wreath of acanthus

59 A

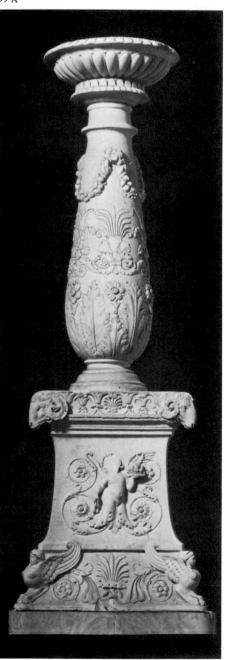

59 B

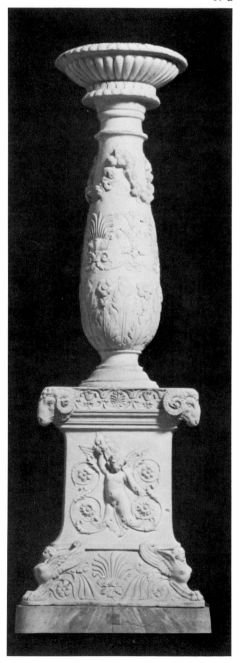

vines and palmettes, and, above, by three connecting swags made up of fruit. The strongly profiled top is composed of a projecting, turned row of petals, with a band of stylized, upright leaves above it. Over this is the fluted bowl (presumed to be modern), with an overhanging rim of leaves.

The clean, clearly defined treatment of the ornament and of the Erotes suggests Late Augustan rather than Trajanic work, as is generally proposed.

This candelabrum most certainly is one of a set of six from Sant'Agnese (one is still there, two are in the Galleria dei Candelabri, and another is in the Galleria Borghese), and formed a pair with no. 59 B. The slight differences among them do not argue against their belonging together. Candelabra served as lamp stands or as thymiaterions (incense burners). If they were not used for religious purposes (and the decoration in no way suggests that they were), they must have been part of the luxurious furnishings of Roman palaces. This type of candelabrum has persisted into the modern era in the form of a candlestick, or Easter light.

59 B. CANDELABRUM

Roman, 1st century A.D.
Marble
Total height, 71 ¼ " (181 cm); height of base,
27 ⅜ " (69.5 cm); height of upper part, 44 ⁵⁄₁₆ "
(112.5 cm)
Galleria dei Candelabri, II 44, Inv. no. 2487

This candelabrum is the mate to cat. no. 59 A. They share the same type of three-sided base, baluster-like shaft, fluted bowl (the upper portion of the shaft of this example was reworked in modern times; the bowl is entirely modern), decoration (including Erotes among vines), and style of carving in the reliefs.

<div align="right">G. D.</div>

BIBLIOGRAPHY: G. Lippold, *Die Skulpturen des Vaticanischen Museums*, III, 2, Berlin, 1956, pp. 188–89, no. 44, pls. 88–89 (cat. no. 59 B), p. 191, no. 51, pls. 90–91 (cat. no. 59 A); J. Bean, *Les dessins italiens de la collection Bonnat*, Paris, 1960, no. 252; W. Helbig, *Führer durch die öffentlichen Sammlungen klassischer Altertümer in Rom: Die Päpstlichen Sammlungen im Vatikan und Lateran*, I, 4th ed., Tübingen, 1963, no. 526; *Antiquity in the Renaissance* (exhib. cat.), ed. W. Stedman Sheard, Smith College Museum of Art, Northampton, Mass., 1978, no. 117.

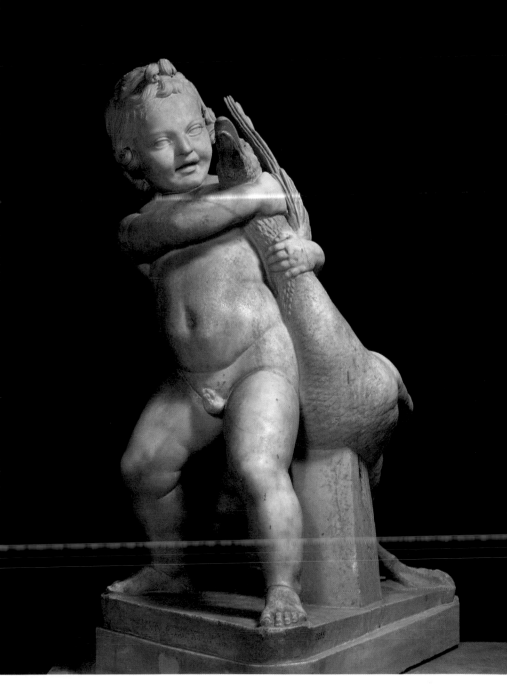

60

BOY WITH A GOOSE

Roman, 1st century A.D., after a Hellenistic original
of the 3rd–2nd century B.C.
Pentelic marble
Height, 33 ½ " (85 cm)
Galleria dei Candelabri, IV 66, Inv. no. 2655

In 1789, Ferdinando Lisandroni restored this sculpture—following a similar copy in the Stanza dell'Ercole (today known as the Stanza del Fauno) of the Museo Capitolino—mainly replacing the heads of the boy and the goose. The statue had been discovered on July 11 of that year—during excavations carried out by the pontifical museums in "Roma Vecchia"—in the Villa "Sette Bassi" in the Via Latina.

A small boy tests his strength on a goose, around whose neck he wraps his arms in a vise-like grip, as though he were going to throttle the bird. The boy stands like a little Hercules, wrestling with a powerful opponent almost bigger than he is. The seemingly serious effort expended on child's play imparts to the work a lighthearted quality.

Pliny (*Nat. Hist.*, 34, 84) mentions an "infans amplexando . . . anserem strangulat," a famous bronze by the artist Boethos; the present example is among the numerous extant copies of the work. The group is masterfully composed, in the form of a pyramid. The two bodies are pitted against each other, their weight thrust upward by the parted legs that brace and bear the conflict. The struggle culminates in the heads, the look of the tortured animal in sharp contrast to the mischievous pride on the face of the boy.

The original work typifies the genre and pathos of Hellenistic art at the turn of the third century B.C. Although the Roman copyist of the first century A.D. turned the work into a fountain—the water was piped through the support at the back—such a sculpture most probably was made for the sanctuary of a god of healing, as thanks for a young boy's recovery.

<div align="right">G. D.</div>

BIBLIOGRAPHY: G. Lippold, *Die Skulpturen des Vatican-ischen Museums*, III, 2, Berlin, 1956, pp. 325–27, 550, no. 66, pl. 145.

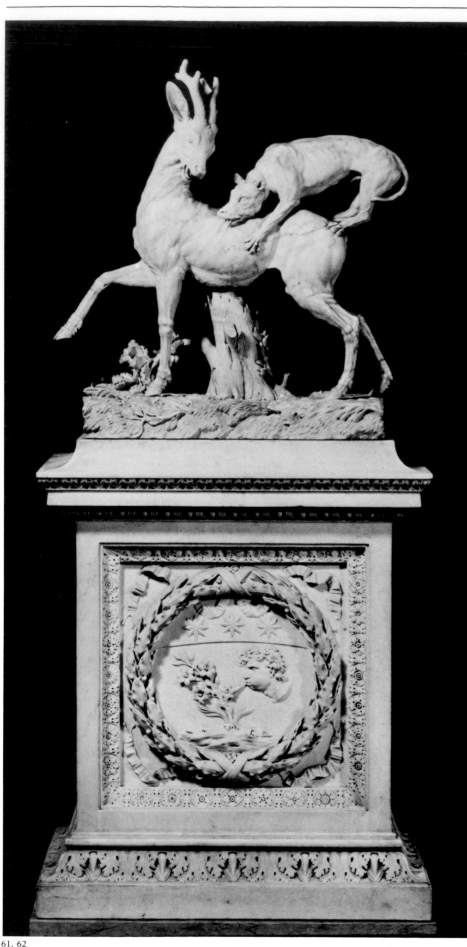

61

DOG ATTACKING A STAG

*Antique fragment, incorporated into a classicistic
 reconstruction*
Dark-veined marble
*Height, 31 ⅛" (79 cm); width, 28 ⅜" (72 cm);
 depth, 14 ³/₁₆" (36 cm)*
*Museo Pio-Clementino, Sala degli Animali,
 Inv. no. 441*

The body of the stag, the head of the dog—who
has bitten deeply into the animal's back—and
the dog's legs are original. About 1780, this frag-
ment provided Francesco Antonio Franzoni
(1734–1818) with a welcome incentive to cre-
ate the present animal group. The antique parts
were restored then, their surfaces brought to a
high polish.

The powerful representations of fighting ani-
mals that, in archaic Greek times, embellished
temple pediments as images of mortality in later
antiquity served merely as decoration. Animal
sculptures then became occasions for the intense
observation of nature, an academic exercise for
artists. The value of these works lies in their
specific content, rather than in their overall effect.

G. D.

BIBLIOGRAPHY: W. Amelung, *Die Sculpturen des Vati-
canischen Museums*, II, Berlin, 1903, pp. 328–29, no. 107,
pl. 39; W. Helbig, *Führer durch die öffentlichen Samm-
lungen klassischer Altertümer in Rom: Die Päpstlichen
Sammlungen im Vatikan und Lateran*, I, 4th ed., Tübingen,
1963, no. 103; on the subject of animals in antiquity: O.
Keller, *Die antike Tierwelt*, I, II, Leipzig, 1909, 1913; J. M. C.
Toynbee, *Animals in Roman Life and Art*, London, 1973.

62

MARBLE BASE WITH RELIEF

Rome, c. 1780
Carrara marble
*Height, 37 ¹³/₁₆" (96 cm); width, 30 ¹⁵/₁₆"
 (78.5 cm); depth, 19 ¹¹/₁₆" (50 cm)*
*Museo Pio-Clementino, Sala degli Animali,
 Inv. no. 441a*

This marble base belongs to the furnishings of
the Sala degli Animali, for which it was made
about 1780. It is probably by Franzoni, who re-
stored the animal groups displayed in that gallery.

The square base has a cyma, or molding, of
acanthus leaves below, and an egg-and-dart
molding and Lesbian cyma above. On each of
the four sides of the block a square field is framed
by a border ornamented with rosettes. Only the
front is decorated with a relief. Inside a bound
laurel wreath is a simplified rendering of the
coat of arms of Pius VI (Braschi; 1775–99): a
lily bends under a gust from Boreas, the north
wind, represented as a head, above which, sepa-
rated by a molding, are three stars.

The coat of arms no longer has its initial form
of a triangular shield with convex sides; also,
the signs of the original heraldic images have
been omitted to allow the narrative quality of
the picture to dominate. Boreas may refer to the
Swedish origin of the Braschi family. The sym-
bols and emblems remain somewhat puzzling,
even to the most knowledgeable scholars.

61, 62

At the beginning of the pontificate of Pius VI, his coat of arms was more richly ornamented: besides the wind, the lily, and the three stars, there was an imperial double eagle and a stylized lily. A verse affixed to the "Pasquino" group (which stands in front of the Palazzo Braschi in Rome) contained a mockery of it:

Give back the eagles to the empire, the lilies to the king of the French/Give back the stars to the sky, Braschi, and keep the rest for yourself.

The response to which was:

The lilies mean the Bourbons are friendly, the queen of the birds shows the Austrians are well disposed, the stars tell that God is on his side. But what about the snow-white flowers that endure while Zephyr blows? They stand for the character of an innocent prince.

G. D.

BIBLIOGRAPHY: P. Massi, *Indicazione antiquaria del Pontificio Museo Pio-Clementino in Vaticano*, Rome, 1792, p. 105, no. 35 (cf. also p. 36, no. 3); G. Ceccarelli, *I Braschi*, Rome, 1949, pp. 2, 11–12.

63

BEAR ATTACKING A BULL

Antique fragment, incorporated into a classicistic reconstruction
Marble
Height, 13 ⅜ " (34 cm); width, 16 ⅛ " (41 cm); depth, 7 ¹¹⁄₁₆ " (19.5 cm)
Museo Pio-Clementino, Sala degli Animali, Inv. no. 439

Only the body and neck of the bull and the forepart of the bear are original. Franzoni created a new sculpture from these antique fragments about 1780.

The bear lunges head on at its prey, while the bull tries to gore the flanks of its opponent, from below.

G. D.

BIBLIOGRAPHY: W. Amelung, *Die Sculpturen des Vaticanischen Museums*, II, Berlin, 1903, p. 329, no. 108, pl. 39.

64

PANTHER ATTACKING A GOAT

Antique fragments, combined in a classicistic composition
Marble
Height, 15 " (38 cm); width, 17 ⁵⁄₁₆ " (44 cm); depth, 8 ¹⁄₁₆ " (20.5 cm)
Museo Pio-Clementino, Sala degli Animali, Inv. no. 440

The original sections appear to be the bodies of the panther and goat, and bits of one of the panther's paws. Franzoni combined and reworked the two parts so skillfully that it is no longer certain what is antique and what is modern. Judging from the type of the paw, it is also possible that the animal attacking the goat might have been a lion.

G. D.

BIBLIOGRAPHY: W. Amelung, *Die Sculpturen des Vaticanischen Museums*, II, Berlin, 1903, p. 366, no. 174, pl. 39.

65

PIERINO DA VINCI (Vinci 1531–Pisa 1554)
**COSIMO I DE' MEDICI AS PATRON OF
PISA**

After 1549
Carrara marble
Height, 29 ⅛" (74 cm); width, 39 ¾" (108 cm)
*Museo Pio-Clementino, Galleria delle Statue, Inv.
 no. 742*

Until 1981, this relief was set into the south wall
of the Galleria delle Statue of the Museo Pio-
Clementino, which once had served as the prin-
cipal wing of the Palazzetto del Belvedere of In-
nocent VIII, on the site of the chapel decorated
by Mantegna. The original has been replaced
permanently with a plaster cast. The relief de-
picts Cosimo I de' Medici, of Tuscany, amidst
personifications of his own virtues, expelling
from Pisa "the many vices and natural defects
of the place that, like enemies, were besieging
and afflicting it everywhere" (G. Vasari, *Le Vite*,
1568, Milanesi ed., VI, 1878, pp. 128–29).

The grand duke, holding a scepter, is at the
center, in the act of raising to her feet (again in
Vasari's words) "a Minerva representing Wis-
dom and the Arts, which were revived by him
in the city of Pisa." According to E. Steinmann
(1908, pp. 40–42), the scene records Cosimo's
founding of the new University of Pisa in 1542,
its opening in 1543, and the creation, in 1547,
of the Ufficio de'Fossi (Office of Canals), a sort
of ministry of water control that improved liv-
ing conditions in the city. It is not known for
what purpose or for what monument this panel
was sculpted. Curiously, Vasari called the work
unfinished, "imperfetto"—perhaps, however,
referring to the project for which it was made. In
any case, it is one of the most beautiful and most
significant works of the very young Pierino that
is believed to have been executed upon his re-
turn from a stay in Rome during 1548 and 1549.
As Venturi (1936, X, 2, p. 332) noted, the tech-
nique resembles that of "a goldsmith who has
cast his figures in metal and then has subtly
incised their outlines on the background, while
softening their flesh in the manner of Bandinelli."
There are many references to the work of
Michelangelo, which Pierino certainly studied
very carefully during his Roman visit. Accord-
ing to P. A. Massi (1846, p. 76, no. 249), one of
the Virtues has Michelangelo's facial features—
perhaps the bearded figure in the second row,
on the left, framed by the two vessels carried by
a man and a woman. The Michelangelesque
quality of the relief suggested an attribution to
the master, himself, to Winckelmann's friend B.
Cavaceppi, who owned the work and published
it thus, in 1772 (cf. B. Cavaceppi, pl. 60). The
relief was purchased from Cavaceppi by G. B.
Visconti, who paid five hundred scudi, on be-
half of the Museo Clementino Vaticano—as re-
vealed by an autograph memorandum discov-
ered by Carlo Pietrangeli (which he kindly shared
with me). The document is important, for it in-
forms us that, prior to entering Cavaceppi's
collection, the relief was owned by the Salviati
family, and it provides a valuable indication of
the tastes that informed Visconti's choices. The

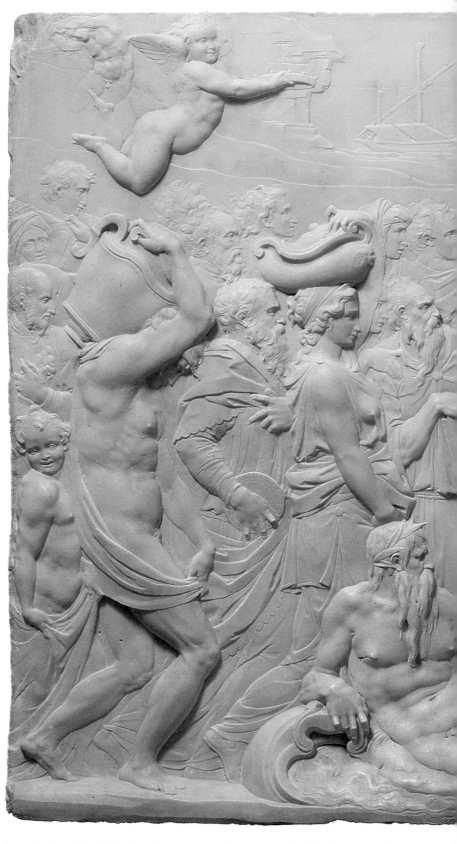

relief, then attributed to Michelangelo, was
considered—with much exaggeration—"of its
type the most elegant and famous work of the
sixteenth century, the restorer of the fine arts.
Indeed, how much prestige and esteem will come
to the Vatican, which, until then, had owned a
plaster cast of it, if it [the Vatican] could boast

of having acquired, in the space of a century,
the bas-relief from the Ottoboni tomb (the fu-
nerary monument of Alexander VIII by A. de
Rossi in Saint Peter's); the *Attila* (of Algardi in
the chapel of Saint Leo I in Saint Peter's); and
the present work, the most beautiful specimen
of the sixteenth century—that is to say, the

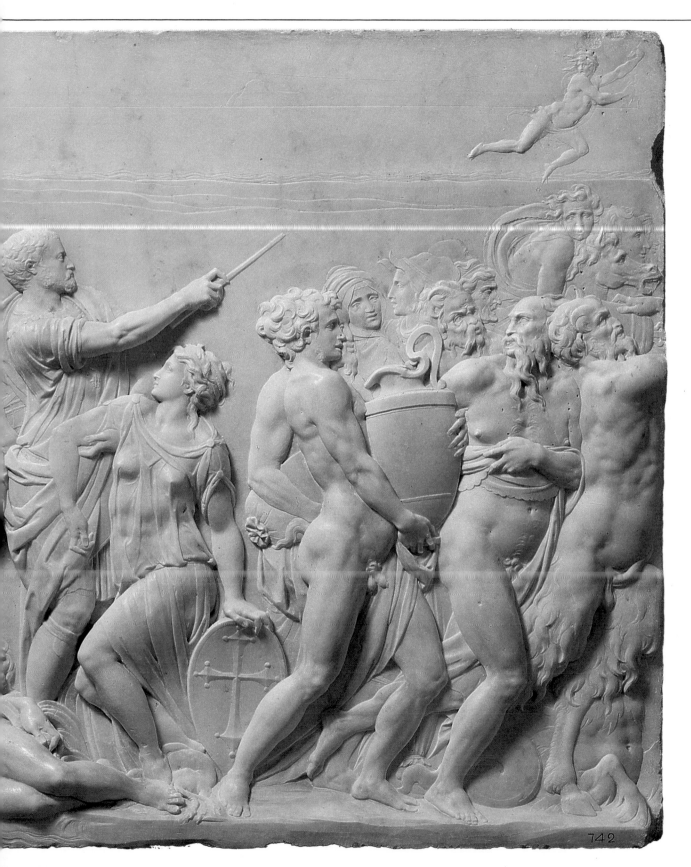

742

flowers of three centuries'' (cf. ''Giustificazioni del Museo Clementino,'' in the Archivio di Stato Roma, Camerale II, no. 308). Perhaps because of its ''exemplary'' character, Pierino's relief was the only Renaissance art exhibited in the Museo Clementino, providing a comparison with the sculpture of antiquity. *F. M.*

BIBLIOGRAPHY: B. Cavaceppi, *Raccolta d'antiche statue*, Rome, 1772, pl. 60; P. A. Massi, *Museo Pio-Clementino al Vaticano*, Rome, 1846, p. 76, no. 249; G. Vasari, *Le Vite de' più eccellenti pittori, scultori ed architettori*, 1568, Milanesi ed., Florence, VI, 1878, pp. 128–29; E. Steinmann, ''Zur Ikonographie Michelangelos,'' in *Monatshefte für Kunstwissenschaft*, I, 1908, pp. 40–52; *idem, Die Porträtdarstellung des Michelangelo*, Leipzig, 1913, p. 49; W. Gramberg, ''Beiträge zum Werk und Leben Pierino da Vincis,'' in *Jahrbuch der Preussischen Kunstsammlungen*, II, 1931, pp. 225–26; A. Venturi, *Storia dell'Arte Italiana*, Milan, X, 2, 1936, p. 332; C. Pietrangeli, ''Il Museo Clementino Vaticano,'' in *Rendiconti della Pontificia Accademia Romana di Archeologia*, XXVII, 1951–52, p. 106; J. Pope-Hennessy, *Italian High Renaissance and Baroque Sculpture*, London-New York, 1970, p. 361.

PINACOTECA

FIG. 34. BENJAMIN ZIX. MASTERPIECES FROM THE VATICAN'S COLLECTION OF PAINTINGS
EXHIBITED IN THE GRANDE GALERIE OF THE MUSÉE NAPOLÉON (NOW THE MUSÉE NATIONAL DU LOUVRE)
IN PARIS. WATERCOLOR FOR A SÈVRES VASE COMMISSIONED TO CELEBRATE
THE MARRIAGE OF NAPOLEON AND MARIE LOUISE, IN 1810. SÈVRES, MUSÉE NATIONAL DE CÉRAMIQUE

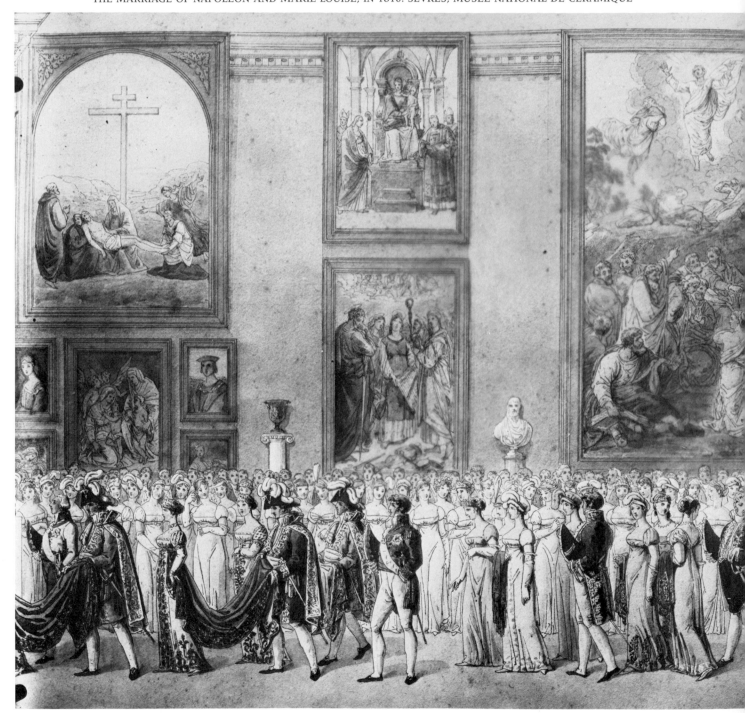

Paintings from the Vatican collections have been publicly exhibited for two centuries, but the present Pinacoteca, one of the newest buildings of the Vatican, opened to visitors just over fifty years ago, in 1932. The formation of the collection is associated with four popes: Pius VI (1775–99), Pius VII (1800–1823), Pius X (1903–14), and Pius XI (1922–39). About 1790, Pius VI created the first Pinacoteca in what is now the Galleria degli Arazzi. The space then consisted of three large rooms, and the pope ordered that a vaulted ceiling be constructed and decorated. The collection numbered 118 paintings, of varying provenance. Three of these—Poussin's *Martyrdom of Saint Erasmus*, *The Mass of Saint Gregory* by Sacchi, and Valentin's *Martyrdom of Saints Processus and Martinian*—had been removed from Saint Peter's for reasons of conservation and replaced by mosaics. Paintings by Reni and Guercino, Barocci's *Rest on the Flight into Egypt*, and a group of flower pieces by Seghers were also exhibited. Only works of the sixteenth, seventeenth, and early eighteenth centuries were displayed in the Gallery of Pius VI. As was typical of the taste of that time, paintings of earlier date—the so-called primitives, and Byzantine icons—were excluded, although such works had already entered the collections of the Museo Sacro of the library. The gallery was short-lived. Following the Treaty of Tolentino (1797), a number of the most important works were taken to Paris (fig. 34); as a result, and to give more space to the sculpture collection, the gallery was closed in 1802, and the remaining pictures were dispersed.

After the fall of Napoleon, Antonio Canova and Gaetano Marini secured the restitution of a number of works from the papal states that had been taken to France. In accordance with the allies' wishes, the most important of these were not returned to their places of origin, but were exhibited to the public as a group, as they had been in Paris. Thus, the new Pinacoteca, which opened in 1817 in the six rooms of the Borgia Apartment (fig. 35), included twenty-six works returned from Paris. Among these were Raphael's *Transfiguration*; paintings by Perugino, Reni, and Guercino; two predella panels by Fra Angelico; Barocci's *Blessed Michelina* and *The Annunciation*; and the *Pietà* by Giovanni Bellini. To this nucleus were added paintings from the Palazzo del Quirinale, Capitoline collections, and pontifical apartments—for example, Titian's *Madonna in Glory*, from San Nicolò dei Frari in Venice; and two Veroneses, *Saint Helen* and the small octagonal *Allegory*. The Pinacoteca of Pius VII included only forty-four pictures, but all were of the highest quality, a collection of masterpieces from the Renaissance and after. Salviucci's catalogue of 1821 describes the arrangement of the galleries. In the first room, the Sala dei Pontefici, three works of the sixteenth century and two of the seventeenth, very different in style and date, were exhibited: Raphael's *Transfiguration*, Giulio Romano's cartoon for *The Martyrdom of Saint Stephen*, and the paintings by Titian, Poussin, and Valentin mentioned above. The second room, the Sala dei Misteri, was even more heterogeneous. In it were exhibited the predella panels by Fra Angelico, Caravaggio's *Deposition*, Sacchi's *Saint Romuald*, *The Aldobrandini Wedding* (a Roman wall painting acquired by Pius VII in 1818), and five other fragments of ancient

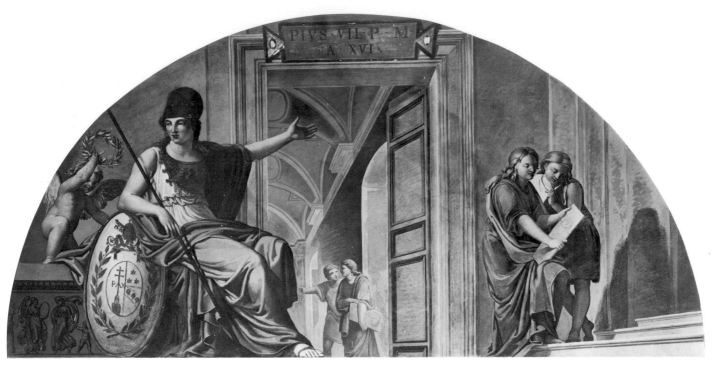

FIG. 35. TOMMASO CONCA. *THE INSTALLATION OF THE NEW PICTURE GALLERY, IN 1817, IN THE BORGIA APARTMENT.* FRESCO. GALLERIA CHIARAMONTI

Roman painting that had been discovered in recent excavations in Rome and its environs.

A number of early Italian paintings were acquired with the Mariotti Collection in 1820. These, however, were not shown in the Pinacoteca but in the library gallery that was set aside for the purpose. This group of early paintings in time was expanded, particularly under Gregory XVI (1831–46) and through the initiative of Monsignor Gabriele Laureani, prefect of the library, who sent an open letter to religious organizations in the papal states asking that paintings at their disposal be donated to the pope.

Although the Pinacoteca was moved several times, it should be emphasized that the collection created by Pius VII remained essentially unchanged throughout the nineteenth century. In 1846, under Gregory XVI, thirty-five pictures were exhibited, and, in 1870, during the pontificate of Pius IX (1846–78), forty-two works were on view. Throughout this period the Picture Gallery maintained its character as a collection of masterpieces exhibited for the pleasure of the pope.

By 1822, the Pinacoteca had been transferred from the Borgia Apartment—which was not well illuminated—to rooms on the third floor of the Logge of Gregory XIII. Having been exhibited briefly in the rooms used for the first Pinacoteca (fig. 36), and in the Apartments of Pius V, the paintings were returned to the Logge of Gregory XIII in 1857, at the request of Pius IX. Under Gregory XVI, Guercino's *Saint John the Baptist* and Carlo Crivelli's *Dead Christ* were added to the collection. Leonardo da Vinci's *Saint Jerome*, which was in the 1845 sale of the collection of Cardinal Fesch, entered the Pinacoteca rather later, in 1857. Under Pius IX, paintings by Guercino, Sassoferrato, Moretto, and Ribera also were acquired, and two by Murillo, *The Adoration of the Shepherds* and *San Pedro Arbués*, were presented by members of the Spanish royal family. Melozzo da Forlì's fresco *Sixtus IV Nominates Platina Prefect of the Vatican Library*, which, originally, had decorated the Latin Room in the Library of Sixtus IV, was transferred to canvas and moved to the Pinacoteca during the pontificate of Leo XIII (1878–1903).

The rooms described above were difficult of access, due to their proximity to the papal apartments; they came to seem small, disorganized, and poorly lit, and were subject to radical changes of temperature according to the season. Thus, with the advent of Pius X, the Pinacoteca was moved once again. The display was radically transformed: didactic criteria were adopted, the size of the collection increased substantially, and 277 works were exhibited. For the first time modern concerns, such as the need for conservation and for more logical organization, came into play. The site chosen for the new Pinacoteca was a series of rooms under the library, on the ground floor of the building to the west of the Cortile del Belvedere. The space was adapted to provide for an entrance area, seven galleries, and a storeroom. The rooms were vaulted, with stuccoed ceilings, and the walls were covered with fabric; the windows were curtained; a modern heating system was installed; and many works were restored to exhibitable state. The installation of the Pinacoteca was entrusted to the painter Ludovico Seitz and, after his death, to Professor Pietro D'Achiardi, who published the first scholarly catalogue of the collection. Again for the first time, each work was identified by a label with a suggested attribution, and all of the paintings were grouped by period and school.

To the existing collections had been added, in 1909, the Byzantine icons from the Museo Sacro, and the primitives from the Vatican Library (Margaritone's *Saint Francis*, Madonnas by Vitale da Bologna and Daddi, Pietro Lorenzetti's *Christ Before Pilate*, and the predella panels from Gentile da

Fabriano's Quaratesi Altarpiece, among others). A number of important works, many of the Quattrocento, were transferred from the Lateran museum—paintings by Carlo Crivelli, Benozzo Gozzoli, and Fra Bartolomeo, for example—as well as a Giulio Romano cartoon.

In fact, the Pinacoteca of Pius X assumed definitively the character of a public museum. The collection, which throughout the nineteenth century remained semiprivate—located near the papal apartments, infrequently open to visitors, and including only a small number of paintings, of excellent quality—was more systematically arranged and made available to a broader public.

The Pinacoteca was transferred during the pontificate of Pius XI to the building that houses it today. In 1922 and 1927, respectively, departments for the restoration of paintings and tapestries had been set up. Later, in accordance with the Lateran Treaty of February 1929, which established the borders of the new Vatican state, the Holy See pledged to make the artistic and scientific treasures of the Vatican available to scholars and visitors, while reserving the right to regulate public access. The present entrance was opened in the Vatican walls. The design and construction of a new building were entrusted to Luca Beltrami, but Pius XI personally selected the site and oversaw the planning of the new structure, which included galleries on the second floor and ancillary services below. The building is freestanding, ensuring ideal lighting conditions for the restoration studios on the ground floor. The exhibition galleries above, on the north side, receive side light, while those on the south side, and the Raphael gallery at the east end, are lit from above. By 1932, no fewer than 463 works were on view. Newly exhibited paintings included *Christ Blessing*, a Roman panel of the twelfth century; the Stefaneschi Altarpiece, painted by Giotto and his school for the high altar of Saint Peter's; the fresco fragments of angels and apostles by Melozzo, which were recovered in 1711 from the Basilica dei Santi Apostoli in Rome; the *Astronomical Observations* by Creti, removed from Castel Gandolfo; and portraits of Alexander VI (1492–1503), Clement IX (1667–69), and Benedict XIV (1740–58).

Again, the increased space permitted a more logical display, in which the works could be presented in chronological sequence, by school, and, where appropriate, by genre. Individual rooms were named after the dominant artist in each. For the first time, eighteenth-century paintings were also on view. On the other hand, the paintings of the fourteenth century and earlier, even then deprecatingly referred to as primitives, were still shown with Byzantine icons that differed radically in style and were centuries later in date. The installation, which was in the hands of Biagio Biagetti, has remained essentially unchanged to this day. A small selection of contemporary works has been acquired more recently, but these were subsequently absorbed into the Collection of Modern Religious Art established by Paul VI (1963–78) in 1973.

In 1972–73, the first three rooms of the Pinacoteca were reinstalled. A separate gallery is being prepared for the Byzantine icons. The panel paintings have been freed of later additions—nineteenth-century frames, for the most part—and

returned to their original dimensions. The modern retouching is integrated, but, at the same time, easily discernible with careful observation. The most important of the restorations completed recently is that of Raphael's *Transfiguration*, and, in 1980, the cleaning of Michelangelo's lunettes in the Sistine Chapel was begun. The year 1979 saw the publication of the first of a series of new catalogues, Volbach's study of all of the paintings in the papal collections dating from the tenth century to the time of Giotto. Further volumes are intended to be equally comprehensive, and a program of inventory and cataloguing has been undertaken in all of the properties of the Holy See.

Fabrizio Mancinelli

BIBLIOGRAPHY: G. A. Guattani, *I più celebri quadri delle diverse scuole italiane riuniti nell'Appartamento Borgia del Vaticano disegnati ed incisi a contorno da Giuseppe Craffonara pittore tirolese e brevemente descritti da G. A. G.*, Rome, 1820; G. and A. D'Este, *Elenco degli oggetti esistenti nel Museo Vaticano*, Rome, 1821, pp. 2–61; *Galleria di quadri al Vaticano*, Rome, 1846; G. Moroni, *Dizionario di educazione storico-ecclesiastica*, XLVII, Venice, 1847, pp. 91–97, LXXXVIII, Venice, 1858, pp. 243–44; *Galleria dei quadri al terzo piano delle Logge Vaticane*, Rome, 1857; X. Barbier de Montault, *Les Musées et Galeries de Rome*, Rome, 1870, pp. 167–72; A. Venturi, *La Galleria Vaticana* (Collezione Edelweiss, II), Rome, 1890; P. D'Achiardi, *La Nuova Pinacoteca Vaticana*, Rome, 1909; idem, *Guida della Pinacoteca Vaticana*, III, Rome, 1913; A. Muñoz, *I quadri bizantini della Pinacoteca Vaticana provenienti dalla Biblioteca Vaticana*, Rome, 1928; P. D'Achiardi, *I quadri primitivi della Pinacoteca Vaticana e del Museo Cristiano descritti e illustrati*, Rome, 1929; B. Biagetti, *La Nuova Pinacoteca Vaticana*, Vatican City, 1932; A. Porcella, *Musei e Gallerie Pontificie. Guida della Pinacoteca Vaticana*, Vatican City, 1933; E. Francia, *La Pinacoteca Vaticana*, Milan, 1961; D. Redig de Campos, *Itinerario pittorico dei Musei Vaticani*, Rome, 1964; C. Pietrangeli, "I Musei Vaticani al tempo di Pio VI," in *Bollettino dei Monumenti Musei e Gallerie Pontificie*, I, 2, 1978, pp. 7–45; *Monumenti Musei e Gallerie Pontificie. Catalogo della Pinacoteca Vaticana*, I, W. F. Volbach, *I dipinti dal X secolo fino a Giotto*, Vatican City, 1979; F. Mancinelli, *Pinacoteca (Musei Vaticani)*, Vatican City, 1981.

FIG. 36. THE PINACOTECA, AS INSTALLED IN THE GALLERIA DEGLI ARAZZI (FROM F. PISTOLESI, *IL VATICANO DESCRITTO ED ILLUSTRATO*, ROME, 1829)

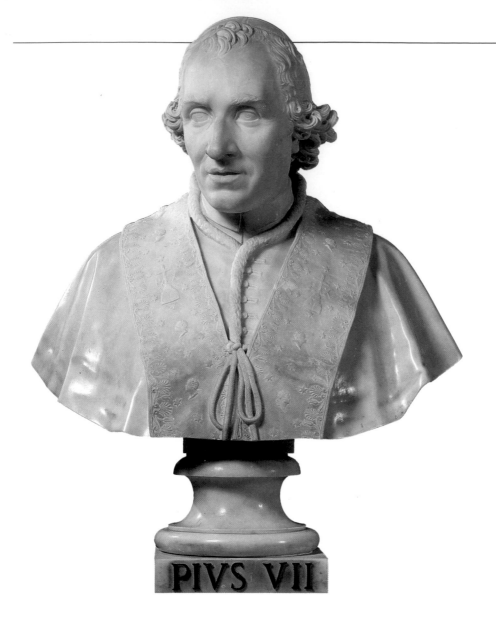

A–C. SAN NICOLA IN CARCERE

These frescoes were formerly part of the decoration of the Roman basilica of San Nicola in Carcere, where they covered the walls and vault of what the sources call the "confessione"—perhaps the crypt, or the three-apsed cella lying beneath the nineteenth-century chapel of the Madonna of Guadalupe. On the occasion of the 1855 restoration of the church (ordered by Pius IX), the surviving frescoes of the confessione were detached, transferred to canvas, and exhibited—together with those from the church of Sant' Agnese—in the Museo Cristiano Lateranense, which had been established a few years before by Gregory XVI. They remained there until 1926, when they were moved to the Vatican, restored, and placed in the storeroom of the Pinacoteca. Two of the tondi with prophets were exhibited in the Pinacoteca in 1973. From A. Ciacconio, who saw the confessione in 1591, we know that in addition to the frescoes that have been preserved (*The Baptism of Christ*; the tondi with the Prophets Amos, Haggai, Jeremiah, and Moses; and nineteen ornamental fragments), the decoration included a *Crucifixion* and a *Flagellation* (documented by Ciacconio's sketches) and four roundels of Saints Abundius, Abundantius, Mark, and Marcellinus (of which no graphic record survives). The *Baptism* roundel was located at the center of the vault and was bordered by the four tondi of the prophets—whose iconographic relationship to the central subject was underscored by the scrolls that they hold, each alluding to Christ and his mission of redemption. The three fragments with partridges and a hare amidst flowering shrubs probably belonged to the ceiling decoration, as well, since part of the same swag of fruits and foliage that appears in these sections was also included in the tondi and the central roundel. However, it is difficult to determine the original location of the other fragments. One of the walls, perhaps on the socle, might have been decorated with intersecting circles surrounding birds resting on, or holding onto, floral elements; these are not unlike the decoration below *The Legend of Saint Alexis* in the Roman basilica of San Clemente. All of the paintings are true frescoes, executed with rapid and impressionistic brushwork on a layer of plaster made of lime and sand and finished with a whitewash of lime and marble dust.

Stylistically, the frescoes of the confessione are related to other Roman paintings of the first quarter of the twelfth century. As W. F. Volbach (1979, pp. 16–17) has revealed, the iconography of the *Baptism* is Roman in all its constituent elements; roundels analogous to those of the prophets are to be found in Rome at Santa Croce and a little to the north in the town of Tuscania, and typologically similar decorative elements appear in Rome both at San Clemente and at Santa Pudenziana, and in the environs of Rome at Castel Sant'Elia. All of these cycles date from between the end of the eleventh and the first half of the twelfth century. Such a dating in the early eleven hundreds is, for the most part, agreed upon in the literature, including the re-

66

ANTONIO CANOVA (Possagno 1757–
Venice 1822)

PORTRAIT OF PIUS VII (1800–1823)

c. 1820–22
Marble
Height, 24 ⅜" (62 cm); with base, 34 ⅝" (88 cm)
Braccio Nuovo, Inv. no. 2301

The bust represents Gregorio Luigi Barnaba Chiaramonti (1742–1823), a Benedictine monk, who successively became bishop of Imola and Tivoli, cardinal in 1783, and Pope Pius VII in 1800. It was Pius VII who was responsible for the creation of the Museo Chiaramonti, the Braccio Nuovo, and the reorganization of the Vatican Pinacoteca. This is the third portrait of the pope executed by Canova. The first, sculpted in 1803–4, is today in the Musée National du Château de Versailles. The second, executed about 1806–7, was given by Canova to Pius VII in 1807; from him, it passed to the Protomoteca Capitolina upon its inauguration in 1820. Canova executed a replica of the latter portrait for

the Braccio Nuovo, which was opened in the same year.

The present work is that replica, signed on the base at the right A. CANOVA FECE. Its rather academic execution suggests the participation of an assistant, perhaps Adamo Tadolini, whose 1816 copy of the original is now in the University of Bologna. In the Capitolina portrait, as in the one at Versailles, Canova attempted to capture Pius VII "at one of those moments, so difficult to record, of serenity and gentle sweetness that characterized his most clement heart," but, in the replica for the Braccio Nuovo, the psychological observation remàins superficial, subordinated to the desire to render individual details with cold precision. The impeccable, almost virtuosic execution of the face and hair contrasts with the generalized and uncertain rendering of the details of the mozzetta and the stole, in which, according to V. Martinelli (1955), the hand of an assistant clearly can be seen.

F. M.

BIBLIOGRAPHY: A. D'Este, *Memorie di A. Canova*, Florence, 1864, p. 253; V. Martinelli and C. Pietrangeli, *La Protomoteca Capitolina*, Rome, 1955, pp. 40–44; G. Pavanello, *L'opera completa di Canova*, Milan, 1976, p. 132, no. 337.

cent studies that have associated the frescoes with the restoration and reconsecration of San Nicola in 1128.

67 A. THE PROPHET MOSES

Roman school, c. 1120–30
Fresco
Diameter, 23 7/16" (59.5 cm)
Pinacoteca, Inv. no. 508

The tondo, restored in 1972 using conservative techniques, is in relatively good condition. As the inscription indicates, the Prophet Moses is represented; he holds a scroll whose text, from Acts (7:37), alludes to the coming of Christ: . . . VOBIS SVSCI / [TABIT] . . . FRATRIB[VS] (This is that Moses, which said unto the children of Israel, A prophet shall the Lord your God raise up unto you . . . him shall ye hear). The fresco was on the ceiling of the confessione and, with the other tondi representing prophets, formed the border of *The Baptism of Christ*.

67 B. THE PROPHET JEREMIAH

Roman school, c. 1120–30
Fresco
Diameter, 23 1/4" (59 cm)
Pinacoteca, Inv. no. 506

The tondo is in fairly good condition; it was restored in 1977 using conservative techniques. As the inscription indicates, the Prophet Jeremiah is represented; he holds a scroll inscribed with a text taken from Jeremiah (11:19), alluding to Christ's sacrifice: . . . CO QVASI AGNVS MAN / [SVET] VS QVI PORTATVR (But I was like a lamb or an ox that is brought to the slaughter; and I knew not that they had devised devices against me . . .). The fresco decorated the ceiling of the confessione and, with the other tondi representing prophets, formed the border of *The Baptism of Christ*.

67 C. DECORATIVE FRAGMENT

Roman school, c. 1120–30
Fresco
Height, 17 3/4" (45 cm); width, 14 3/16" (36 cm)
Pinacoteca, Inv. no. 489

This fragment is in a good state and was restored in 1981 using conservative techniques. It represents a pheasant seen in profile, between two shrubs with leaves and flowers. At the lower right is part of a curved swag—containing leaves and fruit on a black background—the edge of which was drawn with the aid of a compass. The presence of this swag suggests that the fragment might have been part of the decoration between the tondi on the ceiling of the confessione.

F. M.

BIBLIOGRAPHY: A. Ciacconio, *Descriptio coemeterii sive loci sacri subterranei antiquae Ecclesiae Sancti Nicolai in Carcere Tulliano a Fratre Alfonso Ciaccon ordinis praedicatorum elaborata anno Dom. 1591*, Biblioteca Vaticana, Cod. Vat. lat. 5409; O. Marucchi, *Guida del Museo Lateranense*, Rome, 1898, p. 178; L. Magnani, "Frammenti di affreschi medioevali di S. Nicola in Carcere nella Pinacoteca Vaticana," in *Rendiconti della Pontificia Accademia Romana di Archeologia*, VIII, 1932, p. 239; E. B. Garrison, Jr., *Studies in the History of Medieval Italian Painting*, III, Florence, 1957–58, p. 187; *Monumenti Musei e Gallerie Pontificie. Catalogo della Pinacoteca Vaticana*, I, W. F. Volbach, *I dipinti dal X secolo fino a Giotto*, Vatican City, 1979, pp. 11–17, nos. 2 B, D, F.

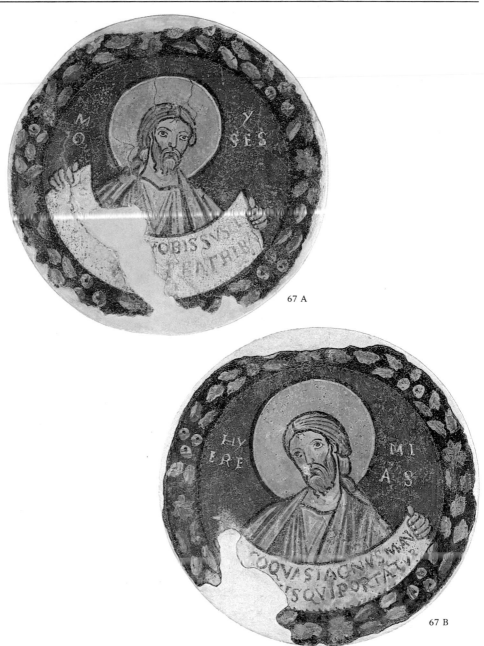

67 A

67 B

67 C

68

MARGARITONE DI AREZZO (MARGARITO DI MAGNANO), Arezzo 1216–c. 1290

SAINT FRANCIS OF ASSISI

c. 1270–80
Tempera on panel (fir)
Height, 50" (127 cm); width, 21 ¼" (53.9 cm)
Pinacoteca, Inv. no. 2

The panel, from the Vatican Library, was transferred in 1909 to the Pinacoteca of Pius X, where it was the earliest work in the gallery. In 1965, it was restored using strictly conservative techniques. Saint Francis is standing in a directly frontal pose, dressed in his usual gray-brown habit, his wounded feet exposed. The saint holds the Gospel in his left hand and raises his right to show the stigmata. At the lower left is the fragmentary signature of Margaritone: M[A]R[G]A[RI]TO D[E] [ARITI]O ME FE Č[IT]. During restoration it was found that the background and the dark-red band on which the saint stands (this band originally rose halfway up the panel) had been repainted; the additions were not removed but simply isolated after exposing the surviving original paint. The hood's once-pointed tip had long since abraded and become rounder, like that in the version in Siena (P. Torriti, 1977, p. 47); the cleaning restored its original form, as intended by the artist.

The painting is one of several versions of the subject by Margaritone. He, like Giunta Pisano, was very active in disseminating the image of Saint Francis, who was greatly venerated in the churches of Central Italy. Unlike Giunta, who added four scenes from the life of Francis to his representation, Margaritone created a prototype with the single, isolated figure of Saint Francis, which, to judge from the large number of surviving versions, enjoyed sufficient public favor to secure the posthumous fame of the Aretine artist. Of the variants, the most notable are those in Siena, Montepulciano, and Rome (the church of San Francesco a Ripa) and two in Arezzo (from Ganghereto, and from the monastery of Sargiano). The prototype may survive among the extant examples. A. M. Maetzke (1973, p. 108; 1974, pp. 28–30) believes that the picture from Sargiano might well be primary, as X rays revealed an earlier version, evidently painted a few years before, beneath the visible composition; this first rendition depicts Francis with his head uncovered and his eyes raised to heaven. For the Vatican panel, E. B. Garrison, Jr. (1949, p. 51, no. 57), and W. F. Volbach (1979, pp. 23–24, no. 6) propose a date between 1270 and 1280— about the time of the version in Siena and of most other known replicas. *F. M.*

BIBLIOGRAPHY: P. D'Achiardi, *Guida della Pinacoteca Vaticana*, III, Rome, 1913, p. 3, no. 1; E. B. Garrison, Jr., *Italian Romanesque Panel Painting*, Florence, 1949, p. 51, no. 57; A. M. Maetzke, "Nuove ricerche su Margarito d'Arezzo," in *Bollettino d'Arte del Ministero della Pubblica Istruzione*, VIII, 1973, p. 108; *idem*, "Margarito di Arezzo e Ignoto Toscano, S. Francesco," in *Arte nell'Aretino* (exhib. cat.), Florence, 1974, pp. 28–30; P. Torriti, *La Pinacoteca Nazionale di Siena, i dipinti dal XII al XV secolo*, Genoa, 1977, p. 47; *Monumenti Musei e Gallerie Pontificie. Catalogo della Pinacoteca Vaticana*, I, W. F. Volbach, *I dipinti dal X secolo fino a Giotto*, Vatican City, 1979, pp. 23–24, no. 6.

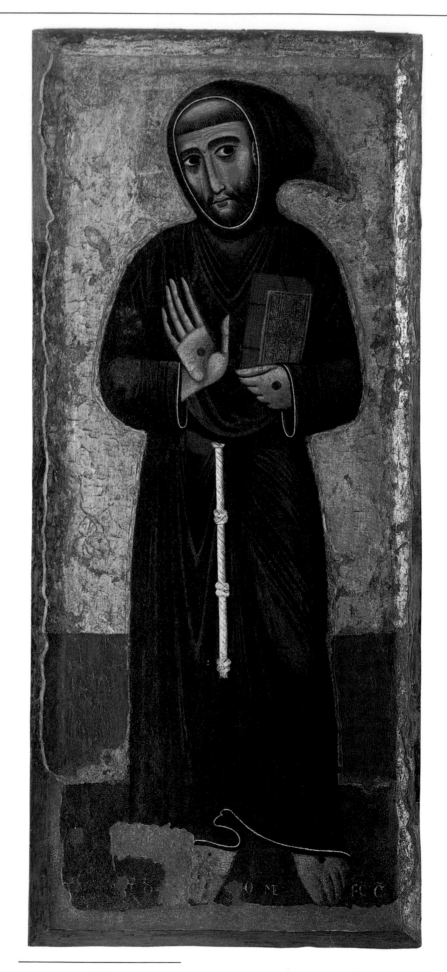

69

BERNARDO DADDI (Florence c. 1290–1355)
MADONNA AND CHILD

c. 1335–40
Tempera on panel
Height, 37¾" (96 cm); width, 24" (61 cm)
Palazzi Vaticani, Appartamento Pontificio, Inv. no. 180

This picture, restored in 1963, is in good condition. In 1909, it was transferred to the Pinacoteca of Pius X from the Vatican Library; in 1964, Pope Paul VI had the work brought to the Sala dei Papi in the Pontifical Apartment, where it remains today. The Madonna is represented half length, holding the infant in her arms. He toys with the collar of her dress and raises his right hand to tenderly caress the face of his mother. The theme, typifying the emotional relationship between mother and child, is expressed through gestures and the silent exchange of glances. The figures are monumentally conceived and rendered with a volumetric solidity that is underscored by a use of color highly decorative in effect but restricted in range. The panel is very close to several mature works by or attributed to Daddi: the *Madonna* in the Berenson Collection at Villa I Tatti; the triptych (or panels from a polyptych), dated 1334, in the John G. Johnson Collection at the Philadelphia Museum of Art; the *Madonna and Child with Saints Matthias and George, Four Angels, and a Donor*, dated 1336, at Bagno a Ripoli; and, to a lesser extent, the *Madonna* in the Acton Collection in Florence. On the basis of these similarities, G. von Vitzthum and Bernard Berenson attributed the picture to Daddi, himself, while O. Sirén, F. M. Perkins, and R. Offner considered it a work of his school—a hypothesis that is contradicted by the very high quality of the painting.

F. M.

BIBLIOGRAPHY: G. von Vitzthum, *Bernardo Daddi*, Leipzig, 1903, pp. 21–22; F. Mason Perkins, "Note su alcuni quadri del Museo Cristiano nel Vaticano," in *Rassegna d'Arte*, VI, 1906, p. 123; O. Sirén, "Notizie critiche sui quadri sconosciuti nel Museo Cristiano Vaticano," in *L'Arte*, IX, 1906, p. 330; P. D'Achiardi, *Guida della Pinacoteca Vaticana*, III, Rome, 1913, p. 4, no. 5; R. Offner, *Corpus of Florentine Painting*, sec. III, vol. IV, New York, 1934, p. 36; B. Berenson, *Italian Pictures of the Renaissance*, London, 1932, p. 167; *idem, Italian Pictures of the Renaissance. Florentine School*, London, 1963, p. 57.

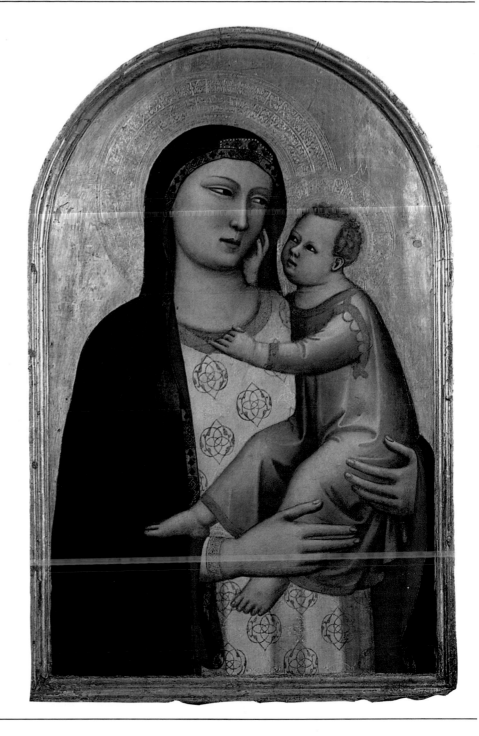

70

PIETRO LORENZETTI (Siena c. 1280–1348)
CHRIST BEFORE PILATE

c. 1335
Tempera on panel
Height, 15" (38 cm); width, 10 13/16" (27.5 cm)
Pinacoteca, Inv. no. 168

This small panel, restored in 1981 using conservative techniques, comes from the Vatican Library and was first exhibited in the Pinacoteca during the pontificate of Pius X (1903–14). The condition of the work is relatively good, despite some scratches and losses and an old, too-radical cleaning. Both the figures and the architectural and ornamental elements were first drawn with a stylus on the gesso priming of the panel, which is painted on both sides. The episode of the confrontation of Christ and Pontius Pilate, described in all the Synoptic Gospels, is represented on the obverse. The moment portrayed is that referred to by John (18:33–35), when Pilate asks Christ: "Art thou the King of the Jews? Jesus answered him, Sayest thou this thing of thyself, or did others tell it thee of me? Pilate answered, Am I a Jew? Thine own nation and the chief priests have delivered thee unto me: what hast thou done?" Pilate points to himself as he speaks.

The scene is rigorously designed to emphasize the two protagonists; Christ and Pilate are isolated at the right, while at the left are the High Priest and a small group of soldiers. The architectural elements, of great elegance and formal simplicity, determine the space in which the action takes place and, at the same time, divide the figures into two distinct, dramatically opposing groups. Despite its small dimensions, the picture possesses an extraordinary monumentality. On the reverse, the panel has not been left rough and untreated; rather, like the obverse, it has been smoothed and prepared with a gesso priming. A fictive marble design with a silvered border has been applied, of which a few traces remain of a reddish bole preparation. This deco-

ration indicates that the panel was intended to be seen on both sides and, originally, was part of a diptych or, more probably, a triptych painted for private devotion.

The painting is almost unanimously attributed to Pietro Lorenzetti, whose Sienese education, modified by Florentine influence, is evidenced by its chromatic, richly ornamental texture and by the placid solemnity and monumentality of the whole. Typical of the artist's more mature works is the particularly complex perspectival structure of the scene. Stylistically, the picture resembles the altarpiece from the chapel of Saint Sabinus in the cathedral of Siena, painted between 1335 and 1342 and now divided between the Museo dell'Opera del Duomo in Siena and the National Gallery in London, and the predella of the 1328 altarpiece from the Chiesa del Carmine in Siena, now in the Pinacoteca of that city. Martin Davies (1961, p. 301) believes that the panel might have been part of the predella from the chapel of Saint Sabinus, but the presence of the decoration on the reverse seems to exclude this hypothesis.

F. M.

BIBLIOGRAPHY: P. D'Achiardi, *Guida della Pinacoteca Vaticana*, III, Rome, 1913, p. 6, no. 9; M. Davies, *The Earlier Italian Schools. National Gallery Catalogues*, 2nd ed., London, 1961, p. 301; E. Carli, *Pietro e Ambrogio Lorenzetti*, Milan (Siena), 1970; *idem, Pittori Senesi*, Milan, 1971, p. 108.

70

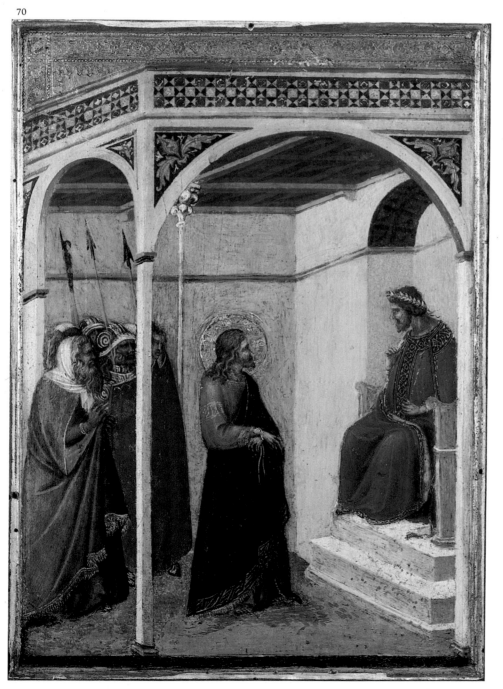

71

SASSETTA (STEFANO DI GIOVANNI),
Siena c. 1400–1450
THE VISION OF SAINT THOMAS AQUINAS

1423–26
Tempera on panel (poplar)
Height, 9 ⅞" (25 cm); width, 11 ¼" (28.5 cm)
Pinacoteca, Inv. no. 234

This work, which entered the Pinacoteca in 1909 from the collection of the Vatican Library, is one of the predella panels from Sassetta's dismembered Arte della Lana triptych (P. D'Achiardi, III, 1913, pp. 78–79). A restoration employing modern conservation techniques was undertaken in 1974; the painting is in fairly good condition despite some losses, particularly in the background. The picture, which still maintains its original dimensions, represents a well-known event in the life of Saint Thomas Aquinas. According to his biographers, in 1273 Thomas was praying before a crucifix at the monastery of San Domenico in Naples when he heard a voice asking him: "Thomas, you have written well of me; what reward do you wish to receive for your labors?" To which he replied, "Lord, nothing but you." In Sassetta's interpretation the image before which the saint kneels is not carved or painted but is, instead, a materialization of the crucified Christ, which is in turn draped with a veil. The book held by Thomas and the writing desk in the cell beyond clearly allude to the saint's career as a writer.

Sassetta does not place the scene in its actual locale, the chapel of the monastery of Saint Nicholas; rather, the event is set in a kind of loggia, before Thomas's cell, beside a courtyard with arches and pilasters viewed in perspective to give depth to the scene. The palette employed is at once extremely subdued and refined, in order to emphasize the spirituality of the moment represented. The triptych to which this predella panel belonged was painted by Sassetta between July 1423 and December 1426 as an altarpiece for the chapel of the Arte della Lana (the Wool Guild) in Siena. This chapel was attached to the former church of San Pellegrino and was used by the guild to celebrate its own festival: on the occasion of the Feast of Corpus Domini, a procession would leave the chapel and proceed to the nearby Chiesa del Carmine. In 1423, the altar of the chapel was still devoid of any altarpiece, and the members of the guild, disgraced and ashamed, agreed to solicit funds for one; from this arose the commission granted Sassetta. With the transfer of the celebration of Corpus Domini to the cathedral, the chapel of the Arte della Lana lost its importance. In 1798, it was severely damaged by an earthquake, and in 1816 it was demolished, along with the church of San Pellegrino. At that time, the triptych was dismembered and dispersed, but its appearance is known from eighteenth-century descriptions by Girolamo Carli and also by Angiolo Maria Carapelli, who noted that the frame was Gothic, "ending in many very pointed pinnacles." The central panel represented a subject related to the guild's feast, *The Exaltation of the Corpus Domini*,

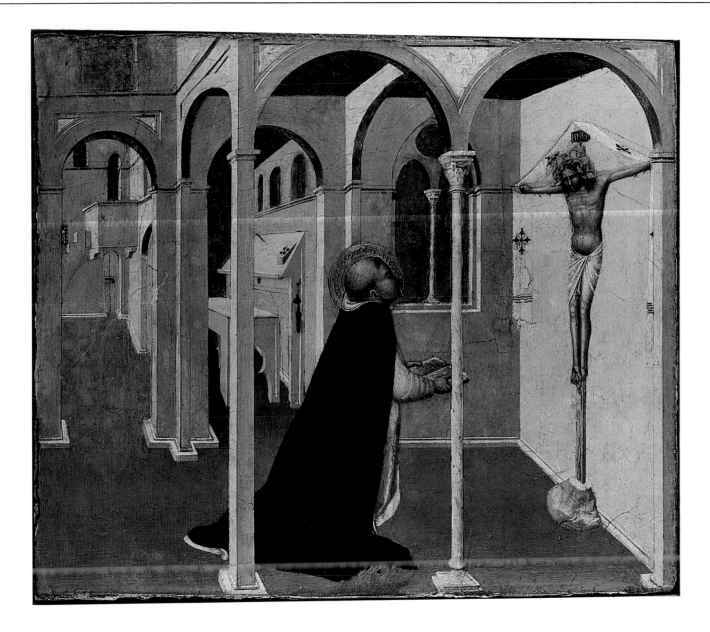

and featured a monstrance held by angels flying between other music-making angels—all, above a landscape with two castles, towers, and domes. The main part of this panel is lost, but E. Borsook (1966, p. 37) and F. Zeri (1973, pp. 29–32) believe that two fragments of the landscape survive in *A City on the Sea* and *A Castle on the Lakeshore* (Inv. nos. 70, 71) in the Pinacoteca in Siena; this proposal, however, has been rejected by P. Torriti (1977, pp. 113–15). Above the central panel was a *Coronation of the Virgin* (since lost). On the left was a *Saint Anthony Abbot*, identified by Zeri (1956, pp. 37–41) and, more recently, by Torriti (1977, p. 240)—in opposition to J. Pope-Hennessy (1956, pp. 364, 369)—with a work in the Costa Collection in Genoa; above this was an *Annunciate Virgin* (in the Yale University Art Gallery). To the right stood a *Saint Thomas Aquinas* (also presumed lost) surmounted by an *Angel Annunciate* (in the Museo Civico in Massa Marittima). On the pilasters were standing figures of Saints Jerome, Gregory, Ansanus, Victor, Ambrose, Augustine, Sabinus, and Crescentius (now in the Siena Pinacoteca). On the pinna-

cles were busts of the Prophets Elijah and Elisha (in the Pinacoteca in Siena), among others. The predella had as its central panel the *Last Supper* (also in Siena). At the left were the *Saint Thomas Aquinas in Prayer* (in the Szépmüvészeti Múzeum in Budapest), *The Vision of Saint Thomas* (in the Vatican), and *The Miracle of the Holy Sacrament* (in the Bowes Museum at Barnard Castle). On the right were *Saint Anthony Beaten by the Devils* (in the Siena Pinacoteca), *The Burning of a Heretic with the Elevation of the Host* (in the National Gallery of Victoria in Melbourne), and another panel (also lost). The triptych was one of the most beautiful and important Sienese works of the fifteenth century. Despite the Gothic frame, which was probably the wish of the patrons, certain aspects of the work are typical of a fully Renaissance conception: the naturalistic observation in the definition of the figures; the perspectival construction of architectural spaces, which are no longer Gothic; and the depth of the landscape backgrounds. Furthermore, the triptych is the first documented work by Sassetta, who signed it with self-conscious pride: HIC

OPVS OMNE. PATRES. STEPHANVS CONSTRVXIT AD ARAS SENENSIS JOHANNIS. AGENS CITRA LAPSVS ADVLTOS (following Pope-Hennessy's reading [1939, p. 39, n. 9], "Behold, Fathers [of the Guild], Stefano di Giovanni built this whole altarpiece for the altars of Siena without regard to the mistakes of the elders").

F. M.

BIBLIOGRAPHY: A. M. Carapelli, *Notizie delle chiese e cose riguardevoli di Siena*, 1718, Biblioteca Comunale di Siena, Ms. B VII 10, f. 30; G. Carli, *Notizie di Belle Arti*, c. 1768, Biblioteca Comunale di Siena, Ms. C VII 20, ff. 81–82; P. D'Achiardi, *Guida della Pinacoteca Vaticana*, III, Rome, 1913, pp. 78–79, no. 176; J. Pope-Hennessy, *Sassetta*, London, 1939, pp. 6–16, 39, n. 9; *idem*, "Rethinking Sassetta," in *The Burlington Magazine*, XCVIII, 1956, pp. 364–70; F. Zeri, "Towards a Reconstruction of Sassetta's Arte della Lana Triptych," in *The Burlington Magazine*, XCVIII, 1956, pp. 36–41; E. Carli, *Sassetta e il Maestro dell'Osservanza*, Milan, 1957, pp. 7–13; C. Volpe, "Sassetta e il Maestro dell'Osservanza," in *Arte Antica e Moderna*, I, 1958, pp. 83–86; E. Borsook, *Ambrogio Lorenzetti*, Florence, 1966, p. 37; F. Zeri, "Ricerche sul Sassetta: La Pala dell'Arte della Lana (1423–1426)," in *Quaderni di Emblema*, II, 1973, pp. 22–34; P. Torriti, *La Pinacoteca Nazionale di Siena, i dipinti dal XII al XV secolo*, Genoa, 1977, pp. 115, 240.

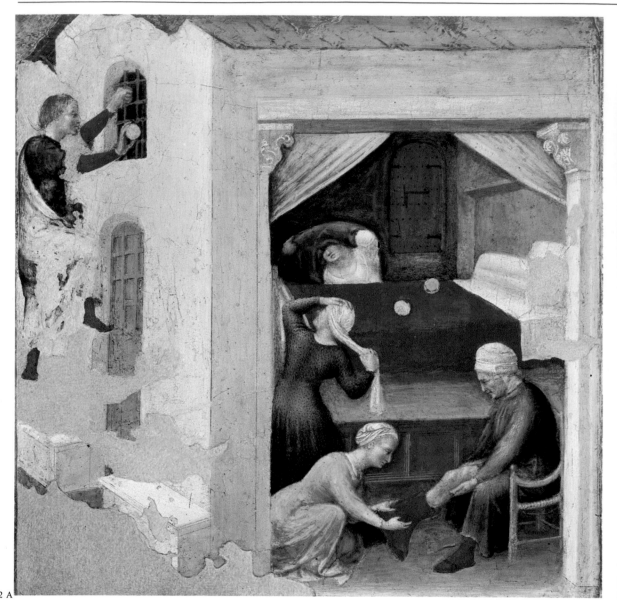

72 A

72

GENTILE DA FABRIANO (Fabriano
c. 1370–Rome 1427)

**A, B. PREDELLA PANELS FROM THE
QUARATESI ALTARPIECE**

The Quaratesi Altarpiece, which Vasari considered Gentile da Fabriano's finest painting, is one of the latest works of the Marchigian master. It was, in fact, painted two years before the artist moved to Rome (1427), where he died between August 2 and October 14 of 1427. The polyptych was commissioned from Gentile by the Quaratesi family for the principal altar of the church of San Nicolò sopr'Arno in Florence and was completed in May 1425 as the lost inscription indicated: OPVS GENTILIS DE FABRIANO MCCCCXXV MENSIS MAII (cf. S. Roselli, *Sepoltuario Fiorentino*, 1657, I, f. 193 r., Biblioteca Nazionale, Florence, Ms. II–IV, 534; and Richa, *Notizie delle*

chiese fiorentine, Florence, 1762, X, p. 270). In 1830, the polyptych was dismembered; the various panels are now divided among London; Florence; Washington, D.C.; and the Vatican (on the history of the altarpiece, see K. Christiansen, 1982, pp. 43, 104–5). The central panel, the *Madonna and Child with Angels*, was in the collection of Warner Young Ottley in 1835, from which it passed into the British royal collection in 1846; it is now on loan to the National Gallery in London. The lateral panels—*Saint Mary Magdalene, Saint Nicholas of Bari, Saint John the Baptist*, and *Saint George*—were donated to the Uffizi in 1879 by the Quaratesi family. One of the predella panels, representing *Cripples and Pilgrims at the Tomb of Saint Nicholas*, was acquired by Tommaso Puccini of Pistoia; it is now in The Samuel H. Kress Collection, National Gallery of Art, Washington, D.C. The picture was published independently by R. Longhi (p. 190) and W. Suida (p. 351) in 1940. The four other predella panels entered the Vatican Library in the nineteenth century, perhaps during Monsignor Gabriele Laureani's tenure as prefect (1838–49); they were transferred to the Pinacoteca in 1909.

The subjects of these works are *The Birth of Saint Nicholas, Saint Nicholas Gives Three Balls of Gold to Three Poor Maidens, Saint Nicholas Revives Three Youths*, and *Saint Nicholas Saves a Storm-Tossed Ship*. Sirén (1906, p. 334) associated these panels with the predella of the Quaratesi Altarpiece, but the attribution to Gentile at first was questioned. As Grassi (1953, p. 63) indicated, this doubt was due, in large part, to the condition of the panels. Until 1972, the four predella panels in the Vatican remained heavily overpainted, with losses reconstructed in a rather arbitrary fashion. Conservation treatment in 1973 brought to light damages caused by the removal of the original frame and by an irresponsible cleaning, presumably with soda and abrasive compounds. However, the treatment also revealed the extraordinary quality of the predella, which had prompted Vasari (1568; Milanesi ed., 1878, III, p. 7) to say that "there can be nothing more beautiful." As has been widely noted, in this work Gentile's fundamentally Gothic taste was adapted to the style then current in Florence. A broader handling of the paint replaced the meticulous and precise technique—Lombard in origin—that is

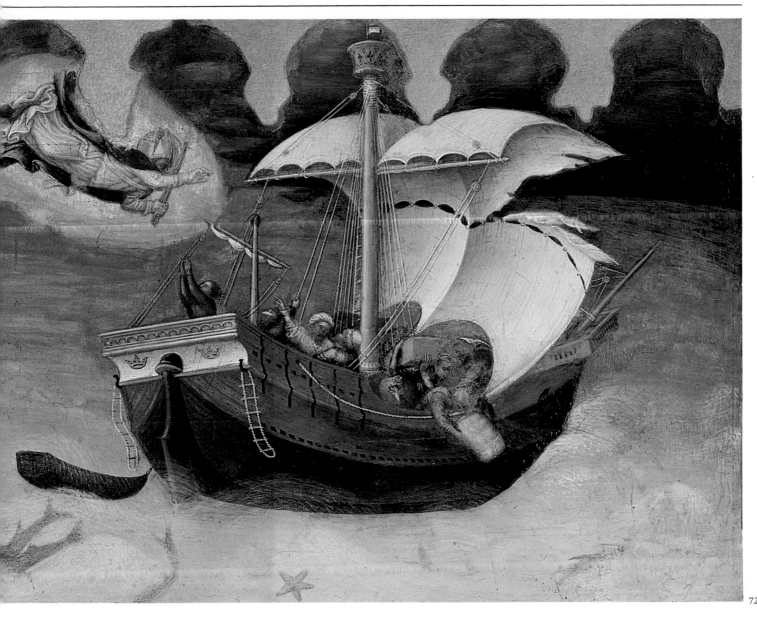

still perceptible, if only as a decorative element, in the dress of the poor maiden standing in the scene of the gift of the three gold balls. Furthermore, the figures acquired greater solidity and a more monumental conception, as did the entire compositional structure of the scenes. What remained Gothic were Gentile's extremely refined sense of color, the delicate play of shadows, and the imaginative and fanciful spirit with which he illustrates the story of the saint.

72 A. SAINT NICHOLAS GIVES THREE BALLS OF GOLD TO THREE POOR MAIDENS

1425
Tempera on panel (poplar)
Height, 14 3/8" (36.5 cm); width, 14 3/8" (36.5 cm)
Pinacoteca, Inv. no. 248

This work was restored in 1973 using strictly conservative techniques. The panel, whose original dimensions had been reduced, has several lacunae in the upper part that correspond with the contour of the original Gothic frame. It is presumed that the panel was originally on the left side of the predella (cf. L. Grassi, 1953, p. 62). Gentile records an episode from the youth of Saint Nicholas: he gave three gold balls that he made to three poor maidens so that their father would not be forced to sell them into prostitution. The story, one of the most famous in the life of the saint, is recorded in *The Golden Legend* of Jacobus de Voragine and is referred to by Dante in the *Purgatorio* (XX, 31–33) when Ugo Capeto speaks of "the bounty which Nicholas showed to the maidens to guide their youth to honor."

72 B. SAINT NICHOLAS SAVES A STORM-TOSSED SHIP

1425
Tempera on panel (poplar)
Height, 11 13/16" (30 cm); width, 24 7/16" (62 cm)
Pinacoteca, Inv. no. 249

This panel was also restored in 1973 using strictly conservative techniques; it no longer retains its original dimensions, and the lacunae along the top of the panel follow the pattern of the molding of the original Gothic frame. This work was the central panel of the predella and represents the saving of a ship in a tempest—one of the most celebrated posthumous miracles of Saint Nicholas, the patron saint of sailors. The cleaning of the picture brought to light the curvature of the horizon, which accentuates the fantastic character of the scene and accords well with the panel's central location.

F. M.

BIBLIOGRAPHY: G. Vasari, *Le Vite de' più eccellenti pittori, scultori ed architettori*, 1568, Milanesi ed., Florence, 1878, III, pp. 6–7; L. Cust, "The Quaratesi Altarpiece by Gentile da Fabriano," in *The Burlington Magazine*, VI, 1905, p. 470; O. Sirén, "Notizie critiche sui quadri sconosciuti nel Museo Cristiano Vaticano," in *L'Arte*, IX, 1906, pp. 332–34; R. Longhi, "Fatti di Masolino e di Masaccio," in *La Critica d'Arte*, V, 1940, pp. 190–91; W. Suida, "Two Unpublished Paintings by Gentile da Fabriano," in *The Art Quarterly*, III, 1940, pp. 348–52; L. Grassi, "Considerazioni intorno al Polittico Quaratesi," in *Paragone*, II, no. 15, 1951, pp. 23–29; idem, *Tutta la pittura di Gentile da Fabriano*, Milan, 1953, pp. 33–42, 61–64; E. Micheletti, *L'opera completa di Gentile da Fabriano*, Milan, 1976, pp. 90–91, nos. 37, 38; K. Christiansen, *Gentile da Fabriano*, Ithaca, 1982, pp. 43–48, 102–5, no. XIV.

73

MASOLINO DA PANICALE (TOMMASO DI CRISTOFORO FINI), Panicale c. 1383– ? after 1435

THE BURIAL OF THE VIRGIN

1428

Tempera on panel (poplar)
Height, 7¾" (19.7 cm); width, 19 1/16" (48.4 cm)
Pinacoteca, Inv. no. 245

This panel was restored in 1982 using conservative techniques. The figures are quite abraded due to an old overcleaning that exposed, at several points, the green underpainting of the faces and, in places, the preparatory design of the costumes—executed with the end of a paintbrush on the gesso priming. A sizable loss affects the chest of the apostle farthest to the left. The panel, which was part of the predella of an altarpiece, retains its original height, as can be seen by the gilded borders and the raised edges at top and bottom; it has been cut down (probably only slightly) at the sides. Its thickness, 1.07 centimeters, appears to be original.

The Burial of the Virgin, a theme not treated in the Gospels, is infrequently represented. Usually the Madonna is shown being lowered into the tomb by angels, but here the apostles, grouped about the sarcophagus, perform the deed. At the

sides, two pairs of angels, each holding a candle in a tall candlestick, frame the scene. At the center, Christ holds in his left arm the soul of the Virgin, represented as a baby in swaddling clothes, and extends his right hand—in which he holds a palm, symbolic of the promised paradise—toward the corpse of the Virgin. The figures of Christ holding the soul of Mary and Saint Peter reading a book are not usually found in representations of the Burial of the Virgin, but rather in scenes of her death. A. Schmarsow (1895, III, pp. 85 ff.) published the panel as a work by Masaccio, but Sirén (1906, p. 332) subsequently proposed the name of Masolino, an attribution that has been maintained since. Schmarsow also suggested that this panel, together with the small *Crucifixion* also in the Vatican (Inv. no. 260), was part of an altarpiece described by Vasari as a work by Masaccio (1568; Milanesi ed., 1878, II, pp. 293–94): " . . . in the church of Santa Maria Maggiore [in Rome], in a small chapel near the sacristy; in which there are four saints so well carried out that they appear to be in relief; and the Virgin of the Snows in the middle; and the portrait from life of Pope Martin who with a spade marks the foundations of that church; and beside him is the Emperor Sigismund II. " U. Procacci (cf. M. Davies, 1961, p. 355) identified the chapel described by Vasari as the one at the extreme east end of the church, between the choir and the north aisle—the chapel of the Colonna family dedicated to Saint John the Baptist. The altarpiece comprised *The As-*

sumption and *The Miracle of the Snow* (in the Museo di Capodimonte in Naples), the two panels in the Johnson Collection in Philadelphia representing *Saints Martin and John the Evangelist(?)* and *Saints Peter and Paul*, and the two in the National Gallery in London of *Saints Liberius(?) and Matthias* and *Saints Jerome and John the Baptist*. These panels almost certainly formed a triptych, painted on both sides (M. Davies, 1961, pp. 353–54). Masaccio's participation and the date of the work have been much discussed. Nevertheless, it is generally agreed that the altarpiece was executed by Masolino in 1428 (the other suggested dates are 1423 and 1425) and that Masaccio was responsible only for the *Saints Jerome and John the Baptist* in the National Gallery. It is not clear whether the Vatican panels representing *The Burial of the Virgin* and *The Crucifixion* belonged to the altarpiece. This hypothesis was maintained by Pope-Hennessy (1943, pp. 30–31), rejected by M. Salmi (1948, p. 222), and considered as possible by Davies (1961, p. 355). In any case, the provenance of the two Vatican panels is entirely different from that of the other pictures; in 1653, the works now in Naples, London, and Philadelphia were in the Palazzo Farnese in Rome and all of them were marked with the Farnese seal, which does not appear on the paintings in the Vatican. Pope-Hennessy (1943, pp. 30–31) published a small panel of *The Marriage of the Virgin* that is particularly close to *The Burial of the Virgin*; this work, which was destroyed during World War II, was

almost identical in size to the *Burial* and surely was part of the same altarpiece. The Masaccesque elements that characterize the figures in the Vatican panel appear there: the monumentality of the figures, despite their small size, and the simplified rendering of the drapery. The preparatory drawing can be seen in the overcleaned areas, and there is an important *pentimento* in the arrangement of the hands of the apostle who holds the head of the Virgin—originally, they were joined.

F. M.

BIBLIOGRAPHY: G. Vasari, *Le Vite*, 1568, Milanesi ed., Florence, 1878, II, pp. 293–94; A. Schmarsow, *Masaccio-Studien*, III, Kassel, 1895, pp. 85 ff.; O. Sirén, "Notizie critiche sui quadri sconosciuti nel Museo Cristiano Vaticano," in *L'Arte*, IX, 1906, p. 332; P. Toesca, *Masolino da Panicale*, Bergamo, 1908, pp. 69–70, n. 2; R. Longhi, "Fatti di Masolino e di Masaccio," in *La Critica d'Arte*, V, 1940, pp. 145–90; J. Pope-Hennessy, "A Predella Panel by Masolino," in *The Burlington Magazine*, LXXXII, 1943, pp. 30–31; M. Salmi, *Masaccio*, Milan, 1948, p. 222; K. Clark, "An Early Quattrocento Triptych from Santa Maria Maggiore, Rome," in *The Burlington Magazine*, XCIII, 1951, pp. 339–47; J. Pope-Hennessy, "The Santa Maria Maggiore Altarpiece," in *The Burlington Magazine*, XCIV, 1952, pp. 31–32; M. Salmi, "Gli scomparti della pala di Santa Maria Maggiore acquistati dalla National Gallery," in *Commentari*, III, 1952, pp. 14–21; U. Procacci, "Sulla cronologia delle opere di Masaccio e di Masolino tra il 1425 e il 1428," in *Rivista d'Arte*, XXVIII, 1953, pp. 3–55; M. Davies, *The Earlier Italian Schools. National Gallery Catalogues*, London, 2nd ed., 1961, pp. 352–61; L. Berti, *L'opera completa di Masaccio*, Milan, 1968, pp. 100–101.

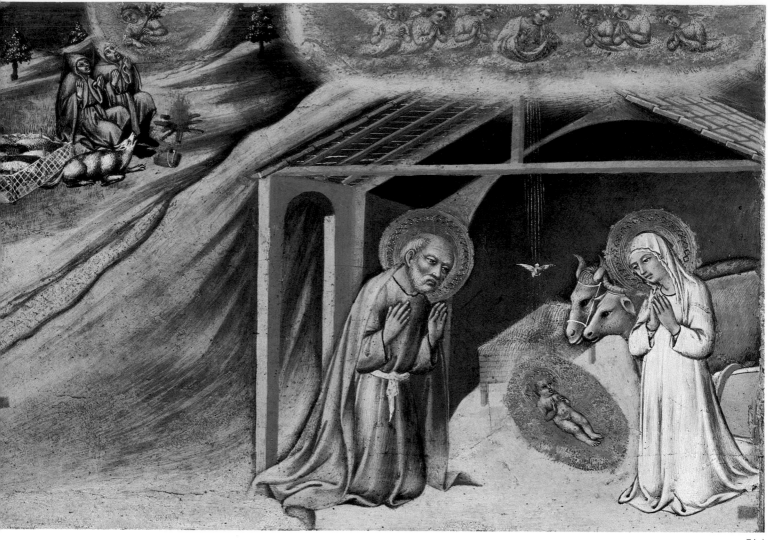

74

SANO DI PIETRO (Siena 1406–1481)

A, B. PREDELLA PANELS WITH
SCENES OF THE INFANCY
OF CHRIST

These two works representing the Nativity and the Flight into Egypt came from the Vatican Library and were first exhibited in the Pinacoteca in 1909. The provenance of the panels is unknown, but it has been suggested that, together with at least two others — *The Adoration of the*

Magi and *The Massacre of the Innocents* (both in The Metropolitan Museum of Art)—they once formed the predella of a large lost altarpiece. The attribution to Sano di Pietro, proposed by D'Achiardi (III, 1913, p. 83), is generally accepted, as is a dating between 1445 and 1450—before the qualitative decline in the artist's work occasioned by the level of commercial activity in his shop. In favor of a dating toward 1445 are the refined execution of the figures, which have not yet become rigidly stylized; the dream-like lyricism of the landscape in *The Flight into Egypt*, a worthy example of the Gothic tradition; and the soft spraying of paint in the rendering of the cobbled paths, which, in later paintings, would be effected with short brushstrokes (cf. C. Brandi, *Quattrocentisti Senesi*, Milan, 1949, p. 80, no. 57). The trees are typologically derived from those

in the predella of Sano's Osservanza Altarpiece of 1436 (Siena, Pinacoteca, Inv. no. 216) and particularly recall those in the *Saint Jerome in the Desert* (Siena, Pinacoteca, Inv. no. 265); the physiognomic types of Joseph and Jerome also may be compared. The group of shepherds in *The Nativity* anticipates the analogous rendering in Sano's *Annunciation to the Shepherds* (Siena, Pinacoteca, Inv. no. 262), which E. Sandberg Vavalà (cf. *Sienese Studies*, Florence, 1953, p. 271) dates between 1445 and 1450, and P. Torriti (cf. *La Pinacoteca Nazionale di Siena, i dipinti dal XII al XV secolo*, Genoa, 1977, p. 276) places after 1450. It should also be pointed out, however, that a later dating of the four panels divided between the Vatican Pinacoteca and the Metropolitan Museum has been proposed (F. Zeri and E. E. Gardner, 1980, p. 82).

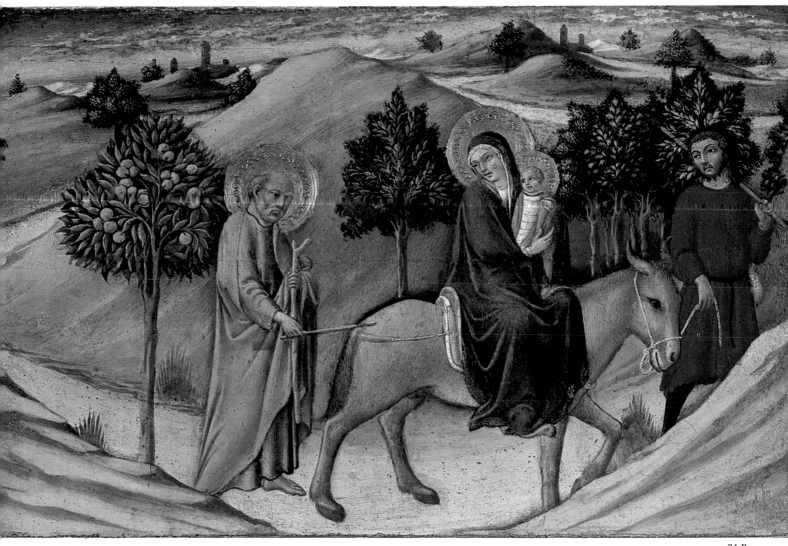

74 A. THE NATIVITY

c. 1445
Tempera on panel
Height, 12 ⅜" (31.5 cm); width, 17 ¾" (45 cm)
Pinacoteca, Inv. no. 144

The panel, which was restored in 1977, is in generally good condition, with a few small losses (near the bottom and in the background) inpainted with vertical hatching. The source is the Gospel of Saint Luke (2:6–14), which, with that of Matthew, records the Infancy of Christ. Joseph and Mary appear within a shed, kneeling in adoration before the Child, who is warmed by the breath of a pair of oxen; above is God the Father in glory, flanked by angels. The Virgin wears a white dress, symbolic of her purity,

while the dove descends toward the Christ Child, thus aligning the Trinitarian group of Father, Son, and Holy Spirit. In the background at the left is the Annunciation to the Shepherds.

74 B. THE FLIGHT INTO EGYPT

c. 1445
Tempera on panel
Height, 12 ⅜" (31.5 cm); width, 18 ½" (47 cm)
Pinacoteca, Inv. no. 145

Despite a scratch and some small losses (inpainted with vertical hatching), this panel, which was cleaned and restored in 1976, is in good condition. The Flight into Egypt, described in the Gospel of Matthew (2:13–15), is set in a

hilly countryside with the figures all proceeding to the right. Joseph is at the rear of the group and prods the donkey on which the Madonna and Child sit; an unusual addition is the figure of a servant, who pulls the animal along by the reins and looks back (as does the Virgin) to the road already traveled. A *pentimento* is visible in one of the donkey's hind legs.

F. M.

BIBLIOGRAPHY: P. D'Achiardi, *Guida della Pinacoteca Vaticana*, III, Rome, 1913, p. 83, nos. 183–184; B. Berenson, *Italian Pictures of the Renaissance. Central Italian and North Italian Schools*, London, 1968, p. 378; F. Zeri and E. E. Gardner, *Italian Paintings: Sienese and Central Italian Schools*, New York, 1980, p. 82.

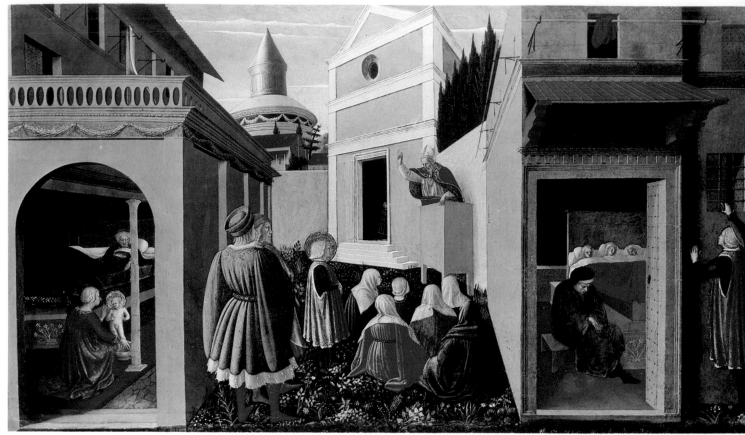

75 A

75

FRA ANGELICO (GUIDO DI PIERO),
Florence c. 1400–Rome 1455

A, B. PREDELLA PANELS FROM THE
PERUGIA TRIPTYCH

1437

The Perugia Triptych was painted by Fra An-
gelico in 1437 for the chapel of Saint Nicholas
in the church of San Domenico in Perugia; it
was, perhaps, commissioned under the terms
of the will of a former patron, the bishop, Bene-
detto Guidalotti (died 1429). The date of the
picture is known from Bottonio's *Annali*, which
survives in manuscript in the Biblioteca Comu-
nale in Perugia (Ms. ii, c. 72; published by
W. Bombe, 1912, p. 77). At some time before
1706, the triptych was transferred from the
chapel to the Sacristy of the church, where it
remained until 1797. In that year, following the
terms of the Treaty of Tolentino, the entire altar-
piece was sent to the Louvre in Paris; at the
time of their restitution, in 1817, these two pan-
els were placed on exhibit in the new Vatican
Pinacoteca of Pius VII (cf. G. and A. D'Este, 1821,
pp. 15–16, 33). After the predella was taken
apart, the main panels of the triptych were
moved to the chapel of Saint Ursula, also in
San Domenico, while the remaining predella
panel was hung above the door of the Sacristy.
In 1863, all the parts left in Perugia were trans-

ferred to the Galleria Nazionale dell'Umbria,
where they are today. The triptych was tem-
porarily reassembled in 1955, on the occasion
of the large exhibition commemorating the five-
hundredth anniversary of Fra Angelico's death.
At the center was the *Madonna and Child with
Angels*, flanked by two panels with two saints
each; on the left were *Saints Dominic and Nicho-
las* and on the right *Saints John the Baptist and
Catherine of Alexandria*. On each of the adjacent
pilasters were three pairs of saints in successive
ranks. Two tondi representing *The Annunciatory
Angel* and *The Virgin Annunciate* were above the
lateral panels; below were the three predella pan-
els recording scenes from the life of Saint
Nicholas, the patron saint of the chapel. Most
of the triptych is generally thought to be
autograph; however, Pope-Hennessy (1974, pp.
17, 199) has suggested that the panel at the right
is by an assistant who worked from Angelico's
cartoon and that the predella also may evidence
some collaboration. W. Weisbach (1901, p. 38)
and L. Collobi-Ragghianti (1955, p. 39), in par-
ticular, have proposed that the two panels in
the Vatican are by Pesellino—a suggestion refut-
ed in more recent criticism.

The Perugia Triptych is one of the most im-
portant of Angelico's works and anticipates the
full maturity of the San Marco Altarpiece. In
their monumentality, the figures are totally Ren-

aissance in conception, and the single light source from the left constitutes a rational element that serves to unify the whole. To these qualities is added a gem-like, crystalline color—in part taken up by Domenico Veneziano—that transfigures the scenes and imparts to them an unreal, otherworldly dimension. Some years after the execution of the Perugia Triptych, Angelico was called to Rome by either Eugene IV or Nicholas V; there, he worked in Saint Peter's and in the Vatican palaces and frescoed the chapel of Nicholas V (in the papal palace), one of the finest examples of his art.

75 A THE BIRTH OF SAINT NICHOLAS, HIS VOCATION, AND THE GIFT TO THE THREE MAIDENS

1437
Tempera on panel (poplar)
Height, 13" (33 cm); width, 24 13/16" (63 cm)
Pinacoteca, Inv. no. 251

This panel was restored in 1955 on the occasion of the exhibition commemorating the five-hundredth anniversary of Fra Angelico's death. There are some small paint losses, which have been integrated; the altered color, visible along the bottom and sides of the panel, is a product of the restoration. This work was at the left of the predella of the Perugia Triptych. The three episodes from the youth of the saint are all set in a cityscape open at the center but flanked by two projecting structures that give depth to the composition. The first scene documents the extraordinary precociousness of the saint, who, just after his birth, stood by himself when he was bathed in a basin. In the center is the calling of the young Saint Nicholas, who is seen listening to the bishop. At the right is the most famous episode from the saint's life—a subject also painted by Gentile da Fabriano (see cat. no. 72 A)—Nicholas's surreptitious gift of a dowry to three impoverished maidens whose father, fallen into misery, would have been forced to sell them into prostitution.

75 B. THE MEETING OF SAINT NICHOLAS WITH THE EMPEROR'S MESSENGER AND THE MIRACULOUS RESCUE OF A SHIP

1437
Tempera on panel (poplar)
Height, 13" (33 cm); width, 24 13/16" (63 cm)
Pinacoteca, Inv. no. 252

This panel also was restored on the occasion of the Fra Angelico exhibition in 1955. There are a number of small losses, which have been integrated; the band of varying color along the bottom of the painting is a result of restoration, and the eyes of some of the figures, which were damaged by a vandal long ago, also have been restored. This panel was at the center of the predella. The scene is a seascape of great depth accentuated by the diagonal placement of the figures; a second diagonal is formed by the rocks that separate the two episodes and underscore, with their abstract forms, the fabulous character of the tale. The pebbles on the beach are not painted with the end of the brush but, rather, are rendered by sprinkling the paint—a technique used by Gentile da Fabriano, which also reappears in Siena in the work of Sassetta, of the so-called Osservanza Master, and in that of the young Sano di Pietro. The two episodes portrayed are posthumous miracles of Saint Nicholas. At the left, Saint Nicholas appears to an imperial messenger (recognizable by his pointed hat). Through the intervention of the saint, a shipment of grain was delivered to the city of Myra, saving the people from famine. At the right, Saint Nicholas, the protector of sailors, materializes to rescue a ship from the stormy sea (see cat. no. 72 B).

F. M.

BIBLIOGRAPHY: G. and A. D'Este, *Elenco degli oggetti esistenti nel Museo Vaticano*, Rome, 1821, pp. 15 16, 33; W. Weisbach, *Pesellino und die Romantik der Renaissance*, Berlin, 1901, p. 38; W. Bombe, "Geschichte der Peruginer Malerei bis zu Perugino und Pinturicchio," in *Italienische Forschungen, herausg. vom Kunsthistorischen Institut in Florenz*, V, 1912, pp. 77–79; J. Pope-Hennessy, *Fra Angelico*, London, 1952, pp. 9–10, 170–72; L. Collobi-Ragghianti, "Studi angelichiani," in *Critica d'Arte*, IX, 1955, p. 39; E. Francia, *Tesori della Pinacoteca Vaticana*, Milan, 1964, p. 43; U. Baldini, *L'opera completa dell'Angelico*, Milan, 1970, p. 99, nos. 57 F, G; J. Pope-Hennessy, *Fra Angelico*, 2nd ed., Ithaca, 1974, pp. 17–18, 198–99.

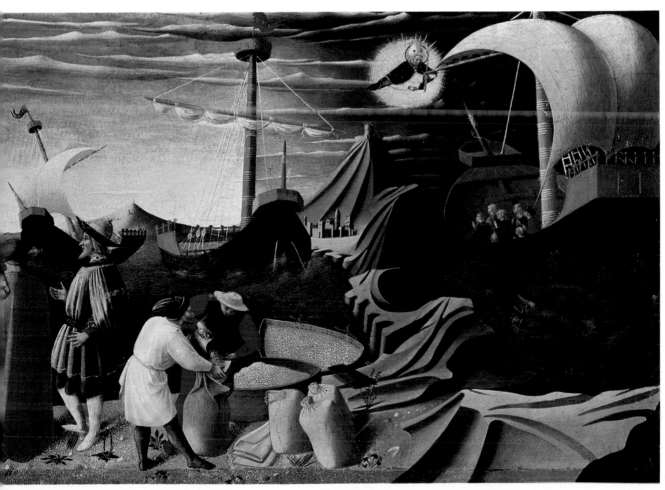

75 B

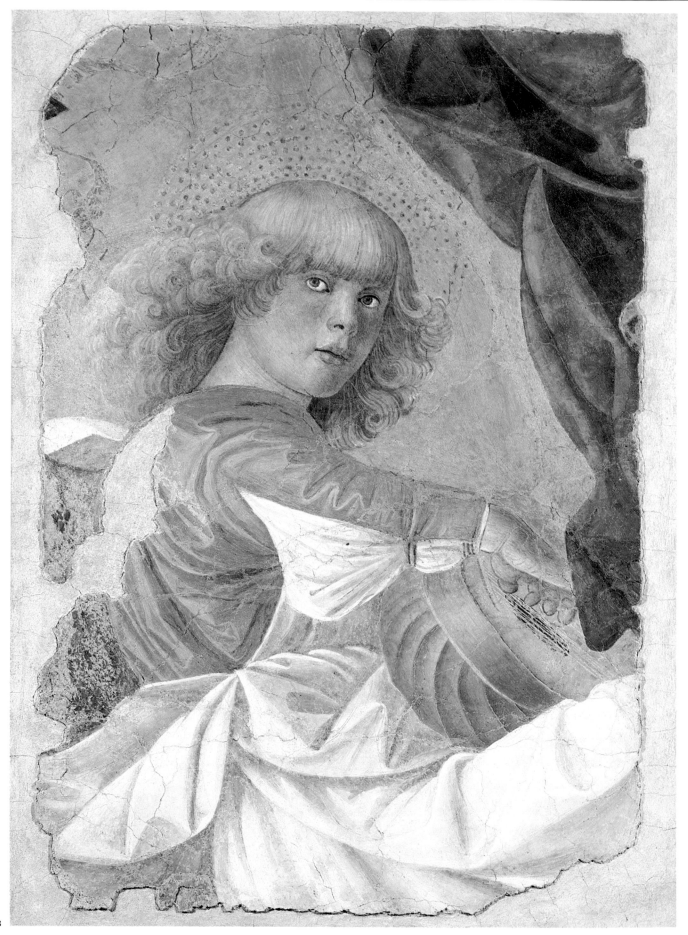

76 B

76

MELOZZO DA FORLÌ (MELOZZO DEGLI AMBROGI), Forlì 1438–1494
A, B. MUSIC-MAKING ANGELS

These two fresco fragments of music-making angels were part of *The Ascension of Christ*, the apse decoration of the Basilica dei Santi Apostoli painted by Melozzo shortly after the renovation of the church ordered about 1475 by Cardinal Giuliano della Rovere (nephew of Sixtus IV), the future Julius II (cf. E. Müntz, *Les Arts à la cour des papes*, Paris, 1882, III, p. 154). According to Vasari (1568; Milanesi ed., 1878, III, p. 52), the patron "by whom he [Melozzo] was richly rewarded" was Cardinal Riario, another nephew of Sixtus IV. Scholars generally date this work about 1480, soon after the fresco *Sixtus IV Nominates Platina Prefect of the Vatican Library* (now in the Pinacoteca) and the other documented works (since lost) for the Library of Sixtus IV. Vasari speaks with much admiration of the "Ascension of Jesus Christ, in the midst of a choir of angels who are leading him up to Heaven, wherein the figure of Christ is so well foreshortened that it seems to be piercing the ceiling, and the same is true of the angels, who are circling with various movements through the spacious sky. The Apostles, likewise, who are on the earth below, are so well foreshortened in their various attitudes that the work brought him much praise, as it still does, from the craftsmen, who have learnt much from his labours." This is the only document of the appearance of the work before it was detached from the wall. C. Ricci (1911, p. 8) believed that the entire fresco was reproduced in the background of another fresco representing *Sixtus V Proclaiming Saint Bonaventure a Doctor of the Church in the Basilica of the Santi Apostoli* (now in the Vatican Library), but this hypothesis was rightly rejected by A. Venturi (1913, VII, 2, p. 24, n. 1) and M. Salmi (1938, p. 236, n. 7). A reconstruction proposed by B. Biagetti, which is exhibited with the surviving fragments in the Pinacoteca, also appears hypothetical in some details. The *Ascension* remained *in situ* until 1711, when, under Clement XI, the apse was destroyed in order to enlarge the tribune. The surviving fragments were detached and restored by Giuseppe Chiari. The largest part, *Christ Ascending to Heaven Surrounded by Seraphim and Cherubim*, was sent to the Palazzo del Quirinale, while the heads of apostles and angels were given to the Vatican, through the intervention of the Oratorian Father Sebastiano Resta and Agostino Taja; these fragments were installed in the hemicycle of the Belvedere apartment, in the area currently occupied by the Museo Gregoriano Etrusco (A. Taja, 1750, pp. 360–61). Later in the eighteenth century, the Vatican fragments were moved to one of the octagonal rooms in the dome of Saint Peter's (E. Pistolesi, 1829, II, p. 177); after a restoration by Camuccini, they were transferred to the Sala Capitolare, or Chapter room, of the Sacristy. In 1932, Pius XI had them placed in the renovated Pinacoteca, thus uniting them with Melozzo's *Sixtus IV Nominates Platina Prefect of the Vatican Library*, which had been moved to the Pinacoteca during the reign of Leo

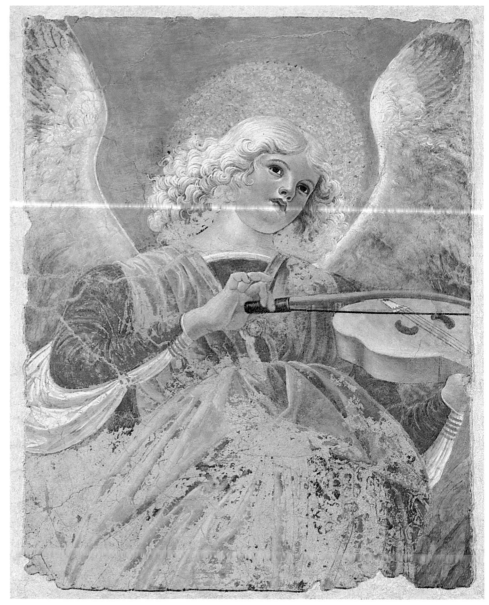

76 A

XII (1823–29). The Santi Apostoli fresco is a major work by Melozzo, a founder of the Accademia di San Luca who signed its charter in 1478 "Melotius Pi[ctor] pa[palis]" or "pa[latii]." It testifies to his full maturity and absolute mastery of perspective. The solemn, monumental figures are akin to the warriors by Bramante in the Casa Panigarola (now in the Pinacoteca di Brera in Milan). This fresco should be compared also with the decorations by Mantegna in the Camera degli Sposi in Mantua, which Melozzo might have known. Given the dimensions of the apse, Melozzo surely relied on workshop assistance. Although different hands are evident in the individual fragments, the unity of the whole was not sacrificed.

76 A. MUSIC-MAKING ANGEL

c. 1480
Fresco
Height, 44 5/8" (113 cm); width, 35 13/16" (91 cm)
Pinacoteca, Inv. no. 269–D

This work was restored in 1982 using conserv-

ative techniques and is in fairly good condition, except for those losses and abrasions dating from the time when the fresco was detached from the wall. Previously, the halo had been regilded, and only traces of the original gilding remain. The angel, looking upward, plays a stringed instrument, apparently a vielle. This fragment probably was part of the median band of the apse and, given the position of the body, was most likely to the viewer's left. The artist transferred the cartoon using pouncing and chalk dust for the head and hands, and incising for the wings and clothing. The blue sky is lapis lazuli.

76 B. MUSIC-MAKING ANGEL

c. 1480
Fresco
Height, 39 3/4" (101 cm); width, 27 1/2" (70 cm)
Pinacoteca, Inv. no. 269–0

This fragment was restored in 1982 using conservative techniques and is in a fairly good state; the losses date from the time when the fresco was

detached from the wall. The right eye of the angel is now inpainted with vertical hatching. Previously, the halo was heavily regilded; of the original gold, only traces remain. Early retouching, which was done with great care, may have been the work of Camuccini.

The angel looking out at the viewer is playing a lute. In Biagetti's reconstruction, this fragment was in the middle band of the apse, more or less at the center, as the position of the body is slightly turned to the observer's left. The red drapery and ribbons visible above belong to the *Angel Playing a Fife and Drum* (Inv. no. 269–F). The cartoon was transferred using pouncing and charcoal dust for the hands and head—traces of which remain on the lips and eyes—and incising for the wings and clothing. The blue in the sky and blouse is lapis lazuli.

<div align="right">F. M.</div>

BIBLIOGRAPHY: G. Vasari, *Le Vite*, 1568, Milanesi ed., Florence, 1878, III, pp. 51–52, 64; A. Taja, *Descrizione del Palazzo Apostolico Vaticano*, Rome, 1750, pp. 360–61; E. Pistolesi, *Il Vaticano descritto ed illustrato da Erasmo Pistolesi*, Rome, 1829, II, pp. 176–77; C. Ricci, *Melozzo da Forlì*, Rome, 1911, p. 8; A. Venturi, *Storia dell'Arte Italiana*, Milan, 1913, VII, 2, pp. 24–37; A. Tulli, "La Sala di Melozzo nella nuova Pinacoteca Vaticana," in *L'Illustrazione Vaticana*, III, 1932, pp. 5–6; M. Salmi, "Melozzo e i suoi rapporti con la pittura toscana e umbra," in *Melozzo da Forlì*, XVI, 1938, pp. 235–36; A. Schiavo, "Melozzo a Roma," in *Presenza Romagnola*, 1977, pp. 89–110.

77

PERUGINO (PIETRO DI CRISTOFORO VANNUCCI), Città della Pieve 1450/52–Fontignano 1523

A–C. THREE PANELS FROM THE SAINT PETER ALTARPIECE

1495–98

These three panels were part of an altarpiece painted for the high altar of the church of San Pietro in Perugia; the work was commissioned from Perugino by the Benedictine monks of the adjoining monastery on March 8, 1495 (the documents were reviewed by F. Canuti in 1931). The frame and the panels on which the painter worked had been ordered from the Veronese artisan Giovanni di Domenico on August 26, 1493. Perugino's contract stipulated that within two years he would execute the central panel representing the Ascension with the twelve apostles, the Virgin, and angels; the lunette above, with God the Father in a glory of angels; and the predella "ornatam ad voluntatem domini abbatis pro tempore existentis." Excluded from this agreement was what the document referred to as the "capsa quae circundat dictam tabulam" and the "ornamenta posita in summitate dictae capsae." What the "capsa" was is not altogether clear, and the reconstruction proposed by W. Bombe (1914, pp. 49, 238) and, in large part, accepted by F. Canuti (1931, I, p. 111, n. 1) and E. Camesasca (1959, pp. 71–73; 1969, pp. 97–98), among others, does not seem absolutely convincing. In any case, on November 24, 1496, Perugino signed a new contract to paint and decorate the "capsa," which was to include certain figures of the prophets. The documents are contradictory: according to the contemporary

humanist Maturanzio (F. Canuti, 1931, I, p. 113), the altarpiece was painted in 1496; in May 1498, the work is referred to as if completed ("de' avere di resto della penctura della ancona et chassa che depinse"; F. Canuti, 1931, II, p. 180); but the consecration did not take place until January 13, 1500. The altar was dedicated to Saints Peter and Paul, who are represented in the principal panel, and was also intended to house the relics of Saint Catherine and the body of Saint Peter Abbot.

In the seventeenth century, Perugino's altarpiece was moved to the choir and, at that time, probably taken apart (C. Crispolti, 1648, p. 91). In 1751, the *Ascension* was installed in the chapel of the Holy Sacrament, the lunette of *God the Father in Glory* was placed between the doors leading to the monastery and the Sacristy, and the figures of prophets were hung beside the entrance to the church. The documents also include a description of the predella, which was made up of five panels: *The Adoration of the Magi, The Baptism of Christ, The Resurrection*, and two panels of the patron saints of Perugia, *Constantius* and *Herculanus*. In addition, around the bases of the two columns that flanked the *Ascension* were panels of six Benedictine saints: *Saint Benedict* himself; his sister *Saint Scholastica*; his disciples *Saint Maurus* and *Saint Placidus*; *Saint Flavia*, the virgin martyr and sister of Placidus; and *Saint Peter Abbot*, the founder and first abbot of the church.

Following the Treaty of Tolentino in 1797, Napoleon had most of the panels brought to France, leaving in Perugia only the ones representing Saints Herculanus, Constantius, Maurus, Peter Abbot, and Scholastica; all remain there, except the *Saint Scholastica*, which was stolen in 1916 and never recovered. The *Ascension* and *God the Father in Glory* are in the Musée des Beaux-Arts in Lyons, where they were taken in 1811; the tondi of the Prophets *Jeremiah* and *Isaiah* are in the Musée des Beaux-Arts in Nantes (since 1809); and the three scenes from the predella are in the Musée des Beaux-Arts in Rouen, where they were sent in 1803. The panels representing Saints Benedict, Placidus, and Flavia were returned to Italy in 1815, and Pius VII had them placed in the collection of masterpieces in the new Vatican Pinacoteca (G. and A. D'Este, 1821, p. 35).

Vasari (1568; Milanesi ed., 1878, III, p. 588) judged the Saint Peter Altarpiece "the best of Perugino's oil paintings in Perugia," and L. Scaramuccia (1674, p. 85) said that the predella panels were painted "with the finest exquisiteness and diligence that Pietro knew to employ." The altarpiece is now generally considered to be completely autograph, with the possible exception of the predella panels with scenes from the life of Christ. It is among the most "Raphaelesque" of Perugino's works, so much so that Venturi (1913, VII, 2, pp. 816–24) attributed to the young Raphael the design of the two prophet tondi in Nantes. This hypothesis is no longer accepted, but Raphael must have studied such paintings in his most Peruginesque phase, and later he seems to have employed some typological elements from the Saint Peter Altarpiece—for example, the foreshortened head of Perugino's Saint Flavia must have influenced Raphael's Saint Thomas in the *Coronation of the Virgin* (the Oddi Altarpiece).

77 A. SAINT BENEDICT

1495–98
Oil on panel (poplar)
Height, 12½" (31.8 cm); width, 9¼" (23.6 cm)
Pinacoteca, Inv. no. 319

Of the three Perugino panels in the Vatican, this work, restored in 1981 using conservative techniques, has suffered the most damage. In a restoration carried out sometime before 1797, the backgrounds of all the panels were repainted blue, thereby covering balusters that had previously been visible behind the figures of the saints. The two comparable panels in Perugia are still in this state. The blue was removed from the Vatican panels probably during a nineteenth-century restoration; this restoration presumably made use of soda and abrasive compounds that damaged the original color and revealed in some areas the dark-gray preparation of the azurite underpainting and even the gesso priming. These damages, which, in general, are limited to the background, have recently been inpainted in a slightly different color. In the *Saint Benedict* panel, the saint's face, as well, is slightly abraded. Besides this, the panel no longer retains its original dimensions, having been cut most obviously on the left and right sides. Saint Benedict was the founder of the order to which the monks who commissioned the altarpiece belonged. He wears the usual Benedictine habit, and he holds the book of the Benedictine Rule and the bunch of twigs with which he punished a rebel monk.

77 B. SAINT FLAVIA

1495–98
Oil on panel (poplar)
Height, 11⅞" (30.1 cm); width, 10⁹⁄₁₆" (26.8 cm)
Pinacoteca, Inv. no. 320

The treatment of this panel, which was restored in 1981, was similar to that described in the catalogue entry for the *Saint Benedict*. Here, however, the damage is limited exclusively to the background; the figure is in almost perfect condition and manifests such a high quality of execution that an attribution to Perugino himself is assured. Typical of the master's hand are the calligraphic details with which individual elements are rendered and the sophisticated chromatic palette of the picture as a whole. The panel has been thinned and cradled but, as indicated by the two lateral edges, it has not been cut down. Probably during the nineteenth-century restoration, a strip approximately two centimeters wide was added along the bottom so as to equalize the height of the three Vatican panels; this now has been removed, thereby returning the work to its original size.

According to the eighteenth-century description of the work in the abbots' records, the saint represented is Flavia, the sister of Placidus, who was a disciple of Saint Benedict. Together with her brother, Flavia was martyred at Messina in the course of a Saracen raid. However, the presence of the crown is incongruous. Alternatively, she may be either Flavia Domitilla, the niece of the Emperor Vespasian, or Saint Catherine of Alexandria, among whose attributes is a crown. The altar in San Pietro contained relics of Saints Catherine and Peter Abbot, the founder of the monastery, and Peter Abbot appears among the saints represented in the panels from the base.

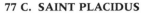

77 C. SAINT PLACIDUS

1495–98
Tempera on panel (poplar)
Height, 12¾" (32.5 cm); width, 11⅜" (28.9 cm)
Pinacoteca, Inv. no. 321

This painting, which was restored in 1981, has essentially the same conservation history as the other two. As with the *Saint Flavia*, the damages are limited to the background, while the figure is in excellent condition. The extremely high level of execution confirms the attribution to Perugino himself. While apparently the pendant to the *Saint Flavia* panel, the *Saint Placidus* is clearly larger than its mate, and must have been even larger originally, since the lateral borders are lacking. There is a *pentimento* at the right side of the saint's face. The palm held by Saint Placidus alludes to his legendary martyrdom.

F. M.

BIBLIOGRAPHY: G. Vasari, *Le Vite*, 1568, Milanesi ed., Florence, 1878, III, p. 588; C. Crispolti, *Perugia augusta*, Perugia, 1648, p. 91; L. Scaramuccia, *Le finezze de pennelli italiani*, Pavia, 1674, p. 85; B. Orsini, *Vita, elogio e memorie dell'egregio pittore Pietro Perugino e degli scolari di esso*, Perugia, 1804, pp. 146–75; G. and A. D'Este, *Elenco degli oggetti esistenti nel Museo Vaticano*, Rome, 1821, p. 35; A. Venturi, *Storia dell'Arte Italiana*, Milan, 1913, VII, 2, pp. 816–24; W. Bombe, *Perugino: Des Meisters Gemälde*, Stuttgart-Berlin, 1914, pp. 49–63, 237–38; F. Canuti, *Il Perugino*, Siena, 1931, I, pp. 111–17, II, pp. 176–78, nos. 223, 224, 228, p. 180, no. 232, pp. 182–83, nos. 236, 237; E. Camesasca, *Tutta la pittura del Perugino*, Milan, 1959, pp. 71–76; R. Jullian, "Le Retable de l'Ascension par Pérugin," in *Bulletin des Musées et Monuments Lyonnais*, II, 1961, pp. 381–404; E. Camesasca, *L'opera completa del Perugino*, Milan, 1969, pp. 97–98, nos. 56 G, M, O.

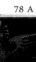

RAPHAEL (RAFFAELLO SANZIO),
Urbino 1483–Rome 1520
**A–C. PREDELLA FROM THE ODDI
ALTARPIECE**

c. 1502–3
Oil on panel (poplar)
Height, 15 ⅜" (39 cm); width, 74 ¹³⁄₁₆" (190 cm)
Pinacoteca, Inv. no. 335

78 A

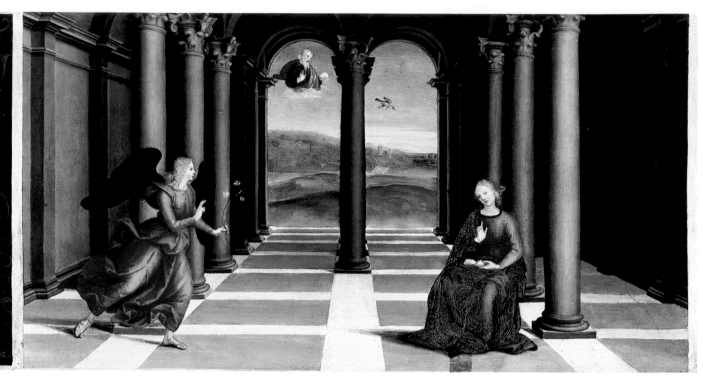

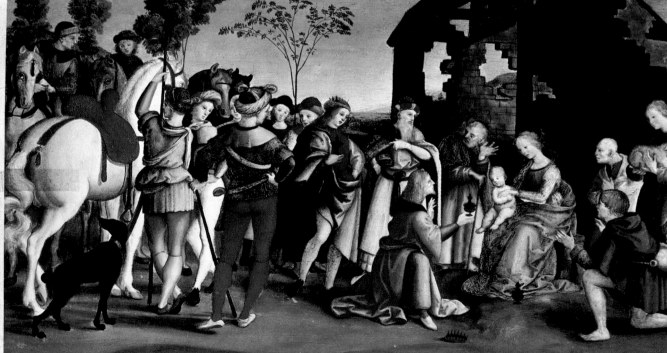

78 B

The predella is part of the altarpiece that Raphael painted, about 1502–3, for the altar of the Oddi Chapel in the church of San Francesco in Perugia; it was probably commissioned by Alessandra di Simone degli Oddi (W. Bombe, 1911, pp. 304–5; cf. also D. Redig de Campos, "L'Incoronazione della Madonna di Raffaello e il suo restauro," in *Fede e Arte*, VI, 1958, p. 343), rather than by Maddalena degli Oddi, who is mentioned by Vasari (1568; Milanesi ed., 1878, IV, p. 317), but is not named in documents. The principal panel represents *The Coronation of the Virgin*, while the predella includes three scenes from the Infancy of Christ: *The Annunciation* (Luke 1:26–38), *The Adoration of the Magi* (Matthew 2.11), and *The Presentation in the Temple* (Luke 2:22–32). All three episodes, as represented in the predella, are based on the biblical texts. In *The Presentation in the Temple*, the presence of two turtledoves in the hands of one of the companions of the Virgin alludes to the holy offering that was customarily made on that occasion. Of particular interest in *The Annunciation* is the distant landscape, in which one might possibly recognize in the mists the twin towers of the Palazzo Ducale of Urbino.

The altarpiece remained in Perugia until 1797, when it was taken to France following the terms of the Treaty of Tolentino. Shortly before that date, the work was restored by a certain Francesco Romero (L. Dussler, 1971, p. 10). A second restoration was undertaken at the Louvre by the restorers Haquin and Roeser (D. Redig de Campos, op. cit., p. 346); at that time, *The Coronation of the Virgin* was transferred to canvas. The altarpiece was not returned to its original site in Perugia after 1815, but was placed in the new Vatican Pinacoteca created by Pius VII (cf. G. and A. D'Este, 1821, pp. 36–37). Other works by Raphael acquired at the same time—the *Madonna di Foligno*; *Faith, Charity*, and *Hope*, from the Baglioni Altarpiece; and *The Transfiguration*—document the principal periods in the stylistic evolution of the painter who, with Michelangelo, was considered one of the greatest artists of the Renaissance. To this end, and with a clear critical awareness of their quality, Pius XI (1922–39) had decided that all these works, together with the Sistine Chapel tapestries executed after Raphael's designs, should be exhibited in a single room. *The Coronation of the Virgin* was cleaned again in 1957 (D. Redig de Campos, op. cit., p. 343), and the predella was similarly treated in 1959 (F. Mancinelli, 1977, p. 140); apart from changes in the blue pigment (lapis lazuli) of the Madonna's dress, the condition of the work is nearly perfect.

In all probability, the Oddi Altarpiece was the first work carried out by Raphael in Perugia, and marked the first direct confrontation between Raphael and Perugino, who, according to Vasari, was Raphael's master after his initial apprenticeship in his father's workshop. The similarities in the work of the young Raphael to that of Perugino are very evident—especially in the Oddi Altarpiece—and Vasari's statement traditionally has been accepted. However, P. De Vecchi (1981, pp. 8–19) has argued very convincingly against Raphael's apprenticeship in the workshop of Perugino. He proposes an interpretation of the Peruginesque elements in the paintings of the young Raphael in terms of competition rather than imitation—in much the same methodological manner as Raphael's later confrontations with the works of Leonardo and Michelangelo. The composition of *The Coronation of the Virgin* is derived from Perugino's Saint Peter Altarpiece, but it has been transformed by the insertion of the diagonal sarcophagus, which gives to the entire conception greater depth and spaciousness. Numerous typological—and, in particular, physiognomic—details also are drawn from the Saint Peter Altarpiece. Foreshortened heads similiar to that of Perugino's *Saint Flavia* appear often in the artist's later work—perhaps because the type met with such notable success and was adapted by Raphael for the head of Saint Thomas in *The Coronation of the Virgin*. The Oddi Altarpiece is clearly related, as well, to the predella of Perugino's Fano Altarpiece. The compositional scheme and typology of the figures in *The Annunciation* and *The Presentation in the Temple* follow those of the analogous panels by Perugino, as A. M. Brizio (1963, col. 223) has noted, but with increasing breadth and luminosity, and, as De Vecchi (1981, p. 15) has written, with greater realism and a clearer and more precise sensitivity toward spatial relationships.

F. M.

BIBLIOGRAPHY: G. Vasari, *Le Vite*, 1568, Milanesi ed., Florence, 1878, IV, pp. 317–18; G. and A. D'Este, *Elenco degli oggetti esistenti nel Museo Vaticano*, Rome, 1821, pp. 36–37; W. Bombe, "Raffaels Peruginer Jahre," in *Monatshefte für Kunstwissenschaft*, IV, 1911, pp. 304–5; A. M. Brizio, "Raffaello," in *Enciclopedia Universale dell'Arte*, XI, Venice-Rome, 1963, col. 223; L. Dussler, *Raphael*, London-New York, 1971, p. 10; F. Mancinelli, "Arte Medioevale e Moderna," in *Bollettino dei Monumenti Musei e Gallerie Pontificie*, I, 1977, p. 140; P. De Vecchi, *Raffaello. La Pittura*, Florence, 1981, pp. 8–19, 239–40, no. 12.

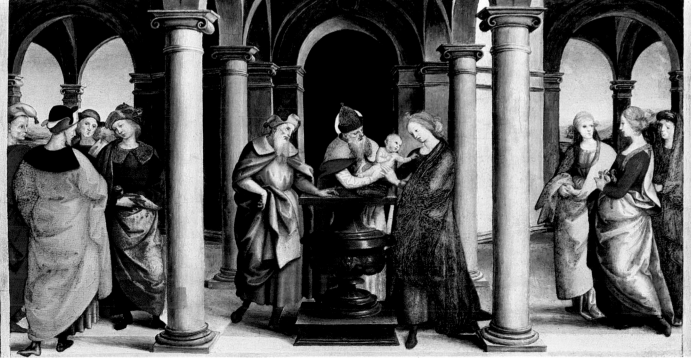

78 C

79

RAPHAEL (RAFFAELLO SANZIO),
Urbino 1483–Rome 1520
A–C. PREDELLA FROM THE
BAGLIONI ALTARPIECE
1507

The three panels representing the Theological Virtues—Faith, Charity, and Hope—constitute the predella for an altarpiece commissioned from Raphael by Atalanta Baglioni, and intended for the altar of the Baglioni family chapel in the church of San Francesco in Perugia (L. Dussler, 1971, p. 23). Raphael probably received the commission in the middle of 1506; he signed and dated the principal panel RAPHAEL./ VRBINAS./ M.D.VII. With this altarpiece Atalanta Baglioni sought to commemorate the death of her son Grifone, who was assassinated in July 1500 during a conflict between opposing branches of the family over the control of Perugia. Originally, the altarpiece was composed of a central panel with *The Deposition* (in the Galleria Borghese in Rome); a pinnacle representing *God the Father Blessing, Surrounded by Angels* (in the Galleria Nazionale dell'Umbria in Perugia); and the predella in the Vatican. Raphael, as mentioned, signed *The Deposition*—however, C. L. Ragghianti (1947, p. 9) believes that it was executed with some studio assistance. The predella is generally attributed to Raphael, but the pinnacle seems to have been painted by Domenico Alfani, after Raphael's design (L. Dussler, 1971, p. 24). It has been suggested, in the past, that Atalanta was portrayed in the guise of the Virgin or the Magdalene, and that the dead Christ or the bearer to the right may have the features of Grifone; these notions probably are unfounded. The altarpiece remained in the church until 1608, when the main panel was secretly sent to the Borghese pope, Paul V, in Rome; he gave it to his nephew Cardinal Scipione Borghese. Faced with objections from the people of Perugia and from Braccio Baglioni, Atalanta's descendant, Paul V responded with a brief in which he declared the painting to be private property. At the same time, Scipione Borghese had Lanfranco paint a copy (which has since been lost) and send it to Perugia; another contemporaneous copy, not mentioned in the documents, is by Cavalier d'Arpino (in the Galleria Nazionale in Perugia).

The Deposition was taken to Paris in 1809 by Camillo Borghese, husband of Pauline Bonaparte, but in 1815 it was returned to the Galleria Borghese, where it has remained since. The pinnacle always has been in Perugia—assuming that the work now in the museum there belonged to Raphael's altarpiece, and that it is not a seventeenth-century copy; De Vecchi (1966, p. 97) reproduced a sixteenth-century replica from a private collection, which Camesasca (cf. *Tutta la pittura di Raffaello*, 1962, I, pp. 83–84) believes may be closer to a lost original. The predella was expropriated by the French in 1797 and remained in Paris until 1815; following its restitution to Pius VII (1800–1823), it entered the renovated Vatican Pinacoteca, thereby complementing the group of Raphael's works acquired by the Braschi pope, Pius VI (1775–99) (cf. G. and A. D'Este, 1821, p. 45). The Baglioni Altarpiece just precedes Raphael's arrival in Rome and is as important a work in the artist's career as *The Transfiguration* would be thirteen years later; in it, as S. Staccioli writes (1972–73, p. 7), Raphael presents a summation of his previous experiences in Umbria and Florence and, at the same time, gives an indication of his future style. Raphael's preparatory drawings for the main panel—which was initially conceived as a Lamentation and was then transformed into a Deposition—testify, as does the finished picture, to a variety of stimuli. At the outset, he was inspired by Perugino's *Pietà* (now in the Palazzo Pitti), from which the first idea for the composition came, but later he looked to Signorelli, to Mantegna, and ultimately to Michelangelo. The influence of Michelangelo is evident in the central panel of the predella—exhibited here—thus illustrating Raphael's early interest in the work of the artist who would become his competitor on the Roman scene.

F. M.

BIBLIOGRAPHY: G. and A. D'Este, *Elenco degli oggetti esistenti nel Museo Vaticano*, Rome, 1821, p. 45; E. Wind, "Charity," in *Journal of the Warburg and Courtauld Institutes*, I, 1937/8, pp. 329 ff.; C. L. Ragghianti, *La deposizione di Raffaello*, Milan, 1947; A. M. Brizio, "Raffaello," in *Enciclopedia Universale dell'Arte*, XI, Venice-Rome, 1963, cols. 226–27; P. De Vecchi, *L'opera completa di Raffaello*, Milan, 1966, p. 97, no. 70; L. Dussler, *Raphael*, London-New York, 1971, pp. 23–25; L. Ferrara, S. Staccioli, and A. M. Tantillo, *Storia e restauro della Deposizione di Raffaello*, Rome, 1972–73; P. De Vecchi, *Raffaello. La Pittura*, Florence, 1981, p. 244, no. 426.

79 A. FAITH
1507
Oil on panel (poplar)
Height, 7 1/8" (18 cm); width, 17 5/16" (44 cm)
Pinacoteca, Inv. no. 332

The predella is painted in grisaille. Each of the three panels has a niche-like cavity to the left and right of a wider central compartment that contains a slightly recessed medallion with figures on a green ground. This panel was at the left. It represents Faith, with her traditional attribute, the Eucharistic chalice. The winged putti carry tablets with Greek monograms—C̄P̄X̄ and IH̄S—alluding to Christ as the object of faith.

79 B. CHARITY
1507
Oil on panel (poplar)
Height, 7 1/8" (18 cm); width, 17 5/16" (44 cm)
Pinacoteca, Inv. no. 331

The middle panel of the predella represents Charity, whose symbolically dominant role is indicated by her central placement. One of the putti carries on his back a flaming cauldron; the other overturns a basin filled with coins—perhaps an allusion to the abundance generated through Charity. The tondo in the center closely recalls Michelangelo's *Pitti Madonna*, which seems to have furnished the model for the female figure.

79 C. HOPE
1507
Oil on panel (poplar)
Height, 7 1/8" (18 cm); width, 17 5/16" (44 cm)
Pinacoteca, Inv. no. 330

This panel was at the right of the predella. As indicated by the pose—one that Ripa's *Iconologia* later made canonical—the subject is Hope. The trusting attitudes of the winged putti flanking the central figure are analogous.

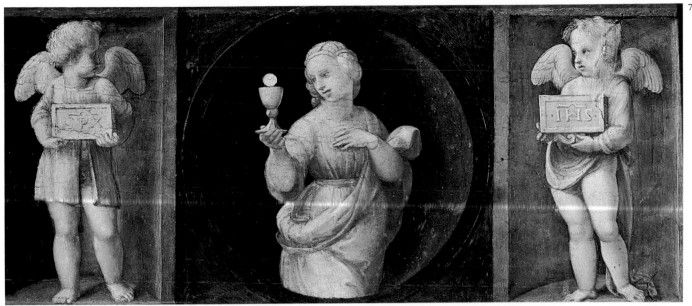

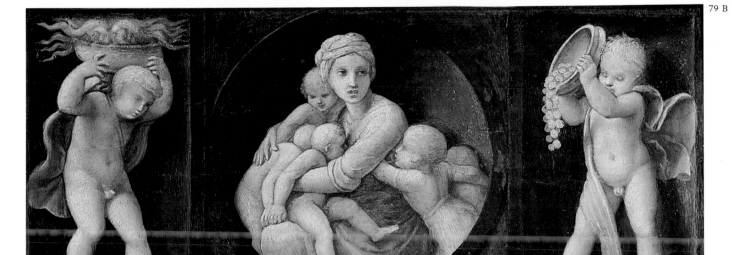

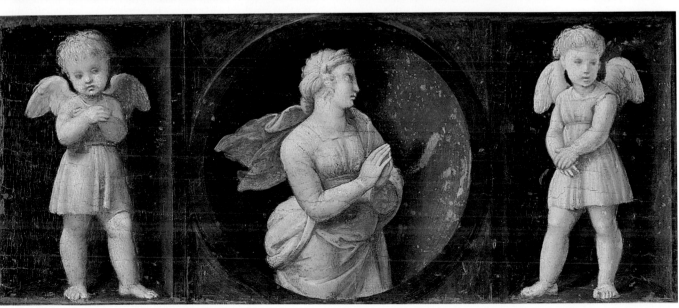

LEONARDO DA VINCI (Vinci 1452–
Amboise 1519)
SAINT JEROME
c. 1482
Oil on panel (walnut)
Height, 40 ⁹⁄₁₆" (103 cm); width, 29 ½" (75 cm)
Pinacoteca, Inv. no. 337

Leonardo painted this image of Saint Jerome on a panel composed of two irregularly shaped walnut boards, glued and reinforced where they are joined by three dovetailed wedges. The surface is very dirty and is covered by a thick layer of discolored yellow varnish, which alters the original palette. There are numerous old re-

touches, some of which were intended to disguise the damages incurred in the nineteenth century, when four cuts were made in the upper part of the picture and the head of the saint was removed. A rigid cradle was applied to the reverse of the panel in 1929, replacing an oak backing that had been glued on in the nineteenth century. The *Saint Jerome* has not been cleaned in this century, if ever (B. Nogara, 1931, pp. 5–7).

This famous painting, mentioned for the first time in 1803, in the will of the Swiss painter Angelica Kauffmann (1741–1807), who had lived in Rome, was attributed to Leonardo (J. Langl, 1888–89, p. 298). (From an inventory of 1680, we know that a picture identical in subject, also attributed to Leonardo, was in the Palazzo del Giardino in Parma, but the dimensions seem to argue against its being the Vatican picture; cf. G. Campori, *Raccolta di cataloghi ed inventari inediti . . . dal secolo XV al secolo XIX*, Modena, 1870.) The picture disappeared after the death of Angelica Kauffmann, but, fortunately, was rediscovered by Napoleon's uncle Cardinal Joseph Fesch, who died in Rome in 1839. Regarding this find, D'Achiardi (1913, p. 69), without citing the source (which almost certainly was F. Wey, 1878, pp. 28–31), tells the following —somewhat romantic—story. The cardinal first discovered the painting, with the head cut out, being used as a cover for a chest in a second-hand shop. Subsequently, he located the missing part of the panel in a cobbler's shop. The details of the story are probably fictitious, but the cuts in the panel indicate that the head was removed by someone who thought that it would be more easily salable alone. However it may have been, Cardinal Fesch had the various pieces of the picture reassembled; the complete work was auctioned in his estate sale, which took place at Palazzo Ricci, on the Via Giulia in Rome, during March and April 1845. The picture was valued at 2,500 francs, but it is not clear whether it actually was sold then and if so to whom (B. Nogara, 1931, p. 7, n. 4). G. Moroni (1858, p. 244) records that Pius IX was the first to exhibit the work in the Pinacoteca, in 1857; since then, it has never been moved, except for an exhibition held in Lucerne for the benefit of the Biblioteca Ambrosiana, which had been damaged during World War II.

Leonardo's Penitence of Saint Jerome is entirely traditional iconographically. The saint, ascetic in visage and physique, prays before a crucifix lightly sketched in profile; in his right hand is a stone that he will use to beat his breast, which he bares with his left hand. The setting is a grotto, from which a rocky landscape, only partially blocked in, opens on the left. In the foreground is a roaring lion, Jerome's traditional attribute. In what appears to be an opening in the rocks, the façade of a church has been drawn on the gesso priming; despite the generic quality of the representation, some scholars have identified it as Santa Maria Novella in Florence, completed by Leon Battista Alberti in 1470. The painting is actually a sketch, with some parts of the landscape and, in particular, the face of the saint slightly more developed. The attribution

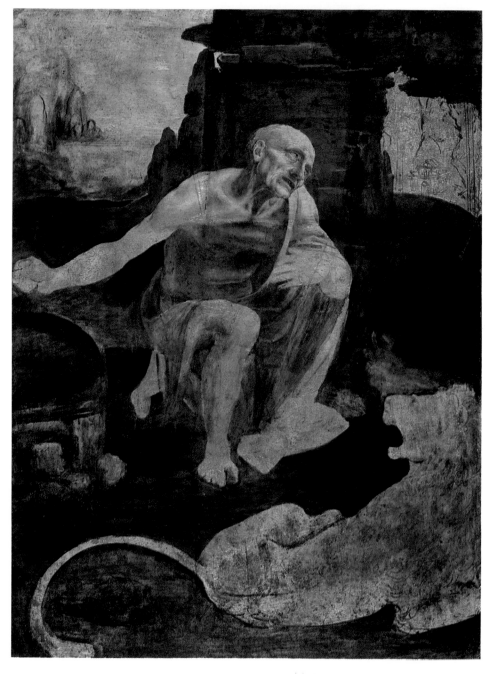

to Leonardo proposed by Angelica Kauffmann has always been upheld, since the panel clearly is related to other works by Leonardo—specifically, to *The Adoration of the Magi*, commissioned from the artist in 1481. The *Adoration* is also a sketch, and in it, as Redig de Campos (1977, p. 66) has written, one finds the same techniques of sketching the work in giallolino (yellow priming paint) and bister, and of drawing by painting, with absolute supremacy given to the sfumato (roughly defined as shading) without sacrificing the solid framework of Florentine draftsmanship. As an example, one should note the analogous drawing of the mountain in the two works. L. H. Heydenreich (1958, col. 566) sees the influence of Florentine art in the springing motion of the body—almost an anatomical study, which recalls the work of Pollaiuolo. In the absence of documentation or contemporary evidence, the painting must be dated on stylistic grounds. With the exception of J. Strzygowski (1895, pp. 166–68), who dated the work to Leonardo's first visit to Milan (at the time of *The Last Supper*), all scholars place the *Saint Jerome* in the artist's first Florentine period, about 1482, just before his departure for Milan.

<div align="right">F. M.</div>

BIBLIOGRAPHY: *Galerie de feu S. E. le Cardinal Fesch. . . . Catalogue des tableaux des écoles italiennes, et espagnole, par George, peintre, Commissaire-Expert du Musée royal du Louvre*, Rome, 1845, pp. 174–76, no. 838—750; *Galleria dei quadri al terzo piano delle Logge Vaticane*, Rome, 1857, p. 9; G. Moroni, *Dizionario di educazione storico-ecclesiastica*, LXXXVIII, Venice, 1858, p. 244; F. Wey, *I musei del Vaticano*, Milan, 1878, pp. 27–31; J. Langl, "Das Testament der Angelica Kauffmann," in *Zeitschrift für bildende Kunst*, XXIV, 1888–89, p. 298; J. Strzygowski, "Studien zu Leonardos Entwickelung als Maler," in *Jahrbuch der Preussischen Kunstsammlungen*, XVI, 1895, pp. 166–68, 171, 173; P. D'Achiardi, *Guida della Pinacoteca Vaticana*, III, Rome, 1913, p. 69; B. Nogara, "Gli ultimi restauri del S. Girolamo di Leonardo da Vinci," in *Miscellanea di Studi Lombardi in onore di Ettore Verga*, Milan, 1931, pp. 5–7; E. Verga, *Bibliografia Vinciana*, Bologna, 1931; L. H. Heydenreich, *Leonardo da Vinci*, New York, 1954; idem, "Leonardo da Vinci," in *Enciclopedia Universale dell'Arte*, VIII, Venice-Rome, 1958, cols. 562, 566; D. Redig de Campos, "S. Girolamo," in *Leonardo: La Pittura*, Milan, 1977, pp. 65–68.

81

VERONESE (PAOLO CALIARI), Verona 1528–Venice 1588

THE VISION OF SAINT HELENA

c. 1580
Oil on canvas
Height, 65 ⅜" (166 cm); width, 52 ¾" (134 cm)
Pinacoteca, Inv. no. 352

This picture is in good condition; the cleaning in 1982 brought back its delicacy and chromatic variety. Benedict XIV (1740–58) acquired the

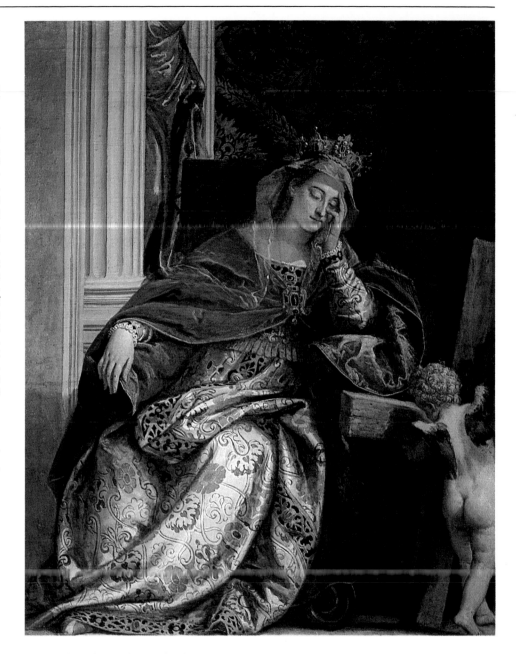

painting from the Pio di Carpi family (T. Pignatti, 1976, p. 150), and Pius VII (1800–1823) placed it in the restored Vatican Pinacoteca (G. and A. D'Este, 1821, pp. 37–38), where it has remained since. The subject is the Vision of Saint Helena—so called, as it was more a dream than a vision. The saint is seated, her eyes closed, her head resting on one hand. She wears a crown, and a sumptuous sixteenth-century dress under a cloak fastened with a brooch, at the center of which is a cameo with a cupid. A winged putto holds up a cross—the manifestation of the dream that, according to legend, guided her to the place where the true cross was buried. The atmosphere is solemn and peaceful. Saint Helena is the subject of a painting in the National Gallery in London, as well as of other works by Veronese since lost (cf. C. Gould, *The Sixteenth-Century Venetian School. National Gallery Catalogues*, London, 1959, pp. 147–48). As Gould indicates, the iconography is not that generally employed in Venice, where the saint is usually shown standing beneath the cross. He has identified as the probable

source for the London picture (which may be dated about 1570) an engraving by a follower of Marcantonio Raimondi in which the vision of a female saint—perhaps Saint Agnes—is represented. The prototype of that engraving, a drawing in the Uffizi, has now been attributed to Raphael by Konrad Oberhuber (cf. *Raphaels Zeichnungen*, IX, Berlin, 1972, pp. 95–96, no. 409 a, r.). The Vatican picture, a later version of the subject, differs from all of these in that the cross is no longer held aloft. G. Fiocco (1928, p. 193) dated it about 1575, while R. Marini (1968, p. 119, no. 193) has suggested a date closer to 1580.

<div align="right">F. M.</div>

BIBLIOGRAPHY: G. and A. D'Este, *Elenco degli oggetti esistenti nel Museo Vaticano*, Rome, 1821, pp. 37–38; G. Fiocco, *Paolo Veronese*, Bologna, 1928, pp. 86, 193; E. Francia, *Tesori della Pinacoteca Vaticana*, Milan, 1964, p. 80; R. Marini, *L'opera completa del Veronese*, Milan, 1968, pp. 112, 119, no. 193; T. Pignatti, *Veronese*, Venice, 1976, p. 150, no. 256.

82

GIROLAMO MUZIANO (Acquafredda
[Brescia] 1528–Rome 1592)
SAINT JEROME
c. 1585–92
Oil on panel, transferred to canvas
Height, 57⅞" (147 cm); width, 38⁹⁄₁₆" (98 cm)
Pinacoteca, Inv. no. 369

This picture, which was restored in 1981–82
and is in good condition, comes from the church
of Santa Marta, which once stood behind Saint
Peter's basilica, to the left of the church of San
Stefano degli Abbissini (on the history and dec-
oration of the building, see C. Pietrangeli, 1982,
pp. 209–13). Santa Marta was built in 1538
during the pontificate of Paul III (1534–49). Be-
ginning in 1582, under Gregory XIII (1572–85),
the church underwent a radical reconstruction,
which was undertaken by Ottaviano Mascherino,
architect of the papal palaces since 1578. Work
proceeded under Sixtus V (1585–90), whose
coat of arms appeared on the façade, and con-
tinued during the reign of Clement VIII (1592–
1605). Muziano's painting decorated the altar of
the second chapel—on the right of the church—
commissioned by Ludovico Canossi (died 1626)
and dedicated to Saint Jerome. The stucco wall
decorations included figures of Saints Peter, Paul,
Martha, and Mary Magdalene, and four scenes
from the life of Saint Jerome; these works are
lost, but are documented in photographs and in
several casts in the storerooms of the Vatican
Museums. The *Saint Jerome* was saved when, in
1930, the church was demolished—because, ac-
cording to the cynical assertion of *Il Messaggero*,
it "no longer had a reason to exist." The panel
was acquired by the Vatican Museums, restored,
and transferred to the Pinacoteca in 1932, where
it was exhibited.

The altarpiece represents Saint Jerome in
prayer before a crucifix. In his right hand, he
grasps a rock with which he will beat his chest.
Next to him are his customary attributes, the
lion and the cardinal's hat. Despite its high
quality, the work has never attracted scholarly
interest, and Ugo da Como only mentioned it
in his 1930 monograph on the artist (p. 122). In
this century, the attribution to Muziano has not
been doubted, although it was questioned in the
past—for example, by G. Alveri (1670, II, p.
221), who wrote that the painting was thought
to be by Muziano but was said to have been
designed by Daniele da Volterra. This doubt, as
Pietrangeli has pointed out, must have been sug-
gested by the emphatic Michelangelism of the
figure—typical of Muziano's work after his ar-
rival in Rome, where he was one of the founders
of the Accademia di San Luca. The limited color
range, which is also Michelangelesque, contrib-
utes to the sculptural effect, and the skillful use
of glazes recalls the artist's Venetian origins. The
subject was treated often by Muziano, and this
version is one of the finest. It was probably paint-
ed during the pontificate of Sixtus V or slightly
later, rather than under Gregory XIII, who initi-
ated the rebuilding of the church.

F. M.

BIBLIOGRAPHY: G. Alveri, *Della Roma in ogni Stato*, Rome,
1670, II, p. 221; U. da Como, *Girolamo Muziano*, Bergamo,
1930, p. 122; A. Porcella, *Musei e Gallerie Pontificie, Guida
della Pinacoteca Vaticana*, Vatican City, 1933, p. 179;
C. Pietrangeli, "In ricordo di una chiesa distrutta: S. Marta
al Vaticano," in *Arte e letteratura per Giovanni Fallani*,
Rome, 1982, pp. 209–13, pls. 11–16.

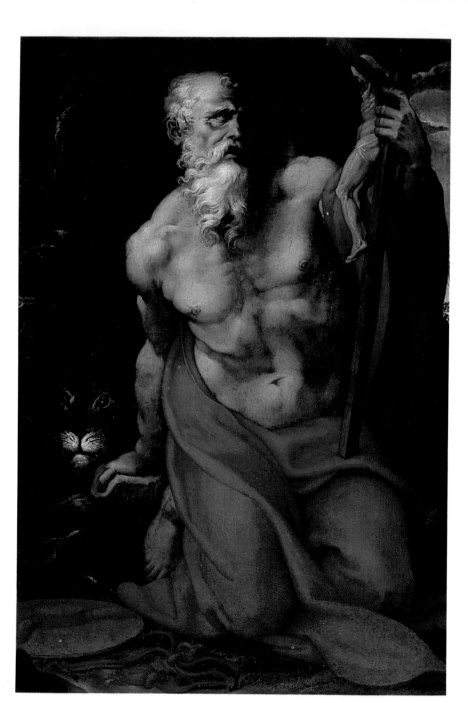

83

BAROCCI (FEDERICO FIORI), Urbino
1535–1612
**SAINT FRANCIS RECEIVING
THE STIGMATA**
c. 1594–95
Oil on canvas
Height, 65" (165 cm); width, 46⁷⁄₁₆" (118 cm)
Pinacoteca, Inv. no. 380

This canvas, restored in 1981, is in excellent con-
dition, save for a loss inpainted with vertical
hatching that affects part of the face, shoulder,
and book of Brother Rufinus. With the removal
of repaint and discolored varnish, it became clear
that the work is a sketch. The glazing applied to
the figure of Saint Francis, which is the most
elaborate and highly finished part, is not found
in other areas; the rest was roughed in, almost as
if the artist drew as he painted, preparing with
dark colors the areas in shadow, and with light
colors those in light. The underpainting is gray,

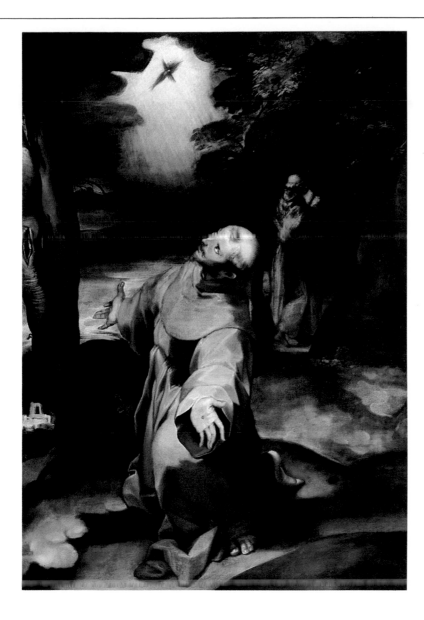

BIBLIOGRAPHY: A. Porcella, *Musei e Gallerie Pontificie, Guida della Pinacoteca Vaticana*, Vatican City, 1933, p. 183, no. 380; H. Olsen, *Federico Barocci*, Copenhagen, 1962, p. 161; *Mostra di Federico Barocci* (exhib. cat.), entry by A. Emiliani for the *Saint Francis Receiving the Stigmata* in Fossombrone, Bologna, 1975, pp. 102–3.

84

BAROCCI (FEDERICO FIORI), Urbino
1535–1612
THE REST ON THE FLIGHT INTO EGYPT
c. 1570–73
Oil on canvas
Height, 52 ⅜" (133 cm); width, 43 ⁵⁄₁₆" (110 cm)
Pinacoteca, Inv. no. 377

In this work, restored in 1981–82, small losses affecting both the figures and the background have been inpainted with vertical hatching. The cleaning has brought to light the extraordinarily delicate, subtly shaded coloring typical of Barocci. As Giovanni Pietro Bellori (1672, p. 196) described the technique: "After the laborious work of preparing numerous drawings and sketches, he applied the paint very rapidly, often blending it with his thumb, so as to shade without using a brush." The use of oil glazes over tempera is also typical of the artist. The attribution to Barocci has never been questioned. In subject, the picture corresponds to—but is almost certainly not identical with—one described by Bellori (1672, p. 193) as having been painted for Duke Guidobaldo della Rovere: "For Duke Guidobaldo, the father of Francesco Maria, he painted a small cabinet picture, with the Virgin resting from her journey to Egypt: she sits, and with a cup takes water from a flowing stream, while Joseph lowers a branch of an apple tree, holding it out to the Infant Jesus, who smiles and extends his hand to it. This work was sent as a gift to the Duchess of Ferrara [Lucrezia d'Este], and because the invention was pleasing, various replicas were made, and a life-size gouache was also made, which Count Antonio Brancaleoni had sent to his castle of Pieve del Piobbico." According to Olsen (1962, p. 154), that painting was given to the Duchess of Ferrara just before her marriage (on January 2 or 3, 1571) and would, therefore, date to about 1570. The work, which passed by inheritance into the collection of Cardinal Pietro Aldobrandini in 1598 or shortly after, remained in the Aldobrandini family until about 1800. In that year and the following, Alexander Day may have exhibited it in London for sale by private contract; M. Passavant (cf. *Tour of a German Artist in England*, I, London, 1836 ed., pp. 228–29) saw it in the collection of George Channing, first Baron Garvagh; in 1898, long after Channing's death, it was sold with works from his estate (Christie's, London, June 13, 1898, no. 130) and has never been found since.

The replica that Barocci describes as having been painted for Count Brancaleoni is in the church of San Stefano in Piobbico.

Olsen (1962, p. 154) and Emiliani (1975, pp. 85–86) agree that the Vatican picture could not be the one painted for Duke Guidobaldo, in

and only the figure of the saint was transferred by incising the outline with a stylus; some *pentimenti* can be seen in the fingers of the right hand. The painting represents the moment when, as Saint Bonaventure relates, Francis had a vision of the crucified Christ between the wings of a seraph and received the stigmata. The setting is Mount Averna, and there is a view of a Franciscan monastery. The figure of Saint Francis is identical to that in the *Perdono di Assisi* (in San Francesco in Urbino), completed in 1576, while Brother Rufinus recalls a comparable figure in a drawing in the British Museum (Inv. no. Pp. 3–203), which also includes the tree and the distant monastery.

Opinions on the painting have varied. H. Olsen (1962, p. 161) considered it a workshop picture, and A. Emiliani (1975, p. 102) has called it a copy. Since then, it has been restored. Only the figure of Saint Francis is derived with little variation from the *Perdono*, and the very high quality of execution of the Vatican picture rules out workshop participation. The underpainting and incising are also typical of the artist. The presence of unresolved passages, especially in the rocks, and the sketch-like technique strongly suggest

that this canvas was a preparatory study for one of the versions of *Saint Francis Receiving the Stigmata*, to which Barocci returned many times after painting the *Perdono*. It should thus be grouped with Barocci's print of the subject; the drawings in the Uffizi (Inv. no. 11500P) and the British Museum; numerous studies of rocks and trees; and, above all, with the Fossombrone *Saint Francis Receiving the Stigmata* (Museo Civico), which, as Emiliani has indicated, is also sketch-like in its handling. According to Emiliani, the British Museum drawing and the Fossombrone picture precede the *Saint Francis Receiving the Stigmata* in Urbino (Galleria Nazionale delle Marche), which was probably finished in 1595. A similar dating for the Vatican version—before the Urbino picture—is suggested by the dramatic treatment of light and by the palette, which is characterized by a subtle use of brown and gray. The Vatican picture may precede the one in Fossombrone, as the figure of Saint Francis is closer to the saint in the *Perdono di Assisi*. Such a repetition of motif, in any event, typifies Barocci's working methods. The history of the painting, which was brought to the Pinacoteca in 1932 from a room in the Vatican palaces, is not recorded. *F. M.*

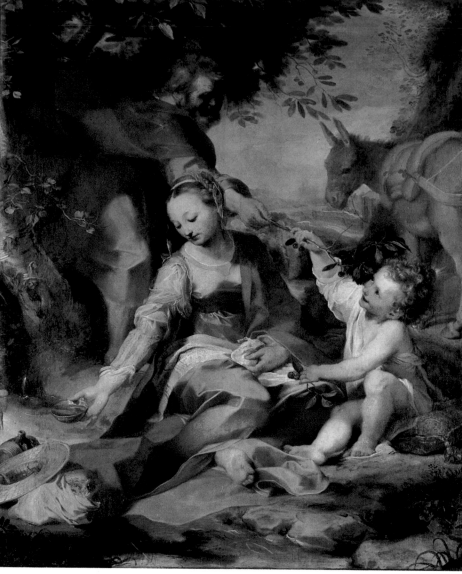

84

CARAVAGGIO (MICHELANGELO MERISI),
Bergamo 1573–Porto Ercole 1610
THE DEPOSITION

1604
Oil on canvas
Height, 118 ⅛" (300 cm); width, 79 ¹³/₁₆" (203 cm)
Pinacoteca, Inv. no. 386

This picture, which was restored in 1982, comes from the Chiesa Nuova (Santa Maria in Vallicella) in Rome. It was commissioned for the chapel of the Vittrici family, probably toward the end of 1601, as a document refers to work already in progress there as of January 9, 1602. The patron must have been a nephew of Pietro Vittrici (died March 26, 1600), who had been Master of the Household to Gregory XIII and had purchased the chapel in 1577. The painting was certainly finished by September 6, 1604, for on that date, according to an entry from the records of the church, the nephew of Signor Pietro Vittrici asked for and was given a picture of the Pietà which had been on the altar of the chapel before the picture by Caravaggio was painted (cf. L. Lopresti, "Un appunto per la storia di Michelangelo da Caravaggio," in *L'Arte*, XXV, 1922, p. 116).

Scholars disagree on the exact date of the painting. A summary of the various arguments about the date, together with the relevant bibliography, is in Maurizio Marini's monograph (1974, pp. 398–99). Marini, himself, believes that Caravaggio began the altarpiece in 1602 and finished it in 1604. There were, he maintains, various reasons for the unusually long period of execution: the libel suit and subsequent trial instituted by Baglione, Caravaggio's future biographer; the temporary relocation of the artist to the Marches; the legal problems resulting from an altercation with Pietro da Fusaccia, a waiter at the Osteria del Moro alla Maddalena in Rome; and, finally, the numerous other commissions the artist received concurrently. The painting remained in the Vittrici Chapel until 1797, when, following the terms of the Treaty of Tolentino, it was sent to Paris; it was replaced with a copy by Vincenzo Camuccini. Caravaggio's painting was returned to Rome in 1817 and installed in the new Pinacoteca of Pius VII; at the same time, Camuccini's copy was replaced with one by Michel Köck, which remains in the church. *The Deposition* was exhibited in Lucerne in 1948.

Caravaggio's treatment of the subject presents numerous anomalies when compared with more traditional representations. This is not a burial scene like Raphael's Baglioni Altarpiece, as the protagonists here are not in motion, nor is it a Deposition, in the strict sense, since the body of Christ is not being lowered into the tomb. Despite the presence of the Virgin, it is not a Pietà, given the number and type of the characters depicted. Furthermore, according to the Gospels, only Nicodemus, Mary Magdalene, and Mary Cleophas were present—not, as here, the Virgin and Saint John. As M. A. Graeve (1958, pp. 227–28) and W. Friedlaender (1955, p. 188) have shown, Caravaggio represented the moment

which—to judge from an engraving of 1772 by Cappellano—the Child is seated on the right knee of the Virgin. Rather, it would seem to be identifiable with a painting that Bellori (1672, p. 176) called a Nativity: "After returning to Urbino, he sent, out of friendship for Signor Simonetto Anastagi, the gift of a Nativity by his own hand about four feet in height." In 1602, upon the death of Anastagi, the picture, accompanied by a letter dated October 2, 1573 (Piancastelli Collection, Forlì), passed into the hands of the Jesuits of Perugia, who hung it in the Sacristy of their church. With the suppression of the order in 1773, the painting was taken to the Palazzo del Quirinale in Rome. Pius VI had the work included among those in the first Vatican Pinacoteca, which was inaugurated about 1790 (C. Pietrangeli, 1975, p. 355). It remained there only until 1798, or slightly later, when, after the removal of the pictures that the Napoleonic commissioners sent to the Louvre, *The Rest on the Flight into Egypt* was taken to the apostolic palaces. It was returned to the Pinacoteca only in the time of Pius X (1903–14). During the pontificate of Gregory XVI, what the

1846 catalogue called the *bozzetto* (or sketch) for the painting was exhibited in the Pinacoteca, evidently as a replacement; given the high level of quality of the collection, it is unlikely that this *bozzetto* is identifiable with the picture now in the Accademia di San Luca — which is a mediocre seventeenth-century copy, of different dimensions.

The Rest on the Flight into Egypt was one of Barocci's most popular works, as indicated by the number of autograph replicas and its almost immediate reproduction (1575) in an engraving by Cornelis Cort. The composition, derived from Correggio's *Madonna della Scodella*, is an example of Barocci's characteristic elegance of execution and an image of extraordinary lyricism.

F. M.

BIBLIOGRAPHY: G. P. Bellori, *Le Vite de' pittori, scultori et architetti moderni*, Rome, 1672, pp. 176, 193, 196; *Galleria di quadri al Vaticano*, Rome, 1846, pp. 35–36; P. D'Achiardi, *Guida della Pinacoteca Vaticana*, III, Rome, 1913, p. 140, no. 253; H. Olsen, *Federico Barocci*, Copenhagen, 1962, pp. 60–61, 154–56; *Mostra di Federico Barocci* (exhib. cat.), entry by A. Emiliani, Bologna, 1975, pp. 85–87; C. Pietrangeli, "I Musei Vaticani dopo Tolentino," in *Strenna dei Romanisti*, 1975, p. 355.

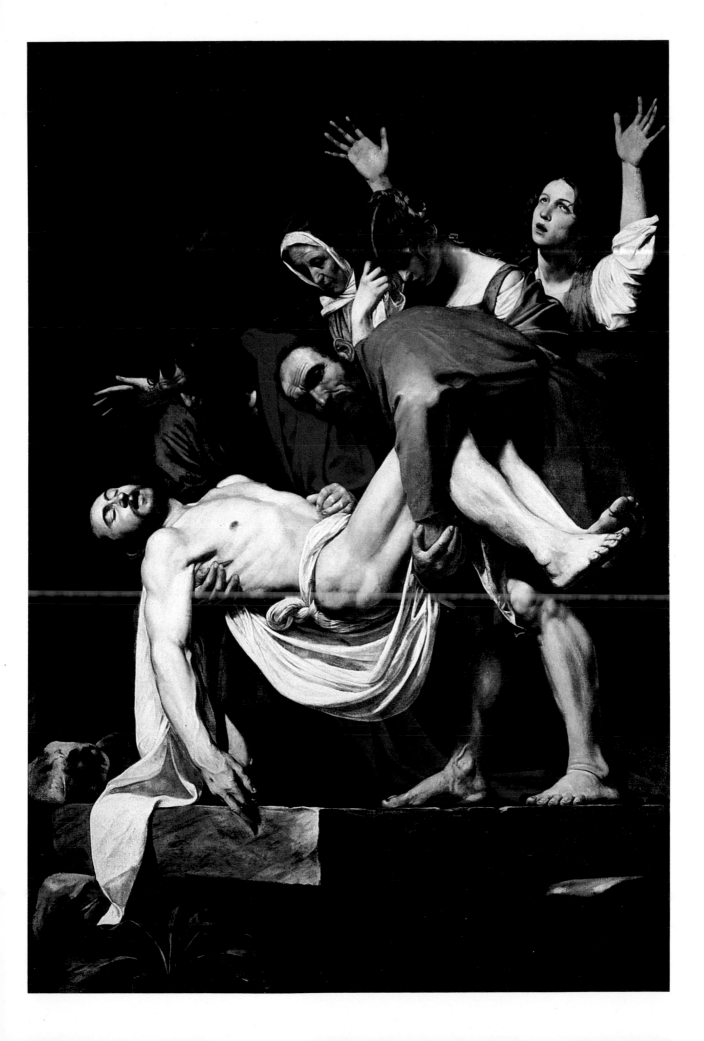

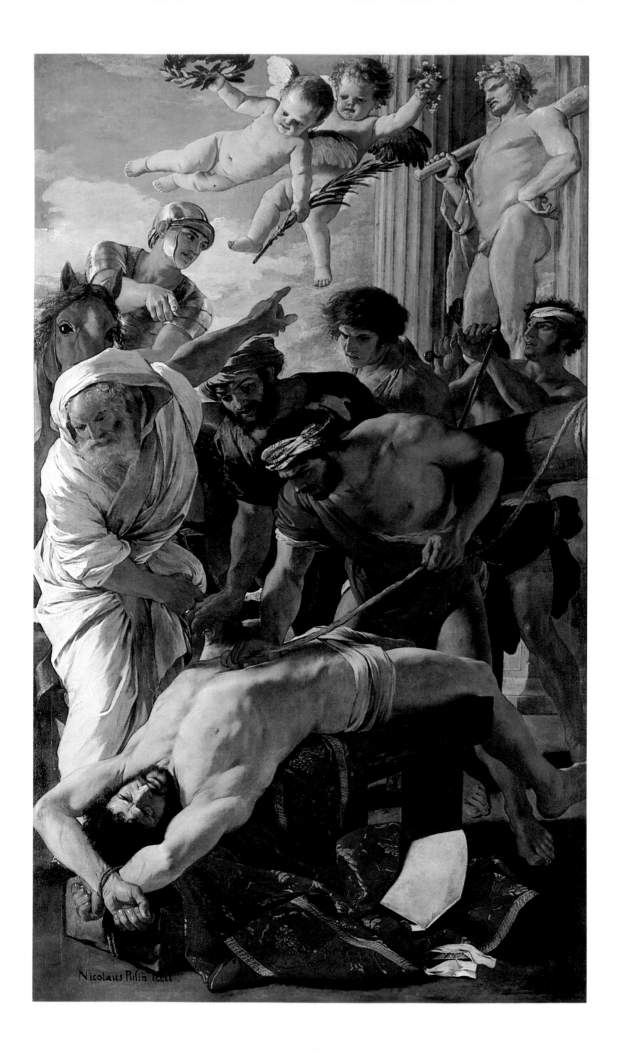

when the body of Christ was placed on the Stone of Unction, which then would be used as the slab to seal his tomb. Symbolically, as M. Calvesi (cf. "Caravaggio o la ricerca della Salvazione," in *Storia dell'Arte*, IX–X, 1971, pp. 121–23, n. 108) has noted, the slab alludes to Christ as the cornerstone and foundation of the Church. Marini (1974, p. 33) has suggested that the inclusion of the yew beneath the stone and the fig beside the entrance to the sepulcher has symbolic import, as well. The former recalls a passage in Isaiah (53:2) that refers to Christ, while the latter is not the accursed fig tree of Matthew (21:18–22) and Mark (11:13–14) but, more probably, the Resurrection symbol of the two parables in Luke (13:6–9, 21:29–31). The anomalous presence of the Virgin is due to the necessity of representing the same subject, the Pietà, that appeared in the

previous altarpiece in the chapel: the iconographic program could not be changed, since each of the chapels was planned by Saint Philip Neri to invite meditation on a single Mystery of the Rosary. (It should be noted that the features of Nicodemus are curiously reminiscent of those of Philip Neri's death mask.)

The composition of Caravaggio's altarpiece recalls Raphael's Baglioni *Deposition*, Peterzano's *Deposition* at San Fedele in Milan, and the Michelangelo *Pietà* in Saint Peter's. The hypothesis that the figure of Mary Cleophas was a later addition is without foundation (G. C. Argan, 1943, pp. 40–43; R. Longhi, 1943, pp. 100–102). Caravaggio painted *The Deposition* shortly after completing the decoration of the Cerasi Chapel in Santa Maria del Popolo and the Contarelli Chapel in San Luigi dei Francesi. The

picture is one of the few about which there has been almost universal agreement: As G. Baglione (1642, p. 137) noted, it was said to be Caravaggio's greatest work.

F. M.

BIBLIOGRAPHY: G. Baglione, *Le Vite de' pittori scultori et architetti, dal pontificato di Gregorio XIII, del 1572, in fino a' tempi di papa Vrbano Ottauo nel 1642*, 1642, p. 137; G. and A. D'Este, *Elenco degli oggetti esistenti nel Museo Vaticano*, Rome, 1821, pp. 17–19; G. C. Argan, "Un'ipotesi caravaggesca," in *Parallelo*, II, 1943, pp. 40–43; R. Longhi, "Ultimissime sul Caravaggio," in *Proporzioni*, I, 1943, pp. 100–102; W. Friedlaender, *Caravaggio Studies*, Princeton, 1955, pp. 123–30, 186–89, no. 25; M. A. Graeve, "The Stone of Unction in Caravaggio's Painting for the Chiesa Nuova," in *The Art Bulletin*, XL, 1958, pp. 223–38; M. Marini, *Io Michelangelo da Caravaggio*, Rome, 1974, pp. 32–33, 180, 398–99, no. 48.

86

NICOLAS POUSSIN (Les Andelys 1594– Rome 1665)

THE MARTYRDOM OF SAINT ERASMUS

1629
Oil on canvas
Height, 126" (320 cm); width, 73 1/4" (186 cm)
Pinacoteca, Inv. no. 815

This painting was restored in 1980 on the occasion of the exhibition "Bernini in Vaticano" (1981). A rather sizable damage near the left shoulder of the soldier in the foreground— sustained long ago—has been inpainted with vertical hatching. The subject, the martyrdom of Saint Erasmus, was first represented in the fourteenth century; virtually unknown in France in Poussin's time, it was only rarely met with in Italy, though Saraceni's altarpiece for the cathedral of Gaeta is an important precedent. Poussin's *Martyrdom*, intended for one of the altars in the right transept of Saint Peter's, was commissioned in February 1628. A. Félibien (1666–85; 1725 ed., IV, p. 19) states that Poussin secured the commission through his patron Cassiano dal Pozzo, although Bernini told P. Fréart de Chantelou (1665; 1885 ed., p. 146) that the suggestion was his. In any event, it was Poussin's first public commission since his arrival in Rome in 1624. He completed the painting in 1629, and signed

it: Nicolaus Pusin fecit. The work met with only limited success; contemporaries preferred the *Martyrdom of Saints Processus and Martinian*, which Valentin had painted in the same year for the altar on the opposite wall of the transept. *The Martyrdom of Saint Erasmus* remained in Saint Peter's until the eighteenth century, when it was replaced by a mosaic copy and moved to the Palazzo del Quirinale. Following the terms of the Treaty of Tolentino, the painting was sent to Paris in 1797; it was returned to Rome in 1817, and entered the collection that Pius VII had assembled as the new Vatican Pinacoteca.

The commission had been awarded first to Pietro da Cortona, whose preparatory drawing influenced Poussin's work. Venetian characteristics in *The Martyrdom of Saint Erasmus* confirm the artist's supposed stay in Venice: according to M. Stein (1952, pp. 5–6), his conception is derived from Veronese's *Martyrdom of Saints Primus and Felicianus*, painted for the Abbey of Praglia (now in the Museo Civico in Padua), while for A. Blunt (1966, p. 67), Titian's Pesaro Altarpiece in the church of the Frari in Venice is the source. Both critics note that the two putti were taken from Titian's *Death of Saint Peter Martyr* (then in Santi Giovanni e Paolo, Venice, but since lost), while Stein believes that the figure of the soldier on horseback is a reflection of

Veronese's *Martyrdom of Saint Sebastian*, created for the Venetian church of the same name.

The picture is painted with extraordinary sureness: There are very few *pentimenti*, and the pigment is laid on in broad, flat masses, creating strong contrasts of light and shadow. The recent restoration has revealed an extremely intense palette that is Venetian in origin—closer to that of Veronese than to Titian—but with a different tonal accent. In fact, Poussin used almost pure pigments, applied thinly over reddishbrown underpainting. It is this ground, exposed in the shadows, that gives the painting its warm, fiery tonality. The limited palette and the rigorous formal structure of the composition produce an impression of restrained yet expressive violence.

F. M.

BIBLIOGRAPHY: P. Fréart de Chantelou, *Journal du voyage du Cavalier Bernin en France* (1665), Paris, 1885, pp. 67, 72, 146; A. Félibien, *Entretiens sur les vies et sur les ouvrages des plus excellens peintres anciens et modernes* (1666–85), Paris, 1725, III, p. 227, IV, p. 19; M. Stein, "Notes on the Italian Sources of Nicolas Poussin," in *Konsthistorisk Tidskrift*, XXI, 1952, pp. 5–6; A. Blunt, *The Paintings of Nicolas Poussin. A Critical Catalogue*, London, 1966, pp. 66–68, no. 97; F. Mancinelli, "Nicolas Poussin. Il Martirio di S. Erasmo," entry in *Bernini in Vaticano* (exhib. cat.), Rome, 1981, pp. 61–62, no. 36.

87

GUERCINO (GIOVANNI FRANCESCO
BARBIERI), Cento 1591–Bologna 1666

MARY MAGDALENE

1622
Oil on canvas
Height, 86 ⅝" (220 cm); width, 78 ¼" (200 cm)
Pinacoteca, Inv. no. 391

This picture was restored in 1982; the face of
the Magdalene and the background are some-
what abraded, and the dark colors, particularly,
were damaged in a previous overcleaning. The
work was painted for the high altar of a church in
Rome that was dedicated to Saint Mary Magda-
lene, the Convertite al Corso. As D. Mahon
(1968, p. 111) has pointed out, the painting
should be dated 1622, when it was engraved by
G. B. Pasqualini. A. Porcella (1933, p. 196) holds
that it was executed in 1623, the year in which
it was registered by Guercino's brother Paolo
Antonio; however, this date probably refers to a
subsequent payment. The identity of the patron
is not recorded. F. Titi (1675; 1763 ed., p. 348)
speaks of restoration work in the church, which
had burned in 1617, that was carried out, under
Paul V (1605–21), by Cardinal Pietro Aldobran-

dini (died 1621) and his sister Olimpia, so that it
is possible that the cardinal was also responsible
for the commission. Until the church was sup-
pressed—probably during the Napoleonic era—
the picture remained there; afterward, it was sent
to the Palazzo del Quirinale, where Camuccini
restored it. In 1817, it was transferred to the new
Vatican Pinacoteca and, thus, entered Pius VII's
collection (G. and A. D'Este, 1821, p. 38).

Guercino illustrates the meeting of Mary
Magdalene and the angels at the empty sepul-
cher of Christ, an episode based on the Gospel
of John (20:11–13). Here, however, the subject
is given a somewhat moralistic, typically post-
Tridentine interpretation, which is clearly re-
flected in G. Passeri's description (1772; 1934
ed., p. 352). He noted that Guercino painted
Mary Magdalene repenting her vanities and
errors: the saint kneels on the hard ground and
laments her faults, while one of the angels as-
sisting in her penitence presents her with the
nails with which Christ was crucified; the other
points to heaven to indicate the true hope for
her salvation, comforting her. The theme of the
Magdalene was particularly popular at this time,
and even had inspired an ode by Cardinal Maffeo
Barberini, published in Paris in 1618.

In comparison with other works of this date,
the *Mary Magdalene* is closest in style to the artist's
pre-Roman paintings. Nonetheless, to para-
phrase Mahon (1968, p. 112), the lighting and
atmosphere do not dominate the forms as much
as would previously have been the case; the
figures do not give the impression of fluidity
and change, and the pointing gesture of the angel
has a curiously statue-like stability. Mahon de-
scribes the effect as somewhat closer to that of a
bas-relief against a background, rather than that
of figures fused with their environment. The
picture, which Passeri (1772; 1934 ed., p. 352)
thought incomparable, is one of the milestones
of Guercino's Roman period.

F. M.

BIBLIOGRAPHY: F. Titi, *Descrizione della pitture, sculture e
architetture esposte al pubblico in Roma* (1675), Rome, 1763,
pp. 348–49; G. Passeri, *Vite de' pittori, scultori, e architetti, che
hanno lavorato in Roma, e che sono morti dal 1641 al 1673*,
1772, Hess ed., Leipzig and Vienna, 1934, p. 352; G. and
A. D'Este, *Elenco degli oggetti esistenti nel Museo Vaticano*,
Rome, 1821, p. 38; A. Porcella, *Musei e Gallerie Pontificie,
Guida della Pinacoteca Vaticana*, Vatican City, 1933, p. 196;
N. Barbanti Grimaldi, *Il Guercino*, Bologna, 1968, p. 92;
D. Mahon, *Il Guercino. Catalogo critico dei dipinti* (exhib.
cat.), Bologna, 1968, pp. 111–12.

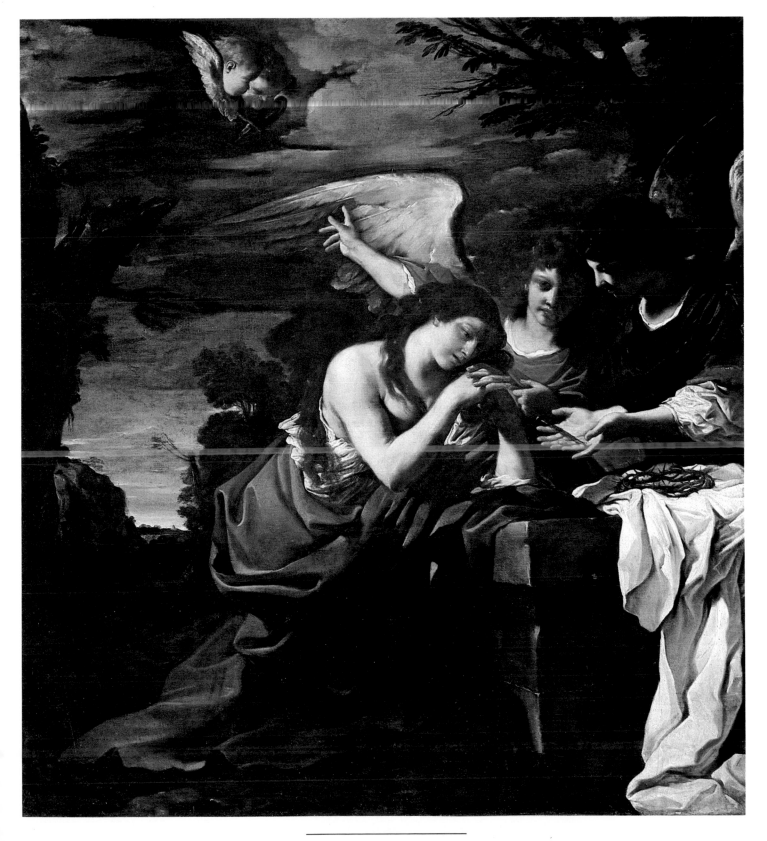

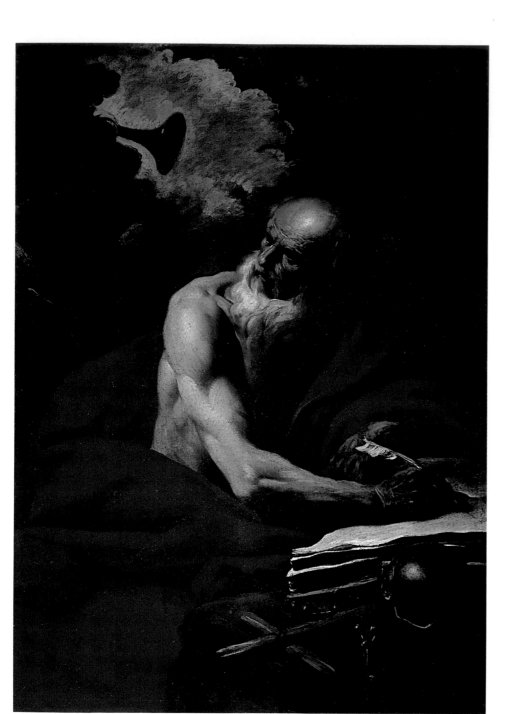

PIERFRANCESCO MOLA (Coldrerio
 [Como] 1612–Rome 1666)
SAINT JEROME
c. 1660
Oil on canvas
Height, 53 ⅛" (135 cm); width, 39" (99 cm)
Pinacoteca, Inv. no. 403

This picture, which is in perfect condition, was
restored in 1978. Its provenance is unknown;
before 1932, when it entered the Pinacoteca, it
was in the pontifical villa at Castel Gandolfo
(A. Porcella, 1933, p. 206). Mola depicts Saint
Jerome listening to the trumpet of the Last
Judgment, a subject that was first represented
in the sixteenth century. The saint is seen in half-
length, three-quarter view, wrapped in—but at
the same time emerging from—the bulky red
cloak that is the dominant chromatic element in
the painting. He grasps a quill in his right hand,
which rests on the book in which he has been
writing. Adjacent are three characteristic attri-
butes: a skull, a cross, and a rosary. The picture is
broadly painted—note, for example, the cloak—
and may be a study rather than a finished work.

Porcella (1933, p. 206) attributed this work
to Mola, dating it to the period when the artist
was most influenced by Ribera. He also noted
that it is close in style to the *Saint Jerome* in the
Galleria Barberini. Despite its undoubted quality,
this painting has attracted little notice. E. Water-
house (1976, p. 97) considers the attribution
probable but not certain. There are a number of
late works by Mola representing Saint Jerome, as
as A. Czobor (cf. "On Some Late Works of Pier
Francesco Mola," in *The Burlington Magazine*,
CX, 1968, figs. 41, 43) has demonstrated; among
these are two drawings of Saint Jerome listen-
ing to the trumpet of the Last Judgment—one
in the Kupferstichkabinett in the Staatliche
Museen in East Berlin; the other in the Teylers
Museum in Haarlem. Czobor, like Porcella,
emphasizes the importance of Ribera's influence
on Mola—many of whose works were erro-
neously attributed to the Spanish painter in the
past. The painting by Ribera that most closely
resembles, and may in fact have inspired, the
Vatican picture is the *Saint Jerome* in the Galleria
Doria-Pamphili in Rome.

F. M.

BIBLIOGRAPHY: A. Porcella, *Musei e Gallerie Pontificie,
Guida della Pinacoteca Vaticana*, Vatican City, 1933, p. 206;
E. Waterhouse, *Roman Baroque Painting*, Oxford, 1976,
p. 97.

89

CARLO MARATTA (Rome 1625–1713)
PORTRAIT OF CLEMENT IX (1667–69)

1669
Oil on canvas
Height, 57 ⅛" (145 cm); width, 45 ¹¹/₁₆" (116 cm)
Pinacoteca, Inv. no. 460

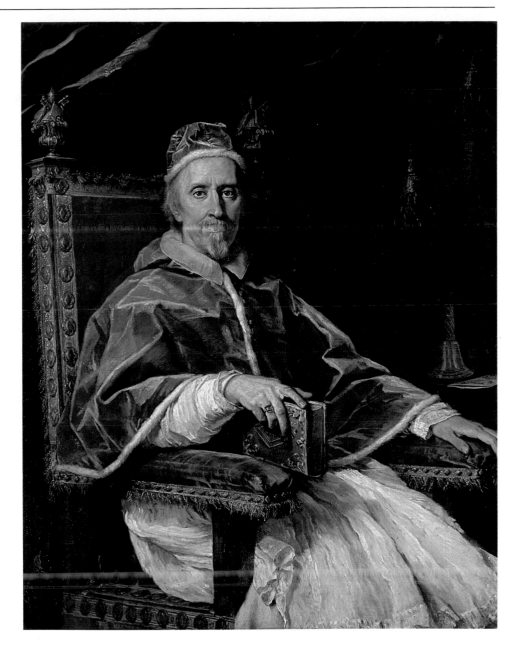

Formerly in the Rospigliosi Collection, this painting was acquired by Louis Mendelssohn of Detroit, who donated it to Pius XI on March 8, 1931. It is in excellent condition, and was exhibited in Florence in 1911 (cf. *Il ritratto italiano*, entry by C. Gamba, Bergamo, 1927, pp. 25–26) and at the Staatliche Museen Preussischer Kulturbesitz in Berlin in 1980 (E. Schleier, 1980, pp. 223–24). Clement IX, who was born Giulio Rospigliosi, in 1600, is here portrayed in the last year of his life; he died on December 9, 1669. The pope is seated on a throne very similar to that of Innocent X (1644–55), which is still in the pontifical villa at Castel Gandolfo. The pope wears the violet camauro, mozzetta, and rochet, and holds a book in his right hand; on the table to his left is a sheet of paper inscribed with Maratta's dedication, which Bellori (c. 1700, in M. Piacentini, 1942, pp. 87–88) described as a shrewd way of better reconciling himself with the pope. The text, which differs slightly from what Bellori reported, reads "Alla Santità di Papa Clemente IX da Carlo Maratti." This work was not an official portrait, nor was it made for a specific location; rather, it was painted in order to comply with the pope's wish, as he felt death approaching, to sit for his favorite artist.

According to Bellori, Clement IX asked to see Maratta's portrait of the pope's nephew Cardinal Giacomo Rospigliosi. Maratta, who had just finished the picture, brought it to the pontiff, and, after Clement had praised it, he asked the painter, "When shall we have ours done?" To this proposal Maratta responded, "Whenever it pleases your Holiness." During the Carnival of 1669, Maratta began the portrait at the monastery of Santa Sabina on the Aventine, to which Clement IX had, according to his custom, retired. Work on the picture continued until Ash Wednesday, but did not proceed smoothly due to the pope's precarious health. On one occasion, as Maratta was working, Clement grew faint and was in danger of falling from his chair; the painter, who was alone, had no choice but to rush forward and offer him support. Given the pope's failing health, only a few sittings were possible, and the artist, having finished the face, completed the rest of the picture at home. Maratta was for the most part occupied with large altarpieces, and portrait painting was a relatively minor aspect of his oeuvre; nevertheless, he attained very high levels of quality, as indicated by the patronage accorded him.

The *Portrait of Clement IX* is among the finest seventeenth-century Roman portraits. The only precedents of equivalent quality are Van Dyck's *Portrait of Cardinal Bentivoglio* and Velázquez's *Innocent X*, which, according to H. Voss (1924, p. 599), may have been Maratta's immediate source. Schleier (1980, p. 223) finds Velázquez's painting more expressive, and superior in its psychological depth, while Maratta's is distinguished by its monumentality and dignity; each captures the essence of its subject. In Maratta's portrait the chair is less strongly foreshortened, so that the diagonal orientation of the figure and his gesture are emphasized. The artist's conception, and the palette that he has chosen, suggest the pope's state of physical exhaustion; the characterization is a masterpiece of psychological penetration.

F. M.

BIBLIOGRAPHY: H. Voss, *Die Malerei des Barock in Rom*, Berlin, 1924, p. 599; A. Porcella, *Musei e Gallerie Pontificie, Guida della Pinacoteca Vaticana*, Vatican City, 1933, p. 233; M. Piacentini, *Le vite inedite del Bellori* (c. 1700), I, Rome, 1942, pp. 87–90; P. Bautier, "À propos d'un portrait du Pape Clément IX au Musée de Bruxelles," in *Pro Arte*, V, 1946, pp. 3–7; A. Mezzetti, "Contributi a Carlo Maratti," in *Rivista dell'Istituto Nazionale d'Archeologia e Storia dell'Arte*, n.s., IV, 1955, pp. 296–97, 345, no. 151; *Bilder vom Menschen* (exhib. cat.), entry by E. Schleier, Berlin, 1980, pp. 223–24, no. 13.

90

DONATO CRETI (Cremona 1671–Bologna 1749)

A–H. THE ASTRONOMICAL OBSERVATIONS

1711

The origin of Creti's astronomical scenes is associated with an unusual but shrewd idea on the part of Creti's patron, Count Luigi Ferdinando Marsili (1658–1730): with these paintings he hoped to convince the Albani pope, Clement XI (1700–1721), to support the construction of an observatory in Bologna. In 1703, Marsili—a soldier, passionate naturalist, and dilettante astronomer—had an observatory constructed in his own palazzo; he entrusted the operation of the observatory, furnished with the most modern equipment, to the mathematician Eustachio Manfredi (1674–1739). In 1709, Marsili's family, opposing his plan to donate the entire complex to the city of Bologna, refused to renounce their claims to the property.

Marsili then dismantled the observatory, but again he offered the equipment to the Bolognese Senate on the condition that the Senate provide for the construction of a new observatory and

90 A. THE ASTRONOMICAL OBSERVATIONS: THE SUN

1711
Oil on canvas
Height, 20¼" (51.5 cm); width, 13¾" (35 cm)
Pinacoteca, Inv. no. 432

This work was restored in 1973. It represents the observation of the sun, which is seen at its most brilliant, through a telescope resting on an adjustable shelf that is mounted on a stand. One of the three astronomers holds a piece of paper on which the image of the sun is projected.

90 B. THE ASTRONOMICAL OBSERVATIONS: THE MOON

1711
Oil on canvas
Height, 20¼" (51.5 cm); width, 13¾" (35 cm)
Pinacoteca, Inv. no. 433

This canvas represents the observation of the full moon, seen low on the horizon, with craters and seas clearly visible. One of the two astronomers looks at it through a telescope supported on a pedestal.

furnish a home for the Istituto delle Scienze that he had founded. The money needed for the project was lacking in the civic coffers, and, since Bologna was under pontifical authority, the Senate decided to seek from the pope not only his approval but also the necessary means to implement the work. Marsili decided to send the pope the plans and documentation, as well as a visual demonstration of the discoveries of such an astronomical observatory. Creti, then at the height of his fame, thus was commissioned to paint eight landscapes to which, following Manfredi's instructions, the miniaturist Raimondo Manzini would add the five planets then known, the sun, the moon, and a comet; these would be shown as if seen through a telescope—which explains their abnormal dimensions with respect to the landscape. In addition, Creti would depict astronomers working with the equipment to be housed in the new observatory.

Manfredi advised the count, in a letter of August 30, 1711, that Creti had begun work. Toward the end of the year he finished the paintings, for, shortly afterward, Marsili brought them to Rome. He obtained the support he was hoping for (although the pope did not approve another project that he had sponsored—a plan for geographic reform). On January 11, 1712, the count donated to the city his natural history specimens and scientific instruments; in 1714,

90 C. THE ASTRONOMICAL OBSERVATIONS: JUPITER

1711
Oil on canvas
Height, 20 ¼" (51.5 cm); width, 13 ¾" (35 cm)
Pinacoteca, Inv. no. 437

This picture was restored in 1973. It represents the nighttime observation of Jupiter by two astronomers; next to them is a long telescope raised on a standard. On the surface of the planet are the six major bands and, above the center, the great red spot as it appears in a refracting telescope; three of Jupiter's moons, aligned on the same plane, are also visible.

90 D. THE ASTRONOMICAL OBSERVATIONS: SATURN

1711
Oil on canvas
Height, 20 ¼" (51.5 cm); width, 13 ¾" (35 cm)
Pinacoteca, Inv. no. 438

This painting represents the observation of Saturn. Although the setting is a daylight landscape, in reality, Saturn is only visible at night. In the middle ground are the astronomers, next to a tall standard at the top of which is a horizontal bar used to hold an aerial telescope without tubes. The kneeling man looks through a tubular instrument, probably part of the aerial telescope. Saturn is represented imprecisely and with only one ring.

the Istituto was established in the Palazzo Poggi (with Manfredi as director), and, in 1725, construction was completed on the adjoining observatory, which was designed by G. A. Torri.

The eight *Astronomical Observations* document the results of Creti's study of Venetian painting, and of the work of Marco Ricci. As R. Roli notes (1979, p. 59), Creti gives more than a pre-Enlightenment report on astronomical instruments: he also records a fascinating situation. In the transition from preparatory drawing to finished painting, Manfredi's instruments are diminished in prominence as they are absorbed into the landscape; this certainly did not meet with the astronomer's approval, but, rather, with the patron's and the pope's. After their presentation to Clement XI, the *Astronomical Observations* remained in the Vatican, where they may have decorated the pontifical apartments. At the beginning of the twentieth century, they were at Castel Gandolfo and, in 1932, when the Pinacoteca finally opened its doors to eighteenth-century paintings, the pictures became part of the gallery of Pius XI. All were exhibited in Bologna in 1979; *Jupiter* and *The Moon* were also exhibited in Bordeaux in 1959.

F. M.

90 E. THE ASTRONOMICAL OBSERVATIONS: VENUS

1711
Oil on canvas
Height, 20 ¼" (51.5 cm); width, 13 ¾" (35 cm)
Pinacoteca, Inv. no. 435

This work was restored and transferred to canvas in 1969. It represents the observation of Venus at dawn, with two astronomers occupying the middle ground. Next to them, partially hidden by a tree, is a quadrant supported on a pedestal.

90 F. THE ASTRONOMICAL OBSERVATIONS: MARS

1711
Oil on canvas
Height, 20 ¼" (51.5 cm); width, 13 ¾" (35 cm)
Pinacoteca, Inv. no. 436

The painting was restored in 1973. Despite the very clear sky, it represents the nocturnal observation of Mars. Slightly more than half of the planet is visible. The apparatus used in the observation appears at the edge of the painting, next to the three astronomers.

BIBLIOGRAPHY: A. Porcella, *Musei e Gallerie Pontificie, Guida della Pinacoteca Vaticana*, Vatican City, 1933, pp. 223–24; *La découverte de la lumière des Primitifs aux Impressionistes* (exhib. cat.), entries by G. Martin-Méry, Bordeaux, 1959, p. 78, nos. 147–48; R. Roli, *Donato Creti*, Milan, 1967, pp. 31–32, 96, nos. 83–90; *L'Arte del Settecento Emiliano. La pittura* (exhib. cat.), entry by R. Roli, Bologna, 1979, p. 59, nos. 92–99; S. A. Bedini, "The Vatican's Astronomical Paintings," in *Proceedings of the Eleventh Lunar and Planetary Science Conference*, I, 1980, pp. xiii–xxiii.

90 G. THE ASTRONOMICAL OBSERVATIONS: MERCURY

1711
Oil on canvas
Height, 20 ¼" (51.5 cm); width, 13 ¾" (35 cm)
Pinacoteca, Inv. no. 434

The painting represents the observation of Mercury, of which slightly more than half can be seen. In the foreground, two astronomers are engaged in discussion; next to them is a quadrant raised on a pedestal.

90 H. THE ASTRONOMICAL OBSERVATIONS: THE COMET

1711
Oil on canvas
Height, 20 ¼" (51.5 cm); width, 13 ¾" (35 cm)
Pinacoteca, Inv. no. 439

This work was transferred to canvas and restored in 1969. It depicts the passage of a comet, a phenomenon unnoticed by the woman seated in the foreground. The representation of the heavenly body is not based on direct observation by the miniaturist; the comet was probably drawn from sketches that Manfredi made during the passage of two comets in 1702.

91

GIUSEPPE MARIA CRESPI (Bologna 1665–1747)

THE HOLY FAMILY

c. 1735–40
Oil on canvas
Height, 23 ¼" (59 cm); width, 17 5/16" (44 cm)
Pinacoteca, Inv. no. 388

This canvas was restored in 1982; in a previous cleaning the surface had been abraded and the fingers of the Madonna's right hand severely damaged. The painting was first exhibited in the seventeenth-century room in the Pinacoteca in 1924–25 (B. Biagetti, 1924–25, p. 483); it came from the collection of the Cherubini - Menchetti family, who may have given it to Pius XI in 1923, at the time that the pope granted them a noble title.

X-radiographs taken during the most recent restoration show that Crespi originally conceived the composition in a slightly different manner; in the finished picture Joseph holds a cane, while in the preliminary version he raised the Madonna's veil, probably to better illuminate her weeping face. The *Madonna with the Sleeping Child* in the Tinozzi Collection in Bologna is similar in composition, although it is limited to only two figures (M. Pajes Merriman, 1980, fig. 31). The theme of the Holy Family was often treated by Crespi between 1720 and 1740. The Vatican picture, small in dimensions and with only three

figures, seems to be one of the later versions, datable between 1735 and 1740 (M. Pajes Merriman, 1980, pp. 256–57). Crespi focuses on the sorrowful meditation of the Virgin as she contemplates the future of her Son. He holds a cross, the symbol of his sacrifice, and raises his right hand to caress his mother affectionately; behind them, Joseph, an indistinct presence, emerges from the shadows.

The melancholy mood is underscored by the Virgin's gesture and by the dramatic use of light. Here, the illumination comes from two sources, much as in the contemporary *Lamentation beneath the Cross* (cf. M. Pajes Merriman, 1980, fig. 63). The cross held by the infant Jesus is a post-Tridentine motif that was often employed in Emilian painting of the late sixteenth century. Crespi uses it in his small oval *Holy Family* in Ascoli Piceno, as well, but there it appears as a shining object without the tragic overtones of the Vatican canvas. Another oval picture that faithfully repeats many details of the Vatican painting was published by F. Arcangeli ("Due inediti di G. M. Crespi," in *Paragone*, III, no. 25, 1952, pp. 46–47, pl. 30) as a work by Crespi; it is thought by M. Pajes Merriman (1980, p. 257) to be by his workshop.

F. M.

BIBLIOGRAPHY: B. Biagetti, "Relazione IV," in *Rendiconti della Pontificia Accademia Romana di Archeologia*, III, 1924–25, p. 483; A. Porcella, *Musei e Gallerie Pontificie, Guida della Pinacoteca Vaticana*, Vatican City, 1933, p. 194; *La découverte de la lumière des Primitifs aux Impressionistes* (exhib. cat.), entry by G. Martin-Méry, Bordeaux, 1959, p. 32, no. 59; M. Pajes Merriman, *Giuseppe Maria Crespi*, Milan, 1980, pp. 256–57, no. 76.

92

GIUSEPPE MARIA CRESPI (Bologna 1665–1747)

PORTRAIT OF BENEDICT XIV (1740–58)

1740
Oil on canvas
Height, 102 3/8" (260 cm); width, 70 7/8" (180 cm)
Pinacoteca, Inv. no. 458

This canvas, which was lined and restored in 1981, had suffered three tears, two in the lower part and one above the right shoulder of the pope; these were repaired long ago by patching the reverse side. Before cleaning, the painting was in excellent condition, although the surface was clouded by oxidation. With cleaning it has regained its original freshness.

Crespi depicts Benedict XIV (Lambertini; born 1675, died 1758), founder of the Museo Sacro (1756) in the Vatican Library and of the Galleria Lapidaria, an enlightened pontiff whom the painter knew well. Benedict wears a white rochet, a deep-red mozzetta, and a papal stole and camauro. He has just gotten up from his worktable, on which are a book, papers, inkwells, a triple-crown tiara—another papal emblem—and a sketch of an altar with an altarpiece of the Madonna and Child, a kneeling saint, and angels. A figure in a cassock lifts a curtain, revealing bookshelves containing the volumes of Lambertini's work on canonization, and, on one shelf, several open books and the plan for a public building. The sketch and the plan probably refer to projects completed in Bologna while Lambertini was cardinal: the restoration of the Seminario Maggiore; and Donato Creti's altarpiece for Saint Peter's, which he himself may have commissioned, as Elisabeth Kieven has suggested.

The portrait was discovered in 1932 by A. Porcella in the Sala dei Foconi of the Vatican palace and exhibited in the Pinacoteca that year; it is among the best-documented paintings in the collection, for Crespi's son Luigi recounts its history in his *Vite de' pittori bolognesi . . .* (1771, pp. 219–20), the details of which are confirmed by the correspondence among Crespi, the pope, and his secretary of state, Cardinal Valenti Gonzaga (T. Valenti, 1938, pp. 15–31). The portrait had been commissioned by Lambertini, perhaps in 1739, for the Seminario Maggiore. A splendid sketch, which is generally dated 1739, in the Collezioni Comunali d'Arte in Bologna (M. Pajes Merriman, 1980, p. 288), shows him in skullcap, white mozzetta, rochet, red surplice, and *cappa magna*, with the square red cardinal's biretta on the table. When, on August 17, 1740, Lambertini became pope, the vice-legate of Bologna asked if the portrait should remain in the seminary or follow Lambertini to Rome. On September 10, Crespi wrote for instructions, letting it be known that he preferred the second solution, if only because he hoped to gain favor for himself and his family. Initially, Benedict was against this, and his opinion was conveyed to Crespi by Cardinal Gonzaga on September 24; at the beginning of October, however, once Benedict heard that the painting was still in the studio of the artist, who was dressing it like a pope (T. Valenti,

X-radiograph of 92

1938, p. 24), the pontiff decided to have the portrait brought to Rome. On October 26, it was finished and dispatched and, on November 2, Benedict asked Valenti to inform Crespi of the pope's satisfaction with it, and of his nomination as painter to the pope. Benedict also promised to find a position for Crespi's son Luigi.

The documentation concerning the portrait has been confirmed by the X-radiographs made during its restoration, which revealed that two preliminary versions preceded the definitive one. At first, the portrait was almost identical to the sketch. In the intermediate stage, Crespi enlarged the chair, adorning it with moldings and a tiara with the papal keys, and replaced the biretta with the triregnum. It is not clear whether the

substitution of the skullcap with the camauro was the only change in the pope's clothing. Finally, Crespi effected a much more radical transformation by enlarging the dimensions of the figure and further modifying the furnishings and the clothing. In consequence, he heightened the monumentality of the portrait and isolated the pontiff at the center, endowing his sitter with authority equal to his new position. Crespi employs a carefully modulated series of soft brown and red tones, which give the whole an appropriate solemnity. The focal point is the intensely expressive, thoughtful face of the pope, which has as its counterpart the sharply characterized profile—presumably a portrait—of his attendant. The objects that surround Benedict XIV convey

his cultivated and refined nature, and the whole is rendered with an ease of expression in broad, sure brushstrokes—a testimony to the artist's vitality, even in the last years of his life.

F. M.

BIBLIOGRAPHY: L. Crespi, *Vite de' pittori bolognesi non descritte nella "Felsina pittrice,"* Bologna, 1771, pp. 219–20; A. Porcella, "Un portrait de Benoît XIV à la Pinacothèque Vaticane," in *Illustrazione Vaticana*, III, 1932, pp. 655–57; T. Valenti, "Benedetto XIV e Giuseppe Maria Crespi detto 'lo Spagnolo,' pittore bolognese," in *L'Archiginnasio*, XXXIII, 1938, pp. 15–31; R. Roli, *Pittura bolognese 1650–1800: Dal Cignani ai Gandolfi*, Bologna, 1977, p. 171; M. Pajes Merriman, *Giuseppe Maria Crespi*, Milan, 1980, pp. 288–89, no. 190.

93

POMPEO BATONI (Lucca 1708–Rome 1787)
PORTRAIT OF PIUS VI (1775–99)

1775
Oil on canvas
Height, 54 3/8" (138 cm); width, 37 13/16" (96 cm)
Pinacoteca, Inv. no. 455

This picture, restored in 1975, is in excellent condition. It comes from the storerooms of the Floreria Apostolica and was first exhibited in the Pinacoteca in 1932; it may always have been part of the pontifical collections. The portrait represents the Braschi pope, Pius VI (1717–1799), who was responsible for the completion of the Museo Clementino and the creation of the first Vatican Pinacoteca. The pope is seated on a throne decorated with his coat of arms; he wears a rochet, mozzetta, and stole, and a white cap—Pius VI was the first pope portrayed in this dress—without the camauro, which is on the adjacent table, next to a large clock of polychromed porcelain.

The painting is a sketch, although the clock was executed carefully with attention to detail. An identical but more highly finished version (in the Museo di Roma) is inscribed by the artist: Alla Santità di N.ro Sig.re Papa Pio VI Per P. Batoni Pinxit 1775. The attribution of the Vatican picture to Batoni is therefore also assured (formerly the work had been given to Anton Raphael Mengs), as is the date, 1775—the year of Pius VI's election as pope. A replica is in the Galleria Sabauda in Turin and another version is in the Muzeum Narodowe in Warsaw. The fresh, sketch-like quality and the high level of execution of the Vatican picture suggest—as noted by G. Incisa della Rocchetta (1957, p. 4)—that this was the portrait that Batoni painted from life, and that it became the model for various replicas, which are attributable either to the artist himself, or to his workshop. With such portraits Batoni achieved popular success in his own time; the technique—precise and elegant, yet rather cold—is typical of his style.

F. M.

BIBLIOGRAPHY: G. Incisa della Rocchetta, "Il ritratto di Pio VI del Batoni al Museo di Roma," in *Bollettino dei Musei Comunali di Roma*, IV, 1957, pp. 1–4; *Mostra di Pompeo Batoni* (exhib. cat.), entry by I. Belli Barsali, Lucca, 1967, p. 160.

MUSEO GREGORIANO EGIZIO

The history of the collections of the Museo Gregoriano Egizio is intricately linked with two waves of Egyptomania that occurred about two thousand years apart. The first of these waves reached the shores of Italy during the time of the Roman Republic and continued well into the period of the Roman Empire. Among those fascinated by Egypt's charms were the poet Catullus, the rogue Clodius, and the general Pompey.

Repeatedly, during the first century B.C., the Oriental cult of the Egyptian goddess Isis was officially banned in Rome, only to become public again. The conflict between Republican mores and imported Orientalism came to a head at the Battle of Actium in 31 B.C. when the Roman forces of Octavian, the future Emperor Augustus (27 B.C.–A.D. 14), collided with the might of Egypt, led by Cleopatra VII and her paramour, Mark Antony. Despite Cleopatra's defeat, many Roman citizens remained enthralled with Egypt. The poet Propertius, writing during the principate of Augustus, created an intensely personal poem about his feelings toward the cult of Isis. Augustus himself, who banned Egyptian culture in an attempt to eradicate the memory of Mark Antony, nevertheless was responsible for removing obelisks and other monuments from Egypt, transporting them across the Mediterranean Sea, and reerecting them in the Eternal City.

Augustus's lead was followed by other Roman emperors, notably the Flavian Domitian (A.D. 81–96), whose villa at Paola Lagoon and temple at Beneventum were adorned with objects imported from Egypt and with Roman works made in an Egyptianizing fashion. Domitian's passion was surpassed only by that of the Roman Emperor Hadrian (A.D. 117–38), who constructed the Canopus, an architectural complex that was a personal evocation of the Egypt that he loved, as part of his villa near Tivoli.

The Fall of Rome in the fourth century, the concomitant rise of Christianity, and the gradual abandonment of ancient sites in Italy contributed to a break with the traditions of Egypt in the West. Egyptian monuments in Italy remained under the earth until they were discovered in modern times, giving birth to the science of Egyptology.

That birth was spectacularly assisted by the Frenchman Jean François Champollion, who in 1818 announced that he had deciphered the ancient Egyptian hieroglyphs, based on the texts found on the Rosetta Stone. It was Champollion's subsequent relationship with the Holy See that inaugurated the second wave of Roman Egyptomania and paved the way for the founding of the Museo Gregoriano Egizio.

This relationship began with Pope Pius VII (1800–1823) and Pope Leo XII (1823–29). Under their pontificates, the Vatican acquired a collection of Egyptian papyri from the Franciscan missionary Angelo da Pofi and from Giovanni Battista Belzoni, a circus strongman turned adventurer who was the first European, in 1817, to enter the burial chamber of the pyramid of Chephren at Giza and who, that same year, discovered the tomb of Seti I in the Valley of the Kings. The care of the papyrus collection was entrusted to Angelo Mai (1782–1854), Prefect of the Vatican Library. Aware of Champollion's theories, Mai invited him to Rome to work on the papyri at a time when antagonism toward the Frenchman was strongest. Abbot Michelangelo Lanci (1779–1867) condemned Champollion's findings as false since, in the abbot's opinion, they contradicted the Bible. Notwithstanding the protestations of Lanci, Champollion studied the Vatican papyri, and, in the spring of 1825, he was summoned to an audience with Pope Leo XII.

The farsighted Mai used his newly formed friendship with Champollion to advantage, and the Frenchman was soon introduced to both the enthusiastic young Orientalist Ippolito Rosellini (1800–1843) and the Barnabite Father Luigi Maria Ungarelli (1779–1845), an accomplished philologist. In 1828, Champollion and Rosellini embarked on a joint Franco-Italian archaeological survey in Egypt, eventually publishing their results in the opus *I monumenti dell'Egitto e della Nubia* (5 vols., Pisa, 1832–44).

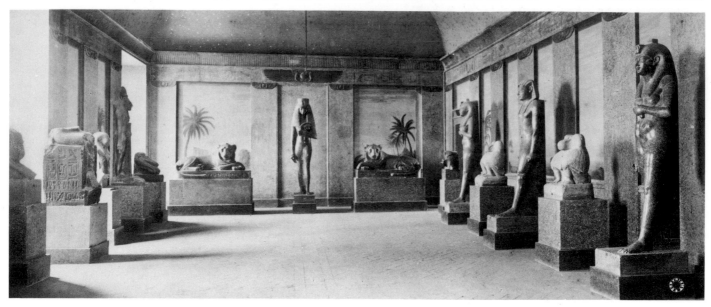

FIG. 37. A FORMER INSTALLATION OF THE MUSEO GREGORIANO EGIZIO, WITH PAINTINGS OF EGYPTIAN LANDSCAPES ON THE WALLS

At the beginning of the nineteenth century, the Camaldolese monk Bartolomeo Alberto Cappellari (1765–1846) was in residence at the Curia Romana, the central administrative body of the Catholic Church, and, in 1826, he was appointed by Pope Leo XII to the post of Cardinal and Prefect of Propaganda Fide. Mauro, as Cappellari was named, was renowned for his intelligence and for his open-mindedness on many of the issues of the day, both secular and clerical. Having attentively followed the early disputes between Champollion and his detractors, Mauro developed a passion for Egyptology. On February 12, 1831, he was elected pope and took the name Gregory XVI. His fascination with Egyptology, along with his interest in the humanities in general—spawned by the controversial theological implications of the latest Egyptological scholarship—imbued him with a keen desire to build several archaeological collections that would enhance the public's understanding of the Bible.

On February 2, 1837, Gregory XVI founded the Museo Etrusco in the Vatican. He also conceived of a similar museum for Egyptian antiquities, and he asked Rosellini to assist him in its establishment. Rosellini, preoccupied with the work of the Franco-Italian expedition, declined the offer, but he highly recommended Ungarelli. As a result, Ungarelli was appointed curator of the soon-to-be-opened Museo Egizio, along with Giuseppe Fabris, who was at that time director general of the Vatican Museums. Ungarelli and Fabris, in consultation with Gregory XVI, planned and designed the exhibition space. The objects to be housed and shown in the new museum were to come from various collections in and around Rome that were familiar to the pope.

The core of the Egyptian museum's collections came from the Vatican's own holdings, established by Pope Clement XIV (1769–74) and enriched by Pius VI (1775–99). Included were Egyptian objects that had been discovered at the ancient Roman sites of Paola Lagoon and Hadrian's Villa near Tivoli. These were augmented by purchases from Carlo De Assule of İzmir and by objects from the basement of the Biblioteca Casanatense, as well as from the Villa Borghese and the Villa Farnesina. A small but significant number of pieces came from the Museo Kircheriano, which had been founded by the Jesuit scholar Athanasius Kircher (1601–1680). Kircher contributed to the progress of Egyptology with his brilliant suggestion that the Coptic language used by the Early Christians in ancient Egypt was a very late stage of the hieroglyphic language. Further purchases were made for the Egyptian museum on the Italian art market. Both Pope Pius VII and Pope Leo XII, for example, bought objects from the antiquarians Filippo and Pietro Cavazzi, Giuseppe Basseggio, and Silvestro Guidi.

With a substantial collection already in the possession of the Vatican, Gregory XVI arranged for the transfer of additional Egyptian objects from the Capitoline museums, the Horti Sallustiani on the Pincio, and the Temple of Isis in the Campus Martius. The continued explorations at Hadrian's Villa yielded even more finds, and further purchases, among them those made in Egypt by Guidi, rounded out the museum's holdings (fig. 37).

The systematic acquisition of available works of art, and a competent staff headed by Ungarelli and Fabris, made it possible for the Vatican's Museo Egizio, with its newly designed space, to be opened by Pope Gregory XVI in February 1839. Known today as the Museo Gregoriano Egizio, in honor of its guiding spirit, the museum was the first in Europe to be established solely for the purposes of displaying and promoting an understanding of Egyptian art. It is a fitting tribute to Gregory XVI that some of the objects that he personally selected for the Vatican's collections were included in the American exhibition.

Christian Sturtewagen, S.J.,
and Robert S. Bianchi

BIBLIOGRAPHY: O. Marucchi, *Il Museo Egizio Vaticano*, Rome, 1899; *Miscellanea Gregoriana*, Vatican City, 1941; G. Botti and P. Romanelli, *Le sculture del Museo Gregoriano Egizio*, Vatican City, 1951; M. Malaise, *Inventaire préliminaire des documents égyptiens découverts en Italie*, Leiden, 1972; A. Roullet, *The Egyptian and Egyptianizing Monuments of Imperial Rome*, Leiden, 1972.

94

TORSO OF THE EGYPTIAN PHARAOH NECTANEBO I

Dynasty XXX (380–342 B.C.); reign of Nectanebo I
(380–362 B.C.)
Nepi (?), township of Latium
Black granite
Height, 31 ½" (80 cm)
Museo Gregoriano Egizio, Inv. no. 22671

Nectanebo I was the founder of Egypt's last native dynasty, the Thirtieth. He secured his nation's frontiers and ensured peace and prosperity by defeating the combined forces of Persia, commanded by Pharnabazus, and Greek mercenaries, led by Iphikrates. The reign of Nectanebo I inaugurated a flowering of the arts, especially sculpture in the round, as exemplified by this torso.

The torso is damaged on the right side, and the limbs and the head are lost. The modeling is strong, carefully executed, and lively. Traditionally, Egyptian craftsmen rendered the male torso in bipartition, focusing on the pectoral and lower abdominal regions while glossing over the ribcage area in between. Here, however, the torso is modeled in tripartition, with each of the three component elements—pectoral region, ribcage, and lower abdomen—clearly defined by merging planes that are particularly evident along the body's symmetrical axis and in the treatment of the teardrop-shaped navel. Such tripartition is infrequently encountered in early Egyptian sculpture but becomes more firmly established in the art of Dynasty XXVI (664–525 B.C.). In an attempt to rediscover their heritage, the artists of Dynasty XXX used sculptures from Dynasty XXVI as their models. This archaistic tendency kept artistic traditions alive and provided Nectanebo I with a sculptural vocabulary, based on Egyptian classical norms, that visually linked his creations—and, by extension, his political policies—to the glorious achievements of Dynasty XXVI.

The torso is not merely a shallow evocation of the past. The pleating of the kilt is innovatively treated as a series of sharply ribbed scallops—a stylistic feature peculiar to Dynasty XXX. The belt represents a beaded web with a buckle shaped like a cartouche, or royal ring, and contains the hieroglyphs for the king's name. The treatment of the buttocks and of the thighs emerging from beneath the kilt attests to the artist's skill in revealing flesh beneath fabric. The inscriptions on the back pillar, which displays the names and partially preserved titles of Nectanebo I, translate as: "The Horus, The One Strong of Arm, The One Who Belongs to the Two Ladies, The One Who Makes Flourish the Two Lands, The Horus of Gold, The One Beloved of the Eye of the Gods, The King of Upper and of Lower Egypt, Kheper-ka-ra, The Son of Ra, Nectanebo I."

The provenance of this torso is not known. It was donated by the township of Latium to Pope Gregory XVI in 1838, one year before the Vatican's Egyptian museum was opened.

C.S., R.S.B.

BIBLIOGRAPHY: G. Botti and P. Romanelli, *Le sculture del Museo Gregoriano Egizio*, Vatican City, 1951, pp. 10–12; J. J. Clère, "À propos de l'ordre de succession des rois de la XXXᵉ dynastie," in *Revue d'Égyptologie*, 8, 1951, pp. 25–29; C. Pietrangeli, "La provenienza dei monumenti del Museo Egizio Vaticano," in G. Botti and P. Romanelli, op. cit., p. 136, n. 21; W. C. Hayes, *The Scepter of Egypt*, I, New York, 1953, p. 180, fig. 110; B. V. Bothmer, H. De Meulenaere, and H. W. Müller, *Egyptian Sculpture of the Late Period*, Brooklyn, 1960, pp. xxxv, 10, 20, 54, 60, 68, 94, 95–96, 102, 103, 105, 112, 114–16, 127, 177; H. De Meulenaere, "Une Statue de prêtre héliopolitan," in *Bulletin de l'Institut Français d'Archéologie Orientale*, 61, 1962, p. 39; E. Bresciani, "Egypt and the Persian Empire," in *The Greeks and Persians*, trans. P. Johnson, ed. H. Bengston, New York, 1968, pp. 348–49; B. V. Bothmer, "Apotheosis in Late Egyptian Sculpture," in *Kêmi*, 20, 1970, pp. 46–47; C. Vandersleyen, *Das alte Aegypten*, Berlin, 1975, pp. 261–63; R. S. Bianchi, "Ex-Votos of Dynasty XXVI," in *Mitteilungen des Deutschen Archäologischen Instituts, Abteilung Kairo*, 35, 1979, p. 15; C. Aldred, "Statuaire," in *L'Égypte du crépuscule*, ed. J. Leclant, Paris, 1980, pp. 156–60; H. De Meulenaere, "Nektanebo I," in *Lexikon der Aegyptologie*, 4, Wiesbaden, 1980, pp. 450–51; W. Stevenson Smith, *The Art and Architecture of Ancient Egypt*, ed. W. Kelly Simpson, 2nd rev. ed., New York, 1981, pp. 418–22.

95

A, B. PAIR OF LIONS, INSCRIBED FOR PHARAOH NECTANEBO I

*Dynasty XXX (380–342 B.C.); reign of Nectanebo I
(380–362 B.C.)*
*Originally from Tell Baqlîya, Egypt; discovered at
the Pantheon in Rome*
Gray granite with red veining
*Height, each, 28 ¾" (73 cm); width (A), 72 ¼"
(185 cm), (B), 77 ½" (197 cm); depth, each,
9 ⁷⁄₁₆" (24 cm)*
Museo Gregoriano Egizio, Inv. nos. 22676, 22677

From very early times the lion symbolized might
and power to the ancient Egyptians, character-
istics that made it an eminently suitable motif
to adorn the entrances to temples, where it func-
tioned as a formidable guardian, warding off
evil from the sacred precincts. Recent investiga-
tions suggest that the Vatican lions originally
were erected before the gateway to a temple at
the site of Tell Baqlîya, in honor of Nectanebo
I, for whom they are inscribed. It is assumed
that both lions were subsequently transported
to Rome, possibly by order of the Emperor
Augustus. The lions were later installed in front
of the Pantheon, where they were discovered in
the twelfth century. In 1586, they were trans-
ferred to the fountain of the Acqua Felice, remain-
ing there until Pope Gregory XVI removed them
to the Vatican's Museo Egizio. During the nine-
teenth century, the lions frequently were copied
in the West, where they had been long known
and greatly admired. As early as the thirteenth
century, they had been used in Rome as models
for the various lions carved by the Cosmati; in
1865, replicas of the Vatican lions decorated the
Fontaine des Innocents in Paris.

A matched set, the lions are mirror images of
each other. They represent the high level of artis-
tic achievement that occurred under Nectanebo
I, whose craftsmen, in accord with the archaistic
tendencies of the time, selected a prototype that
is best exemplified by the earlier Prudhoe lions,
now in the British Museum. As with the torso
of Nectanebo I (see cat. no. 94), these lions are
not shallow reflections of the prototype. They
combine naturalistic detail with an abstract
compositional framework that resembles that of
the Prudhoe lions. Each lion's pose is an ac-
centuated C-shaped curve, the head and rear
haunches pulled forward toward the front of the
plinth. This arrangement is best appreciated by
viewing the lions from above. Their heads are
rendered in frontal view and the forepaws are
crossed, as are those of the Prudhoe lions.
Whereas on the Prudhoe lions the rear paws lie
flat, here they are drawn up next to the animals'
bodies and their undersides can be seen. The
tails, which rest in front of the plinths, act as
compositional devices directing the spectator's
gaze along the gateway's main axis. Originally,
the lions would have been erected flanking that
axis, with their heads juxtaposed.

Within this abstract arrangement, the sculp-
tors have drawn certain details from nature. The
inverted pear shape of the lion's head, which is
framed by incisions delineating the mane and
the tuft of fur at the top; the modeling of the

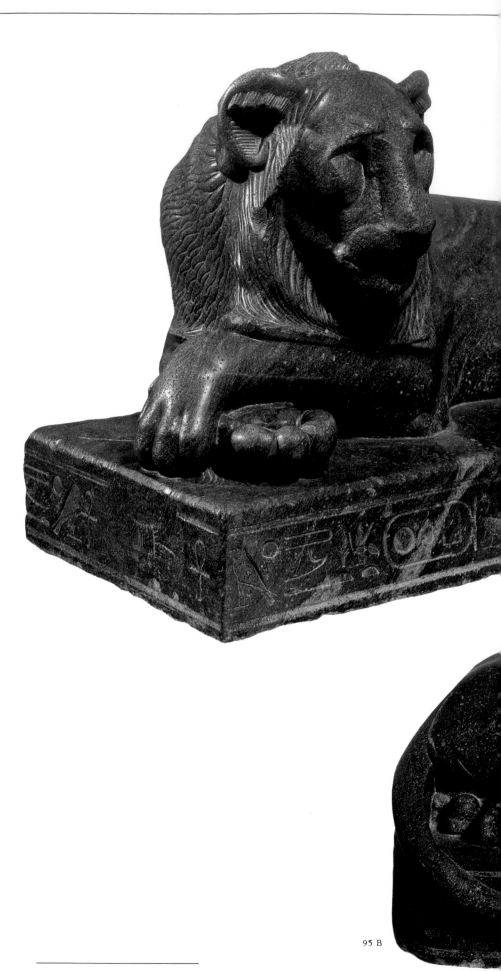

95 B

musculature of the paws; the representation of the rib-cage area; and the treatment and placement of the genitals are handled far more naturalistically than in their counterparts on the Prudhoe lions. Both the tail and the *shen*-sign project into the spectator's space. The *shen*-sign, which represents the cartouche, or royal ring, in its original circular form, is depicted in relief on the top and the side of the plinth, and appears to be kept from falling by the lion's upper paw. Such an interest in the third dimension is parallel to, but quite independent of, the treatment of space in the works of the classical sculptors of the fourth century B.C.

The inscriptions around the plinth of lion (A) read: "The Living Horus, The One Strong of Arm,

The One Who Belongs to the Two Ladies, The One Who Causes the Two Lands to Flourish, The Horus of Gold, The One Who Does That Which the Gods Love, The King of Upper and of Lower Egypt, The Lord of the Two Lands, Kheper-ka-ra, The Son of Ra, The Lord of the Diadems, Nectanebo, May He Live Eternally, The One Who Is Beloved of the God Ptah in the City of Rehwey"—a shortened version of which is found around the plinth of the other lion.

C. S., R. S. B.

BIBLIOGRAPHY: E. A. Wallis Budge, *Egyptian Sculpture in the British Museum*, London, 1914, pl. XXV; G. Roeder, "Freie Rundbilder von Löwen aus Aegypten," in *Miscellanea Gregoriana*, Vatican City, 1941, pp. 179–92; U. Schweitzer, *Löwe und Sphinx im alten Aegypten*, Glückstadt, 1948; G. Botti and P. Romanelli, *Le sculture del Museo Gregoriano Egizio*, Vatican City, 1951, pp. 14–18; C. Pietrangeli, "La provenienza dei monumenti del Museo Egizio Vaticano," in G. Botti and P. Romanelli, op. cit., p. 136, notes 26, 27; H. W. Müller, "Löwenskulpturen in der Aegyptischen Sammlung des Bayerischen Stattes," in *Münchner Jahrbuch der bildenden Kunst*, 16, 1965, pp. 7–46; P. Humbert, "Les Monuments égyptiens et égyptisants de Paris," in *Bulletin de la Société Française d'Égyptologie*, 62, 1971, pp. 9–29; A. Roullet, *The Egyptian and Egyptianizing Monuments of Imperial Rome*, Leiden, 1972, pp. 131–32; A. Eggebrecht, "Baklija," in *Lexikon der Aegyptologie*, I, Wiesbaden, 1975, p. 606; R. S. Bianchi, "Two Ex-Votos from the Sebennytic Group," in *The Society for the Study of Egyptian Antiquities Journal*, 11, 1981, pp. 31–36; C. De Wit, *Le Rôle et le sens du lion dans l'Égypte ancienne*, 2nd ed., Luxor, n.d.; A.-P. Zivie, *Hermopolis et le nome de l'ibis*, Cairo, n.d., pp. 122–26.

95 A

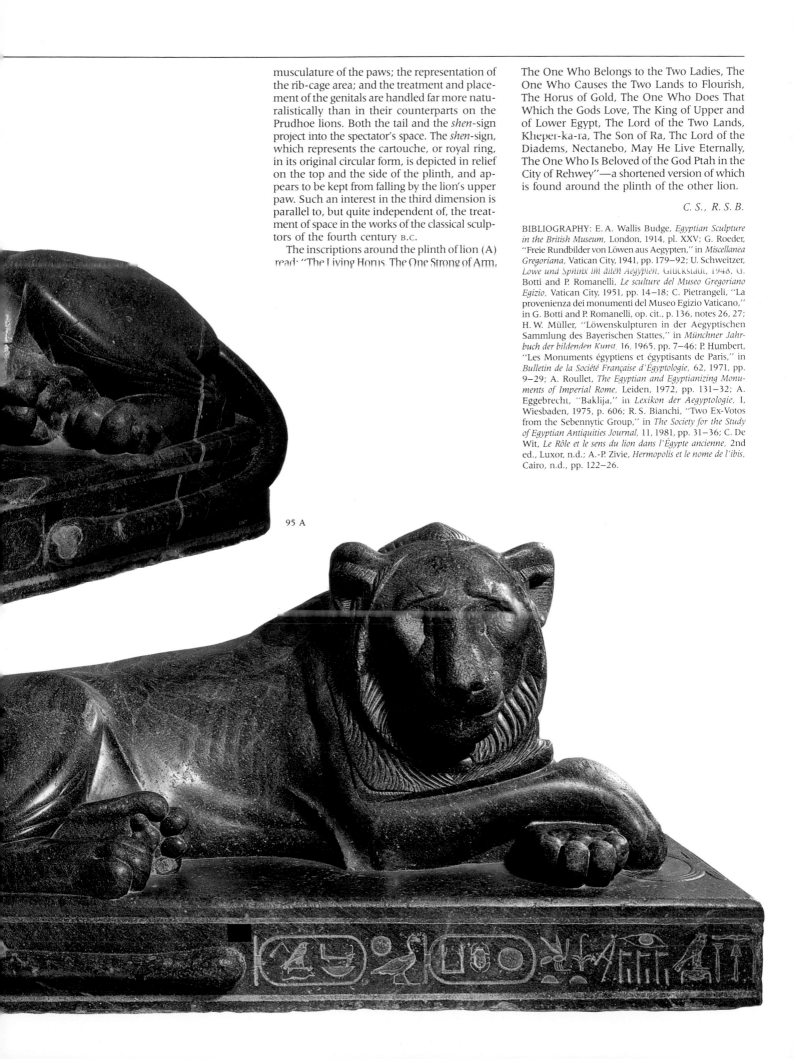

96

ANTHROPOMORPHIC REPRESENTATION OF THE APIS BULL

Late Dynastic period (656–332 B.C.)–Early Ptolemaic
period (332–250 B.C.)
From the Collection of Francesco Piranesi
Dark granite with red veining
Height, 29 ¹⁵/₁₆" (76 cm)
Museo Gregoriano Egizio, Inv. no. 22808

As early as the Badarian culture (4000–3600 B.C.) of predynastic Egypt, the ancient Egyptians interred bovines in their cemeteries, very often alongside human corpses. Although the character of Egyptian bull cults changed over time, by the Late Dynastic period the cult of Apis had eclipsed all others. Shortly thereafter, adherents of the cult could be found throughout the cities of the Hellenistic and Roman worlds.

The Egyptians' great attraction to Apis was rooted in the bull's fecundity and generative

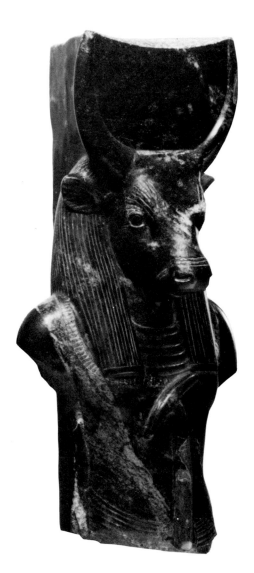

powers, which, when transferred to the deceased, would help to ensure his or her rebirth in the hereafter. From the Ramesside period (1320–1085 B.C.) on, the Apis bull was associated with the god Ptah of Memphis and came to be regarded as his earthly manifestation. As time passed, the idea that Apis had a regenerative nature was reinforced by other Egyptian myths, which linked Apis with Osiris, the preeminent god of the dead. In those tales, the goddess Isis was assisted by Apis when she collected the dismembered remains of her husband, Osiris, whose body had been mutilated by the Typhonic deity Seth. The association between Osiris and Apis was further reinforced when the cults of Ptah-Sokar-Osiris and Osiris-Apis were introduced by the Egyptians themselves and, somewhat later, by the Ptolemies.

Beginning in the Ramesside period, when an Apis bull died it was accorded honors similar to those bestowed upon a deceased pharaoh. The bulls were buried at Memphis in the Serapeum, a vast system of catacombs cut into the limestone beneath the desert sands that still can be visited. Immediately after the death of an Apis, a committee of priests was appointed to search Egypt for its successor, which was required to exhibit twenty-nine characteristics. Among these were a rich black coat intermingled with white patches, and a triangular blaze on the forehead. Once selected, the new Apis was enthroned in his own palace, or Sikos, located to the south of the temple of Ptah at Memphis.

This statue is a composite figure, a deity with a bull's head joined to a human male torso. Between the horns is a sun disk, the top of which is chipped. The deity wears a broad collar and a kilt and holds a straight staff, or *was*-scepter, surmounted by the head of an animal and symbolizing the concepts of dominion and lordship. Although it is not inscribed, the statue probably represents an Apis bull.

The dating of stone sculptures of deities, difficult because there are so few for comparison, is especially problematic in this case because almost all depictions of Apis show him as a striding bull rather than as an erect anthropomorphic figure. The stylistic peculiarities evident in the kilt and in the treatment of the belt as a pleated sash—with the pleats drawn close together at the buckle—are inconclusive as dating criteria because these features also appear in representations of a falcon-headed deity assigned to Dynasty XIX (1320–1200 B.C.) and of a jackal-headed deity attributed to the Late Dynastic period. On the other hand, the polished surface, proportions of the head to the body, and modeling of the torso conform to what is known of the art of the Late Dynastic period and reflect the canons of Dynasty XXX. These observations are consistent with the fact that Apis has been represented in a relief of the Late Dynastic or Early Ptolemaic period as a bovine-headed, striding male figure holding a *was*-scepter. The available evidence substantiates a date between 650 and 250 B.C. for this sculpture.

The statue was acquired in 1779 by Francesco Piranesi, who, like his more famous father, Giovanni Battista, strove to provide alternatives to the predominantly classical tastes of his age. He later sold the statue to the Vatican's Egyptian museum.

C. S., R. S. B.

BIBLIOGRAPHY: G. Daressy, *Statues de divinités*, I, II, Cairo, 1906, p. 138, no. 38517, pl. XXX; C. Boreux, *Antiquités égyptiennes: Catalogue-guide*, I, Paris, 1932, p. 172; G. Botti and P. Romanelli, *Le sculture del Museo Gregoriano Egizio*, Vatican City, 1951, pp. 104–5; C. Pietrangeli, "La provenienza dei monumenti del Museo Egizio Vaticano," in G. Botti and P. Romanelli, op. cit., p. 140, n. 156; A. Herman, "Der letzte Apisstier," in *Jahrbuch für Antike und Christentum*, 3, 1960, pp. 34–50; W. Kaiser, *Aegyptisches Museum, Berlin*, Berlin, 1967, p. 90; P. R. S. Moorey, *Ancient Egypt*, Oxford, 1970, pp. 11, 14; A. Roullet, *The Egyptian and Egyptianizing Monuments of Imperial Rome*, Leiden, 1972, pp. 88, 90; J. E. Stambaugh, *Serapis Under the Early Ptolemies*, Leiden, 1972, pp. 1–13; W. Hornbostel, *Serapis*, Leiden, 1973, pp. 45, 50, 341, 369; G. J. F. Kater-Sibbes and M. J. Vermaseren, *Apis*, I, Leiden, 1975, pl. XIX, *passim*, II, Leiden, 1975, III, Leiden, 1977; D. Wildung, *Imhotep und Amenhotep*, Munich, 1977, p. 41; E. Winter, *Der Apiskult im alten Aegypten*, Mainz, 1978; M. Raven, "Papyrus-Sheaths and Ptah-Sokar-Osiris Statues," in *Oudheidkundige mededelingen*, 59–60, 1978–79, pp. 251–96.

97

A, B. DOUBLE HERM OF THE EGYPTIAN GODDESS ISIS AND HER OFFSPRING, THE APIS BULL

Hadrianic period (A.D. 117–38)
From Hadrian's Villa, near Tivoli
Black marble with white veining, and white
marble (horns)
Height, 19 ¹¹/₁₆" (50 cm)
Museo Gregoriano Egizio, Inv. no. 22807

The double herm, or bust, was a Greek invention that made use of surrounding space by forcing the spectator to walk around the sculpture in order to see the paired, complementary heads. The viewer was thereby simultaneously made to experience the double herm visually, as a creation in the round, and to intellectualize the thematic link between the heads.

This double herm has no inscription; it represents a female figure and a bovine. Stylistically, the herm can be attributed to the Roman imperial period. At that time it was customary to imbue figures with a decidedly Egyptian flavor by adding what were often incongruously rendered Egyptianizing elements. It is clear from the treatment of the female bust on this herm that its Roman sculptors had access to Egyptian models, through which they became acquainted with typically Egyptian elements. The cold expression imparted by the upper eyelid passing over the lower one, the undefined earlobes, and the drilling of the corners of the mouth clearly exhibit an Egyptianizing style, as do the broad planes of the face and the smooth transitions between these planes. The headdress also betrays a non-Egyptian hand, particularly in the treatment of the overly narrow lappets, which descend as broad ribbons to the tops of the breasts. The bull's white marble horns (the rest of the herm is made of black marble with white veining) are visible when viewing the female bust and are placed intentionally to create the illusion that the horns spring from the female's head. The lotus is a modern addition.

The head of the bull on the other side of the herm is rendered in a more naturalistic fashion

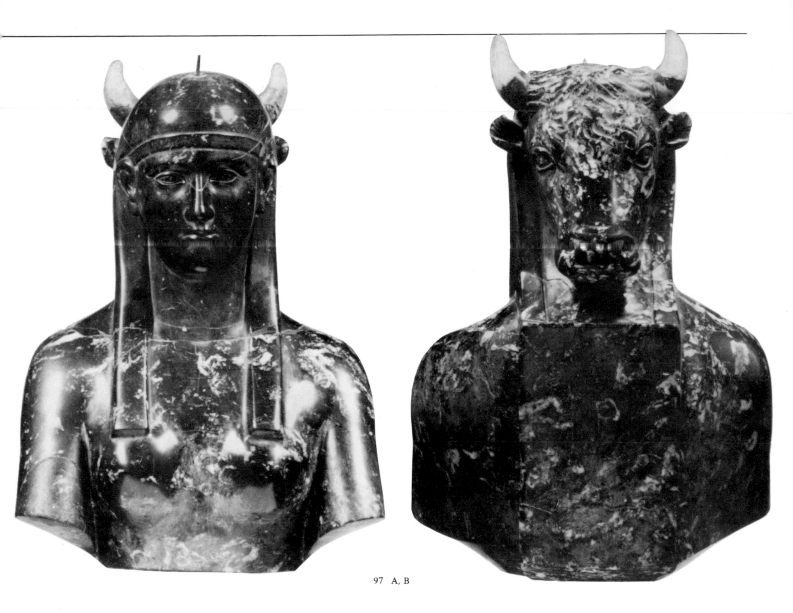

97 A, B

than are representations of bulls in purely Egyptian style. The close stylistic parallels between this head and that of a bull in Alexandria, inscribed for Hadrian, assure a date in the second century A.D. for this bust.

By the time of Nectanebo II (362–342 B.C.), the Egyptians had built a shrine at Saqqara to the goddess Isis, mother of Apis. Before the recent excavation of this shrine, its existence had been suspected from the numerous ostraca and graffiti excavated in the area, each alluding to this manifestation of Isis. During the Roman period, the cult of Isis eclipsed those of all other Egyptian goddesses, and, in Italy, flourished despite successive bans on its rites. The popularity of Isis and of Apis in Roman spheres is well documented, particularly in terracotta figurines that depict Isis nursing her offspring, the Apis bull. Therefore, it is not surprising to find a sculptor in the employ of the Roman Emperor Hadrian creating a double herm of Isis and Apis.

The double bust was discovered during explorations at Hadrian's Villa conducted by the Jesuits during the reign of Benedict XIV (1740–58). Subsequently exhibited in the Capitoline museums, the bust was transferred to the Vatican by Gregory XVI in 1838 for the Egyptian museum.

C. S., R. S. B.

BIBLIOGRAPHY: G. Botti, "L'Apis de l'empereur Adrien trouvé dans le Serapeum d'Alexandrie," in *Bulletin de la Société Archéologique d'Alexandrie*, 2, 1899, pp. 27–36; G. Botti and P. Romanelli, *Le sculture del Museo Gregoriano Egizio*, Vatican City, 1951, pp. 103–4; C. Pietrangeli, "La provenienza dei monumenti del Museo Egizio Vaticano," in G. Botti and P. Romanelli, op. cit., p. 140, n. 155; L. Castiglione, "Kunst und Gesellschaft im römischen Aegypten," in *Acta Antiqua Academiae Scientiarum Hungaricae*, 15, 1967, p. 128; W. B. Emery, "Preliminary Report on the Excavations at North Saqqâra, 1966–7," in *Journal of Egyptian Archaeology*, 53, 1967, pp. 192–93, pl. XXII, figs. 1, 2; A. Roullet, *The Egyptian and Egyptianizing Monuments of Imperial Rome*, Leiden, 1972, p. 90; R. E. Witt, *Isis in the Graeco-Roman World*, London, 1972; F. Dunand, *Le Culte d'Isis dans le bassin oriental de la Méditerranée*, I, II, Leiden, 1973; G. T. Martin, "Excavations in the Sacred Animal Necropolis at North Saqqâra, 1971–2: Preliminary Report," in *Journal of Egyptian Archaeology*, 59, 1973, pp. 13–14; S. K. Heyob, *The Cult of Isis Among Women in the Graeco-Roman World*, Leiden, 1975; G. J. F. Kater-Sibbes and M. J. Vermaseren, *Apis*, I, Leiden, 1975, pl. LXV, *passim*; I. Becher, "Augustus und Dionysos—Ein Feindverhältnis?," in *Zeitschrift für aegyptische Sprache und Altertumskunde*, 103, 1976, pp. 88–101; H. Smith, "Preliminary Report on Excavations in the Sacred Animal Necropolis, Season 1974–1975," in *Journal of Egyptian Archaeology*, 62, 1976, pp. 16–17.

98

ANTINOUS (THE FAVORITE OF THE ROMAN EMPEROR HADRIAN)

Hadrianic period (A.D. 117–38)
From Hadrian's Villa, near Tivoli
Parian marble
Height, 94⅞" (241 cm)
Museo Gregoriano Egizio, Inv. no. 22795

The Roman Emperor Hadrian, perhaps best known for his famous wall in Great Britain, was enamored of Egypt and journeyed throughout that country in A.D. 130. He was accompanied by the handsome youth Antinous, who was a native of the Roman province of Bithynia (now northern Turkey), on the Black Sea. During their travels, an oracle predicted that Hadrian would suffer a heavy loss. To avert harm from befalling the emperor, Antinous took it upon himself to fulfill the prophecy by drowning himself in the Nile. The suicide is said to have occurred near Sheikh Abada, about 170 miles south of

Cairo, where the Emperor Hadrian subsequently founded the city of Antinoë to commemorate the unfortunate event and to inaugurate the cult of Antinous. Regarded in the context of ancient Egypt's religious precepts, the deification of Antinous becomes part of a long tradition whereby divine rites were accorded those who perished in the Nile. The Temple of Dendur, for example, which was built during the reign of the Roman Emperor Augustus, is dedicated in part to Pihor and Pedesi, brothers who drowned in the Nile and were later deified.

In an attempt to integrate the religious overtones of the deification of Antinous with the classical beauty for which he was renowned, the creators of this statue posed the youth in the attitude of Polyclitan athletes, an attitude first established in Greece during the fifth century B.C. The weight of the figure is borne by the firmly planted right leg. The stride adjusts the musculature so that an S curve, or contrapposto, results. This classical posture is slightly altered by the atypical forward thrust of the chest, which emphasizes the muscular physique of the youth. The arms are held away from the sides of the body, and the fists, like those depicted on statues from pharaonic Egypt, clasp cylindrical objects that are thought to represent rolled pieces of linen. Marble struts connect the arms to the torso at the level of the belt, and a tree trunk behind the right leg supports the statue.

In a Greek or a Roman sculpture, such a classical stance, celebrating the beauty of a youth, would normally have been reserved for a nude figure. Here, however, the subject is clad in a traditional Egyptian kilt and wears a headdress, or *nemes*—an accessory usually associated with pharaohs—in order to establish a connection with Egypt. Absent from the headdress is the royal cobra, or uraeus, an omission that is appropriate to a person of nonroyal status. The idealized face differs markedly from strictly classical depictions of Antinous, but the treatment of the body is similar. The lack of the uraeus, the Egyptian trappings, and the fact that the statue was found at Hadrian's Villa further support the belief that the figure is a representation of Antinous.

In 1742, Michilli donated the statue to Benedict XIV (1740–58), who placed it in the Capitoline museums. It remained there until 1838, when Pope Gregory XVI transferred it to the Vatican for the Egyptian museum.

C. S., R. S. B.

BIBLIOGRAPHY: A. Rowe, "Antinous, the Favorite of Hadrian," in *Annales du Service des Antiquités de l'Égypte*, 40, 1940, pp. 25–26; G. Botti and P. Romanelli, *Le sculture del Museo Gregoriano Egizio*, Vatican City, 1951, pp. 95–97; C. Pietrangeli, "La provenienza dei monumenti del Museo Egizio Vaticano," in G. Botti and P. Romanelli, op. cit., pp. 138–39, n. 143; C. W. Clairmont, *Die Bildnisse des Antinous*, Rome, 1966; A. Roullet, *The Egyptian and Egyptianizing Monuments of Imperial Rome*, Leiden, 1972, p. 87; K. Parlasca, "Osiris und Osirisglaube in der Kaiserzeit," in *Les Syncrétismes dans les religions grecque et romaine*, Vendôme, 1973, pp. 96–97; H. G. Fischer, "An Elusive Shape Within the Fisted Hands of Egyptian Statues," in *Metropolitan Museum Journal*, 10, 1975, pp. 9–21; G. Poethke, "Antinoos," in *Lexikon der Aegyptologie*, I, Wiesbaden, 1975, pp. 323–25; J. Quaegebeur, "Les 'Saints' égyptiens préchrétiens," in *Orientalia Lovaniensia Periodica*, 8, 1977, pp. 129–43; R. S. Bianchi, "Augustus in Egypt," in *Archaeology*, 31, 1978, pp. 4–11.

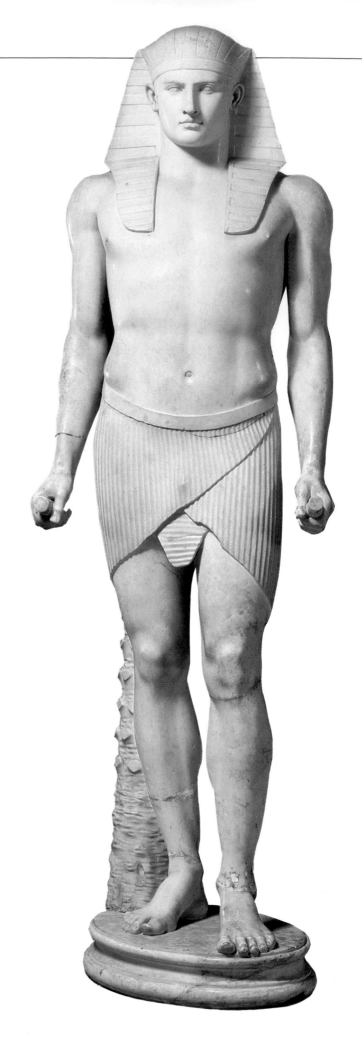

MUSEO GREGORIANO ETRUSCO

The opening of the Museo Gregoriano Etrusco in 1837 culminated two centuries of acquisition by the papacy of antiquities found in Etruria. At the outset, it should be noted that, well into the nineteenth century, the word "Etruscan" still was applied to material made by the Etruscans as well as to the imports —particularly vases produced in Athens —that came to light in Etruscan burials. Thus, the museum is "Etruscan" only with respect to the sites of its finds but not to their original sources.

During the eighteenth century, there was considerable excavation in the Tuscan area of Etruria —Cortona, Volterra, Siena, Chiusi—but the main beneficiaries were private collections. Some of these collections entered the Vatican; that of Cardinal Gualterio of Orvieto, for example, was acquired by the Vatican Library through the efforts of Pope Clement XII (1730–40). With the two measures introduced by Pope Pius VII, in 1802 and 1820, to regulate the movement and sale of works of art and to provide purchase funds, the papal collections, for the first time, were able to secure material, often from their own territories. In 1815, Pius acquired more "Etruscan" pottery for the Vatican Library (fig. 38). In 1829, some vases from the Candelori Collection, found mainly in Vulci, were added. In 1834, the Vatican participated in the excavations conducted by Vincenzo Campanari in Vulci. In 1835, it acquired the bronze *Mars* just discovered at Todi and, a year later, the contents of the incomparably rich Regolini-Galassi tomb from Cerveteri.

The question of where to house the growing "Etruscan" collection already had been considered, in 1816, when Pius VII proposed a suite of rooms (the so-called Appartamenti Zelada), within the Palazzetto del Belvedere, formerly occupied by the librarian and secretary of state to Pius VI. The

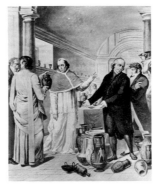

FIG. 38.
PIUS VII GIVES
ETRUSCAN VASES TO THE
LIBRARY. FRESCO. 1818

decision to use these apartments was taken in November 1836, three months before the opening of the collection. Though unfinished for the occasion, the roughly chronological sequence of rooms displayed vases, bronzes, and urns, and ended with a small-scale reconstruction of an Etruscan tomb; the idea, realized in late 1837– early 1838, was evidently derived from the highly successful Etruscan exhibition organized by Secondiano and Vincenzo Campanari in Pall Mall in London.

A papal decree, in 1840, put an end to the collecting of Etruscan antiquities. The Italian state was established in 1870, and, in 1889, the Museo Nazionale di Villa Giulia was founded as the repository of finds from Etruria. Despite these developments, the Museo Gregoriano Etrusco did not lie dormant. In 1900, Bartolomeo Nogara became the first director trained as an Etruscologist. Under him and his successors, study of the collections went hand in hand with their organization; G. Pinza and, later, Luigi Pareti worked on the Regolini-Galassi tomb, Carlo Albizzati catalogued pottery, A. D. Trendall published the Etruscan and South Italian vases, specifically. Nor did acquisition cease completely. In 1934, Pius XI accepted the vases of Marchese Benedetto Guglielmi (published by J. D. Beazley and F. Magi), and, in 1967–68, the collection of Mario Astarita was presented to Paul VI. The reinstallation of the Museo Gregoriano Etrusco currently in progress segregates and puts in meaningful sequence the indigenous Etruscan objects, the Greek ceramic imports, and the Roman legacy; however, its ambience preserves part of the antiquarian flavor of the original nineteenth-century installation.

Francesco Roncalli

BIBLIOGRAPHY: F. Roncalli, "Il reparto di antichità etrusco-italiche," in *Bollettino dei Monumenti Musei e Gallerie Pontificie*, I, 3, 1979, pp. 53–114.

99

BLACK-FIGURED OLPE

Corinthian, c. 630–615 B.C.
Attributed to the Painter of Vatican 73: his
name-piece
Height, 12 ¼" (32.3 cm)
Museo Gregoriano Etrusco, Inv. no. 16334

The figured decoration, consisting of animals
and monsters, is in four zones that circle the
vase. Dot rosettes are used as filling ornaments.
Rosettes also appear on the neck.

The Painter of Vatican 73 is one of the chief
exponents of the Corinthian Transitional style.
A highly disciplined artist, this painter insisted
on rigid symmetry in his heraldic groupings.

D. v. B.

BIBLIOGRAPHY: C. Albizzati, *Vasi antichi dipinti del
Vaticano*, fasc. I–VII, Rome, 1925–39, pp. 27–28, pl. 5; H.
Payne, *Necrocorinthia*, Oxford, 1931, p. 277, no. 146, pl.
11, 5, pl. 16, 3, 5; D. A. Amyx, *Corinthian Vase-painting of
the Archaic Period*, forthcoming, p. 69.

100 (detail)

100

BLACK-FIGURED COLUMN-KRATER

Corinthian, c. 560 B.C.
On the shoulder is the mission of Menelaos and
Odysseus to Troy; in the zone below, goats and
panthers; on each handle-plate, a gorgoneion
Height, 18 ⅝" (47.3 cm)
Museo Gregoriano Etrusco (Gift of Mario Astarita,
A 565)

The Astarita krater (as this vase is called) is
one of the most monumental Corinthian vases
known to us. The names of practically all of the
figures are inscribed, thus allowing us to interpret
each detail of the scene. Seated on the stepped
altar in the sanctuary of Athena at Troy are
Menelaos, Odysseus, and the herald Talthybios.
They are approached by Theano, her two maids
Dia and Malo, and her nurse. Behind them fol-
low fifteen mounted horsemen and two youths
on foot. The names that are given are Harmatides,
Glaukos, Eurymachos, Ilioneus, Politas, and
Polyphas. (Eurymachos and Glaukos were the
sons of Antenor and Theano.)

The Greeks had come to Troy to ask for the
peaceful surrender of Helen. They are seen
inside the city, having just arrived, and Theano
has gone out to meet them. Antenor, the most
important Trojan next to King Priam, must have
enjoyed especially close ties of hospitality with
either Menelaos or Odysseus; Theano, as the
priestess of Athena, must have suggested to the
Greeks to take refuge in the temple of Athena
for their safety. The embassy to Troy was not
successful, however, and the Trojan War broke
out, but during the Sack of Troy the Greeks
spared the house of Antenor.

D. v. B.

BIBLIOGRAPHY: J. D. Beazley, "ʽΕΛΕΝΗΣ ʼΑΠΑΙΤΗΣΙΣ,"
in *Proceedings of the British Academy*, 43, 1957, pp. 233–44,
pls. 11–16; M. I. Davies, *Lexicon iconographicum mytholo-
giae classicae*, 1, Zurich, 1981, p. 815.

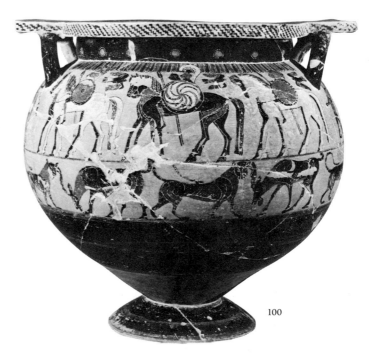

100

101

BLACK-FIGURED KYLIX

Laconian, c. 555 B.C.
Interior, Atlas and Prometheus
Attributed to the Arkesilas Painter
Height, 5½" (14 cm); width, 10⅞6" (26.5 cm);
* diameter, 7¹³⁄₁₆" (20.2 cm)*
Museo Gregoriano Etrusco, Inv. no. 16592

Atlas is at the left, holding up the sky, while
an eagle picks at the chest of Prometheus, who
is tied to a column, at the right. A small bird is
perched on the column. In the exergue, below
the main picture, are a Doric column and two
flowers. The sphere of heaven extends along the
upper edge of the tondo from the starry portion
of the sky to the head of Prometheus. The
groundline, supported by the column in the
exergue, must represent the disk of the earth,
seen in cross section.

<div align="right">D. v. B.</div>

BIBLIOGRAPHY: C. Albizzati, *Vasi antichi dipinti del
Vaticano*, fasc. I–VII, Rome, 1925–39, pp. 66–67; C. M.
Stibbe, *Lakonische Vasenmaler des sechsten Jahrhunderts v.
Chr.*, Amsterdam, 1972, pp. 32, 118, 280, no. 196, pls.
63–64; H. Jucker, *Festschrift für Frank Brommer*, Mainz,
1977, pp. 195–96, pl. 55, 1.

102

BLACK-FIGURED AMPHORA

Attic, c. 530 B.C.
Obverse, Eos mourning her dead son Memnon (?);
* reverse, the recovery of Helen*
Attributed to the Painter of the Vatican Mourner:
* his name-piece*
Height, 17⁹⁄₁₆" (44 cm)
Museo Gregoriano Etrusco, Inv. no. 16571

The Painter of the Vatican Mourner, named
after this vase, has chosen for his principal pic-
ture a deeply moving subject worthy of Exekias,
to whom he is related. The scene, set in a forest,
shows a dead, naked warrior laid out on a bed
of pine branches. His armor, helmet, greaves and
shield, and his short chiton are leaning against,
or are suspended from, the two trees on the left.
A raven perches on one of the pine trees. The
woman in the center, probably Eos, the mother
of Memnon, bends over the body of the dead
hero and tears at her hair in the time-honored
gesture of mourning. On the reverse, Menelaos,
accompanied by a youth and another warrior,
menaces Helen with a sword. This encounter
took place after the Sack of Troy, when Mene-
laos, enraged at his faithless wife, threatened to
kill her. Aphrodite intervened and counseled
Helen to reveal her beauty, which led to a
reconciliation.

<div align="right">D. v. B.</div>

BIBLIOGRAPHY: C. Albizzati, *Vasi antichi dipinti del
Vaticano*, fasc. I–VII, Rome, 1925–39, pp. 137–38, fig.
71, pl. 44; J. D. Beazley, *Attic Black-figure Vase-painters*,
Oxford, 1956, p. 140, no. 1; *idem, Paralipomena*, Oxford,
1971, p. 58, no. 1.

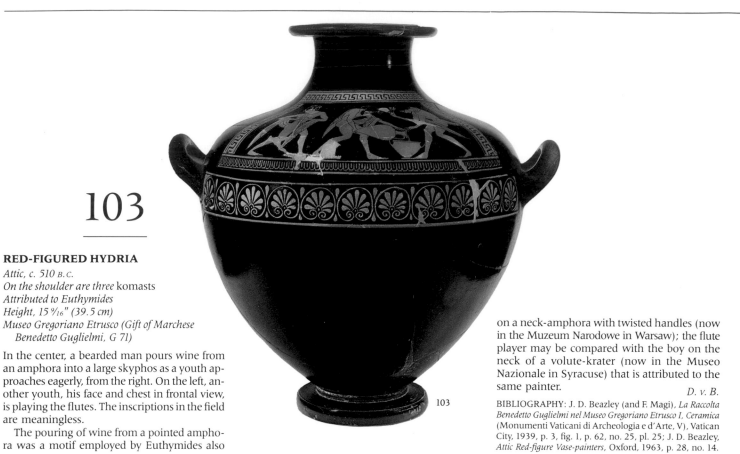

103

RED-FIGURED HYDRIA

Attic, c. 510 b.c.
On the shoulder are three komasts
Attributed to Euthymides
Height, 15 9/16" (39.5 cm)
Museo Gregoriano Etrusco (Gift of Marchese
Benedetto Guglielmi, G 71)

In the center, a bearded man pours wine from an amphora into a large skyphos as a youth approaches eagerly, from the right. On the left, another youth, his face and chest in frontal view, is playing the flutes. The inscriptions in the field are meaningless.

The pouring of wine from a pointed amphora was a motif employed by Euthymides also on a neck-amphora with twisted handles (now in the Muzeum Narodowe in Warsaw); the flute player may be compared with the boy on the neck of a volute-krater (now in the Museo Nazionale in Syracuse) that is attributed to the same painter.

D. v. B.

BIBLIOGRAPHY: J. D. Beazley (and F. Magi), *La Raccolta Benedetto Guglielmi nel Museo Gregoriano Etrusco I, Ceramica* (Monumenti Vaticani di Archeologia e d'Arte, V), Vatican City, 1939, p. 3, fig. 1, p. 62, no. 25, pl. 25; J. D. Beazley, *Attic Red-figure Vase-painters*, Oxford, 1963, p. 28, no. 14.

103

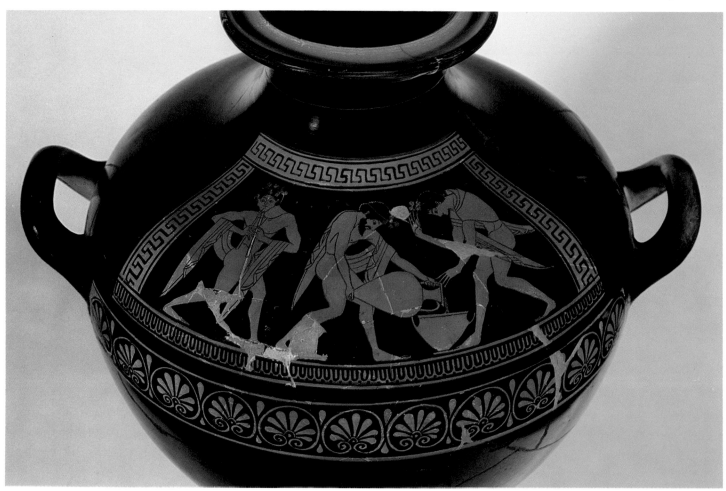

103 (detail)

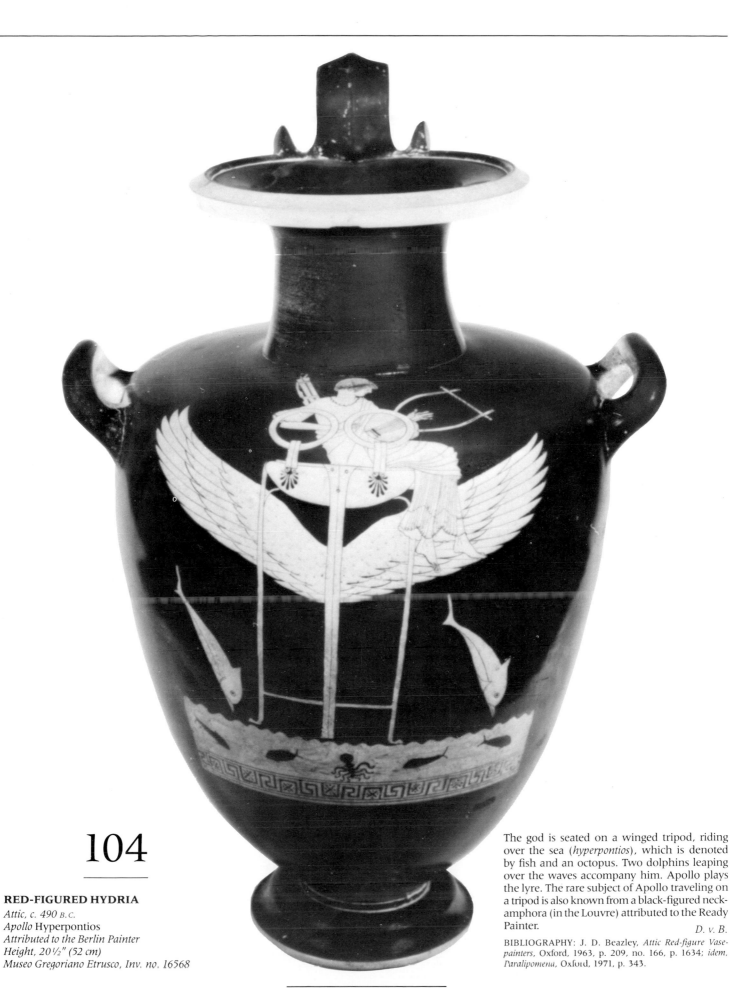

104

RED-FIGURED HYDRIA

Attic, c. 490 B.C.
Apollo Hyperpontios
Attributed to the Berlin Painter
Height, 20½" (52 cm)
Museo Gregoriano Etrusco, Inv. no. 16568

The god is seated on a winged tripod, riding over the sea (*hyperpontios*), which is denoted by fish and an octopus. Two dolphins leaping over the waves accompany him. Apollo plays the lyre. The rare subject of Apollo traveling on a tripod is also known from a black-figured neck-amphora (in the Louvre) attributed to the Ready Painter.

D. v. B.

BIBLIOGRAPHY: J. D. Beazley, *Attic Red-figure Vase-painters*, Oxford, 1963, p. 209, no. 166, p. 1634; *idem. Paralipomena*, Oxford, 1971, p. 343.

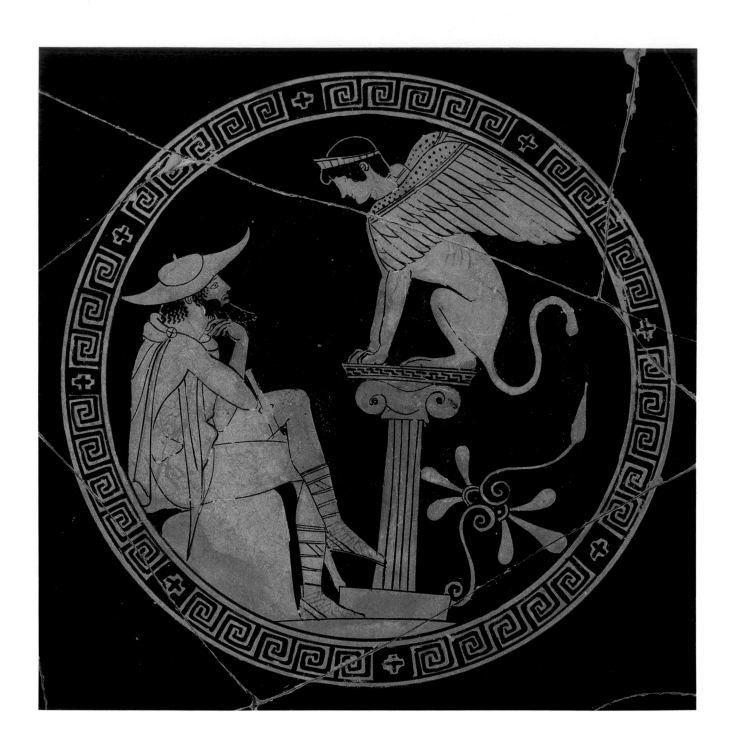

105

RED-FIGURED KYLIX

Attic, c. 470 B.C.
Interior, Oedipus and the Sphinx; exterior,
 satyrs cavorting
Attributed to the Oedipus Painter: his
 name-piece
Diameter, 10⅜" (26.3 cm)
Museo Gregoriano Etrusco, Inv. no. 16541

Oedipus (his name is inscribed), in the garb
of a traveler, sits before the legendary Sphinx
of Thebes that devoured those who did not an-
swer its riddle (part of which is written be-
tween the mouth of the Sphinx and the face of
Oedipus). The Sphinx sits on a column, much
in the way that sphinxes were shown on Attic
grave reliefs of the Archaic period. The exteri-
or scene is of considerable interest, as it was
copied on a cup (now in the Musée Rodin in
Paris) by an Etruscan vase painter.

<div align="right">

D. v. B.

</div>

BIBLIOGRAPHY: J. D. Beazley, *Attic Red-figure Vase-
painters*, Oxford, 1963, p. 451, no. 1, p. 1654; *idem,
Paralipomena*, Oxford, 1971, p. 376.

106

RED-FIGURED AMPHORA

Attic, c. 450 B.C.
Obverse, Achilles; reverse, woman (Briseis?)
Attributed to the Achilles Painter: his name-piece
Height, 24⁷⁄₁₆" (62 cm)
Museo Gregoriano Etrusco, Inv. no. 16571

The young Greek hero is shown in frontal
view, his head turned to his left; he wears a
short chiton and a cuirass and has a cloak over
his left arm, with which he shoulders an enor-
mous spear. The woman on the other side,
perhaps Briseis, holds an oinochoe and a phiale,
traditional vases for the sacrificial libation that
preceded a departure for battle. The painter has
identified the warrior by writing the name
Achilles next to him.

The Achilles Painter was the first great classic
vase painter, much of whose finest work is on
white lekythoi.

<div align="right">

D. v. B.

</div>

BIBLIOGRAPHY: J. D. Beazley, *Attic Red-figure Vase-
painters*, Oxford, 1963, p. 987, no. 1, p. 1677; *idem,
Paralipomena*, Oxford, 1971, p. 437.

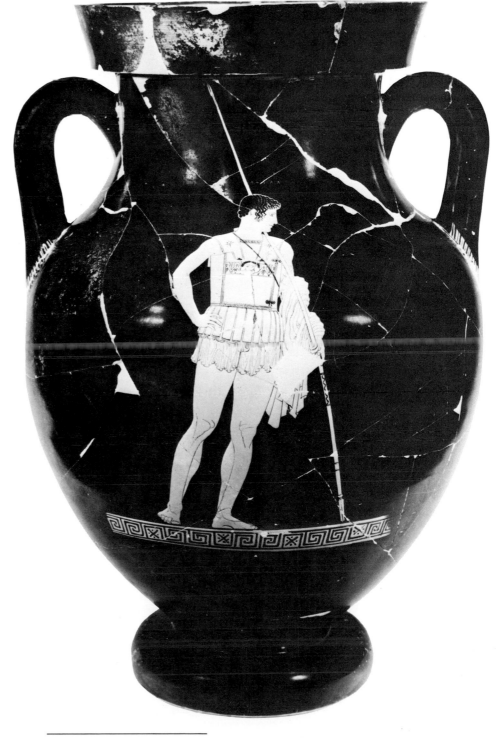

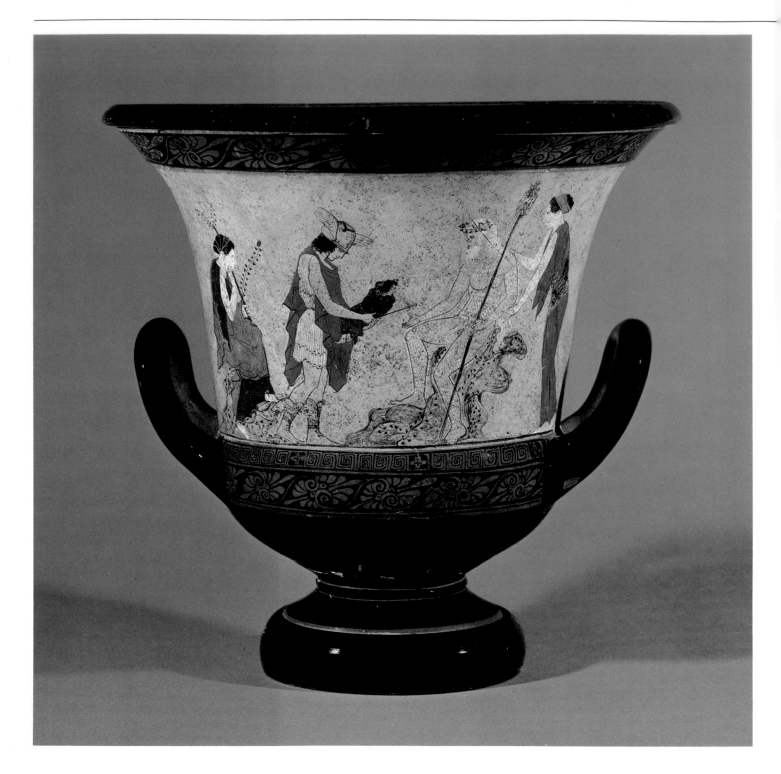

107

WHITE-GROUND CALYX-KRATER

Attic, c. 440–430 B.C.
Obverse, Hermes bringing the infant Dionysos
to Papposilenos and the nymphs; reverse, a
seated Muse playing the lyre, between two
standing Muses
Attributed to the Phiale Painter
Height, 12 ¹⁵/₁₆" (32.8 cm)
Museo Gregoriano Etrusco, Inv. no. 16586

This splendid krater, painted in polychromy on a white engobe (or slip), is the work of the Phiale Painter—the pupil of the Achilles Painter. Like his teacher, he did much work on lekythoi, continuing the classic tradition of his master.

Dionysos was raised by the nymphs of Nysa. His schooling must have begun very early, as we learn from a neck-amphora by the Eucharides Painter (on loan to The Metropolitan Museum of Art) on which Zeus himself carries his infant son to a nymph, who is shown with lyre, flute case, and writing tablet.

D. v. B.

BIBLIOGRAPHY: J. D. Beazley, *Attic Red-figure Vase-painters*, Oxford, 1963, p. 1017, no. 54; *idem, Paralipomena*, Oxford, 1971, p. 440.

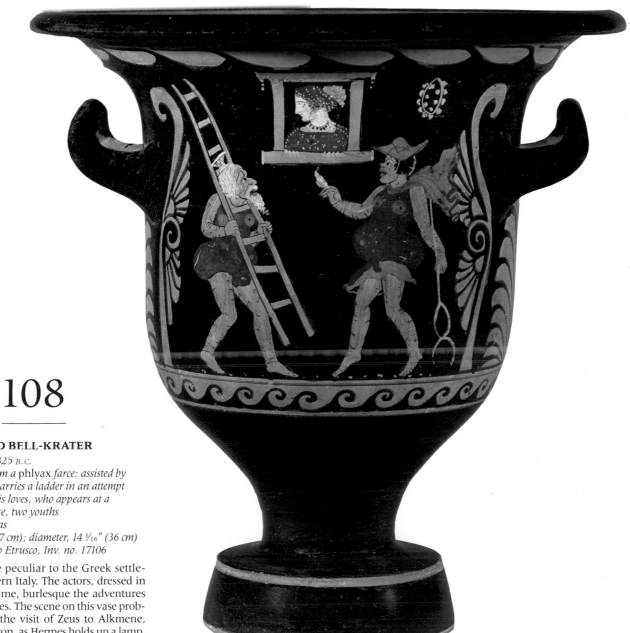

108

RED-FIGURED BELL-KRATER

Paestan, c. 350–325 B.C.
Obverse, scene from a phlyax *farce: assisted by Hermes, Zeus carries a ladder in an attempt to visit one of his loves, who appears at a window; reverse, two youths*
Attributed to Asteas
Height, 14 9/16" (37 cm); diameter, 14 3/16" (36 cm)
Museo Gregoriano Etrusco, Inv. no. 17106

Phlyax plays are peculiar to the Greek settlements in Southern Italy. The actors, dressed in humorous costume, burlesque the adventures of gods and heroes. The scene on this vase probably represents the visit of Zeus to Alkmene, wife of Amphitryon, as Hermes holds up a lamp, at the right. Another vase by the same painter (in the British Museum) shows the sequel: Zeus is actually climbing the ladder.

D. v. B.

BIBLIOGRAPHY: A. D. Trendall, *Vasi antichi dipinti del Vaticano, Vasi Italioti ed Etruschi a Figure Rosse*, fasc. I, Vatican City, 1953, pp. 27–29, pls. 7 b, 9 b.

109

PAIR OF ARM BANDS

Cerveteri (necropolis of Sorbo, Regolini-Galassi tomb)
Middle of the 7th century B.C.
Gold
Length, 10¼" (26 cm); width, 2⅝–2 ¹¹/₁₆" (6.7 –6.9 cm); diameter, 3⅝–3 ¹⁵/₁₆" (9.3–10 cm)
Museo Gregoriano Etrusco, Inv. nos. 20562, 20563

This jewelry came from the last chamber of the famous Regolini-Galassi tomb, a large aristocratic burial that was excavated at Cerveteri in 1836 and 1837. The tomb, partly dug out in the tufa and partly built of squared blocks of the same material, was reached by a long corridor, flanked by two small chambers of circular plan; the main chamber was, itself, divided into two parts. In the area at the end, a woman, to whom these arm bands and other extremely rich jewelry belonged, was buried, while, in the opposite part, a man—in all probability her husband—was interred, along with an equally impressive collection of bronze pieces.

Each arm bracelet is made up of a rectangular band of gold, bent in the shape of an open cylinder and decorated on the ends with two pieces of gold foil—one on the inside and the other on the outside. The catch consists of a small bar, secured with a small chain.

The central part of each bracelet is decorated with repeated scenes of three standing female figures—frontal, except for their feet, which are in profile—who hold a palm in each hand. The representations—framed by maeanders and chevrons—were stamped and then outlined by granulation.

The bands at each end are decorated with a more complex scene: two palms surround a woman who stands between two confronted lions, each stretching out a front paw and leaning the other on her shoulder. The two male figures behind the two lions attack them with daggers. The decorative motifs vary here: guilloches alternate with lotus flowers.

A comparison of the exuberant decoration of these and of other gold pieces from the Regolini-Galassi tomb— and from other Etruscan tombs of the same period—shows that this very fine work was executed locally. The typical granulation heightens the effect of the ornament and scenes, achieved by expert use of separate punches, allowing the goldsmith of Cerveteri to create variations on the theme of ΠOTNIA ΘHPΩN (the Mistress of the Animals).

The urban development of such coastal centers as Cerveteri, between the eighth and the seventh century B.C., permitted these cities and the dominant class within them to exercise a stricter control over the already densely populated hinterlands. Their agricultural and mineral resources furnished the metropolises with the power to attract Oriental trade—above all, that of the Phoenicians—enabling them not only to export finished products but also to import such raw materials as gold, silver, and ivory, which were worked by local artisans and passed along the internal commercial routes to Vetulonia, Chiusi, Palestrina, and elsewhere.

F. R.

BIBLIOGRAPHY: L. Pareti, *La Tomba Regolini-Galassi di Cerveteri*, Vatican City, 1947, pp. 182–84, nos. 3–4; T. Dohrn, in W. Helbig, *Führer durch die öffentlichen Sammlungen klassischer Altertümer in Rom: Die Päpstlichen Sammlungen im Vatikan und Lateran*, I, 4th ed., Tübingen, 1963, p. 483, no. 624.

110

SILVER BOWL, DECORATED WITH FIGURES

Cerveteri (necropolis of Sorbo, Regolini-Galassi tomb)
Middle of the 7th century B.C.
Gilded silver
Diameter, 7⅝" (19.4 cm); depth, ¹⁵/₁₆" (2.5 cm)
Museo Gregoriano Etrusco, Inv. no. 20368

This bowl came from the niche on the left-hand side of the Regolini-Galassi tomb, along with other furnishings that probably belonged to the man buried in the central corridor. The cup must have been fastened to the wall of the room because the trace of an iron nail shows in the center.

Among the objects of Oriental origin whose presence in Etruria—although not only in Etruria—best characterizes its richness, commercial relations, culture, and taste between the end of the eighth and the close of the seventh century B.C., there is the series of silver bowls, of which this example is one of the best preserved.

The bowl, decorated in repoussé with engraving, is divided into four principal areas: the central disk, two concentric bands, and a smooth rim that lacks the gilding that covers the entire remaining internal surface. The outside of the bowl originally was covered with silver foil.

In the center, two lions attack a bull in a typically Egyptian setting. In the inner band, in a landscape characterized by a small mountain and by papyrus and palms, is a series of episodes from a hunt: an archer and a lancer aid a man fallen beneath a lion; another man stabs a lion, upright on its back paws, with a dagger; and a horseman chases a fawn on a mountain.

The outer band depicts a file of soldiers, on foot and on horseback, in which the most eminent is clearly the man who, armed and accompanied by a squire, occupies the chariot. The two bands narrate two symbolic elements of the life of a great dynasty.

The bowl belongs to a class whose Oriental origin is certain, and whose diffusion throughout the Mediterranean basin—in particular, on the Tyrrhenian coasts of Italy—is traditionally attributed to Phoenician trade. Some scholars have spoken of Phoenician, Cypriot, or Syrian centers as the sources of these objects. Certainly, their production must have depended on "beach-heads" in Italy, most probably in southern Etruria: such a center as Cerveteri, for example, which perhaps not only absorbed and distributed these objects, but which also may have had artisans capable of refinishing them and making them more elaborate to suit local tastes.

F. R.

BIBLIOGRAPHY: L. Pareti, *La Tomba Regolini-Galassi di Cerveteri*, Vatican City, 1947, pp. 312–15, n. 323, pl. XLIV; T. Dohrn, in W. Helbig, *Führer durch die öffentlichen Sammlungen klassischer Altertümer in Rom: Die Päpstlichen Sammlungen im Vatikan und Lateran*, I, 4th ed., Tübingen, 1963, pp. 491–92, no. 641; on the entire class: I. Strøm, *Problems Concerning the Origin and Early Development of the Etruscan Orientalizing Style*, Odense, 1971; F. Canciani and Fr. W. von Hase, *La Tomba Bernardini di Palestrina*, Rome, 1979, pp. 5–6.

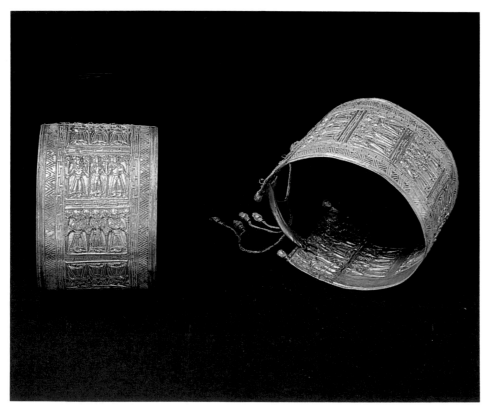

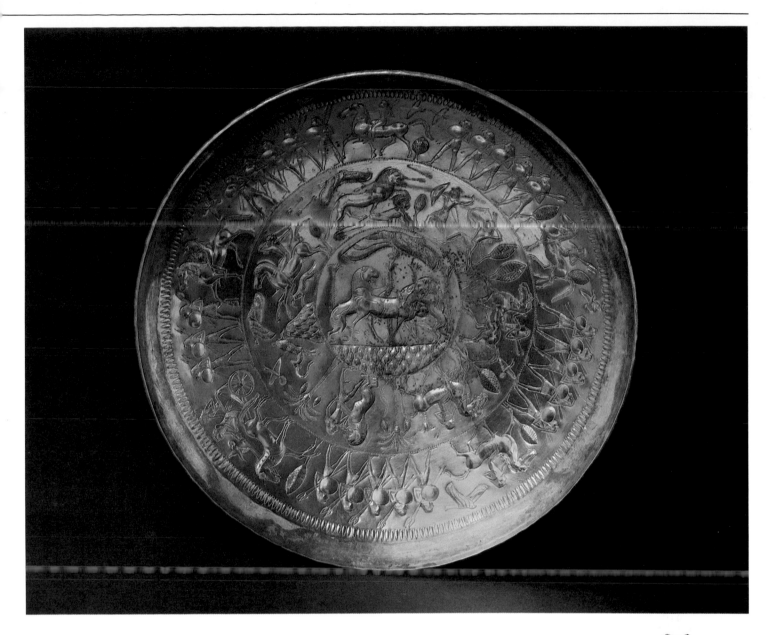

111

VASE WITH FIGURES

Cerveteri (necropolis of Sorbo, Calabresi tomb)
Late 7th century B.C.
Bucchero
Height (with foot that does not belong), 11 ¹³/₁₆"
(30 cm)
Museo Gregoriano Etrusco, Inv. no. 20235

In the composition of this exceptional vase, made of the finest *bucchero* from Cerveteri and with incised decoration, a variety of different elements come together. The ancient tradition, taken up in Italo-Geometric pottery, of forming handles or the knobs of lids in the shape of animals here is allied with the Geometric tradition of the *askos*, an animal skin made into a water container and modeled as a quadruped or a bird. The Vatican example is a fresh interpretation of a type of tall jug with a transverse, cask-like body, famous

from an example from Bisenzio in the Museo di Villa Giulia in Rome. A long vertical neck ending in a trefoil spout rises from the body, which is placed on a support of purely ceramic derivation. The elaborate plumes on the perforated spouts in the shape of animal heads are certainly Oriental in tradition, and serve as stoppers for the two halves into which the vase is separated, inside and out. The human figure on the body of the vase—who holds in his extended hands the horses' harness—as well as the circular ornament on the side of the vase suggest that the idea that the potter wished to capture was that of a fantastic chariot whose body is fused with that of the two horses. The foot, although probably true to this type of vase, does not belong.

F. R.

BIBLIOGRAPHY: L. Pareti, *La Tomba Regolini-Galassi di Cerveteri*, Vatican City, 1947, pp. 367–68, n. 400, pl. LIV; T. Dohrn, in W. Helbig, *Führer durch die öffentlichen Sammlungen klassischer Altertümer in Rom: Die Päpstlichen Sammlungen im Vatikan und Lateran*, I, 4th ed., Tübingen, 1963, p. 497, no. 651.

112

DISK, WITH A LION'S HEAD

Tarquinia (necropolis of Monte Quaglieri)
Late 6th century B.C.
Bronze
Diameter: overall, 14 ¼" (36.2 cm), head, 4 ¹⁵/₁₆"
(12.5 cm); maximum depth, 2 ⁹/₁₆" (6.5 cm)
Museo Gregoriano Etrusco, Inv. no. 12623

Concerning the origin of the disk, the circumstances of its discovery, and its function, the reader is referred to entry no. 113. The central cavity of the shaped disk, distinguished, in this case, by a smooth part made to hold the mask, and by two concentric, circular zones of tongues, also includes a central lion's head—as in the majority of examples known (about thirty) of this class of object.

The head, raised from a single sheet of bronze, was attached with two pairs of rivets placed opposite each other, piercing the thin area of metal around the lion's head. The eyes are filled with glass paste: white for the cornea, black for the iris. The state of preservation of the mask is good; the disk underneath has many holes. The lion is represented, as is usual, with its jaws wide open and its tongue hanging down. Its mane is parted on top into two rows of locks: the first, from behind which its ears stick out, is in more marked relief; the second is delineated by an incised contour. Worth noting in the depiction of the muzzle (which varies within this series of disks) is the treatment of the fur under the jaws, the indication of the skin on either side of the tongue in two lobes marked by crosshatched incisions, and the flattened hairs above the eyes, rendered as two spiraling curls.

Stylistically, the head fits into the Etruscan canon typical of the second half of the sixth century B.C. One should compare, in particular,

the examples from Vulci executed in stone, and the painted ones that decorate the tympana of the funeral chambers at Tarquinia.

The prevalence of this motif (along with that of the ram's head, which occurs almost as frequently)—within this class of object as opposed to other motifs whose function was more clearly apotropaic (such as the masks of satyrs and of maenads)—is an indirect confirmation of the original function of these disks, and of the typological development that brought about the transition from the smaller functional disk to this enlarged ornamental one. The circular shape and the prominence of the head— often used to decorate such wooden objects as the hubs of wheels and the poles of carts—made the form particularly adaptable to the ornamentation on the heads of the dowels placed in the center of such a disk. In this connection one should compare two disks found in the necropolis of Peschiera near Todi that have bronze pins in their centers: the head of each pin ends in a lion's head.

F. R.

BIBLIOGRAPHY: T. Dohrn, in W. Helbig, *Führer durch die öffentlichen Sammlungen klassischer Altertümer in Rom: Die Päpstlichen Sammlungen im Vatikan und Lateran*, I, 4th ed., Tübingen, 1963, p. 522, no. 692; on this subject: W. L. Brown, *The Etruscan Lion*, Oxford, 1960, pp. 101–4; on the examples from Todi: G. Bendinelli, in *Monumenti Antichi*, XXIII, 2, 1916, p. 684.

113

DISK, WITH THE HEAD OF ACHELOÖS

Tarquinia (necropolis of Monte Quaglieri)
Early 5th century B.C.
Bronze
Diameter, 15 ¹⁵/₁₆" (40.5 cm); maximum depth, 2 ⁹/₁₆"
(6.5 cm); height of mask, 10 ¹³/₁₆" (27.5 cm)
Museo Gregoriano Etrusco, Inv. no. 12461

This bronze disk was found in the winter of 1829, together with no. 112 and nine other pieces, in a funeral chamber in a necropolis situated about two miles north of the ancient city of Tarquinia in the locality of Monte Quaglieri. (All were acquired in 1830 for the papal collections.) The disk was hammered into its present shape, concave in the center and framed by a wide convex ring. Around the smooth central disk are two concentric bands with a tongue pattern designed to frame the head, which, likewise, was hammered separately from a single piece of bronze, and then attached to the disk by a pair of rivets. The conical horns and the ears also were executed separately and attached with rivets having special tongues for support. The eyes were rendered by filling cavities in the bronze with glass paste: white for the cornea, black for the iris. From several examples in which this filling has fallen out, we have learned that at the bottom of the eye cavity two small holes were drilled to allow for a better hold between the paste and the metal. The state of preservation of this disk is excellent.

The head, representing a bearded male figure with a bull's horns and ears, is identified as the Greek river god Acheloös, son of Thetis and Okeanos, described, in mythology, as being bested by Herakles in the contest for the hand of Deianeira. The composite nature of this figure —depicted sometimes as a centaur, sometimes as a bull with a man's head, sometimes as a sea monster, and sometimes as a man with a bull's head (overlapping, in the last case, with the iconography of the Minotaur)—was a common theme in Greek and Italiote art of the sixth and fifth centuries B.C. Thus, it recurred in Etruria, in representations of an apotropaic character. The theme was, for the most part, limited—as in this case—to the head: it is found, thus, in the heads decorating antefixes and the pendants of necklaces. (For a probable representation of the entire figure of this creature, see the smaller frieze in the first room of the Tomb of the Bulls in Tarquinia.)

112

113

The head of Acheloös recurs in more than ten examples of this class of object (which consists of about eighty pieces). Much more common are the heads of lions (as in cat. no. 112) and of rams.

Stylistically, although the emphasis on such details as the eyes, moustache, and beard, and the triangular structure of the face with its flattened forehead obviously recall a decidedly archaic tradition (of the middle of the sixth century B.C.), the more fluid modeling and the stylization of the curls on the forehead—above all, compared with those of an earlier version of this theme, in the same class—force us to consider the possibility that the disk may date from the beginning of the fifth century B.C.

The original function of these disks has been discussed at length: they have been interpreted as decorative ornaments for furniture, funeral biers, coffered ceilings, and for the walls of tombs (in the last case, either as pure decoration or as votive offerings to the deceased). In the tomb from which the Vatican objects came, they were stacked up one on top of the other, in an arrangement that tells us nothing about their original function, quite aside from the tampering that the contents of the necropolis had undergone before the excavations of the nineteenth century. The presence of large metal pins that pass through the centers of these disks (the head was added only *after* the disk was attached) assures us that the disks were placed on flat surfaces and had ornamental functions together with magical-protective ones. Their peculiar structure, moreover, represents the decorative enlargement of a type of disk, with an average diameter of a few centimeters, that was used in various Etruscan necropolises as a brazier ornament (as were those found at Vulci) or to decorate other, wooden objects, including (as in the case of several burial tombs in the necropolis of Peschiera near Todi) the caskets that contained the dead. One may compare the disks with the concentric circles that, rendered in painting, decorate the *columen* of certain tombs of the early fifth century B.C. in Tarquinia (the Tomb of the Chariots and the Tomb of the Funeral Bed). More problematic because of the chronological gap is the comparison with the disks sculpted on the urns in the Tomb of the Volumni in Perugia (first century B.C.) although, perhaps, the comparison is justified, historically, by the presence—in an archaic, unpublished tomb in the necropolis of the "Palazzone"—of a disk with a lion's head belonging to this same class. Tarquinia surely was the center of production of all of those disks whose origins are known. It, therefore, can be determined that these disks were actually applied to the sides of biers or to other wooden structures within the tomb.

F. R.

BIBLIOGRAPHY: *Mostra dell'arte e della civiltà etrusca*, Milan, 1955, p. 63, n. 249, pl. XXXIX; T. Dohrn, in W. Helbig, *Führer durch die öffentlichen Sammlungen klassischer Altertümer in Rom: Die Päpstlichen Sammlungen im Vatikan und Lateran*, I, 4th ed., Tübingen, 1963, p. 522, no. 692; on the entire class: M. Pallottino, "Tarquinia," in *Monumenti Antichi*, XXXVI, 1937, p. 352; R. Mengarelli, *Notizie degli Scavi*, 1941, p. 365; W. Hornbostel et al., *Kunst der Antike, Schätze aus norddeutschem Privatbesitz*, Mainz, 1977, pp. 85–86; on the subject: J. Jannot, "Achéloos, Le taureau androcéphale et les masques cornus dans l'Étrurie archaïque," in *Latomus*, XXXIII, 4, 1974, p. 765.

114

REVETMENT IN THE FORM OF A WINGED HORSE

Cerveteri
Early 5th century B.C.
Polychromed terracotta
Height, 18 1/8" (46 cm); depth, 15 15/16" (40.5 cm)
Museo Gregoriano Etrusco, Inv. no. 14130

This horse's forepart crowned the lower-left corner of a temple in Cerveteri from about the first quarter of the fifth century B.C. The piece still has traces of its original polychromy: red, black, and yellow. Perhaps the horse's mouth once held a bit. The front hooves (which projected), the top of the mane, and part of the flat tile to which the plastic element was attached have broken off.

Winged beings (such as the Aurora with young Cephalus, on the famous piece from Cerveteri now in the Staatliche Museen Preussischer Kulturbesitz in Berlin) often populated the skyline of Etrusco-Italic temple buildings.

This Pegasus—although perhaps the allusion is to a sea horse—is one of the finest products of the art of Etruscan temple decoration that, a few decades before the probable date of this revetment, had exerted its prestigious influence on Rome, itself—where Vulca, the terracotta craftsman from Veii, worked on the Temple of the Capitoline Jupiter. The influence of Greek art of the early fifth century B.C. is evident in the spare and vigorous rendering of the Vatican winged horse.

F. R.

BIBLIOGRAPHY: A. Andrén, *Architectural Terracottas from Etrusco-Italic Temples*, Lund/Leipzig, 1940, I, p. 46, III: I, and II, pl. 14, no. 47; T. Dohrn, in W. Helbig, *Führer durch die öffentlichen Sammlungen klassischer Altertümer in Rom: Die Päpstlichen Sammlungen im Vatikan und Lateran*, I, 4th ed., Tübingen, 1963, pp. 580–81, no. 784.

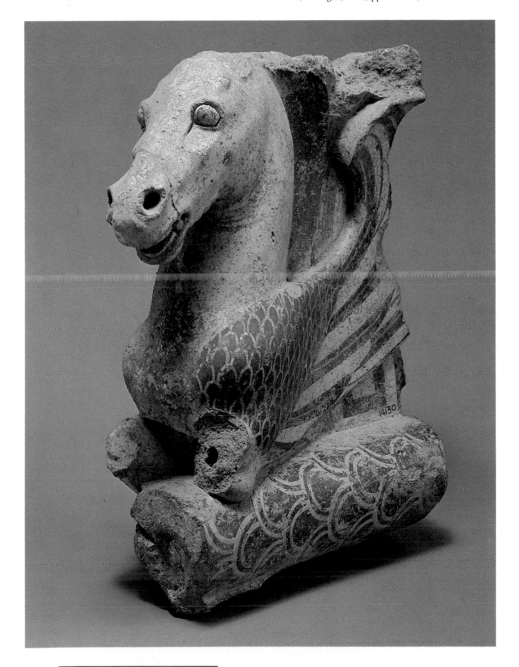

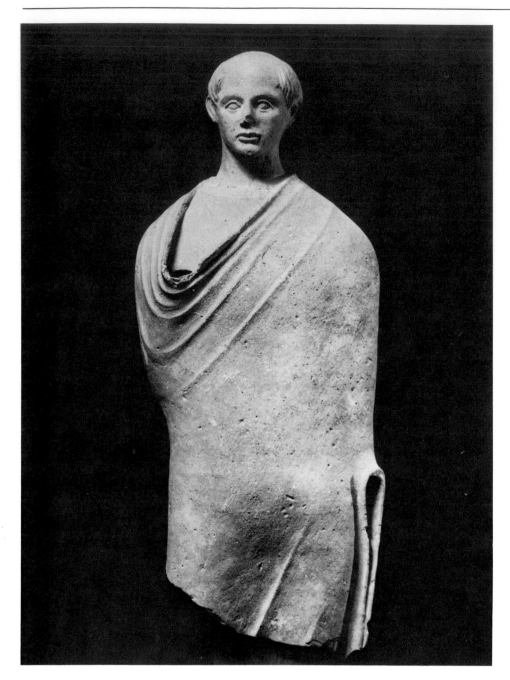

provided with hands, which were executed separately. They were inserted in openings in the cloak, whose drapery is very flat and simplified. The figure, strictly frontal in conception even though its pose is not rigidly frontal, narrows to a width of 5 ¼ to 5 ½ inches at its lowest remaining part. In format, the statue is the same as those small Etruscan bronzes in which the simplification of the bodies results in elongated, flat, or wiry figures.

F. R.

BIBLIOGRAPHY: G. Hafner, "Eine Porträtstatue aus Terrakotta im Museo Gregoriano Etrusco," in *Rendiconti della Pontificia Accademia Romana di Archeologia*, XXXVIII, 1965/1966, pp. 105–11; M. F. Kilmer, *The Shoulder Bust in Sicily and South and Central Italy: A Catalogue and Materials for Dating* (Studies in Mediterranean Archaeology, LI), Göteborg, 1977, pp. 225–26, n. 108, fig. 178 (only the head).

116

TWO HEADS OF HORSES

Etruscan, late 4th century B.C.; found in Vulci, at the entrance to a tomb
Nenfro
Height, c. 22 ¹⁄₁₆" (c. 56 cm)
Museo Gregoriano Etrusco, Inv. nos. 14953, 14954

Each of the two heads is bridled, with a decorative collar around the neck. *Nenfro* is a volcanic stone, native to Etruria, and some of the finest Etruscan sculptures are of this material. In antiquity, horses often had a sepulchral meaning, but it is not clear whether this pair was part of a chariot group or should be considered architectural adjuncts.

D. v. B.

BIBLIOGRAPHY: C. Q. Giglioli, *L'Arte Etrusca*, Milan, 1935, pl. 262, 1; T. Dohrn, in W. Helbig, *Führer durch die öffentlichen Sammlungen klassischer Altertümer in Rom: Die Päpstlichen Sammlungen im Vatikan und Lateran*, I, 4th ed., Tübingen, 1963, p. 473, no. 610.

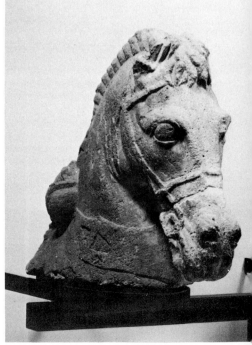

115

VOTIVE PORTRAIT STATUE OF A MAN

Cerveteri
Etruscan, 2nd century B.C.
Terracotta
Height: overall, 4' 1 ³⁄₁₆" (125 cm); head, 8 ⁵⁄₈" (22 cm)
Museo Gregoriano Etrusco, Inv. no. 17874

The pertinence of the head—which already had been identified and studied separately—to the body was recognized by G. Hafner in 1964. The head derives from a well-known prototype depicting a young man with a rather flat, triangular-shaped face, the ears sticking out and the cap-like hair in thin locks, parted over the forehead (as in cat. nos. 117, 118, but in less plastic relief).

This basic type is faithfully followed in another votive head, of the same origin, also preserved in the Museo Gregoriano Etrusco (Inv. no. 13871). In the present example, however, the artisan has strayed from the pattern with his expertise in modeling. He has removed most of the hair, leaving only a ring along the temples and the back of the neck; traced some wrinkles on the forehead; and attempted to mark the skin at the edge of the mouth more deeply. However, the age of the prototype is clearly younger than that of the derivative statue, and that, together with the attempt to convey a sense of aging, creates an appealing effect.

The man is dressed in a tunic over which is a cloak that Hafner identifies as a toga, worn in the manner of the Greek himation, which usually reached a little below the calves.

The statue—the lower part is missing and the left part of the nose is chipped—originally was

117

VOTIVE HEAD OF A MAN

Cerveteri
Etruscan, 4th century B.C.
Terracotta
Height: overall, 10¼" (26 cm); head, 7⁷⁄₁₆" (19 cm)
Museo Gregoriano Etrusco, Inv. no. 13854

A comparison, made for the first time by Guido von Kaschnitz-Weinberg, between this head and the following one (Inv. no. 13852) is highly instructive. The two faces, in fact, came from identical molds. The young man's head in cat. no. 118 was modeled and brought "to life" by a few finishing touches, including the colors paint-

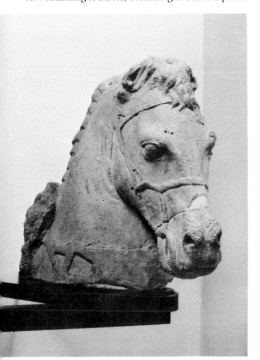

ed on top of a whitish slip applied over the purified, pinkish clay. The present example, made of a rougher, dark-red clay that might not have been slipped, shows a different effort at characterization—although it still belongs to an idealized type—and greater technical simplicity.

The craftsman who made this head wished to portray a mature man, so that he reworked extensively, if not in depth, what came out of the mold. With a modeling tool he cut wrinkles across the forehead, incised bristling eyebrows, and perforated the cheeks and chin to suggest a thick beard. The few abrasions in the hair indicate that, although the artist adhered to that of the given model, he wanted it to appear more disheveled. While the neck does not show any traces of having been made for insertion into a statue (as does cat. no. 118), it definitely reveals the artist's intention to render its connection with the shoulders realistically.

All of these variations, meant to convey advanced age, are signs with which the face is suffused but which remain superficial. The artisan did not feel the need to give the head a convincing volume, "closing" the portion that includes the face, and flattening it rather than integrating it, as is the case with the head in cat. no. 118, where the occipital part has been given adequate depth (sometimes achieved with a complementary mold).

This proof of a flourishing Etruscan craftsmanship of average quality illustrates quite well the singular contradiction that characterizes much of Etruscan art, especially at the beginning of the fourth century B.C. There is an insistent and historically determined recourse to the clearly admired themes and schemes elaborated upon in classic Greek art, which did not exclude, even in the greatest works, constant deviations by a taste that believed more in the evidence of detail and in the evocative power of the particular than in the logic and rigor of an organic whole.

This head is datable in the fourth century B.C.

F. R.

BIBLIOGRAPHY: G. von Kaschnitz-Weinberg, "Ritratti fittili etruschi e romani dal secolo III al I, Av. Cr.," in *Rendiconti della Pontificia Accademia Romana di Archeologia*, III, 1924/1925, pp. 337–38, pl. XXI, 2; T. Dohrn, in W. Helbig, *Führer durch die öffentlichen Sammlungen klassischer Altertümer in Rom: Die Päpstlichen Sammlungen im Vatikan und Lateran*, I, 4th ed., Tübingen, 1963, p. 587, no. 796; S. Steingräber, "Zum Phänomen der etruskisch-italischen Votivköpfe," in *Römische Mitteilungen*, 87, 1980, p. 223, pl. 70, 2; M. F. Kilmer, *The Shoulder Bust in Sicily and South and Central Italy: A Catalogue and Materials for Dating* (Studies in Mediterranean Archaeology, LI), Göteborg, 1977, p. 227, no. 110, fig. 180.

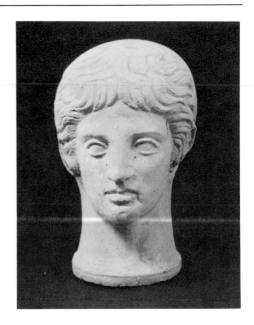

118

VOTIVE HEAD OF A MAN

Cerveteri
Etruscan, second half of the 4th century B.C.
Terracotta
Height: overall, 10¼" (26 cm); head, 7⁷⁄₁₆" (19 cm)
Museo Gregoriano Etrusco, Inv. no. 13852

This head probably came from Cerveteri, as did the head in cat. no. 117. The base of the neck, intact and thickened into a kind of flat "fillet," assures us that this example is the most common form of ex-voto—the neck-bust type—that directly reproduced the image of the devotee.

The youthful head is rather rigidly placed on an overly long and wide neck. The face is triangular, and the hair thick. The flame-like locks that radiate from the top of the head, separate over the forehead, and fall in front of the ears, which are placed too low; the dilated eyes; and the down-turned mouth are characteristics that found particular favor beginning in the fourth century B.C. This model is based upon a type of the Polyclitan youth, numerous versions of which were made between the fourth and the third century B.C., both in bronze and in terracotta.

The dating of such terracotta ex-votos, executed with molds that perpetuated particularly favored types for decades, is problematical. Without a precise archaeological context that allows the dating of an individual piece, one is reduced to dating the *type*—in this case, within the second half of the fourth century B.C.

F. R.

BIBLIOGRAPHY: T. Dohrn, in W. Helbig, *Führer durch die öffentlichen Sammlungen klassischer Altertümer in Rom: Die Päpstlichen Sammlungen im Vatikan und Lateran*, I, 4th ed., Tübingen, 1963, p. 587, no. 796; M. F. Kilmer, *The Shoulder Bust in Sicily and South and Central Italy: A Catalogue and Materials for Dating* (Studies in Mediterranean Archaeology, LI), Göteborg, 1977, pp. 226–27, n. 109, fig. 179; S. Steingräber, "Zum Phänomen der etruskisch-italischen Votivköpfe," in *Römische Mitteilungen*, 87, 1980, pp. 223, 224, 228, pl. 70, 1.

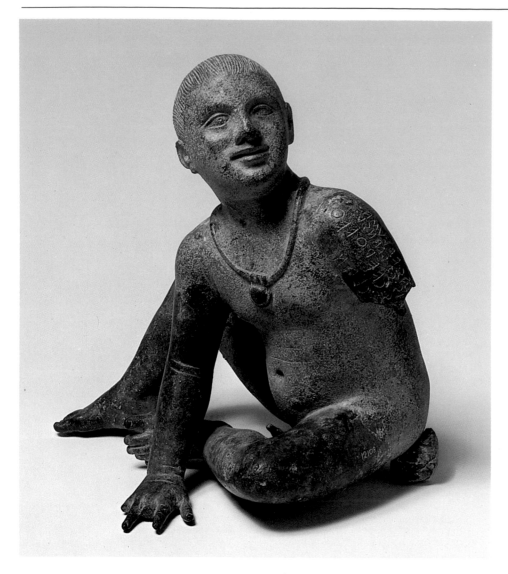

to the wrist, ankles, and abdomen.

The following inscription—in four lines, of which only the last two remain—was incised deeply, from right to left, on the outside of the left arm after casting (the text, in fact, overlaps the seam where the arm joins the shoulder):

(. . . .) ṇas : veluśa
(. . . .) xis selvansl:
(. . . .) ạs : cver: ⊙ve⊙li
(. . . .) : clan

The text says that a certain son of Vel (first name of the boy's father) and of a certain ⊙ve⊙li (the family name of his mother) was the subject of this votive offering (*cver*) to the god Selvans. Thus, the statue belongs to the category of ex-votos that feature children crouching, nude or half nude, in the act of making an offering (of a small animal, or fruit) to a divinity. In this group from Etruria are several large examples in bronze, such as this one and another—also in the Museo Gregoriano Etrusco—discovered at Pila near the Lago Trasimeno, and some terracottas, such as those from Cerveteri (now in the Museo Gregoriano Etrusco) and from Vulci (in the Museo di Villa Giulia in Rome). A Late Hellenistic date (second century B.C.) usually is proposed for these objects, but, in reality, the subject already was known in Greece in small-scale versions beginning in the fifth century B.C., and was particularly popular in Etruria in the fourth century, where it recurs in decorated mirrors, in both the principal and subsidiary scenes. The subject figures in depictions of gods and semi-divine children (Maris, Hercle) or other beings—sometimes winged—and probably of chthonic creatures. While scholars await the results of current studies of the votive material found at the "Ara della Regina," it is best to assign a date not later than the first half of the third century B.C. to this piece (which also is supported by the inscription).

The forced tension of the bust and of the head; the unmistakable singularity of the closely cropped hair; and the animated face of the child, who, looking up, "speaks from below"—so different from those laughing faces of "rococo" Hellenistic putti—immediately suggested to Passeri the idea (since resurrected by R. Herbig and E. Simon, 1965) that the bronze figure represents the mythic Tages. Tages was the infant seer, the newborn with the face of an old man, who suddenly sprang from the earth before the eyes of a Tarquinian farmer (according to some sources Tarquin, the founder of Tarquinia) and revealed to him and to the other Etruscan leaders gathered together for the purpose the secrets of Etruscan religious discipline and, in particular, the art of divination (Cicero, *De div.*, II, 23, 50).

Some scholars object to this hypothesis, stressing the fact that the name of the boy is given in the inscription, and that his "lay" character is indicated by the bulla, which marked children of free birth. Such a confrontation of opposing views is inconclusive. Whomever the small statue portrays (and it should be noted that the bulla is worn regularly by the divine and semidivine in the mirror decorations previously mentioned), it is clear that a mythic figure as important as Tages very likely heavily influenced the means of portraying the infant and of making it a part of the official religious iconography in Etruria—and, above all, in Tarquinia. One must remem-

119

VOTIVE STATUE OF A CHILD (THE "PUTTO CARRARA")

Tarquinia
First half of the 3rd century B.C.
Bronze
Height (excluding the piece attaching the
* statue to the pedestal), 12 7/8" (32.7 cm)*
Museo Gregoriano Etrusco, Inv. no. 12108

Excavated in 1770 "from the Tarquinian ruins near Corneto" (J. B. Passeri, 1771, p. 12), this small statue came from one of the cult areas of the ancient city; among those known to us, the "Ara della Regina" seems the most likely place.

The statue was presented by Monsignor Francesco Carrara to Pope Clement XIV in 1771, and was placed in the Museo Profano of the Vatican Library, which, in turn, gave it to the new Museo Etrusco in January 1837.

The bronze, which is hollow, was cast by the lost-wax process in separate parts (torso, head, limbs, genitals). The alloy is 49 percent copper, 12.5 percent tin, 38 percent lead, and one percent zinc, with traces of iron; it is characterized by its high degree of lead. The metal wall is of considerable and consistent thickness (0.6 mm); the inside shows those points where the respective parts were joined, as well as a few pieces of the original core that still adhere. The feet of the statue have been left open, and another quadrangular opening occurs at the point of support on the pedestal. A projection of bronze is attached to the figure's left buttock; still preserved is part of a lead wedge meant to anchor the statue at its base. The overall state of preservation is good, although the little and middle fingers of the right hand are missing, and the left arm has been broken off above the elbow.

The child is portrayed seated on the ground, his left leg bent horizontally, his right leg vertical and out to the side. His right hand, with flattened palm, leans on the ground; his body faces left, the head turned upward. Around his neck the figure wears a bulla suspended from a ring (perhaps meant to represent leather) that has no clasp. His hair, without volume, is rendered in thick, parallel stripes that emanate from the top of the head. The boy's lips are barely parted. The irises and pupils of his eyes are incised. The modeling is extremely simplified and generalized (notice the thick ankles), articulated by a few engraved lines, added after casting,

ber that, located in Tarquinia, perhaps only a short distance from the place where this remarkable votive offering came to light, was the "memorial" to the miraculous birth of Tages.

<div align="right">F. R.</div>

BIBLIOGRAPHY: S. Borgia, *Alphabetum veterum etruscorum et nonnulla eorumdem monumenta*, Rome, 1771, pp. 29–31, 37, n. III; J. B. Passeri, *De pveri etrvsci aheneo simvlacro . . .*, Rome, 1771; T. Dohrn, in W. Helbig, *Führer durch die öffentlichen Sammlungen klassischer Altertümer in Rom: Die Päpstlichen Sammlungen im Vatikan und Lateran*, I, 4th ed., Tübingen, 1963, p. 536–37, no. 717; for the inscription: M. Pallottino, *Testimonia Linguae Etruscae*, Florence, 1954, p. 148; for Selvans: D. von Bothmer and J. Heurgon, "An Etruscan Bronze in New York" (Fondation Eugène Piot, *Monuments et Mémoires*, 61), 1977, pp. 44–59; for the subject: R. Herbig and E. Simon, *Götter und Dämonen der Etrusker*, Mainz, 1965, pp. 30, 10, pl. 17, on the Tages monument: M. Torelli, *Elogia Tarquiniensia*, Florence, 1975, pp. 120, 129, 140, n. 5.

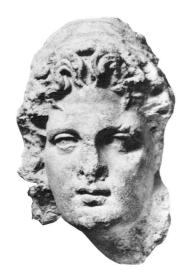

120

HELLENISTIC HEAD OF A MAN

Provenance unknown (Vulci?)
Mid-2nd century B.C.
Nenfro
Maximum height, 13" (33 cm); height of
 head, 9 13/16" (25 cm)
Museo Gregoriano Etrusco, Inv. no. 14945

The head, of life size, has suffered abrasions where the modeling is in highest relief (as in the nose and hair). A large fracture extends from the neck along the left side of the head to the nape. This area clearly contrasts with the more elaborately modeled right side, which assures us that the piece comes from a high relief, and must, originally, have been seen from below and from the right. The head is twisted sharply toward the left, suggesting that the thrust of the complete figure was toward the right. The prominent forehead, the deep-set eyes accentuated by the strongly demarcated upper lids, and the parted lips give the face an emotional intensity that is unmistakably Hellenistic, as is the wavy hair, two locks of which are drawn up from the hairline. The headgear, two bands overlapped and crisscrossed like a *tutulus*, has been interpreted erroneously as a Phrygian cap or a *pilos*.

It is difficult to reconstruct the original placement of this fragment (in which G. von Kaschnitz-Weinberg recognizes Paris or one of the Dioskouroi); perhaps it belonged to the pediment on the front of a tomb, or projected from the side of a capital, similar to the famous example on the so-called Campanari tomb at Vulci. The attitude, however, is identical to that of the female, winged demons in numerous relief friezes on urns from Volterra of the second century B.C.

<div align="right">F. R.</div>

BIBLIOGRAPHY: G. von Kaschnitz-Weinberg, *Le sculture del magazzino del Museo Vaticano*, Vatican City, 1937, pp. 251–52, n. 582, pl. XCIII; T. Dohrn, in W. Helbig, *Führer durch die öffentlichen Sammlungen klassischer Altertümer in Rom: Die Päpstlichen Sammlungen im Vatikan und Lateran*, I, 4th ed., Tübingen, 1963, pp. 471–72, no. 607.

121

VOTIVE PORTRAIT BUST OF A WOMAN

Cerveteri
First half of the 3rd century B.C.
Terracotta
Height: overall, 13 5/8" (34.7 cm); head, 6 11/16" (17 cm)
Museo Gregoriano Etrusco, Inv. no. 14107

This bust, together with the votive heads and the statue previously discussed (cat. nos. 115, 117, 118), was excavated in the early nineteenth century at the site of the ancient Etruscan city of Caere (in Etruscan, *ceizra*) in the Vignali area. (All four objects came to the Vatican in 1826.) Before being set aside in one of the *favisae*, or votive deposits, the bust, originally, must have been placed in one of the numerous temples whose existence R. Mengarelli ascertained in the course of excavations and studies conducted during the first half of the twentieth century.

The work, which was executed by hand and finished with a modeling tool, represents a woman of about thirty. Her pose is strictly frontal, and her head inclines slightly to the left. Her upward gaze is common to such portraits. She wears a light, pleated undergarment, with a V-form neckline; a cape, falling in vertical folds over the left shoulder; and earrings (which one must imagine as gold) made of a tubular hoop ending in a lion's head. The exceedingly simple hairdo accords with the directness of the portrait. Her hair, parted in the middle, rises up at the top of her forehead in two locks—the right one is restored—and then falls close to the skull, behind her ears, where some is gathered in a small chignon at the nape and some reaches her shoulders. Two locks of hair curl in front at her temples.

The woman's physiognomy is characterized by a high forehead, a large chin and nose, strong cheekbones, and hollowed cheeks (the right one has a small scar). Irises and pupils are marked by light incisions. Reconstructed from fragments, the bust lacks the right shoulder and the left earring, and it has a few abrasions and gaps in the hair.

What is striking, in this apparent effort to present the truth, is the vague, unfocused expression that links this bust to those mass-produced with molds (see cat. nos. 115, 117, 118), which

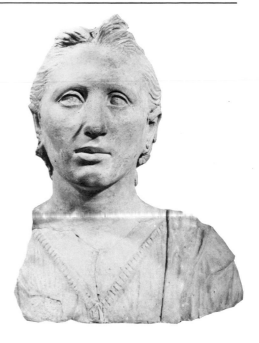

less well-to-do worshipers left behind after their visits to the sacred places of the Etruscan and Italic cults. This faithful portrait—unquestionably individualized—is exceptional, cut, as it is, at the shoulders. Such a form is, in fact, common in Latium and in Magna Graecia for both votive and funeral portraits, but it is rare in Etruria. Instead, in Etruria it is much more usual to find —besides ex-votos reproducing various parts of the human body—the features of the votary reduced to just the head or, sometimes, even to only one side of the head, shown in profile.

This portrait has been dated between the end of the second and the beginning of the first century B.C. Nonetheless, the date of the earring, clearly recognizable as a type of Greek-Italiote object found in Tarentine tombs of the fourth century B.C., makes one reconsider. This detail coincides with the already indicated Latin—and, perhaps indirectly, southern Italian—correspondences for the bust. Moreover, the preference to represent a more ethically attractive reality rather than an aesthetically pleasing one seems to place the sculpture in that "central Italic" portrait tradition better known through its male examples, such as the Capitoline *Brutus* and other portraits in bronze and terracotta, with which, by now, the Vatican bust is commonly grouped.

We should consider this sculpture an exceptional work, an expression of the taste of the aristocracy that might have existed at Caere— a cultivated and precociously philo-Roman city—in the middle of the Republican era. I propose a date for the bust within the first half of the third century B.C.

<div align="right">F. R.</div>

BIBLIOGRAPHY: T. Dohrn, in W. Helbig, *Führer durch die öffentlichen Sammlungen klassischer Altertümer in Rom: Die Päpstlichen Sammlungen im Vatikan und Lateran*, I, 4th ed., Tübingen, 1963, pp. 589–90, no. 799; M. F. Kilmer, *The Shoulder Bust in Sicily and South and Central Italy: A Catalogue and Materials for Dating* (Studies in Mediterranean Archaeology, LI), Göteborg, 1977, pp. 228–29, n. 112, figs. 183–185; for the earrings: G. Becatti, *Oreficerie antiche dalle minoiche alle barbariche*, Rome, 1955, p. 194, n. 376, pl. XCVIII; for the Capitoline *Brutus*: F. Zevi, in *Roma Medio Repubblicana*, Rome, 1973, pp. 31–32, n. 1.

THE COLLECTIONS
OF
GREEK AND ROMAN
ANTIQUITIES
IN THE 19th AND 20th CENTURIES

The names of two popes are connected with the founding of new museums for classical antiquities in the nineteenth and twentieth centuries: The family name of Pius VII (1800–1823) distinguishes the Museo Chiaramonti, and Gregory XVI (1831–46) gave the Museo Gregoriano Profano in the Palazzo Lateranense both its name and its purpose. The first-named museum comprises the easterly corridor connecting the Papal Palace with the Palazzetto del Belvedere and the new structure called the Braccio Nuovo. The other was set up in the Palazzo Lateranense as a "national museum" of the papal states; it remained there for nearly one hundred and twenty years, until, in 1963, its collections were transferred to the Vatican.

When Pius VII entered Rome on July 3, 1800, after having been elected pope in Venice on March 14, he found that the Vatican Museum contained only the empty pedestals on which antique statues and busts had stood. One, therefore, can understand how the pope, in 1801, would wish to forbid the statue of Perseus, just completed in Rome by Antonio Canova, to be taken out of the papal states. Instead, he bought it himself for 3,000 zecchini, and had it placed on the pedestal of the *Apollo Belvedere* in the Cortile Ottagono, "Cura Pii VII" ("thanks to the providence of Pius VII"), as an inscription on its base proclaims. Perseus holds up the head of the Medusa triumphantly in his left hand, while, in his lowered right hand, he carries his sickle-shaped sword—the pose unmistakably borrowed from the *Apollo Belvedere*. In 1802, Canova was entrusted with the supervision of monuments throughout the entire state. He created the Museo Chiaramonti, and he commissioned young painters from the Accademia di San Luca to represent the glorious deeds of the Chiaramonti pope in the lunettes of the museum's gallery.

The inscription under the painting depicting the gallery of the new museum founded by Pius VII reads: MVSEVM •

CLARAMONTANVM/PIOCLEMENTINO • ADIECTVM. It was painted by Filippo Agricola (fig. 39). The winged genius of the arts appears seated in the center. He has placed his left arm gently and encouragingly across the shoulders of a putto, whose attributes mark him as being representative of Sculpture. With his extended right hand the genius points to the entrance of the Museo Chiaramonti. One clearly can recognize the two columns at the entrance to the Galleria Lapidaria, behind which various antique statues on grave altars are visible. Opposite the genius are two additional putti, their attributes associating them with Architecture and Painting. The latter holds an unrolled scroll in front of his picture frame inscribed PIVS • VII / P • M • / A[NNO] • VII, with the date of the depicted event, the opening of the new museum in the years 1806–7.

In the following year, 1808, the first part of an ambitious catalogue appeared: *Il Museo Chiaramonti aggiunto al Pio-Clementino*, by Filippo Aurelio Visconti and Giuseppe Antonio Guattani. The introduction speaks of "this collection of ancient inscriptions, of which Europe sees no other that is similar. . . ." Gaetano Marini (1740–1815) arranged the more than 3,300 stone inscriptions according to thematic context and title. He placed the profane inscriptions on the east side of the corridor facing the city, and the Christian ones on the opposite wall facing the courtyard. With respect to the exhibition of the sculptures, one reads in the same introduction: "We have differed in the disposition of the monuments from the system of the Museo Pio-Clementino, for, in ours, the statues, busts, [and] reliefs are combined, in order to deal comprehensively with each subject." It was attempted, therefore, to group the sculptures according to theme. The walls are divided by a simple arrangement of pilasters. There are nearly one thousand sculptures and fragments, their original installation by and large preserved even today: statues of gods and portrait sculptures, busts and herms, altars and architectural ornaments, urns and sarcophagi. The disposition

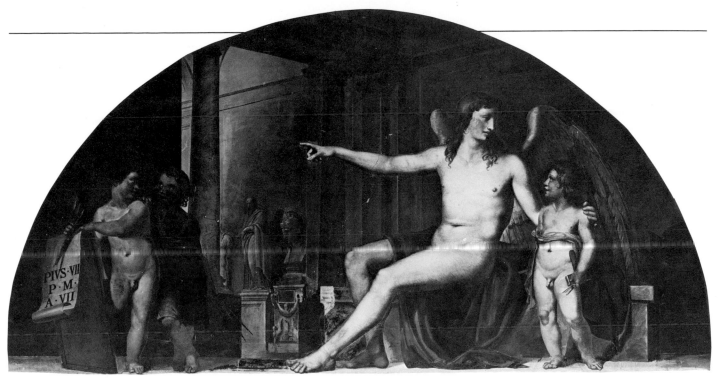

FIG. 39. FILIPPO AGRICOLA. *THE OPENING OF THE MUSEO CHIARAMONTI IN 1806.* FRESCO. GALLERIA CHIARAMONTI

of the sculptures within the individual compartments is governed by the laws of symmetry; compartments with only three large statues alternate with others displaying a quantity of busts, heads, and fragments. Opposite walls correspond to each other in the organization of the compartments; however, portraits and heads with portrait-like features predominate on the east wall (the city side), while on the west wall (the courtyard side) one finds primarily idealized sculptures. The Greek tomb relief depicting a mounted rider (see cat. no. 122) was also exhibited in the Museo Chiaramonti in 1823; it had been acquired by the cardinal-camerlengo one year after Canova's death and remained there until 1960, when, in the course of gathering together the few Greek originals in the Vatican for didactic purposes, the horseman was transferred to the Salette degli Originali Greci.

With the fall of Napoleon, in 1815, the return of the works of art from Paris became a possibility. At the urging of Cardinal-Secretary of State Consalvi, who represented Rome's interests at the Congress of Vienna, Pius VII dispatched Canova to Paris. The understandable resistance on the part of the French commissioners was only overcome with the energetic support of the representatives of the Protestant countries—above all, William Richard Hamilton, Wilhelm von Humboldt, and the Duke of Wellington. Their efforts ensured the transport of these treasures back to Rome.

The return of the ancient sculptures to Rome permitted Pius VII to realize his plans for the expansion of the museum that had been developing since 1806. The architect of the Apostolic See, Raffaele Stern, brought them to an adequate solution in 1817. Stern's presentation of his designs to the pope is depicted as an event from the year 1818 in a wall fresco by Domenico De Angelis in the Sala Clementina of the Vatican Library (fig. 40). Below the fresco is the inscription (in Latin): "By order of Pius VII, the Museum and Library were connected by a lofty portal and a chamber built

from the foundations, where the collected works were placed, in the year 1818." The setting of the scene is at the entrance leading from the Galleria Lapidaria into the Museo Chiaramonti. Behind the pope one can already see the door opening into the Braccio Nuovo, and the coat of arms of Pius VII above it, with the dedicatory inscription (in Latin): "Pius VII Pontifex Maximus built a new space, intended for the display of the works recovered and collected by him, in the eighteenth year of his pontificate."

The Braccio Nuovo connects the two long, corridor-like wings of Bramante's courtyard plan. Its interior is reproduced most impressively in the engraving by Antonio Acquaroni (fig. 41). The middle point is developed as a central space, with a dome and apses, while the two arms, covered by coffered barrel vaulting, stress the essence of the whole as an extended corridor. The walls and ceiling are arranged and decorated in the antique manner, the exhibited sculptures forming an integral part of the system of ornamentation. The statues are set quite regularly in the niches, alternating with busts of nearly identical height, on fragments of columns also of approximately the same height. Above, between the arches of the niches, there is a regular repetition of busts placed on consoles, and, at the top, a plaster frieze that is not antique, although its composition and motifs are modeled carefully after antique examples. These reliefs were created by Maximilien Laboureur. The interior receives its sole illumination from overhead, through the apex of the vaulting. Early-nineteenth-century taste deemed it best to display antique sculptures in this way, providing them with a classical context. When the Braccio Nuovo first opened, the *Portrait Statue in the Form of Omphale* (see cat. no. 133) was displayed there, as was the *Augustus of Prima Porta* (see cat. no. 128), in the very year that it was discovered. The *Augustus* replaced a statue of Asklepios that had been exhibited in the Braccio Nuovo from 1833 to 1863.

In the opinion of Pope Gregory XVI, it was not enough that the Vatican Museums enriched the "Magnificenza" of the Eternal City and maintained its primacy in the three arts of architecture, sculpture, and painting; this was praiseworthy, but it could not be everything. "These images of false gods, these likenesses of consuls, of emperors, of men in togas [*togati*], who either did not know, or who persecuted the Christian religion, at a glance, they likewise can be seen as the spoils of defeated enemies, as *trophies* of the victory won by the Cross over idolatry and idolators."

One such "trophy" is the statue of Sophokles (see cat. no. 131). It was a gift to Gregory XVI in 1839 from the Antonelli family of Terracina. Since this portrait statue could be given no appropriate place in the existing museums in the Vatican and on the Campidoglio—although the sculpture was one of the noblest to have survived from antiquity—the pope used the necessity for providing a worthy setting for the *Sophokles* as the justification for establishing the Museo Gregoriano Profano in the Palazzo Lateranense, which just then was being restored. The antique finds from the papal states, primarily from Rome, Cerveteri (Caere), Veii, and Ostia, which had been collecting in the storerooms of the Vatican because of the Pacca Edict of April 7, 1820, were now moved to the Palazzo Lateranense and set up in the ground-floor rooms. On May 16, 1844, the Feast of the Ascension, the Museo Gregoriano Profano Lateranense ceremoniously was opened. When the papal states were dissolved in 1870, this museum no longer had the same function, and it now stood outside the territorial possessions of the pope. With the formation of the Italian state, the Museo Nazionale Romano delle Terme became the repository of new finds. To be sure, a few small territories remained under the sovereignty of the Vatican, as a result of the Lateran Treaty of 1929, among them the Palazzo della Cancelleria on the Corso Vittorio Emanuele. When foundation work became necessary on this structure in 1937—and, for this purpose, excavations were made beneath it—the remains of the tomb monument of Aulus Hirtius and some large Roman friezes were discovered at a depth of more than sixteen feet. One of the latter reliefs is the *Frieze of the "Altar of the Vicomagistri"* (see cat. no. 130). The relief slabs were placed in the Vatican, and, since 1970, have been exhibited in the newly built Museo Gregoriano Profano.

On the eve of the Second Vatican Council, Pope John XXIII (1958–63) contemplated giving more importance to his bishop's seat in San Giovanni in Laterano. He expressed such a wish on June 24, 1962, the Feast of Saint John the Baptist, in an address in the basilica: "The Pope, Bishop of Rome, consolidating the offices of the Administration of the Diocese near the basilican cathedral, the gleaming Lateran [*Lateranum fulgens*], and disposing of the palaces that surround it, would be able to collect there, with more breathing space, all or almost all of the organization of the Diocese of Rome." On February 1, 1963, the museums in the Palazzo Lateranense were closed and the collections immediately moved to the Vatican. To house them, a new wing was erected to the north of the Pinacoteca, connected to the existing museum complex that had evolved through the centuries.

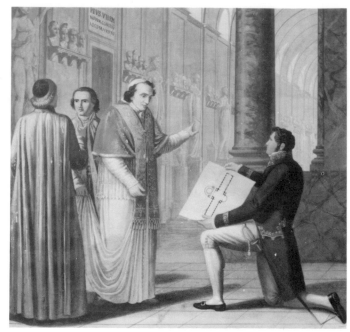

FIG. 40. DOMENICO DE ANGELIS. *RAFFAELE STERN PRESENTING HIS PLANS FOR THE BRACCIO NUOVO TO PIUS VII*. FRESCO. 1818. GALLERIA CLEMENTINA, VATICAN LIBRARY

The task was accomplished by the Passarelli firm of architects. An attempt was made to use this opportunity to sort, separate, and reorganize the artistic heritage and to present it in a new way. Thus, this newly established museum differs in kind and in arrangement from the older sculpture galleries in the Vatican, standing in sharpest contrast to them. The Museo Pio-Clementino and the Museo Chiaramonti with the Braccio Nuovo, which have remained virtually unchanged in structure, not only display their antique sculpture but present it in the manner in which it was understood in the second half of the eighteenth century and the beginning of the nineteenth. On June 15, 1970, the Museo Gregoriano Profano once again became accessible in the Vatican. The dedicatory inscription (in Latin) at its entrance proclaims: "These most remarkable monuments . . . John XXIII Pontifex Maximus wished to have fittingly and suitably transferred to this place built as a great undertaking and Roman enterprise near the glorious memorial to Saint Peter."

Georg Daltrop

BIBLIOGRAPHY: On the Museo Chiaramonti: *Il Museo Ciaramonti aggiunto al Pio-Clementino da N. S. Pio VII p.m.*, I, con l'esplicazione de'sigg. F. A. Visconti e G. A. Guattani, Rome, 1808, II, con la dichiarazione di A. Nibby, Rome, 1837, III, con la dichiarazione di A. Nibby e i monumenti descritti da L. Biondi, Rome, 1843; F. A. Visconti and G. A. Guattani, *Il museo Chiaramonti*, Milan, 1820 (Vol. I above, in smaller format, with foreword by G. Labus); E. Massi, *Museo Chiaramonti al Vaticano*, Rome, 1858; B. Nogara, "Il Card. Ercole Consalvi e le antichità e le belle arti," in *Nel I centenario della morte del Card. Ercole Consalvi 24 gennaio 1924*, Rome, 1925, pp. 84–101; C. Pietrangeli, "I musei Vaticani dopo Tolentino," in *Strenna dei Romanisti*, 1975, pp. 354–59; U. Hiesinger, "Canova and the Frescoes of the Galleria Chiaramonti," in *The Burlington Magazine*, 120, 1978, pp. 655–65; C. Pietrangeli, "Il primo regolamento dei musei Vaticani," in *Strenna dei Romanisti*, 1981, pp. 362–73; on the Museo Gregoriano Profano Lateranense: R. Garrucci, *Monumenti del Museo Lateranense descritti e illustrati*, Rome, 1861; O. Benndorf and R. Schöne, *Die antiken Bildwerke des lateranensischen Museums*, Leipzig, 1867; O. Marucchi, *Guida del Museo Lateranense profano e cristiano*, Rome, 1922; E. Josi, "Il Museo Gregoriano Lateranense," in *Gregorio XVI, Miscellanea commemorativa a cura dei padri Camaldolesi di S. Gregorio al Celio*, I, Rome, 1948, pp. 201–21; F. Mancinelli and F. Roncalli, "Trasferimento delle raccolte lateranensi al vaticano," in *Bollettino dei Monumenti Musei e Gallerie Pontificie*, I, 1 (1959–74), 1977, pp. 15–29, and also in *Rendiconti della Pontificia Accademia di Archeologia*, 48, 1975/76, pp. 401–15.

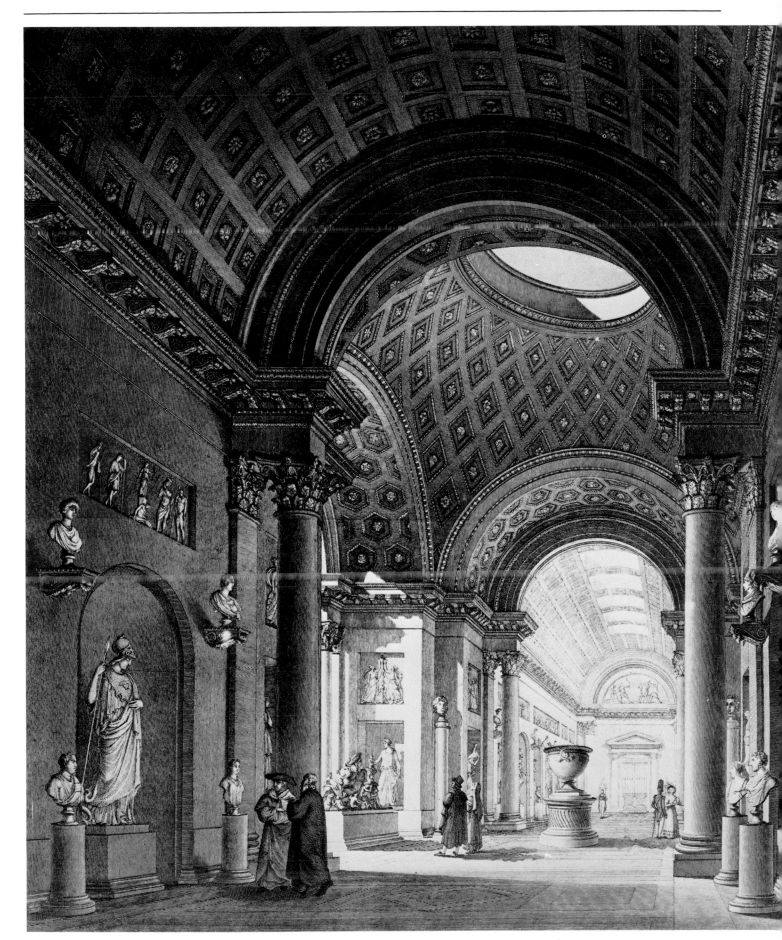

FIG. 41. ANTONIO ACQUARONI. THE BRACCIO NUOVO IN 1822. ENGRAVING

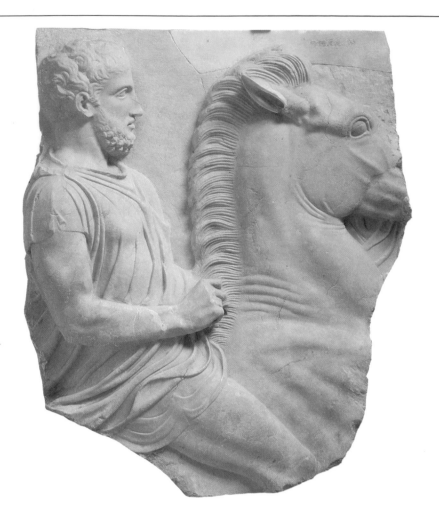

123

GREEK VOTIVE RELIEF, WITH A HORSEMAN

Presumably from Tyndaris (Sicily), early 4th century B.C.
Marble (Pentelic ?)
Height, 21 ¼" (54 cm); width, 24 ½" (62.7 cm); depth, 1 ⁹⁄₁₆" (4 cm)
Biblioteca Apostolica Vaticana, Sala Clementina, Inv. no. 4092

Except for the upper-right corner, the relief is completely preserved. The missing reins possibly were represented by strips of bronze, to which the hole for attachment on the horse's neck would attest, or they might have been painted on, as was also the case with the strap of the petasos (or broad-brimmed hat).

Ceremoniously excavated in Pompeii in the presence of Pius IX, in 1849, and presented to the pope as a gift by Ferdinand II, King of the Two Sicilies, the relief appears to have been buried there only a short time before, planted—as it were—for the pope to find. It is assumed to have come from the storerooms of the Naples museum, where antique sculptures from Tyndaris are believed to have been transferred just before.

A young rider is represented, without a saddle, reining in his horse. He swings a whip in his right hand, while, in his left, he must have held the reins. He wears a chiton and a chlamys fastened on his right shoulder, a petasos, and sandals. The horse rears up on its hind legs, its forelegs extended well forward and its neck arched back.

The dynamic of the composition, based upon and suffused by the contrasting strengths of horse and rider, is developed in even the slightest details. The competing wills of man and animal are ultimately tested in the moment of reining in, the violent motion of which is imparted by the diagonals, although the whole forms a balanced unity. This harmony of freedom and constraint is characteristic of Greek classicism of about 400 B.C.

In format, this small relief, with its projecting edge and cyma at the top, belongs to the class of votive sculptures that were set up in a sanctuary as testimony to a solemn pledge. If it does, in fact, come from Tyndaris—named after the sons of Tyndareus, the Tyndaridae or Dioskouroi—it is likely that the work was consecrated to the Dioskouroi, or even to Kastor, the horse tamer, alone.

The respect enjoyed by horsemanship in Athens during the Classic period of the fifth and fourth centuries B.C. is evidenced by the numerous representations of horsemen, such as the previous grave relief (see cat. no. 122) and, most notably, the Parthenon frieze, but the writings of Simon and Xenophon tell us even more, especially the latter, who, for the benefit of young people, recorded his experiences and his thoughts on horsemanship, after a lifetime of dealing with horses. According to Xenophon, a parade horse must possess a "noble soul" and a "powerful body" (τὴν ψυχὴν μεγαλόφρονα καὶ τὸ σῶμα εὔρωστον).

This vivid image of a rider on a rearing horse represents the new and bold manner in which

122

GREEK GRAVE RELIEF, WITH A HORSEMAN

Boeotia, c. 430 B.C.
Limestone
Height, 27 ⁹⁄₁₆" (70 cm); width, 22 ¹³⁄₁₆" (58 cm); depth, 6 ⁵⁄₁₆"–3 ⁹⁄₁₆" (16–9 cm)
Museo Gregoriano Etrusco, Saletta degli Originali Greci, Inv. no. 1684

The horse and rider belonged to a large grave relief. Only the neck and the upper portion of the head of the horse are preserved; missing from the rider are his right calf and foot and the part of his garment that would billow back. The nose and wrist of the rider and the ear of the horse have been restored. In the upper-right-hand corner of the block, a piece has been added with the inscription "1823.c.c.30," the date of its acquisition by the cardinal-camerlengo. (The cardinal-camerlengo supervises the property and temporal rights of the Holy See.)

This fragment of a stele was brought back from Greece as war booty by the Venetians, under Francesco Morosini, in 1687. It was owned by Doge Marcantonio Giustiniani, and later became part of the collection in the Palazzo Giustiniani in Rome. At the suggestion of the commission on monuments, in 1823 it was obtained by the cardinal-camerlengo for the Vatican Museums, through the efforts of Vicenzo Camuccini, and, until 1960, it was displayed in the Museo Chiaramonti (XXXI, 17).

A bearded, mature man is riding a spirited horse bareback. The rider appears to be calm and self-assured. He sits upright, looking directly ahead. He wears a short chiton and the chlamys, or mantle, buttoned at the right shoulder. His extended fist held the rein, which, presumably, was of bronze, and has been lost. The close-reined horse holds its head high. Its cropped mane is splendidly portrayed. Below the horse's head are the folds of a cloak that must belong to another rider.

In style, the relief shows the direct influence of the Parthenon frieze and of the art of Pheidias. The play of forces between the impetuous horse, with its large eye, and the relaxed rider constitutes the charm of the work.

Funerary monuments were among the most important forms of Greek sculpture. As memorials to specific individuals, they provided sculptors with the opportunity to confer permanence on the deceased while expressing universal, rather than specific, human characteristics.

G. D.

BIBLIOGRAPHY: W. Amelung, *Die Sculpturen des Vaticanischen Museums*, I, Berlin, 1903, pp. 533–34, no. 372 A, pl. 58; W. Helbig, *Führer durch die öffentlichen Sammlungen klassischer Altertümer in Rom: Die Päpstlichen Sammlungen im Vatikan und Lateran*, I, 4th ed., Tübingen, 1963, no. 871.

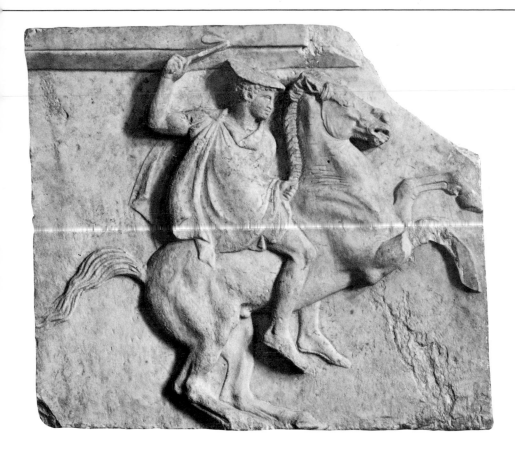

the theme was expressed in the fifth to the fourth century B.C. It provided an important source of inspiration for the artists of the Renaissance—above all, for Leonardo da Vinci—and was transfused with Baroque pathos in the art of Bernini and of Étienne Maurice Falconet.

G. D.

BIBLIOGRAPHY: P. Arndt and G. Lippold, in Brunn-Bruckmann, *Die Denkmäler griechischer und römischer Sculptur*, Munich, pl. 729 (rt.); W. Helbig, *Führer durch die öffentlichen Sammlungen klassischer Altertümer in Rom: Die Päpstlichen Sammlungen im Vatikan und Lateran*, I, 4th ed., Tübingen, 1963, no. 471; F. Magi, "La stele greca della Biblioteca Vaticana," in *Mélanges Eugène Tisserant*, III, Vatican City, 1964, pp. 1–9, pl. 1; G. Daltrop, in L. von Matt, *Die Kunstsammlungen der Biblioteca Apostolica Vaticana*, Cologne, 1969, pp. 11–12, 165, pl. 2.

124

HERM OF PERIKLES

*Roman copy (2nd century A.D.), after a Greek
 original of c. 429 B.C.*
Pentelic marble
Height, 72 1/16" (183 cm)
*Museo Pio-Clementino, Sala delle Muse,
 Inv. no. 269*

The portrait herm is recomposed out of four pieces: the face; the back of the head, with the helmet; and the upper and lower portions of the shaft. In 1780, it was restored and reconstructed by Giuseppe Pierantoni, who added the tip of the nose, the right cheek portion and the lower point of the left cheek of the helmet, and

the left shoulder with part of the armpit.

The herm was excavated in April 1779 on the site of the so-called Villa of Cassius, south of Tivoli, where, four years before, the statues of the Muses and the *Apollo Musagetes* (see cat. nos. 54–56) had come to light. At the pope's behest, Giovanni Corradi, Inspector of Excavations in the papal states, carried out the excavations for the Vatican Museums. That May, in the same excavation, a replica of the *Herm of Perikles* was found that was sold through Gavin Hamilton to the Townley Collection as a duplicate, later to be acquired by the British Museum.

The Greek inscription on the shaft, "Perikles, son of Xanthippos, the Athenian," identifies the portrait as the statesman who was born about 500 B.C. and died of the plague in Athens in 429 B.C. The Corinthian helmet shows the man as a strategos, or commander-in-chief, the official position to which Perikles was elected fifteen times, and whereby he established the base of his power to influence the Athenian state. Critics of Perikles called him "onionhead" because of the anomalous shape of his skull, a fault that, according to Plutarch (Perikles 3), artists sought to conceal by means of the helmet. In fact, in the Vatican copy locks of Perikles' hair are visible through the eyeholes of the Corinthian helmet, which has been pushed back from his face.

Four other Roman copies of this portrait head are known. Among them, the present example is distinguished by clean, clear, and precise workmanship, particularly in the representation of the hair and beard, and it seems to have captured most faithfully the severity of the original—which, in all probability, was a bronze statue; one may visualize the original in terms

of the bronze statues recently discovered in the sea off Riace. The herm-and-bust portrait is a Roman invention, an abbreviation of portrait statues. According to Pausanias (I, 25, 1; I, 28, 2), such a portrait statue stood on the Akropolis in Athens, and Pliny (*Nat. Hist.*, 34, 74) relates that it was created by Kresilas, who, along with Pheidias and Polykleitos, was one of the famous bronze sculptors of the fifth century B.C. (The original base of the statue may be preserved on the Athenian Akropolis.) Pliny finds the art of Kresilas remarkable, particularly the portrait of the Olympian Perikles, because it makes noble men even more superior: "nobiles viros nobiliores fecit."

The Greeks invented and developed the classic art of depicting an individual in a portrait. The artists of the fifth century B.C. explored the manifold aspects of man's outward appearance in images that became portraits. In the statue of Perikles on the Akropolis, Kresilas created one of the first portraits, through the characterization of individual peculiarities, such as the shape of the skull. The contemporary historian Thucydides has Perikles say of himself: "As concerns the public estimation of the individual, it is not the fact that one belongs to a higher class that places one at an advantage in the community, but solely one's personal ability" (Thucydides II, 37).

G. D.

BIBLIOGRAPHY: G. Lippold, *Die Skulpturen des Vaticanischen Museums*, III, 1, Berlin, 1936, pp. 86–89, no. 525, pl. 15; W. Helbig, *Führer durch die öffentlichen Sammlungen klassischer Altertümer in Rom: Die Päpstlichen Sammlungen im Vatikan und Lateran*, I, 4th ed., Tübingen, 1963, no. 71; G. M. A. Richter, *The Portraits of the Greeks*, I, London, 1965, pp. 102–4, no. 1, ills. 432, 433, 435.

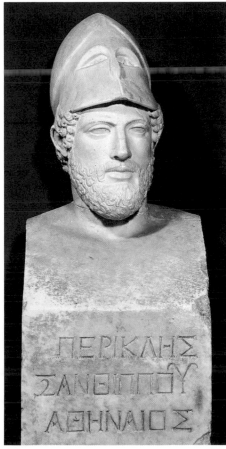

124 (detail)

125–127

STATUES OF ATHENA AND MARSYAS, AND **FRAGMENT OF A HEAD OF ATHENA**

Roman copies (2nd century A.D.), after a Greek bronze group by Myron, c. 440 B.C.

125. ATHENA

Pentelic marble
Height, 58 11/16" (149 cm); width, 20 1/16" (51 cm); depth, 11 13/16" (30 cm)
Collection of the Lancellotti Family

The statue is completely preserved except for the head—which, originally, was worked separately—and the right arm and shoulder. The left arm, in all probability the original, also was worked separately and has been fitted on; at the elbow and in the forearm it has been cleanly cut through. The only other repairs have been to the ends of the drapery folds, which, in part, have fallen off.

The *Athena* belongs to the family of Massimo Lancellotti, who owned the Villa Peretti on the Esquiline where this sculpture once stood.

126. MARSYAS

Pentelic marble
Height: overall, including base, 67 5/16" (171 cm); statue, 61 7/16" (156 cm)
Museo Gregoriano Profano, Inv. no. 9974

The statue is almost completely preserved, except for the two arms (incorrectly restored during the second quarter of the nineteenth century and removed in 1925). Both ears, the left calf, and the front portion of the right foot, together with the part of the plinth just below it, are restored. The neck, the left thigh and foot, and the right calf below the knee and above the ankle are broken, as is the docked tail, which was surely long, originally, for traces of it still can be seen on the left thigh.

The *Marsyas* was excavated in April 1823 by Ignazio Vescovali on the Esquiline, in the Via dei Quattro Cantoni, No. 46–48, and was acquired by the cardinal-camerlengo in 1824, as the inscription on the base relates: "1824.C.C. 312." A further inscription, MVNIFICENTIA • PII • IX • PONT • MAX, alludes to the fact that the statue was placed in the Museo Gregoriano Profano in 1852—specifically, in the Palazzo Lateranense, Sala VII, 379—where it stood until 1963. Since 1970 it has been in the Vatican Museums.

127. FRAGMENT OF A HEAD OF ATHENA

Pentelic marble
Height, 6 3/4" (17.2 cm); width, 4 7/16" (11.3 cm)
Museo Gregoriano Profano, Inv. no. 9970

Most of the face and the cheeks as far as the ears are preserved. The forehead, hair, helmet, and neck have been restored in plaster, following other copies of this head type in Frankfort

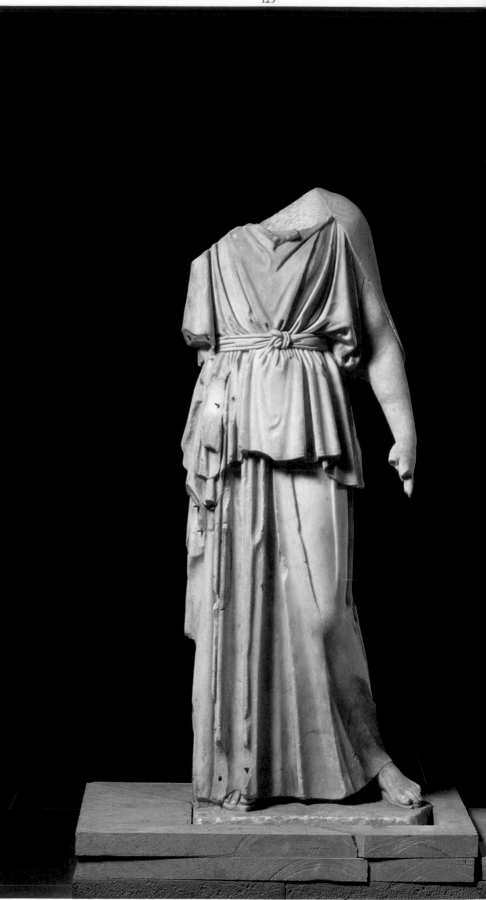

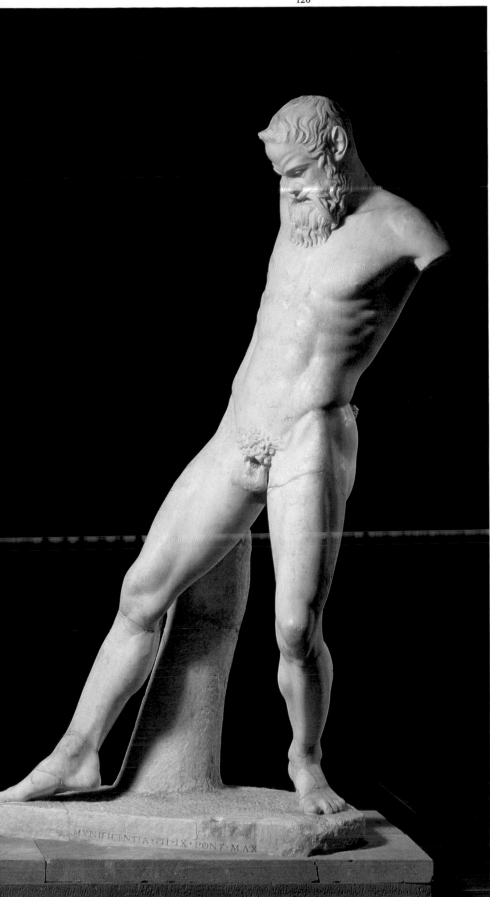

126

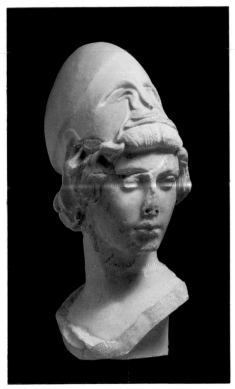

127

and in Dresden. The nose, mouth, and chin are damaged.

The head, whose provenance is unknown, was discovered and identified by Walther Amelung in the sculpture storerooms of the Vatican in 1922. It was exhibited in the Cortile Ottagono in 1935–36; in the Museo Gregoriano Profano, in the Palazzo Lateranense, from 1948 to 1963; and, since 1970, in the Vatican.

THE ATHENA–MARSYAS GROUP

The naked, bearded man obviously belongs to the order of satyrs and sileni by virtue of his shaggy appearance; his horse's tail and his pointed ears have been accurately restored. Athena is clearly recognizable from her helmet; the fact that the head and body belong together is apparent from the Frankfort copy. The pertinence of one statue to the other is established by their respective size and interaction. The attitude of the satyr reveals that he is advancing delicately and inquisitively, but, at the same time, his face and his raised right arm express a sudden hesitation and recoil. Athena represents the opposite pole from this woodland creature. She stands firmly and with dignity on her right foot, her peplos falling to her toes; only the ball of her left foot touches the ground, as if she is about to step away. Her face is turned sharply left, inclined in the direction of her exposed foot. She holds her left arm down at her side, her fingers extended in a gesture of command. Neither figure makes sense alone, but each refers to the other.

The ancient poets recount the goddess's encounter with Marsyas: Athena invented the

aulos (a reed instrument). Marsyas crept up to the goddess while she was playing it, and, when she flung down the instrument and cursed it, he leapt back in fright, but without letting the musical instrument at his feet out of sight. His determination to possess the instrument proved to be his undoing. Once he mastered it, he challenged Apollo to a musical contest, lost, and, in accordance with Athena's curse, was flayed alive.

In style and composition, the sculptures were designed specifically to capture this confrontation between Athena and Marsyas, the group and its details conceived in relation to each other. Though these figures are copies, the strong contrapposto and the rhythmic interplay of the elements of the original composition are clearly perceptible here.

Myron of Eleutherai—along with Pheidias and Polykleitos one of the best-known Athe-nian sculptors of bronze in the fifth century B.C.—created an Athena–Marsyas group that was placed on the Akropolis in Athens; this we can determine by combining the testimony of two writers from antiquity, Pliny and Pausanias. The group is reflected in a contemporary Attic vase painting in which two auloi are shown in mid-air, falling between Athena and Marsyas; this moment was denied to the sculptor in his three-dimensional representation.

These marble copies of Myron's Athena–Marsyas group are of extreme importance, inasmuch as they permit us a glimpse of a lost masterpiece of Greek sculpture that was mentioned in the ancient literature and alluded to in contemporary vase painting. In essence, Marsyas and Athena embody the confrontation between an orgiastic world of intoxication and one of melodic Olympian clarity and purity. The fig-ures are composed in such a way that they do not merely stand next to each other, as in archaic representations; rather, they are linked, not by a common action (as, for example, in the *Tyrannicides* group by Kritios and Nesiotes), but through opposing forces. The meeting between Athena and Marsyas is depicted at the moment when impending fate—the seizing of the wind instrument—perhaps, still could be averted. The open space in the center of the composition is left free for the musical instrument—the reason for the confrontation, yet, at the same time, the key to Marsyas's "tragedy."

G. D.

BIBLIOGRAPHY: H. A. Weis, "The 'Marsyas' of Myron: Old Problems and New Evidence," in *American Journal of Archaeology*, 83, 1979, pp. 214–19; G. Daltrop, *Il gruppo mironiano di Athena e Marsia nei Musei Vaticani*, Vatican City, 1980.

128

AUGUSTUS OF PRIMA PORTA

Rome, about the time of the birth of Christ
Luni marble, with traces of ancient polychromy
Height: overall, including base, 86 ¼" (219 cm);
* statue, 81 ½" (207 cm); head, 11 ⁷⁄₁₆" (29 cm)*
Braccio Nuovo, Inv. no. 2290

Under the direction of the Roman sculptor Pietro Tenerani, this superbly preserved statue, slightly larger than life, was restored only minimally—most noticeably, in the fingers of the right hand and the forefinger of the left hand. The plinth has been set into a modern base. Significant are the traces of paint, which must have been more obvious when the statue was discovered; the use of a reddish circle to indicate the iris of the eye is especially noteworthy. The head was carved separately. The back of the statue is not finished, its reliefs incomplete (the tropaion, or victory monument, and Nike's wings), suggesting that, originally, the *Augustus* was placed in a niche.

On the Via Flaminia, above the village of Prima Porta, some nine miles north of Rome, this armored statue was discovered on April 20, 1863, in the ruins of the Villa "ad Gallinas Albas," which belonged at one time to Livia, the second wife of Augustus. On September 1, 1863, in the eighteenth year of the pontificate of Pius IX, the *Augustus* was installed in the Braccio Nuovo. The first custodian recorded a visit from the pope two days later: "After the Holy Father had studied it carefully, he praised the work of the armor, the head, and especially the drapery."

From the portrait head, the figure can be identified without doubt as Augustus. Characteristic is the way his hair is worn on his forehead, with a part over his left eye and a double lock over his right. He is portrayed as a general, for, on top of the short undergarment, he wears parade armor embellished with reliefs, and around his hips he has draped his paludamentum, or officer's cloak. The fingers of the right hand have been restored in such a way that they suggest the gesture of *ad locutio*, or address, but it is also possible that the right hand once held a lance (*hasta*). A scepter has been placed in the left hand, but a sword is more likely to have been there originally; the battle standard recaptured from the Parthians is also a possibility. The return of this standard, which had been lost in 53 B.C. under Crassus, forms the central scene in the relief on the breastplate. The Parthian is surrendering it to the Roman in military dress. Above this scene is the sky-god Caelus and the quadriga with the sun-god Sol, preceded by Aurora with a torch and the Morning Dew with a jug. Mother Earth reclines below, with a cornucopia, a garland of wheat, and two frolicking children. A god approaches from either side: Apollo, with his lyre, riding a griffin; Diana, with a torch, seated on a stag. On either side of the central scene are long-haired seated figures, personifications of Roman provinces: the conquered one with an empty sheath, the unconquered with a sword. The dolphin with the small Amor that functions as a support evokes the sea-born Venus, who, as Venus Genetrix, was the revered ancestress of the imperial house.

Every aspect of the sculpture is developed not for its own sake, but for its allegorical and symbolic value. The *Doryphoros* of Polykleitos—which the Romans thought of as "effigies Achillea" (Pliny, *Nat. Hist.*, 34, 18)—was the model for the statue type. Though certain details, such as the raised arm, have been changed, the image of the *Doryphoros* is still present, as in the stylized treatment of the hair.

This Augustus is not an original work, but, rather, a reworking of classical models—as was typical of Attic workshops about 20 B.C. (when the banner lost by Crassus was peaceably returned to Augustus). It would appear to have been based on a bronze original that Livia had placed in her villa outside the gates of Rome. Originally, the statue must have honored Augustus for his diplomatic victory in achieving the return of the standard on peaceful terms. This success, worthy of a triumph, made more of an impression than an actual victory in battle would have, in Rome. "Your age, Augustus, permitted the fields to bear rich harvests once more, and returned to our skies the battle standards, wrenched from the proud barbarians" (Horace, *Carmina*, IV, 15, 4–7).

Art has become the purveyor of an idea. The grandeur of the Roman imperium is personified by the emperor. Augustus announces the end of an earlier humiliation with a bloodless victory and the recognition of the preeminence of Rome. He demonstrates his successful politics of peace, the *pax augusta*, which Virgil (*Aeneid*, VI, 851–853) formulated as Rome's destiny:

Remember thou, O Roman, to rule the
 nations with thy sway—
these shall be thine arts—to crown
 peace with law,
to spare the humbled, and to tame in war
 the proud.

And, in fact, with the advent of the Emperor Augustus, a new age began: "And it came to pass in those days, that there went out a decree from Caesar Augustus, that all the world should be taxed." (Luke 2:1)

G. D.

BIBLIOGRAPHY: W. Amelung, *Die Sculpturen des Vaticanischen Museums*, I, Berlin, 1903, pp. 19–28, no. 14, pl. 2; W. Helbig, *Führer durch die öffentlichen Sammlungen klassischer Altertümer in Rom: Die Päpstlichen Sammlungen im Vatikan und Lateran*, I, 4th ed., Tübingen, 1963, no. 411; H. Jucker, "Dokumentation zur Augustusstatue von Primaporta," in *Hefte des Archäologischen Seminars der Universität Bern*, 3 (1977), pp. 16–37 (extensive annotated bibliography); K. Vierneisel and P. Zanker, *Die Bildnisse des Augustus* (exhib. cat.), Munich, 1978, pp. 45–46, 50–51.

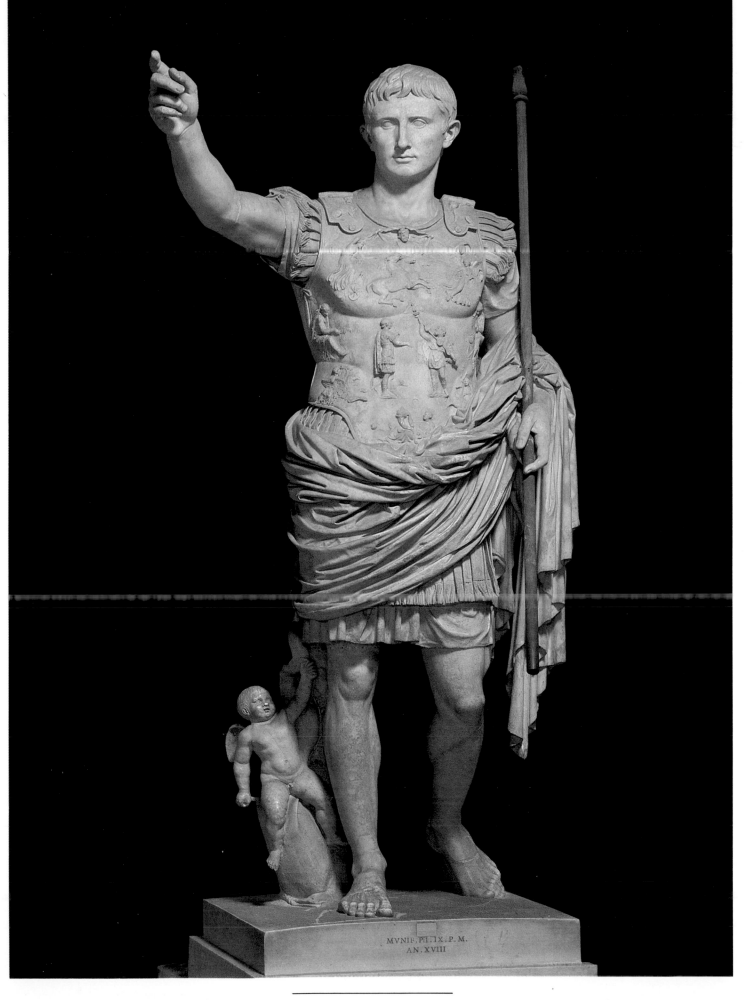

MVNIF·PII·IX·P·M·
AN·XVIII

129

DOUBLE PORTRAIT OF GRATIDIA M. L. CHRITE AND M. GRATIDIUS LIBANUS

Rome, last quarter of the 1st century B.C.
White marble, with traces of polychromy
Height, 23 ¾" (68 cm); width, 35 ⁷⁄₁₆" (90 cm);
* depth, 11" (28 cm)*
Museo Pio-Clementino, Sala dei Busti, Inv. no. 592

The back of the sculpture has been sawed off, and the tops and backs of the heads are roughly cut. The base, and the portions of drapery directly on top of it, are modern restorations. Otherwise, there is only minimal damage—to the drapery folds and to the edges of the ears. The traces of pigment suggest that the work may once have been painted.

On the basis of information in the *Codex Barberinianus* (Vat. Barb. lat. 2016), of about 1580, the double portrait was in the Roman garden of the Florentine Archbishop Cardinal Alessandro de' Medici (in 1605, he became Pope Leo XI), in the vicinity of the Basilica of Con-

stantine and the Temple of Venus and Roma. What is most important is that the only remaining mention of the inscription, with the names of the couple, "Gratidia M. L. Chrite, M. Gratidius Libanus," is given in the *Codex*. The actual inscription is lost; it was removed along with the back of the marble block and the frame around the busts.

The group, which is so effectively three-dimensional, was originally a relief in a niche. (The condition suggests that the reworking is modern.) It served as a funerary relief, of the type usual at the end of the Republic and the beginning of the Empire. In 1770, Clement XIV acquired the sculpture from the Mattei Collection for his museum in the Vatican. (The French inscription on the back dates from the time of the sculpture's deportation to Paris: 1798–1816.)

Because of their stern and righteous appearance, the pair came to be known as Cato and Porcia. The busts are side by side, the wife on the husband's right. Their clasped hands join them in the gesture of *dextrarum iunctio*. The heads are turned toward one another, but they do not relate. The man's left hand grasps the border of his toga, while the wife's left hand rests on her husband's right shoulder. He wears

a tunic and toga; she, an undergarment and mantle. Her hair is parted in the middle and pulled back in flat strands, presumably gathered at the nape, leaving her ears free. His hair, indicated by broad, flat, closely spaced grooves, appears to be cut short. Her face, in its stylized depiction, is smooth, and, therefore, rather timelessly youthful—a characteristic of Augustan classicism—while his is striking in its rigorously rendered detail: it is deeply furrowed, the eyes set beneath the shadow of the protruding brow. These sober, unsentimental characterizations, aiming at realism, are representative of the Late Republican style.

The pair was incorporated into the façade of a tomb as a relief. They appeared to be looking out of their "domus aeterna," as if through a window. From the late first century B.C. on, this type of portrait was favored, above all, by freedmen. The clasped hands of the couple indicate their status; as slaves they would not have been permitted to marry. Gratidius bears a Greek cognomen, "Libanus"; he is doubtless the son of a freedman: *libertino patre natus*. The wife's name, Chrite, also indicates a non-Roman ancestry; she, too, is from the class of freedmen.

Of the more than one hundred known Roman

130

FRIEZE OF THE "ALTAR OF THE VICOMAGISTRI"

Rome, mid-1st century A.D.
Italian marble
Height, 40 ¹⁵⁄₁₆" (104 cm); width, at base, 15' 5 ⅞"
* (472 cm); depth, at base, 8 ¹¹⁄₁₆" (22 cm)*
Museo Gregoriano Profano, Inv. nos. 1156, 1157

Two slabs of different lengths fit together to form this frieze, once part of a monument, presumably a large altar. The upper edge is prepared for

further blocks. At each end of the frieze, the ornamentation continues back along the sides. Thus, it is clear that the original length of this side of the relief, with its sacrificial procession, is preserved. Because the larger slab was broken into six fragments, the surface of its relief is less well preserved than that of the smaller one. Except for scattered damage—above all, to the heads, arms, and legs—the reliefs are in good condition.

The slabs were discovered in Rome—one in 1937, the other in 1939—during work on the foundation of the Palazzo della Cancelleria. They lay more than sixteen feet below the northwest corner of the palace. The smaller slab was leaning, relief side down, against the west wall

of the tomb of the consul Aulus Hirtius, while the other was in a horizontal position, relief side up (hence, its poorer state of preservation). In ancient Rome, this site was part of the Campus Martius, and the Senate authorized a state burial there for Aulus Hirtius, who was killed at the Battle of Mutina in 43 B.C.

The relief depicts a sacrificial procession of thirty-eight men and boys, moving right. A sacrificial bull, calf, and cow occupy the center of the scene. They have been decked out for the sacrifice with knotted woolen fillets on their heads and broad bands (*dorsulae*) around their flanks. A number of sacrificial attendants busy themselves around the animals. In front of them march three trumpeters; lyre and flute players

tomb reliefs of this type, none compares even remotely with the portraits of the Gratidii in quality and representative imposingness. The noble Roman virtues of *fides* and *concordia* are exemplified by this double portrait. It belongs among the series of portraits of married couples that includes, for example, the wedding portrait of Giovanni Arnolfini and Giovanna Cenami by Jan van Eyck (of 1434), and Rubens's *Self-Portrait with Isabella Brant* (of 1609–10), set in a honeysuckle arbor. Between 1838 and 1841, inspired by the monument of the Gratidii, Christian Rauch created the gravestone for the founder of modern historical science, Barthold Georg Niebuhr, and his wife; it is in the cemetery in Bonn, a gift of Friedrich Wilhelm IV

<div align="right">G. D.</div>

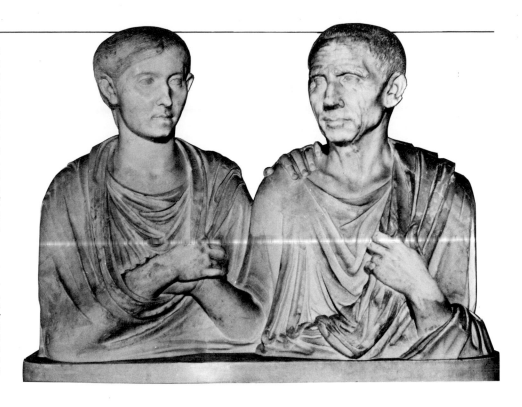

BIBLIOGRAPHY: W. Amelung, *Die Sculpturen des Vaticanischen Museums*, II, Berlin, 1903, pp. 572–74, no. 388, pl. 65; C. Hülsen, "Die Grabgruppe eines römischen Ehepaares im Vatikan," in *Rheinisches Museum für Philologie*, 68, 1913, pp. 16–21; W. Helbig, *Führer durch die öffentlichen Sammlungen klassischer Altertümer in Rom: Die Päpstlichen Sammlungen im Vatikan und Lateran*, I, 4th ed., Tübingen, 1963, no. 199; P. Zanker, "Grabreliefs römischer Freigelassener," in *Jahrbuch des Deutschen Archäologischen Instituts*, 90, 1975, pp. 285–87, ill. 17.

follow. The procession is led by two *togati* in patrician shoes (*calcei patricii*). The three lictors carrying fasces (bundles of rods, with projecting axes) in the background suggest that these two *togati* are, in fact, the two consuls. A group of boys (*ministri*) and a group of men follow the sacrificial animals and the musicians; in the plane behind stand *togati* with laurel wreaths on their heads. The four boys are barefoot, and each has a fringed tunic covering his head. In their left hands three of them carry a figurine on a base: two of these are Lares (dancing figures in short tunics, with raised drinking horns); the third is a statuette of a *togatus*, representing the genius of the ruling emperor, which—since the time of Augustus—was honored along with the Lares.

The four *togati* bringing up the rear, wearing long-tongued boots, and laurel wreaths on their heads, are the vicomagistri.

The peculiarities of the style, the repetitious arrangement of the frieze, the regular alignment of the figures, and the proportion of figures to the whole suggest that the relief dates to the time of Claudius—about A.D. 50. The togas, the detailing of the surviving heads (which are typically Roman) in the foreground of the very high relief, and also the archaizing severity in the representation of ornaments on the profiles all correspond to the style of this period.

The processional frieze belongs within the architectonic context of a large monument—in all probability, a monumental imperial altar such as the Ara Pacis. Among the sacrificial animals in the procession, the bull symbolizes the genius of Augustus. The cult of the Lares, headed by four vicomagistri, was reestablished in Rome by Augustus, and associated with the worship of the protective spirit of the emperor. Soon after, the Lares and this genius had been fused into a single entity, known as the Lares Augusti, that, essentially, served the cult of the emperor. This cult did not worship his person, but, rather, the power of the Roman Empire that he embodied. Participation in the cult was an expressed recognition of a political reality, not a religious confession.

In size and character, the processional frieze of the vicomagistri has its place among the historic reliefs of antiquity: Its exalted forerunner is the Parthenon frieze, and a close relation is the Ara Pacis of Augustus.

From 1946 to 1970, the two reliefs were displayed in the Gabinetto dell'Apoxyomenos; since 1970, they have been in the Museo Gregoriano Profano.

<div align="right">G. D.</div>

BIBLIOGRAPHY: F. Magi, in G. Lippold, *Die Skulpturen des Vaticanischen Museums*, III, 2, Berlin, 1956, pp. 505–12, pls. 229–233; H. Kähler, *Rom und seine Welt*, Munich, 1958, pl. 129; W. Helbig, *Führer durch die öffentlichen Sammlungen klassischer Altertümer in Rom: Die Päpstlichen Sammlungen im Vatikan und Lateran*, I, 4th ed., Tübingen, 1963, no. 258; R. Brilliant, *Roman Art*, London, 1974, p. 242, fig. IV 24.

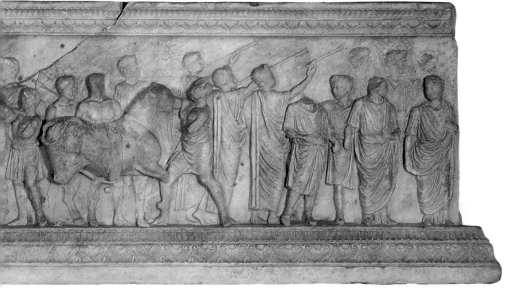

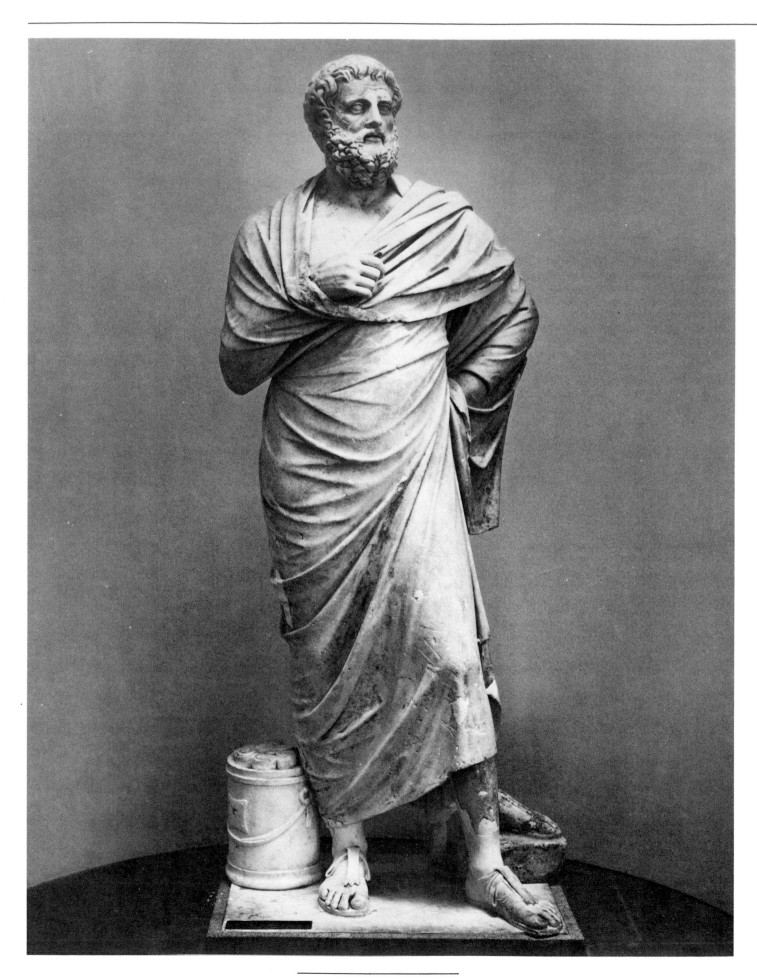

131

STATUE OF SOPHOKLES

*Roman copy (1st century A.D.), after a Greek bronze
of the 4th century B.C.*
Marble
*Height: overall, 80 ⁵⁄₁₆" (204 cm); head, 10" (25.5
cm)*
Museo Gregoriano Profano, Inv. no. 9973

The statue was restored by the Roman sculptor Pietro Tenerani. The feet and base, including the *scrinium* (containing the scrolls), and the right hand were reconstructed in marble; repairs to the face, however, are in plaster.

The statue was found in Terracina "among the ruins of ancient Anxur," probably a few years before 1839, when it was given to Pope Gregory XVI by the Antonelli family; an inscription on the modern base commemorates the gift. The pope used the need for an appropriate setting to display the *Sophokles* as an incentive to found a new museum for classical antiquities in the Palazzo Lateranense.

The identification of this freestanding, self-assured figure, who gazes into the distance—his cloak drawn about his shoulders—is confirmed by the inscribed portrait herm in the Sala delle Muse of the Museo Pio-Clementino (Inv. no. 322). Both copies from Roman imperial times are based on Greek originals in bronze. Two portraits of Sophokles are mentioned in classical literature: one was erected by his son Iophon after Sophokles' death at ninety, in 406 B.C.; the other was placed, with those of Aischylos and Euripides, in the Theater of Dionysos in Athens, for the 110th Olympiad (between 340 and 336 B.C.), at the behest of the statesman and orator Lykourgos.

The fillet in his hair indicates Sophokles' priestly office. He welcomed the god of physicians, Asklepios, into his house when the Asklepios cult first became popular in Athens. After Sophokles' death, the Athenians honored him as "Heros Dexion," calling him "theophiles" ("beloved of the gods") and "eudaimon" ("blessed one").

The impressiveness of the statue derives from its broad, sure stance, open posture, and contrapposto composition: The weight of the body rests on the right leg, while the left foot is advanced. The contrast between the free and engaged legs is clearly apparent through the drapery, articulated by its flowing folds. The oblique stance occasions a powerful torsion in the body; it finds its counterpart in the contrasting position of the arms, which the lines of the cloak oppose and balance. The gestures of the arms are crowned by the slightly raised head, which is turned in the direction of the left foot.

The style of this statue of Sophokles is of the time of the renovation and embellishment of the Theater of Dionysos that was undertaken by Lykourgos, about 330 B.C. There is no doubt that the sculpture is a faithful marble copy of the bronze that was publicly set up some seventy-five years after the poet's death. Sophokles is commemorated in the way that he appeared before his people, the Athenians who saw his tragedies countless times in the grand theater where they were first performed. In antiquity, some 123 dramas by Sophokles were known, only seven of which survive.

Perhaps the greatest significance of the *Sophokles* is that it is one of the few whole statues preserved from the wealth of Greek portraits that originated in the second half of the fifth century B.C. and flourished into the first century B.C., and one of the even smaller number whose subject is certain.

G. D.

BIBLIOGRAPHY: O. Benndorf and R. Schöne, *Die antiken Bildwerke des Lateranischen Museums*, Leipzig, 1867, pp. 153–59, no. 237, pl. 24; W. Helbig, *Führer durch die öffentlichen Sammlungen klassischer Altertümer in Rom: Die Päpstlichen Sammlungen im Vatikan und Lateran*, I, 4th ed., Tübingen, 1963, no. 1066; G. M. A. Richter, *The Portraits of the Greeks*, I, London, 1965, p. 129, no. 2, figs. 675–677, 680; G. Daltrop, "Il Reparto di Antichità Classiche," in *Bollettino dei Monumenti Musei e Gallerie Pontificie*, I, 3 (1959–74), 1979, p. 27, figs. 33–35.

132

PORTRAIT OF MARCUS AURELIUS

Rome, c. A.D. 176
Marble
*Height: overall, 29 ½" (75 cm); head, 12 ³⁄₁₆"
(31 cm)*
Museo Gregoriano Profano, Inv. no. 10223

The portrait head has been placed on a bust to which it does not belong. The right eye and the hair above the left brow have been damaged slightly. Parts of the nose and of the left ear are restored. The face has been cleaned, slightly affecting the surface.

The head was found in the vicinity of San Giovanni in Laterano, during construction of the convent near the Scala Santa. The bust, in the form of a Greek philosopher wearing a himation (which leaves the right shoulder bare), comes from the Vatican storerooms; the head was added to the bust before the sculpture was exhibited in the Museo Gregoriano Profano Lateranense in 1853 (or 1859).

The subject of the head is definitely identifiable as Emperor Marcus Aurelius on the basis of portraits of the emperor on coins and on historical reliefs (such as those, in Rome, on the triumphal arch of A.D. 176 and on the column that bears his name). The style of the head is embodied in the contrast between the mass of the hair, which surrounds the face with rich shadows, and the smooth modeling of the transparent, lustrous surface of the face. The hair is set high above the forehead in tight curls that extend down into the thick, full beard that conceals the mouth. Individual features have been generalized to suggest the inner, spiritual being of this unusual man, who ruled the Roman Empire guided by wisdom and goodness. The eyeballs, which are given prominence under the raised brows, are partly covered by the broad upper lids. Drilled depressions have been used for deliberate effect, as in the pupils—ovoid in form—which make the emperor appear to glance into the distance.

Marcus Aurelius, a Spaniard, became emperor at the age of forty, in A.D. 161, and reigned for nineteen years. He died in Vienna in A.D. 180, defending the Empire against the dangers represented by the Marcomanni. The Senate and the Roman people already had commissioned a triumphal arch to commemorate his victory over the Germans and the Sarmatians; its relief decoration is preserved today in the Palazzo dei Conservatori. In iconographic details and style, the emperor, on these historical reliefs, is so close to the Museo Gregoriano Profano portrait that, undoubtedly, the same model was used for both—one, presumably, made on the occasion of the victory celebrations.

When Marcus Aurelius waged war in the North to save the Roman Empire from the inroads of the Germans, he recorded his thoughts in a diary, so that we have his own account of his opinions and of his spiritual constitution. He no longer expected external reward, and fame had lost its glamour: "The time is near when you will have forgotten everyone, when all will have forgotten you" (VII, 21). This attitude could well justify the nineteenth-century choice of a philosopher's bust on which to place this portrait head. Yet, the contrast between external and internal, between body and soul, for the first time in the history of portraiture is made visible, here, in the *Portrait of Marcus Aurelius*.

G. D.

BIBLIOGRAPHY: O. Benndorf and R. Schöne, *Die antiken Bildwerke des Lateranischen Museums*, Leipzig, 1867, p. 10, no. 15; M. Wegner, *Die Herrscherbildnisse in antoninischer Zeit*, Berlin, 1939, pp. 33–46, 193–94; A. Giuliano, *Catalogo dei Ritratti Romani del Museo Profano Lateranense* (Monumenti Vaticani di Archeologia e d'Arte, X), Vatican City, 1957, 57, no. 63, pl. 39; W. Helbig, *Führer durch die öffentlichen Sammlungen im Vatikan und Lateran*, I, 4th ed., Tübingen, 1963, no. 1095; A. R. Birley, *Marcus Aurelius*, Boston, 1966.

133

PORTRAIT STATUE IN THE FORM OF OMPHALE

Rome, c. A.D. 200
Marble
Height: overall, 71 ¹¹/₁₆" (182 cm); base, 3 ⅛" (8 cm);
face (chin to hairline), 6 ¹¹/₁₆" (17 cm)
Museo Gregoriano Profano, Inv. no. 4385

The statue appears to be completely preserved, although the nose, the left hand with the club, the index finger of the right hand, and the right leg have been restored; the lion skin is restored on the left side of the head; and the feet, with a portion of the plinth, have been set into a modern base. The portrait head and the idealized statue belong together and are unbroken. In this uncommon degree of preservation lies the charm of the sculpture.

The provenance of the statue is unknown. The Gaetani are first mentioned as its owners, then the Ruspoli and the Vitali, all noble Roman families. The *Omphale* was acquired by the Vatican at the beginning of the nineteenth century, and was given a place in the Braccio Nuovo. From 1833 to 1970, it was in storage; since 1970, it has been displayed in the Museo Gregoriano Profano.

The female figure wears only a lion skin, which hangs down her back, its forepaws knotted across her breast, and the upper part of the lion's skull covering her head. She holds a club with her left hand (certainly accurately restored). Both attributes, the lion skin and the club, belong to Herakles. On Zeus' orders, Herakles was forced to serve the Lydian queen Omphale, who had him dress in women's clothing and spin wool while she assumed his lion skin and cudgel.

This type of female figure is reminiscent of the *Aphrodite of Knidos* by Praxiteles, from the 4th century B.C., a work frequently mentioned and highly praised in ancient literature. The head, however, is recognizably a portrait, with its individual hairstyle and features. The coiffure, drilled eyes, and modeling of the cheeks suggest that the *Omphale* dates to sometime near the close of the second century A.D.—stylistically, not much later than the *Bust of Commodus*, in the Palazzo dei Conservatori, which also bears the attributes of Herakles.

In all probability, this sculpture served as a funerary statue in a mausoleum. The deceased woman wished to be remembered as having been as beautiful as Venus and as strong as Herakles, and had herself portrayed thus in her apotheosis, in her life after death. At the same time, however, the allusion to the love of Herakles for Omphale in the portrait implies an exchange of roles between man and wife. By fusing portrait and symbol, the sculptor transformed the immediacy of the individual into a suprapersonal realm. Likeness and allegory intermesh, creating a fertile field for future Western art. The statue reflects, as well, the conflict in Roman art between the adoption of Classic models and the desire for the heightened significance of realistic portraiture. The Roman sculptor utilized the form of the Greeks, but, at the same time, he gave the *Omphale* a more specific identity, an added dimension that he required.

G. D.

BIBLIOGRAPHY: G. von Kaschnitz-Weinberg, *Le Sculture del Magazzino del Museo Vaticano*, Vatican City, 1936–37, pp. 295–96, no. 727, pl. 113; G. Becatti, *Arte e gusto negli scrittori latini*, Florence, 1951, p. 491, pls. 64, 125; J. Meischner, "Das Frauenporträt der Severerzeit," dissertation, Berlin, 1964, p. 134, no. 26; R. Schlüter, *Die Bildnisse der Kaiserin Iulia Domna*, dissertation, Münster, 1971 (printed 1977), p. 157; on this type of representation, in general: H. Wrede, *Consecratio in formam deorum. Vergöttlichte Privatpersonen in der römischen Kaiserzeit*, Mainz, 1981.

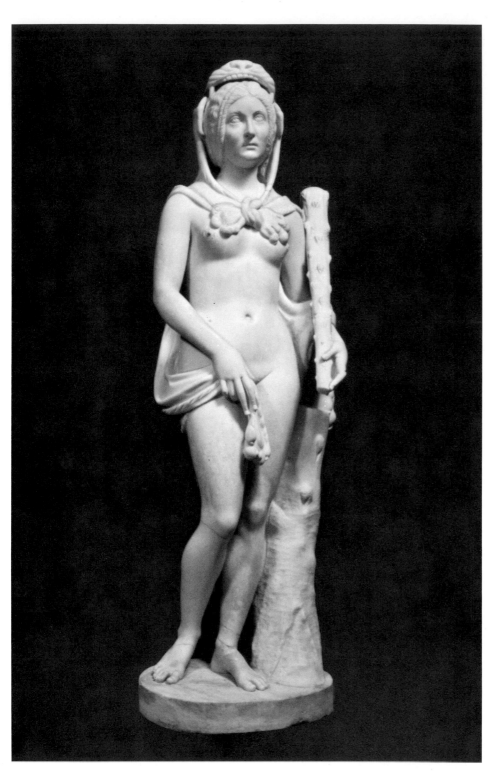

MUSEO PIO CRISTIANO

The Palazzo Lateranense—the pope's residence as Bishop of Rome—was converted into museums by Gregory XVI (1831–46): In 1844, he founded the Museo Gregoriano Profano, and directed that it be installed in the palazzo. His successor, Pius IX (1846–78), chose the same location for the installation of the Church's collection of Early Christian sculpture. Pius's contribution to this museum's establishment has been recognized both in the museum's title and by the fact that his portrait formerly stood at the entrance to the collection. Although the Museo Pio Cristiano in the Palazzo Lateranense was closed in 1963, after Pope John XXIII (1958–63) decided to locate the offices of the Holy See of Rome in the palazzo, the bust of Pius IX was installed in the foyer of the museum when it reopened in 1970 in its new building by the Passarelli brothers at the Vatican. Pius IX's portrait bust was made of cast iron, an indication of his great faith in the modern technology of the mid-nineteenth century.

Pius IX's foresight in recognizing the usefulness of new materials also extended to his fostering of the arts and of literature, and to an intense desire to further scientific archaeological investigations of pagan and Christian antiquities in Rome. The latter particularly enjoyed the pontiff's interest and enthusiasm. In 1852, he established the Commissione di Archaeologia Sacra with sufficient funds to initiate new investigations of many Christian sites. The opening of the Catacomb of Callixtus for intensive research was especially important. So pleased was the pope with the results that he celebrated Mass there on November 22, 1861.

Pius IX's profound concern for the preservation of the remains of the Early Christian Church in Rome contrasted sharply with the attitude of one of his Renaissance predecessors. Paul III (1534–49), for example, had the gold objects from the tomb of Maria—wife of the Roman Emperor of the West, Honorius (395–423)—in Old Saint Peter's melted down to help finance the construction of the new basilica. Not long afterward (in 1578), however, the discovery of the cemetery of Santa Priscilla in the Via Salaria Nuova aroused great curiosity. Pope Gregory XIII (1572–85) recognized its importance, and, according to contemporary reports, the visitors to the site were deeply moved by thoughts of the persecutions suffered by early members of the Church who were buried there, and they were renewed in their faith.

The rediscovery of this catacomb and its effect on Christians of the sixteenth century are signs not only of a reawakened interest in the history and archaeology of the early Church, but also of a new religious outlook whose foremost advocate was Saint Philip Neri (1515–1595), "the apostle of Rome." This view was expressed in such images as Tommaso Laureti's *The Triumph of Religion*, on the ceiling of the Sala di Costantino in the Stanze of Raphael, in the Papal Palace (fig. 42). The painting depicts an antique statue of the god Mercury lying broken on the ground, at the base of the triumphant cross of Christ. Even the famous sculpture of the *Laocoön*, in the papal collections, was reinterpreted by the artist El Greco in Christian terms.

Antique works of art that survived in Rome were also Christianized in the aftermath of the Council of Trent (1545–63). The famous columns of the Roman Emperors Trajan and Marcus Aurelius were consecrated to Saint Peter and Saint Paul, and statues of the saints were placed upon the columns during the pontificate of Sixtus V (1585–90). Newly discovered Christian art also was carefully preserved. It was during this period that the three reliefs of the "Traditio Legis"—illustrating events from the Gospels—which open this catalogue (see no. 1), were discovered and assembled as a single sarcophagus. In his discussion of four coins left to Pope Clement VIII (1592–1605) in 1600, the writer Fulvius Orsini viewed them as testimony to important events in Church history rather than as significant examples of Late Roman numismatics. In the Vatican, Christian monuments thus were

FIG. 42. TOMMASO LAURETI.
THE TRIUMPH OF RELIGION.
FRESCO. 1585.
SALA DI COSTANTINO

endowed with a documentary, apologetic value.

The first efforts to establish a museum of Early Christian art at the Vatican began under Clement XI (1700–1721), but it was not until the Museo Sacro was founded by Benedict XIV (1740–58) in 1756, as part of the Biblioteca Apostolica Vaticana, that they came to fruition. The statue of *"The Good Shepherd"* (cat. no. 134) was deposited there the next year, as well as other sculptures; because of the new museum's restricted size, it became primarily a collection of smaller Christian antiquities. The larger sculptures remained in the Museo Sacro for nearly one hundred years before they were transferred to the new Museo Pio Cristiano at the Palazzo Lateranense, which was officially opened by Pius IX on November 8, 1854.

The statue of *"The Good Shepherd"* joined numerous other sculptures of the third through the fifth century A.D. that make up one section of the collection: primarily sarcophagi. A very large group of inscription plaques makes up the other section. The sarcophagi came from Early Christian churches and catacombs, the most impressive from the excavations below Saint Peter's and San Paolo fuori le Mura; in both places, noblemen and noblewomen of the fourth century sought to be buried next to the graves of the princes of the apostles. The sculpture was arranged according to subject rather than chronology at the Palazzo Lateranense, and this system has been retained in the 1970 installation in the Passarelli building at the Vatican. The only nineteenth-century addition to the type of display occurred during the pontificate of Pius XI, when plaster casts of important sculpture from other collections were included, in order to present the visitor with a sort of résumé of Early Christian imagery.

The thousands of plaques with inscriptions dating from the fifth to the sixth century in the Museo Pio Cristiano were arranged by the noted scholar and curator Giovanni Battista De Rossi in two categories: "inscriptiones sacrae" and "epitaphia selecta." The former includes inscriptions related to churches, foundations, and martyria, and a separate group of epigrams of Pope Damasus I (366–84) in honor of the martyrs, which represents the classical phase of Early Christian art. The "epitaphia selecta" are made up of three types of gravestones: those that are dated in their inscriptions, those that are decorated with signs and symbols, and those for which only the provenance is known.

These Early Christian antiquities are manifestations of true faith. The stones proclaim the Gospels. De Rossi's enthusiasm for their role as witnesses to the Christian faith through the ages is evidenced by the inaugural speech that he gave at the opening of the Museo Pio Cristiano, in its Palazzo Lateranense installation, in 1854: at the conclusion he quoted Dante, "alle cose mortali andò di sopra" (*Divine Comedy*, "Paradise," XXXI, 36).

Georg Daltrop

BIBLIOGRAPHY: G. B. De Rossi, "Il Museo epigrafico cristiano Pio-Lateranense," in *Triplice Omaggio alla Santità di Papa Pio IX nel suo giubileo episcopale offerto dalle tre Romane accademie*, Rome, 1877, pp. 77–129, pls. I–XXIV; J. Ficker, *Die altchristlichen Bildwerke im christlichen Museum des Laterans*, Leipzig, 1890; O. Marucchi, *Guida del Museo Cristiano Pio Lateranense*, Rome, 1898; idem, *I monumenti del Museo Cristiano Pio Lateranense*, Milan, 1910; idem, *Guida del Museo Lateranense Profano e Cristiano* (Musei e Gallerie Pontificie, IV), Rome, 1922, pp. 109–207; E. Josi, "Museo Pio Cristiano già Museo Lateranense Cristiano," in *Enciclopedia dell'arte antica classica e orientale*, VII, 1966, p. 1101.

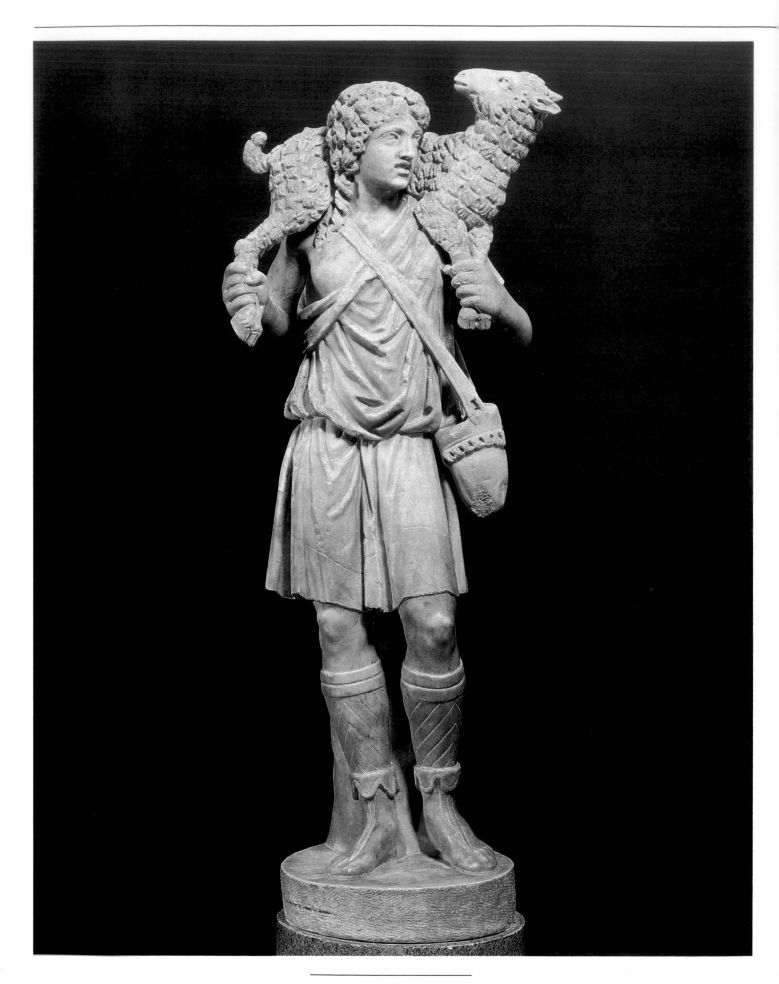

134

"THE GOOD SHEPHERD"

Rome, late 3rd century A.D.
Marble
*Height: as restored, 39 ⅜" (100 cm), as preserved,
21 ⅝" (55 cm); head, 6 ³/₁₆" (15.5 cm)*
Museo Pio Cristiano, Inv. no. 28590 (ex 103)

This statuette appears to be complete, but large parts of it are restorations. These include the entire lower portion up to the middle of the thighs (together with the tree trunk that serves as a support), both arms and the right hand, as well as the back legs of the sheep. Repairs to the face include the nose, the right brow with a portion of the forehead, the upper and lower lips, and the chin. Restored portions of the sheep include the back of the head with the ears and neck, a small part of the tail, and the portion of the sheep along the neck of the shepherd, at the back of the statuette. With the exception of the restoration work on the reverse side, the antique portion of the statuette seems to have been so completely reworked that there is nothing to disprove the assumption that this sculptural fragment originally was part of a column, or even of a relief. The upper surface of the hair is very heavily damaged.

The provenance of the statuette is unknown. J. Ficker (1890, p. 37) incorrectly maintains that it was acquired from Agostino Mariotti in Rome at the beginning of the nineteenth century, for he refers to G. B. De Rossi (*Bullettino di archeologia cristiana*, 5 [1887], pp. 136–42, and *Bullettino della commissione archeologica comunale di Roma*, 1889, pp. 131–39), who provides such a provenance, although it is quite clearly only for the second statuette of *The Good Shepherd* (with staff added) in the same museum (J. Ficker, 1890, no. 105). Both sculptures were first mentioned by E. Platner, C. Bunsen, E. Gerhard, and W. Röstell (*Beschreibung der Stadt Rom*, II, 2, Stuttgart, 1834, p. 330). They were placed at the entrance to the Museo Sacro, in the Biblioteca Apostolica Vaticana, beside the statue of *Aelius Aristides*. A list from 1757 of restorations executed by Bartolomeo Cavaceppi mentions *The Good Shepherd* as being in the library. In 1854, the statuette was moved to the Museo Pio Cristiano in the Palazzo Lateranense and, since 1963, it has been in the Vatican Museums.

The shepherd is recognizable as such by his dress. He wears the *exomis*, a short, belted garment that leaves his right shoulder bare. On his left side hangs a sheepskin bag that is attached to a long band that extends over his right shoulder. He carries a sheep across his shoulders, holding its feet in both his hands. He has a boyish appearance, with no trace of a beard on his face. Thick locks of hair cover his head and fall over his ears, a few corkscrew curls cascading over his shoulders.

The stylistic singularity of the sculpture lies in the strong contrast between the boy's smooth face and his deeply modeled hair, although one must bear in mind the statuette's poor state of preservation, in regard to both the considerable restorations to the face and the abrasions to the hair. There, the original, deep furrows still are visible, having been drilled out into channels; these serve to define the formal manner of the work. Shallower indentations were made with the drill, most obviously, in the representation of the pupils. This style—with its unmistakable tendency toward the ornamental—began and developed in the time of the Emperor Gallienus (253–68), shortly after the middle of the third century A.D. Because of the deeply belted garment that the figure wears, the impression of mass is prevented from coming into play. The statue is presented as if it were on a single plane. Despite the efforts of the modern restorer to make the sculpture appear freestanding by means of a composition suggestive of contrapposto, its effect remains that of a portion of a relief.

The significance of the shepherd cannot be deduced from the sculpture itself, inasmuch as nothing is known of its origins or of the surroundings in which it originally was displayed—its architectural and iconographic contexts. Nonetheless, repeated attempts have been made to relate it to the familiar parables of the "Good Shepherd" in the Scriptures (Matthew 18:12–14; Luke 15:3–7; John 10:11–16), to Paul's Epistle to the Hebrews (13:20), and to the First Epistle of Peter (2:25; 5:4). Clement of Alexandria commented on the symbolic aspect of the figure of the shepherd as early as A.D. 200 (*Protrepticus* 11:116,1), claiming that God had always desired to save (σώζειν) the human flock: "Therefore, the good Lord sent also the good shepherd." From the point of view of the Church Fathers,

the shepherd can be construed in a sepulchral context as the bearer of redemption and of salvation (σωτηρία); one frequently sees his image on sarcophagi of the second half of the third century. Accordingly, the shepherd is not to be understood as a representation of Christ, but as the paradigm of the parable suggestive of deliverance. Eusebius (*Vita Constantini*, 3, 49) gives a concrete reference to an allegorical interpretation of the subject. When cataloguing the buildings erected by Constantine in the new capital, he includes a descripton of a fountain in the agora with a statue of the lovely shepherd that is familiar to anyone who is well versed in the Scriptures (τὰ τοῦ καλοῦ παμένος σύμβολα).

Representations of shepherds in the form of Kriophoroi are known from classical antiquity, from as early as the beginning of the great age of Greek sculpture in the seventh century B.C. These were votive gifts, representations of the worshiper offering his sacrificial animal to the deity. Figures of shepherds formed part of the repertory of bucolic themes in Classic–Hellenistic times. Rome was to provide a mythological background for the shepherd, for it was a shepherd, Faustulus, who discovered Romulus and Remus. Under Augustus, bucolic motifs came to symbolize the peace that he had attained, so that the figure of the shepherd assumed an allegorical significance. The portrayal of the Emperor Philip the Arab on the coin commemorating the millennial celebration in A.D. 248 of the founding of Rome has just such a metaphorical meaning. There, a shepherd with seven sheep is pictured as their savior. Toward the close of the third century A.D., when the Museo Pio Cristiano youth carrying a sheep was created, non-Christians interpreted the shepherd as a symbol of the *vita felix*, while those familiar with the Scriptures would have recognized in the sculpture an allusion to the "Good Shepherd." The creation of images of shepherds was a tradition that ended—at the latest—in the sixth century A.D. G. D.

BIBLIOGRAPHY: J. Ficker, *Die altchristlichen Bildwerke im christlichen Museum des Laterans*, Leipzig, 1890, pp. 37–39, no. 103; J. Wilpert, *I sarcofagi cristiani antichi*, I, Rome, 1929, pl. 52, 1; E. Josi and L. von Matt, *Früchristliches Rom*, Zurich, 1961, pl. 2; N. Himmelmann, *Über Hirten-Genre in der antiken Kunst*, Opladen, 1980, pp. 158–59; G. Morelli, in *Bollettino dei Monumenti Musei e Gallerie Pontificie* II, 1981, p. 74 n. 70, p. 85, no. XXXV (restoration by Cavaceppi).

135

SARCOPHAGUS, WITH RELIEFS OF THE TYPE OF THE PASSION SARCOPHAGI

Rome, c. A.D. 360
Marble
Height, 26 ⅜" (67 cm); width, 81 ½" (207 cm);
 depth, 30 ⁵⁄₁₆" (77 cm)
Museo Pio Cristiano, Inv. no. 28591 (ex 164)

The sarcophagus, with reliefs only on the front side, lacks its lid. The reliefs are well preserved, with the exception of the heads of the doves on the cross. A smooth cut runs vertically through the right-hand niche (through the figure of Job's wife). The sarcophagus came from the hypogaeum of the Confessio of San Paolo fuori le Mura. It has been in the Museo Pio Cristiano since 1854.

The relief frieze is divided into five sections by six olive trees. The branches of these trees, which intertwine along the top to form arches, are filled with birds and their nests. In the center is the monogram of Christ within a laurel wreath ornamented with gems and ribbons. Below it is a cross, on the arms of which are two doves with outspread wings that pick at the wreath (one of the dove's heads has been correctly restored, the other one is missing). Two soldiers are crouched below the cross: one of them leans against his shield, asleep; the other looks upward at the monogram. In the section immediately to the left is Peter, being led away by two soldiers; on the right side is Paul, whose hands have been tied behind his back. A bailiff is drawing his sword. Reedy plants in the background suggest that the scene is located in the lowlands along the Tiber. On the far left, Abel and Cain present gifts to God the Father; on the far right is the seated, youthful Job, with his wife and a friend standing in front of him. Job's wife places her left hand on her chin in a gesture of mourning.

The three-dimensional figures and the framework of trees surrounding them clearly are set apart from the background, which is at some depth behind them. This is especially apparent with regard to the cross and the monogram of Christ, which appear to be freestanding. Thus, these symbols not only occupy the center of the frieze, but they also are further stressed by the manner of their execution. On either side are groups of figures in aedicula-like niches—like actors on stage before the footlights—each niche depicting a biblical event. The three-dimensionality of the figures is underscored particularly by the execution of details: The irises and pupils of the eyes are carefully rendered. A stylistic proximity to the sarcophagus of Junius Bassus—a work from about A.D. 359—is unmistakable, even though the level of quality of that work is not attained here.

The meaning of this sarcophagus relief derives from the symbol of the cross as *crux invicta*, which occupies the center of the composition, framed by Peter and Paul. The two apostles experience their martyrdoms, but the cross with the laurel wreath, the symbol of victory over death, is before them. The three-part grouping of the monogram of Christ, Peter, and Paul is, in turn, framed by two Old Testament scenes, each of which is significant in terms of salvation. The youthful Abel, who offers a sacrificial lamb, will die at the hand of his brother—an allusion to the sacrificial death of Christ. Job, in his suffering, suggests unshakable faith in God's promise.

The cross with a laurel wreath as a symbol of triumph was new in the representative art of this time. It is a sign of victory, a tropaion, originally erected in classical antiquity on the spot where the enemy was forced to turn and flee; the captives at the foot of this tropaion are Roman soldiers. Thus, it is not the suffering Jesus who is evoked, but, rather, the savior who has triumphed over death. With just such images, the Christians of the fourth century A.D. created their own pictorial vocabulary.

G. D.

BIBLIOGRAPHY: J. Ficker, *Die altchristlichen Bildwerke im christlichen Museum des Laterans*, Leipzig, 1890, pp. 109–10, no. 164; J. Wilpert, *I sarcofagi cristiani antichi*, I, Rome, 1929, pp. 125, 164, pls. 142–143; F. W. Deichmann, G. Bovini, and H. Brandenburg, *Repertorium der christlichantiken Sarkophage, I, Rom und Ostia*, Wiesbaden, 1967, pp. 57–58, no. 61, pl. 19; H. Brandenburg, in *Römische Mitteilungen*, 86, 1979, p. 465, pls. 150–151.

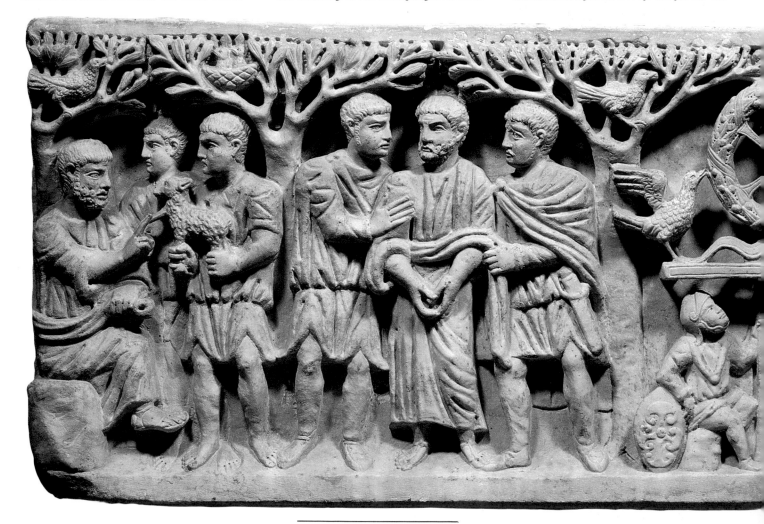

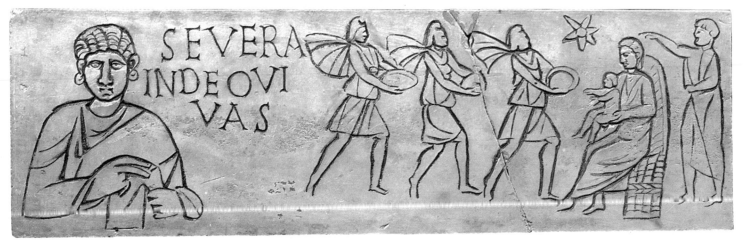

136

GRAVESTONE OF SEVERA

Rome, c. A.D. 330
Marble
Height, 12 ⁹⁄₁₆" (32 cm); width, 40⅛" (102 cm);
* depth, ¹⁵⁄₁₆" (2.4 cm)*
Museo Pio Cristiano, Inv. no. 28594

This rectangular marble slab, the present shape of which is modern, comes from the Catacomb of Priscilla. It is broken between the first and second Wise Men. The slab has been cleaned, and the red pigment of the incisions has been restored.

A portrait bust of Severa is depicted on the left. Next to it is the inscription SEVERA/IN DEO VI/VAS (Severa, may you live in God). The Adoration of the Magi is represented at the right. According to Matthew (2:1–12), three Wise Men in the East became aware of the birth of a king in Judea and were directed to Bethlehem by Herod's scribes. There, with the help of the star, they came upon the Christ Child and his mother. Mary sits in a wicker chair with a high back, holding the Child on her lap. The three Wise Men, with their Phrygian caps, are striding forward to present their gifts to him. The prophet Balaam (Bileam) stands behind the Mother of God, pointing with his outstretched hand to the star: "Orietur stella ex Jacob" ("There shall come a Star out of Jacob," Numbers 24:17).

G. D.

BIBLIOGRAPHY: O. Marucchi, *I monumenti del Museo Cristiano Pio Lateranense*, Milan, 1910, p. 57, pl. LVII, 1; J. Wilpert, *I sarcofagi cristiani antichi*, III, Rome, 1938, pp. 48–49, ill. 271; E. Kirschbaum, "Der Prophet Balaam und die Anbetung der Weisen," in *Römische Quartalschrift*, 49, 1954, p. 129; E. Dinkler, in *Age of Spirituality*, New York, 1979, p. 400, ill. 57.

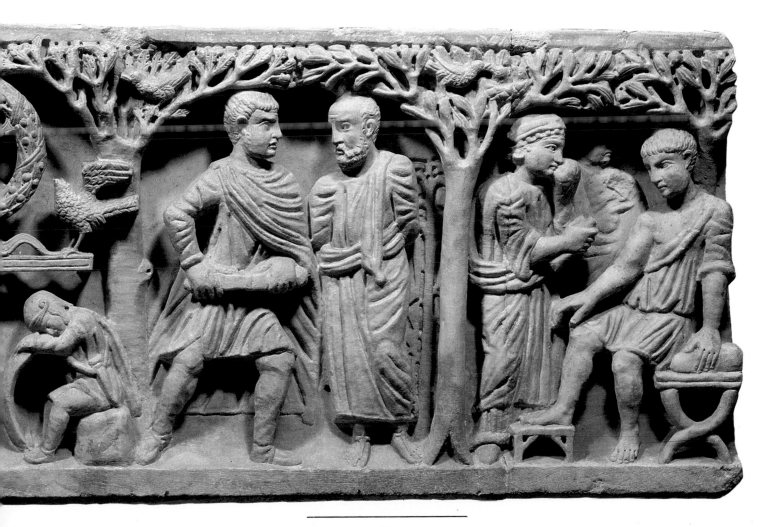

137

GRAVESTONE FOR MOUSĒS AND HIS WIFE

Rome, 3rd or 4th century A.D.
Marble
Height, 35 1/16" (89 cm); width, 46 7/16" (118 cm);
depth, 2 15/16" (7.5 cm)
Museo Pio Cristiano, Inv. no. 28595

A portion of the left side of this gravestone—which came from the Catacomb of Callixtus—as well as its lower-right corner have broken off from what was, originally, an elongated rectangular slab. The inscription relates that Mousēs had this memorial erected for himself and his wife while he was still alive. On one side, an orant figure of a woman, who has pulled her cloak up over her head and raised her arms in the gesture of prayer, is depicted. The other side shows a tree and, next to it, a sheep and a shepherd leaning on his staff. Representations of the shepherd and of orant figures were popular in this period, but now it is impossible to say just what they might have signified in combination. One thinks of the praying woman as representing piety (*pietas*) and the shepherd humanity (*humanitas*).

<div align="right">G. D.</div>

BIBLIOGRAPHY: O. Marucchi, *I monumenti del Museo Cristiano Pio Lateranense*, Milan, 1910, p. 57, pl. LVII, 5; A. Ferrua, *Inscriptiones christianae urbis Romae*, IV, Rome, 1964, no. 10659.

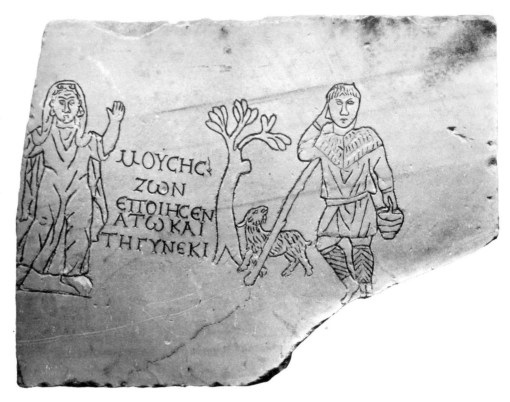

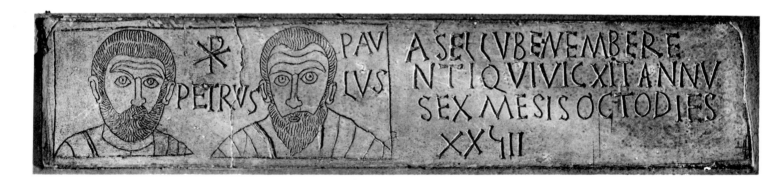

138

GRAVESTONE FOR THE BOY ASELLUS

Rome, late 4th century A.D.
Marble
Height, 7 1/4" (18.5 cm); width, 34 1/16" (86.5 cm);
depth, 1 1/4" (3.2 cm)
Museo Pio Cristiano, Inv. no. 28596

This gravestone, which came from the Catacomb of Saint Hippolytus, is an elongated rectangular slab, whose present shape is modern; it has a vertical crack between the heads of Saints Peter and Paul. It is inscribed ASSELV BENEMBERE/NTI QVI VICXIT ANNV/SEX MESISOCTO DIES/XXIII (For the well-deserving Asellus, who lived six years, eight months, and twenty-three days). Next to the inscription are the heads of Saints Peter and Paul, labeled as such and depicted full face. Undoubtedly, the apostles were included in the hope that they would intercede for and accompany the soul of the deceased into paradise. The monogram of Christ appears between the two heads.

<div align="right">G. D.</div>

BIBLIOGRAPHY: O. Marucchi, *I monumenti del Museo Cristiano Pio Lateranense*, Milan, 1910, p. 57, pl. LVII, 42; A. Silvagni, *Inscriptiones christianae urbis Romae*, I, Rome, 1922, no. 1513.

139

GRAVESTONE FOR THE TWENTY-YEAR-OLD DATUS

Rome, 3rd or 4th century A.D.
Marble
*Height, 11 ¹³/₁₆" (30 cm); width, 34 ¼" (87 cm); depth,
⅞" (2.3 cm)*
Museo Pio Cristiano, Inv. no. 28597

Although the tomb and mummy of Lazarus are damaged, the figure of Christ is in better condition. The provenance of this gravestone—a rectangular marble slab, whose present shape is modern—is unknown, but it was formerly in the Biblioteca Apostolica Vaticana.

The inscription says that the parents of Datus have erected this monument to their son, who lived only twenty years, so that he might rest in peace. Next to the inscription, the Raising of Lazarus is depicted. Christ points with his staff toward a tomb, in the aedicula of which is the body of Lazarus—greatly reduced in size and represented as a mummy. The scene signifies that the young Datus, like Lazarus, can look forward to being reawakened by Christ.

G. D.

BIBLIOGRAPHY: O. Marucchi, *I monumenti del Museo Cristiano Pio Lateranense*, Milan, 1910, p. 26, pl. XXXV, 5; A. Silvagni, *Inscriptiones christianae urbis Romae*, I, Rome, 1922, no. 1587.

140

GRAVESTONE DEPICTING JONAH

Rome, c. A.D. 300
Marble
*Height, 16 ¹⁵/₁₆" (43 cm); width, 35 ⁷/₁₆"
(90 cm); depth, ¹¹/₁₆" (1.8 cm)*
Museo Pio Cristiano, Inv. no. 28592 (ex 221)

This gravestone, from the Catacomb of Praetextatus, is a rectangular marble slab that has been broken into six pieces; its surface is badly damaged and partially pitted. The scene is incised and the lines filled in with red pigment that is now faded.

Typologically, the subject belongs to salvation imagery. The style is simple and unsophisticated. Jonah has been cast up onto land by the sea serpent (κῆτος). Above the monster is a bird (perhaps, a dove). The story prefigures the Resurrection, as the Evangelist Matthew suggests (12:39–41): the Son of Man will repeat the trial of Jonah, which God will bring about as a verification of Jesus. Just as Jonah was saved, so will the deceased be. In this context, the dove also may symbolize salvation.

G. D.

BIBLIOGRAPHY: J. Ficker, *Die altchristlichen Bildwerke im christlichen Museum des Laterans*, Leipzig, 1890, p.165, no. 221; O. Marucchi, *I monumenti del Museo Cristiano Pio Lateranense*, Milan, 1910, p. 27, pl. XXXIX, 6.

141

GRAVESTONE OF CASSIA FARETRIA

Rome, 3rd or 4th century A.D.
Plaster cast of an original marble in situ in the
Catacomb of Callixtus
Height, 14 ⅝" (37.2 cm); width, 42 ½" (108 cm);
depth, 1 ¹⁵⁄₁₆" (5 cm)
Museo Pio Cristiano, Inv. no. 28593

The original of this rectangular Loculus slab is in the Catacomb of Callixtus, not far from the grave of Saint Eusebius (309). Its inscription reads: AFLIVS SATVRNINVS / CASSIE EARETRIAE CLARISSIME / EEMINE CONIVGE BENEME / RENTI DEPOSTIO TERTV NO / NAS E EBRARIAS (Aelius Saturninus graciously erected this memorial for his wife Cassia Faretria, a woman of the senatorial class. She was buried here on February 3 [three days before the Nones of February]). Below the inscription a dove is eating the fruit of a tree. In the writings of Ambrosius (*De Isaac*

et anima, IV, 34), the dove symbolizes the human soul. In such a context, the tree represents paradise and the dove a Christian soul entering paradise and finding nourishment there.

G. D.

BIBLIOGRAPHY: O. Marucchi, *I monumenti del Museo Cristiano Pio Lateranense*, Milan, 1910, p. 55, pl. LV, 5; E. Josi, *Il cimitero di Callisto*, Rome, 1933, pp. 103–4; A. Ferrua, *Inscriptiones christianae urbis Romae*, IV, Rome, 1964, no. 10879.

142

GRAVESTONE OF JUDAS

Rome, c. 2nd to 3rd century A.D.
White marble
Height, 9 ¹⁄₁₆" (23 cm); width, 29 ½" (75 cm);
depth, 1 ⅜" (3.5 cm)
Museo Pio Cristiano, Lapidario Ebraico ex
Lateranense, Inv. no. 17584 (ex 118)

This gravestone came from the Jewish Cata-comb on the Via Portuense, on the edge of the present-day Trastevere quarter of Rome, outside the Porta Portese. The text, in Greek, is enclosed by decorative elements still current in Jewish funerary symbolism: the seven-branched candelabrum, palmette, dove, and flask. The top and bottom of the inscription are surrounded by a continuous, incised line that functions rather like a frame in the shape of a *tabula ansata*. The simple inscription reads: ΙΟΥΔΑΣ ΜΗΝΩΝ Z ΕΝΘΑΔΕ ΚΕΙΤΕ (Judas, of seven months, lies here). Thus, the gravestone is that of a seven-month-old boy whose name was quite common among the Jewish commu-

nities of the Roman Empire. The number of months of the boy's life is indicated by an alphabetical numbering system: Z is the seventh letter in the Greek alphabet. Among the symbols, the dove and the palmette also occur frequently in Early Christian iconography. The use of Greek on Jewish gravestones is usual, although inscriptions in Hebrew are not rare either.

I. Di S. M.

BIBLIOGRAPHY: J. B. Frey, *Corpus Inscriptionum Iudaicarum*, I, Vatican City, 1936, p. 272, n. 348.

143

GRAVESTONE OF FIRMIA VICTORA

Rome, 3rd century A.D.
Marble
Height, 12" (30.5 cm); width, 32 ¼" (83.3 cm);
depth, 1 ¼" (3.2 cm)
Museo Pio Cristiano, Inv. no. 28598

This rectangular marble slab, its edges slightly damaged, came from the Coemeterium Jordanorum. The pigmentation that fills the incised lines has been restored.

The epitaph reads: FIRMIA • VICTORA • QVE VIXIT ANNIS/LXV (Firmia Victora, who lived sixty-five years). Below the inscription are a ship on the high seas and a four-story tower; on top of the tower a fire blazes. In his *De mortalitate* (26), Cyprianus of Carthage (beheaded in A.D. 258) describes the death of a Christian as "navigare in patriam." The lighthouse suggests the harbor, and the ship symbolizes the journey of the deceased woman into the port of eternity, her "fatherland."

G. D.

BIBLIOGRAPHY: O. Marucchi, *I monumenti del Museo Cristiano Pio Lateranense*, Milan, 1910, p. 58, pl. LVIII, 63; G. Stuhlfauth, "Der Leuchtturm von Ostia," in *Römische Mitteilungen*, 53, 1938, p. 152, ill. 6.

144

GRAVESTONE DEPICTING A BLACKSMITH AT WORK

Rome, 3rd or 4th century A.D.
Marble
Height, 11 ¹³⁄₁₆" (30 cm); width, 26 ¾" (68 cm);
depth, 1 ³⁄₁₆" (3 cm)
Museo Pio Cristiano, Inv. no. 28599

This rectangular marble slab, with its smoothed corners, came from the Catacomb of Domitilla. A blacksmith's shop is suggested by the furnace, behind which a man operates a bellows, and by the anvil, on which the master smith hammers the iron made malleable in the fire—thereby refining, hardening, and giving the metal the desired form. Presumably, this scene refers to the vocation of the deceased, but, at the same time, the representation may have a symbolic significance, alluding to the words of Paul (see I Corinthians 3:13–15), that the fire shall test the worth of each man's work—on the day of the Lord. In the First Epistle of Peter (1:7), the apostle also illustrates the preservation of the faith in times of trial by comparing it with metal (gold) that is tested in the fire.

G. D.

BIBLIOGRAPHY: O. Marucchi, *I monumenti del Museo Cristiano Pio Lateranense*, Milan, 1910, p. 58, pl. LIX, 33.

PONTIFICIO MUSEO MISSIONARIO-ETNOLOGICO

In 1692, the missionary Fray Francisco Romero brought to Rome wooden carvings from an Indian shrine in northern Colombia. He presented them to Pope Innocent XII (1691–1700), who directed that they be housed in the Palazzo di Propaganda Fide. These works (see cat. nos. 154, 155, 156; fig. 43) formed the modest beginnings of the collection of non-European ethnography and archaeology now found in the Pontificio Museo Missionario-Etnologico. They were incorporated into the collections of Cardinal Stefano Borgia (1731–1804), Prefect of Propaganda Fide. After Borgia's death, one part of his collection remained in the Vatican as the Museo Borgiano di Propaganda. During the nineteenth century, the Museo Borgiano's many new accessions came from missionaries throughout the world; notable among these objects were a group of carvings (see cat. nos. 145, 146, 147) from the Gambier Islands of Polynesia. A large "Esposizione Vaticana," held in 1887, included a number of objects that, at the exhibition's close, also were added to the Museo Borgiano.

A new phase began for the museum in 1924 when Pope Pius XI (1922–39) organized the "Esposizione Missionaria," extolling missionary endeavor throughout the non-Western world. When the exhibition ended, the pope said: "The Esposizione Missionaria . . . is and will remain like a great, an immense book; every object is a page, a phrase, a line in this book. . . . The Esposizione Missionaria will close, but the precious furnishings . . . will not disperse, they will remain as the Museo Missionario, as a school, as a book, which is always open." On November 12, 1926, the pope proclaimed in the motu proprio "Quoniam tam Praeclara" the formation, title, purpose, and location of the new museum, the Pontificio Museo Missionario-Etnologico. The museum was to be housed in the Palazzo Lateranense, already the home of the Museo Gregoriano Profano and the Museo Pio Cristiano, so that "the dawn of faith among the infidel of today can be compared to the dawn of faith which . . . illuminated pagan Rome." Its direction was firmly set: the new institution was not to be an art museum; rather, it was to be a didactic and scientific museum at the service of the missions.

An organizing committee was formed, headed by the distinguished anthropologist Father Wilhelm Schmidt, founder of the Anthropos Institut. In accordance with the directions of Pius XI, Schmidt planned a tripartite arrangement of the museum. The first area was to detail the history of missionary work from the first to the twentieth century; the second was to be devoted to contemporary mission work and would include ethnographic material and illustrate Schmidt's theories of cultural development; the third was to focus on the future of the missions. This plan was never realized; only the second area, which Schmidt considered the most important, came near to completion. The museum opened to the public on December 21, 1927, the feast day of Saint Thomas, apostle of the Indies. In 1938, Father Michele Schulien, who had assisted Father Schmidt in the original planning, succeeded him as director.

When Pope John XXIII (1958–63) decided to centralize the offices of the Roman diocese in the Palazzo Lateranense, the museum had to be closed, and in February 1963 its contents were moved to the Palazzo di San Callisto in Trastevere. At the same time, the pope ordered the construction of two new buildings in Vatican City to house the three museums of the Palazzo Lateranense. This project was halted by Pope Paul VI (1963–78), who, as a great patron of contemporary art, wished to have a single building in a late-twentieth-century idiom. In an open competition, the architects Vincenzo, Fausto, and Lucio Passarelli were chosen to design the building. Toward the end of the construction phase, in May 1965, the plans were revised, and the exhibition space was increased from 5,500 square yards (4,600 square meters) to 6,579 square yards (5,500 square meters). Included in this space were three large glassed-in areas for smaller objects and open areas for larger and more important pieces.

In 1968, following the death of Father Schulien, Father Jozef Penkowski was appointed director of the museum and was charged with organizing the arrangement and installation of the new museum's collections. As was evident from the outset forty years earlier, an attempt to create a museum

FIG. 43. *SOUTH AMERICAN INDIANS WORSHIPING IDOLS.*
(STATUES OF FIVE OF THE OBJECTS DEPICTED HERE
ARE IN THE VATICAN COLLECTIONS.) WOODCUT
(FROM FRANCISCO ROMERO, *LLANTO SAGRADO DE LA
AMERICA MERIDIONAL, QUE BUSCA ALIVIO*, MILAN, 1693)

about the missions faced almost insuperable ideological and practical problems. Moreover, by the 1960s the concept of mission work had changed radically, especially following the innovative ideas of the Second Vatican Council (1962–65). The goal no longer was to Europeanize the Third World but, instead, to establish foundations of Christianity in local cultures. The position of the Church with respect to other religions had also changed, encouraging open dialogue rather than confrontation. Promoting an understanding of other religions, therefore, was considered essential. Accordingly, Father Penkowski proposed the formation of a museum of world religions that would show that man is by nature religious. This proposal, accepted by Vatican officials, was carried out under Penkowski's direction. The museum's main galleries were opened to visitors in April 1973, and installation of the secondary collections as study-storage was completed in 1979. The entire holdings of the museum comprise more than 61,000 objects, of which approximately 10,000 are from Africa, 10,000 from the Americas, 20,000 from Asia, and 6,000 from Oceania; another 15,000 objects are prehistoric.

The galleries are divided into twenty-five sections, each of which is devoted to a country or cultural region of the non-Western world. The material on display illustrates the historical and ideological development of religions worldwide. Every religion represented is based on the concept of a supreme being, personal or impersonal, and, except in Christianity, never represented figurally. A supreme being is depicted in the museum's objects only when it is a composite of dualistic elements, such as masculine and feminine, that represent the being as the origin of life. Two major preoccupations are evidenced by the objects: the cult of the dead and the cult of ancestors, which in some cases involves an immediate kinship group and in others encompasses an entire community. Works relating to the world's higher religions are exhibited in both geographic and chronological arrangements, and a rich collection of indigenous Christian art from Third World countries also is shown.

In spite of the transformations that the Pontificio Museo Missionario-Etnologico has undergone since 1926, it has, for the most part, been faithful to the ideals of Pope Pius XI. The museum has retained its didactic and scientific character, and it has remained a "school" that instills respect for all religions, as well as a "book," each page of which reveals man's eternal search for the divine.

Jozef Penkowski

BIBLIOGRAPHY: *L'Esposizione Vaticana illustrata*, II, 1887–88; H. de Ragnau, *L'Exposition Vatican*, Valence, 1888, p. 107; Pius XI, 'Allocuzione del 10.1.1926," in *Rivista illustrata della Esposizione Missionaria Vaticana, Supplemento I*, 1926, pp. 72–75; idem, "Quoniam tam Praeclara," in *Acta Apostolicae Sedis*, 28, 1926, pp. 478, 479; idem, "Rerum Ecclesiae," in *Acta Apostolicae Sedis*, 28, 1926, pp. 65–83; W. Schmidt, "Museo Missionario-Etnologico," in *Piccola guida dei Musei Lateranensi*, Rome, 1928, pp. 16–55; P. Ercole, "Dall'Esposizione Missionaria Vaticana al Museo Missionario-Etnologico del Laterano," in *Annali Lateranensi*, I, 1937, pp. 9–12; Te Rangi Hiroa, "Ethnology of Mangareva," in *Bulletin*, 157, Bernice P. Bishop Museum, 1938, p. 520; P. dalla Torre, "Le plastiche a soggetto indigeno nordamericano del Pettrich nel Pontificio Museo Missionario-Etnologico," in *Annali Lateranensi*, IV, 1940, pp. 9–96; H. Bischof, "Una Colección Etnográfica de la Sierra Nevada de Santa Marta (Colombia)—Siglo XVII," in *Atti del XL Congresso degli Americanisti*, Rome, 1972, pp. 391–98; J. Penkowski, "Museo Missionario-Etnologico," in *Vaticano e Roma Cristiana*, Vatican City, 1975, pp. 261–77; idem, "Il Museo Missionario-Etnologico," in *Bollettino dei Monumenti Musei e Gallerie Pontificie*, I, 1, 1977, pp. 193–97; "Trasferimento delle raccolte Lateranensi al Vaticano," in *Bollettino dei Monumenti Musei e Gallerie Pontificie*, I, 1, 1977, pp. 15–32.

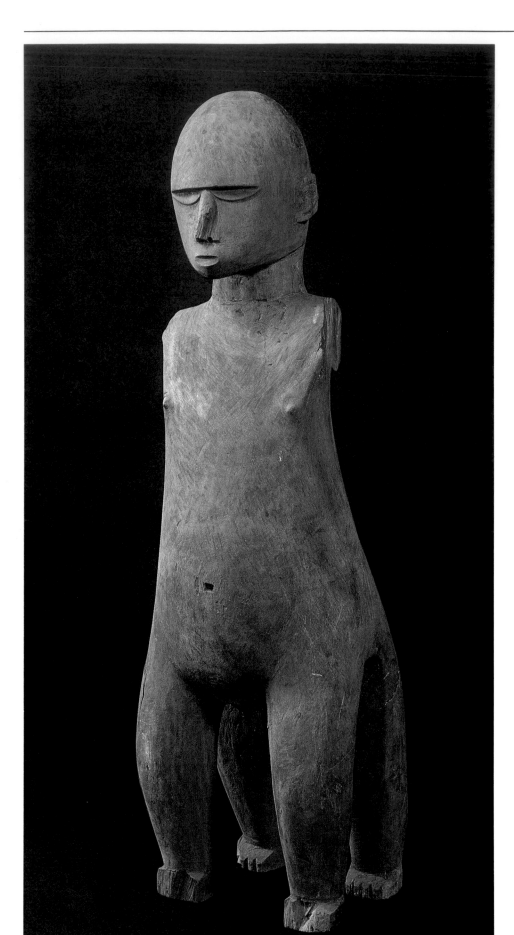

THE GOD TU

Polynesia (Gambier Islands, Mangareva Island)
Collected 1834–36
Wood
Height, 44 ½" (113 cm); maximum width, 11"
(28 cm); depth, 9 ¹/₁₆" (23 cm)
Pontificio Museo Missionario-Etnologico, Inv. no.
AU 2148

The figure of a sturdily built man, with dispro-portionately small but firmly placed feet, is sup-ported by four legs bent at the knees. The large abdomen, with the navel indicated by a square; the narrow chest; and the outstretched (now missing) arms (Te Rangi Hiroa, 1938, fig. 66) create the image of a strong man who is ready for anything. The figure's bald head with its conical cranium is a sign, perhaps, of artificial head deformation. The delineation of the face is harmonious: the almond-shaped eyes, un-broken arch of eyebrow, and half-opened, mys-teriously smiling mouth accurately give the impression that this object portrays a truly im-portant personage.

The sculpture, carved from a single piece of wood, represents the god Tu. According to mythology, Tu, the supreme god of Poly-nesia, was the first-born son of Tagaroa and of Haumea, a deified forefather. A famous warrior-navigator, Tu became the god of war, except on Mangareva Island, where he was worshiped as the god of agriculture, responsible especially for the cultivation of breadfruit and bananas. Yet, even on Mangareva, Tu appeared in the form of a thunderbolt or a comet—typical man-ifestations of war gods.

Stylistically, the sculpture of Mangareva (see also cat. no. 146) is very different from that of the rest of Polynesia. The figures always have bent knees; their arms, flexed ninety degrees at the elbows, reach forward; their eyebrows form a continuous curve; and their sexual organs, even those of fertility gods, are not exaggerated.

This statue of the god Tu is unique. A number of sculptures of this divinity exist, but only the one shown here depicts him with four legs. There is no explanation for this four-leggedness other than the name Tu, meaning "that which stands" —strong and unmoving, like the navigator of a ship in the middle of a storm.

In April 1836, Father François Caret, the first Catholic missionary on Mangareva, sent this and several other Gambier Islands objects to the head-quarters of the Order of Picpus Mission at Braine-le-Comte, Belgium. The "N[o]. 1." on the torso corresponds to Caret's list and notes. In 1837, the statue was presented to Pope Gregory XVI (1831–46), who had it placed in the Museo Borgiano di Propaganda.

J. P.

BIBLIOGRAPHY: Te Rangi Hiroa, "Ethnology of Manga-reva," in *Bulletin*, 157, Bernice P. Bishop Museum, 1938, pp. 462, 464, fig. 66.

146

THE GOD ROGO

Polynesia (Gambier Islands, Mangareva Island?)
Collected 1834–36
Wood
Height, 35 7/16" (90 cm); maximum width, 7 7/8"
 (20 cm); depth, 5 1/8" (13 cm)
Pontificio Museo Missionario-Etnologico, Inv. no.
 AU 913

A male figure stands on two thick legs bent at the knees. The rounded, protruding abdomen with its circular navel; the well-developed thorax; the arms, held away from the body and flexed at the elbows; and the head, with its conical crown, convey a sense of well-proportioned slimness. The face, dominated by a large nose; the mouth, half-opened as if the figure were about to speak; and the almond-shaped eyes, with eyebrows in a single, smooth curve—all testify to the skill of the object's Mangarevan (?) sculptor and are reminiscent of the work of the unknown maker who carved the statue of the god Tu (see cat. no. 145). Only the fingers and toes are coarsely and schematically indicated.

The statue represents Rogo, sixth son of Tagaroa and Haumea, the mythological first inhabitants of Mangareva (Te Rangi Hiroa, 1938, pp. 420, 422). At first merely an ancestor, Rogo became, with the passage of time, god of peace, agriculture, and hospitality in all of Polynesia. On Mangareva Island, deposed by Tu, he was invoked especially in rites connected with the cultivation of turmeric tubers. As god of hospitality, he was considered protector of singer-poets, who passed along tribal traditions through their chants. Rogo revealed himself in the form of a rainbow and as fog—typical manifestations of agricultural gods.

The figure was sent by Father François Caret to the headquarters of the Order of Picpus Mission at Braine-le-Comte, Belgium, in 1836. It became the property of the Museo Borgiano di Propaganda in 1837.

J. P.

BIBLIOGRAPHY: Te Rangi Hiroa, "Ethnology of Mangareva," in *Bulletin*, 157, Bernice P. Bishop Museum, 1938, pp. 420, 422, fig. 62.

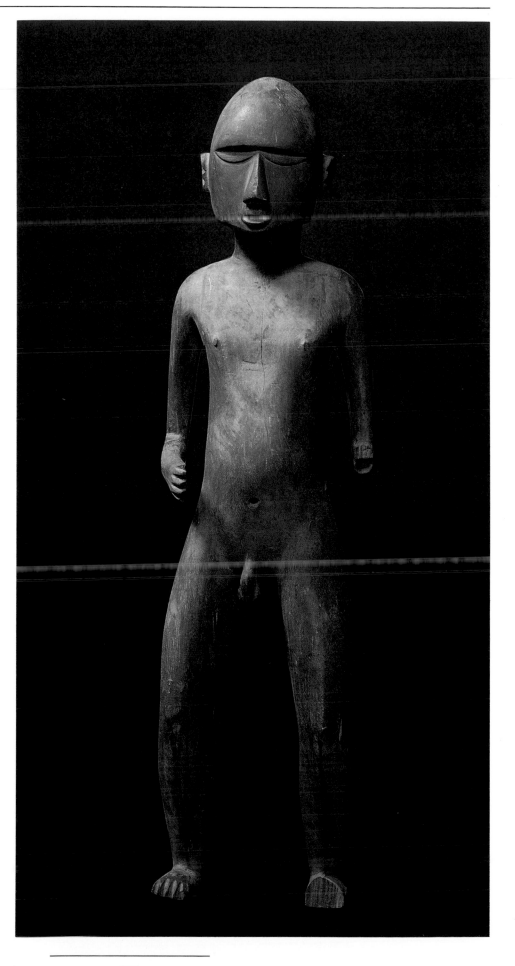

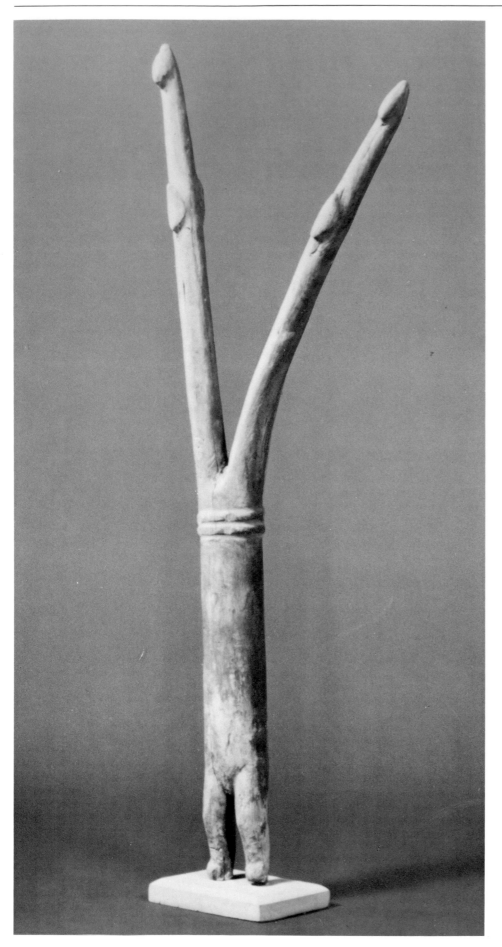

THE GOD TUPO

Polynesia (Gambier Islands, Akamaru Island)
Collected 1834–36
Wood
Height, 33 ½" (85 cm); maximum width, 11 ¹³/₁₆"
(30 cm); depth, 2 ⅜" (6 cm)
Pontificio Museo Missionario-Etnologico, Inv. no.
AU 2617

At first glance, this object might be taken for a contemporary abstract sculpture. Two enormously long arms extend upward from a cylindrical body that is adorned with two rings carved in high relief. Each arm has three elliptical protuberances, which appear to be supports of some sort. Only the legs—very short, slightly flexed at the knees, with the feet barely indicated—show that this sculpture is meant to represent a human being, albeit an asexual and headless one (Te Rangi Hiroa, 1938, fig. 60).

The object has a double significance. According to the notes of Father Hilarion, the sculpture represents Tupo, a god who is associated with the cultivation of tubers and who causes chaos and disorder in the universe (Te Rangi Hiroa, 1938, p. 465). Nothing precise is known about this divinity. In Mangarevan mythology there is frequent reference to a certain Tupa, who introduced the cult of Tu to the island, but whether Tupo and Tupa are the same never has been ascertained.

Father François Caret explained that this sculpture was used for a rite called *eketea*, which was part of every Mangarevan religious ceremony and consisted of raising toward heaven strips of bark cloth (*tapa*) on a wooden support, to invoke the divinity in whose honor the ceremony was being held. The rite, the strips, and even the wooden support were all called *eketea*. Bifurcated *eketeas*—this is one of two in existence—were used only on Akamaru Island (H. Laval, 1938, pp. 335, 336). Judging from the specific position of the legs, it is probable that this is a Mangarevan work. Other elements of comparison are lacking.

The object was acquired, along with two others illustrated here (see cat. nos. 145, 146), between 1834 and 1836, and was number four on Caret's list. It entered the Pontificio Museo Missionario-Etnologico in 1925.

J. P.

BIBLIOGRAPHY: H. Laval, *Mangareva*, Paris, 1938, pp. 335, 336; Te Rangi Hiroa, "Ethnology of Mangareva," in *Bulletin*, 157, Bernice P. Bishop Museum, 1938, p. 465, fig. 60.

148

CRUCIFIX

Zaire; Bakongo people
17th century
Bronze
Height, 15 ¾" (40 cm); maximum width, 7 ½"
(19 cm)
Pontificio Museo Missionario-Etnologico, Inv.
no. 9335

Although the cross is the primordial and essential symbol of Christianity, this one seems to lie outside that tradition. It was cast in a bronze alloy in one piece using the "à ciel ouvert" (open-mold) technique. On the flat surface of the cross, whose edges are raised and cross-hatched, the body of Christ is executed in high relief. The image is that of an African Christ: curly hair, broad nose, and protruding navel. His outstretched arms, crossed feet, prominent ribs, and loincloth tied in a knot on one side reflect a European model. This is a Christ who is not yet dead. His head is not bent, and his chest has not been pierced. Below Christ, on the upright of the cross, a naked woman covers her breasts with one hand and her pudenda with the other. Above Christ, on the arms of the cross, two naked figures sit with their hands folded in prayer. A third and similar figure is on the upper part of the upright.

What do the four nude figures that the artist has added to the cross represent? The female figure at the bottom is surely the Madonna. Opinions are very diverse regarding the identities of the other three. The Trinity, three apostles, souls of the dead saved by Christ and on their way to heaven, relatives who mourn the dying Christ—all are possible explanations but may not be accurate (W. Hirschberg, 1980, pp. 50, 51).

At first, for Africans, too, the cross had a strictly Christian significance. As the influence of the missions diminished, however, the religious meaning of the cross changed so radically that it became a protective spirit called *Nkangi kiditu* ("attached Christ"). The cross was invoked especially in judicial cases—perhaps a tradition left over from Christian judgment—but it also was considered a symbol of the authority of the tribal chief.

The cross was introduced to the Lower Congo region by the first Portuguese missionaries in the fifteenth century. By the sixteenth century, crosses had begun to be manufactured in Africa. Initially, these crosses imitated European examples, but over time they were transformed into completely African works (W. Hirschberg, 1980, p. 51). This cross must have been made toward the end of the seventeenth century, when the missions had lost their influence and stylistic and ideological transformations became resolved. It was collected by Redemptionist fathers in the Lower Congo and sent from Brussels to the Vatican in 1924 for the "Esposizione Missionaria" in 1925.

J. P.

Unpublished.

Comparative work cited: W. Hirschberg, "Bemerkungen zu einem 'doppelgeschlechtlichen Korpus' aus dem alten Kongoreich," in *Christliches Afrika*, Sankt Augustin, 1980, pp. 45–57.

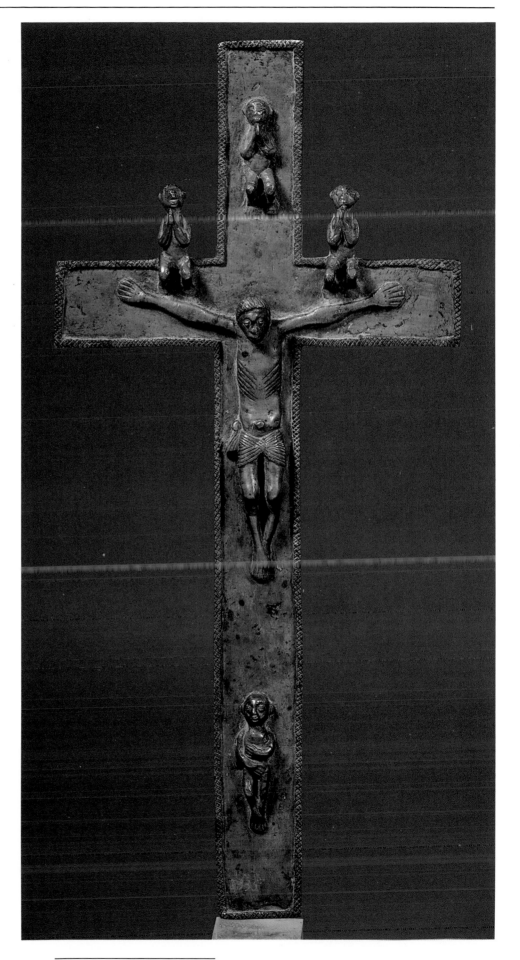

149

MASK

Congo; Vili people
First quarter of the 20th century
Collected before 1924
Painted wood and leather
Height, 11 ¹³/₁₆" (30 cm); maximum width, 6 ¹¹/₁₆"
* (17 cm); depth, 4 ¾" (12 cm)*
Pontificio Museo Missionario-Etnologico, Inv.
* no. AF 7978*

People like to disguise themselves. Thus, masks
have figured in all epochs of human history,
among all social strata. This mask features a
well-constructed human face with a broad nose,
fully articulated ears painted white, an open
mouth with teeth in the upper jaw, a tongue
projecting over the lower lip, and a chin adorned
with a leather goatee. The entire mask, a typical
example of the moving realism of the cultural
area of the Lower Congo, is covered in a sym-
metrical and contrasting mosaic of white, red,
and black. Only the skull is devoid of any
adornment; it was covered—as evidenced by
the holes in it—by a hood that formed part of

the costume, completely concealing the person
wearing the mask.

Generally, in so-called primitive cultures,
masks were used for worship by secret societies
or in initiation rituals. The Museum für Völk-
erkunde in West Berlin has an almost identi-
cal mask, collected in 1887 by Wilhelm Joest,
who annotated it as a "mask used by medicine
men to cure the sick" (K. Krieger and G. Kut-
scher, 1960, ills. 64–66)—that is to say, it was
employed by an individual in the practice of his
craft of healing.

This mask belonged to the Vili people, who
live on the Atlantic Coast between the Congo
and Niari rivers. Masks from this tribe are not
common in collections of African art. This one
must have been carved about the beginning of
the 1920s, as indicated by the manner in which
the goatee is attached and by the excellent state
of preservation. The latter leads one to believe
that it had not been used in any ceremonies.

Collected by an unknown missionary, this
mask was sent to the Vatican in 1924, to be in-
cluded in the "Esposizione Missionaria" in 1925.

<div align="right">J. P.</div>

Unpublished.

Comparative work cited: K. Krieger and G. Kutscher,
Westafrikanische Masken, Berlin, 1960, ills. 64–66.

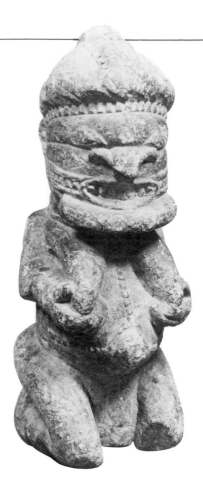

150

ANDROGYNOUS FIGURE (*POMDO*)

Guinea or Sierra Leone; Kissi people
18th century (?)
Collected before 1924
Stone
Height, 8 ¼" (21 cm); maximum width,
* 2 ⁹/₁₆" (6.5 cm); depth, 2 ⁹/₁₆" (6.5 cm)*
Pontificio Museo Missionario-Etnologico,
* Inv. no. AF 535/6*

This very curious sculpture, carved in grayish
stone, represents a kneeling androgynous human
figure. Its bulging abdomen, accentuated by an
excessively protruding navel, is covered with
scarification lines. Its arms, flat against its body,
bent at right angles, and adorned with three
bracelets, support extremely long breasts that
appear to issue from the female figure's neck—
ornamented with a necklace, yet crowned by
an oblique masculine head wearing typical Afri-
can headgear. The face gives the sculpture an
appearance of truly monstrous cruelty: it has a
mouth indented in a broad grin (the indentation
is artificially prolonged by scarification all the
way to the back of the head); a flat nose with
very wide nostrils; narrow, barely indicated eyes;
receding ears; and a broad, flat, semicircular
beard.

Originally, small statues of this kind were used
as tomb offerings by the Bullom people, but over
time the images developed into representations
of deified ancestors. Later, other peoples arrived
in the Guinea–Sierra Leone area, and the Mende

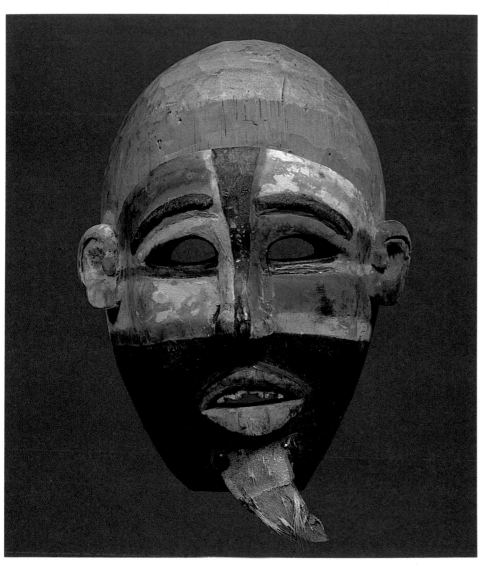

and Kissi tribes who unearthed these statues during the cultivation of their crops radically altered their religious significance and gave them a special name. The Mende called them *nomoli*, and the Kissi *pomdo*. From images of ancestors they became the seats of spirits who provided protection against the theft of rice from the paddies, ensured the fertility of land and of mankind (A. Lommel, 1976, p. 214), and served as oracles.

These statuettes were produced between the thirteenth and eighteenth centuries (K. Dittmer, 1967, p. 184). This one must date to the late period because it unites both the early, so-called grinning style—note the open mouth—and the fertility image introduced later—the breasts supported by the arms.

This *pomdo* was collected before 1924 from the Kissi people of Guinea or Sierra Leone. It is a very rare example of its type, as Bullom statuettes generally are masculine, not androgynous.

J. P.

Unpublished.

Comparative works cited: K. Dittmer, "Bedeutung, Datierung und kulturhistorische Zusammenhänge der 'prähistorischen' Steinfiguren aus Sierra Leone und Guinée," in *Baessler-Archiv*, 15, 1967, pp. 183–238; A. Lommel, *Afrikanische Kunst*, Munich, 1976, p. 214.

151

MAIDEN-SPIRIT MASK (*AGBOGHO MMWO*)

Nigeria; Igbo people
19th–20th century
Collected before 1924
Painted wood
Height, 19 5/16" (49 cm); maximum width, 13 3/8"
(34 cm); depth, 7 1/16" (18 cm)
Pontificio Museo Missionario-Etnologico, inv. no.
AF 804

This mask depicts the fine, delicate features of a young Igbo woman. Her narrow, elongated face is painted white, the color not only of the spirit world but also of things that are considered beautiful and good by the Igbo. The designs made by scarification on the woman's forehead and temples—symbols of beauty as well as of ethnic identity—show that she has been marked by the values of her society. Her intricate coiffure of painstakingly plaited hair studded with ornaments and combs is a further indication of the admiration and respect due her. Masks such as this one are in sharp contrast to other, dark-colored Igbo masks with exaggerated, deformed, or animalistic features.

Maiden-spirit masks are part of costumes that consist of tight-fitting pants and shirts appliquéd with brilliantly colored pieces of cloth. Masked dancers skillfully imitate the daily activities and movement patterns of Igbo women. Despite their feminine features, maiden-spirit masks are meant to be worn by strong young men, members of the *mmwo*, or "spirit," society whose function is to appease and honor the spirits of the dead, since it is they who intercede with the gods on behalf of the living. If satisfied, the ancestors bring good fortune, health, children, and pros-

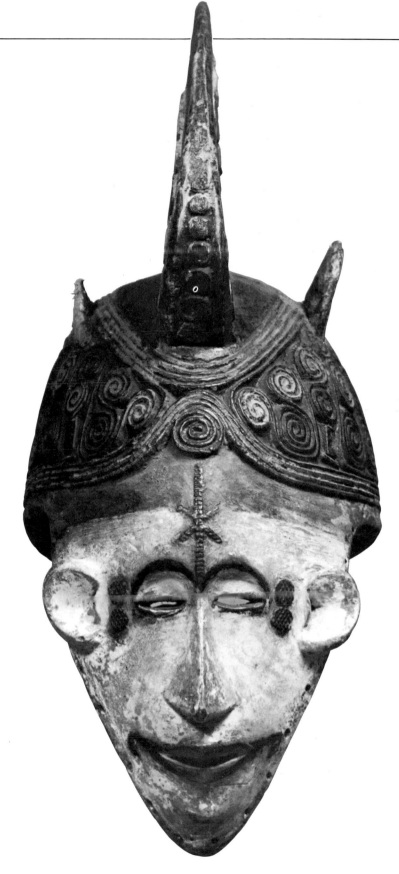

perity to their descendants; if not, they bring disaster. Among the northern Igbo, maiden-spirit masks are worn at the most important celebration of the year, that of the harvest, and, later, during the dry season, at the feast of the earth goddess (J. S. Boston, 1960, p. 60).

Collected by missionaries, and brought to the Vatican for the "Esposizione Missionaria" in 1925, this mask then became the property of the Pontificio Museo Missionario-Etnologico.

J. P.

Unpublished.

Comparative work cited: J. S. Boston, "Some Northern Ibo Masquerades," in *Journal of the Royal Anthropological Institute of Great Britain and Ireland*, 61, 1960, pp. 54–65.

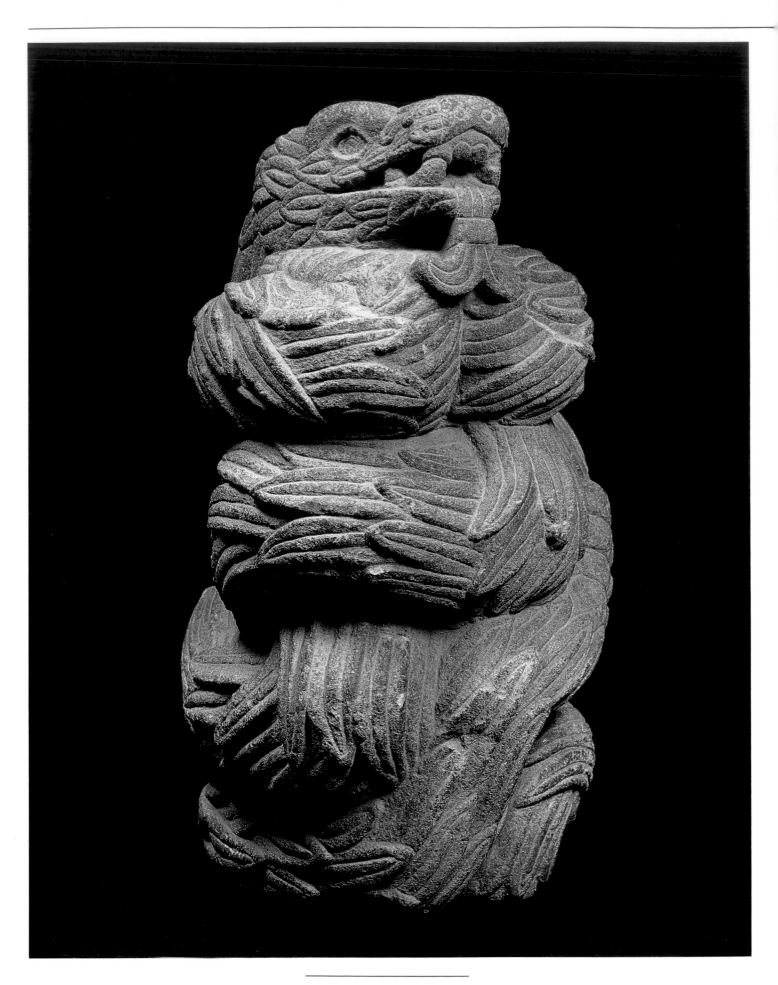

152

QUETZALCOATL ("THE PLUMED SERPENT")

Mexico; Aztec
Classic period (15th century)
Stone
Height, 20¹/₁₆" (51 cm); maximum width, 10¼"
 (26 cm); depth, 10¼" (26 cm)
Pontificio Museo Missionario-Etnologico, Inv. no.
 AM 3296

The Aztec word *quetzalcoatl* means "the plumed serpent." This sculpture, executed in reddish stone, represents a coiled serpent with an upright body entirely covered with feathers, in the center of which appears an ear of Indian maize. The almost aquiline head, with its large, sharp eyes and forked, projecting tongue, gives the sculpture an aura of mysterious horror appropriate to the Aztec pantheon.

This mythological reptile is the symbol of one of the principal Aztec gods. It carries the same name, and expresses the dualistic nature of this god as the deity of wind and of fire and light. As the god of wind, Quetzalcoatl is as fast as a serpent (which, due to its smooth body, does not know obstacles) yet flies like a bird and must, therefore, be plumed. In this aspect, the deity destroyed the world at the end of the second mythological era—that of the "Four Winds"—during which it had been the dominant god. As the deity of fire and light, Quetzalcoatl is connected with the planet Venus, the herald of dawn and the carrier of civilization—represented by the ear of Indian maize, which, in order to renew itself, had need of frequent human sacrifice.

This sculpture, of exquisite quality and the finest execution, came from the Mexican plateau. It dates from the Classic period of Aztec art, but nothing is known about the date of its discovery. Formerly, it belonged to the Museo Borgiano di Propaganda.

J. P.

BIBLIOGRAPHY: *Kunst der Mexikaner* (exhib. cat.), Kunsthaus, Zurich, 1959, p. 82, pl. 105.

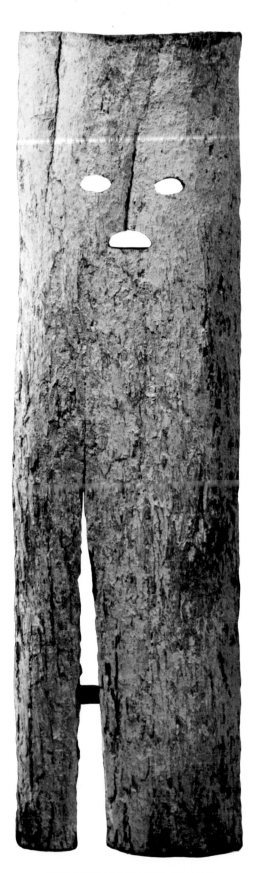

153

MASK

Chile (Tierra del Fuego); Yaghan
Collected 1920–24
Painted bark
Height, 32¼" (82 cm); maximum width,
 8⅝" (22 cm); depth, 3¹⁵/₁₆" (10 cm)
Pontificio Museo Missionario-Etnologico,
 Inv. no. AM 3198/B

This mask is very simple—a piece of bark, dried and painted white, with three holes: one for the mouth, the other two for the eyes. The internal crossbars, added to keep the mask rigid, are not original. Masks of this type, although painted in different ways, were the only kind used by the Yaghan, a tribe who lived in Tierra del Fuego. Their masks were broadened at the base in order to accommodate the head of the wearer, and squeezed together at the top into a conical shape. Judging from the position of the holes for the mouth and the eyes, this one was an exception in that the cone points downward rather than up.

The Yaghan used masks of this type during the Kina festival in the second initiation rites (M. Gusinde, 1937, pp. 1328, 1329). All such masks were cut out in practically the same manner. Only the color of the mask changed, depending upon which mythical being the maker wished to depict. White masks were worn to portray the spirit of the sea perch in the *wasenim-yaka* (corbina-fish) dance and in the *lepalus-yaka* (little-red-fish) dance (M. Gusinde, 1937, p. 1373).

The Yaghan tribe has become almost extinct, and few of its masks are found in collections of primitive art. This one once was part of the private museum of Father Martin Gusinde of Santiago, Chile. He gave the mask to the Pontificio Museo Missionario-Etnologico in 1927.

J. P.

Unpublished.

Comparative work cited: M. Gusinde, *Die Yamana* (Die Feuerland Indianer, II), Mödling, 1937, pp. 1328, 1329, 1373.

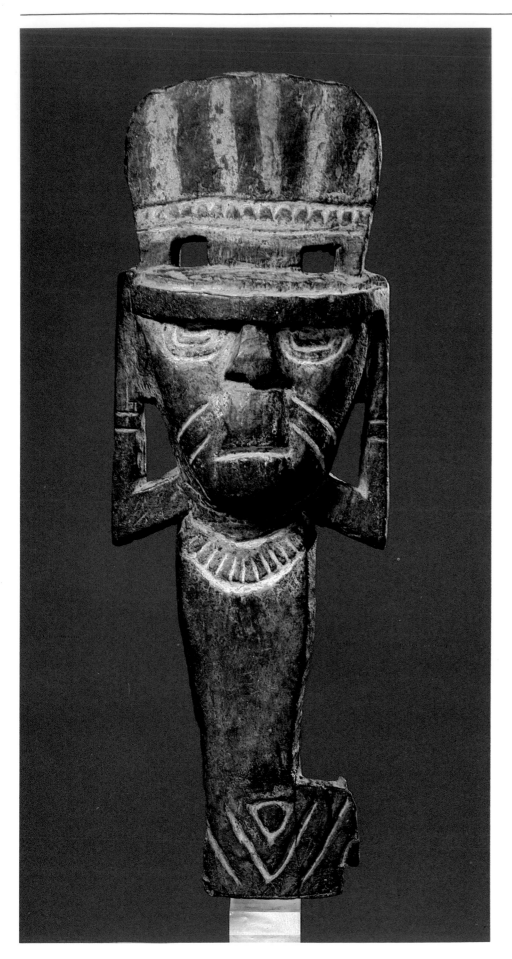

154

FIGURE OF A DIVINITY

Colombia (Sierra Nevada de Santa Marta);
 Aruaco (?)
16th century (?)
Collected 1691
Painted wood
Height, 18 7/8" (48 cm); maximum width, 6 5/16"
 (16 cm); depth, 1 7/8" (5 cm)
Pontificio Museo Missionario-Etnologico, Inv. no.
 AM 2864/A

This sculpture in the form of a human being is carved from a plank of wood, with traces of white paint that originally probably covered the entire object. The body, which is not modeled, is more a relief than a statue, although it is supported on a base (now almost completely destroyed) carved with geometric decoration. The face of the sculpture is very strange. Two wide-open eyes surrounded by white circles stare from beneath a tall hat with white stripes. A roughly indicated nose and a mouth with a protruding tongue turned upward complete the image. Two semicircular scarifications appear on either side

of the mouth. The arms, each ornamented with two bracelets, are raised and seem to support the heavy hat. The chest of the figure is engraved with a pectoral—made of blade-shaped segments (of mother-of-pearl?)—like those worn today by the Amerinds.

This object displays an inexpert sculptural hand. One need only examine the area of the nose, mouth, and chin to realize how little experience in sculpting its maker possessed. The artist who created the mask illustrated in catalogue number 156 surely could not have made this one, even if both objects were found in the same sanctuary.

As there is no precise information concerning the religious beliefs of the Amerinds in the seventeenth century, one is forced to rely on recent reports regarding the beliefs of the people living today in the region in which the object was collected. Thus, the figure must represent the great mother Munkulu, about whom little is known. Probably, Munkulu was a deified ancestor connected with the cult of fire (K. T. Preuss, 1926, pp. 77, 78, ill. 25). This sculpture is unique. A careful study of the work would perhaps shed light on the beliefs of the Amerinds at the time of the Spanish Conquest (H. Bischof, 1972, p. 393).

Information on the history and provenance of the statue appears in the catalogue entry for number 156.

<div align="right">J. P.</div>

BIBLIOGRAPHY: K. T. Preuss, Forschungsreise zu den Kágaba, Mödling, 1926, pp. 77, 78, ill. 25; H. Bischof, "Una Colección Etnográfica de la Sierra Nevada de Santa Marta (Colombia)—Siglo XVII," in Atti del XL Congresso degli Americanisti, II, Rome, 1972, p. 393.

155

SUPPORT

Colombia (Sierra Nevada de Santa Marta);
Aruaco (?)
16th century (?)
Collected 1691
Painted wood
Height, 6 3/16" (16 cm); maximum width, 13 1/8"
(34 cm); depth, 3 1/16" (7.8 cm)
Pontificio Museo Missionario-Etnologico, Inv. no.
AM 3233

Carved in the shape of a feline, this wooden object is incised with geometric designs and coated with white paint. The rectangular head is joined to the body by a nearly square neck with a reinforcement above it extending to the tail. The body, with its two lateral apertures, was intended as a support for some kind of sculpture, which was inserted into a vertical slot in the upper part of the object. The long tail, now broken, served as a handle. The execution is reminiscent of the wood figure seen in catalogue number 154, and it is possible that the same artist created both pieces.

The animal represented by the sculpture is the puma, often shown with anthropomorphic features. As a god of fire, he was venerated during the drying out of the fields preparatory to their cultivation.

Another support of this type is also in the Pontificio Museo Missionario-Etnologico (Inv. no. AM 3232) and forms part of the group of sculptures taken from a shrine at Sierra Nevada de Santa Marta in 1691. For the history and provenance of this object, see the entry for catalogue number 156.

<div align="right">J. P.</div>

BIBLIOGRAPHY: K. T. Preuss, Forschungsreise zu den Kágaba, Mödling, 1926, pp. 77 ff.; H. Bischof, "Una Colección Etnográfica de la Sierra Nevada de Santa Marta (Colombia)—Siglo XVII," in Atti del XL Congresso degli Americanisti, II, Rome, 1972, pp. 391–98.

156

MASK

Colombia (Sierra Nevada de Santa Marta);
 Aruaco (?)
16th century (?)
Collected 1691
Wood
Height, 7 1/16" (18 cm); maximum width, 5 7/8"
 (15 cm); depth, 3 15/16" (10 cm)
Pontificio Museo Missionario-Etnologico, Inv. no.
 AM 2864/B

This realistic mask, with an aquiline nose and a half-open mouth, depicts a tranquil human face that originally may have had inlaid eyes. The lower lip is broken, but the protruding tongue remains visible. The knot in the right cheek suggests the presence of a coca quid (H. Bischof, 1972, p. 393). The mask must have been surmounted by a crown (possibly of feathers) since there are attachment holes along the upper edge. Traces of a light cream color remain on the entire surface of the mask, a well-proportioned work of great refinement and detail, like an actual death mask.

The mask represents the great-grandmother Sun, venerated during the drying out of the fields preparatory to their cultivation. Together with a wooden figure and a wooden support (see cat. nos. 154, 155) and two other pieces now in the Pontificio Museo Missionario-Etnologico, this object was collected in July 1691 by Fray Francisco Romero when he destroyed a native sanctuary in the Sierra Nevada de Santa Marta in Colombia. Romero gathered from the sanctuary a few examples of objects that he described as "idols" and "instruments of idolatry."

In 1925, Marshall H. Saville (pp. 86, 105–6, n. 115), relying on erroneous information provided in 1885 by Giuseppe Angelo Colini (pp. 316–25, 914–32), ascribed the sculptures to ancient Mexico. Henning Bischof corrected this view in 1972 and documented the provenance of the sculptures, dating them to the sixteenth century, or possibly earlier. They belonged to Cardinal Stefano Borgia (1731–1804).

J. P.

BIBLIOGRAPHY: G. A. Colini, "Collezioni etnografiche del Museo Borgiano," in *Bollettino della Società Geografica Italiana*, XIX, XXII, ser. II, X, Rome, 1885, pp. 316–25, 914–32; M. H. Saville, "The Wood-Carver's Art in Ancient Mexico," in *Contributions from the Museum of the American Indian, Heye Foundation*, IX, New York, 1925, pp. 86, 105–6, n. 115; H. Bischof, "Una Colección Etnográfica de la Sierra Nevada de Santa Marta (Colombia)—Siglo XVII," in *Atti del XL Congresso degli Americanisti*, II, Rome, 1972, pp. 391–98.

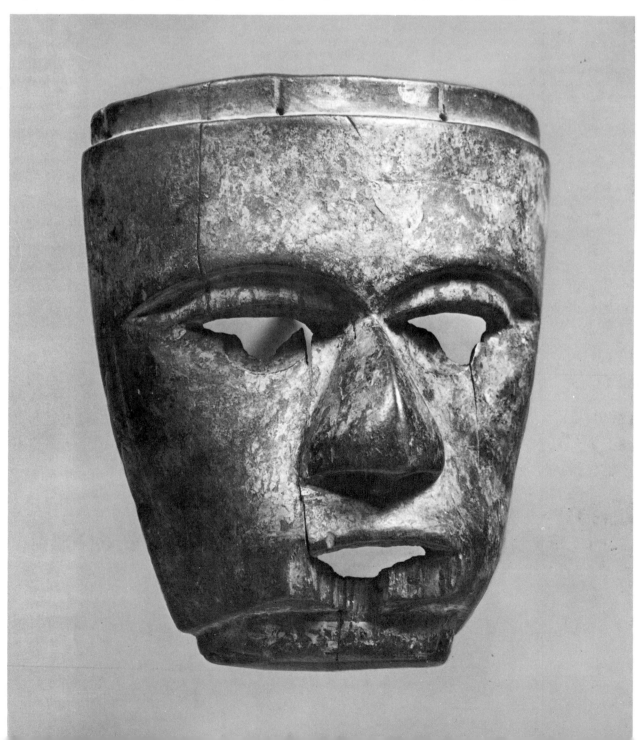

157

HOOK (SAMBUN)

Papua New Guinea (East Sepik Province, Kaminimbit village); Iatmul people
Collected before 1924
Painted wood
Height, 59 ¹/₁₆" (150 cm); maximum width, 9 ¹/₁₆"
(23 cm)
Pontificio Museo Missionario-Etnologico, Inv. no. AU 1535

This wooden suspension hook, or *sambun*, is carved and painted to depict a female being who is part human and part bird. The head is adorned with a conical crest pierced by three holes for cane bands, from which the hook is meant to hang. The oval face, its large, round eyes encircled with ocher and white; the aquiline nose, with a hollow space substituting for a septum and nostrils elongated into crescents that become circles around the eyes; and the delicate mouth, also crescent shaped, make for an image of extraordinary refinement. The neck of the figure is at the same time the neck of a bird, probably a white-bellied sea eagle. The bird's beak is joined to the neck, and its head juts out beneath the figure's face. The bird's wings form the arms of the figure, and the upper part of the figure's chest, engraved with zigzag lines, displays the bird's feathers. The bosom, though flat, is painted and carved to indicate the breasts. From the narrow abdomen rises an enormous navel with scarification circles. The legs, very thin and straight, end in lunette shapes from which two hooks protrude. The object is painted ocher and white on the front and back.

A masterpiece of Melanesian sculpture in terms of both religious content and artistic execution, this *sambun* is a classic example of the suspension hooks of the East Sepik region of Papua New Guinea. The finesse of the features and the proportions of the supernatural being portrayed testify to the expertise and imagination of the artist, whose skill as a sculptor is illustrated by the three half-moons—the extended nostrils, the small, fine mouth, and the anchor-like base.

The object represents a female aquatic spirit, Kamboragea, important to the success of fishing—an economic activity essential to Iatmul survival—and to the fertility of Iatmul women. Because religious faith was closely related to daily life in Iatmul society—as in all so-called primitive societies—the hook, intended for general use, also served as a ritualistic and, consequently, a sacred object.

Father Franz Kirschbaum collected this sculpture, adding it to a group of objects that were given to the Vatican Museums in 1924 by the missionaries Verbiti.

J. P.

Unpublished.

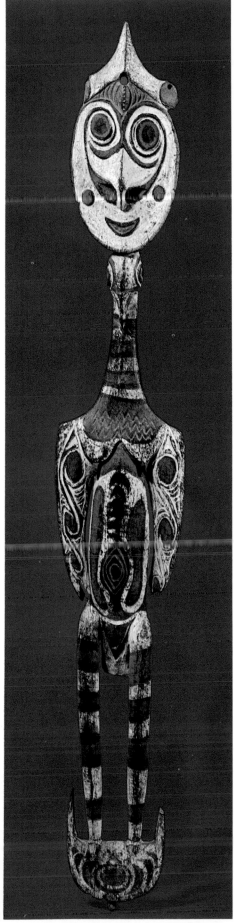

157
(front)

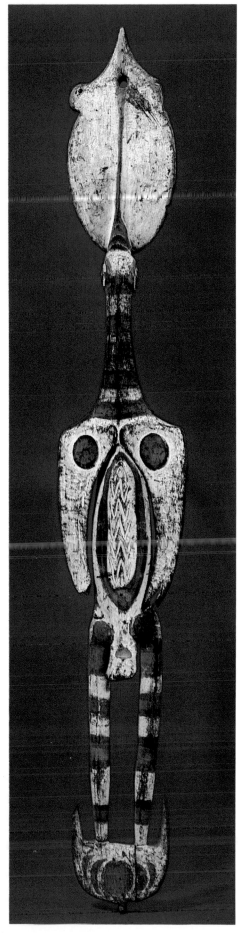

157
(back)

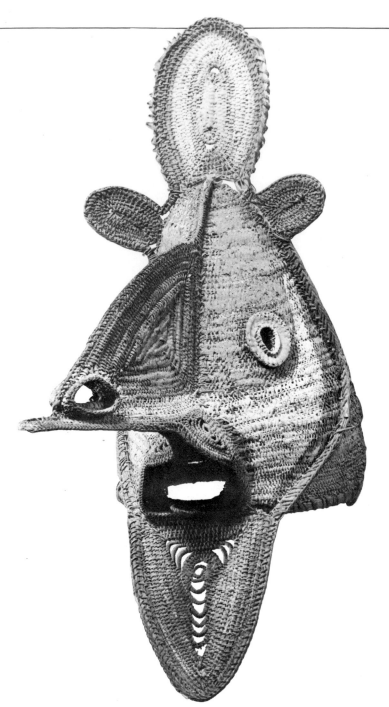

CARVED BOARD (*MALU-SAMBUN*)

Papua New Guinea (East Sepik Province,
 Kaminimbit village)
Collected before 1924
Painted wood
Height, 50" (127 cm); maximum width, 13 ¾"
 (35 cm)
Pontificio Museo Missionario-Etnologico, Inv. no.
 AU 2266/R

This board, carved with stone tools and per-
forated, at first seems to be a fanciful, random
design, difficult to interpret. It was originally
painted ocher and white, but the color has almost
completely disappeared from the front, the
uppermost part of which is dominated by a large
face in low relief. Enormous eyes surrounded
by white and dark circles occupy the major por-
tion of the face. A very narrow, long nose, now
broken away, once hid a tiny, barely delineated
mouth. As can be seen from traces on the
abdomen, the nose descended all the way to
the two diminutive, bird-shaped feet. On each
side of the neck is a small pig, and in the spaces
between the thin body and the edges of the slab
four large birds (perhaps eagles) are symmetri-
cally arranged—two facing up and two down.
Eight hooks extend upward from a panel on
the lowest section of the board, in the center of
which an owl-like face is carved. The back of
the board, though resembling the front, lacks
the nose and the bottommost area of the face,
and displays a large, open mouth and better-
preserved paint.

The female figure depicted here is probably
the aquatic spirit Kamboragea (see also cat. no.
157). However, some scholars have recognized
the figure as a depiction of the tree of life. Oth-
ers have seen it as an archetypal portrayal of a
cannibal, endowed with supernatural powers al-
though incorporating natural forms. If this last
interpretation is correct, the board must have
been used as a rack for human trophy skulls.

Father Franz Kirschbaum, who worked in
New Guinea for many years, says that slabs like
this one, which he calls *ramu-tyamban*, were used
as wall ornaments in homes and were highly
prized as wedding gifts. Passed from generation
to generation as family treasures, by the 1920s
objects of this sort were no longer being pro-
duced. According to Kirschbaum, the boards
were to be found in the territory between Tam-
banum and Parimbai along the Sepik River;
recent research indicates that they were carved
by the Sawos, a tribe living just north of the
Sepik, and were traded to inhabitants of the river
villages.

This example was sent to the "Esposizione
Missionaria" of 1925.

J. P.

Unpublished.

158

MASK

Papua New Guinea (East Sepik Province);
 Kapriman or Kaningara people
Collected before 1932
Painted cane
Height, 27 ³/₁₆" (69 cm); maximum width, 11 ¹³/₁₆"
 (30 cm); depth, 27 ⁹/₁₆" (70 cm)
Pontificio Museo Missionario-Etnologico, Inv. no.
 AU 2265/A

This mask is made of cane woven over a wood-
en frame, and represents a mythological animal.
It includes a number of Sepik-area stylistic
features—the crested head; the relatively small
ears; the large, round eyes; the long nose; and

the mouth, wide open as if about to devour
someone or something. All of these elements
give the object a terrifying aspect. To emphasize
the extraordinary, unearthly strangeness of the
being represented, the mask is painted black and
white—the colors of the supernatural and of
life, respectively. Such masks were kept in men's
ceremonial houses and were taken out only dur-
ing initiation rites to teach initiates the tradi-
tions of the tribe.

Father Franz Kirschbaum, in notes on his
collection, said that, although woven masks of
this type were made exclusively by the Kapriman
and Kaningara peoples, they were used as well
by neighboring tribes, who either traded for or
stole them.

Father Kirschbaum gave this mask to the Vati-
can Museums in 1932.

J. P.

Unpublished.

240

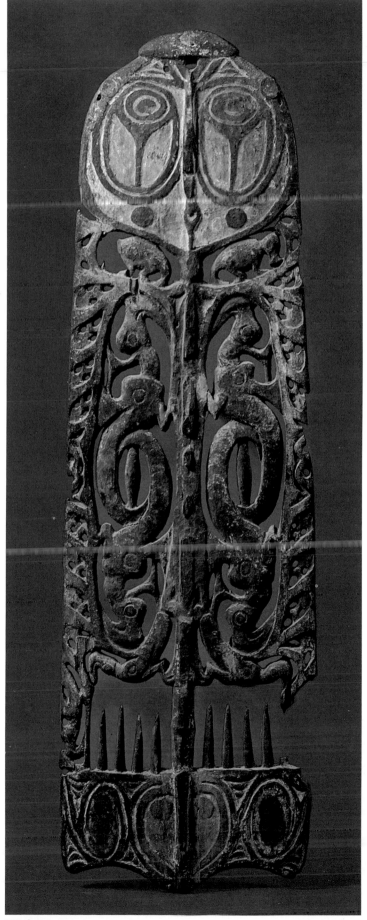

159 (front)

159 (back)

COLLEZIONE D'ARTE RELIGIOSA MODERNA

The collection of modern painting, sculpture, and graphic arts installed in 1973 in the Vatican Museums is composed of the gifts of contemporary artists and collectors. They are the most direct proof of art's "prodigious capacity for expressing, besides the human, the religious, the divine, the Christian." With these words, spoken on June 23, 1973, Pope Paul VI (1963–78) inaugurated the Vatican's newest collection, which now includes more than 500 works of art, signed by 250 artists, on display in 55 rooms in the Papal Palace (figs. 44, 45).

This event marked the end of an undertaking that began in the Sistine Chapel on May 7, 1964, at a meeting with artists requested by Paul VI. On that occasion the pope recalled the long tradition of friendship between artists and the Church, from which had arisen the artistic and spiritual patrimony that is mankind's universal heritage. The meeting place, itself, was the most moving evidence of this statement. Over the years this collaboration, said Pope Paul VI, seemed to have been interrupted: the themes of religious art had become tired repetitions of the past, and rules had been imposed on artists that did not leave room for free inventiveness. A clarification had become necessary: "We must again become allies. We must ask of you the possibilities which the Lord has given you and therefore, within the limits of the functionality and the finality which form a fraternal link between art and the worship of God, we must leave to your voices the free and powerful chant of which you are capable."

The response to this open invitation formulated by Paul VI for a rapprochement between the Church and art came from artists, collectors, corporations (both private and public), and various national committees, and was coordinated by Monsignor Pasquale Macchi, the pope's private secretary.

The difficult task of arranging a new museum in the limited space available in the interior of the Vatican palaces was resolved by the Vatican's General Management of Technical Services, which restored a series of spaces previously used as storage rooms and as living quarters, arranging the rooms around the nucleus provided by the old residences of the popes, from Nicholas III (1277–80) to Sixtus V (1585–90).

A selection of the works in this new collection comprised those previously given to the Holy See that had been exhibited in the Contemporary Art Section of the Pinacoteca. This section, inaugurated in 1960 during the papacy of John XXIII (1958–63), was the result of an initiative approved by Pius XII (1939–58) on December 28, 1956, and carried out

FIG. 44. ONE OF THE GALLERIES OF THE COLLEZIONE D'ARTE RELIGIOSA MODERNA, SHOWING THE BRONZE STATUE OF PAUL VI BY LELLO SCORZELLI (1965), *THE DEPOSITION* BY FELICE CARENA (1938–39), AND *THE SUPPER AT EMMAUS* BY PRIMO CONTI (1951)

FIG. 45. VIEW OF THE SALA DEI MISTERI, WITH SCULPTURES BY
LUCIO FONTANA, PERICLE FAZZINI, AND MARIO RUDELLI

by Monsignor Ennio Francia, the representative of the Unione Messa degli Artisti, and by an advisory commission operating in both Italy and France. Works of the School of Pont-Aven, given by Abbot Pierre Tuarze in 1963 and in 1966, were added to the original nucleus.

The task that followed, the arrangement of the Collection, was directed by Professor Dandolo Bellini, Honorary Inspector for Contemporary Religious Art. The undertaking was made difficult by the spaces available and by the lack of works, limiting, in part, the ability to apply chronological artistic development as a criterion for the installation. The current arrangement offers, by the express will of Paul VI, a panorama of today's art in relation to its capacity to express religious sentiment.

Within the range of its purposes, above all documentary in nature, the Collection established a program of exhibitions and seminars in collaboration with those organizations created in its preparatory phase. With the help of artists, "Evangelization and Art" (1974), a review centered on the theme of "The Face of Christ," was realized, as were the exhibitions "Saint Paul in Contemporary Art" (1977) and "Witness of the Spirit" (1979), both in homage to Paul VI's eightieth year.

In collaboration with the Friends of American Art in Religion, an active cultural association presided over by Terence Cardinal Cooke, Archbishop of New York, two seminars and related exhibitions were organized on the themes "The Influence of Spiritual Inspiration on American Art" (1976) and "Craft, Art, and Religion" (1978). In 1980, a large exhibition of American landscape art of the last one hundred and fifty years, entitled "A Mirror of Creation," was held.

The Collection's acquisitions during the past few years were exhibited to the public in 1980 in the Braccio di Carlo Magno, a large space behind Bernini's colonnade adjoining the basilica of Saint Peter's that has become the customary site for exhibitions organized by the Vatican Museums. These new works form a solid core of additions to the Collection and contribute effectively to the reduction of its imbalances, which are inevitable in a young museum.

Mario Ferrazza

160

ANDRÉ DERAIN (Châtou 1880–Paris 1954)
**THE CHURCH AT CARRIÈRES-
SAINT-DENIS**

1909
Oil on canvas
Height, 34 ⅝" (88 cm); width, 45 ¹¹/₁₆" (116 cm)
Signed, lower right
*Collezione d'Arte Religiosa Moderna, Gift of D. P.,
 Inv. no. ARM 23722*

This painting marks Derain's rupture with Fauvism and the beginning of his Cubist experiment, which, later, due to his temperament and culture, he abandoned in order to reelaborate the themes of the classical French tradition. During the summer of 1909, Derain stayed with Georges Braque in Carrières-Saint-Denis. Stimulated by the presence of his friend, who the previous year in L'Estaque had created—along with Picasso—the first Cubist landscapes, Derain painted with an inspiration clearly derived from Paul Cézanne, but with a geometric simplification of architec-

ture and a sobriety of palette, which he reduced to dense green, slate gray, and ocher tones.

Previously designated by the title *Châtou* (it appears thus in G. Hilaire, 1959), this work was given its current name by Madame Derain, who indicated that the painting had been done in Carrières-Saint-Denis (cf. the comment regarding a picture of the same subject in D. Sutton, *André Derain*, Cologne, 1960, ill. 23, p. 153).

M. F.

BIBLIOGRAPHY: G. Hilaire, *Derain*, Geneva, 1959, pl. 80.

161

CARLO CARRÀ (Quargnento
[Alessandria] 1881–Milan 1966)
THE DAUGHTERS OF LOT

1940
Oil on canvas
Height, 31 ½" (80 cm); width, 23 ⅝" (60 cm)
Signed and dated, lower left
*Collezione d'Arte Religiosa Moderna, Gift of Franco
 Marmont du Haut Champ, Inv. no. ARM 23713*

Carrà's third rendering of this theme was replanned during the years when his painting tended to shift in the direction of feeling and his color assumed clearer tones without, however, diluting his stylistic rigor and that restrained emotion, that immanence of drama, which remain the central motifs of his art.

The theme, taken from the Bible, has been known since the sixth century (see, for example, the miniature of the *Genesis* in Vienna), and was discussed by medieval and Counter-Reformation theologians, who held opposing opinions on the morality of the behavior of the two women (and, in general, of the women of Israel, who considered sterility the greatest shame) because they wanted to "preserve seed of [their] father" (Genesis 19:32). More explicit, in this regard, is the position of Saint Jerome: "Liberorum magis desiderio quam libidinis" ("More from desire to have children than from lust").

This subject, previously treated by Altdorfer, Guercino, Rubens, and Courbet, was first confronted by Carrà in 1919 after a metaphysical experience. He kept within the ideas upheld by *Valori plastici*, Mario Broglio's review (which gave its name to the artistic movement of the 1900s), and he directed his search toward the recovery

of the Italian traditions of the Trecento and the Quattrocento. Carrà's second version, of 1925, was destroyed by the artist in 1926. An engraving of it exists in the Scheiwiller Collection in Milan, and it was published by G. Raimondi in *Disegni di Carrà* (Milan, 1942).

M. F.

BIBLIOGRAPHY: P. Torriano, *Carrà*, Milan, 1942, colorplate XXXIX; R. Longhi, *Carrà*, 2nd ed., Milan, 1945, pl. XXXI; M. Carrà, *Carrà, tutta l'opera pittorica, II, 1931–50*, Milan, 1968, p. 695, pls. 37–40, p. 381, colorplate; P. Bigongiari and M. Carrà, *L'opera completa di Carrà* (Classici dell'Arte Rizzoli, 44), Milan, 1970, p. 103, ill. 317; G. Mascherpa, V. Mariani, and G. Fallani, *Collezione Vaticana d'Arte Religiosa Moderna*, Milan, 1974, p. 179, ill. 544; on the subject: L. Réau, *Iconographie de l'art chrétien*, Paris, 1956, II, p. 115.

162

OTTO DIX (Untermhaus 1891–Singen 1969)
CHRIST AND VERONICA

1943

Oil on panel
Height, 31 ⅞" (81 cm); width, 39 ⅜" (100 cm)
Signed with a monogram and dated, lower right
Collezione d'Arte Religiosa Moderna, Gift of D. P., Inv. no. ARM 23723

This painting belongs to Dix's "Christlicher Mystizismus" ("Christian Mysticism") period, that is, to the years from 1940 to 1946 in which the painter developed the themes of beauty and sweetness. They were vaguely indicated in the *Mother and Child* of 1932 and then more decisively confronted, ten years later, in his images of the Madonna in *The Nativity of Christ* and *The Rest on the Flight into Egypt*, and in the small angelic figure of Saint Veronica who wipes the sweat of Christ on the Via Crucis.

The attenuation of the violence of the images and the less corrosive drawing in works from this period, when compared with Dix's previous art, have resulted in some critics considering this phase as one of lessened moral commitment by the artist, who, on the contrary—with a different style—kept unchanged his condemnation of a society that observes from the sidelines the unfolding of a tragedy.

The work is also known by the title *The Bearing of the Cross*.

M. F.

BIBLIOGRAPHY: O. Conzelmann, *Otto Dix*, Hanover, 1959, pp. 55–56; F. Löffler, *Otto Dix, Leben und Werk*, Vienna and Munich, 1967, p. 111.

163

GEORGES ROUAULT (Paris 1871–1958)
THE HOLY FACE (SAINTE FACE)
c. 1946
Oil on cardboard
Height, 20⅛" (51 cm); width, 14 9/16" (37 cm)
Signed, lower left
Collezione d'Arte Religiosa Moderna, Gift of Isabelle
Rouault, Paris, Inv. no. ARM 23690 (ex 554)

Rouault's Christian feeling is revealed in its purest
and most powerful form in his explorations of the
Passion of Christ, a theme that symbolizes the
suffering of all humanity. The artist, once de-
scribed as "the only Christian who has realized
in his painting the drama of our times" (P.
Courthion, 1964), turned to this subject in 1912
(Hahnloser Collection in Winterthur), in 1933
(Musée National d'Art Moderne in Paris), and in
the 1950s—these last versions produced with
the full resources of his mature years.

The present work is, perhaps, the most mov-
ing example because of the intense plasticity of
the face and the insistence, on the part of the
painter, upon a subject matter that appears
charged with an inner luminosity all its own.
When the painting was adapted for a large tap-
estry (now in the church in Hem, France), the
richness of the impasto, an evocative device in
Rouault's art, proved difficult for the tapestry
weaver, J. Plasse-le-Caisne, to capture. He re-
called the process during a memorial service in
homage to Rouault at the Centre Catholique des
Intellectuels Français in Paris, on May 19, 1958,
two months after the painter's death (cf. P.
Courthion, 1964, n. 451).

From 1937 on, Rouault virtually stopped dat-
ing his art, although he continued to collect
newspaper clippings about himself and his work.
These have provided Pierre Courthion, his friend,
with a rare form of documentation on which to
base his critical analyses of the artist.

M. F.

BIBLIOGRAPHY: P. Courthion, *Rouault. La vita e l'opera*,
Milan, 1964, pp. 252, 255, colorplate; *idem*, in *Hommage
à Georges Rouault*, Paris, 1971, pp. 66, 78, colorplate; W.
George and G. Nouaille Rouault, *L'Univers de Rouault*, Paris,
1971; N. Possenti Ghiglia, in *Rouault*, Ancona, 1977, p.
173; M. Ferrazza, "Reparto d'arte dell'ottocento e contem-
poranea: Allestimenti," in *Bollettino dei Monumenti Musei e
Gallerie Pontificie*, II, 1981, p. 151, ill. p. 152.

GRAHAM SUTHERLAND (London 1903–1980)
STUDY FOR THE CRUCIFIXION
1947
Oil on Masonite
Height, 40 3/16" (102 cm); width, 48 1/16" (122 cm)
Unsigned and undated
Collezione d'Arte Religiosa Moderna, Gift of Cardinal Alberto di Jorio, Inv. no. ARM 23591 (ex 443)

The present study is no less moving than the *Crucifixion* of 1946, commissioned by Canon W. Hussey in 1944 for the church of Saint Matthew in Northampton, England (the same church for which Henry Moore executed a serene *Madonna and Child*, from 1943 to 1944).

As Giorgio Testori, the Italian art critic and author, recounts, "When I asked him why, then, he had chosen the theme of the 'Crucifixion' for the large altarpiece in Northampton, rather than the proposed theme of 'Christ in Gethsemane,' Sutherland replied: 'Because it is the most tragic of themes and, at the same time, the only one which contains the promise of Salvation.'"

For Sutherland, this dual inspiration remained constant, giving rise to successive interpretations of the subject—that of 1947 (Evill Collection in London) and the imposing altarpiece of 1960–61 (for Saint Aidan's Church in London)—images of the martyred body of Christ of such tragic solemnity, and rendered with such expressive force, that they immediately recall related art of the Cinquecento, as well as Matthias Grünewald's *Isenheim Altarpiece*.

M. F.

BIBLIOGRAPHY: D. Cooper, *The Work of Graham Sutherland*, London, 1961; A. Henze, *Das christliche Thema in der modernen Malerei*, Heidelberg, 1965, p. 59, pl. p. 213; F. Arcangeli, *Graham Sutherland*, Milan, 1973; G. Mascherpa, V. Mariani, and G. Fallani, *Collezione Vaticana d'Arte Religiosa Moderna*, Milan, 1974, p. 146, colorplate 77 p. 129; G. Testori, "Graham Sutherland. La dolcezza e le spine," in *Corriere della Sera*, Milan, February 17, 1981, p.3.

MARIO SIRONI (Sassari 1885–Milan 1961)
CHRIST AND THE SAMARITAN WOMAN
1947–48
Oil on panel
Height, 22 1/16" (56 cm); width, 27 9/16" (70 cm)
Signed, lower right
Collezione d'Arte Religiosa Moderna, Gift of Cardinal Alberto di Jorio, Inv. no. ARM 23575 (ex 51)

The subject, from the Gospel of Saint John (4:1–30), tells of Christ's meeting with the Samaritan woman, near Jacob's well. The effective symbolism of the allegory, the living water of Baptism—that is, Truth and Grace—is found in Christian art from the first frescoes in the catacombs as well as in medieval and modern art, its fixed iconography allowing only modest

changes in the arrangement of the two figures: they are seated at the edge of the well in the Oriental tradition (more faithful to Saint John's text), or arranged symmetrically at the sides of the well in the Occidental tradition.

By emphasizing the light and almost obliterating the pictorial image, the artist conveys the gist of the conversation and the intimacy of the meeting. Sironi's particular interpretation of the story was an outgrowth of that natural religious bent that, in the years following World War II, succeeded in attenuating his dramatic vision.

M. F.

BIBLIOGRAPHY: M. Valsecchi, *Mario Sironi*, Rome, 1962, p. 121, pl. 65; G. Mascherpa, V. Mariani, and G. Fallani, *Collezione Vaticana d'Arte Religiosa Moderna*, Milan, 1974, p. 105, colorplate 119; E. Camesasca and C. Gian Ferrari, *Mario Sironi, Scritti editi e inediti*, Milan, 1980, p. 456.

166

BEN SHAHN (Kovno, Lithuania 1898–New York 1969)

THIRD ALLEGORY

1955
Watercolor and tempera on paper, mounted on Masonite
Height, 39 3/16" (99.5 cm); width, 25 3/8" (64.5 cm)
Signed, lower right
Collezione d'Arte Religiosa Moderna, Gift of Mr. and Mrs. H. Garfinkle, Miami, Inv. no. ARM 23570 (ex 366)

The *Third Allegory* is rich in the imagery that recurs throughout Shahn's work, and, perhaps, best illustrates the meaning of an allegory—the recall of ancient events. The symbolism of man's terror in front of the flames, embodied in the chimerical beast that appears in the first version of the work (of 1948), grew out of the artist's deep emotion at the death of four black children in a fire in Chicago. Shahn explored the subject again, in 1953, in the *Second Allegory*, where the terror suggests infernal fire; it is reelaborated upon, here, in an absolutely personal and fanciful way.

More explicit in Shahn's work are the references to the artist's early childhood spent in Russian Lithuania, and his felicitous attachment to Hebraic themes; these became inspirational motifs for redesigning the letters of the alphabet (a very fine version of which appears in the silk screen *Decalogue*, of 1961) and for his series of musicians with ancient instruments, illustrating Psalm 150. The latter were preparatory drawings for a mosaic mural for the Jewish community of Rockville, Maryland, but the mural was not executed due to the death of the artist. The drawings were published posthumously in the *Hallelujah Suite* (1969–70).

M. F.

BIBLIOGRAPHY: M. Bentivoglio, *Ben Shahn*, Rome, 1963, p. 62, colorplate 3; J. T. Soby, *Ben Shahn*, Milan, 1963, pp. 141–42, pl. 152, p. 208; A. Del Guercio, *Ben Shahn, La forma e il contenuto; opere scelte*, Rome, 1964, colorplate; B. Bryson Shahn, *Ben Shahn*, New York, n.d. (1972), pp. 233, 257, colorplate p. 261 (the caption that appears here was erroneously switched with that of the work on p. 256); G. Mascherpa, V. Mariani, and G. Fallani, *Collezione Vaticana d'Arte Religiosa Moderna*, Milan, 1974, p. 171, colorplate 102, p. 154.

HENRI MATISSE (Le Cateau-Cambrésis
1869–Nice 1954)
THE TREE OF LIFE (L'ARBRE DE VIE)
1949
Cut and painted paper on cardboard
Height, 16' 9⅝" (512 cm); width, 8' 2¼"
 (252 cm)
Unsigned
Collezione d'Arte Religiosa Moderna, Inv. no. ARM
 23757–23758

This collage of *papiers découpés* is the final, full-size maquette for the stained-glass window in the apse of the Chapel of the Rosary of the Dominican Sisters of Vence. Employing a technique that he had experimented with already in his studies for designs for the decorative arts, Matisse had large sheets of paper prepared with only three colors of gouache paint: lemon yellow, light green, and ultramarine. From these, he cut out a series of free-form floral motifs, which he then assembled and pasted onto a separate sheet of paper.

The chapel afforded the artist the opportunity to realize "the creation of a religious space" (cf. N. Calmels, 1975, p. 150). Not only did Matisse conceive of the decoration, but he designed the sacred furnishings and the architecture, as well. At the consecration of the chapel, in 1951, Matisse explained, "This work has taken me four years of exclusive and assiduous work, and it represents the result of my entire active life. I consider it, in spite of its imperfections, to be my masterpiece" (A. H. Barr, Jr., 1951, p. 287).

This maquette, along with the plans for the stained-glass windows in the left aisle of the nave and in the choir; the series of five silk chasubles with liturgical motifs; and the designs and preliminary studies for the *Virgin and Child*, in the right aisle of the nave, are part of the Vatican Collection. (The stained-glass windows in Vence were executed by Paul Bony.) Together, they are a unique statement of the strong commitment of a great modern artist to religious art.

M. F.

BIBLIOGRAPHY: A. H. Barr, Jr., *Matisse, His Art and His Public*, New York, 1951; G. Diehl, *Henri Matisse*, Paris, 1954; H. Matisse, *Chapelle du Rosaire des Dominicaines de Vence*, Vence, 1963 ed.; G. Marchiori, *Matisse*, Milan, n.d. (1965); J. Lassaigne, *Matisse*, Ital. ed., Geneva, 1966; A. Verdet, "Architecture et Décoration," in *Hommage à Henri Matisse*, Paris, 1970, p. 74; G. Mascherpa, V. Mariani, and G. Fallani, *Collezione Vaticana d'Arte Religiosa Moderna*, Milan, 1974; N. Calmels, *Matisse: La Chapelle du Rosaire des Dominicaines de Vence et de l'Espoir*, Digne, 1975; J. Cowart, intro. to *Henri Matisse Paper Cut-Outs*, New York, 1977.

168

GIACOMO MANZÙ (Bergamo 1908–)
ADOLESCENCE (PORTRAIT OF FRANCESCA BLANC)

1940–41
Bronze
Height, 38 ⅜" (97 cm); width, 15 ¾" (40 cm); depth, 22 ⅞" (58 cm)
Signed, below the left foot
Collezione d'Arte Religiosa Moderna, Gift of Anita Blanc, Rome, Inv. no. ARM 23319 (ex 557)

The female figure, instilled with an emotional charge all Manzù's own, recurs throughout his art. As the artist explained in a letter of November 12, 1979, to Monsignor Donato de Bonis, Francesca "was a child of thirteen or fourteen. I asked her mother to let me see her nude, and she kindly allowed her to undress, and I saw her as flowers are seen in the spring. A short time later I returned to Rome and began the portrait, which I think I finished in 1941, happy to have made this flower without leaves, because the soul is nourished by the purity of child-like beauty."

A first version of this subject, from 1940, is now in the Raccolta Amici di Manzù in Ardea, Italy. It was redesigned in the two models now in the Pezzotta Collection in Bergamo (cf. L. Bartolini, 1944, and C. L. Ragghianti, 1957, pls. 11, 29, respectively), and was elaborated upon once again in this final version, presented at the IV Quadriennale Nazionale d'Arte in Rome, where it won the Grand Prize for sculpture in 1943.

The image of Francesca continued to exercise a strong influence on Manzù. In 1953, it was the subject of a series of drawings exhibited in Turin but later destroyed by the artist—except for a few examples that had been "rashly given as gifts" (Manzù, himself, recalls this).

M. F.

BIBLIOGRAPHY: N. Bertocchi, *Manzù*, Milan, 1943, pl. 30; M. Venturoli, *Viaggio intorno alla Quadriennale*, Rome, 1943, p. 53, pl. p. 61; L. Bartolini, *Manzù*, Rovereto, 1944, p. 21, pl. 13; A. Pacchioni, *G. Manzù*, Milan, 1948, p. 19, pl. 35; E. Hüttinger, *Giacomo Manzù*, Amriswil, Switzerland, 1956, p. 8, pl. 7; C. L. Ragghianti, *Giacomo Manzù*, Milan, 1957, p. 23, pl. 36; M. Carrà, *I maestri della scultura, Giacomo Manzù*, Milan, 1966, colorplate IV (erroneously given as Collection Pio Manzù); M. De Micheli, *Giacomo Manzù*, Milan, 1971, p. 16, colorplate 26; M. Ferrazza, "Reparto d'arte dell'ottocento e contemporanea: Allestimenti," in *Bollettino dei Monumenti Musei e Gallerie Pontificie*, II, 1981, pp. 151–52, ill. p. 155.

SAINT PETER AND HIS SUCCESSORS

This list of popes and antipopes is derived from one compiled by A. Mercati in 1947 under the auspices of the Vatican, though some changes have been made on the basis of recent scholarship and the list has been brought up to date. The dates of each pope's reign follow his name; for popes after the end of the Great Schism (1378–1417), family names are given as well. The names of antipopes are enclosed in brackets, while alternative numberings of papal names appear in parentheses.

SAINT PETER (67)
SAINT LINUS (67–76)
SAINT ANACLETUS (CLETUS) (76–88)
SAINT CLEMENT I (88–97)
SAINT EVARISTUS (97–105)
SAINT ALEXANDER I (105–15)
SAINT SIXTUS I (115–25)
SAINT TELESPHORUS (125–36)
SAINT HYGINUS (136–40)
SAINT PIUS I (140–55)
SAINT ANICETUS (155–66)
SAINT SOTER (166–75)
SAINT ELEUTHERIUS (175–89)
SAINT VICTOR I (189–99)
SAINT ZEPHYRINUS (199–217)
SAINT CALLISTUS I (217–22)
[SAINT HIPPOLYTUS (217–35)]
SAINT URBAN I (222–30)
SAINT PONTIANUS (230–35)
SAINT ANTERUS (235–36)
SAINT FABIAN (236–50)
SAINT CORNELIUS (251–53)
[NOVATIAN (251)]
SAINT LUCIUS I (253–54)
SAINT STEPHEN I (254–57)
SAINT SIXTUS II (257–58)
SAINT DIONYSIUS (259–68)
SAINT FELIX I (269–74)
SAINT EUTYCHIAN (275–83)
SAINT GAIUS (CAIUS) (283–96)
SAINT MARCELLINUS (296–304)
SAINT MARCELLUS I (308–9)
SAINT EUSEBIUS (309)
SAINT MILTIADES (311–14)
SAINT SILVESTER I (314–35)
SAINT MARK (336)
SAINT JULIUS I (337–52)

LIBERIUS (352–66)
[FELIX II (355–65)]
SAINT DAMASUS I (366–84)
[URSINUS (366–67)]
SAINT SIRICIUS (384–99)
SAINT ANASTASIUS I (399–401)
SAINT INNOCENT I (401–17)
SAINT ZOSIMUS (417–18)
SAINT BONIFACE I (418–22)
[EULALIUS (418–19)]
SAINT CELESTINE I (422–32)
SAINT SIXTUS III (432–40)
SAINT LEO I (440–61)
SAINT HILARY (461–68)
SAINT SIMPLICIUS (468–83)
SAINT FELIX III (II) (483–92)
SAINT GELASIUS I (492–96)
ANASTASIUS II (496–98)
SAINT SYMMACHUS (498–514)
[LAWRENCE (498; 501–5)]
SAINT HORMISDAS (514–23)
SAINT JOHN I (523–26)
SAINT FELIX IV (III) (526–30)
BONIFACE II (530–32)
[DIOSCORUS (530)]
JOHN II (533–35)
SAINT AGAPITUS I (535–36)
SAINT SILVERIUS (536–37)
VIGILIUS (537–55)
PELAGIUS I (556–61)
JOHN III (561–74)
BENEDICT I (575–79)
PELAGIUS II (579–90)
SAINT GREGORY I (590–604)
SABINIAN (604–6)
BONIFACE III (607)
SAINT BONIFACE IV (608–15)

SAINT DEUSDEDIT I (615–18)
BONIFACE V (619–25)
HONORIUS I (625–38)
SEVERINUS (640)
JOHN IV (640–42)
THEODORE I (642–49)
SAINT MARTIN I (649–55)
SAINT EUGENE I (654–57)
SAINT VITALIAN (657–72)
DEUSDEDIT II (672–76)
DONUS (676–78)
SAINT AGATHO (678–81)
SAINT LEO II (682–83)
SAINT BENEDICT II (684–85)
JOHN V (685–86)
CONON (686–87)
[THEODORE (687)]
[PASCHAL (687)]
SAINT SERGIUS I (687–701)
JOHN VI (701–5)
JOHN VII (705–7)
SISINNIUS (708)
CONSTANTINE (708–15)
SAINT GREGORY II (715–31)
SAINT GREGORY III (731–41)
SAINT ZACHARY (741–52)
STEPHEN (752)
STEPHEN II (III) (752–57)
SAINT PAUL I (757–67)
[CONSTANTINE (767–69)]
[PHILIP (768)]
STEPHEN III (IV) (768–72)
ADRIAN I (772–95)
SAINT LEO III (795 816)
STEPHEN IV (V) (816–17)
SAINT PASCHAL I (817–24)
EUGENE II (824–27)
VALENTINE (827)
GREGORY IV (827–44)
[JOHN (844)]
SERGIUS II (844–47)
SAINT LEO IV (847–55)
BENEDICT III (855–58)
[ANASTASIUS (855)]
SAINT NICHOLAS I (858–67)
ADRIAN II (867–72)
JOHN VIII (872–82)
MARINUS I (882–84)
SAINT ADRIAN III (884–85)
STEPHEN V (VI) (885–91)
FORMOSUS (891–96)
BONIFACE VI (896)
STEPHEN VI (VII) (896–97)
ROMANUS (897)
THEODORE II (897)
JOHN IX (898–900)
BENEDICT IV (900–903)

LEO V (903)
[CHRISTOPHER (903–4)]
SERGIUS III (904–11)
ANASTASIUS III (911–13)
LANDO (913–14)
JOHN X (914–28)
LEO VI (928)
STEPHEN VII (VIII) (928–31)
JOHN XI (931–35)
LEO VII (936–39)
STEPHEN VIII (IX) (939–42)
MARINUS II (942–46)
AGAPETUS II (946–55)
JOHN XII (955–64)
LEO VIII (963–65)
BENEDICT V (964–66)
JOHN XIII (965–72)
BENEDICT VI (973–74)
[BONIFACE VII (974; 984–85)]
BENEDICT VII (974–83)
JOHN XIV (983–84)
JOHN XV (985–96)
GREGORY V (996–99)
[JOHN XVI (997–98)]
SILVESTER II (999–1003)
JOHN XVII (1003)
JOHN XVIII (1004–9)
SERGIUS IV (1009–12)
BENEDICT VIII (1012–24)
[GREGORY (1012)]
JOHN XIX (1024–32)
BENEDICT IX (1032–44)
SILVESTER III (1045)
BENEDICT IX (1045)
GREGORY VI (1045–46)
CLEMENT II (1046–47)
BENEDICT IX (1047–48)
DAMASUS II (1048)
SAINT LEO IX (1049–54)
VICTOR II (1055–57)
STEPHEN IX (X) (1057–58)
[BENEDICT X (1058–59)]
NICHOLAS II (1059–61)
ALEXANDER II (1061–73)
[HONORIUS II (1061–72)]
SAINT GREGORY VII (1073–85)
[CLEMENT III (1080; 1084–1100)]
BLESSED VICTOR III (1086–87)
BLESSED URBAN II (1088–99)
PASCHAL II (1099–1118)
[THEODORIC (1100)]
[ALBERT (1102)]
[SILVESTER IV (1105–11)]
GELASIUS II (1118–19)
[GREGORY VIII (1118–21)]
CALLISTUS II (1119–24)
HONORIUS II (1124–30)

[CELESTINE II (1124)]
INNOCENT II (1130–43)
[ANACLETUS II (1130–38)]
[VICTOR IV (1138)]
CELESTINE II (1143–44)
LUCIUS II (1144–45)
BLESSED EUGENE III (1145–53)
ANASTASIUS IV (1153–54)
ADRIAN IV (1154–59)
ALEXANDER III (1159–81)
[VICTOR IV (1159–64)]
[PASCHAL III (1164–68)]
[CALLISTUS III (1168–78)]
[INNOCENT III (1179–80)]
LUCIUS III (1181–85)
URBAN III (1185–87)
GREGORY VIII (1187)
CLEMENT III (1187–91)
CELESTINE III (1191–98)
INNOCENT III (1198–1216)
HONORIUS III (1216–27)
GREGORY IX (1227–41)
CELESTINE IV (1241)
INNOCENT IV (1243–54)
ALEXANDER IV (1254–61)
URBAN IV (1261–64)
CLEMENT IV (1265–68)
BLESSED GREGORY X (1271; 1272–76)
BLESSED INNOCENT V (1276)
ADRIAN V (1276)
JOHN XXI (1276–77)
NICHOLAS III (1277–80)
MARTIN IV (1281–85)
HONORIUS IV (1285–87)
NICHOLAS IV (1288–92)
SAINT CELESTINE V (1294)
BONIFACE VIII (1294; 1295–1303)
BLESSED BENEDICT XI (1303–4)
CLEMENT V (1305–14)
JOHN XXII (1316–34)
[NICHOLAS V (1328–30)]
BENEDICT XII (1335–42)
CLEMENT VI (1342–52)
INNOCENT VI (1352–62)
BLESSED URBAN V (1362–70)
GREGORY XI (1370; 1371–78)
URBAN VI (1378–89)
BONIFACE IX (1389–1404)
INNOCENT VII (1404–6)
GREGORY XII (1406–15)
[CLEMENT VII (1378–94)]
[BENEDICT XIII (1394–1423)]
[ALEXANDER V (1409–10)]
[JOHN XXIII (1410–15)]
MARTIN V (COLONNA, 1417–31)
EUGENE IV (CONDULMER, 1431–47)
[FELIX V (1439; 1440–49)]

NICHOLAS V (PARENTUCELLI, 1447–55)
CALLISTUS III (BORGIA, 1455–58)
PIUS II (PICCOLOMINI, 1458–64)
PAUL II (BARBO, 1464–71)
SIXTUS IV (DELLA ROVERE, 1471–84)
INNOCENT VIII (CIBO, 1484–92)
ALEXANDER VI (BORGIA, 1492–1503)
PIUS III (TODESCHINI-PICCOLOMINI, 1503)
JULIUS II (DELLA ROVERE, 1503–13)
LEO X (MEDICI, 1513–21)
ADRIAN VI (FLORENSZ, 1522–23)
CLEMENT VII (MEDICI, 1523–34)
PAUL III (FARNESE, 1534–49)
JULIUS III (CIOCCHI DEL MONTE, 1550–55)
MARCELLUS II (CERVINI, 1555)
PAUL IV (CARAFA, 1555–59)
PIUS IV (MEDICI, 1559; 1560–65)
SAINT PIUS V (GHISLIERI, 1566–72)
GREGORY XIII (BONCOMPAGNI, 1572–85)
SIXTUS V (PERETTI, 1585–90)
URBAN VII (CASTAGNA, 1590)
GREGORY XIV (SFONDRATI, 1590–91)
INNOCENT IX (FACCHINETTI, 1591)
CLEMENT VIII (ALDOBRANDINI, 1592–1605)
LEO XI (MEDICI, 1605)
PAUL V (BORGHESE, 1605–21)
GREGORY XV (LUDOVISI, 1621–23)
URBAN VIII (BARBERINI, 1623–44)
INNOCENT X (PAMPHILI, 1644–55)
ALEXANDER VII (CHIGI, 1655–67)
CLEMENT IX (ROSPIGLIOSI, 1667–69)
CLEMENT X (ALTIERI, 1670–76)
BLESSED INNOCENT XI (ODESCALCHI, 1676–89)
ALEXANDER VIII (OTTOBONI, 1689–91)
INNOCENT XII (PIGNATELLI, 1691–1700)
CLEMENT XI (ALBANI, 1700–1721)
INNOCENT XIII (CONTI, 1721–24)
BENEDICT XIII (ORSINI, 1724–30)
CLEMENT XII (CORSINI, 1730–40)
BENEDICT XIV (LAMBERTINI, 1740–58)
CLEMENT XIII (REZZONICO, 1758–69)
CLEMENT XIV (GANGANELLI, 1769–74)
PIUS VI (BRASCHI, 1775–99)
PIUS VII (CHIARAMONTI, 1800–1823)
LEO XII (DELLA GENGA, 1823–29)
PIUS VIII (CASTIGLIONI, 1829–30)
GREGORY XVI (CAPPELLARI, 1831–46)
PIUS IX (MASTAI-FERRETTI, 1846–78)
LEO XIII (PECCI, 1878–1903)
SAINT PIUS X (SARTO, 1903–14)
BENEDICT XV (DELLA CHIESA, 1914–22)
PIUS XI (RATTI, 1922–39)
PIUS XII (PACELLI, 1939–58)
JOHN XXIII (RONCALLI, 1958–63)
PAUL VI (MONTINI, 1963–78)
JOHN PAUL I (LUCIANI, 1978)
JOHN PAUL II (WOJTYLA, 1978–)

CONTRIBUTORS
TO THE
CATALOGUE

R. S. B. **ROBERT S. BIANCHI**
Associate Curator, Department of Egyptian and
Classical Art, The Brooklyn Museum, Brooklyn,
New York

B. D. B. **BARBARA DRAKE BOEHM**
Senior Administrative Assistant, Department of
Medieval Art, The Metropolitan Museum of
Art, New York

D. v. B. **DIETRICH von BOTHMER**
Chairman, Department of Greek and Roman
Art, The Metropolitan Museum of Art, New
York

K. R. B. **KATHARINE REYNOLDS BROWN**
Senior Research Associate, Department of
Medieval Art, The Metropolitan Museum of
Art, New York

G. D. **GEORG DALTROP**
Curator of Classical Antiquities, Monumenti
Musei e Gallerie Pontificie, Vatican City

J. D. D. **JAMES DAVID DRAPER**
Associate Curator, Department of European
Sculpture and Decorative Arts, The Metropoli-
tan Museum of Art, New York

D. MacK. E. **DAVID MacKINNON EBITZ**
Assistant Professor, Department of the History
of Art, University of Maine, Orono

M. F. **MARIO FERRAZZA**
Curator of Contemporary Art, Monumenti
Musei e Gallerie Pontificie, Vatican City

E. F. **ENNIO FRANCIA**
Monsignor, Canon, Capitolo di San Pietro in
Vaticano, Vatican City

A. F. **ALFRED FRAZER**
Professor, Department of Art History and
Archaeology, Columbia University, New York

M. E. F. **MARGARET ENGLISH FRAZER**
Curator, Department of Medieval Art, The Met-
ropolitan Museum of Art, New York

C. G-M. **CARMEN GÓMEZ-MORENO**
Curator, Department of Medieval Art, The Met-
ropolitan Museum of Art, New York

C. T. L. **CHARLES T. LITTLE**
Associate Curator, Department of Medieval Art,
The Metropolitan Museum of Art, New York

F. M. **FABRIZIO MANCINELLI**
Curator of Byzantine, Medieval, and Modern
Art, Monumenti Musei e Gallerie Pontificie,
Vatican City

I. DI S. M. **IVAN DI STEFANO MANZELLA**
Assistant Professor, University of Rome

G. M. **GIOVANNI MORELLO**
Curator, Musei Sacro and Profano, Biblio-
teca Apostolica Vaticana, Vatican City

J. P. **JOZEF PENKOWSKI**
Reverend, Curator of the Ethnological Collec-
tions, Monumenti Musei e Gallerie Pontificie,
Vatican City

C. P. **CARLO PIETRANGELI**
Director General, Monumenti Musei e Gallerie
Pontificie, Vatican City

O. R. **OLGA RAGGIO**
Chairman, Department of European Sculpture
and Decorative Arts, The Metropolitan Mu-
seum of Art, New York

F. R. **FRANCESCO RONCALLI**
Professor of Archaeology, University of Perugia,
and former Curator of Etruscan Antiquities,
Monumenti Musei e Gallerie Pontificie, Vati-
can City

C. S. **CHRISTIAN STURTEWAGEN, S. J.**
Professor of Biblical Studies, Pontificio Istituto
Biblico, Rome

W. D. W. **WILLIAM D. WIXOM**
Chairman, Department of Medieval Art and
The Cloisters, The Metropolitan Museum of Art,
New York

G. Z. **GIUSEPPE ZANDER**
Architect, Director, Ufficio Tecnico, Reverenda
Fabbrica di San Pietro in Vaticano, Vatican City

PHOTOGRAPH CREDITS

All color photographs, including those for the frontispiece and the cover/jacket, were provided by Scala, Istituto Editoriale, Florence, with the exception of the following: entries 1, 6, 9, 22, 23, 24, 33: Saskia Ltd., Littleton, Colorado; 2 B: Reverenda Fabbrica di San Pietro, Vatican City; 9, 34, 35, 37, 38, 39, 41, 45, 46, 47, 48, 49, 50, 52, 53: Biblioteca Apostolica Vaticana, Archivio Fotografico, Vatican City; 101: Musei Vaticani, Archivio Fotografico, Vatican City; figures 18, 26: Editorial Photocolor Archives, Inc., New York.

All black-and-white photographs were provided by Scala, Istituto Editoriale, Florence, with the exception of the following: entries 10: Reverenda Fabbrica di San Pietro, Vatican City; 11, 92: Musei Vaticani, Archivio Fotografico, Vatican City; 12: The Metropolitan Museum of Art Photograph Studio, New York; 36, 40 (detail), 42, 43, 44, 45, 46, 51, 123: Biblioteca Apostolica Vaticana, Archivio Fotografico, Vatican City; figures 1, 4, 9, 10, 11, 20, 21, 28, 29, 35, 36, 38, 39, 40, 41, 42, 43, 44, 45: Musei Vaticani, Archivio Fotografico, Vatican City; 2: Rijksmuseum, Amsterdam; 3: The British Library, London; 5: Biblioteca Comunale, Fermo; 6: Foto Oscar Savio, Rome; 7: Nationalmuseum, Stockholm; 8: Photo L. Ionesco, *Réalités*, Paris; 12, 27, 30, 31, 32, 33: Biblioteca Apostolica Vaticana, Archivio Fotografico, Vatican City; 13: Reverenda Fabbrica di San Pietro, Vatican City; 14, 22: The Metropolitan Museum of Art Photograph Studio, New York; 15, 16, 17, 23, 25: Alinari, Florence; 19: Warburg Institute, London; 34: Musée National de Céramique, Sèvres; 37: Anderson, Rome.

Composition by U.S. Lithograph, Inc., New York

Printed and bound by The Arts Publisher, Inc., Richmond and New York